MADISON

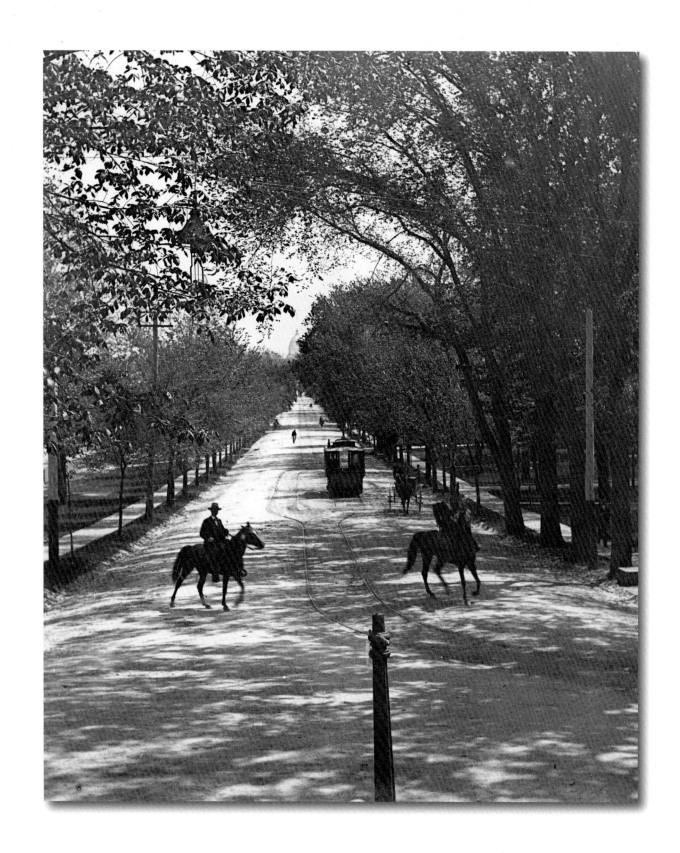

MADISON

The Illustrated Sesquicentennial History, Volume 1

1856–1931

Stuart D. Levitan

The University of Wisconsin Press

The University of Wisconsin Press
1930 Monroe Street
Madison, Wisconsin 53711

www.wisc.edu/wisconsinpress/

3 Henrietta Street
London WC2E 8LU, England

Printed in Canada

Many of the illustrations used in this book come from the University of Wisconsin Archive
and the Visual Materials Archive of the Wisconsin Historical Society. All illustrations will be
attributed in the captions except those in the public domain. All illustrations from the
Wisconsin Historical Society will be designated by the initials WHi and the image
identification number.

Cover and interior design by Jane Tenenbaum

Library of Congress Cataloging-in-Publication Data
Levitan, Stuart D.
Madison : the illustrated sesquicentennial history / Stuart D. Levitan.
v. cm.
Includes bibliographical references.
Contents: v. 1. 1856–1931
ISBN 0-299-21674-8 (pbk. : alk. paper)
1. Madison (Wis.)—History. 2. Madison (Wis.)—History—Pictorial works. I. Title.

F589.M157L48 2006
977.5'83—dc22 2006024421

Cover photograph: Air View of the Isthmus (detail from WHi-10328)
Cover insets: Eight of the era's most significant Madisonians (from left), James Duane Doty
(WHi-11337), Rosaline Peck (WHi-3941), Leonard J. Farwell (WHi-11334), William F. Vilas
(WHi-37831), John Johnson, John Bascom (University of Wisconsin Archives), John Olin
(University of Wisconsin Archives), William T. Evjue (The Capital Times)
Frontispiece: State Street, 1896 (WHi-1893)

The University of Wisconsin Press and the author gratefully acknowledge the generous support
of the following donors in making this book possible:
Madison Gas & Electric Foundation, Inc.
The Evjue Foundation, Inc., the charitable arm of The Capital Times
Spectrum Brands, Inc.
Madison Arts Commission with additional funds from the Wisconsin Arts Board
Daniel W. Erdman Foundation
CUNA Mutual Group Foundation
Madison Trust for Historic Preservation
Historic Madison, Inc.

CONTENTS

For my family and my city,
with love and thanks

Where there is no vision, the people perish.

—Proverbs 29:18

All the years combine, they melt into a dream.

—Robert Hunter, "Stella Blue"

PREFACE

This is the illustrated history of Madison's first century, more or less, from the perspective of a journalist/plan commissioner/politician. It's a picture book about political developments and the built environment, and how they came to be that way.

It's neither an encyclopedia nor a social history; it's more a municipal yearbook, showing the city's events and people through time.

The past matters because the past lives; land use and development decisions made before the city even existed have set our fundamental reality to this day, and evermore. I hope that by looking at, and learning about, that past, readers will better understand their present—and with that understanding, will better appreciate how acts today will shape the future.

A book about politics and development is a book about the people with power and capital. For Madison in these years, as for almost all America, the people with power and capital were exclusively white men. So a history book like this will seem sexist, racist, and classist, because it is—as was the history itself. Certainly, women, minorities, and the working class have always been essential elements in the life of Madison, but only a few of their tales fit the focus of this work. This book is about those who had the means and motive to make things happen, and what happened when they did.

The University of Wisconsin has had great history professors for over a hundred years, from Turner to Cronon, with Williams, Goldberg, and Mosse in between; regrettably, I never had the chance to study with any of them. So I lack a full understanding of true historical forces, other than to accept Hegel's notion of History as the Idea moving through Time.

But I think the Idea acts though individuals. As the namesake of a Madison school (page 196) wrote, "Biography is the only true history." I do understand, of course, the significance of broad economic conditions, commercial and technological developments, and national events. But beyond those underlying conditions, I see individuals with unique impact. These are some of their stories. Stories of our mayors and other movers and shakers. Stories of industrialists and journalists and activists. Stories of those after whom so many streets and parks and buildings, even neighborhoods, are named. Stories of the University of Wisconsin, the single greatest influence in city history, and stories of its presidents—often as important to the city as the mayor, sometimes more so (and almost always more interesting). Given the university's overwhelming impact on the city's economic, intellectual, political, cultural, land use, and housing development, I hope the reader does not find excessive this attention to matters technically non-municipal.

Both on campus and off, I hope to give readers a personal, historic context to the city's landscape, to help them understand and appreciate some of the people whose efforts and activities affect us to this day. So when they pass certain parks, they think of John Olin and the various philanthropists; when they enjoy the Arboretum, they reflect on the legacies of Michael Olbrich and Joe Jackson; when they see the capitol from afar or Martin Luther King Jr. Blvd. up close, they remember the teachings of John Nolen.

I also hope to help readers understand something they didn't realize they didn't know—why there's that odd angle at University Avenue and Gorham Street and what almost happened there, or how a mayoral veto affected the entire history of downtown development, or what grand structure came before that parking ramp (take your pick).

Some may find that this report dwells unduly on bad news and improper behavior. It may; as noted above, there's a journalist's perspective at play.

There are dangers in dealing in such detail with structures and the stories behind them. The images could seem static or become repetitive; I may indeed have a few too many pictures of certain buildings and steeples, and too few of faces.

Beyond the book's bias toward people with power, its greatest weakness is its failure to cover the east side as well as the west. Four east-side neighborhoods—First Settlement, Tenney-Lapham, Williamson/Marquette, and Schenk's-Atwood/Fair Oaks—developed during these years, yet get only a fraction of the attention given to neighborhoods across town. That was wrong.

There are some partial explanations. Factory owners left a fuller historical record than did factory workers. The verdant, hilly west side is far-better photographed than the flat and marshy east side. The location of the university gives a western orientation to a recurring image, down State Street to campus (and beyond). And the western suburbs all started in the Town of Madison; maybe I found that an easier nexus than the Blooming Grove origin of Fair Oaks. Whatever. I failed to give a proper accounting to several east-side *and* downtown neighborhoods (one of which I was once president of) and I'm very sorry about that. I wish I had done better. I also wish I had given a fuller account of the ethnic experience in Madison. That I didn't is again an outgrowth of the book's emphasis on those who made, rather than "just" lived, our history. I trust other authors will continue to explore those stories. Finally, I regret that time did not allow preparation of a full index. Something for the second edition.

This volume ends in the early nineteen thirties, with the city's landscape stretching, more or less, from the Arboretum to Oscar Mayer. I know my friend Tracy Will will improve and expand upon this effort as he brings the city's story to the present in volume two.

I don't think a book like this can help a city figure out its future. All I can do is try to show the past. As the song goes, "Don't know where I'm going, but I sure know where I've been; don't know what I'm looking for, but sure know what I've seen."

I hope that's enough. After all, those who don't remember their past . . . won't understand the irony when it repeats.

Of the entire book, this is my favorite page.

It's an honor to be published by the University of Wisconsin Press, and my deep thanks to everyone involved: associate director Steve Salemson and director Robert Mandel, who acquired the book; their successors, Raphael Kadushin and Sheila Leary; production manager Terry Emmrich and assistant production manager Carla Aspelmeier; marketing manager Andrea Christofferson and publicist Benson Gardner. I am especially grateful to my editor, Adam Mehring, for his tremendous skill and undue patience in getting this to press. There wouldn't be a book without him.

One of the reasons the Press agreed to publish this book was because my friend Jane Tenenbaum had agreed to be its designer. You'll soon see why; no one could have made a better-looking book. Given the production pressures I created, I don't think any designer other than Jane could have even *made* a book.

Words cannot convey how grateful I am to my friend Michael Kienitz, a photographer and digital wizard, for the time and effort he donated. His digital enhancements grace many of the images herein, and all of the best ones. Mickey even *created* several of the images, most notably the first map (page 7) and all the public library scans.

Maps are important to this book, and the most important are the series showing each decade's events. These maps are integral to the book's function, and I have David Michael Miller and the Isthmus Publishing Company to thank for this very cool feature.

Like every Madison historian, I offer praise and thanks to Frank Custer for the vast collection of newspaper clippings he gave to the Wisconsin Historical Society; many items in this book originated in the "Custer Cards." It was a privilege and a pleasure to work with Frank at *The Capital Times* and *Madison Press Connection,* and I like to think he would enjoy this volume. All Madisonians owe David Mollenhoff a great debt for *Madison: The Formative Years* and *Frank Lloyd Wright's Monona Terrace* (with coauthor Mary Jane Hamilton). I could not have written this book without these outstanding works; they are the gold standard for Madison histories, which anyone interested in the topic should own. I also deeply appreciate the many courtesies David showed throughout the preparation of this book.

I spent a lot of time on the microfilm machines at the downtown Madison Public Library, and I'm so thankful that director Barb Dimmick, reference supervisor Carol Froistad, and the entire staff were as accommodating and pleasant as they were. I'm thrilled to be working with the library on a Web site for material supplementing this book. Given Madison's proud library history (see page 150), I hope the public will subscribe readily if an expansion plan requires donations.

Of all the buildings *in* this book, the one that meant the most to this book is the Wisconsin Historical Society; how wonderful to have such world-class resources as the library and archives just minutes away. This book would not exist without the archives, source for most of the images and some of the best the information herein. Ric Pifer, Harry Miller, and Andy Kraushaar and their archives staff preserve and display the manuscript and photographic record of our existence—and are about the nicest, and most competent, existentialists I've ever known. A special shout-out to the energetic yet calm business manager Lisa Hinzman and master scanner Sheri Dolfen.

Because the university is so important to the book, its archives were critical; my needs were more than met. Bernard Schermetzler, whose vast photo collection provided many pleasant days of browsing, gave phenomenal reproduction service. And manuscript research was just as easy and enjoyable, thanks to archivist David Null and his staff.

Among its cornucopia of media, Madison is fortunate in both its weekly newspaper and monthly glossy. I've been very lucky to have been able to write for both, especially material excerpted from this book. For it all, my heartfelt thanks to Vince O'Hearn, Marc Eisen, and Bill Leuders at *Isthmus,* and Jen Winiger, Neil Heinen, and Brennan Nardi at *Madison Magazine,* and their entire staffs. I've also used some of this material on Madison's Progressive Talk, 92.1, so thanks as well to the station and Clear Channel.

Writing about Madison can be a challenge; so many people know so much about so many things. Whatever topic I tackle, someone else has already done so, and always more ably. I thank several of those world-class experts—Jack Holzhueter, Mary Jane Hamilton, Carolyn Mattern, Ann Waidelich, and David Egan—for graciously agreeing to answer questions or review certain selections herein. Errors of fact or analysis that remain are entirely my fault.

Of the many people and organizations doing so much to preserve our history, some had special significance for this work.

Historic Madison, Inc.'s outstanding sesquicentennial programming let me combine research with entertainment and a nice walk. But I especially thank HMI for its illustrated necrologies, *Forest Hill Cemetery* and *Bishops to Bootleggers,* of value beyond limit as both reference material and biography. They were next to my desk as I wrote and they belong on a Madison bookshelf right next to *The Formative Years* and *Wright's Monona Terrace.* I am honored that HMI served as fiscal agent for this project, and I thank president Mark Gajewski and all for all they have done.

Everyone interested in Madison's history should thank the city and its taxpayers for the Landmarks Commission and Kitty Rankin. I especially thank them (and the respective authors and neighborhood associations) for the Madison Heritage walking tour books, a superb series of neighborhood histories whose reprinting is long overdue.

Madison has an astonishing level of activity by its neighborhood associations, and those within my geographic focus (roughly the Arboretum to Oscar Mayer) all contributed to my understanding of the city.

I find continuing inspiration in the many old buildings still around, and thank the Madison Trust for Historic Preservation for its ongoing activities in that regard.

I could not have written this book without time off from my job as a labor mediator and arbitrator with the Wisconsin Employment Relations Commission. I fully appreciate this great indulgence and apologize to my colleagues for any increase to their workload due to my absence. I will try and make it up to you all.

The economics of modern publishing often require outside underwriters. My great thanks to the individuals, organizations, and businesses providing financial support for this project (see page iv).

Finally, my thanks to everyone else who contributed to my life in Madison over the past thirty-one years and/or the development of this book. You know who you are.

MADISON

PROLOGUE

Humans came to the land we now call Madison more than eleven thousand years ago, Paleo-Indians hunting ice-age mammals over a glacial tundra and through fir-laden forests.

As the climate warmed over the next several thousand years, hardwood stands and grasslands developed, creating conditions for a race of hunter-gatherers known as the Archaic Indians.

Peoples of the Woodland tradition were in the area about twenty-five hundred years ago, making Madison a thriving center of Native American life. In their later stage, from about 400 to 1300, they built thousands of mounds around modern Wisconsin, the greatest concentration of conical and effigy mounds on the continent. The mound builders, possibly ancestors of the Ho-Chunk, had camps and villages throughout modern Madison: their mounds, almost all on hills with views of water, were almost all later lost to vandalism, pillage, or construction.

By the seventeenth century, Wisconsin was being opened by the colonial powers. Thanks to the explorers Marquette and Joliet, the French were first, in 1673, establishing a flourishing fur trade. After defeating France in the Seven Years War, Great Britain took title to a vast area that included Wisconsin through the Treaty of Paris in 1763.

It was not until the years after the War of 1812 that America assumed control of the general area through forts at Prairie du Chien and Green Bay. Construction of Fort Winnebago in Portage in 1828 brought an American presence to the Four Lakes Country.

The state's economic and cultural underpinnings changed forever with the Indian cession of southwestern Wisconsin in 1828, which opened the land for the newly arriving lead miners and farmers. Among them was Dane County's first white settler, Blue Mounds miner Ebenezer Brigham of Massachusetts. Passing through Madison on his way to Portage for supplies that May, he camped near the current corner of King Street on the Capitol Square and predicted a city would arise on the lovely locale. The following spring

Ma-Ka-Tai-Me-She-Kia-Kiah, also known as Black Hawk, ca. 1842 (WHi-3772)

would bring the first visit by the man who would make Brigham's vision come true—Michigan territorial judge James Duane Doty, traveling from Green Bay to Prairie du Chien by land rather than his usual canoe. The next visitor of European descent appears to have been Jefferson Davis, future president of the Confederate States of America, who camped in Madison in the summer of 1829.

At the time, several Ho-Chunk villages and camps dotted the area, but not the isthmus proper. The Indians kept cornfields on what would become North Pinckney Street, but the Madison that Doty would plat had no permanent inhabitants. There were a handful of French and American traders based farther west near Middleton, including Wallace Rowan, whose log cabin near Pheasant Branch Creek was the first permanent structure and whose wife was the first white woman in the area. There was one business, likely Madison's first, Oliver Armel's primitive trading post near the current intersection of Wisconsin Avenue and Johnson Street.

Though there would be a few final fur harvests to bring hundreds of Winnebago to Armel's shanty, Wisconsin's future lay with the pick and the plow, not the muskrat trap.

But first there was one last bit of nasty business before full-scale settlement by white Americans—the Black Hawk War of 1832.

Under an 1804 treaty of questionable legitimacy, the Sauk and Fox tribes had ceded about fifty million acres of land in southern Wisconsin and northern Illinois, retaining the right to remain on their land until the government sold it to settlers. As the influx of white settlers began in earnest in the mid-1820s, a split developed in the Sauk ranks; one group followed Keokuk to an Iowa reservation in 1831, while another tried to return to their village of Saukenuk (near modern Rock Island) to raise corn. This group of about a thousand followed the warrior Black Hawk.

But the Illinois militia blocked Black Hawk's return. The next year he tried again, and once more encountered military opposition. Disheartened at the lack of support from the Winnebago, Potawatomi, and Kickapoo, Black Hawk sent messengers to surrender. But the untrained militia,

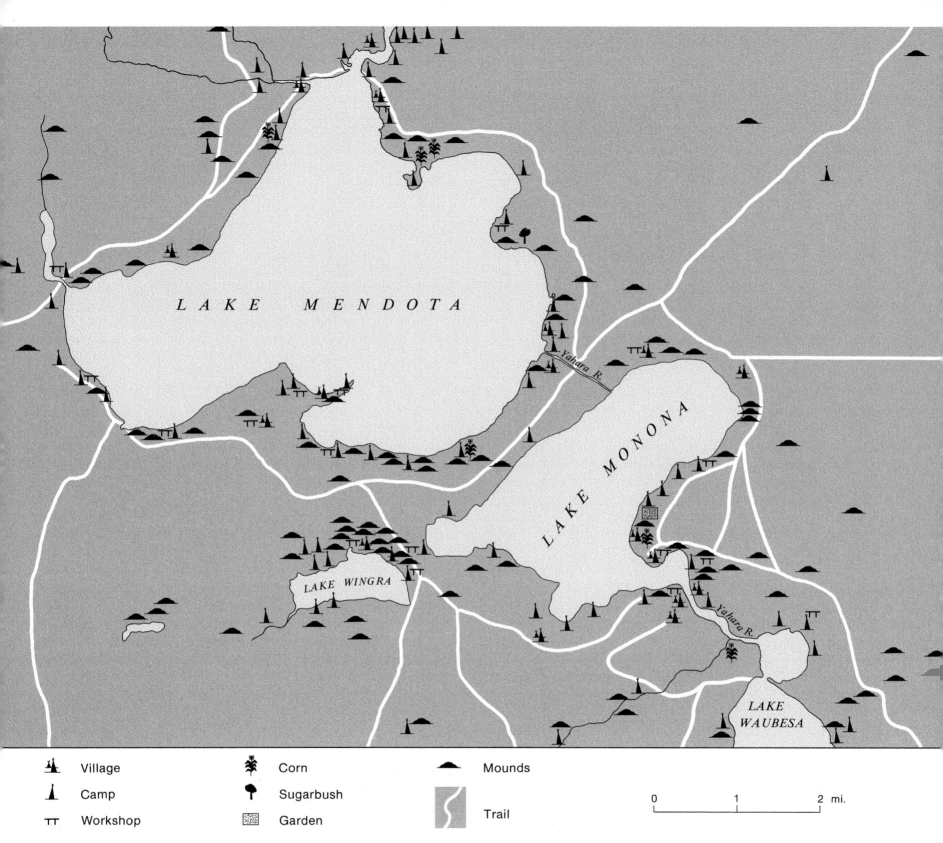

Village	Corn	Mounds
Camp	Sugarbush	
Workshop	Garden	Trail

0 1 2 mi.

LAKE MENDOTA

LAKE MONONA

LAKE WINGRA

LAKE WAUBESA

Yahara R.

Mounds, Campgrounds, and Trails
Some of the physical legacy of Native American life in Tay-cho-per-ah, the Four Lakes Country, as catalogued by archeologist Charles E. Brown.

(University of Wisconsin Cartographic Laboratory, courtesy of David Mollenhoff)

unsettled by the simultaneous arrival of the Sauk and another group, opened fire, killing one of Black Hawk's men. The Sauk retaliated with a series of fierce attacks on frontier outposts, and the Black Hawk War began.

For four months, Black Hawk and his band managed to avoid U.S. Army General Henry Atkinson and his three thousand troops. But in mid-July, a chance encounter near what is now Watertown put Atkinson hot on Black Hawk's trail—a trail that led straight through the isthmus and almost resulted in a bloody pitched battle in modern day Middleton.

"We were close to the Four Lakes," one soldier recalled, "and we wished to come up with them before they could reach that place, as it was known to be a stronghold for the Indians." But even the long summer day proved too short, and the soldiers were still more than a mile east of the Catfish (Yahara) River when night fell. The commanding officer thought about pressing on, but the French-Indian guide Peter Pauquette warned him "the underwood stood so thick" that the troops "could not get through it at night."

While the main force set up camp near today's Olbrich Park, a small party moved out to track the Sauk location. They soon overtook Black Hawk's rear guard, and a brief skirmish broke out in the heavily wooded area between the river and the future Fair Oaks neighborhood. "An Indian was wounded," one pioneer recalled, "who crept away and hid himself in the thick willows and alders about where the Catfish now debouches into the lake, where he died."

His bones remained on the spot, unburied, for more than a decade. Another Sauk, sitting stoically on a newly dug grave—most likely of his wife—was later shot dead on the bank of the lake near Blair Street.

The army was right to encamp where it did. Black Hawk had left half his warriors just west of the river, about where Williamson Street is today; had the soldiers kept going on the evening of July 20, they would have marched right into his trap. This rear guard later rejoined the full force, which had passed a little north of what would become the Capitol Square and out along the lake toward modern Middleton.

The next morning, the soldiers soon knew that Pauquette "had told us

no lie; for we found the country that the enemy was leading us into to be worse, if possible, than what he told us. We could turn neither to the right nor left, but was compelled to follow the trail the Indians had made," rimming the edge of the lake around Schiller Street.

There was one last brutal act before the soldiers left the isthmus, as a physician/journalist from Galena, Illinois, scalped an elderly Indian lookout in the middle of the modern Marquette neighborhood.

Moving westward, the soldiers reached the Wisconsin River bluff about five o'clock that afternoon. Black Hawk tried to surrender, but his attempts were either misinterpreted or rejected. So in the rain and gathering gloom of twilight, the Battle of Wisconsin Heights began; the encounter was a tactical, if brief, success for Black Hawk, as it enabled his forces to slip away across the river.

Black Hawk and about five hundred followers reached the eastern bank of the Mississippi near the mouth of the Bad Axe River on August 1. Some of the Sauk escaped to safety, but the crossing was soon checked by the arrival of the steamboat *Warrior*. Wading out into the water under a white flag, Black Hawk again tried to surrender, but once again the soldiers couldn't—or wouldn't—understand him. They soon opened fire; two hours later, more than twenty Sauk and Fox warriors were dead.

The bloody Battle of Bad Axe began in earnest before dawn the next day—eight hours of slaughter as the soldiers shot every man, woman, and child they saw. Most of the four hundred Native Americans were killed or captured; Black Hawk himself escaped to the Winnebago village at La Crosse but surrendered on August 27. Of the twelve hundred Sauk who had sought to return to their homeland, barely one-tenth survived.

The war ended a month later with the Rock Island Treaty, which punished the Winnebago for allegedly supporting Black Hawk by forcing them to leave their lands in south central Wisconsin by June 1, 1833. But although the treaty made it illegal for any Winnebago to live in the area—which included the Four Lakes Country—their removal was short-lived. Within a few years, more than a thousand Winnebago returned to their ancestral home and camps.

They would not be alone for long.

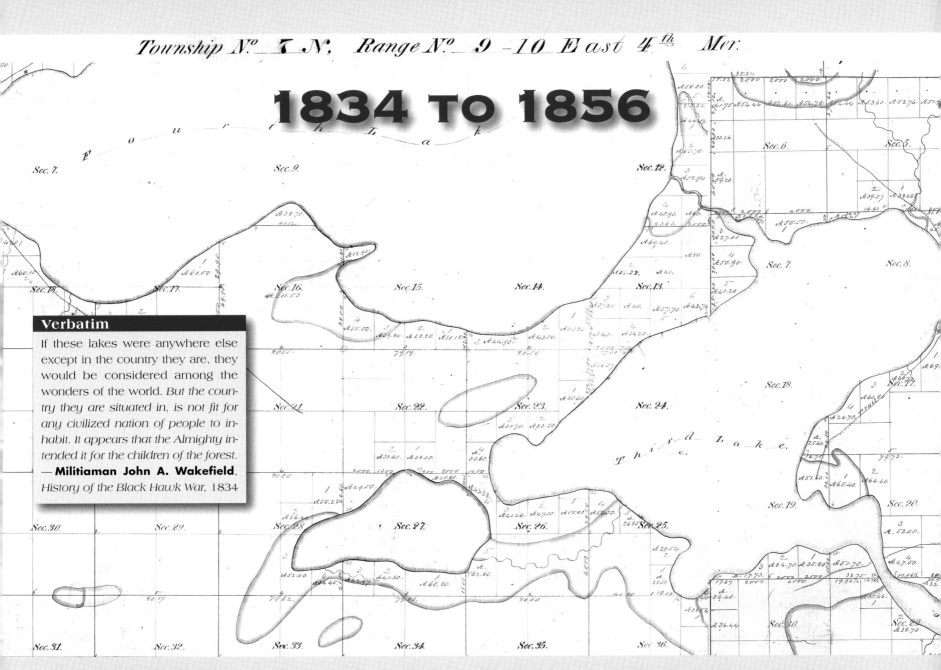

1834 TO 1856

Verbatim

If these lakes were anywhere else except in the country they are, they would be considered among the wonders of the world. *But the country they are situated in, is not fit for any civilized nation of people to inhabit. It appears that the Almighty intended it for the children of the forest.*
— **Militiaman John A. Wakefield**, *History of the Black Hawk War, 1834*

The First Map of Madison

After the close of the Black Hawk War, the U.S. Commissioner of Public Lands began a comprehensive survey of the area; in December 1834, surveyor Orson Lyon and his crew reached the seventh township north of the Illinois border. At latitude 43 degrees, 4 minutes, and 20 seconds north, and longitude 89 degrees, 20 minutes west from Greeenwich, England, and 12 degrees, 20 minutes west from Washington, D.C., they found an undulating isthmus amidst four shimmering lakes. This map, which combines their surveys of Town 7 North, Ranges 9 and 10 East, is the first nonnative visual representation of the land that would become Madison. Lyon described the uninhabited wilderness as "rolling and second rate land, timbered with burr, white and black oak," with a heavy undergrowth of oak and grass. "The bank of the third Lake [Monona] is high, dry, and rich land except a part of the Southwest side of the Lake . . . which is low and marshy," Lyon wrote in his field notes, mentioning also a marshy area on "the southeast and west side of a pond," now known as Lake Wingra. Lyon described "a perpendicular bluff of rocks about sixty feet high" near a "fine grove of sugar trees, containing about two hundred acres of ground," and observed that the "lakes are shallow, and well supplied with a variety of fish." Lyon did not discuss the substantial ridge just west of Monona Bay, a half-mile long and eight stories high, but he did note the Indian trail leading from the house of Canadian-Winnebago trader and trapper Michel St. Cyr, northwest of Fourth Lake (Mendota), which swung around south of the lakes and headed east. (WHi-28202, WHi-4997)

MADISON'S FOUNDING

The land that became Madison was seized in 1832, surveyed in 1834, and put up for sale in 1835. Then history happened in decades, as Madison became the territorial capital and county seat in 1836, a village in 1846, and a city in 1856.

This is how it all began.

On August 1, 1835, land on and around the isthmus went on sale at the federal land office in Green Bay for $1.25 an acre. The land that became Dane County was then a part of the Michigan Territory, divided among the counties of Milwaukee, Brown, and Iowa. The opportunities of the isolated virgin land in the Michigan wilderness were evidently not obvious; it was not until October 7 that Francis Tillou of New York bought the first one hundred acres. James Duane Doty waited until October 28, 1835, to make his first purchase, about a hundred acres on either side of the river that meandered through the eastern edge of the isthmus. By then, Virginian William B. Slaughter had already purchased three hundred acres across Fourth Lake (Mendota), at Livesey's Springs, which was likely to become a canal connecting the Rock and Wisconsin rivers.

Perhaps Doty was focused on another August event — the completion, very close to Colonel Slaughter's land, of the military road connecting Fort Crawford (Prairie du Chien) and Fort Winnebego (Portage). Doty had lobbied aggressively for this first road through southern Wisconsin, and he was made commissioner in charge of its design. The thirty-foot-wide path was built by soldiers under the command of Zachary Taylor, who in 1849 would become the twelfth U.S. president.

April 1836 was the next momentous month for Madison. On the sixth, Doty and Stevens Mason, a former acting governor of Michigan, bought a little more than a thousand acres in the heart of the isthmus — centered on a hill about halfway between Third and Fourth lakes (Monona and Mendota), at the juncture of

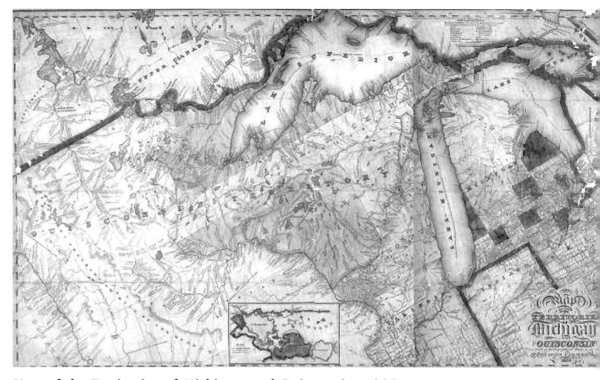

Map of the Territories of Michigan and Ouisconsin, 1830
This was part of James Duane Doty's jurisdiction as circuit judge from 1823 to 1832. (WHi-41281)

sections 13, 14, 23, and 24 — for $1,500. On the twentieth, Congress adopted the Organic Act creating the Wisconsin Territory, which encompassed all of what is now Wisconsin, Minnesota, Iowa, and part of North Dakota.

It was the Organic Act, which implemented the Northwest Ordinance of 1787, that began the course of events that led to one city's designation as territorial and then state capital. It was Doty's purchase that began the course of events that made that city be Madison.

On June 1, 1836, Doty solidified his control over Madison's development by organizing the Four Lakes Company. With power of attorney and trusteeship from Mason and Tillou, Doty claimed title to 1,361 acres covering most of the isthmus. Unfortunately, Doty's dealings with Mason left a cloud of confusion and controversy over legal title to isthmus lots.

On July 1, Doty drew up a plat of the "Town of Madison," to be built around a square at the juncture of his sections. Doty indeed donated the public square — and yet a few years later there would even be legal challenge over ownership of the Capitol Park itself.

President Andrew Jackson appointed as the first territorial governor a hero of the Black Hawk War, General Henry Dodge, who took office on July 4, 1836. A leader of the growing lead-mining region in the southwest, Dodge served satisfactorily until William Henry Harrison defeated Martin Van Buren in 1840 and he was replaced — by his enemy, Doty.

After a census in the summer of 1836, Dodge apportioned the territory into six huge counties, set elections, and directed territorial delegates to meet in the southwestern community of Belmont on October 25 to choose a territorial capital. Fortunately for the future of Madison, Dodge declared he would support whatever choice the territorial legislature made.

It was an offer he would soon regret.

Doty by now was hedging his bets. He had struck a partnership with Slaughter in late December 1835, and on July 1, 1836, he filed the plat of another entry into the capital sweepstakes. With more promotional flair than practicality, Doty named the new development "The City of the Four Lakes." It prospered at first, with houses and people and a post office

before Madison, but soon became abandoned.

Shortly before the new territorial legislature met, Doty and surveyor J. V. Suydam took two or three days to mark a preliminary layout of Doty's land, working off the federal survey and Doty's July 1 plat. Then they hurried to Belmont, where Suydam drew the official plat while Doty lobbied the legislators through means both foul and fair.

Doty finessed sectional rivalries, touted the value of the centrally located site, and played to patriotic sentiment by naming the town after the recently deceased President James Madison, its primary thoroughfare after George Washington, and its central streets after signers of the Constitution.

He also provided the shivering solons with buffalo robes and made sure a majority of the members had deeds to choice lots, often at reduced prices. Dodge himself indignantly — almost violently — rebuffed Doty's offer of investment opportunities, although his son, along with the clerks of both houses, did become new property owners.

Doty prevailed. On November 24, 1836, after several other sites all failed by one vote, the territorial council endorsed Madison's selection, 7-6. Two days later, the House of Representatives concurred, 15-11, making Madison — a town existing only on paper, with no permanent inhabitants — the territorial capital.

Dodge, who favored locating the capital about a hundred miles north and was outraged at Doty's conduct, strongly considered breaking his pledge not to veto the legislature's action. Still, perhaps hoping for congressional rejection of the selection, Dodge signed the bill into law on December 3, 1836.

When it came time to name the new county Madison would also be the seat of, Doty suggested honoring the late U.S. Representative Nathan Dane, primary author of the Northwest Ordinance of 1787. On December 7, 1836, the territorial legislature did so memorialize the man whose mind and pen brought republican self-government, a Bill of Rights, and the abolition of slavery to the west two years before adoption of the Constitution.

At its creation, Dane County had fewer than forty known nonnative inhabitants.

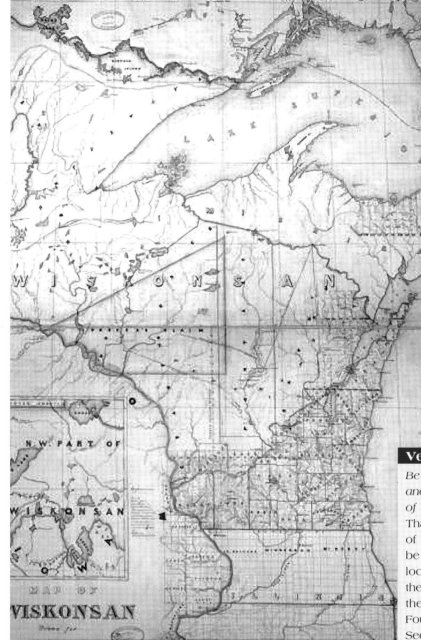

Map of Wiskonsan, 1844

This map of the territory, printed four years before statehood, uses Doty's preferred spelling.
(WHi-36988)

Verbatim

Be it enacted by the Council and House of Representatives of the Territory of Wisconsin. That the seat of government of the Territory of Wisconsin be and the same is hereby located and established at the town of Madison, between the third and fourth of the Four Lakes, on the corners of Section 13, 14, 23 and 24, in Township 7 north, Range 9 east. — **Section 1 of Chapter 11**, enacted November 28, 1836, signed into law by Governor Dodge on December 3

Verbatim

While standing at the section corner, on that beautiful spot between the Lakes, then the central point of a wilderness, with no civilization nearer than Fort Winnebago (Portage) on the north and Blue Mounds on the west, and but very little there; and over which now stands the principal entrance to one of the finest capitol structures in the west — I have no doubt Governor Doty saw in his far-reaching mind, just what we now see actually accomplished, a splendid city surrounding the capitol of Wisconsin at Four Lakes. — **Surveyor J. D. Suydam**, recalling his first visit to the isthmus in October 1836

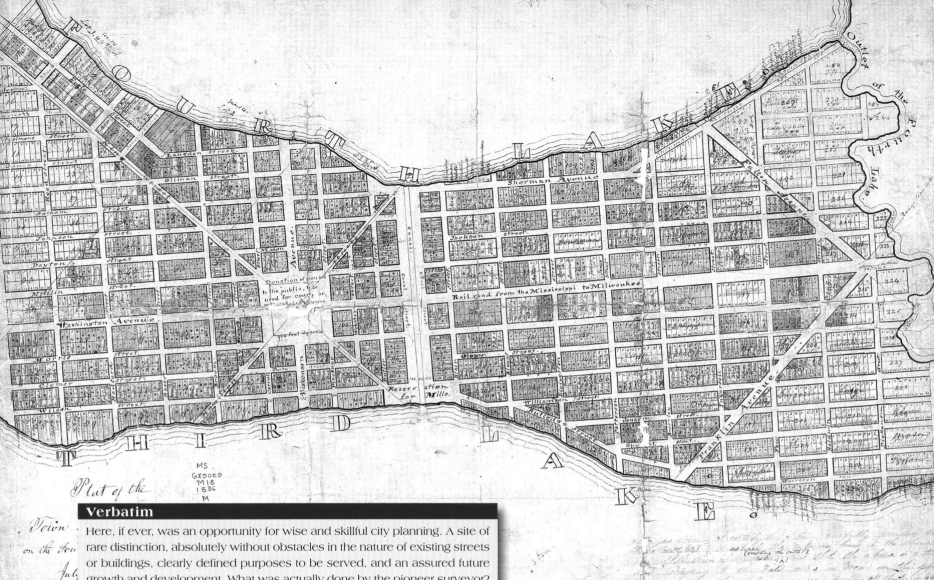

Plat of the

Town

on the Four

July

Here, if ever, was an opportunity for wise and skillful city planning. A site of rare distinction, absolutely without obstacles in the nature of existing streets or buildings, clearly defined purposes to be served, and an assured future growth and development. What was actually done by the pioneer surveyor? In a central situation, on a fine hill, seventy-five feet above Lake Monona, but not fronting on either lake, the Capitol Park of about thirteen acres was located with broad avenues eight rods wide running from its center and narrower ones radiating from its corners. For the rest of Madison, all was the usual commonplace gridiron plan without even discriminating difference in the widths of streets or the sizes of blocks.

It is often stated that this plan for Madison resembles the plan of Washington, and was copied after the latter, but there appears to be small justification for the claim. Aside from the four radial streets — which are inadequate in width, and, with the exception of State Street, lacking in significant location or termination — the Madison plan possesses none of the splendid features of l'Enfant's great plan for Washington. The excellent and well differentiated street plan of the latter finds no true echo in Madison. There are here no open squares, triangles, or circles at the intersection of streets, no reservation of fine sites for public buildings other than the Capitol, and, strangest of all, the lake fronts — the prime and only legitimate factor to justify the selection of Madison as the Capital City — were ignored altogether as far as public utilization was concerned. — **John Nolen**, *Madison: A Model City*

Doty's First Plat, 1836

This is Doty's first plat of Madison, which he recorded on July 1, 1836, and brought to Belmont in October. The faint names identify the legislators and others who purchased or otherwise received lots during deliberations over the location of the territorial capital. Even in this rudimentary state, there are several shortcomings that Doty would continue in the more polished plat (opposite), including inadequate treatment of the Hamilton and King axials, inappropriate sighting of the industrial canal, and two diagonal avenues (Franklin and Fulton) of marginal utility. But Doty would soon drop one bewildering element — dedication of Washington Avenue for a railroad right-of-way, which would have brought the tracks directly onto the Capitol Square. And here, unlike in the finished plat, Doty wasn't burdened by false modesty but did name a street after himself — the second street south of the capitol, the same street the council would change from Clymer to Doty in 1888. (WHi-38589)

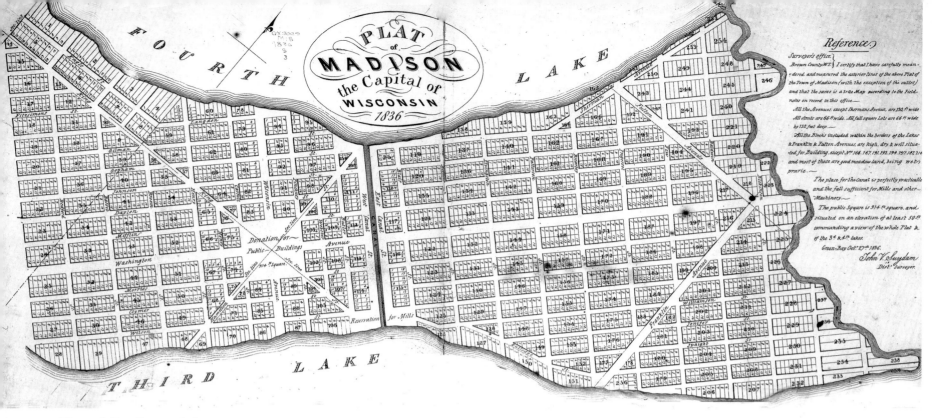

Plat of Madison, 2.0 (WHi-11709)

TURNING POINT

A CAPITAL CITY, BUT NOT A CAPITAL PLAT

Just as Doty gets the credit for Madison's existence as territorial capital, he gets the blame for Madison's limitations as a city.

First, he and surveyor Suydam did a such a slap-dash job in their rudimentary work while hustling to Belmont that they named two different streets Henry. And the plat contained claims that were public relations puffery at best, if not outright deception — like the assertion that the proposed canal four blocks east of the planned capitol was "perfectly practicable," notwithstanding the forty-foot hill right in its path, or that almost the entire isthmus was "high, dry & well situated for Building," when vast areas out East Washington Avenue were in fact marshland and would remain so well into the twentieth century.

The plat, fit for a city of about ten thousand, did have some positive elements. The rudimentary radial design showed that Doty *tried* to be creative even if his execution was lacking. That he doubled the width of Wisconsin Avenue meant Doty understood the power of that view both to and from the capitol.

But the plat had three fundamental flaws, each of which caused the city future development woes and each of which came about because Doty didn't accommodate the physical reality of the land.

First, there was the lost opportunity for lakefront access and other public parklands. Despite the stunning setting, the only public open space is the 13.5-acre Capitol Park and the public waterfront is limited to street ends and the inlet for the industrial canal — an utter failure to capitalize on the new town's unique and most important attribute.

Doty also failed to complete the axial streets properly. Other than West King (State) Street, their design ranged from mediocre to harmful. South Hamilton sliced a residential block in two before its abrupt end, while its northern terminus was at the mouth of the canal. The end of that canal was even worse; that's where Doty thought the mills should go—not only through deep rock but only two blocks from the capitol.

As Doty saw, so it was done; within a few years, and for many decades, both the King and North Hamilton axials would indeed end in industrial uses. It would be left to Leonard Farwell, more than a decade later, to locate the mill at the obvious place — where the river already was.

Seventy years would pass before the city started to address the other shortcomings. Because Doty and Suydam failed to provide opportunities for inland and lakefront recreation, John Olin, the Madison Parks and Pleasure Drive Association, and the parks philanthropists had to. And because Doty and Suydam failed to capitalize on the width of Wisconsin Avenue by reserving the end lots for public use, the city wouldn't consider a grand mall and esplanade until John Nolen urged it to.

Finally, Doty's street-grid ignored geography, with predictable results. Other than West King Street connecting the capitol with what would become the campus, every street west of the capitol on Doty's plat ended in the marsh and open water of Lake Wingra, and no street served the major land mass to the northwest. Because Doty refused to look beyond the edge of the isthmus, it was left to the University Addition in 1850 to provide a western connection — a development with its own series of drawbacks (see page 29).

Madison Notable

Madison's founder, **James Duane Doty** (1800–65), was smart, ambitious, energetic, articulate, and effective. He was also complex, controversial, careless, self-serving, intense, and given to intrigue. Doty came to Detroit from upstate New York at age eighteen and soon became secretary of the city and clerk of the Michigan Supreme Court. Two years later, Michigan governor Lewis Cass named him secretary for a 4,200-mile canoe expedition through the Wisconsin Territory. At twenty-one, Doty lobbied in Washington for a new judgeship covering the Wisconsin Territory; in 1823, the year Doty drafted the first bill to create what he called the "Wiskonsan" Territory, President James Monroe appointed him judge for the huge Western Michigan Territory. Doty canoed the 1,360-mile judicial circuit for nine years, living primarily with his wife in Green Bay, where he founded the first Episcopal church west of Lake Michigan and worked closely with the Winnebago, Chippewa, and Sioux to develop a "native code" based on tribal values and history. Replaced as judge by President Andrew Jackson in 1832, Doty got Cass, now secretary of war, to grant him commissions to build the first military roads in Wisconsin, which linked forts in what are now Prairie du Chien, Green Bay, and Chicago.

James Duane Doty, Madison's founder
(WHi-11337)

Doty served in the Michigan legislature from 1834 to 1836 and was instrumental in creating the Wisconsin Territory on July 3, 1836. At the same time, he was land agent for John Jacob Astor and laid out what is now downtown Green Bay. Doty also bought 3,500 acres at the southern end of Lake Winnebago and created what is now Fond du Lac.

Then Doty went to Belmont and secured Madison's status as capital. But his own status was about to suffer. First, the depression of 1837 almost ruined him (without timely support from Astor it would have). Then Doty was criticized for how he spent federal funds (see page 18), which had been designated for construction of the capitol building, and serious questions arose over the validity of his title to the isthmus lands. Doty's former partner, Stevens Mason, called him a "liar, a calumniator and a swindler" and declared that Doty did not have proper title to any properties. Doty established the legitimacy of his title in 1841, but the controversy clouded Madison's initial development. Finally, there was the muddled matter of Doty's role in two bank failures during the depression.

Yet Doty won election to Congress as a territorial delegate in 1838, after which President John Tyler appointed him territorial governor. Doty served two two-year terms but was again beset by personal and partisan criticism. After a tenure filled with strife and stress and not much success, he left Madison in 1845 for his four-hundred-acre island in Lake Winnebago. Doty served as a delegate to the 1846 Wisconsin Constitutional Convention, failed in a bid for the U.S. Senate, then served in the House of Representatives (1849–53).

At age sixty-two Doty accepted appointment from President Lincoln as superintendent of Indian affairs at Salt Lake City. He became governor of the Utah Territory in 1863 and earned high marks for his skillful administration. Doty died on June 13, 1865, and was buried on a low plateau in the Wasatch Mountains.

In 1868 Governor Lucius Fairchild and Simeon Mills proposed that Doty and his archrival Henry Dodge be the two Wisconsinites honored in the new Statuary Hall in the U.S. Capitol. Without funds to commission the statues, the state put its selection on hold; much later, the honor was accorded Jacques Marquette and Robert M. La Follette.

Doty's memory suffered another affront when the Madison Common Council rejected the first petition to rename the second street south of the capitol in his honor. That street remained Clymer, as Doty had named it, until 1888, when he was at last honored (but only on the blocks between Fairchild and Webster streets).

(Almost) The First Suburb, January 1837

James Doty and partners platted Madison's first suburb three months before Madison's first settlers, the Pecks, arrived. Almost two-thirds the size of the original plat, the nine-hundred-acre Western Addition failed due to the depression that year and was eventually abolished. But the plat had a lasting impact, due to the designation of "Seminary Square" on its eastern edge. By 1838, the elevated area nearby would be known as College Hill; ten years later, the first regents would buy the site for the university campus. As he had done in his first plat of Madison, Doty here memorialized himself, in a street and one of the public squares; partner Stevens Mason was similarly honored. This land mass now encompasses Camp Randall and the Greenbush, University Heights, and Vilas neighborhoods, the last of which would become the first suburb actually developed, fifty-two years later. It is difficult, if not impossible, to align this street grid with the one recorded in 1836.
(WHi-33289)

Dateline
April 1, 1838 Pecks' maid Elizabeth Allen marries carpenter Jairus Potter in county's first wedding.

12

MADISON'S SETTLEMENT

M adison's settlement began in early 1837. It was a time of firsts, and would remain so for several years.

Moses M. Strong, who would later levy the most serious legal challenge to Doty's ownership of the isthmus, surveyed and platted the town site for Doty in February. Assisted by postmaster John Catlin and the Canadian-Winnebago trader Michel St. Cyr, Strong fought through difficult and dangerous winter conditions to mark the metes and bounds.

It was about this time St. Cyr became Madison' first contractor, building a log cabin for Catlin on the corner of East Mifflin Street and Wisconsin (Monona) Avenue. Although the

continued on page 14

Verbatim

We are gratified to learn that all difficulty between ex-Governor Mason and Governor Doty involving the title of this town has been settled. . . . The settlement of the title will considerably enhance the value of property and we may now calculate with some certainty on great improvements being made in town during the present season.— **Wisconsin Enquirer**, January 9, 1841

Settlement Population and Births

Year	Population
1837	1
1838	62
1840	146
1844	216

On September 14, 1837, Victoriana Wisconsiana Peck (James Doty and Simeon Mills suggested the name to parents Eben and Rosaline Peck) became the first white child born in Madison. The first white male born in Madison was also aptly named— James Madison Stoner, born on December 19, 1837. Births elsewhere during the settlement period included four mayors, two U.S. senators, a great university scientist, a patriarch of physicians, the city's greatest philanthropist, and a biracial presidential grandson.

- Beverley Jefferson (1839–1920), livery company proprietor
- John Corscot (1839–1926), industrialist, mayor
- Susan Bowen (1840–1904), matriarch, philanthropist
- William F. Vilas (1840–1908), U.S. senator, philanthropist
- James A. Jackson, Sr. (1840–1921), physician
- John Coit Spooner (1843–1919), U.S. senator
- Stephen Babcock (1843–1931), scientist
- John Groves (1844–1921), mayor
- Robert M. Bashford (1845–1911), mayor, jurist
- Moses R. Doyon (1845–1933), mayor

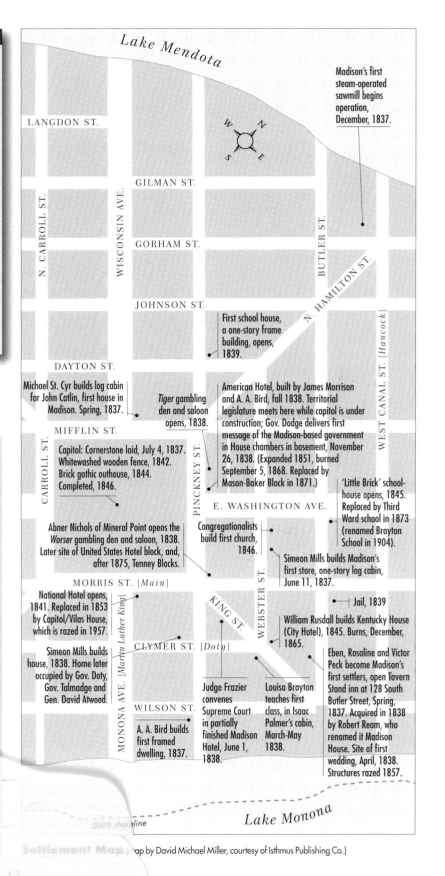

Lake Mendota

LANGDON ST.

GILMAN ST.

GORHAM ST.

JOHNSON ST.

N. CARROLL ST.

WISCONSIN AVE.

BUTLER ST.

N. HAMILTON ST.

WEST CANAL ST. [Hancock]

Madison's first steam-operated sawmill begins operation, December, 1837.

First school house, a one-story frame building, opens, 1839.

DAYTON ST.

MIFFLIN ST.

CARROLL ST.

PINCKNEY ST.

E. WASHINGTON AVE.

Michael St. Cyr builds log cabin for John Catlin, first house in Madison. Spring, 1837.

Tiger gambling den and saloon opens, 1838.

American Hotel, built by James Morrison and A. A. Bird, fall 1838. Territorial legislature meets here while capitol is under construction; Gov. Dodge delivers first message of the Madison-based government in House chambers in basement, November 26, 1838. {Expanded 1851, burned September 5, 1868. Replaced by Mason-Baker Block in 1871.}

Capitol: Cornerstone laid, July 4, 1837. Whitewashed wooden fence, 1842. Brick gothic outhouse, 1844. Completed, 1846.

Abner Nichols of Mineral Point opens the *Worser* gambling den and saloon, 1838. Later site of United States Hotel block, and, after 1875, Tenney Blocks.

Congregationalists build first church, 1846.

'Little Brick' schoolhouse opens, 1845. Replaced by Third Ward school in 1873 (renamed Brayton School in 1904).

Simeon Mills builds Madison's first store, one-story log cabin, June 11, 1837.

MORRIS ST. [Main]

WEBSTER ST.

National Hotel opens, 1841. Replaced in 1853 by Capitol/Vilas House, which is razed in 1957.

Simeon Mills builds house, 1838. Home later occupied by Gov. Doty, Gov. Talmadge and Gen. David Atwood.

CLYMER ST. [Doty]

KING ST.

MONONA AVE. [Martin Luther King]

WILSON ST.

Jail, 1839

William Rusdall builds Kentucky House (City Hotel), 1845. Burns, December, 1865.

Eben, Rosaline and Victor Peck become Madison's first settlers, open Tavern Stand inn at 128 South Butler Street, Spring, 1837. Acquired in 1838 by Robert Ream, who renamed it Madison House. Site of first wedding, April, 1838. Structures razed 1857.

Judge Frazier convenes Supreme Court in partially finished Madison Hotel, June 1, 1838.

Louisa Brayton teaches first class, in Isaac Palmer's cabin, March–May 1838.

A. A. Bird builds first framed dwelling, 1837.

2003 shoreline

Lake Monona

Settlement Map (map by David Michael Miller, courtesy of Isthmus Publishing Co.)

building burned before Catlin could occupy it, the site would remain significant for postal purposes until 1929.

The first white family, the Pecks, arrived on a snowy Saturday, April 15, to start Madison's first business — the hospitality industry. Their first guests, among them three of Madison's most important men, arrived within hours of each other on June 10 — the capitol construction crew under charge of Commissioner Augustus A. Bird and including carpenter Darwin Clark, followed later that afternoon by Madison's first great entrepreneur, Simeon Mills. Catlin began his federal duties and his role as the settlement's first lawyer later that month.

More log structures sprang up — a dormitory in Capitol Park for the construction crews, a boardinghouse, and the first store, run by Mills and Catlin.

On the Fourth of July 1837, the settlement celebrated the sixty-first Independence Day by laying the cornerstone for the territorial capitol. Then it celebrated some more.

But the next month Madison's prospects suffered with the implementation of President Jackson's Specie Circular, which required that payments for all public lands be made in either gold or silver. The order sharply curtailed land sales and helped trigger the Panic of 1837 and a depression that seriously retarded Madison's early growth. It would not be the last time national economic news dimmed Madison's development.

There were other difficulties as well. The land, isolated in the primeval wilderness, was surrounded by water on two sides and marshes at either end; far from population centers or transportation hubs, the town offered farmers no easy access to markets. Early speculation by nonresidents had driven land prices beyond what most settlers could afford, while the continuing efforts by some to relocate the capital to Milwaukee made investment a risky proposition. Further eroding investor confidence was the complex and bitter battle Doty and Mason waged over conflicting claims to title of town lands, litigation not resolved in Doty's favor until June 1841. Finally, there were the standard (and not-so-standard) frontier hardships of In-

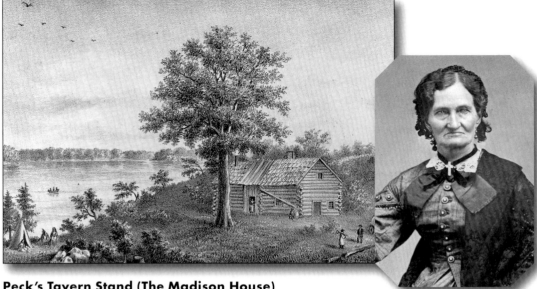

Peck's Tavern Stand (The Madison House)

The first inhabited building in Madison was part of a grouping of three log cabins on Lot 6, Block 107 (about 128 South Butler Street) and served as home and business for frontier innkeepers Eben and Rosaline Peck. They sold the enterprise in the summer of 1838, after which it was renamed Madison House. The new proprietor was Robert Ream, father of famed sculptor Vinnie Ream. Old and crumbling, Madison's first building was razed before it fell in 1857. This representation is from a painting based on the memory of early settlers. (WHi-3804)

Rosaline Peck,
pioneer innkeeper
(WHi-3941)

dians, prairie fires, mosquitoes, polecats, and wolves.

Slowly, the accoutrements of modern society developed, starting with a debating society — the Madison Lyceum, organized by carpenter Darwin Clark in August 1837. That summer, Clark helped William Wheeler build the settlement's first steam-powered sawmill, on the Lake Mendota shore a little west of Butler Street. Trees were cut without regard to ownership and the mill kept busy day and night for about two years. Scows made daily trips from McBride's Point (Maple Bluff) to a wharf at the foot of North Hamilton Street laden with stone for the capitol walls.

Although Madison would later be defined by its active and aggressive newspapers, the settlement lagged behind other communities in the early days; Green Bay, Milwaukee, even Mineral Point all had newspapers before Josiah Noonan began publishing the *Wiskonsin Enquirer* on November 8, 1838. But then the papers came quickly — the *Madison Express* (1839), the *Wis-*

consin Democrat (1842), the *Argus* (1844), the *Statesman* (1850), the *Wisconsin State Journal* (1852), and the *Patriot* and *Staats-Zeitung* (1854).

As the cause of Madison's existence, the territorial government dominated its early development, particularly the need to feed and care for legislators. The government was responsible for Madison's existence, but its impact on Madison was not uniformly positive; legislators were among the regular clientele of two prominent gambling dens across from the capitol, the Tiger and the Worser.

Madison's often contentious relationship with alcohol regulation started in these settlement days. Abner Nichols of Mineral Point was outraged when he couldn't get a tavern license, so he and his partner vowed to establish something "worser," which they did — a two-story frame building on South Pinckney Street where men could not only drink and gamble but venture into the dark cellar and wrestle a wild animal in its den. The building later burned to the ground. The Tiger and the Worser caused

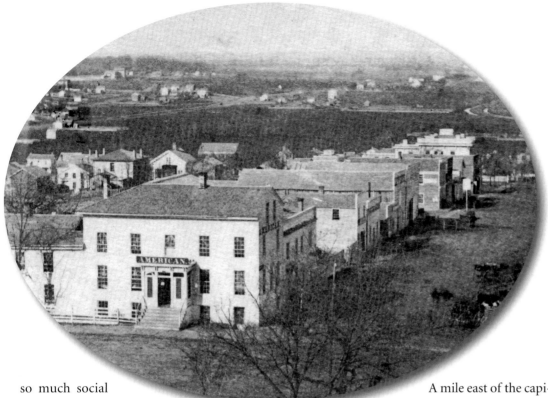

Dateline
July 6, 1837 Liquor runs out, ending Independence Day and capitol cornerstone celebration.

so much social stink that a group of women convened a settlement-wide mass protest meeting at the capitol in 1841. After spirited debate — many of the men were already drunk—the meeting adjourned without action.

In March 1839, the legislature approved the formal political organization of Dane County and the election of county officers. Among the first acts of the new Dane County Board of Commissioners—setting tavern licenses. Even then, the county board knew Madison was more economically important than other communities, setting the tavern license at twenty dollars compared to twelve dollars elsewhere in the county.

That spring, the settlement held about one hundred fifty residents, a third of whom were adult males; the built environment totaled thirty-five buildings, including two stores, three public houses, three groceries, and one steam-powered mill.

Upon public demand, the county board in September set bounty on wolf scalps—but business was apparently so brisk that within days it cut the bounty from three dollars to one. The area we know as Mansion Hill was dense forest where hunters tracking partridge and other game made their way with great difficulty.

A mile east of the capitol hill, the heavy marsh become so covered with water in spring that fishermen in boats could spear fish in abundance. Horses, pigs and cows—and the occasional mad dog—roamed the region at will.

Winter thaws turned the dirt streets into muddy slush that in 1841 became so deep the territorial council considered an amendment concerning the ability of fish to make their way up King Street from Third Lake (Monona) to the capitol.

On February 11, 1842, the county jail received its first inmate of note—Grant County legislator J. R. Vineyard, who had shot Brown County legislator Charles Arndt dead on the territorial council floor. The council rejected Vineyard's resignation and immediately expelled him, but he was somehow found not guilty of manslaughter. He soon moved to California.

By June 1842 there were 199 males and 143 females in the settlement. There were seventy-one buildings, but only two of brick and more than three stories. There were seventeen carpenters and joiners, eleven lawyers, three blacksmiths, two printers, and one physician. The summer brought a bridge across the Catfish (Yahara) River, commissioned by the county board. Four church organizations held services at the capitol.

As capitol construction continued to struggle, the territorial government did start to improve the Capitol Park, for both beauty and efficiency. In 1842, the legislature funded the construction of a whitewashed wooden fence around the grounds and in 1844 built a large brick outhouse—in the Gothic style—near the northwest corner. Both fence and outhouse would outlast the first capitol and remain in place well into the city's incorporation.

The park was still a dense thicket with an almost impassable forest to its west and a primary approach—King Street from the east—that was still almost unbroken sod, with only a modest opening between tree stumps. The hill where the university would locate was inaccessible, overgrown with dense young timber and giant oak. Prairie fires crossed the site from marsh to marsh each year, conflagrations so great as to evoke the later burning of Chicago and Peshtigo.

Madison grew slowly during its settlement years, but as it did, the three county commissioners were hard-pressed to provide sufficient attention and financial support. Public improvements depended on voluntary contributions through subscription drives, always a difficult proposition. Within a few years, Madison had become big enough that it needed its own government with its own laws and own tax base.

On December 5, 1845, a public meeting endorsed the idea of incorporating Madison as a village. On February 3, 1846, the territorial legislature made it so.

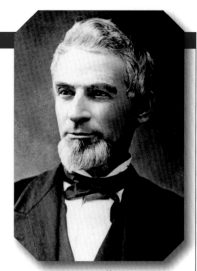

Simeon Mills (1810–95) was the great entrepreneur among Madison's founders and a leading pioneer politician. At age twenty-seven, he walked to Madison from Chicago, arriving on June 10, 1837, just hours after Augustus Bird, Darwin Clark, and the first capitol construction crew. Mills built Madison's second frame house, at about 18 East Clymer (Doty) Street, opened the first store (in a log cabin at the corner of Webster and Main streets), and got the contract to carry mail to Milwaukee. Mills was key to Madison's incorporation as a village and later served two terms as its

Simeon Mills, pioneer entrepreneur (University of Wisconsin Archives)

president. He was the first justice of the peace, first clerk of the territorial supreme court, and first clerk of the U.S. District Court. He was the last territorial treasurer and the first state senator from Dane County. He wrote the bill that became the charter for the University of Wisconsin; served on the first Board of Regents; and bought the land, developed a site plan, and supervised construction of North Hall. He also served on the first school boards for the village and city. Mills started the *Wisconsin Express* newspaper in 1844 and ran it for three years. His stone buildings at 106–116 King Street, built in 1852 and 1855, still stand as the heart of the Simeon Mills National Historic District. Mills was a director of Madison Gas, Light and Coke Company at its incorporation in 1855, a director of the Madison and Portage and Beloit and Madison railroads, and one of the principal investors in the first Park Hotel. Mills's civic status was so high that the council named him street superintendent from 1858 to 1860, even while he was suing the city over his property assessment. Not all his endeavors were happy or profitable, however. Mills was paymaster general for the state during the Civil War, when many soldiers went unpaid, and some of his ventures into banking were sorely misguided. Mills sold his 1837 frame house on East Clymer Street to James Doty for the first governor's residence, and in 1847 he built a frame house across from the capitol on the western corner of West Main Street and Wisconsin (Monona) Avenue. The 1837 house lasted until 1902, but the house on Main was replaced in 1868 by a two-story retail building. In 1863 Mills built a sandstone mansion on his two-hundred-acre farm known as Elmside

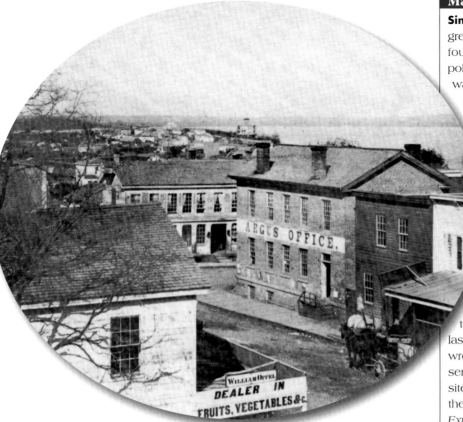

The Argus Building

A view of Madison's oldest commercial building, on Madison's oldest commercial site, the southwest corner of East Main and South Webster streets. Simeon Mills opened a log store, saloon, and post office here in 1837, and in 1847 built this red brick home for his *Argus* newspaper. In 1852 Mills merged the paper with a competitor to form the *Argus-Democrat,* Madison's first daily newspaper. Looking east, Lake Monona and the Farwell House (vacant at this time, soon to become the Harvey Hospital) are visible in this John S. Fuller photo from about 1860. The building is still in use, under the same name, although without the store, post office, or newspaper. (WHi-26961)

Verbatim

Language cannot paint the intoxicating beauty of this garden of the world, before it was touched by the utilizing hand of civilization. . . . These fair and fertile fields, studded with mirrored lakes and coursed with silvery streams, covered with a carpet of mellow-green, figured with wild roses, and crimsoned with ripening strawberries, these undulating meadows as they lay spread out and laughing in the midday sun, revealed a country "ready-made" for use.— **Simeon Mills's** 1890 account of his initial impressions of Madison

Settlement Schooldays

Louisa Brayton Sawin

(Madison's Public Library)

The settlement of Madison was almost a year old when school was first called to order on March 1, 1838, in Isaac Palmer's log cabin on the southwest corner of King and East Clymer (Doty) streets. Some townsfolk, mostly but not all parents, had chipped in to send a sleigh to Aztalan for a young teacher, Louisa M. Brayton, who was paid two dollars per week (offset by a dollar charge for room and board) to instruct a dozen or so students for three months. The next year, a one-story frame building on the north corner of Pinckney and East Dayton opened, but by 1841 this school was so crowded that some students were taught in a tool shed on the capitol grounds. On December 25, 1841, the county school commissioners made the entire township school district No. 1, attaching township 8 the following February.

The town later created a Madison school district under its control, and in 1845 paid Augustus Bird $1,000 to build what they called the "Little Brick" on the southeast corner of East Washington Avenue and Butler Street. The "Brick" was cramped and overcrowded for generations of schoolchildren, as neither county, town, village, nor city government budgeted for improvements. The school board finally built a new Third Ward School on the site in 1887, which it renamed in 1904 in honor of Miss Brayton. Madison's first teacher passed away in 1917, shortly after celebrating her 101st birthday at the Prospect Place home of her daughter Maria, who had married Mayor Augustus Bird's son, George.

Verbatim

Our town, the trade of which two or three years ago would scarcely support a single shop on a small scale, now contains three establishments, each presenting the appearance of a respectable mercantile house.— **Wisconsin Argus**, November 14, 1844

Verbatim

During the last session of the legislature an attempt was made by many citizens to obtain an act of incorporation that would enable the people to improve the naturally beautiful village; which effort was successfully resisted by many others who, if we may be allowed to take their own story for it, had reasons innumerable why the measure should be defeated. Some had no objection to the improvement of streets if they were not taxed for it. Others thought the town should be improved, but then hogs would not be suffered to run at large. Some had no other objection to an incorporation than that new offices would be created thereby; while others really feared that the corporate authorities might levy so high a tax upon dogs as to impoverish the whole community. The last objection we think has about as much heft in it as all the others combined. But, seriously, is there a citizen of Madison who does not blush with shame to behold the unseemly condition of our town? Who does not look with disgust upon our streets bestrewed with lumber, wood and rubbish of every kind, to such an extent that no lady can pass up or down or over a street without the alternative of being perched on the back of her gallant, or wading in the mud to such an extent as to render her situation both unpleasant and unbecoming; and all for the want of a few dollars judicially expended in the construction of sidewalks along our principal streets.—**Wisconsin Argus**, March 4, 1845

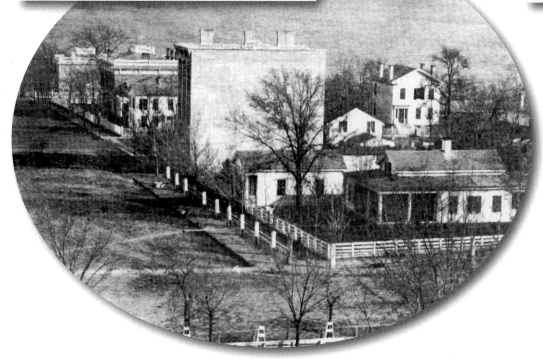

South Wisconsin Avenue, ca. 1865

Simeon Mills's home and office at the corner of West Main Street and Wisconsin (Monona) Avenue. The three-story brick building is the 1859 Gurnee Block, which became the Grand Army of the Republic building after the Civil War. It was razed in 1973 for a parking lot. The red brick building in the next block is the joint Atwood-Buck House (1851), replaced in the 1930s by another parking lot. The building between the Gurnee Block and the Atwood-Buck House is "Monks' Hall," where the railroad lobbyists known as the "Forty Thieves" entertained legislators in the early 1850s. At the end of the avenue is the mansion Jairus Fairchild built in 1849, replaced by the Capitol Annex in 1932. (WHi-26776)

CAPITOL CONSTRUCTION, 1.0

The most important building in Madison has had a star-crossed history, marred by a deadly accident and calamitous fire, mismanagement and corruption, economic exploitation — even its architect's suicide.

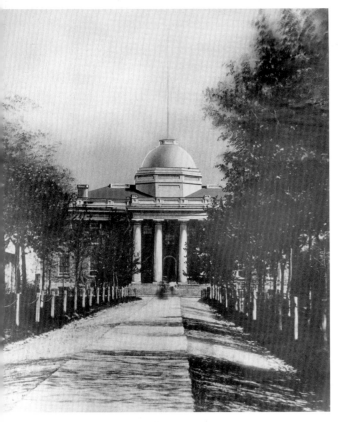

First Capitol, ca. 1861

A retouched view of the West King (State) Street entrance of the original territorial and state capitol, in use from 1838 to 1863. The brick outhouse is visible under the trees at left.
(WHi-23458)

The story starts with scoundrels and scandal.

The 1836 act designating Madison as the state's permanent seat of government created a board of commissioners authorized to "cause the necessary public buildings to be erected at the said town of Madison" under a very precise procedure. The territorial legislature named Doty, Augustus Bird, and John F. O'Neill; they naturally named Doty treasurer, who quickly disregarded the explicit construction process by hiring Moses Strong to survey the site even before the new law took effect.

Doty and O'Neill soon committed three far more serious deviations. They planned a single public building rather than the several called for in the legislation; they set a budget of over $40,000, more than twice the congressional appropriation; and they decided to do the construction themselves rather than follow the mandate to advertise for bids. Then they appointed the absent Bird "acting commissioner" with authority to begin construction; he promptly hired a crew and set out through the wilderness from Milwaukee to Madison.

Bird offered the workers $2.25 a day, but with substantial deductions if they left within three months; otherwise, many men likely would have left early due to the primitive housing conditions, short rations, and dense mosquito swarms.

The commissioners had a further economic hook, thanks to Doty. As treasurer, he had drawn the $20,000 in hard specie and deposited it in his own banks in Green Bay and Mineral Point; but he paid the workers in Madison in banknotes, which lost value at every other financial institution.

That was if they could even be redeemed at all — when Eben Peck brought the payroll to Madison from Green Bay, he had to swim part of the way, soaking the precious paper. After the workers staged a series of strikes, Doty in mid-September finally authorized payment in specie.

Bird again expanded the commission's authority by building wharves and scows to transport stone from McBride's Point (Maple Bluff) to North Hamilton Street, a sawmill to cut timber, and housing for the workers. A special select investigative committee later found that Bird also gave Peck twenty dollars for brandy and wine to keep the workers happy.

Bird proved himself a suitable partner to Doty in other ways. As proprietor of the Madison Hotel on King Street during the early territorial period, Bird regularly offered legislators free room and board, champagne, and a high credit line to secure their support for keeping the capital in Madison.

Whether it was the wine or a surveying error or something else was never fully known, but another problem arose over the summer of 1837. Although the capitol was supposed to be

built directly over the section corners with its axes aligned with the surrounding streets, the building somehow was sited well to the east. The alignment errors weren't corrected until the modern capitol was started in 1906.

That first fall, the board finally went out to bid, but rejected all proposals as too high. When the construction season ended in November, the crew held a small celebration over the mislaid foundation, then left town for the winter.

The following April — more than a year late — the commissioners finally engaged a contractor: Doty's Mineral Point banking partner, James Morrison, whose bid was not the lowest. Morrison also entered into a partnership with his supposed supervisor, Commissioner Bird, for the construction of the American House hotel on the corner of North Pinckney Street and East Washington Avenue.

Suddenly, the pressure was on. Although the 1836 legislation called for construction to be completed by March 1839, the Wisconsin Ter-

ritory was about to lose its temporary capital at Belmont, now placed in the new Iowa Territory. The government would need to meet in Madison in the fall of 1838.

But when they did, they found the capitol unfinished. Fortunately, there was one facility fit for their immediate use — Morrison's American House, where Governor Dodge delivered his first message to the Madison-based legislature on November 28, 1838.

In his rush to complete the capitol, Morrison used wet wood and uncured plaster, resulting in very uncomfortable conditions. Beset by Morrison's herd of pigs in the basement and the bitter cold, legislators offered the first bill moving the capital to Milwaukee. Then they took a one-month recess.

Upon their return, legislators created a special select investigative committee and considered a resolution calling for the removal of the capital from Madison "and converting the present public building into a penitentiary." It failed, 16-9.

Relations between the legislature and the commissioners kept getting worse. In March, the legislature accused the commissioners of acting "in direct violation of the laws under which they were appointed," abolished the board, created a new Commission of Public Buildings, required assurances from Morrison that he would complete his contract, demanded a full accounting — and threatened a lawsuit if the commissioners or Morrison failed to comply.

Doty, by now the territorial delegate to Congress, refused to turn over his books or make any accounting. Then Morrison missed his deadline, prompting the new commissioners to seize the building and install their own locks — which Morrison smashed, retaking the still-unfinished structure. The board had to get a restraining order and a writ of restitution to regain control of the capitol. A similar struggle ensued over ownership of the American House.

Spurred by Doty's nemesis Dodge, the investigations continued. In January 1840, a new report called the initial commissioners "reprehensible in the highest degree" and alleged a conspiracy to defraud. Doty managed to avoid a full accounting until that fall, when he returned $1,700.

But more mischief was still in store.

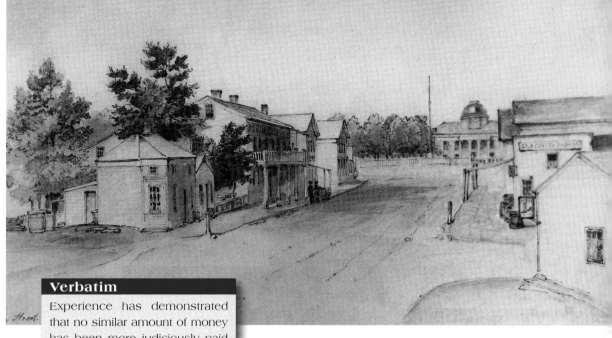

In February 1842 — exactly five years since Moses Strong surveyed the settlement for Doty — the legislature named newspaperman John Y. Smith commissioner of public buildings; among his first priorities was fixing the leaks in the tin dome that were damaging the building's interior.

But when Smith submitted a request for $100 for the work, the territorial treasurer — Doty's appointee, James Morrison — refused. Doty, now the governor thanks to the election of fellow Whig Harrison (and his sudden successor, Tyler), said he would approve the request — but only if the still-pending lawsuits were dropped. Smith refused and paid for the repairs himself. But the dome still leaked.

In 1843, Dane County entered the fray, offering to underwrite the repairs in exchange for office space in the capitol for seven years. The territorial legislature quickly agreed, and the county hired a contractor who knew the building well — Augustus A. Bird.

By 1845, after more than seven years, the first capitol in Madison was finally finished. The lawsuits lingered, however, until 1848, when the legislature had them dismissed to clean the slate as Wisconsin prepared to become a state.

King Street, 1851

The city's first settlement area was east and south of the capitol, with King Street forming the heart of the business district. As late as 1846, when Madison attained village status, King Street was not only home to almost all the buildings, it was also the only defined street—but one still filled with stumps. This watercolor by Austrian artist Johann Wengler shows the view to the first capitol, derisively nicknamed "Doty's Washbowl" for obvious reasons. The balconied building is the Madison Hotel, roughly on the site of the modern Majestic Theater. It was here, in 1855, that fifteen-year-old Dutch immigrant John Corscot was among the lodgers battling bedbugs; within a decade, Corscot would become an alderman and later the mayor. (WHi-2933)

VILLAGE PEOPLE

The Village of Madison was still a western wilderness at its creation in February 1846. Ten years later, it was a metropolis ready for municipal incorporation—thanks mainly to one indefatigable developer and promoter, Leonard J. Farwell.

In 1846, most of the plat was a forest of oak and hazel brush, with only a few streets — primarily King and Morris (Main) — open for travel. The Capitol Park was a jungle of trees and wild grass where cows pastured, game birds flocked, and hogs slept in the cellar of the capitol itself.

By the time the village became a city, Madison had a telegraph line (1848), a first-class hotel (1853), a railroad link to Milwaukee (1854), a gas works (1855), an autonomous school district (1855), and a neighborhood becoming known for its mansions.

Madison also had a leadership cohort that would prove to be its greatest generation. Among those who arrived during the village decade were five future mayors, two powerful United States senators of the twentieth century, three who would lead the University of Wisconsin, a governor, and the city's most important family.

The first village election on March 2, 1846, was not a marvel of modern democracy; under the charter, standard for the time, voting was limited to "all free white male inhabitants" over the age of twenty-one. Most Madisonians supported separate status for the races — at the statewide referendum the following spring, settlers rejected black suffrage, 176-18.

But the settlers weren't that worried about the franchise — they were focused on their newfound power to levy taxes. No longer would every improvement be dependent on voluntary contributions.

Fewer than twenty lots on the Capitol Square held buildings — five hotels, three saloons, three stores, some residences, and an unfinished business block. There was hardly a handful of houses west or north of the capitol; when Horace A. Tenney built his two-story frame house

Road in Madison, 1852

Fifteen years after Madison's settlement and four years before its incorporation, German artist Adolph Hoeffler sketched this pencil drawing of the western wilderness on the outskirts of town. (WHi-31180)

on West Washington Avenue between Carroll and Fairchild streets in 1847, it was only the second on that side of the square. Coming up the hill from the west, the forest of oaks was so dense you almost had to be to Tenney's house before you could even see the small capitol.

South of town, just east of the Catfish (Yahara) River between the Second and Third (Waubesa and Monona) lakes, there was an encampment of about a hundred Ho-Chunk. In the early winter of 1847, another hundred held an aggressive deer hunt on the north side of Fourth (Mendota) Lake that left five hundred carcasses. Whether the Ho-Chunk knew it or not, as the new village began to expand its street system, it would use gravel and stone systematically excavated from the ceremonial mounds that dotted the landscape.

The Congregational and Episcopal churches shared use of the council chamber in the capitol, while the Methodists used the Little Brick schoolhouse for their services. There were

Village Population and Births			
1846	626	1852	2,973
1850	1,672	1854	5,126
1851	2,306	1855	8,664

Births during the village decade included Madison's greatest citizen, two mayors, two members of Congress, Wisconsin's greatest historian, a beloved lawyer and jurist, four park namesakes, Frank Lloyd Wright's first employer, and Wisconsin's most revered politician.

- Burr W. Jones (1846–1935), attorney, jurist, philanthropist
- Philip Spooner (1847–1918), industrialist, mayor
- Nils Haugen (1849–1931), U.S. representative
- Henry Adams (1850–1906), U.S. representative, developer
- Edward Owen (1850–1931), professor, parks philanthropist
- William Rogers (1850–1935), insurance agent, mayor
- John Myers Olin (1851–1924), attorney, professor, prohibitionist, MPPDA founder
- Frank C. Hoyt (1852–1942), parks activist
- Reuben Thwaites (1853–1913), historian
- Allan Darst Conover (1854–1929), architect, engineering professor
- Robert M. La Follette (1855–1925), statesman

now two physicians — one a pleasant and successful incompetent, the other highly trained but with a penchant for drink.

With its future tied to Wisconsin's development as a state, the new village had its hopes for rapid growth dampened with the defeat of the proposed state constitution of 1846. But after provisions protecting women's property rights were removed, along with some other controversial sections, the people ratified a second draft in April 1848. On May 29, 1848, Wisconsin joined the Union as the thirtieth state.

At least the constitution still provided for the institution that would shape Madison more than any other — the University of Wisconsin,

continued on page 22

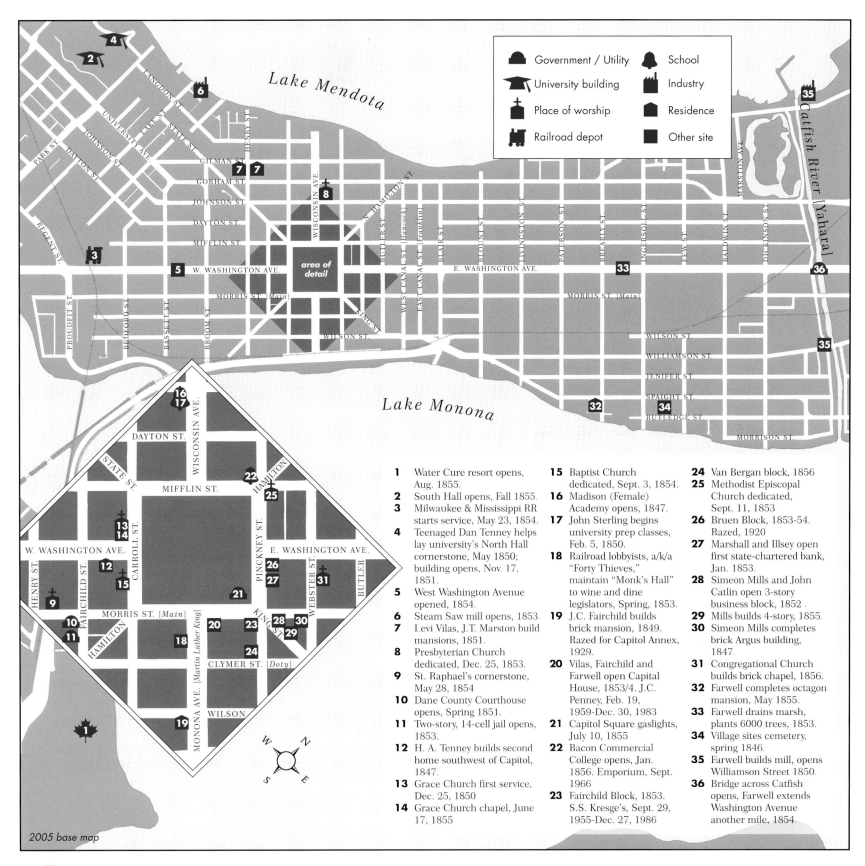

Legend

- ⬤ Government / Utility
- 🎓 University building
- ✝ Place of worship
- 🚂 Railroad depot
- 🔔 School
- 🏭 Industry
- ⬠ Residence
- ■ Other site

Lake Mendota

Lake Monona

Catfish River [Yahara]

1 Water Cure resort opens, Aug. 1855.

2 South Hall opens, Fall 1855.

3 Milwaukee & Mississippi RR starts service, May 23, 1854.

4 Teenaged Dan Tenney helps lay university's North Hall cornerstone, May 1850; building opens, Nov. 17, 1851.

5 West Washington Avenue opened, 1854.

6 Steam Saw mill opens, 1853.

7 Levi Vilas, J.T. Marston build mansions, 1851.

8 Presbyterian Church dedicated, Dec. 25, 1853.

9 St. Raphael's cornerstone, May 28, 1854.

10 Dane County Courthouse opens, Spring 1851.

11 Two-story, 14-cell jail opens, 1853.

12 H. A. Tenney builds second home southwest of Capitol, 1847.

13 Grace Church first service, Dec. 25, 1850

14 Grace Church chapel, June 17, 1855

15 Baptist Church dedicated, Sept. 3, 1854.

16 Madison (Female) Academy opens, 1847.

17 John Sterling begins university prep classes, Feb. 5, 1850.

18 Railroad lobbyists, a/k/a "Forty Thieves," maintain "Monk's Hall" to wine and dine legislators, Spring, 1853.

19 J.C. Fairchild builds brick mansion, 1849. Razed for Capitol Annex, 1929.

20 Vilas, Fairchild and Farwell open Capital House, 1853/4. J.C. Penney, Feb. 19, 1959-Dec. 30, 1983.

21 Capitol Square gaslights, July 10, 1855

22 Bacon Commercial College opens, Jan. 1856. Emporium, Sept. 1966

23 Fairchild Block, 1853. S.S. Kresge's, Sept. 29, 1955-Dec. 27, 1986

24 Van Bergan block, 1856

25 Methodist Episcopal Church dedicated, Sept. 11, 1853

26 Bruen Block, 1853-54. Razed, 1920

27 Marshall and Illsey open first state-chartered bank, Jan. 1853.

28 Simeon Mills and John Catlin open 3-story business block, 1852.

29 Mills builds 4-story, 1855.

30 Simeon Mills completes brick Argus building, 1847.

31 Congregational Church builds brick chapel, 1856.

32 Farwell completes octagon mansion, May 1855.

33 Farwell drains marsh, plants 6000 trees, 1853.

34 Village sites cemetery, spring 1846.

35 Farwell builds mill, opens Williamson Street 1850.

36 Bridge across Catfish opens, Farwell extends Washington Avenue another mile, 1854.

2005 base map

Village Map (map by David Michael Miller, courtesy of Isthmus Publishing Co.)

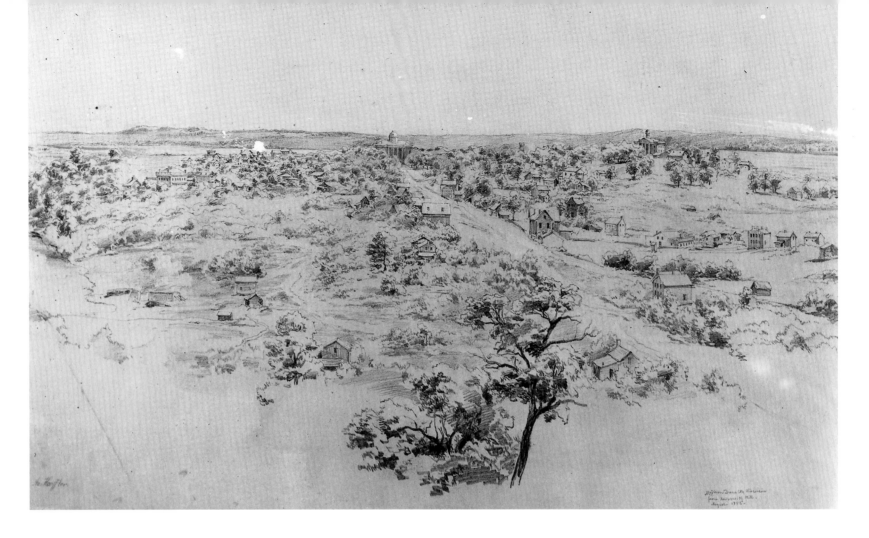

West King Street, 1852

The earliest known representation of State Street — still known as West King Street until renamed by the legislature on March 14, 1855 — is this 1852 sketch from College Hill by Adolph Hoeffler. The squat building at left with a dozen windows is the Levi Vilas mansion on Langdon Street. Arguably more impressive than the already inadequate state capitol is the first Dane County Courthouse (upper right), built in 1851 on the site of both its successor courthouse and later a parking ramp. Other views from this perspective are on pages 34, 46, and 131.
(WHi-11632)

Dateline

February 9, 1853 First meeting of Young Men's Christian Association, held in the courthouse.

VILLAGE PEOPLE *continued from page 20*

another development in the village decade.

And by then, Leonard J. Farwell had made his extensive purchase of lands and was about to begin the improvements that gave the struggling settlement new life.

By 1851, there were great stone mansions, fine business blocks, and a large mill, as statehood and the Farwell improvements triggered a building boom that transformed Madison.

The population, which more than doubled to 1,672 in the village's first three full years, doubled again by 1853, giving the village about 3,500 residents living in about seven hundred dwellings. It also had twenty-six stores, fifteen groceries, eleven taverns, six churches, three sawmills, two planing mills, two printing presses, a book bindery, a large grist mill, an iron foundry, a woolen factory, and the first state-chartered bank.

Among the important structures from the village period still extant as the city celebrated its sesquicentennial were the Simeon Mills Historic District (106–116 King Street), Grace Episcopal Church, St. Raphael's Cathedral, and several landmark homes on Mansion Hill.

As the people poured in, new neighborhoods grew. From the first settlement southeast of the capitol, development spread to Big Bug Hill, east along the ridges above Third Lake and Fourth Lake, down West King Street, and around the railroad depot — in modern terms, Mansion Hill, the Marquette and Tenney-Lapham neighborhoods, down State Street, and into the Bassett neighborhood.

Madison's core demographic changed during the village decade. At its outset, more than 60 percent of all Madisonians — and essentially all the powerful ones — were native born, mostly of Yankee stock from New York and New England. When Madison became a city in 1856, more than 55 percent of the people were foreign born or were children of ones who were. The

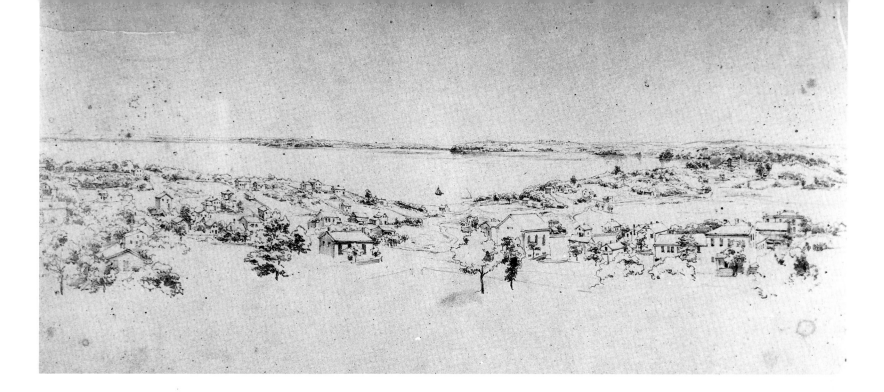

Yankees still held the power and wealth, but they were now outnumbered by the accumulation of Germans, Norwegians, and Irish.

The cultures clashed, especially on Sunday, as the Protestant Yankees derided the Roman Catholicism of many of the immigrants. They also took great offense at the German pastime of drinking, smoking, and having a good time after services. This conflict would remain a critical municipal issue — often *the* municipal issue — for over sixty years.

Just as the people had found their unincorporated status inadequate for the settlement's needs in 1846, a decade later the demands on the village clearly surpassed its legal, financial, and political resources across the range of municipal services. Even as the value of village property hit a quarter-million dollars, the board refused to spend $1,500 for a fire-fighting force. With public sanitation nonexistent, disease was rampant and fatal epidemics a recurring reality. Despite the visionary leadership of our first great school superintendent, the village board failed to fund the schools as required by statute. And even with all the Indian mound gravel the village could use, streets and sidewalks were often more theoretical than passable.

The village could barely even take care of its dead. Although selecting a cemetery site had been one of the new government's first acts in 1846, the 3.5-acre burial ground on Spaight Street near Third Lake was for years a disgrace; due to the lack of a proper enclosure, pasturing cows were free to desecrate the sacred ground. A fence was erected in 1852, but cholera epidemics soon left fewer than half the 256 plots unused. It would be left to the city to solve the cemetery crisis and convert this first site into the modern Orton Park.

The village did act, though, to facilitate the most important development any new outpost could obtain — a railroad connection. Its decision on February 11, 1853, to grant the Milwaukee and Mississippi Railroad a right-of-way for a depot just south of West Washington Avenue had a tremendous — and not entirely positive — impact. This seemed a sensible location, at the edge of the plat about a hundred yards west of Bedford Street, on land covered with a dense thicket of poplar, plum, and crab trees. But as the city's land-use patterns developed, this would prove a woefully wrong location, carving a scar into the residential and university west side without serving any commercial purpose and creating an intolerable traffic condition that would plague the city a hundred years hence. These concerns were far in the future, though, when the first locomotive steamed across Lake Monona on May 23, 1854.

A new building seemed to spring up just

North Hamilton Street, 1852

Hoeffler's pencil sketch of the view to Lake Mendota down the rutted and meandering North Hamilton Street four years before incorporation shows the two important structures book-ending the first block of North Pinckney Street — the Methodist Episcopal Church at East Mifflin Street and the American House on the corner of East Washington Avenue. Within two years of Hoeffler's visit, construction would start on a business block that would stand on the corner of East Mifflin and North Pinckney until 1954 (pages 40 and 46). It is hard to believe Madison would allow this lovely view to the water to be marred by such industrial uses as a planing mill and a hulking ice house, but for many decades it did (page 169). (WHi-11634)

about every day that year, bringing the total since statehood to almost a thousand. The building mania continued through 1855, at an even more frenzied pace. And with all those new people came new possibilities that the village couldn't fully seize and new problems it couldn't fully meet.

Madison had to become a city.

Madison Notable

No one has done more to make Madison grow than **Leonard J. Farwell** (1819–89), who tamed the wilderness and developed it. Born in upstate New York and orphaned at age eleven, Farwell found his way to Illinois at age nineteen and opened a hardware store. He moved to Milwaukee at twenty-one and became quite successful; within a few years, L. J. Farwell and Company was one of the largest hardware houses in the booming West.

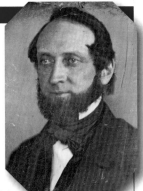

Leonard J. Farwell

(WHi-11334)

Farwell began buying vast tracts east of the capitol directly from James Doty in 1847. Moving to Madison the following year after an extensive foreign tour, he undertook a series of improvements that transformed the fledgling settlement. Over the next several years, Farwell straightened the Catfish (Yahara) River and erected the substantial Madison Mills at its mouth on Fourth (Mendota) Lake, thus making Madison the choice destination for area farmers; cleared and opened Williamson Street and the Fort Winnebago Road (Milwaukee Street); drained parts of the Great Central Marsh between the capitol and the river; laid down a street grid; and graded and improved East Washington Avenue, planting six thousand maple and cottonwood trees in twin rows. Farwell was even responsible for the legislature renaming the four lakes and the river with euphonious, three-syllable Native American words on February 14, 1855. Farwell also served as an officer of the Dane County Bank and the Madison Gas, Light and Coke Company, and aggressively and successfully promoted Madison's prospects through publications and personal recruitment.

Even as he was helping to create a city out of wilderness, Farwell found time to serve as Wisconsin's second, and youngest ever, governor (1852–54). Aided by executive secretary and future mayor Harlow S. Orton, his accomplishments included abolishing the death penalty, building the state Institute for the Deaf and Dumb, and creating the Commission of Immigration — the last idea so successful in expanding European settlement that several other states adopted it.

While governor, Farwell built a magnificent mansion on Lake Monona, a nearly 9,000-square-foot, three-story octagonal stone house with a circumference of two hundred feet; even the barn was of like design and material, 160 feet around. The mansion, the grandest the city had ever seen when it was finished in 1854, occupied the entire lakefront block bounded by Brearly and Spaight streets (see page 52).

Farwell not only built Madison's infrastructure, he also led the successful effort for incorporation as a city in early 1856. Despite compelling fiscal and jurisdictional reasons, Madison's first effort to go from village to city failed in 1852. But when Farwell, who had been a trustee in 1851, returned to the village board in 1855, he energized the drive and helped secure legislative approval of the new charter.

Inexplicably, despite his amazing record (which also included service on the village and city school boards), Farwell was defeated — by nine votes — when he ran for the common council from what is now the sixth district in 1857. It was his last foray into city politics.

That year also brought the total collapse of his empire, when the Panic of 1857 made worthless his extensive investment in the Watertown and Madison Railroad. Farwell lost all his Madison holdings, including the octagonal mansion, and moved to a home he had built and put in his wife's name on the north shore of Lake Mendota, an area he represented in the State Assembly (1859–61). In 1897 the presence of Farwell's second home would provide the name for the Madison Park and Pleasure Drive Association's new rustic road through Maple Bluff — the only remembrance of his critical contribution to the community and one not even within the corporate city limits.

Farwell served in the U.S. Patent Office under President Lincoln and was at Ford's Theater the night of his assassination. He rushed to warn Vice President Andrew Johnson and stayed to protect him from further conspirators. A grateful Johnson offered Farwell his pick of federal posts, but Farwell passed. After his wife died, Farwell moved to Chicago in 1870 to open a patent consulting company. After his firm was destroyed in the great fire the following year, he moved to the tiny town of Grant City, Missouri, and again helped build a new community. That was where he died at age seventy in 1889.

Naming the Four Lakes

Leonard Farwell didn't just build much of early Madison — he renamed critical parts, as well. To the Ho-Chunk, the major bodies of water in this area were long known as Tay-cho-per-ah, or the Four Lakes. But to surveyor Orson Lyon in 1832, they were simply lakes First through Fourth. In 1851, State Representative Augustus A. Bird, apparently unburdened by excessive modesty, proposed that the lakes be named in honor of himself, fellow capitol commissioners James Doty and John F. O'Neill, and pioneer postmaster John Catlin. Finding no support, he dropped the idea. When Farwell was preparing a promotional map in 1854, he wanted names more alluring than the numerical designations. Drawing on work by ethnologist-surveyor Frank Hudson (who also catalogued the effigy and conical mounds on West Wilson Street, page 20) and State Historical Society Secretary Lyman Draper, Farwell asked the legislature to designate the lakes and river with the euphonious names we use today. Hudson had suggested Monona and Mendota as early as 1849, with Draper taking Kegonsa and Waubesa from books five years later. However, although these words are all derived from Indian languages, none was given to these waters by any Native Americans, none of the languages are native to the Four Lakes region, and only Kegonsa and Waubesa (both Chippewa) have the meanings ascribed (fish and swan, respectively).

Dateline

July 13, 1854 Republican Party of Wisconsin holds first large meeting on capitol lawn, adopts resolution naming party and denouncing slavery.

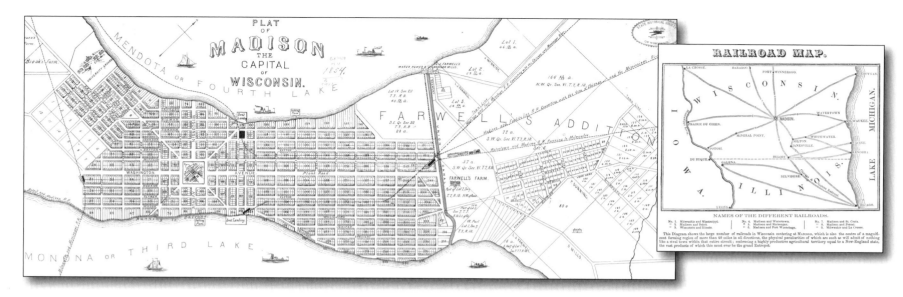

The Future Foretold *(above, above right, below)*

The factory/faculty split that would define Madison development in the twentieth century is already evident in this map from the summer of 1854, as Leonard Farwell's Madison Mills and the Keyes-Rodemund Brewery on the newly named Lake Mendota counter the 1850 University Addition and set the pattern for east-side industrialization. Farwell had just purchased and platted this massive addition, including the future Schenk's Corners at the juncture of historic Indian trails just east of the river; Winnebago Street is here already named, while Atwood Avenue is yet unlabelled and the waterway is called "Union Canal." The location of Farwell's Farm at the end of East Washington Avenue suggests a supplemental personal benefit the incumbent governor found from his planking the road to the capitol. But Farwell would soon lose the farm, and all this land, in the Panic of 1857.

Downtown, a number of streets bear long-forgotten names, echoes from the days of Doty. State Street is here still West King, Wisconsin Avenue runs from lake to lake, Langdon turns into Engle, the modern Main and Doty still honor Morris and Clymer, and West and East Canal have not yet become Hancock and Franklin. New oddities include a second Webster Street in the Farwell Addition (along with streets named for contemporaries Clay and Calhoun), and the anonymous street one block west of Carroll (a second Henry Street on Doty's final plat).

As published by Horace Greeley, the map featured some inset illustrations. Bruen's Block (right), Madison's most important office building from village days to the turn of the century, was a large sandstone building on the southeast corner of East Washington Avenue and South Pinckney Street — still the city's most powerful business address. As shown, tenants included three future mayors — attorney Harlow Orton, homeopathic physician Dr. James Bowen, and *Wisconsin State Journal* founder David Atwood. From 1856 to 1858, the city offices and council meeting room were on the third floor, just down the hall from the Madison Gas Light Company and the Madison Mutual Insurance Company. Bruen's Block was replaced in 1922 by the First National Building, which was replaced by the U.S. Bank building (a.k.a., "the glass bank") in 1973 — continuing a presence dating to an original tenant, the Dane County Bank.

Greeley's illustration also included the legendary "Nine Lines" railroad map (top right), which it said were already "centering at Madison" but which in fact would not be fully realized until 1887. (WHi-38904)

The Railroad Arrives

The most momentous day of the village decade was likely Tuesday, May 23, 1854, when the Milwaukee and Mississippi Railroad first steamed over the bridge and into its depot in the low marshy area southwest of the capitol. About 2,500 celebrants and spectators, along with bands from the Milwaukee fire companies, packed the thirty-two cars pulled by twin locomotives. "It was a grand but strange spectacle," one newspaper reported, describing "this monster train, like some huge, unheard of thing of life, with a breath of smoke and flame, emerging from the green openings — scenes of pastoral beauty and quietude — across Third Lake." But the auspicious day was not without incident — the train was late and the huge crowd so exceeded expectations that there wasn't enough food at the dinner reception.

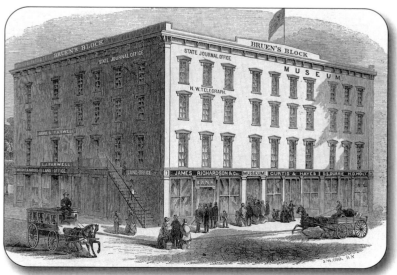

A Pioneer's Regrets

A hundred years of modern development have destroyed the remnants of a Native American culture three thousand years old and changed almost beyond recognition the topography left by the glaciers. Developers didn't just fill marshes and lakeshore to eradicate mosquitoes and create new land for building; they also leveled hills and ridges, many with great cultural significance. Topographically and culturally, the greatest loss was the elimination of the Dividing Ridge between Brittingham Park and Lake Wingra — a half-mile long, as high as an eight-story building, and dense with Indian relics, campsites, and graves — which archeologist Charles E. Brown rightly denounced as "a crime which should never have been perpetrated." Its sand and gravel were used to fill marshes, add land to Vilas Park, and make cement. Eventually, as the remembrance from Horace A. Tenney indicates, early Madisonians realized the damage they were doing. But by then it was largely too late.

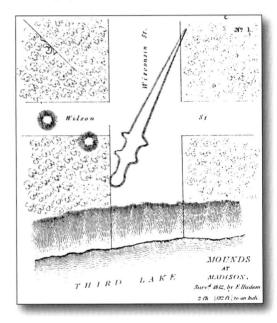

Indian Mound on West Wilson Street (left)

Three civilizations came together at one of Madison's most prominent points, and only one survived. To the left are two burial mounds, built about 1000 BC by peoples of the Woodland tradition. The dagger-like mound is a stylized turtle effigy mound, forty feet wide and over three hundred feet long, likely built between 400 and 1300 AD. This illustration by surveyor Frank Hudson was published in Increase Lapham's *Antiquities of Wisconsin* in 1855.

The Fairchild Mansion and Mound, ca. 1880 (facing page, top left)

This photograph from the 1880s shows the Indian mounds a generation after construction of the 1849 Fairchild mansion at the foot of Wisconsin (Monona) Avenue. This view shows the 318-foot-long turtle mound on the near side of the sidewalk running perpendicular to the house, one of Madison's social centers during and after the gubernatorial administration of Mayor Jairus Fairchild's son, Lucius. It wasn't until the death in 1926 of Governor Fairchild's widow, Frances, that the land was put for public purpose as the site of the Capitol Annex. By then the mounds were long gone, paved over in the Wilson Street right-of-way. After construction of the state office building, the open area to the left of the house was developed as a small park in memory of John Olin. It serves today as the entrance walkway to Monona Terrace Community and Convention Center. (WHi-34320)

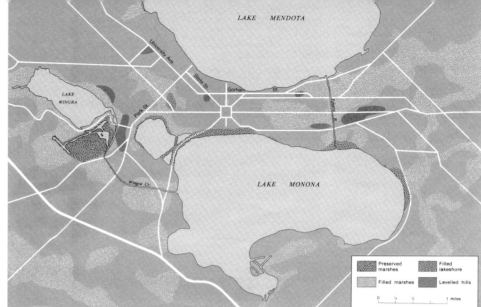

Excavation and Devastation *(top right)*

Historian David Mollenhoff calculates that 3,800 acres of marshland were filled in and 220 acres of lakebed were recaptured during Madison's formative years. This illustration shows where and identifies which hills were leveled for their gravel and sand.

(University of Wisconsin Cartographic Laboratory, courtesy of David Mollenhoff)

Vilas House *(center right)*

In early 1854, after the original developers failed to complete construction, Levi Vilas, Leonard Farwell, Simeon Mills, Jairus Fairchild, and others opened the massive, ninety-seven-room Capital House, one of the finest hotels in the state, at the southeast corner of Wisconsin (Monona) Avenue and Main Street. In 1865 Vilas bought his partners out and renamed it Vilas House. In January 1885 it was remodeled into offices, shops, and rooms and renamed the Pioneer Block. Its last tenant, a Woolworth's five-and-dime store, moved across the square in 1955 to the site of the 1858 city hall; the structure at 1 East Main Street was razed in 1957 for a J.C. Penney department store (1959–1983).

(WHi-35739)

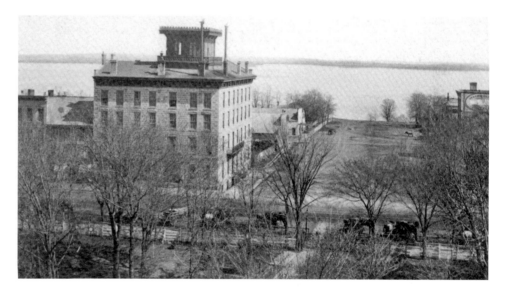

The Vilases at Home *(bottom right)*

The Levi and Esther Vilas family moved to Madison from Vermont in 1851, with profound immediate and permanent consequences for the village and state. Madison's population was roughly three thousand when Vilas spent about $15,000 to build this magnificent and elegant Greek Revival sandstone amid the dense woods and dirt paths of Langdon Street; it and a similar structure that Vilas's longtime friend J. T. Marston built across Henry Street were the first stone houses in the neighborhood later known as Mansion Hill. From 1911 to 1928 this was the Phi Gamma Delta fraternity house. The building was razed in 1965 for a dormitory, now home of the Evans Scholars. This photo of Levi and Esther on their front porch is from the late 1870s, a decade after Vilas's tumultuous term as mayor and shortly before son William rose to national prominence. (WHi-35735)

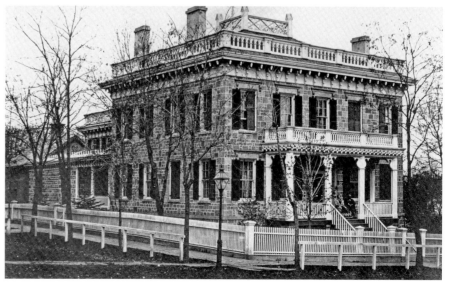

THE UNIVERSITY OF WISCONSIN

The most important phrase in Madison's official history is the constitutional mandate, Article 10, Section 6: "for the establishment of a state university at or near the seat of state government." The University of Wisconsin, far more than state government itself, has made Madison the city it is.

The presence of state government certainly provided security for the city in the formative years, and its economic engine has run strong ever since. But by any measure — economic, cultural, social, intellectual — the impact of the university has dwarfed that of the legislature and combined bureaucracy.

If state government disappeared, average household income would drop significantly, but the essential nature and daily existence of most of Madison would otherwise show little change. But without the University of Wisconsin, Madison would not be Madison.

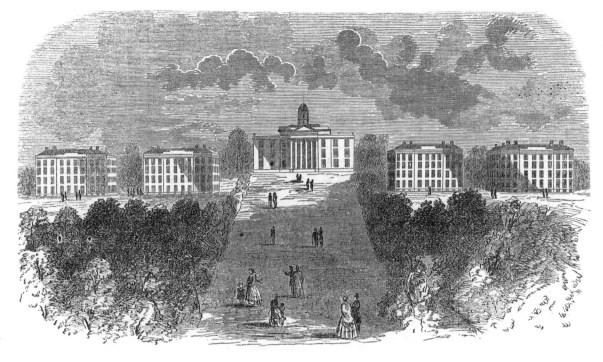

The University of Wisconsin

The first master plan of the University of Wisconsin, an idealized illustration conceived in 1850 and published in 1854. (University of Wisconsin Archives)

Madison Notable

John W. Sterling (1816–85) was called "Father of the University," the indispensable man of its early days. Professor of mathematics on the first faculty and head of the university when it was housed in the former seminary building on Wisconsin Avenue in 1848, he also was the school's administrative officer, responsible for everything from firewood to finances. Dean of the faculty (1860–65), vice chancellor, and vice president (1869–85), Sterling was the university's acting president for six years between Lathrop and Chadbourne. It was Sterling who decided to admit the unschooled John Muir to the preparatory department in 1861, and it was he who helped open the university to women two years later. Sterling Hall is named in his honor.

Madison Notable

John Lathrop (1799–1866), the University of Wisconsin's first chancellor, was a scholarly and urbane man who lacked both the imagination and self-confidence necessary to fight back against petty and penurious politicians. A graduate of and tutor at Yale University, Lathrop practiced law and was an instructor at a military academy before becoming principal of the Gardiner Lyceum in Maine. He was a professor at Hamilton College from 1829 to 1841, then chancellor of the University of Missouri until he was called to Madison in March 1849. Although Lathrop's inauguration on January 16, 1850, was a matter of great celebration — a brass band led the procession around Capitol Square — he soon made repeated political mistakes and ran afoul of those who held the university's purse strings. In an era when the legislature routinely attacked and demeaned the university, Lathrop was timid and ineffective in fighting for financial resources; the legislature did not contribute any fund to the university during Lathrop's administration. He resigned after the university's reorganization in 1858, leaving to become president of Indiana University before returning to the chancellorship in Missouri.

Dateline

February 13, 1855 Enactment of law incorporating Board of Education of Village of Madison, direct predecessor to city school board.

The University Addition

The University of Wisconsin has brought many great benefits to the city of Madison; the 188-lot University Addition, platted on August 28, 1850, and shown on this 1856 map, was not one of them. Block 11, southeast from Frances Street, completely cuts off Bassett Street, and outlot 6, southwest from Dayton Street, blocks Bedford Street. The city would eventually

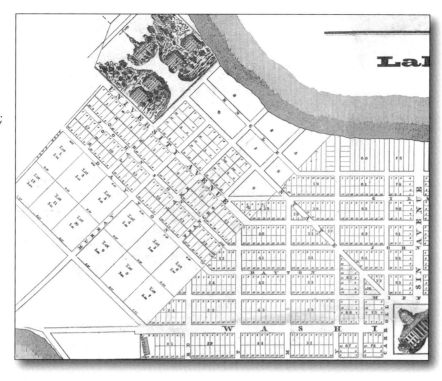

angle Bedford to the right, creating the jog around the site once called Bog Hollow, then developed as Barry Park. Despite the site's proximity to industrial uses, in 1934 the school board placed the new Washington School here, later converting the building to its administrative headquarters. But angling Bassett likewise left an awkward connection with Gorham Street; sixty years later, this is where planners would propose extending University Avenue all the way through to West Washington Avenue. A century and a half after this plat, Madisonians still suffer from the early refusal to accommodate the original street grid. By orienting University Avenue parallel to State Street, the plat also created a new grid that was carried through to the Greenbush and Vilas neighborhoods. There was, however, a good reason for the regents to have prepared this plat. Following Wisconsin's admission as the thirtieth state in May 1848, the regents appointed Simeon Mills to negotiate the purchase of what was already being called College Hill from Aaron Vanderpoel, a New York congressman and partner in speculation with James Doty. A decade earlier, Vanderpoel had offered the land for free, but by 1848 he wanted to sell the entire 157-acre parcel at fifteen dollars an acre; the regents took the deal. But needing operating income and figuring they had more than enough land, they promptly subdivided most of the parcel in early 1849 for residential development. (WHi-37373)

The First University Campus

From February 5, 1849, until 1851, the university used the former Female Academy on the southwest corner of Wisconsin Avenue and East Johnson Street as its "preparatory department" under the direction of John Sterling. Seventeen boys, most from Madison, were in the initial class. The building, visible in the photograph on page 43, was used as the Madison High School from 1860 until 1873, when it was razed for a new high school. (WHi-11698)

VILLAGE SCHOOLDAYS

A new era in the Madison school system began on April 8, 1854, with the arrival of superintendent Damon Y. Kilgore. Students noticed the change immediately; his first day as instructor at the Little Brick, Kilgore was so upset at their unkempt appearance that he sent all twenty-three students home until they were properly bathed and attired.

Kilgore's approach must have struck a chord. By that fall, the student body had grown so large it was necessary to rent space in the Methodist church basement for the older students. There was a further mingling of church and school the next spring, as some of the older students were taught in the Congregational church on Webster Street.

Then Kilgore went after legislation to create a Village of Madison school district. "I had a good opportunity to act as a lobbyist," he recalled years later, because the chairs of the Senate and Assembly Education Committees were tenants at the boarding house he ran. His efforts paid off, and the state incorporated the Village of Madison into a separate self-governed school district on February 13, 1855. The Village School Board — direct predecessor to the current school board — met for the first time on February 24, 1855, making the city's school board more than a year older than city government itself.

Unfortunately, the village board showed no more support for public education than did the town. Although the legislation Kilgore drafted made it "the duty" of the village to issue $10,000 in bonds for a union school house, it failed to do so. As a result, Kilgore had 267 students in one classroom, and schoolhouses he said were "much better fitted for *slaughter houses* than places in which to develop intellect." Kilgore even criticized the community for building churches rather than schools and helped kill a fund drive for a theater.

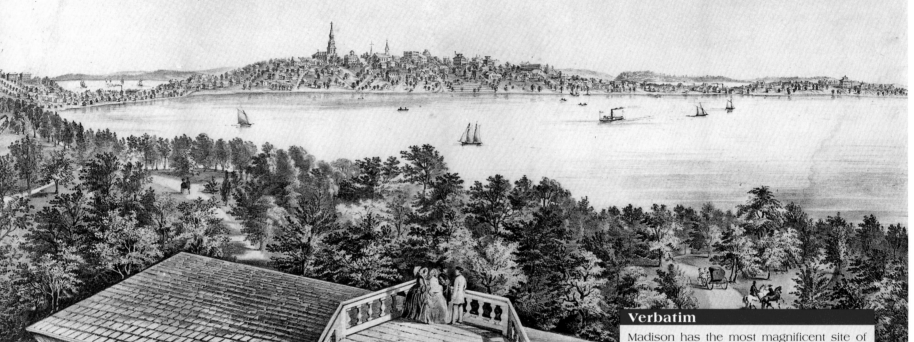

Dateline

February 14, 1855 At urging of former governor Farwell, the legislature renames the Four Lakes as Kegonsa, Waubesa, Monona, and Mendota.

Village on the Verge of Incorporation

From its earliest days, artists and publicists recognized that Madison's best face looked south to Lake Monona. This 1855 Charles Currier lithograph, the only work known to have been drawn by architect Samuel Donnel, was likely intended to capitalize on the glowing account of Madison by renowned newspaper editor Horace Greeley. It certainly portrays the village in a most favorable light, with a far more attractive terrace from Wisconsin (Monona) Avenue to the lake than would ever exist, having the steam locomotive skirt the water rather than cross it, and placing three more buildings on the university campus than were really there. St. Raphael's Church, which had its foundation laid only the year before, is shown with the steeple that would not rise until 1881. One detail that might have seemed fanciful at the time did in fact reflect reality — the Farwell mansion far from the city center, on the right edge of the frame. The stylish foursome in the foreground is atop the Water Cure, a large resort and spa that developers George Delaplaine and Elisha Burdick opened in 1854 on the site of today's Olin Park; it closed in 1857 but was reopened in 1866 as Lakeside House after an $18,000 renovation (see page 81). (WHi-3101)

Verbatim

Madison is situated on rising ground between two little lakes, as lovely as a fairy dream. Indeed, I consider Fairyland a very prosaic sort of place in comparison with this. — **Noble Butler**, *Knickerbocker Magazine*, September 1855

Verbatim

Madison has the most magnificent site of any inland town I ever saw, on a graceful swell of land. . . . A spacious water-cure establishment has just been erected. . . . The university crowns a beautiful eminence. . . . There are more comfortable private mansions now in progress in Madison than in any other place I have visited, and the owners are mostly recent immigrants of means and cultivation from New England, from Cincinnati, and even from Europe. . . .

Madison is growing up very fast; and if she can be speedily and thoroughly rid of some barnacles that have fastened upon her — gamblers and such like vermin — she has a glorious career before her. I beg her authorities to remember that "Righteousness exalteth a Nation" — and a city no less — and that every dollar that may be gained to either by the toleration of vicious haunts will cost her ten in money and still more in character. — **Horace Greeley**, *New York Tribune*, March 1855, republished in the *Wisconsin State Journal*, April 4, 1855

A CALL TO BECOME A CITY

The limitations of the village charter of 1846 were serious. Because of its property tax limit of $5 per $1,000 of assessed value, the village couldn't address such basic and critical needs as streets, schools, and fire protection. Troubling jurisdictional issues arose also; in addition to the poll and road tax issues, the town insisted it could license taverns — and collect the fees — within the village. And in a precursor to a fight over apportionment that would be fought until 1970, Madison's 3,500 residents had the same county board representation as a town one-fiftieth its size. Despite these arguments, the 1852 push for incorporation as a city failed, and lay dormant — until former governor Leonard J. Farwell was elected trustee in 1855.

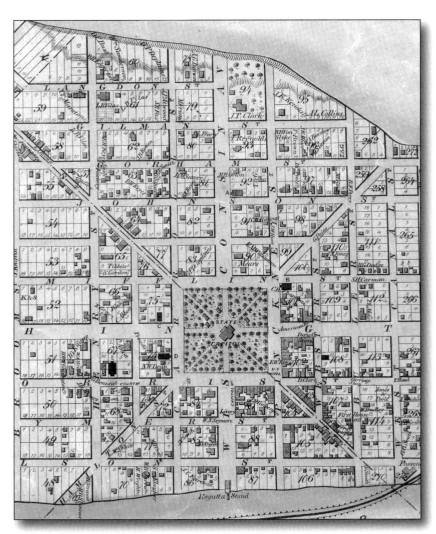

Village Fourths

In 1851, the Village of Madison's fifth Fourth of July celebration turned tragic when the cannon misfired and tore through a journeyman printer in the crowd. DeLancy Thayer's head was mutilated and both arms needed to be amputated at the shoulder. The presiding officer that day was Jairus C. Fairchild, five years before he became Madison's first mayor.

The five officers for the 1853 festivities included three mayors (Vilas, Atwood, and Orton) and a supreme court justice (Orton).

For its last Fourth of July (1855), the village did something special and new — a regatta on Lake Mendota, the first mass gathering of sailboats and rowboats. The nautical celebration drew about three thousand people — more than a third of the village population — and was a great success.

Downtown Detail, 1855

This detail from the Harrison Map (page 32) shows some of the downtown holdings of seven future mayors the year before the city's incorporation. In order of election: Jairus Fairchild, block 86; George B. Smith, block 63; Levi Vilas, blocks 58 and 61; Elisha Keyes, blocks 62, 63, and 102; David Atwood, block 85; and Andrew Proudfit, block 74. The southern segment of Wisconsin Avenue would not be named after the abutting lake until 1877. As block 270 makes painfully clear, not only did Doty fail to protect the axial views and access, he actually placed parcels where they would be split by section lines. (WHi-23644)

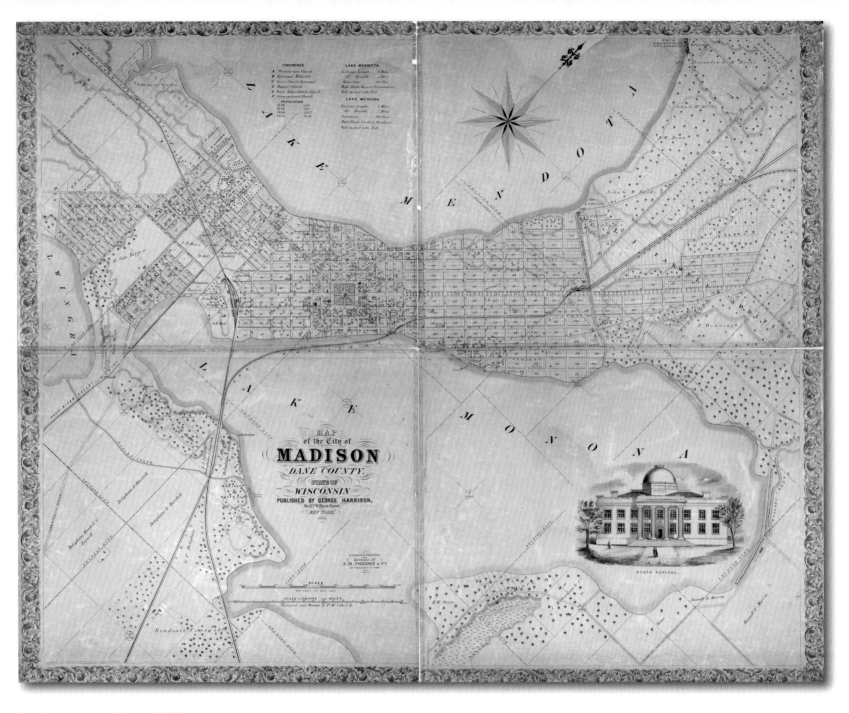

An Inaccurate Map, 1855

Unlike bird's-eye illustrations, which are understood to reflect some artistic license, maps are generally thought to be accurate. This map shows that's not always the case. Especially fanciful is its treatment of the east-side rail line, which did not exist until nine years after this map was created and did not follow the watery path shown here once it was established. The map even errs in its title, which anticipates by a year the incorporation of Madison as a city. But

some things that seem wrong were right at the time: east of Lake Wingra, cartographic evidence of the Dividing Ridge that would be desecrated and destroyed over the next half-century and the Catholic cemetery that in 1912 would become the site for St. Mary's Hospital. West of the Seth Van Bergen property (soon to become the Bowen Addition) is an early iteration — with a slightly different orientation — of part of the future Vilas and Oakland Heights neighborhoods (but without any note of the bear effigy

mound located on the modern Vilas Avenue). This early map of the Greenbush Addition, platted in September 1854, also shows how the University Addition alignment was continued to the southwest, which is why streets from Milton to Erin run parallel to State Street. The map also shows how the section line separating the Bowen, Brooks, and Greenbush additions became Mills Street, the first north-south roadway to be fully improved. (WHi-38341)

1856 THROUGH THE 1860s

THE NEW CITY, 1856

The City of Madison had a stressful birth and a childhood filled with crises. The week of incorporation, the young state of Wisconsin teetered on the brink of electoral chaos, indelibly staining the first local election. Within a year, the city faced down efforts to select a new capital, with another threat soon to follow. By the city's second Christmas, a nationwide economic panic had ruined municipal finances and helped destroy faith in the city leaders. The month after the city turned five, it became home to a major Civil War military base. At seven, Madison had to choose between its two leading citizens on a land-use plan with profound and permanent consequences. The spring the city turned ten, high water rising over the eastern marsh broke the Yahara bridges and carried them away. And soon after the war finally ended and the local economy started to recover, another national recession hit.

Skyline, 1860
There have been countless photographs taken of Madison's Lake Monona skyline. This is the first. (WHi-27111)

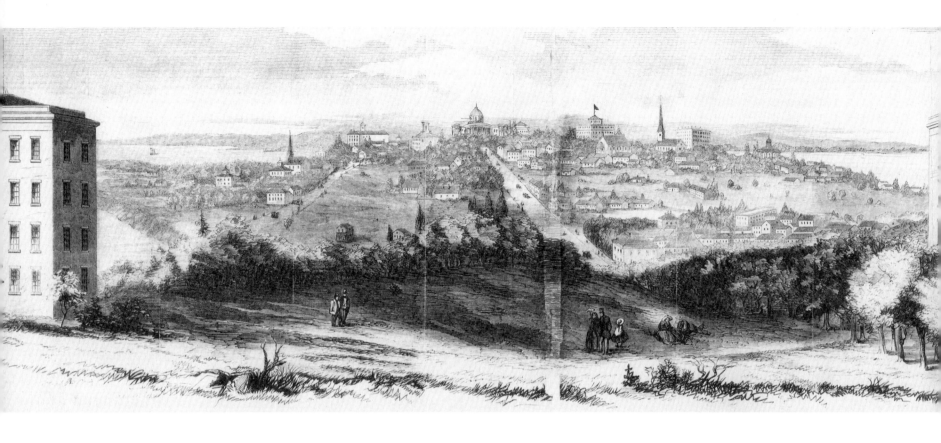

Births and Deaths

1856 Census: 9,161

From incorporation through the end of the 1860s, Madison saw the birth of four future mayors, including the only one who would become governor, a city-shaping philanthropist, a famed historian, and the city's most important builder. Two important progressives were born, but worlds apart. The city suffered the loss of two firsts — its first mayor and the first permanent white resident of Dane County. There was statewide tragedy as well — the accidental death of Wisconsin's first wartime governor. And it was quite a period for architects, busy being born as well as dying. Both members of the city's first important partnership died, one a suicide. But the state's most important architect was born, as was the world's greatest.

- Storm Bull (1856–1907), engineering professor, mayor
- William Curtis (1857–1935), collar manufacturer, mayor
- Arthur Peabody (1858–1942), state architect
- Thomas E. Brittingham (1860–1924), lumberman, philanthropist
- Frederick Jackson Turner (1861–1932), history professor
- Charles Whelan (1862–1928), journalist, orator, mayor
- Solomon Levitan (1862–1940), peddler, banker, state treasurer

- Albert Schmedeman (1864–1946), clothier, ambassador, mayor, governor
- John Findorff (1867–1948), contractor
- Frank Lloyd Wright (1867–1959), architect
- Ernest Warner (1868–1930), state representative, developer, president of Madison Park and Pleasure Drive Association
- Samuel Donnell (1820–1860), architect
- Ebeneezer Brigham (1789–1861), pioneer
- Jairus C. Fairchild (1801–1862), first mayor
- Louis Harvey (1820–1862), governor
- August Kutzbock (1814–1868), architect

View from College Hill, 1858

Frank Leslie's *Illustrated Newspaper* published this panorama on November 20, 1858. Although the drawing includes the typical puffery and inaccuracies — construction of the capitol had only just begun, with the dome not in place until 1869, State Street was neither that broad nor straight, and St. Raphael's Church was still twenty-three years from acquiring its steeple — it does convey the new city's growth since the same perspective was sketched six years earlier (page 22). A photograph of the same view from a few years later appears on page 46. (WHi-11034)

Dateline

Spring 1866 High waters over the marsh east of the capitol wash away the bridges across the Yahara, halting normal travel out of the city.

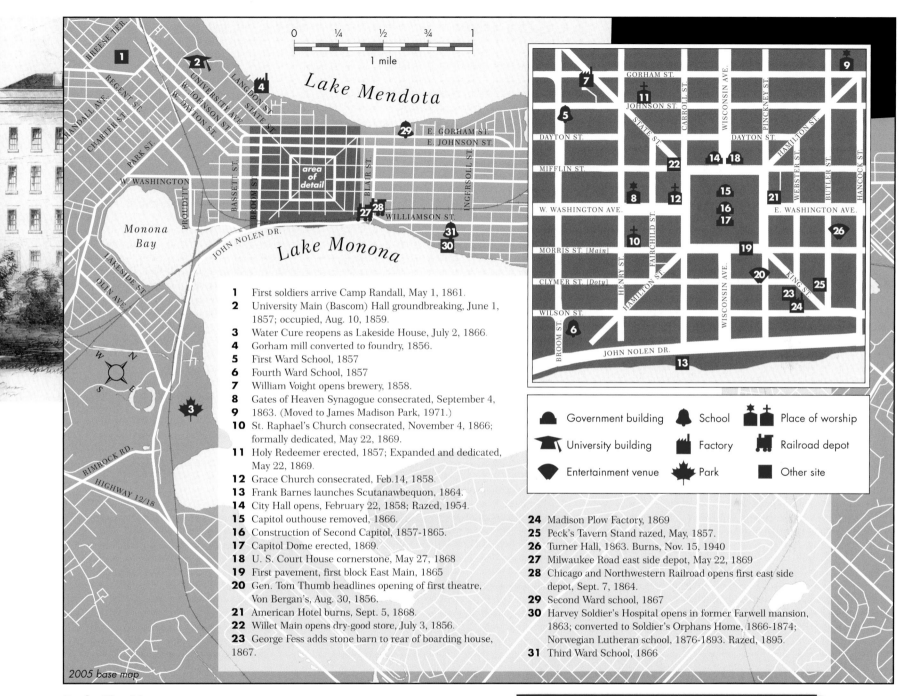

Early City Map (map by David Michael Miller, courtesy of Isthmus Publishing Co.)

1 First soldiers arrive Camp Randall, May 1, 1861.
2 University Main (Bascom) Hall groundbreaking, June 1, 1857; occupied, Aug. 10, 1859.
3 Water Cure reopens as Lakeside House, July 2, 1866.
4 Gorham mill converted to foundry, 1856.
5 First Ward School, 1857
6 Fourth Ward School, 1857
7 William Voight opens brewery, 1858.
8 Gates of Heaven Synagogue consecrated, September 4,
9 1863. (Moved to James Madison Park, 1971.)
10 St. Raphael's Church consecrated, November 4, 1866; formally dedicated, May 22, 1869.
11 Holy Redeemer erected, 1857; Expanded and dedicated, May 22, 1869.
12 Grace Church consecrated, Feb.14, 1858.
13 Frank Barnes launches Scutanawbequon, 1864.
14 City Hall opens, February 22, 1858; Razed, 1954.
15 Capitol outhouse removed, 1866.
16 Construction of Second Capitol, 1857-1865.
17 Capitol Dome erected, 1869.
18 U. S. Court House cornerstone, May 27, 1868
19 First pavement, first block East Main, 1865
20 Gen. Tom Thumb headlines opening of first theatre, Von Bergan's, Aug. 30, 1856.
21 American Hotel burns, Sept. 5, 1868.
22 Willet Main opens dry-good store, July 3, 1856.
23 George Fess adds stone barn to rear of boarding house, 1867.

24 Madison Plow Factory, 1869
25 Peck's Tavern Stand razed, May, 1857.
26 Turner Hall, 1863. Burns, Nov. 15, 1940
27 Milwaukee Road east side depot, May 22, 1869
28 Chicago and Northwestern Railroad opens first east side depot, Sept. 7, 1864.
29 Second Ward school, 1867
30 Harvey Soldier's Hospital opens in former Farwell mansion, 1863; converted to Soldier's Orphans Home, 1866-1874; Norwegian Lutheran school, 1876-1893. Razed, 1895.
31 Third Ward School, 1866

Government building
School
Place of worship
University building
Factory
Railroad depot
Entertainment venue
Park
Other site

Verbatim

O Lovely landscape! Beautiful scene!
Living mosaic of gold and green!
The crystal Monona yonder I view;
And here the Mendota, an ocean of blue!

— **Henry Clay Ainsworth**, *Wisconsin State Journal*,
 June 11, 1856

THE FIRST ELECTION

Madison's first mayoral election featured a brief but bitter campaign that had little to do with municipal issues. Instead, a highly partisan press used the local candidates as proxies in a statewide struggle.

Wisconsin was deep in a dangerous political crisis in early 1856, after the gubernatorial election of 1855 ended in a dead heat between incumbent governor William Barstow, a Democrat, and Coles Bashford, the first gubernatorial nominee of the new Republican Party. Five weeks later, the Democrat-controlled state board of canvassers threw out some Bashford votes, added some for Barstow, and declared the incumbent the victor by 157 votes.

Sworn in on January 7, Barstow readied a cache of arms and brought in some loyal German and Irish militiamen to defend his office — by force if necessary. But Bashford, sworn in privately that same day by Chief Justice Edward Whiton, chose litigation instead and filed suit in the State Supreme Court, two of whose three members were Republicans.

It was at the height of this crisis that Madison's charter was enacted and its first election was held. It was quite a week for Wisconsin municipalities; Green Bay and La Crosse were also incorporated at the same time.

The intense campaign, such as it was, was conducted with dispatch. Governor Barstow signed the first charter on March 4 and a corrective measure regarding date of incorporation on the seventh; the election was four days later.

Both Barstow and Bashford wanted to capitalize on the Madison mayoral race, to trumpet statewide a capital city victory. But first three candidates had to sort themselves out through two partisan nominating conventions. It was a process in which ambition and intrigue seems to have supplanted ideology.

In early 1856, most Madisonians assumed that the first mayor would be Jairus C. Fairchild, 54, a leading businessmen and Wisconsin's first state treasurer. But then pioneer contractor Augustus A. Bird, 53, who helped draft the proposed city charter and introduced the enabling legislation as state representative, also emerged as a candidate — only to drop out under pressure from former governor Leonard J. Farwell,

38, and endorse county judge Julius P. Atwood, 35. Farwell, Fairchild's partner in the development (with Levi Vilas) of the Capital House, apparently hoped to make his contemporary the unanimous choice. But Fairchild had other ideas.

Although Fairchild was always considered a consistent Democrat, the so-called "Shanghai" convention of Democrats, Republicans, and Whigs on March 7 nominated him to lead the People's ticket. Later that night, after Bird declined the honor, the Democratic convention nominated Atwood over Fairchild by a wide margin — branding the younger man with the mark of Barstow. "J. P. Atwood has always been in favor of the Barstow dynasty, and has lost no opportunity to secretly aid the petty schemes of the usurper," the *Daily Patriot* declared on March 10. Fairchild also had the support of the Republican *Wisconsin State Journal* (whose founder, David Atwood, was unrelated to Julius).

Dateline

April 7, 1856 Inauguration of first city officers, first meeting of Madison Common Council.

Although Madison voters had supported Barstow in 1855, the growing evidence of irregularities — and the highly partisan press — caused a massive shift, and Fairchild was elected, 711-506. "The dead weight of Barstowism was placed upon the back of Judge Atwood," the *State Journal* commented on March 12, adding that the results "repudiate everything tainted in the slightest degree with the pestilential breath" of the state election.

But the pro-Atwood *Argus-Democrat* saw another reason for Fairchild's triumph — the united support of voters interested in getting city credit for railroad development. As Fairchild was president of the Watertown and

Madison Railroad — and as subsequent events would soon make clear — this was not a far-fetched analysis.

Farwell's failure at mayor-making may also have accounted for the strange setback he suffered on election day; his support for Atwood was seen, probably unjustly, as favoring Barstow and helped account for his close defeat for the common council.

Barstow resigned on March 21. Three days later, the State Supreme Court ruled the board of canvassers had exceeded its authority in its vote count and declared Bashford the winner by 1,009 votes — meaning Madison's charter had been signed by a governor who held office illegally.

On March 25, Acting Governor Arthur MacArthur — the Democrat who had been lawfully elected lieutenant governor and the grandfather of General Douglas MacArthur — peacefully surrendered the gubernatorial office.

But Barstow's vice did not ensure his successor's virtue; as an 1858 investigation revealed, when the La Crosse and Milwaukee Railroad distributed more than $800,000 in a land grant scheme, the largest bribe — $50,000 in bonds — went to Bashford.

THE ROTARY ALL RIGHT!

NINE THOUSAND CHEERS!

THE SUPREME COURT SUSTAINED BY THE PEOPLE!!

Treason and Conspiracy Rebuked!!!

THE ROTARY

IN FIRST-RATE WORKING ORDER.

COLONEL FAIRCHILD ELECTED MAYOR!

MAJORITY, 305!

10 out of 12 Aldermen Anti-Barstow

Every Constable and Assessor Anti-Treason?

Three out of four Justices Anti-Treason!

Anti-Treason Treasurer 275 maj!

ALL HAIL THE POWER OF THE PEOPLE.

An Awful "Turn" to Conspirators!

CROW YE NOBLE ROOSTER, CROW!!

The Argoose Cleaned Out!

WE ARE TOO FULL FOR UTTERANCE.

ALL HAIL THE CAPITAL!

Election Coverage, 1856 (above)

This combination cartoon/editorial/news report from the *Daily Patriot* of March 12, 1856, exults in Fairchild's victory. The reference to rotary is a play on the nickname of political editor S. D. "Pump" Carpenter, who invented a rotary pump, used here to douse Barstow's supporters, called the Forty Thieves because of a railroad scandal in Barstow's first administration.

"A city by the name of Madison"

— Section 1, Chapter 75, Laws of 1856

Debate has raged for one hundred fifty years over the correct date to celebrate as Madison's birthday. The early historians, including Wisconsin State Historical Society librarian Daniel S. Durrie and state historian Reuben Gold Thwaites, cite March 4, the day in 1856 on which Governor Barstow signed the act chartering the city. Others cite March 11, the day of the first election, or April 7, the day Mayor Fairchild and the first common council were sworn in.

They're all wrong.

The first sentence of the legislation that Governor Barstow signed on March 4 created the city of Madison "from and after the first Monday in March next." March 4, however, was a Tuesday; the "first Monday in March next" was March 6, 1857. Because of this drafting error, Madison would have had to remain a village for another year before the new municipal charter would become effective.

So on Thursday, March 7, 1856, Barstow signed remedial legislation amending the earlier act "so as to read the seventh day of March, one thousand eight hundred and fifty six."

It's not that Barstow *signed* Chapter 119 on March 7 that makes this date Madison's birthday; March 7, 1856, is Madison's birthday because that's the day the charter took effect.

Verbatim

He (Fairchild) had a powerful frame, a large, intellectual head, fine features, a fair complexion, and bright auburn, curling hair. His physical strength was enormous. . . . Though genial in his ways, and under habitual self-control, his passions were strong; and his keen sense of honor led him to quick resentment of any attack upon his character. The first year of his residence in Madison, he walked steadily into a printing office, and, with his own unaided arm, broke up a newspaper from upon the press, then printing false words derogatory to him. This strength and self-reliance in his personal appearance made the feebleness and loss of sight of his last months peculiarly touching. — **Consul Butterfield**, *History of Dane County*

Madison Mayor

Jairus Cassius Fairchild (1801–62), Madison's first mayor and father of Wisconsin's first three-term governor, was not marked for greatness from an early age. Born to a large family in upstate New York, Fairchild was still quite young when his mother died; he left home at age eleven because he didn't get along with his stepmother. Finding it hard to hold a job because he always got up too late, he made his way to Ohio at age twenty-one with an older brother from whom he was soon separated. Fairchild had a

(WHi-36023)

rollercoaster career in business, including running a tannery with the father of abolitionist John Brown. He married Sally Blair, fathered four children, built the first brick building in Kent, Ohio, and became a justice of the peace. The family moved to Cleveland, where Fairchild was bankrupted by the Panic of 1837. A Henry Clay Whig, he campaigned actively for William Henry Harrison and remained loyal to President Tyler upon Harrison's sudden death; his loyalty was rewarded with an appointment to the Secret Service in a location of his choosing. He chose Madison, arriving on a wintry March day in 1846. Fairchild bought a northern sawmill, started a local brickyard, and built a large house at the foot of Wisconsin Avenue in 1849. A delegate to the Wisconsin Constitutional Convention, Fairchild was elected Wisconsin's first state treasurer in 1848 and again in 1849, but he fell just short of the Democratic gubernatorial nomination in both 1851 and 1853. Perceived in 1856 as the anti-Barstow candidate at the height of the crisis over the governorship, Fairchild defeated independent Julius P. Atwood, 711-506. Although Fairchild's term was a success as the new city undertook an extensive building program, his final years weren't happy ones. He was beset by failing health and saw his three sons volunteer for the war that he had opposed (as he had opposed Abraham Lincoln's election in 1860). Eldest son Cassius, a former Madison alderman and state legislator, was seriously wounded at Shiloh and was sent home to recover in the bedroom adjoining that of his ailing father. Fairchild died in 1862, shortly before his second son, Lucius, lost his left arm at Gettysburg and began a political career that would include three terms as Wisconsin's governor and diplomatic posts in Liverpool, Paris, and Madrid.

City Structure and Powers

As decreed by the state legislature, Madison's charter divided the new city into four wards, bounded by Wisconsin and Washington Avenues. The northwest quadrant was the first ward, northeast was the second, southeast the third, and southwest the fourth. Each ward had three aldermen, one justice of the peace, one assessor, and one constable; a mayor, a treasurer, a marshal, and a police justice were elected citywide. The mayor was empowered to "appoint the police force in such numbers as the common council may direct" and directed to "take care" that all laws and ordinances were enforced and observed. The mayor was also required to "communicate in writing to the common council once a year, such information as he may deem necessary, and at all times give such information as the common council may require." The council was empowered to elect several city officers, including a clerk, attorney, and surveyor. Prior to the enactment of the statute providing for general municipal powers, cities had only those powers specifically enumerated in their legislative charters, requiring each charter to be long and frequently amended. Madison's original charter gave the common council "the control and management" of the city's finances and property, as well as the authority to:

Grant licenses for selling spirituous, vinous or fermented liquors . . . provided that no person thus licensed shall sell or give away spirituous, fermented or vinous liquors on election day;

Prevent any riots, noises, disturbances, or disorderly assemblages, suppress and restrain disorderly houses or groceries, and houses of ill-fame, and to authorize the destruction of all instruments used for purposes of gambling;

Establish rates for and license vendors of gun powder, and regulate the storage, keeping and conveying of the same, or other combustible material;

Prevent horse racing, immoderate riding, or driving in the streets, and to regulate the places of bathing in the water within the limits of said city;

Restrain the running at large of horses, cattle, swine, sheep, poultry, and geese, and to authorize the distraining, impounding, and sale of the same;

Dateline

May 10, 1856 Council adopts ordinance to restrain horses and pigs.

Prevent the running at large of dogs, and to authorize the destruction of the same in a summary manner, when at large contrary to the ordinance;

Establish the assize and weight of bread, and to provide for the seizure and forfeiture of bread baked contrary thereto;

Prevent shooting off fire arms or crackers and to prevent the exhibition of fire works in any situation which may be considered by the council dangerous to the city or any property therein;

Restrain drunkards, immoderate drinking, or obscenity in the streets or public places, and to provide for arresting, removing, and punishing any person or persons who may be guilty of the same;

Regulate, prevent, and control the landing of persons from boats, cars, and stages, wherein are contagious and infectious diseases or disorders, and to make such disposition of such persons as to preserve the health of the city;

Subscribe for stock in or loan the credit of the city to any railroad company whose road has a terminus in the city of Madison, to the extent of $300,000 . . . submitted to a vote of the citizens at any regular or special election called for that purpose;

Require the owner of any lot or grounds in the city to set out shade or ornamental trees in the street or streets front the same, and in default thereof to cause the same to be done, and to levy a special tax upon such lot or grounds to pay the expense of the same;

Have jurisdiction over the entire lakes bordering on the city, so as to prevent any deterioration of the waters, or any nuisance being cast therein, by which the health of the inhabitants of the city or the purity of the water shall be impaired; and may also prohibit the taking of fish in the waters thereof, or outlet between the same, during the months of May, June, and July of each year.

Verbatim

We have a responsibility we cannot avoid; a labor we must perform, and our reward will be in seeing the fruits of our labor in blessings in the future. We can fix no limits to our growth.

We challenge the world to produce a location for a city whose position embraces so many practical advantages, combining beauty with utility, health with facilities for living, a climate free from changes that disturb the labor, or impair the energies of our people, on shores of lakes of surpassing loveliness.

I call your attention to the necessity of furnishing a suitable number of carefully constructed buildings, for our common schools. To crowd into badly constructed, half warmed and ill ventilated buildings, young and growing children, is not to be educated, but to destroy physical development, and intellectual growth; and the location and construction of our schoolhouses, should in the future be free from the serious evils of the past.

The erection of suitable market houses together with a City Hall will present itself to your consideration as necessary appurteneid, to our increasing population. It is a band with truth, that no town or city can be complete without some convenient and spacious Hall for public use. Your own convenience and labor will be expedited by such a room, and by a combination of a hall with a market house, or some other public building would combine economy with beauty in its erection.

We must progress, and must seize favorable opportunities, or our neighbors will supplant us.

— Mayor Jairus C. Fairchild, excerpts from his first inaugural address, April 7, 1856

Taxpayer Revolt

No event shook and shattered early Madison as much as the taxpayer revolt of 1857. And no event caused deeper and more lasting problems.

"We commence our city under most favorable circumstances," Mayor Jairus Fairchild declared in his inaugural address on April 7, 1856. "We can fix no limit to our growth." The council responded, using its new municipal powers to borrow and spend as never before.

The scandal started innocently enough on May 16 with the new council's approval of a $100,000 bond issue for such essentials as a city hall, adequate fire protection, schoolhouses, and a hospital. But the bonds brought in only $79,000 and were then used to benefit a politically connected bank. Questions arose and grew into concerns. Not, however, among city officials. Brimming with western bravado and seeing prosperity all around, the first common council continued to borrow and spend. Next on the shopping list was a second railway line, to compete with the rapacious Milwaukee and Mississippi Railroad, which had entered Madison in 1854.

So when the Watertown and Madison Railroad asked for $100,000 in December 1856, the council was happy to help — especially since Mayor Fairchild had just been elected president of the company. Voters agreed, approving the bond 853-19 in a January 1857 special election. The people, united, would soon find themselves defeated by forces beyond their control.

Two months later, the city went to the well again — this time in self-preservation. When talk arose anew about possibly relocating the capital, the council quickly approved a $50,000 bond issue to fireproof and expand the city's centerpiece (see page 63).

Having taken care of the living, the council then attended to the dead, through a $10,000 bond to buy an eighty-acre parcel for a new city cemetery. On the "remonstrance of sundry citizens . . . against the city locating a public cemetery within city limits," the council chose a rolling, oak-covered site in the town a bit more than two miles west of the square.

In its first eleven months of existence, the city of Madison had thus incurred a debt of $260,000. But debts incurred when times are good are tough to pay when things get rough. And in the summer of 1857, things were getting rough after the bubble in Western lands burst on Eastern speculators.

By fall it was a full blown panic. As banks failed in the East, the ripple effect turned into a tidal wave that swamped Wisconsin, its capital city, and many of Madison's leading men. A vicious cycle took hold: property

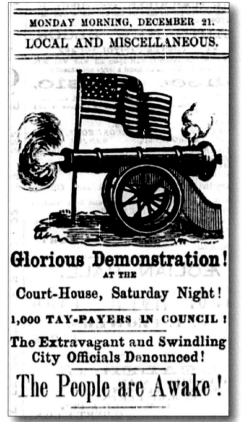

MONDAY MORNING, DECEMBER 21.

LOCAL AND MISCELLANEOUS.

Glorious Demonstration!
AT THE
Court-House, Saturday Night!

1,000 TAY-PAYERS IN COUNCIL !

The Extravagant and Swindling City Officials Denounced!

The People are Awake !

The winter of the people's discontent, December 1857

values plummeted, city revenues dried up, city services were cut, Madisonians moved away in droves, property values fell yet more, and so on.

Then the 1857 tax bill came — and because the city had spent more than twice what it had budgeted, the recent drop in city services was not matched by a reduction in taxes. Adding insult to deep injury was the news that the council, contrary to the city charter, had voted each alderman a direct payment of $250 plus other perks.

On December 19, 1857, more than a thousand angry taxpayers — approximately 10 percent of the city's population — met at the courthouse to denounce the "most extravagant and reckless" council for "rendering our City Government . . . a burden beyond endurance."

The people called for deep reform, and they got it — with a vengeance. In early February 1858 — not yet two years after Madison's incorporation — the state imposed a draconian charter amendment that imposed burdensome mandates and set severe fiscal restrictions, including an $8,000 levy limit for operating expenses and a de facto ban on any further borrowing.

As if its fiscal problems weren't enough, the city in 1858 had to confront another attempt to move the state capital to Milwaukee. Through a series of questionable negotiating tactics and parliamentary maneuvers, Madison managed to retain its status.

The city still had to repay the $260,000 in bonds, though — no small challenge in the years immediately before and during the Civil War. Finally, in March 1864, after years of prodding by mayors George Smith and William Leitch, Madison and its bondholders agreed to reduce the debt to $160,000.

But the legacy of 1857 lived on for another generation — it was not until 1893 that Madison was able to borrow again for further municipal improvements.

Verbatim

The men composing the several Railroad Companies to which I have alluded are men of ripe experience, enterprise, energy and intelligence, with the power and will to do and perform what they undertake. They are emphatically and in fact Western men, endowed with Western energy, enterprise and understanding, and realizing Western progression. Knowing the wants and embarrassments of the country, they know how to supply the one and relieve the other. — **Mayor Augustus A. Bird**, annual message, 1857. By year's end, a railroad company's failure would push Madison into financial and political crisis.

Augustus A. Bird, ca. 1857
(WHi-27657)

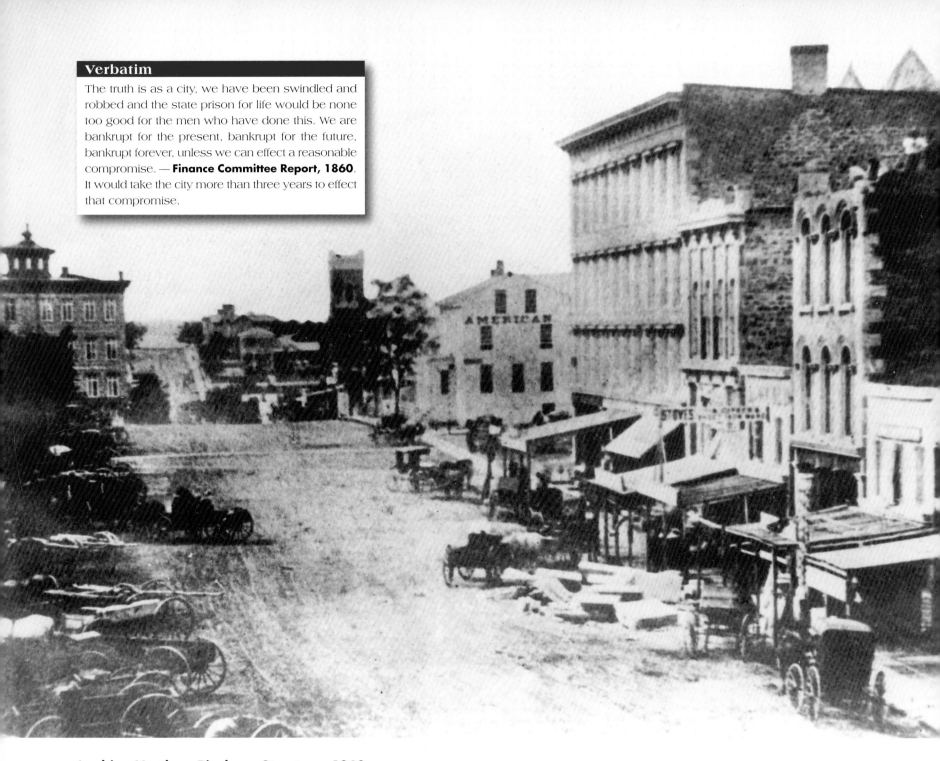

Looking North on Pinckney Street, ca. 1860

Several signature buildings from the Civil War era are seen in this view north on Pinckney Street. The building with cupola on the left is the Bacon Block, built in 1855–56 and the oldest structure on the square when it was demolished in 1965 for a new Emporium department store. Among the building's first tenants was a commercial school that eventually evolved into the Madison Business College. From 1860 to 1870, the *Wisconsin State Journal* was published here. After a series of ownership transfers and remodelings — which included replacing the cupola with a fifth floor — the building in 1900 became the Madison Hotel, and with various commercial tenants it remained known by that name until its razing. On the ridge up Pinckney Street is the Italianate sandstone mansion built by banker N. B. Van Slyke in 1857. The residence of Governor Edward Salomon, it was later occupied by industrialist Morris Fuller and then his

continued on facing page

Napoloen Bonaparte Van Slyke (1822–1909), the archetypal banker-politician, came to Madison from upstate New York in 1853, backed by capital from Eastern railroad interests. Van Slyke started as a cashier of the Dane County Bank, became president of successor First National Bank (predecessor to First Wisconsin and U.S. Bank), president of the Wisconsin Bankers Association, and a member of the executive council of the American Bankers Association. As chair of the Finance Committee on the first common council, Van Slyke took most of the criticism for netting only $79,000 from the city's $100,000 bond issue in 1856. He took even more criticism for depositing the proceeds in his own Dane County Bank, to lend at interest. Still, his Mansion Hill constituency returned him to office the next April and he remained a powerful force in finance and politics into the twentieth century. While on the council Van Slyke was also instrumental in the construction of city hall, the selection and improvement of Forest Hill Cemetery (where he is interred), and the purchase of the city's first firefighting equipment. Van Slyke was state quartermaster during the Civil War, attaining the rank of lieutenant colonel. He built two Mansion Hill landmarks, the Fuller-Bashford House at 423 North Pinckney Street and his own residence at 510 North Carroll Street.

(WHi-39001)

The Budget's Bumpy Ride

In an era when street improvements were the most important municipal function, depression, tax revolt, and war sent the new city's public works budget on a wild rollercoaster ride:

	General Taxes	Expenditures	Public Works
1856	$ 16,810	$ 56,968	$ 17,237
1857	46,040	64,841	12,239
1858	31,166	13,835	4,144
1859	15,091	15,381	4,607
1860	13,188	10,525	$1,184
1861	9,083	9,580	$3,089
1862	4,000	12,731	$3,265
1863	4,000	10,710	$3,807
1864	4,000	14,543	$5,870
1865	8,000	18,045	$8,115
1866	23,000	42,511	$24,551
1867	25,000	35,380	$21,006
1868	41,197	35,794	$10,792
1869	28,130	29,343	$11,404
1870	35,164	39,411	$12,989

Looking North on Pinckney Street *continued from facing page*

daughter Sarah and her husband, Robert Bashford, who would become mayor. The Fuller/Bashford House still stands at 423 North Pinckney Street, although not as prominently as in this perspective. The large tower is part of First Methodist Church on the corner of Pinckney and Mifflin streets. The American House, on the corner of East Washington Avenue, was the city's leading hotel of the time and was the site of the first session of the Wisconsin legislature. It burned in 1868 and was replaced in 1871 by the sandstone Mason-Baker Block, part of which still stands. The four-story building on the right is Bruen's Block, one of Madison's leading office buildings from 1853 until its demolition in 1920; its corner of East Washington Avenue and South Pinckney Street remains one of the city's premier business addresses, today occupied by the U.S. Bank Plaza. This John Fuller photograph also shows how crowded, dusty, and dirty downtown streets were shortly before the first ordinance regulating the parking of carriages and wagons. (WHi-11701)

George B.Smith (1823–79), was the youngest member of the 1846 Constitutional Convention and Madison's first two-term mayor, from 1858 to 1860. He tried, without much success, to get the city to fix its finances after the troubles in 1857. As state attorney general (1854–55), he supported Barstow's reelection. Smith was twice defeated for Congress (1864 and 1872), but was returned to city hall as Madison's sixteenth mayor in 1878.

August 30, 1856 General Tom Thumb headlines the opening of Van Bergen's Theatre upstairs at corner of Pinckney and Clymer (Doty) streets, the first theater auditorium in Madison.

It is now useless to indulge in regrets for the past, or criminations of those who were merely the agents of the people in incurring those large expenditures. . . . The present financial embarrassment admonishes us to prudence for the future. — **Mayor George B. Smith**, first annual message, 1858. At the time, thanks to the lingering debt from the 1857 bonds and the $8,000 levy limit, the city had $5,766 to meet $11,058 in projected expenses.

CITY HALL

An edifice which is an ornament to the city," incoming mayor George Smith called city hall shortly after it opened, and even the world's most famous architect agreed to a point.

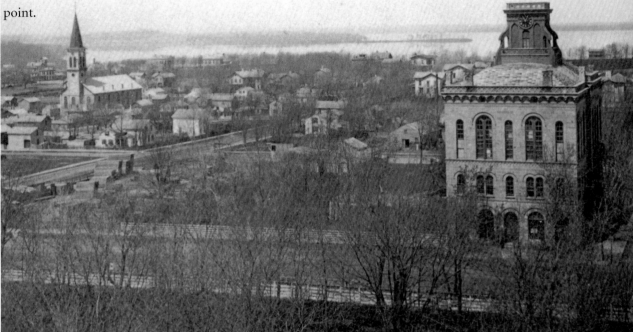

City Hall and Holy Redeemer Church with lumber yards in between, ca. 1868 (WHi-35749)

"Its lean Gothic tracery, tall windows and high ceilings are an honest type of good stone work, and so distinguished," Frank Lloyd Wright said in 1935. "There is a spirit of repose in its native stone." Architects August Kutzbock and S. H. Donnell, who also designed the second capitol, purportedly patterned the three-story Madison sandstone building after the Palazzo Vecchio in Florence, Italy.

The building, fifty by one hundred feet at the corner of Mifflin Street and Wisconsin Avenue, was Madison's first municipal budget-buster. The council on May 16, 1856, appropriated $25,000 for its construction — part of the $100,000 bond issue — and issued contracts for about $22,000. But the actual cost came in at over $40,000. The 80 percent cost overrun was somewhat mitigated, though, when workers were paid in city scrip that was worth only seventy five cents on the dollar.

City hall opened on a bitterly cold Washington's Birthday in 1858. As Mayor Fairchild had proposed in his 1856 message, the building was a fully mixed-use facility. The basement held a corner room that had been finished for a grocery store, rooms on the ground floor were fit for shops, the second floor contained offices and two jail cells. The huge third floor hall — with ticket office and room for nine hundred, lit by two large chandeliers hanging from its twenty-four-foot-high ceiling — served as the first city auditorium; the first performance was by a minstrel group, the George Christy Minstrels, with subsequent lectures and entertainments from such figures as Ralph Waldo Emerson and the renowned Norwegian violinist Ole Bull (no relation to Frances Bull Fairchild). The third floor hall was also used for militia drills and target practice and services for the First Congregational Church. The building also housed two fire engines until a new station was built in 1874, as well as the city library.

The new city hall may have also helped save Madison's status as state capital in February 1858, when legislators proposed a "temporary" relocation of state government to Milwaukee while a new capitol was designed and built. Despite a recent charter amendment that required the city to charge rent for use of the building to help pay off the 1857 bonds, the city offered the state free use of the building during construction, and the state accepted. But after some intricate parliamentary maneuvers kept the capital in Madison, the city rescinded its offer, rented space to the state instead, and mortgaged the building to pay down the outstanding debt.

Citing the continuing need for rental income, from 1858 until 1873 the city leased the basement space for a saloon.

The city sold the site in 1952 for $285,000 and the building was razed. A two-story Woolworth's took its place from 1954 to 1986. A luxury high-rise condominium was erected on the site in 2005.

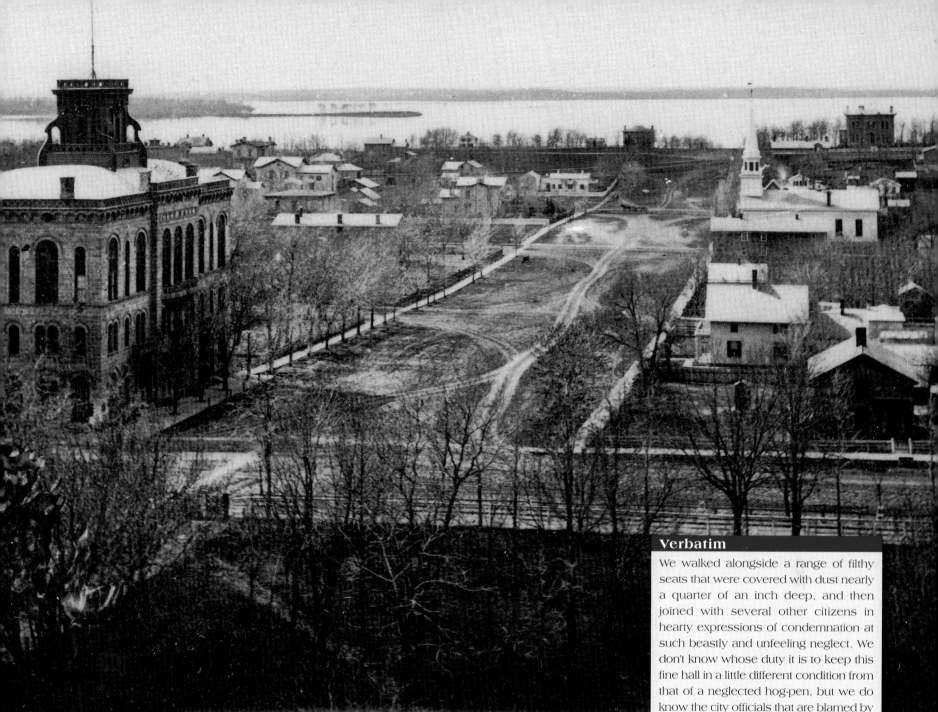

Wisconsin Avenue, ca. 1868

The first city hall, designed by Donnel and Kutzbock, about a decade after it opened at the corner of Mifflin Street and Wisconsin Avenue. The low frame building along Johnson Street is the former Female Academy, first home to university classes in 1850 and, from 1860 to 1873 (with one interruption), the city high school. Just over the academy's roofline is the Daniel K. Tenney house at 401 North Carroll Street, later the home of Breese Stevens. The massive building on the ridge at right is the Julius Clark house, which William F. Vilas bought in 1877 and which was razed for insurance company offices in 1963. In the right foreground is the lot where the first postmaster, John Catlin, built the settlement's first log cabin. Shortly after this photograph, construction would start on the elegant new post office (see page 84). (WHi-40611)

(see page 84)

Verbatim

We walked alongside a range of filthy seats that were covered with dust nearly a quarter of an inch deep, and then joined with several other citizens in hearty expressions of condemnation at such beastly and unfeeling neglect. We don't know whose duty it is to keep this fine hall in a little different condition from that of a neglected hog-pen, but we do know the city officials that are blamed by the fathers and families of this city for such hoggish inattention.

For the sake of common decency and an idea of comfort above that evidenced by the degraded Indian, let us have a City Hall that has cost so much money, kept in a condition suitable for the occasional accommodation of civilized human beings. — **Daily Patriot**, October 19, 1859

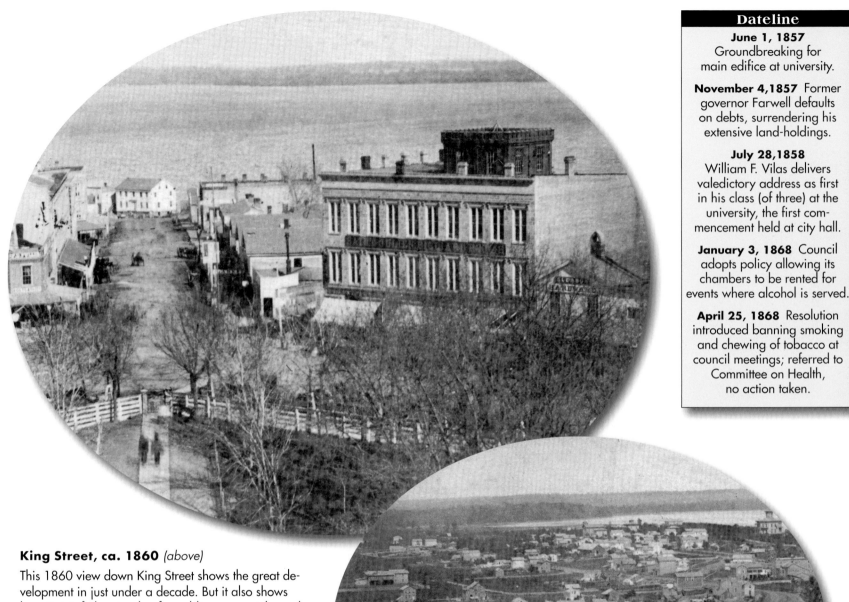

Dateline

June 1, 1857
Groundbreaking for
main edifice at university.

November 4, 1857 Former
governor Farwell defaults
on debts, surrendering his
extensive land-holdings.

July 28, 1858
William F. Vilas delivers
valedictory address as first
in his class (of three) at the
university, the first com-
mencement held at city hall.

January 3, 1868 Council
adopts policy allowing its
chambers to be rented for
events where alcohol is served.

April 25, 1868 Resolution
introduced banning smoking
and chewing of tobacco at
council meetings; referred to
Committee on Health,
no action taken.

King Street, ca. 1860 (above)

This 1860 view down King Street shows the great de-
velopment in just under a decade. But it also shows
how Doty's failure to plan for public access at the end-
points of the axials led to the quick loss of this vital
view to mundane commercial use. The 1852–55
Simeon Mills's Historic District buildings are visible on
the left side of the first block of King Street. The large
commercial building in the foreground on East Main
Street is the 1853 Fairchild Block, home at this time to
the Saint Julien Billiard Rooms. (WHi-23465)

King Street, ca. 1860–63 (right)

This view over the Simeon Mills Historic District shows
the near east side and the former Farwell mansion,
vacant now but soon to become the Harvey Hospital.
(WHi-26870)

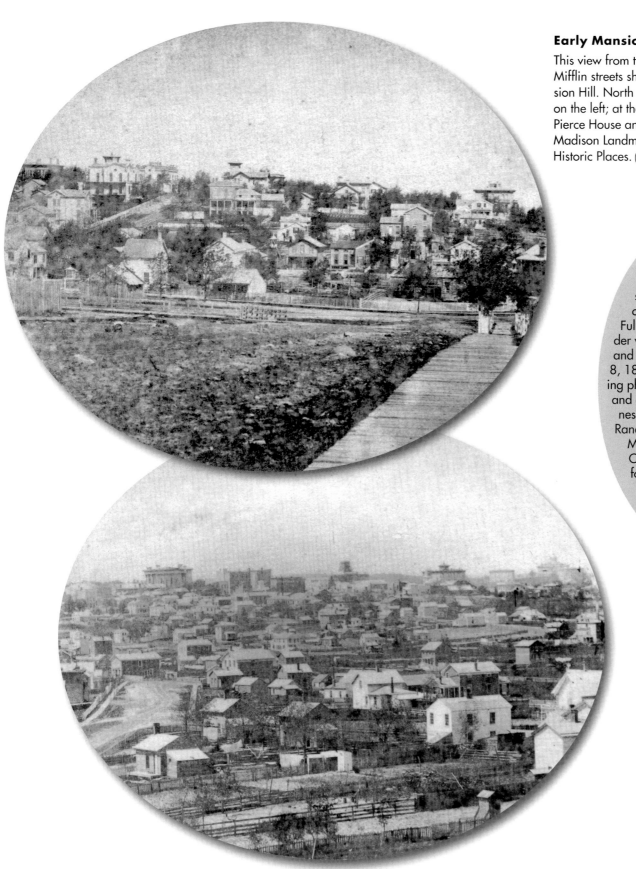

Early Mansion Hill, ca. 1860–63 *(left)*

This view from the corner of North Butler and East Mifflin streets shows the early development of Mansion Hill. North Pinckney Street runs to the horizon on the left; at the crest of the hill are the McDonnell/Pierce House and the Fuller/Bashford House, both Madison Landmarks on the National Register of Historic Places. (WHi-26964)

The Fuller Ovals

The ovals on pages 44–45, and the similarly shaped illustrations later in this chapter, are the work of John S. Fuller (1815–1902), a New Englander who took up photography in 1848 and made his way to Madison by May 8, 1854. Fuller was soon the city's leading photographer, with state commissions and awards and a steady portrait business from soldiers stationed at Camp Randall. Fuller made a comprehensive Madison album before moving to Chicago in 1864; mysterious but fortuitous circumstances brought the forty-six small pasteboard mounts to the Wisconsin Historical Society in 1996.

Downtown from the East, ca. 1860–63 *(left)*

Madison's two great and unique inorganic attributes, the capitol and campus. From the right, North, Main, and South halls, Bacon's Block, city hall, Bruen's Block, and the capitol several years before installation of its dome. (WHi-27083)

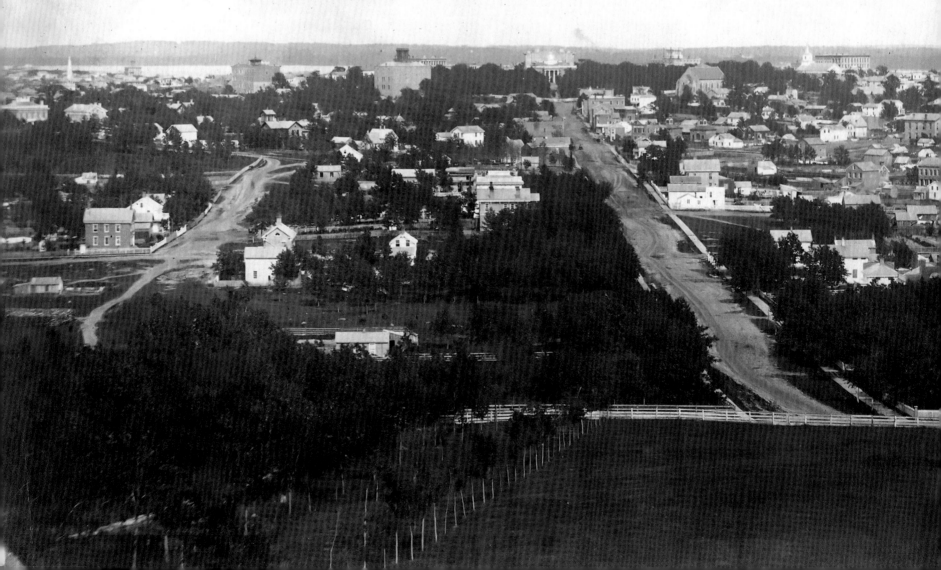

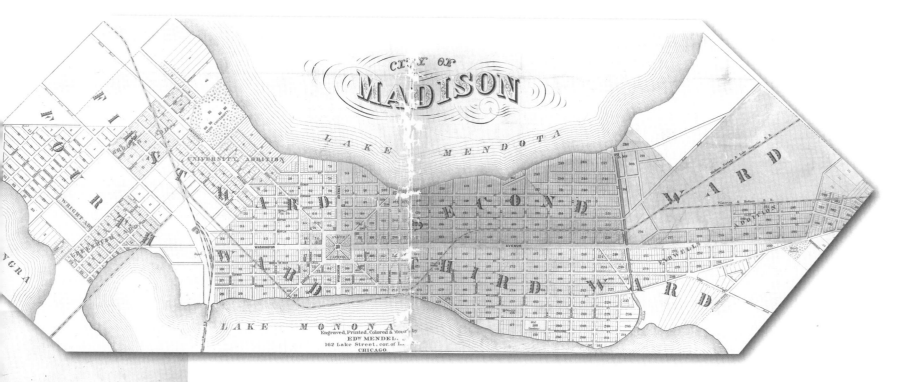

The City at Five *(above)*

This 1861 map shows the city at the start of the Civil War. The "Fi" in "First" marks what will soon become the most important site in the city, Camp Randall (here, at the juncture of the roads to Mineral Point and Monroe.) Embellishments include a campus that reflects the 1850 plan rather than reality and east-side train service three years early. (WHi-36500)

State Street, ca. 1860 *(left)*

This view from Main Hall shows, from the right, the county courthouse, the Fox-Atwood Block, First Baptist Church, Grace Episcopal Church, Capital House, the first capitol with its replacement rising behind it, Bruen's Block, city hall, Bacon's Block, the Farwell House, the Presbyterian Church, and the stone mansions of J. T. Marston and Levi Vilas. (WHi-10487)

Dateline

December 1866 City gets first steam fire engine, the *Elisha W. Keyes*, with 1,000 feet of hose.

The Two General Bryants

For the better part of a half century, Madison had two soldier/statesmen named General Bryant.

Gen. George E. Bryant (1832–1907) was a Civil War hero and political mentor to Robert M. La Follette who enjoyed universal respect. An attorney and captain of the Madison Guards militia, Bryant was elected alderman on April 4, 1861—less than two weeks before Fort Sumter. Bryant had tendered the unit's services to Governor Randall in January, and on April 16 the Madison Guard became Wisconsin's first company enrolled for active service. A military college roommate of future admiral Nelson Dewey, Bryant commanded a brigade in the 12th Wisconsin Volunteer Infantry regiment through several campaigns and later served as Wisconsin quartermaster general. He raised fine horses and held a series of political offices, including state senator, judge, state representative, and federal postmaster under presidents Arthur and Harrison. As member and chair of the Republican state central committee (1896–1904) he was an important ally to La Follette and was rewarded with appointment as Governor La Follette's Superintendent of Public Property (1901–7).

Gen. Edwin E. Bryant (1835–1903), who in 1889 would coin the term "Attic Angels" to describe the charity work undertaken by his teenage daughters, was an attorney and owner of the *Monroe Sentinel* when he enlisted as a private in June 1861. By 1862 he was made adjutant of his regiment, becoming lieutenant colonel with the 50th Wisconsin Volunteer Infantry. He served as adjutant general of the state and private secretary to Governor Fairchild from 1868 to 1871 and later was law partner to U.S. Senator William Vilas, state assemblyman, U.S. assistant attorney general, part owner and editor of the *Madison Democrat*, and dean of the univerity's Law School from 1889 until shortly before his death.

THE WAR AT HOME, PART 1

Then the war came. And although Madison did not give a majority of its votes to Abraham Lincoln in either of his elections, the city was tested and found true in support of the Union and its soldiers. If only the Union and its soldiers had been equally solicitous of the city.

Camp Randall, Winter 1861–62

The only known photograph of soldiers at Camp Randall, taken from south of the railroad tracks during the first winter of the war, shows tents that were replaced in 1862. Most of the trees in the background would be used for firewood over the next few years. (WHi-4226)

Madison men volunteered at a higher percentage than those of any other major Wisconsin city, and they died in higher numbers than the state average. By early 1865 about two-thirds of the adult male population between the ages of twenty and forty-five had gone to war, fighting and dying at Gettysburg, Bull Run, and most other major battles.

Madison citizens gave generously through gifts and special taxes to support soldiers and their families — charity, admittedly, with self-interest, as enlistment bounties recruited the volunteers that helped the city avoid the draft for almost the entire war.

On April 18, 1861, days after the surrender of Fort Sumter, more than a thousand Madisonians jammed the assembly chambers and pledged $7,890 (and one hundred bushels of wheat) to support families of soldiers volunteering for the Union army. By war's end, the city raised more than $100,000 through private donations and special taxes for soldiers and their families.

Six days later, practically the entire city gathered on Capitol Square for the departure of Madison's contribution to the state's first regiment. The Madison Guard, led by Alderman George Bryant, was the first to have its offer of service accepted, followed by the Governor's Guard, led by Mayor Fairchild's eldest son, Lucius. "Madison takes the palm for patriotism," the *Milwaukee News* wrote, and indeed the capital had far surpassed the early turnout by such larger cities as Racine and Janesville.

The Wisconsin Agricultural Society had already offered its ten acres of fairgrounds about a mile and a half west of the capitol as a training camp; state attorney general S. Park Coon, whom Governor Alexander Randall had appointed colonel of the Second Regiment, found the site appropriate and suggested it be named in the governor's honor, which it was. Randall then designated Horace A. Tenney as superintendent to convert the fairgrounds to a military encampment.

Work had barely begun when the first companies, the La Crosse Light Guard, arrived on May 1, 1861. By war's end, some 70,000 of the state's 95,000 volunteers and draftees would pass through the camp's ninety-four buildings, leaving serious trouble in their wake.

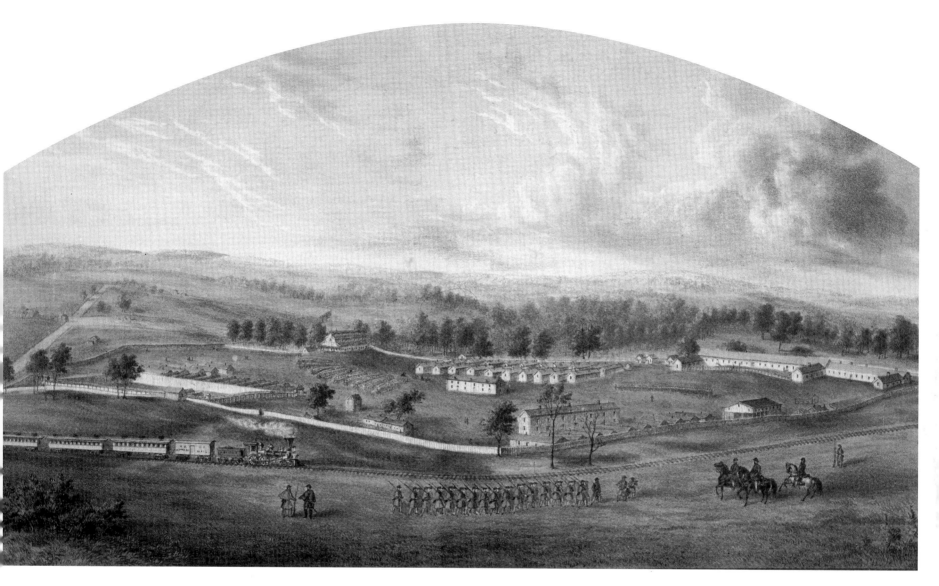

Camp Randall, May 1864

This view from the east shows Camp Randall following a major building program needed to accommodate additional draftees as the war entered its last year. By September, the camp would be home to 3,400 men, whose drunken assaults on Madisonians became almost daily occurrences. In this Moseley brothers lithograph, Monroe Street stretches into the distant hills on the left, with the trees in the middle distance marking the future location of Breese Terrace. The troop train is on the St. Paul and Milwaukee railroad tracks, about at the juncture of Randall Street and University Avenue. The enclosed area to the right of Monroe Street is the prison yard for the approximately 1,100 Confederate soldiers sent here in April 1862. More than 140 died in custody and were interred in the Confederate Rest section of Forest Hill Cemetery. An 1898 view from this Bascom Hall perspective is found on page 140. (WHi-1838)

There were problems from the start. That spring was exceptionally cold and wet, and because Tenney didn't have time to prepare the facility properly, the men were often cold and wet as well. The food was bad, arms and equipment were in short supply, and the level of training and discipline almost random.

On June 10 and 11, 1861, several hundred new recruits on furlough terrorized Madison. One group reportedly assaulted and murdered a German woman while another drunken bunch broke into Voight's Brewery at Gorham and State and exchanged gunfire with the proprietor and patrons. Mayor Vilas called a citizens' meeting to address what he called the "outrages"

continued on page 50

Dateline

April 6, 1865 Theodore Read, son of university professor Daniel Read, becomes second-to-last Union general killed in combat, after ferocious cavalry battle with Robert E. Lee's forces near Appomattox Bridge.

upon the city's residents, but that meeting itself almost erupted into violence.

Over the next three years, soldiers posed an increasing threat to public safety through numerous assaults and drunken brawls. Dissension flared into insubordination on March 17, 1862, when Governor Louis P. Harvey asked the men of the 17th Wisconsin Regiment to embark prior to getting paid. Harvey promised they would be paid in Chicago, but the men — Irish immigrants from Milwaukee and the Fox River Valley — roared their opposition and refused to strike their tents. A St. Patrick's Day banquet failed to quell the growing mutiny, and a suspicious fire on March 18 left the camp shaken and demoralized. When the Irish 17th learned that the Norwegian 15th Regiment had been paid before leaving camp, things got so out of hand that the army sent regular units from Chicago to restore order. Sixty of the regiment's thousand men deserted, but the rest finally boarded the trains.

Blame for inadequate accommodations or tardy pay fell on Madison men, especially superintendent Tenney and paymaster Simeon Mills. It was also Tenney who allowed several saloons to operate within the campgrounds, further eroding discipline and decorum.

The month after the St. Patrick's Day disturbance, Camp Randall also became a prison for more than 1,100 bedraggled rebels, formerly Alabama infantrymen. Some escaped but many more — close to 150 — died and were interred at Forest Hill Cemetery in a section that came to be called Confederate Rest.

On July 1, 1863, the war hit close to home as Lucius Fairchild lost his left arm and was briefly captured at Gettysburg. That fall, Fairchild was elected secretary of state; two years later, he was elected to the first of three terms as governor. His younger brother was not so fortunate — injured at Shiloh, Cassius Fairchild died in 1868, shortly after his wound ruptured while he was serving as pallbearer for a friend.

On November 13, 1863, new federal laws and regulations forced Madison to submit to a draft to meet Lincoln's July call for 300,000 men to serve three years. Antiwar Democrats took great glee when Harold Rublee, editor of the pro-war *Wisconsin State Journal,* was among those

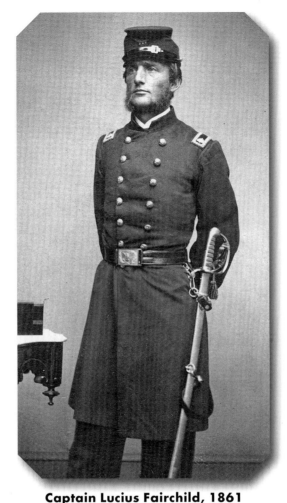

Captain Lucius Fairchild, 1861

Matthew Brady's carte de viste of Captain Lucius Fairchild, shortly before the eldest son of Mayor Jairus Fairchild went to Gettysburg.

(WHi-34323)

drafted; they groused about favoritism when officials declared he was called erroneously due to a miscalculation of the number needed.

Rough relations between the city and the camp grew even rougher after a large contingent of Wisconsin draftees started arriving in February 1864. By early fall, when the soldiers' census peaked at about 3,500 — well more than one soldier for every three city residents — there was an outright reign of terror, with soldiers committing two murders within six weeks. Military patrols on almost every street corner gave the city the appearance of being under martial law, but without really doing much good. "Murder and highway robbery and riot have been

with impunity committed against us," Mayor William Leitch declared in November.

Unlike the wars of the twentieth century, the Civil War did not cause serious disruption of daily life in Madison, other than that caused by the soldiers themselves. Farmers had produced a bumper wheat crop in 1860, which helped the entire Dane County economy recover from the Panic of 1857. Although almost a third of Wisconsin banks failed in 1861 due to their heavy investment in southern bonds, Madison banks were part of a consortium that weathered the war. Manufacturing grew, led by the E. W. Skinner Company making sorghum mills on Lake Mendota Court and the former Farwell mill, converted in 1863 into a woolen mill. The city finally got its second railroad, as the Chicago and North Western steamed down its lakeshore track to a new east-side depot on September 7, 1864. One troubling impact was a growing economic disparity, as inflation far outpaced the increase in wages. And the inflation in one vital item — firewood — caused lasting ecological damage, as the forests of University Heights and Maple Bluff were sacrificed to satisfy Madison's energy needs.

With the war nearly won — Richmond had fallen the day before — on April 4, 1865, the city gave political credit to Lincoln's party by electing Madison's first Republican mayor, Elisha W. Keyes.

There were 171 casualties among the 722 Madison men who went to war.

Verbatim

Well, we are in Madison. . . . Nearly every other house between here and the Capitol sells beer and by the time the lovers of grog get into town they are full to running over. . . . There was close to a mutiny of the two regiments here the other day because so many of the boys had been arrested and jailed in the city. . . . The boys are on the point of revolting against the government, the contractors, or the state for the sour bread and stinking meat rationed out to us. It seems an outrage to get such treatment in the Capital of our State.—**Chauncey H. Cooke**, Company G, 25th Wisconsin Volunteer Infantry

Madison Mayor

Levi B. Vilas (1811–79), one of the leading politicians and lawyers in his native Vermont, was Madison's fourth mayor, one of the first residents of Mansion Hill, and father of one of the most important men in the city's history. Vilas came to Madison in 1851 and became state assemblyman (1855, 1868, and 1873), university regent (1853–65), and founder and first president of the Dane County Bank (where his fourteen-year-old son, William Freeman Vilas, was messenger). An antislavery Democrat, Vilas was elected mayor without opposition ten days before the attack on Fort Sumter in 1861. As mayor, Vilas undertook a vigorous crackdown on dogs and other wild animals running at large through the city streets. A seemingly popular move at first, this led to his defeat, 740-619, as the Union Party candidate for reelection in 1862. A gubernatorial appointee as draft commissioner, Vilas sharply criticized President Lincoln over the Emancipation Proclamation. Staked to a substantial inheritance from his father, Moses, Vilas left an estate valued at $103,371.67 when he died.

(WHi-39000)

Verbatim

I declare that I will never, without making every manly and lawful resistance, surrender the possession of this city to be overrun by horses, cattle, swine and geese, nor its government to those whose highest idea of freedom is to pasture their hogs in their neighbor's garden and roost their geese upon our sidewalks. — **Mayor Levi B. Vilas**, farewell address, April 1862, after losing reelection due to his overly aggressive enforcement of laws against wild dogs and roving animals

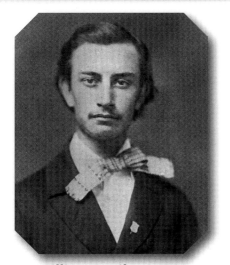

William F. Vilas, 1858

A portrait of the future senator and parks philanthropist as university valedictorian at age eighteen. (WHi-37831)

Verbatim

The people have been swindled so often, and so much, by those elected to fill official position in the various grades of governments, that it is not surprising that taxes have become odious, and that some are beginning to look upon government as a means by which a few can rob the many, instead of the protection of their rights and interests.

I sometimes fear that, with the corruptions of men in office, and the licentious practices that prevail upon the people in selecting them, and the imbecility and disregard of justice and right manifested in the discharge of official trusts, the result will be the overthrow of the best form of government ever established, and the erection upon its ruins of another that is subversive of the rights and liberties of the people. God in mercy grant that this may not be the result. But if it must come, let our skirts be clean of the responsibility. — **Mayor Levi B. Vilas**, annual message, 1861

THE MADISON ZOUAVES
FOR
THE WAR!

TH · NION MUST AND SHALL B PrESERV'D!

This Co. which has been organized and in active Drill

FOR MORE THAN A YEAR, HAS ENLISTED FOR THE WAR!

Under the recent call by the President of the United States. For the purpose of filling the ranks to the required number, a commission has been specially issued by the Governor to the undersigned, the Captain of the Company. The

ARMORY OF THE COMPANY, IN THE CITY HALL AT MADISON, IS NOW OPENED AS THE RECRUITING OFFICE.

All the advantages of enlisting in connection with a *well drilled Company*, and of enlisting for a new regiment, are here presented together. The

HIGHEST BOUNTY & PAY!

given to volunteers, will be given to the men of this Company. The undersigned was a member of the Old Governor's Guard from its earliest orgnaization until called, in 1861, to command the Madison Zouaves ; and can satisfy any applicant as to his competency as a military officer.

The ranks of the Company will be filled by volunteer enlistments by the 15th of August, or after that date ☞DRAFTING WILL BEGIN!☜

The Drafted Soldier gets $11 a month only,& no Bounty!

The Volunteer gets the full Pay and all Bounties!!

☞The pay of Volunteers will begin from the time of enlistment at full rates. What able-bodied man will desert his country in her hour of peril? Where is the coward who will shrink from the contest for the maintenance of our institutions and the preservation of our Constitution! Where the poltroon who will see our flag trampled by rebels and traitors, without a blow!! Rally Men of Dane County! Fill the ranks of our armies with brave hearts and strong hands! for the rescue of the Union!!

[Wisconsin State Journal Print, Madison.] **WM. F. VILAS, Recruiting Officer.**

Zouaves for the War, 1862 *(left)*

To meet the city's quota under the president's call for another 300,000 men, Madison had to find 124 volunteers by August 15, 1862, or it would suffer the ignominy of a draft. This recruiting poster's focus on the financial benefits of volunteering didn't quite do the trick at first; Madison needed, and got, a short extension to meet its goal. Recruiting officer and company captain William F. Vilas, the twenty-one-year-old son of former mayor Levi Vilas, survived the war to become a U.S. senator, postmaster general, and donor of the park that bears his son's name. (WHi-11296)

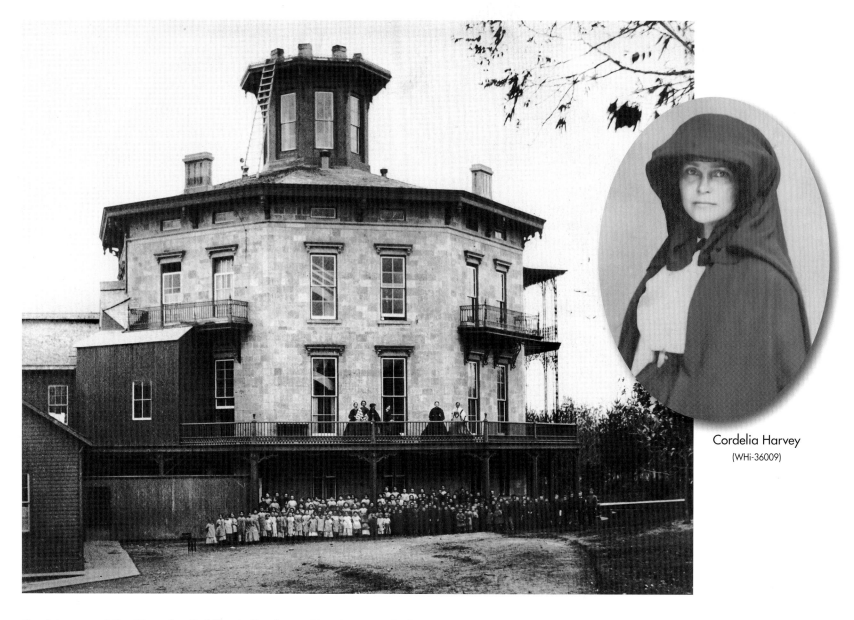

Cordelia Harvey
(WHi-36009)

Students and Staff at the Soldier's Orphans Home, ca. 1870

When Cordelia Harvey's husband, Governor Louis P. Harvey, drowned in the Tennessee River while visiting Wisconsin soldiers injured at Shiloh in April 1862, the extraordinary woman took an extraordinary property and did extraordinary things. First, in September 1863, she got Abraham Lincoln to reverse his opposition to northern military hospitals—he feared desertions—and create three such facilities in Wisconsin; one was the Harvey Hospital, in the grand octagon mansion at Spaight and Brearly streets, vacant since former governor Leonard Farwell's bankruptcy in 1857. Hospital capacity

hit six hundred before the flow of injured soldiers finally stopped, and the hospital closed in September 1865.

But there were still the orphans of those who had borne the battle, and Mrs. Harvey led the fundraising to convert the facility into a school for their education. Thanks to a last-minute loan from pioneer banker Samuel Marshall and a law pushed by civil war hero Governor Lucius Fairchild making the home a state institution, the school opened in 1866. With an average population of about 275, the school offered an academic and practical education to 683 chil-

dren during its nine years of operation. The children grew up, the home closed in 1874, and its title passed to the university regents, who two years later sold the property to the Norwegian synod of the Lutheran church to pay for the university's new Assembly Hall. After a doctrinal split in 1886 and a fire in 1893, the Lutherans sold the property to local developers, who demolished the historic buildings in early 1895. In 1908, as part of the move for increased density, the block was subdivided into eleven lots. (WHi-10028)

William T. Leitch (1808–97), Madison's mayor during the Civil War, was such a staunch antiwar copperhead Democrat that he reportedly refused to assist in recruiting volunteers or raising funds for their bounties. A native of Edinburgh, Scotland, Leitch immigrated to New York in 1829 where he amassed a fortune in the wholesale southern clothing trade. A naturalized citizen, Leitch continued to observe such British traditions as commemorating the queen's birthday, often getting so drunk he had to be escorted home. He was also a long-time vestryman at Grace Episcopal Church and such a devout communicant that he once walked out of a council meeting at midnight Saturday rather than despoil the Sabbath. Leitch's lakeshore home at 752 East Gorham Street, built for $14,000 shortly after his arrival in Madison in 1857, was later home to another mayor, Moses R. Doyon, and also to a member of Congress, Nils P. Haugen. It is now a Madison Landmark on the National Register of Historic Places.

Titans' Tracks Tangle

During the darkest days of the Civil War, the city faced a land use choice that would indelibly determine Madison's entire development. Thankfully, in a battle between the city's leading businessman and its most powerful neighborhood, the people prevailed.

A monopoly since its arrival in 1854, the Milwaukee and Prairie du Chien line was charging such high freight rates that it was cheaper for farmers to take their wheat to the Watertown and Madison Railroad terminal in Sun Prairie (where its progress had stopped with the crash of 1857). But in late 1862, it appeared the city was finally going to get a second railroad to offer competition and save the local economy. And it seemed that Simeon Mills, the great pioneer entrepreneur, would be the man to end the monopoly, either as president of the Madison and Portage Railroad or director of the Beloit and Madison Railroad.

When the Portage line and its promised link to Green Bay and the northern pineries didn't pan out, Mills turned his attention to completing the Beloit line and creating a direct link to Chicago. He readily raised the money — now all he needed was the right right-of-way.

Mills, who was just about to move from the Capitol Square to his Elmside estate well past the Yahara River, wanted to "locate, construct and operate" his railroad "along the line of that part of Johnson Street" between Frances and Blair streets. That is, he wanted to run a twelve-block stretch of railroad tracks through the heart of the city, crossing State Street and skirting the lower edge of the Big Bug Hill neighborhood, later known as Mansion Hill.

The neighborhood fought back, with one of its earliest settlers — former mayor Levi Vilas — squaring off with Mills at the common council meeting of January 19, 1863. When the battle of giants was over, the council had "respectfully refused" the railroad's request and created a special committee to "examine the banks of Fourth and Third Lake" for a possible route.

On April 3, the council adopted the committee's recommendation — access from near the existing Milwaukee Road tracks, running northeast along the bank of Lake Monona. The council thereby saved the central city, forged the railroad tie that would help stimulate the industrial east side, and created the world's only mid-lake railroad crossing.

On September 7, 1864, having been absorbed into the Chicago and North Western Railroad Company, the Beloit and Madison Railroad steamed to its lakeshore depot and ended the Milwaukee and Prairie du Chien's decade-long monopoly.

In 1887, Mills got a taste of what he had wanted for Vilas, when he built a mansion at the corner of Wisconsin Avenue and West Wilson Street — just up the embankment from the very active railroad tracks he brought to town twenty-three years before.

I have disregarded, and shall continue to do so, the cavilings of those who disturb the public ear with crapulous complaints about frivolous matters, when, with the small means at our disposal, and the depreciation of the currency, it has been almost as much as we could to do maintain the essential features of municipal government.

If the present system and limitations are continued, the city may soon be left without the means suitable to maintain the simplest and most necessary applications of local government. We witness with chagrin if not dismay the almost intolerable conditions of our streets, great clamor has been raised thereat, and the entire public incommoded and fouled by the overflowing abundance of mud and filth, and yet we have been powerless to correct the evil on account of the scantiness of our means, enforced by the same limitations of our charter before mentioned. It is congenial to the temper of some individuals to find fault with every suggestion that looks to an increased expenditure and to be purblind to the necessities and advantages demanding the same. Such may pursue their unamiable, and I venture to say, their irrational course, but it is to you gentlemen of the common council, I look for an earnest and discreet co-operation in the project to remodel our system, and to fashion it to the exigencies of the times, and the conditions and demands of our people.
— **Mayor William T. Leitch**, annual message, 1864

Alden S. Sanborn (1820–85), Madison's seventh mayor, committed suicide by ingesting laudanum following the drowning death of his teenage son. Sanborn had come to Wisconsin from Vermont in 1846 and served as Milwaukee County treasurer (1848), district attorney for Brown County (1851, 1853) and Outagamie County (1854), and state representative from Mazomanie (1862–64) before settling in Madison and being elected mayor in 1867 and 1868. After another term in the assembly he was elected judge, which office he held until his death.

Elisha W. Keyes (1828–1910) was Madison's first Republican mayor, John Bascom's nemesis on the Board of Regents, a statewide party leader, and powerful local postmaster who served from Lincoln's administration until Theodore Roosevelt's. Keyes (pronounced Kize) traveled with his Vermont family to Lake Mills in 1837 and in the following years developed strong antislavery views during the U.S.-Mexican War. He came to Madison in 1850 to read the law and was an upset victor as the Republican candidate for district attorney in 1859. More interested in power and patronage for their own sake than for ideological or economic reasons, "Boss" Keyes and his associates in the "Madison Regency" ran state and local affairs through discipline, post office patronage, and the press. As Madison's sixth (1865–67) and twenty-second (1886–87) mayor, Keyes pushed for street improvements, rigid enforcement of the animal control ordinances, and the acquisition of the city's first steam fire engine. He suggested the city plant trees and assess neighboring property owners, and proposed a park at the end of Wisconsin Avenue. As an unwilling candidate in 1894, Keyes came within sixteen votes of upsetting incumbent mayor John Corscot.

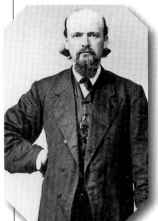

"Boss" Elisha W. Keyes, around the time of his first election as mayor (WHi-37908)

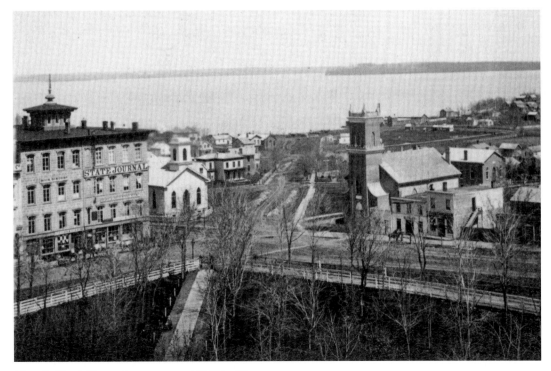

North Hamilton Street, ca. 1865–68

The white 1865 Immanuel Evangelical Church (left) joins the Bacon Block and Methodist Church (right) in flanking North Hamilton Street, as the city continues to underutilize this capitol axial. (WHi-35750)

William Noland (1807–80), dressed to lead his brass band, was the first black man to reside in Madison, the first black father, the first black businessman, the first black appointed notary public (although the secretary of state refused to file his bond), and the first black man to run for mayor. Noland came to Madison in 1850 and undertook a wide range of commercial and service activities. In 1854, while working as a barber with the nickname of "Old Tricopherous," Noland reportedly refused to cut the hair of a customer who had helped capture the fugitive slave John Glover in Milwaukee. Following black enfranchisement in 1866, Democrats tried to draft him to run for mayor against incumbent Republican Elisha Keyes but he declined. Citing the Democratic Party's "malignant hostility" to abolition, Noland endorsed Keyes — but he still got 306 votes to Keyes's 961, a margin approximating the 38 percent of residents who had voted for black suffrage in 1865. In 1876 Noland led the parade observing the nation's centennial. Noland and his wife, A. M., are buried at Forest Hill Cemetery in unmarked graves.

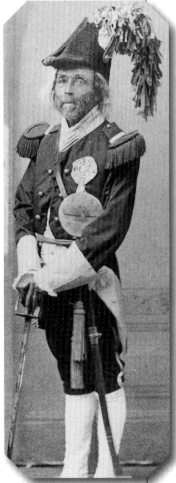

William H. Noland, Madison's first prominent African American (WHi-5082)

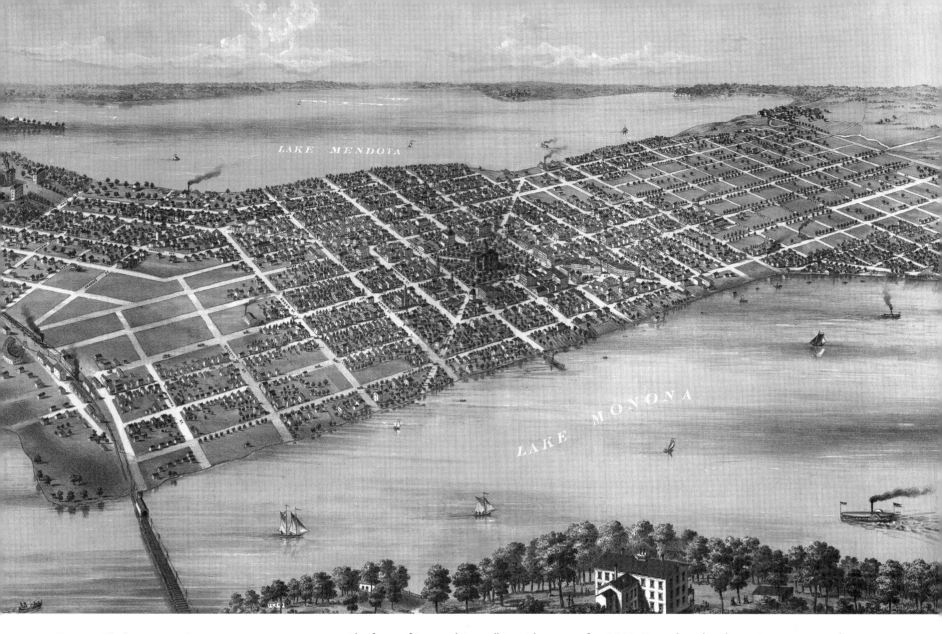

Ruger Bird's-eye, 1867

Madison's first full aerial illustration captures the city just after the Civil War. At left, the Milwaukee and Prairie du Chien Railroad passes the swampy Triangle and carves its scar into the lowlands, just past the cattail marsh between Broom and Lake streets. At the lake end of Lake Street there is industry in the midst of homes and quite close to campus—the smokestack of the E. W. Skinner implement factory, which by the end of the war was producing about five hundred sorghum mills annually. And just as Doty planned, there's a smokestack on East Canal Street (even though there's no canal)—the Hudson and Curtis flouring mill just east of North Hamilton Street on the edge of what should have been lakefront parkland.

The force of Leonard Farwell is evident east of the capitol, in the rows of cottonwood and maple trees he planted, the plank road he laid, and the mill he built (and lost a few years later) at the mouth of the river. On either side of the Yahara River are remnants of the meandering waterway that Farwell straightened and deepened. In the foreground, the former Water Cure building is in its second year as the Lakeside House on the site of present-day Olin Park. Nearby, Captain Frank Barnes's *Scutanawbequons II* steams toward Angle Worm Station at the foot of Carroll Street.

Artistic embellishments encompass both state and church: the capitol dome shown here was not installed until 1869 and the steeple of St. Raphael's Church soars well before its erection in 1881. Two other churches—Grace Episcopal (North Carroll and West Washington) and Holy Redeemer (West Johnson Street)—are among the landmarks extant at the city's sesquicentennial, along with the Simeon Mills Block on King Street and the three university buildings. After the capitol, city hall is the most prominent building downtown. There is one puzzling omission from the illustration—any sign of the Chicago and North Western Railroad tracks, which crossed the Milwaukee and Prairie du Chien tracks en route to its east-side lakeshore right-of-way as of September 1864. This perspective also shows why Simeon Mills might have thought a Frances-to-Blair connection along Johnson Street was the right route (see page 53) and why it would have devastated the city. (WHi-11430)

David Atwood (1815–89) was a successful journalist, military man, and party activist before he became Madison's eighth mayor in 1868 and a successful industrialist afterward. Founder of the *Wisconsin State Journal*, major general in the state militia, and a leader in the creation of the Republican Party, Atwood traced his lineage to Puritans who landed at Plymouth in 1643. Born in Bedford, New Hampshire, he was a childhood friend of famed newspaper editor Horace Greeley and was likely responsible for Greeley's 1855 Madison visit. Atwood was apprenticed to a publishing house at age sixteen, rode ten thousand miles on horseback as an agent for a legal treatise in his early twenties, then began publishing a Whig newspaper with his brother. He anticipated Greeley's famous advice and came west but lost all his savings farming in Illinois for two years. Atwood arrived in Madison in 1847 and joined the staff of the Madison *Express*. By the next year he had enough money to purchase the paper, which he used to support the successful gubernatorial campaign of Leonard J. Farwell. When anti-Whig legislators blocked state printing contracts for the *Express*, a series of consolidations ensued, after which Atwood began publishing the *State Journal* as an anti-slavery Whig paper. The first paper was printed September 30, 1852. The formation of the Republican Party in July 1854 — an event Atwood did much to bring about — made the paper that party's journalistic organ in the capital city. During that time Atwood was also justice of the peace, a village trustee, school board member and president, and was resuming his career with the militia. He represented Madison in the State Assembly in

David K. Atwood, publisher and mayor, 1861 (WHi-36059)

1861, working to enlarge and improve the capitol. Abraham Lincoln appointed him internal revenue assessor for the second congressional district in 1862, but he was removed from that office by President Andrew Johnson in 1866. Atwood was elected mayor in 1868 and while mayor used his newspaper to support his goal of bringing more manufacturing to Madison. In 1869 he was promoted for governor, but fell just short of nomination. When congressman B. F. Hopkins died in January 1870, Atwood was easily elected to complete the term but he declined reelection. A senior vice president of the State Historical Society starting in 1849, Atwood also served as long-time treasurer of the State Agricultural Society, director and president of the Madison Mutual Insurance Company, trustee of the State Hospital for the Insane, president of Madison Gas Light and Coke Company, and on the boards of several railroads. Atwood's daughter Elizabeth married E. P. Vilas, son of Madison's fourth mayor; his daughter Mary was the driving force be-

Verbatim

From an examination of the books in the city offices, it appears that the expenditures during the past year have considerably exceeded the receipts into the treasury; and there is now a floating debt of something like $25,000 which will have to be provided for during the present year. Manufacturing interests have been too much neglected. These establishments, giving employment to industrious mechanics, have an important influence upon the welfare of any city. It is the men who labor for their daily bread who build up our towns and make them prosperous. — **Mayor David Atwood**, annual message, 1868

hind the formation of the Madison Woman's Club, organized in Atwood's home at 214 Wisconsin Avenue. That stately red brick building, built in 1851, was razed in the late 1930s for a gas station and parking lot. Atwood Avenue, a major thoroughfare on the city's east side, is named in his honor.

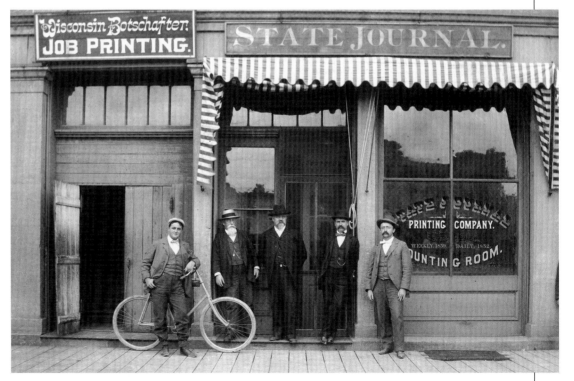

David Atwood (second from left) and editors of the *Wisconsin State Journal* (WHi-37386)

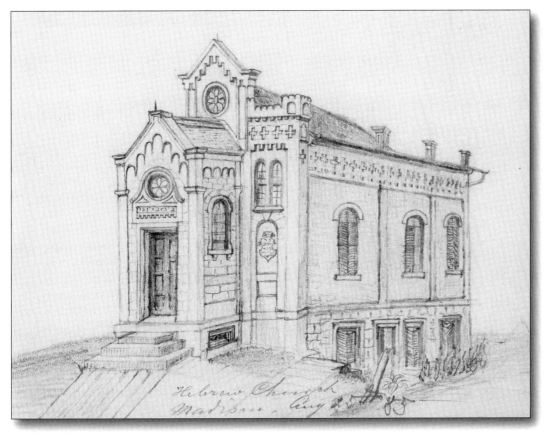

Shaare Shomaim (Gates of Heaven) Synagogue

This sandstone structure served as the synagogue for Madison's first Jewish congregation from 1863 to 1879. Ahavath Achim (Brother Love) was formed on March 21, 1856, by seventeen German families. Simon Sekles was president and merchant Samuel Klauber served as treasurer. It was five years after the first Jewish service in the state, a Milwaukee Rosh Hashanah service on September 10, 1847. The congregation incorporated as Shaare Shomaim (Gates of Heaven) in 1859 and until 1861 held services at Klauber's home. In 1862 the congregation acquired the lot adjoining the Congregational Church chapel on West Washington Avenue and commissioned architect August Kutzbock. His design has been described as both early German Romanesque revival and as a Victorian interpretation of a southwestern Spanish Catholic mission. Among local non-Jewish contributors to the building fund were the Bank of Madison and the Capital State Bank. Klauber donated the Torah scroll and presided at the September 4, 1863, dedication service, which was led by Rabbi Falk of Milwaukee with "quite a number of Gentiles being present as curious spectators." It was at the old synagogue that the legislature met for a public memorial after Lincoln's assassination in 1865. But the Reform congregation never numbered more than twenty and in 1879 started renting the building to various church and temperance groups. Frank Lloyd Wright attended Unitarian services there from 1879 to 1886. Arthur and George Gill bought the old synagogue in 1916 to house their funeral home, maintaining operations until selling the building to the Church of Christ in 1944. When the congregation ceased operations in 1922, it gave its Torah to the Orthodox Agudas Achim synagogue in Greenbush, which found the scroll didn't meet ritual requirements. The government leased the building to store papers during the war; it was also later used as a dental office and for other purposes. In 1971, when the old synagogue was threatened with demolition for development, a citizens group successfully organized to have it moved to James Madison Park. (WHi-2315)

City Schooldays

Municipal incorporation brought quick satisfaction to railroad interests, and those who wanted a new city hall and improved state capitol. But the school system did not, at first, fare as well. Even though the new city council agreed in August 1856 to appropriate $24,000 for a schoolhouse in each of the four wards, it awarded contracts for only the first and third wards. And then, without ever explaining why, the council simply refused to honor the construction bills — resulting in the board being sued.

"Unnecessary and almost criminal delay of the city authorities," Superintendent Damon Kilgore complained years later, which he said was brought about because "the principal citizens of Madison cared more about keeping down the tax rate . . . than they did about the public schools."

The First Ward School, near Monona, and the Third, hard by Mendota, finally opened in fall 1857. Leading historians differ in their evaluation of the identical two-story stone buildings. Daniel Durrie, perhaps because he had been the school board's first clerk, called them "fine," while Reuben Gold Thwaites wrote, "two such unsightly structures . . . are enough in one city." Design aside, many children from the second ward north of East Washington Avenue didn't attend simply because they couldn't cross the cattail marsh that stretched from Blount Street to the Yahara River. The second ward didn't get its school until 1867.

In 1857, the district opened a small school in Farwell's Addition, beyond the river near the flour mill. The next year brought a similar improvement in the Greenbush addition, followed in 1859 by a school out Williamson Street in the Dunning district.

For a makeshift high school, the board had been leasing the Congregational Church. But a deal in December 1857 to buy the building collapsed over conflicting claims to the church bell — the church wanted more money, the board said the bell came with the building — so in August 1858 the board bought the old Female Academy on Wisconsin Avenue, where John Sterling had taught the first preparatory classes for the University of Wisconsin in 1850.

"This choice of location for the High School has been an eminently wise one," Thwaites wrote in 1899, and indeed it was. The board paid $3,500 over ten years for the three lots and dedicated the school on September 26, 1859, and it began a municipal educational presence that would last until Central High School was closed in 1969.

But not without interruption, both administrative and educational. Kilgore, who had been elected principal of Evansville Seminary, was allowed to resign as district superintendent in March 1860, but the board dismissed his intended successor after only a few weeks, leaving informal supervision of its affairs to university professor O. M. Conover. In September, board president David Atwood was elected to the position, serving until the Reverend James Ward was hired in January 1862. Despite its own unsteady leadership, the board voted to exempt itself from governance by the newly created county superintendent of schools in August 1861.

By then, the city's bad finances had become the district's biggest problem. On December 31, 1860, Atwood suspended the high school's operations and offered the facility at no charge to a contractor for both a public school and private female academy. That effort, again supervised by Professor Conover, failed after a year as well, and school stayed closed until fall of 1863. The high school then resumed until it was replaced in 1873.

Toward the end of the Civil War, the city was finally able to complete the initial building program, starting in fall 1865 with an auxiliary to the First Ward School at the corner of University Avenue and Lake Street. On January 7, 1866, the four-teacher Fourth Ward School at Broom and Wilson formally opened, its 256 seats putting the city capacity at 860, about a hundred less than needed. The following winter, the district opened the Second Ward

School on Gorham near Blount — Frank Lloyd Wright's school — and even gave raises to the female principals and teachers of the ward schools. In 1868, the board enlarged and improved the Little Brick at South Butler and East Washington.

But not all was well in the city's schools; the board's own reports described conditions in the high school building — the 1848 Female Academy — as "unsightly, badly arranged and wholly unworthy of the city." It would remain so for several more years.

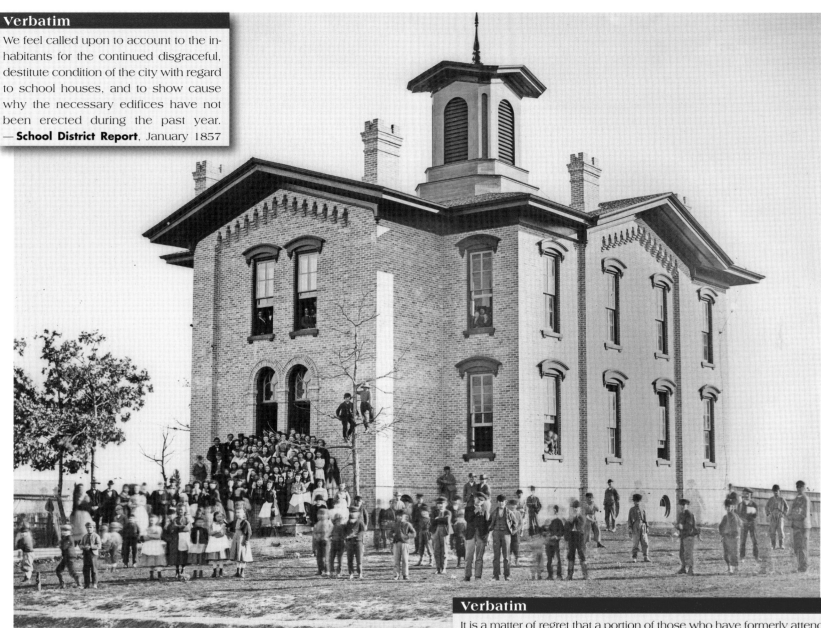

Frank Lloyd Wright's Neighborhood School

The Second Ward School House, where Wright attended seventh and eighth grade in 1879–81. Built in 1867 by William T. Fish for $16,000, it was the first school with indoor plumbing (namely, a sewage pipe into Lake Monona, immediately adjacent to its hillside site on Gilman Street near Blount). The school was replaced in 1915–16 by the Abraham Lincoln school (later home to the Madison Art Center and Lincoln School Apartments). (WHi-27483)

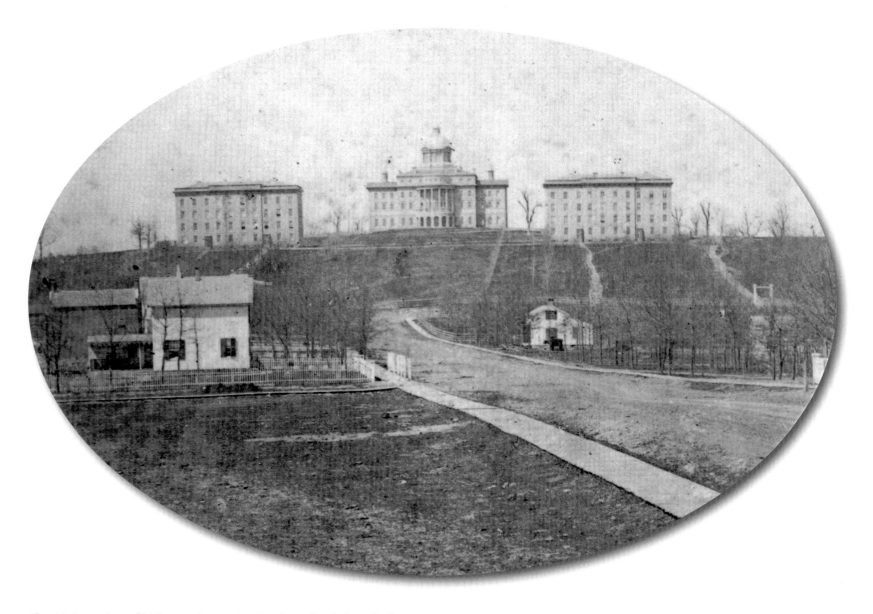

The University of Wisconsin at the Outbreak of the Civil War

North Hall (on right), the university's first building, opened on September 17, 1851, and for the next four years contained the entire university. It was home to three faculty (Sterling, O. M. Conover, and President Lathrop), thirty students, and janitor John Conklin (the father of a future mayor), with lecture rooms and a chapel on the top floor. Its use as a dormitory continued until 1884, when the fire at the first Science Hall required its use for instructional space. The cornerstone was laid in May 1850 by a teenager who had apprenticed as a bricklayer — future gadfly, attorney, and parks philanthropist Daniel K. Tenney. Main Hall (center) was the

first entirely instructional building on campus; by the time it opened on August 10, 1859, a year late and, at a cost of $60,000, fifty percent over budget, its construction and financing had caused the regents considerable embarrassment and difficulty. Known variously as the Main edifice, University Hall, and finally Bascom Hall, it was expanded in 1899, 1905, and 1927. Due to legislative indifference (or worse), the building was partially funded through the sale of bonds to Madisonians. The dome was lost in a fire on October 10, 1916. South Hall (left, 1855) was used for student and faculty housing as well as laboratory and instructional

space until the 1890s, when it became the first Agricultural Hall. Built at a cost of $20,000, it was home to President Lathrop, Professor Sterling, and most of the faculty. Among the students who lived in North and South halls were naturalist John Muir and future U.S. Senators John C. Spooner and William F. Vilas. Throughout this period, cows pastured on campus until they were barred by resolution of the regents on January 17, 1861. This view is from the south side of State Street, between Murray and Lake streets. The small frame house in the center has since been replaced by the headquarters of the Wisconsin Historical Society. (WHi-1885)

Dateline

July 2, 1866 Opening of renovated Lakeside House, the former Water Cure facility on promontory across Lake Monona, starting new era of resort tourism.

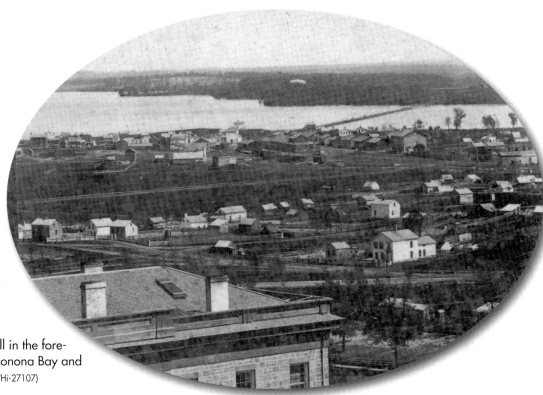

Fourth Ward, ca. 1860–62 *(right)*

This view from the roof of Main Hall, with South Hall in the foreground, shows the 1854 railroad causeway over Monona Bay and the beginnings of the Greenbush neighborhood. (WHi-27107)

Madison Notable

Paul A. Chadbourne (1823–83) was the president who brought the University of Wisconsin back to life, both financially and intellectually. Valedictorian of the class of 1848 at Williams College, a professor there, and ultimately its president, Chadbourne began the Williams-Wisconsin connection that would include John Bascom, John Olin, and E. A. Birge. A self-made man, Chadbourne was a passionate researcher who led expeditions to Greenland, Iceland, and the Nordic countries. So energetic that a contemporary said he was "as quick and alert as one of our squirrels," Chadbourne in 1858 simultaneously held professorships at three colleges and lectured at a fourth. In his *Lectures on Natural History,* given at the Smithsonian Institution in 1860, Chadbourne explained his belief in divine authority and the authenticity of biblical revelations. At a time when the University of Wisconsin was in such a precarious position that its future was seriously in doubt — the legislature's financial disregard of the institution was shameful — Chadbourne had to be coaxed into leaving his post as president of the state agricultural college at Amherst to come to Wisconsin in 1867. Among the final sticking points was the requirement in the Reorganization Act of 1866 that the university be fully co-ed; Chadbourne, who supported educating women separately from men, refused to accept the presidency until the mandate was relaxed to allow the regents to set the terms for the admission of women. A vigorous leader, able administrator, smooth diplomat, and powerful speaker, Chadbourne used his office to establish the departments of law, agriculture, and civil engineering. He also secured a $50,000 appropriation for building a Female College, the first grant for a university building the state ever made. To widespread regret, Chadbourne resigned in 1870, later returning to Williams as its president (which some had felt was his dream all along). Coeducation came shortly after he left, and in 1901 the dormitory and recitation hall that Chadbourne had built to give young women their own education was renamed in his honor. As Dean Birge later explained, "I thought it only fair that Dr. Chadbourne's contumacy regarding co-education should be punished by attaching his name to a building which turned out [to be] one of the main supports of co-education."

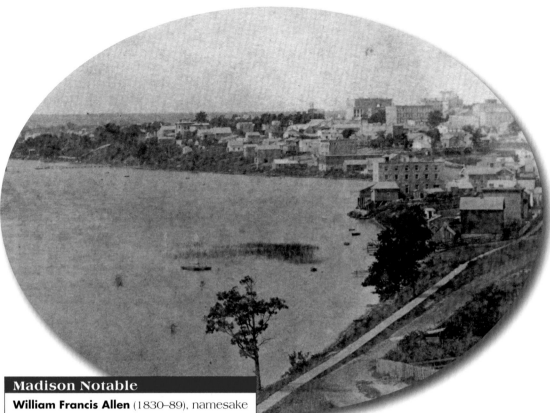

Kilgore and the Board: Some Lessons Learned, Some Not

Looking back on his time in Madison, Kilgore wrote: "It is a source of joy to me that during my administration no corporal punishment was allowed, and no sectarian teaching made it uncomfortable for children of Jews, Roman Catholics, or Agnostics to share equally with Protestants all the advantages the schools could afford."

The school board's legacy from Kilgore was not a lengthy one. Just a few years later, the board's records show an abrupt change:

July 2, 1867 Board of Education defeats a resolution banning corporal punishment and instead directs superintendent to give written report of all instances, including "the nature and size of the instrument used, if any."

January 7, 1868 Board of Education authorizes each school to "commence with reading the Scriptures without note or comment, and by appropriate secular vocal and instrumental music, and no other opening exercises shall be allowed."

At least the board got race right:

July 5, 1865 Board of Education tables action by Alderman William Welch, "that persons of African descent ought not to be admitted into the public schools of the city; that, while making this declaration, we are willing to make adequate provision for their education so far as the public funds are applicable thereto, and without detriment to the education of white children."

Madison Notable

William Francis Allen (1830–89), namesake of the street that forms the western boundary of University Heights, was both a great history professor — among his students was the country's most famous historian, Frederick Jackson Turner — and the man who saved innumerable slave songs and spirituals from oblivion. An 1851 graduate of Harvard, from 1863 to 1865 Allen taught blacks on a South Carolina boundary island as an employee of the Freedman's and Western Sanitary Commission; among the songs he preserved and published in *Slave Songs of the United States* was "Michael, Row Your Boat Ashore." Allen became professor of ancient languages at the university in 1867, later launching the history program that remained a Wisconsin hallmark for more than a century. An eclectic intellect, Allen contributed to nearly every issue of the progressive magazine *The Nation* from its founding in 1865 until his death. Margaret Loring Andrews Allen (1839–1924), Allen's second wife, was a founder of the Woman's Club and Civic Club and a published author in her own right. Her son from her first marriage was a coauthor of "On Wisconsin."

Lakeshore from Farwell Mansion, ca. 1862 *(above)*

A rare photograph of the unimproved Lake Monona shoreline from the east, about two years before the arrival of the Chicago and North Western Railroad. This view from the Farwell mansion overlooks the future B. B. Clarke beach and shows Adam Sprecher's (after 1868, Peter Fauerbach's) brewery (center right). (WHi-27081)

Verbatim

That portion of Wisconsin Avenue east of Wilson street, and bordering on Third Lake is not needed for usual street purposes. With a trifling expense it might be beautified and adorned and converted into a delightful promenade and park. It appears to be the only place, contiguous to that lake, suitable for such a retreat. The pleasure it would afford to our citizens and visitors generally cannot be too highly estimated.

We owe it to ourselves and to the good name and reputation of our city, that we pursue a liberal policy in the management of our municipal affairs in reference to permanent city improvements. The Capital City of our growing and prosperous state should not fall behind the spirit of the age. — **Mayor Elisha W. Keyes**, annual message, 1866. In 1934 the city finally did what Keyes suggested, creating the graceful Olin Terrace.

Capitol Construction, 2.0

Everyone knew that the existing oak and plaster capitol, built in 1837, was a crowded firetrap, unfit for a booming new state. When Governor Bashford said in his January 1857 message that "some provision should be made" to render state records that were kept there more secure, Madisonians realized that vital goal could only be met in one of two ways — by adding a wing with fireproof storage or by building an entirely new capitol. Since new construction likely meant relocation, city leaders knew the situation was serious.

Fortunately, Madison had a man on the inside — Horace Tenney, chair of the assembly's State Affairs Committee. He put together a plan for a new $100,000 wing, underwritten by a $50,000 loan from the city, $30,000 from the state, and proceeds from the sale of some federal lands. Governor Bashford signed the bill on February 28 and on March 14 voters approved the $50,000 bond, 266-1.

Bashford and Secretary of State David Jones hired the local firm of August Kutzbock and Samuel Donnel, whose recent work included the first city hall and Leonard Farwell's octagon stone mansion on Spaight Street. They designed a large semicircular wing with stone-column portico on its eastern face.

Once again, construction delays imperiled the project — and thus Madison's future as the capital. In early 1858, the architects reported to new governor Alexander Randall that contractor John Ryecraft was so far behind schedule that it was highly unlikely he could meet the November completion date. Once again, a legislative investigation found uncomfortable facts — both about Ryecraft's malfeasance and also that the "expansion" was in fact the first step to construction of an entirely new building.

Outraged at the $500,000 price tag, the Senate disapproved the expenditure and voted for the "temporary" removal of the government to Milwaukee while a more appropriate capitol was designed and built. To counter the offer from Milwaukee boosters for free lodging and office space, Simeon Mills pledged funds to underwrite the remaining construction while city officials offered the state free use of its new city hall — in direct violation of the recent charter amendment requiring the city to charge rent to help pay down the 1857 bonds.

After extensive debate, the assembly in mid-May voted 41-38 for the relocation bill; then, by a one-vote margin, it decided to reconsider its action. This time, the motion to relocate tied at forty-one, killing the latest threat to Madison's future.

Satisfied they were once again safe, city officials quickly rescinded their offer of free office space in city hall, and used the rental income to help satisfy the outstanding debt.

Work to replace the old capitol resumed, and generally went smoothly over the next decade — with one tragic exception. Donnel and Kutzbock's plan provided for a small, lantern-like dome in scale with the rest of the building. But in 1866 state officials began pressing for a more impressive dome; they wanted something like the new dome on the U.S. Capitol, the construction of which during the Civil War made the dome the shining symbol of republican government.

The conflict grew so intense that Kutzbock resigned (Donnel had died in 1861) as architect, leading to Governor Fairchild's selection of war hero Stephen Vaughn Shipman to design a dome based on the one in Washington. Work on Shipman's rotunda was completed in 1868, and a $90,000 contract to construct the cast iron dome was let.

On November 1, 1868, shortly after work began on the dome, Kutzbock loaded his pockets with rocks and walked into the cold waters off Picnic Point. His obituary said he was concerned about his failing health, but many believed he was despondent over the drastic change to his most important commission.

Madison's second capitol received its dome — 225.5 feet high at the top of its flagstaff — in 1869.

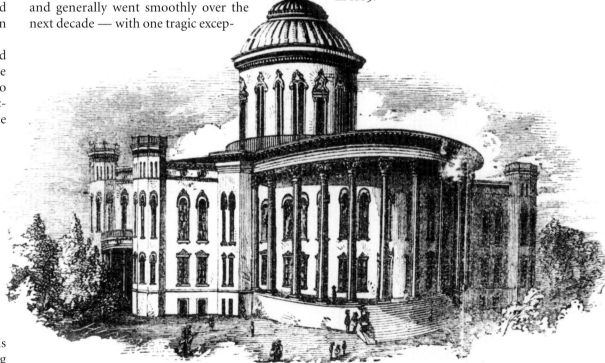

Donnel and Kutzbock Capitol Design, ca. 1857
A dispute over the dome would have tragic consequences. (WHi-34339)

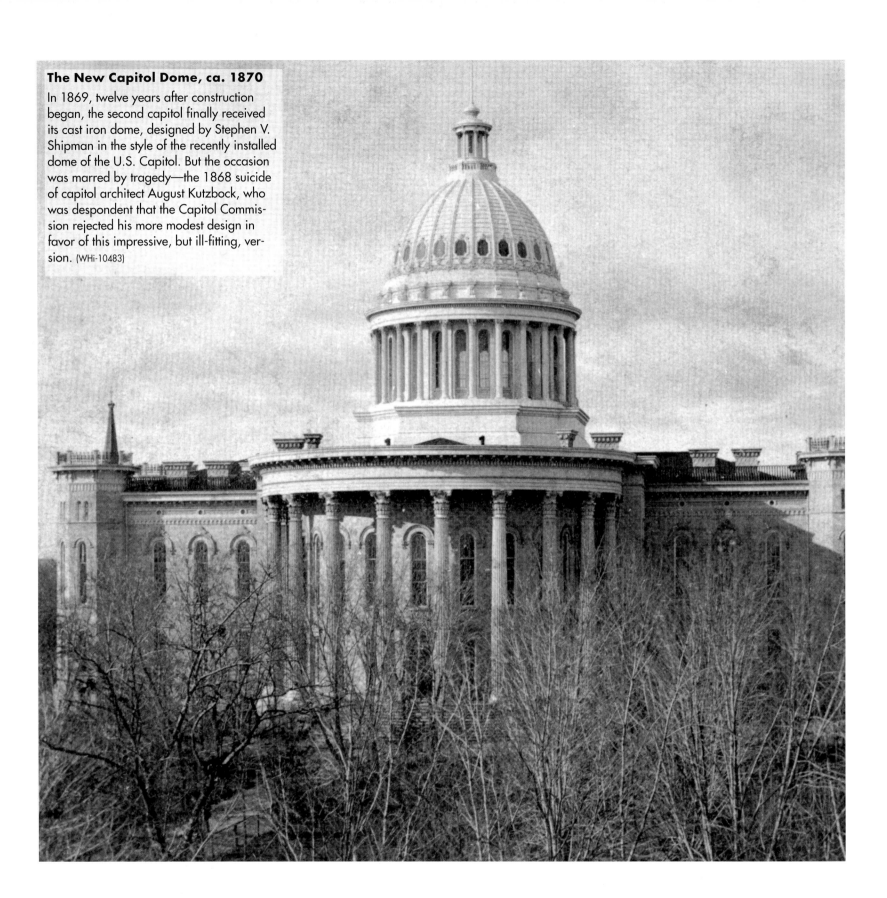

The New Capitol Dome, ca. 1870

In 1869, twelve years after construction began, the second capitol finally received its cast iron dome, designed by Stephen V. Shipman in the style of the recently installed dome of the U.S. Capitol. But the occasion was marred by tragedy—the 1868 suicide of capitol architect August Kutzbock, who was despondent that the Capitol Commission rejected his more modest design in favor of this impressive, but ill-fitting, version. (WHi-10483)

THE 1870s

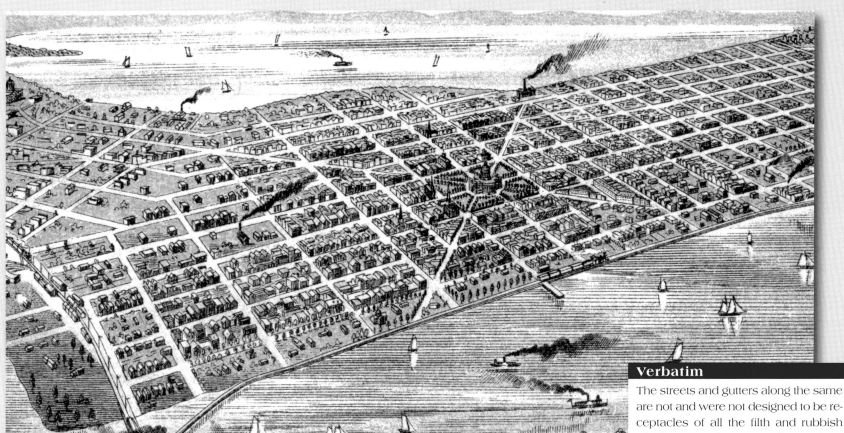

Bird's-eye View of Madison and Its Surroundings, ca. 1871

The world's only midwater railroad crossing makes its first appearance in this postcard, which yet neglects to note either the 1869 Chicago, Milwaukee and St. Paul Railroad depot at Blair and Wilson streets or the 1871 Chicago and North Western depot on South Blount. The artist anticipates completion of St. Raphael Church ten years hence but omits the 1869 spire of Holy Redeemer Church. The illustration is also likely the first to portray Ladies (Chadbourne) Hall (far left, below State Street on Park) and the Park Hotel, both from 1871, but it does not include the federal post office at Mifflin and Wisconsin from that same year. The 1869 capitol dome is shown, along with the 1872 Capitol Park landscaping. The western marsh appears far more developed than in the 1867 aerial (page 55), and the planing mill at the foot of North Hamilton Street far more obnoxious. (WHi-12439)

Verbatim

The streets and gutters along the same are not and were not designed to be receptacles of all the filth and rubbish which accumulates on adjacent lots. The practice which has hitherto obtained, of depositing ashes, decayed vegetables, broken crockery and bottles, unserviceable boxes and barrels, and other refuse on the sidewalks or in the gutters or streets, must be considered at an end; and all ordinances calculated to put an end to such practices and usages will be strictly enforced. The ordinance restraining the running at large of cows and other animals within the city limits, unless modified or changed by the council, will be enforced as during the past year.—**Mayor Silas U. Pinney**, annual message, 1874

Four extraordinary men — and one brash boy — moved to Madison within a few years of each other in the 1870s, future world figures who also had a profound effect on municipal affairs. That four of the five — including the city's greatest private citizen and Wisconsin's most important public servant — came for the university highlights the dominant role the campus has played in city history.

Madison began the decade down, still mired in the lingering recession from the late 1860s. But in 1871 there came a construction spurt that extensively and permanently transformed downtown. Within a matter of months, five important buildings rose on the Capitol Square: a hotel built explicitly to keep Madison the capital; an impressive post office, now long gone; two elegant sandstone office buildings still in use; and, fifteen years after Mayor Fairchild cited the need, the first true auditorium. The next year, the state followed suit, giving the city's only park a landscaping makeover worthy of the new capitol and its new neighbors.

But in September 1873, as in 1837 and 1857, a national economic event shattered the local prosperity, when Eastern money markets failed and triggered the worst depression the country would suffer until 1929. Even the city's economic safety net was tattered, as state government slashed its payroll and budget. University enrollment was also down, despite a building boom that brought several signature structures to College Hill. The city's population at least held steady, but by 1880 it was still below the high point before the Panic of 1857.

One demographic change, however, accelerated: by the end of the decade 73 percent of Madisonians had parents born abroad, double the per-

East Side Depot, ca. 1875

Boys pose in the 600 block of Williamson Street as the industrial east side begins to take shape. Centered under the capitol is the Milwaukee Road depot at about the current site of a city water substation across Wilson Street from the Cardinal Bar and Hotel. The Chicago and North Western depot is hidden behind the building with the stacked lumber. Shortly after the C & NW arrived on the east side in 1864, city leaders proposed a station at Blair Street to serve both lines and save land. The C & NW, even though it had just been denied its preferred Johnson Street route, readily agreed, but the Milwaukee Road refused and in 1869 built its own depot — not only duplicating a land use within two blocks but taking prime lakefront land to boot and starting eight decades of land use intransigence. The Chicago and North Western and Milwaukee Road depots were replaced in 1885 and 1886, respectively (pages 102 and 103). The frame buildings at the left were replaced in 1898 with an early shopping center for agricultural implements, Machinery Row (page 136). (WHi-11269)

centage in 1860. The influence of immigration was thus much in evidence. Although true economic and political power still belonged primarily to the old New York and New England families, the foreign factor figured heavily in areas as diverse as education, religion, and recreation. Unfortunately, tensions that dated to the village decade grew worse, as cultures clashed over an issue that combined business and pleasure — German ownership and patronage of the city's breweries.

And throughout the decade, Madisonians debated their city's future, as advocates of industry and tourism began a dispute that would last for generations.

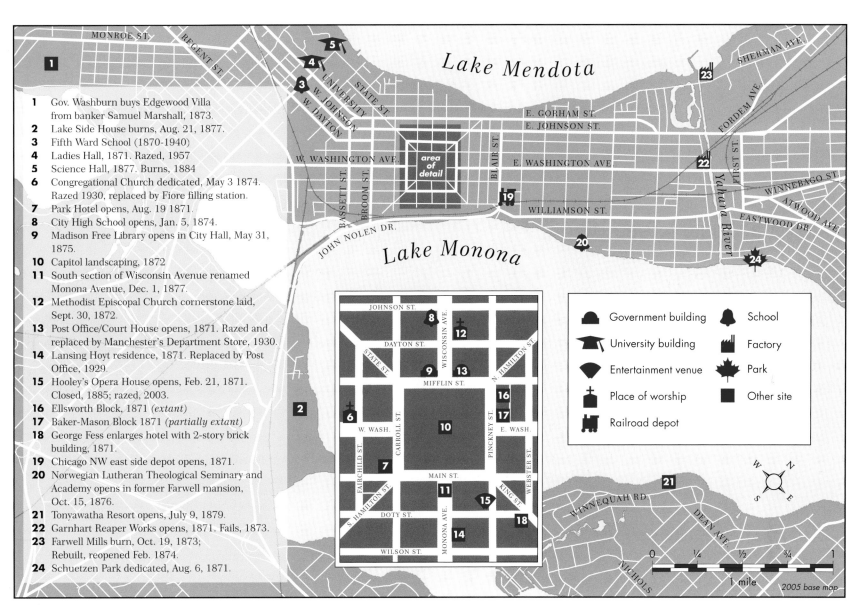

1 - 24 Map Legend:

1 Gov. Washburn buys Edgewood Villa from banker Samuel Marshall, 1873.
2 Lake Side House burns, Aug. 21, 1877.
3 Fifth Ward School (1870-1940)
4 Ladies Hall, 1871. Razed, 1957
5 Science Hall, 1877. Burns, 1884
6 Congregational Church dedicated, May 3 1874. Razed 1930, replaced by Fiore filling station.
7 Park Hotel opens, Aug. 19 1871.
8 City High School opens, Jan. 5, 1874.
9 Madison Free Library opens in City Hall, May 31, 1875.
10 Capitol landscaping, 1872
11 South section of Wisconsin Avenue renamed Monona Avenue, Dec. 1, 1877.
12 Methodist Episcopal Church cornerstone laid, Sept. 30, 1872.
13 Post Office/Court House opens, 1871. Razed and replaced by Manchester's Department Store, 1930.
14 Lansing Hoyt residence, 1871. Replaced by Post Office, 1929.
15 Hooley's Opera House opens, Feb. 21, 1871. Closed, 1885; razed, 2003.
16 Ellsworth Block, 1871 (extant)
17 Baker-Mason Block 1871 (partially extant)
18 George Fess enlarges hotel with 2-story brick building, 1871.
19 Chicago NW east side depot opens, 1871.
20 Norwegian Lutheran Theological Seminary and Academy opens in former Farwell mansion, Oct. 15, 1876.
21 Tonyawatha Resort opens, July 9, 1879.
22 Garnhart Reaper Works opens, 1871. Fails, 1873.
23 Farwell Mills burn, Oct. 19, 1873; Rebuilt, reopened Feb. 1874.
24 Schuetzen Park dedicated, Aug. 6, 1871.

Legend:
- Government building
- University building
- Entertainment venue
- Place of worship
- Railroad depot
- School
- Factory
- Park
- Other site

1870s Map (map by David Michael Miller, courtesy of Isthmus Publishing Co.)

Births and Deaths

1870 Census: 9,173

Births this decade included an important journalist, a vital businessman and civic leader, two mayors, our most versatile and successful architect, and our greatest activist for economic development.

- Emil Frautschi (1871–1959), undertaker, civic leader
- Joseph Schubert (1871–1959), photographer, mayor
- August Roden (1874–1924), newspaper editor
- Isaac Milo Kittleson (1874–1958), banker, mayor
- Frank Riley (1875–1949), architect
- Joseph W. Jackson (1878–1969), founder of Madison and Wisconsin Foundation

Several pioneers died this decade, including the father of the first white male born in Madison, two early mayors, a hotelkeeper, a builder/politician, and the first postmaster.

- John Stoner (1791–1872), pioneer cabinetmaker
- John Catlin (1803–1874), pioneer postmaster
- George Fess (1816–1875), hotelier
- Peter Von Bergen (1809–1879), builder, last village president
- Levi B. Vilas (1811–1879), industrialist, mayor, patriarch
- George Smith (1823–1879), attorney, mayor

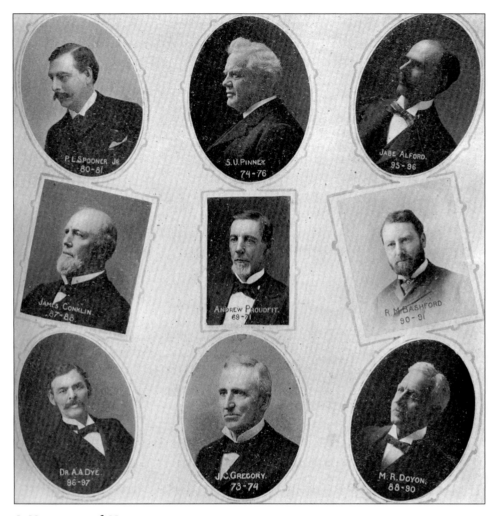

A Montage of Mayors (WHi-35751)

Verbatim

He was an agreeable and entertaining speaker . . . eminently of gentle and peaceful disposition. He did not particularly devote himself to the consideration of complex legislation or the study of complicated legal problems. — **Silas Pinney** on fellow mayor and law partner Jared C. Gregory, 1892

Madison Mayor

James Barton Bowen (1815–81), elected Madison's tenth mayor in 1871, went to work in a Connecticut cotton mill at age eleven and was the supervisor of a hundred workers at age sixteen. He made and lost two fortunes in the cotton industry. He came to Madison in 1852 as the area's first homeopathic physician and developed a good reputation. In 1859 he bought former alderman Seth Van Bergen's fifty-six-acre estate on the city's southwest border; the house, later given the address 302 South Mills Street, survives. President of Park Savings Bank, charter member of a new Masonic lodge, and with a growing medical practice, Bowen bought and sold more than $500,000 worth of real estate.

James Barton Bowen, physician, politician, and patriarch

(Historic Madison, Inc.)

The West Side Elmside, ca. 1877

The James Bowen estate, not to be confused with the Simeon Mills estate with the same name on the other side of town.

(Historic Madison, Inc.)

Verbatim

Madison is fortunate in that almost everything has been done for it by nature. [But] Madison cannot have a reasonable hope of growth and substantial prosperity simply on the purity of its atmosphere and the surpassing beauty of its scenery, nor yet upon the extraordinary educational facilities it hopes to enjoy at no distant day. We should also embrace in our plans for the future the building up of a manifold and thriving industry in our midst.

A few factories, such as might with great advantage be established here, would infuse into our population a new life, and beget an activity in business of every description to which we are now almost total strangers. They would furnish full and remunerative employment to hundreds of our half idle population, induce thousands to come to us who are now debarred by the utter impossibility of finding anything to do, supply a ready home market for the produce of our farmers, add millions to our active cash capital, greatly enhance the value of our real estate, and convert Madison from a delightful humdrum retreat into a thriving and prosperous city that would be felt as a positive and beneficent power in the northwest. — **Mayor James B. Bowen**, annual message, 1871

Madison Mayor

Silas U. Pinney (1833-99) was a giant of the law both before and after he became one of Madison's most influential mayors. In neither capacity, however, was he a particularly pleasant man. "He had a Napoleonic brain and a Napoleonic love of conquest," a boyhood friend recalled after Pinney's death, with "an unfortunate nervous temperament which often made him irritable and impatient."

Pinney taught school for three years in his late teens, read the law, and in 1853 joined the law firm of another future mayor, Levi Vilas. After stints as city attorney (1858) and alderman (1865), he accepted a supreme court appointment to publish Pinney's Wisconsin Reports, documenting the decisions of the earliest territorial and State Supreme Courts. But within a few years, his work with a thousand-fold more books had even deeper impact.

Prior to his election as mayor in 1874, Pinney was a leader of the Madison Institute, a private library that in 1866 Mayor Keyes allowed to locate in the treasurer's office in city hall. In his first message Pinney urged the council to establish and support a free public library — starting with the Institute's 3,500 volumes. Seven months later, on November 21, 1874, the council established the Madison Free Library, to be housed in city hall "until a permanent location be otherwise provided" and supported by an annual $1,500 appropriation. After his easy reelection, Pinney noted that the library was operational and called for a formal opening with appropriate festivities. On the evening of May 31, 1875, throngs attended the gala ceremony at city hall, viewed the extensive collection, heard addresses from Pinney and university president John Bascom, and donated another two hundred volumes. The first librarian was Virginia Robbins Baltzell, whose husband, John, became mayor in 1879. Contrary to enthusiastic press accounts that continue to this day, Madison's was not the first free public library in the state; Sparta had organized its library a year earlier.

Pinney also got tough on trash, declaring that if the streets and gutters were not kept clean, "the Street Superintendent will attend to it and the expense of doing it will be entered according to law as a special tax against the lots where the delinquency is found to exist." Returning to the topic after his reelection, Pinney decried the "scandalous practices" prevalent in some parts of town. "The practice of setting fires in the streets to burn rubbish deposited there is contrary to the ordinances and must be absolutely discontinued," he declared, vowing "to organize a police force" to enforce all ordinances. To aid voluntary compliance, he asked the council to "provide at once for the removal of such refuse and objectionable matter by a scavenger cart to pass along each street at least once a week." Madisonians thereafter did a little better job keeping the streets clear. But it was not until 1907 that Madison started a tentative program of garbage collection and not until 1917 that a successful tax-supported sanitation program began.

Pinney's only daughter, Bessie, born on the Fourth of July 1870, was killed in a carriage accident near the corner of Gilman Street and Wisconsin Avenue a month before she turned twenty-one. Her brother Clarence also died young, at age nineteen in 1879.

Pinney was appointed to the State Supreme Court in 1892 but resigned due to ill health in 1898. With his resignation letter he enclosed a certified check for $706.52 — reimbursing the state for salary he had already received that he felt he now didn't deserve.

A branch library on the city's east side is named in Pinney's honor.

Madison Mayor

Andrew Proudfit (1820–83), a builder and industrialist, was elected Madison's ninth mayor in 1869. Born in upstate New York, he came to Madison in 1854 following two terms as chair of the Waukesha County Board and service on the Fox and Wisconsin River Commission. While serving in the State Senate (1858–59), he listed his occupation in the city directory as "gentleman." Proudfit built a portion of the second state capitol in 1864 and two wings of the Mendota state hospital. As vice president of the Madison Business Board he was instrumental in bringing the Chicago and North Western Railroad to the city in 1864. His homestead on a large parcel at the southeast corner of Fairchild Street and West Washington Avenue was once considered as a site for a new city hall before it was sold for the Hotel Loraine. A director of the Madison Gas Light and Coke Company and the Park Hotel, Proudfit was also for many years vice president of the First National Bank, which his son A. E. Proudfit later led. A street five blocks to the west of his property is named in Proudfit's honor.

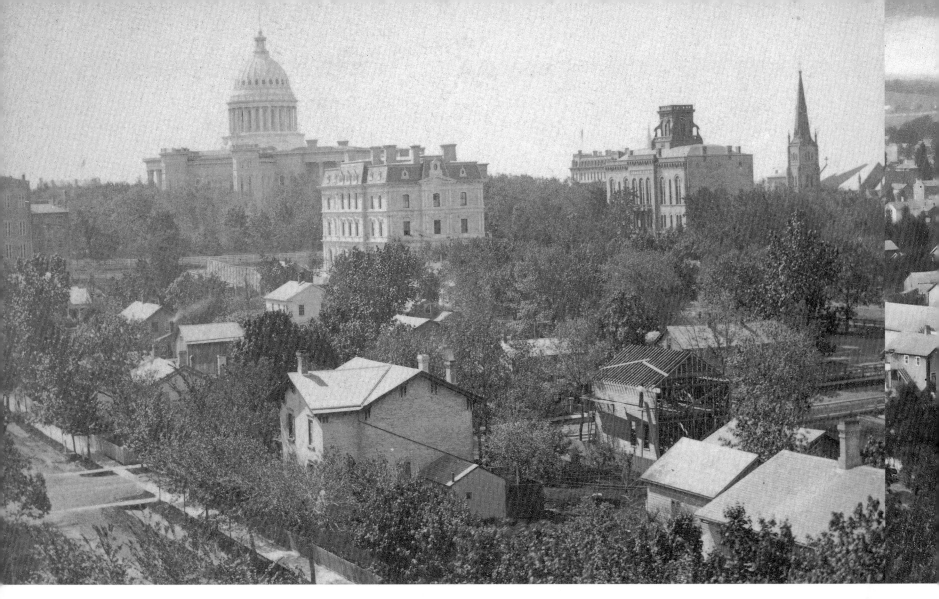

Government Plaza, ca. 1875

The second capitol, U.S. post office and courthouse, and city hall, viewed from assemblyman-postmaster-mayor E. W. Keyes's front yard at the corner of Gorham and Pinckney streets. "The most elegant edifice, an ornament to the state," contemporary historian Daniel Durrie wrote of the federal facility, "built by the government without regard to expense." The building was razed and replaced in 1930 by Manchester's Department Store and its function moved to Monona Avenue (see page 241). The Park Hotel (like the post office and capitol dome, designed by Stephen Shipman) and Grace Episcopal Church flank city hall. (WHi-35789)

Madison Mayor

Harlow S. Orton (1817–95) ran the state as executive assistant to Governor Leonard Farwell while the latter was developing Madison, so it was only fitting that Orton would have the chance to run Madison as well, as its fifteenth mayor in 1877. His service was modest, its highlight probably the tie-breaking vote he cast to preserve the former cemetery on the east side for parkland rather than let it be sold for residential development. It was in acknowledgment of this vote that the council named the park in his honor on May 15, 1883. Before his election Orton served in the State Assembly, as circuit court judge, and as dean of the University of Wisconsin Law School. He was a supreme court justice from 1878 until his death on the Fourth of July 1895. Although he headed the Dane County cavalry at the outbreak of the Civil War, his devotion to the cause seems suspect — Orton wrote his brother following the fall of Fort Sumter in April 1861 that he "fully and totally and emphatically" opposed Lincoln's policies, which he called war-mongering by the North that would "destroy all hope of Union forever." Perhaps not surprisingly, Orton waited two days after Fort Sumter to call a meeting of the company, and then his men voted by better than two to one not to answer the president's call for troops.

Harlow S. Orton, jurist and mayor

(Historic Madison, Inc.)

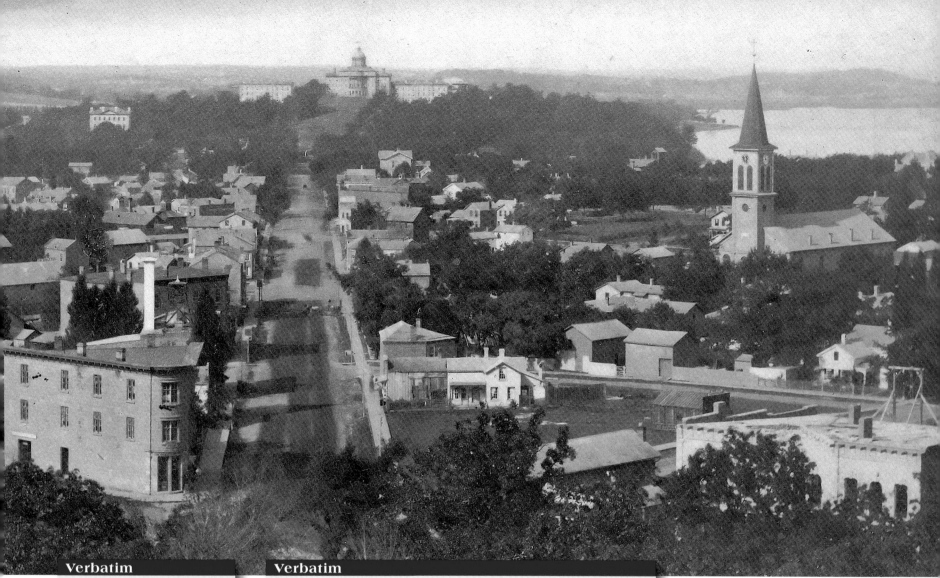

I am happy to say, that so far as I know, the management of our city affairs has given no just occasion for the charge that rings and conspiracies for the benefit of favorites and for plunder and other corrupt purposes have ever been formed, and even in this day, so noted for municipal corruption, speculation, and fraud in some of the larger cities of the country, the record of this city, at least in that respect, is clear of any aspersion or complaint, and it is our highest duty to keep it so. — **Mayor Harlow Orton**, annual message, 1877

Moreover, of late years, there has been much neglect on the part of lot owners in cleaning snow from their sidewalks, a neglect that not only affects the comfort and endangers the safety of the people who pass over them, but renders the city liable in suits for damages for injuries thereby incurred. There are ordinances relating to this matter which should be energetically enforced the ensuing year.

There is no matter of greater importance to be brought under your consideration than that of the public health. It is time we should wake up in this matter. I therefore recommend that the committee on public health and the police take vigorous measures to abate all nuisances, to have the filth removed from private premises as well as the streets, to drain off the stagnant waters, and generally to enforce all ordinances relating to this most important subject. It should be understood and felt that it is in the interest of all that the public health should be maintained against the carelessness or recklessness of those persons who put their private convenience against the common safety, and that public opinion will cordially justify the most rigorous measures. — **Mayor John R. Baltzell**, annual message, 1879

State Street, ca. 1871–76

The six most prominent buildings pictured here all remain — on campus (from left) Ladies (Chadbourne), South, Main, and North halls; Holy Redeemer Church; and in the left foreground, the village-era Main building. Just past the Main block, at the foot of Fairchild Street, is the Nolden Hotel, which stood from 1856 until it was razed for Kessenich's department store in 1921. At upper left are the fairgrounds and Breese Stevens's farm, about twenty years before their transformation into Camp Randall and University Heights. (WHi-36054)

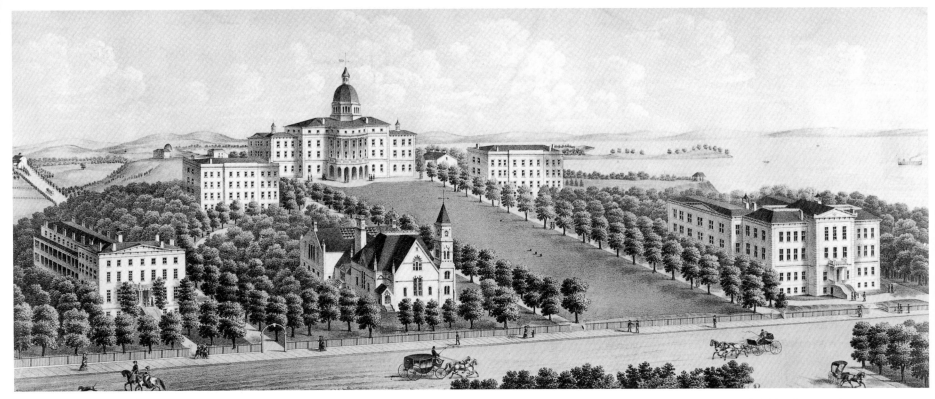

John Bascom's Campus, ca. 1882

This idealized illustration shows the campus about eight years into the administration of President John Bascom, after the university finally found firm financial footing. The 1870s began on a high note, as the legislature responded to the emphatic call from President Chadbourne and the regents for a new Female College building with a March 1870 appropriation of $50,000 — the first appropriation of tax dollars to the university. Previously, the state had funded campus construction by selling off the lands Congress had given (at ridiculously low prices, to stimulate European migration into the state). The three-story Ladies Hall (lower left) opened in September 1871 with recitation rooms in the main building, dormitories in the wing, and the first indoor plumbing on campus. It was razed in 1957, when it was the oldest women's dormitory on a coeducational public campus in the country. In 1872 the state passed legislation that provided an annual $10,000 appropriation and contained an extraordinary admission in its preamble — a declaration that the university had "suffered serious loss and impairment" due to the legislature's previous policy of selling land at bargain rates and using the funds for construction rather than operating expenses. Four years later, the legislature did even better, replacing the flat appropriation with an annual one-tenth mill tax dedicated to university support; its first use brought the campus $42,359.62. The law also granted free tuition to state residents, and, as requested by former governor Washburn, appropriated a sum for the teaching of astronomy, "so soon as a complete and well equipped observatory shall be given the University in its own grounds without cost to the state." That observatory (upper left), funded by and named after Washburn, was dedicated in 1882. At right is the first Science Hall, which opened on June 21, 1877, nine months late

and almost $30,000 over its $70,000 budget. The second purely instructional building on campus, it burned on December 1, 1884. Bascom's pride and joy was the Assembly Hall and Library (center bottom), where he gave regular Sunday talks to the entire university community. The building, which also provided a better library than the cramped and dismal little effort in Main Hall, opened with great fanfare on March 2, 1880 — five months late — as Assembly Hall. After the building's name was changed to Library Hall in 1885, campus growth caused the building's purpose to change as well. The meeting hall function moved to the Armory/Gymnasium in 1894, and when the library moved to

University President John Bascom, ca. 1877

The man who inspired Robert La Follette and hired John Olin.

(University of Wisconsin Archives)

the Historical Library building in 1900, the music department moved here from Ladies Hall, with the name officially changed to Music Hall in 1910. In 1901, President E. A. Birge renamed Ladies Hall after his anti-coeducation predecessor, Paul Chadbourne — prompting an indignant Florence Bascom to wonder why her father had not been similarly memor-ialized. On June 22, 1920, Main Hall (center top) was formally rededicated as Bascom Hall. For a contemporaneous photograph, see page 97. (WHi-11262)

JOHN BASCOM'S PRESIDENCY OF THE UNIVERSITY OF WISCONSIN

John Bascom (1827–1911), the first great leader of the most important institution in the city, hired John Olin and inspired Robert La Follette and future university president Charles Van Hise. His presidency of the University of Wisconsin from 1874 to 1887 was a turning point that forever changed Madison.

Too bad the regents ran him out of town.

Raised in upper New York in genteel poverty by the widow of a Congregationalist minister who died when he was a toddler, Bascom maintained a strict Puritan morality, which led him to champion prohibition, coeducation, women's suffrage, and workers' rights to unionize and strike.

Bascom graduated from Williams College in 1849 and, after burying his wife of two years, returned to Williamstown in 1855 as a professor of rhetoric. A highly regarded scholar, but with no long-term future at Williams, Bascom readily accepted the call to succeed the failed John Twombly in Madison.

At first, Bascom more than met the high expectations of his national reputation. An early proponent of the new Social Gospel of Christian Socialism, Bascom was a leader of liberal thinkers; he brought extensive experience and great aptitude as a teacher and he had the requisite executive skills to administer the growing university.

In his Sunday seminars at Assembly Hall and in baccalaureate addresses, Bascom stated an early version of the Wisconsin Idea of university service to the state that two members of the class of 1879 — La Follette and Van Hise — would more fully establish.

It turned out, though, that the very characteristics that led the regents to hire Bascom caused an irreparable rift in their relationship. Some objected to his ardent advocacy of prohibition; almost all resented his active involvement in the university's business affairs, which they regarded as their exclusive area of expertise and influence. For his part, Bascom thought the regents were petty politicians more interested in power and prestige than educational excellence.

The two regents Bascom disliked most were powerful Madisonians — banker and executive committee chair Napoleon Bonaparte Van Slyke, whom Bascom thought was a narrow-minded dictator, and Elisha W. Keyes, whom he thought a corrupt bully.

As Keyes well knew, Bascom even tried to prevent his appointment in early 1877. When the appointment was made and Keyes succeeded Van Slyke as the most powerful regent, Bascom's fate was sealed.

But Bascom would not go quietly.

Madison Notable

By inspiring Robert La Follette and Charles Van Hise, John Bascom indirectly helped change Wisconsin and the United States. But by hiring **John Myers Olin** (1851–1924), he directly and dramatically changed the future of Madison. The most important encounter in Madison's history occurred when Olin walked into Bascom's classroom at Williams College on April 20, 1871.

John Olin, ca. 1875
(University of Wisconsin Archives)

Descendant of a Welshman who escaped a British man-of-war in Boston Harbor in 1676, Olin grew up poor on a small farm in rural Ohio. He was the ninth of eleven children, and his mother died when he was eight. Teaching school to earn tuition, Olin attended Oberlin College for a year before transferring to Williams in September 1870. Graduating Phi Beta Kappa in 1873, Olin gave the Philosophical Oration at commencement, "Is the culture of the intellect our only need?"

Olin returned to Ohio, working as high school principal and school superintendent while he read the law. That's when Bascom, impressed by Olin's address, offered a job in rhetoric and oratory. Thankfully, the school board let him out of his contract and Olin arrived in Madison on August 28, 1874, about four months after Bascom began his presidency.

For the next three years Olin boarded with Bascom and his family, as did his Williams classmate and future university president E. A. Birge. "It requires no imagination for one to appreciate the influence upon a young man of this close association with Dr. Bascom," Olin wrote years later.

Bascom had promised that he would make Olin a full professor after three years. But bad blood between Bascom and powerful professor S. H. Carpenter curtailed Olin's university career, as Carpenter convinced the regents to reject Bascom's proposal, 6-5 (at the same time they gave Olin a raise to $1,600 a year). "The vote of the regents was the best thing that ever happened to me," Olin wrote another Williams classmate years later. "After that action I never once considered the possibility of entering any profession except the law."

Birge, a frequent debating opponent in their undergraduate days, agreed. Olin's "power and vigor," Birge said, were better suited for the law than "in teaching the average undergraduate." Birge knew Olin well; their two families both lived in the 700 block of Langdon Street for many years. Olin taught through 1878, then entered the university law school. Finishing the two-year course in one, he was admitted to the bar as La Follette and Van Hise were graduating in June 1879.

The works that would make him Madison's greatest private citizen — creating the city's parks system and bringing John Nolen to town — were yet to come. First, he would return to his mentor's side for a bracing battle against demon rum.

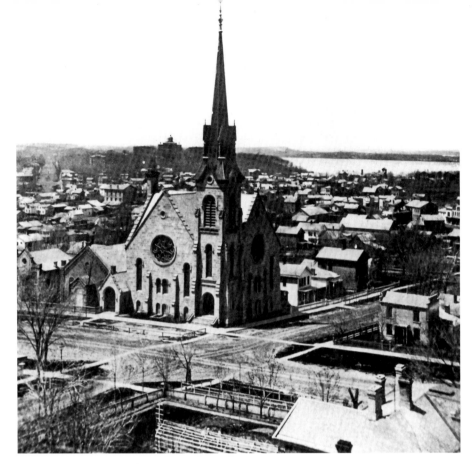

Mayor Proudfit's Neigbhorhood, 1874–79 *(left)*

The university campus — Ladies, South, Main, and North halls — looms behind the new Congregational Church at the corner of West Washington Avenue and Fairchild Street. Mayor Andrew Proudift's property is in the immediate foreground of this view from the back of the First Baptist Church on South Carroll Street. Around this time, had he a spypiece, the mayor could have seen Bob La Follette and Charlie Van Hise on their way to class or John Bascom in conversation with John Olin. He could also have seen the foundry smokestack near the water on Lake Mendota Court.

The Congregationalists were the capital's pioneer church, having been organized in 1840. This $35,000 church was dedicated on May 3, 1874, and for a while featured the largest and lowest church bell in town. Note the hitching rails all along the intersection. This church was razed in 1930 when the congregation opened its new church on Breese Terrace, and replaced with a Fiore filling station. This is a rare contemporary photograph of the 1863 Shaare Shomaim (Gates of Heaven) synagogue, the small sandstone building to the left of, and smaller than, the church parish house. The road pointed directly at the synagogue is University Avenue, which Proudfit's successors forty years later would fight to extend to this very corner (page 215). (WHi-31601)

Verbatim

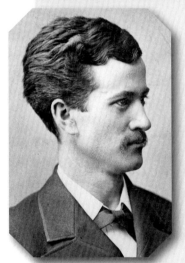

Robert M. La Follette, Class of 1879

Wisconsin's greatest statesman as a college senior. (University of Wisconsin Archives)

R. M. La Follette
The Victor of the Inter-Collegiate Contest,
Welcomed Home by His Fellow Students and the Citizens of Madison.
Grand Reception in the Assembly Chamber
Speeches by Col. E. W. Keyes, Geo. B. Smith, Col. Vilas and Others.

———

R. M. La Follette, the University senior who carried off the honors at the Inter-State Collegiate Oratorical Contest . . . returned home at 4 P.M. Saturday. About two hundred and fifty students, among whom were many of the fair denizens of Ladies' Hall, awaited the victor at the C. & N.W. depot; there were also present some two or three hundred citizens, many of them in carriages. The young gentlemen students marched with Mr. La Follette up to the campus, headed by Lewis' brass band. . . .

At eight o'clock, a large number of persons — citizens and University students — gathered in the Assembly Hall, to give further expression to their gratification at the triumph of Mr. La Follette.

After the band had performed a piece of appropriate music, Hon. E. W. Keyes, with Mr. La Follette and other friends, took seats on the Speaker's stand, amid the deafening applause of the audience. . . [Following brief remarks by Keyes, Col. Wm. F. Vilas, Prof. David Frankenberger, and Mayor Smith, La Follette bowed to the crowd's demand and delivered his award-winning oration, "Iago."]

With this, the exercises at the stand concluded, and the hall was cleared for dancing. A short time was spent in this delightful exercise, when all returned to their homes, satisfied that merited justice had been done to the victorious young student of the University, who had honored the Institution and the State, in the recent Oratorical Contest of the Colleges of the Northwest — Mr. Robert Marion La Follette. — **Wisconsin State Journal**, May 12, 1879

Schooldays

"Our high school building is scarcely less than a disgrace," Mayor Bowen declared in his 1871 inaugural address, telling the council "the time is at hand" to replace Madison's oldest continuing educational building, the former Female Academy on the southeast corner of Wisconsin Avenue and Johnson Street.

As the decade began, the district's building program continued with the opening of the Fifth Ward School at Park and Johnson streets in November 1871 and a small brick school in the Farwell Addition past the Yahara River that same season. Then things stalled, leaving the older students cramped into the frame building that housed the first university preparatory classes in 1850. Despite Bowen's plea, three years passed before the city gave the board funds to build the first high school on the same, well-established site. This $25,000 quasi-Italian brick building with a Chinese-style tower and lots of wainscoting, built by James Livesey and future mayor Hiram Moulton, was much admired when it opened in the late fall of 1873 under new superintendent Samuel Shaw. The school was dedicated on January 5, 1874, and held its first graduation on July 2, 1875. Eight of the fourteen in that city hall ceremony enrolled at the university.

Then a new state law severely complicated the district's affairs — an 1876 measure granted free tuition to the university and its preparatory department, which resulted in the immediate reduction in the size of the high school's upper grades and the departure of the best students. That year, there were only eight graduates.

But the district quickly bounced back, and on March 17, 1877, it was added to the university's accredited list of schools whose recommended graduates enjoyed automatic admission. Later that year, the graduating class was up to twenty-four, twenty of whom enrolled at the university.

But the teachers did not share in the students' good times. The board cut salaries in June 1877, leading thirteen ward teachers, four of five ward

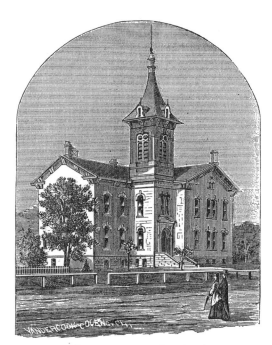

The First City High School
(courtesy of David Mollenhoff)

principals, and all but two of the high school teachers to resign. At least their replacements included five graduates of the city high school and eight from the university.

In 1879 the high school commercial course graduated its first class of two boys and two girls (including merchant Samuel Klauber's daughter Sophie, later a charter member of the Woman's Club in 1893). And the decade ended on a high note, with Superintendent Shaw's endowment of two hundred dollars, the annual interest on which was to be given to the graduating student with the greatest talent in com-

position and elocution. The board named the award the Shaw Prize, and it quickly assumed an important place in the commencement exercise.

Among those who attended school in this building were two dynamic characters who would become bitter foes — Frank Lloyd Wright and Joseph W. Jackson.

Capitol Park Fence and Hitching Rail *(right)*

The territorial legislature kept this whitewashed wooden fence, or one like it, around the capitol grounds from 1842 to 1872, mainly to keep out the horses and livestock. The hitching post, though, created its own nuisance of horses and wagons congregating on the square. After the second capitol was finished in 1869, the embarrassing disparity between the shining building and the rustic grounds — where the brick outhouse on the west lawn had only been removed in 1866 — prompted incoming governor Cadwallader C. Washburn to propose an ornamental iron fence and general landscaping. The legislature appropriated $40,000, created a parks commission, and outlawed hitching horses to the new fence or anywhere on Capitol Square (which led to the development of the market in the first block of East Washington Avenue, possibly an even greater nuisance than the one prevented). Not surprisingly, Washburn awarded the contract to Stephen Vaughn Shipman, the Madison war hero then in Chicago whose designs were all around the square, including the post office, Park Hotel, the sandstone office block at the corner of Pinckney Street and East Washington Avenue, and even the dome of the capitol itself. (WHi-23574)

King Street Pedestrian Entrance, Capitol Park, ca. 1875 *(left)*

This view west on Main Street from the King Street entrance to the park shows Shipman's elegant iron fence, stately pedestrian entrance, and the double sidewalk. The Vilas House edges into the picture on the extreme left, with Simeon Mills's two-story retail building on the far corner of Monona Avenue. Unfortunately, Shipman's design, to Washburn's specifications, put a full sidewalk beyond the fifty-four-inch-high fence, in addition to the sidewalk on the inside of the fence, thus taking eight feet previously occupied by the street. Opposition was fierce, bipartisan, and broad — a liberal Milwaukee minister even preached against it — but Washburn didn't waver. The fence, over budget and lacking several amenities, was installed in the early summer of 1873, with the sidewalk coming in June 1874. In May 1899 Governor Edward Scofield had the fence and sidewalk removed to widen the street, which was given to the city to pave and maintain. The state gave parts of the fence to two state institutions, some sections remained in place, some were sold for scrap, and 1,500 feet now stand before the Executive Residence in Maple Bluff. At least Washburn won universal praise for one capitol improvement — an underground vault built for the five-hundred-ton pile of coal that was then being stored in a heap on the lawn. (WHi-23216)

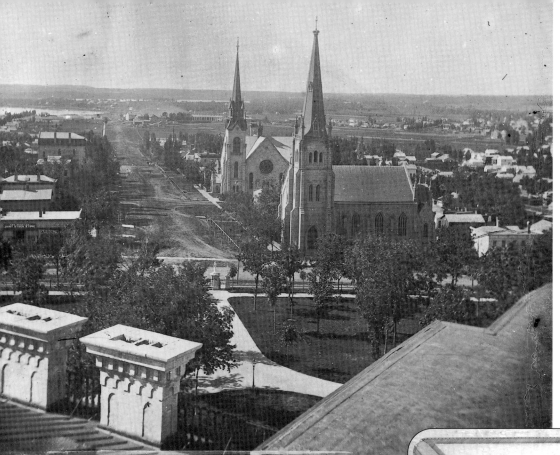

Roundhouse and Spires, mid-1870s *(left)*

With the Milwaukee Road roundhouse on Regent Street visible just to the left of the Congregational Church spire, this Andreas Dahl photo captures two vastly different worlds just one mile apart. As shown in the contemporaneous bird's-eye illustrations (pages 55 and 65), there is a broad cattail marsh between Broom and Frances streets, then industrial and railroad uses just northeast of Monona Bay. The foreground features Grace Episcopal Church, the oldest building on the Capitol Square and the only remaining church of the four that formerly fronted there. Built 1855–58, Grace Church is a Madison Landmark listed on the National Register of Historic Places. The Proudfit homestead is diagonal from the Congregational Church. The roundhouse, just across West Washington Avenue from where Proudfit Street would later be located, was razed in 1984 and replaced with office buildings. (WHi-4122)

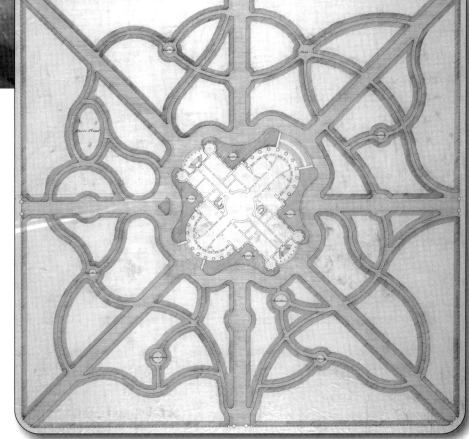

Horace W. S. Cleveland, Plan of Capitol Park, 1872 *(right)*

Cleveland, a nationally prominent landscape architect, produced this serpentine design for the Capitol Park Commission, but it was only partially fulfilled. Just one of the four fountains was installed, the landscaping was insufficient, and no walkways snaked through the grass. But the Monona Avenue entrance did get its bandstand, just as Cleveland proposed. (WHi-38993)

BAR WARS, ROUND ONE

While the New England émigrés of Mansion Hill dominated the political and cultural landscape during the city's first quarter-century, the size and influence of the foreign population was on the rise.

And the largest and most culturally significant immigrant group was the Germans, who accounted for more than 40 percent of the foreign composition in the city. Their Turnverein Society for physical and mental development was a year older than the city, their Schuetzen Club beyond the city limits on the far east side provided a haven for shooting and other relaxations, their votes kept the Democratic Party in power — and their breweries bedeviled the abstemious "codfish" aristocrats.

The cultural battle was particularly intense on Sundays. The New Englanders believed in church and quiet contemplation; the Germans believed in church and boisterous relaxation. With an 1859 state law purporting to close all nonessential activities giving them support, a coalition of prohibitionists and Sabbatarians persuaded the council in April 1870 to close the billiard halls on Sunday, assuming that would cut into the bar business. But the public outcry was so great and immediate that the council repealed the ordinance in early July.

The anti-saloon forces tried again in May 1873, holding a large mass meeting in the assembly chambers to demand the saloons be shut on Sunday. But the council, still smarting over its first foray, rejected a resolution calling on Mayor Jared C. Gregory to enforce the ban. But then Gregory had to leave town on business, and acting mayor Chandler Chapman, who had been in the minority on the earlier vote, directed the police to enforce the ban aggressively. They did, and on August 3 most of the saloons were shut down. The next day, more than two hundred protesters responded to a handbill — in German — and jammed the Turnverein's Turnerhalle to decry the selective prosecution.

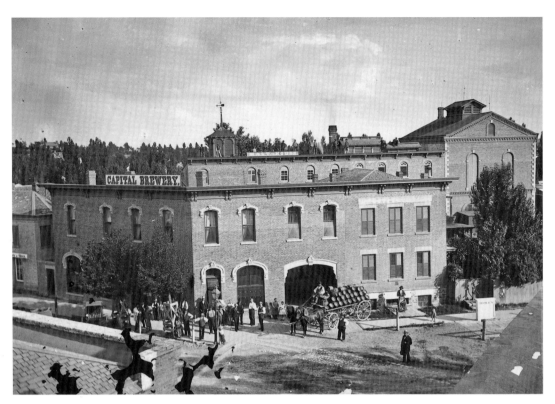

The Capital Brewery, 1879

The Hausmann family's Capital Brewery at the corner of State and Gorham streets was the largest of the city's five breweries, all of them owned by Germans. It was established by William Voigt in 1858 and was the primary destination for Camp Randall soldiers on leave (authorized or not). Joseph Hausmann acquired it in 1863, expanded the facility, and kept buying adjoining property until he owned more than two-thirds of the block. Among the brewery's attractions — especially appreciated by budget-conscious university students — was the full lunch of meats and cheeses set out every day, free with a nickel beer. The brewery's sixty-five-year career ended in a disastrous fire on March 19, 1923, after which a gas station was opened on this corner (page 217).

Three of the other four breweries were also in the downtown area. In 1848 Adam Sprecher built at the corner of Williamson and Blount streets the city's first brewery, which Peter Fauerbach acquired and modernized in 1868 (page 96). John Keyes opened a brewery near the mouth of Lake Mendota in 1850. It was soon acquired by John Rodermund, who went bankrupt after attempting to enter the Chicago market; the parcel then passed to Joseph Hausmann (page 135). In 1865 Mathias Breckheimer converted a plow factory in the second block of King Street into the city's third brewery (page 146). In 1866 Bernard Mautz opened a small brewery on the north side of State at Gilman Street, which he sold to John Hess in 1874. (WHi-11692)

Chapman refused to bend. When Mayor Gregory returned, he struck a compromise — saloons had to stay shut Sunday mornings but could open in early afternoon, after the New Englanders were safely home from church. The temperance-minded *Wisconsin State Journal* was not impressed: "Mr. Gregory is too wise a man and too good a lawyer to issue any proclamation or in any official form tell men they are only required to conform to the laws half the time." But Gregory was also a good politician; his pragmatic plan worked, and the issue died.

The coda came that fall; on November 2, 1873, the council reversed its 1868 policy allowing beer sales in the council chambers and closed the saloon in the city hall basement.

HOOLEY'S OPERA HOUSE

Few issues had tenure as long, or debates as intense, as the city's search for a proper auditorium. "No town or city can be complete without a spacious Hall for public use," Mayor Fairchild declared in 1856, and fifteen years later, Madison finally got its first with the opening of Hooley's Opera House on February 21, 1871.

"A Music Hall Worthy the Capital," the *Wisconsin State Journal* declared after the "brilliant opening" of musical and dramatic acts before a capacity crowd of seven hundred.

An early effort had opened on December 25, 1854, in Fairchild's Hall, the remodeled upper story in the stone block building erected by the future mayor on the Capitol Square; the next year an ambitious subscription drive to fund a new theater failed—possibly due to strident opposition from school superintendent Damon Kilgore, who bitterly protested funds going for "an institution of at least questionable merit while six hundred children are unprovided with even decent school-houses."

Three new theaters opened in 1858: the Lecture Room on the third floor of city hall; the private Turner Hall, primarily Germanic in orientation; and the Madison Lyceum in the expanded third floor of Peter Van Bergan's 1856 brick building on the northwest corner of Pinckney and Doty streets. The Lyceum, with a saloon conveniently located downstairs, could accommodate about a thousand patrons but lacked cushions or a sufficient heating system. The Lyceum closed after a Chicago company walked out in 1868 because the building was unsafe.

Two years later, developer-politician-parks philanthropist George Burrows convinced Chicago theater owner R. M. Hooley—former leader of the Christy Minstrels—to buy the building and put in a proper theater. Hooley did just that, constructing a "commodious, comfortable, and handsome hall" featuring a grand entrance on Pinckney Street, gas chandeliers, carpeted aisles, a large stage, and handsome curtains. Madison was now set to become a standard stop for top-tier traveling talent.

But after thirteen seasons, water seeping from an adjoining Turkish bath weakened the rear wall, forcing Hooley's Opera House to close on January 8, 1885. The top two floors were removed and the building converted to apartments and stores that remained in use until it was razed in 2004 and replaced with a recreation of the 1856 Van Bergan Block.

Once again, Madison was "without a spacious Hall for public use."

Fairchild Block, 1879 *(right)*

Fairchild's Hall once occupied the top floor of this business block at the corner of East Main and South Pinckney streets, which Jairus Fairchild built three years before he was elected Madison's first mayor. In the center bay is a store belonging to Samuel Klauber, the city's first permanent Jewish resident and the leading merchant of his time. Hooley's Opera House is partially visible down Pinckney Street. (WHi-36052)

Sunday Billiards Ban Repeal

When the council voted on April 19, 1870, to enforce the Blue Laws and close billiard halls on Sunday as a way to stop people from drinking beer, opposition was quick and furious. The council repealed the ordinance on July 2, after receiving the following committee reports:

Majority Report

Your committee deem it unnecessary for the public peace and quiet, and oppressive to the laboring classes, to have in force in this city an ordinance that prohibits the citizens or any portion of them from spending their Sabbath in whatever place or manner their judgment or conscience may direct, and believe it an act of injustice to those who perform hard labor during the week and who observe Sunday not only as a day of rest but as a day of enjoyment and recreation, to prescribe by ordinance that they shall not spend that day in whatever manner to them may seem proper if they do not interfere with or prevent others from doing the same thing.

Minority Report

The Sabbath is a day set apart, as a day of rest, and observed as such by the whole Christian world. That it is a violation of higher law, which makes it obligatory upon all men, "To remember the Sabbath day to keep it holy." It is an offense against society, and opens an avenue to sin and vice, by tempting not only the young, but adults, to spend their weekly earnings and impoverish their families.

Dateline

August 6, 1871 Madison Schuetzen Club formally dedicates its shooting and drinking park on the grounds formerly known as "Sommers' Woods" on the east-side lakefront around Dunning Street.

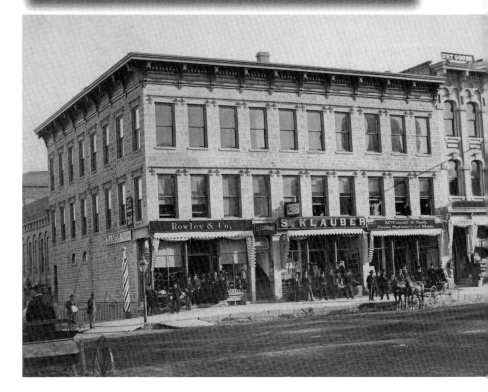

Two Hotels, 1.0

In the early 1870s, two of Madison's most important buildings were hotels. One was designed for pleasure, to create a new trade in tourism. The other was built for business, and municipal self-preservation. One lasted little more than a decade; the other, after a fashion, endures to this day.

At decade's dawn, as Milwaukee legislators and business leaders renewed their long-standing quest to wrest the capital from Madison, a constant criticism was the city's lack of a first-class hotel. Since Madison had only two hotels of any consequence — the 1853 Vilas House at 1 East Main Street and the 1866 Rasdall House at 208 King Street — the Milwaukeeans had a point.

"There is no use in concealing the deficiencies of Madison in this respect," the *State Journal* editorialized. "We have been plainly told by two committees of the Legislature that we should erect a hotel, and the only question is how it is to be done."

The method emerged in February 1870 during assembly consideration of the latest relocation bill — incorporation by some of Madison's wealthiest and most important leaders of the Park Hotel Company. Even when the assembly killed the relocation bill 55-31 on March 9, 1870, the incorporation efforts continued, and on March 18, 1870, the legislature chartered the Park Hotel Company. Madison pioneers led the concern — entrepreneur Simeon Mills became president, banker N. B. Van Slyke was named treasurer, and the board of directors included former governor Lucius Fairchild, banker and former mayor Andrew Proudfit, and merchant Samuel Klauber.

Now all they needed to do was choose one of three sites — a vacant lot at the corner of Pinckney Street and East Washington Avenue; Mills's property at Monona and Main, across from the Vilas House; or a lumberyard at the corner of South Carroll and West Main streets, owned by the hotel company's largest stock-

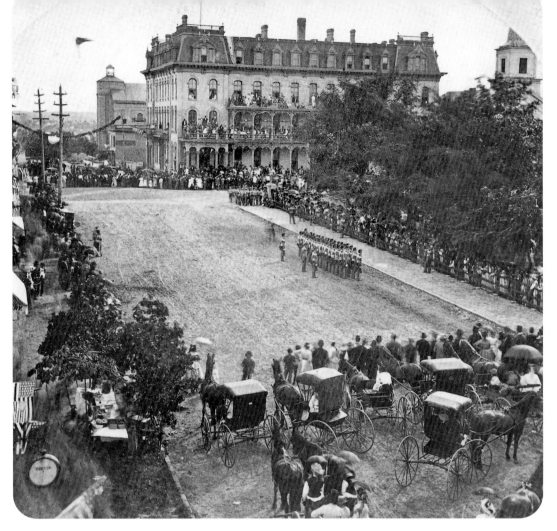

Fourth of July, 1876

The original Park Hotel, flanked by St. Raphael's Church (before erection of its steeple) and First Baptist Church (steeple out of view), centers this photograph of Capitol Square ceremonies celebrating the nation's centennial. (WHi-11265)

holder, industrialist and politician Nathaniel Dean.

The decision was announced on May 1, 1870 — the Park Hotel would replace the two-story brick building on Mills's corner, at the head of Monona Avenue. Or would it? With a sudden and unexpected $10,000 in new stock subscriptions, the board reversed itself and the next day announced a new site — Dean's corner at Carroll and Main, the highest point between the lakes.

After construction delays pushed the opening back from December 1870 and doubled the projected cost, the hotel received good marks when it finally opened on August 19, 1871. The $125,000 facility, designed by Civil War hero Colonel Stephen V. Shipman, fit its site well

with four stories of pressed Milwaukee brick and Madison sandstone under an elaborate French mansard roof, with a double-decker piazza along its 116 feet of Carroll Street frontage. The 99 feet of Main Street frontage lacked a veranda but did provide a ladies entrance.

With 118 sleeping rooms (a dozen of them suites), parlors grand and small, a ballroom, and the finest of interior furnishings, the hotel opened with every convenience — including the first full indoor plumbing on the square.

In addition to serving the traveling trade, the Park Hotel also served as an unofficial gubernatorial headquarters before the state bought the mansion at 130 East Gilman Street as an executive residence in 1885. It also thus quickly be-

came the favored watering hole for lobbyists and legislators.

After a series of ownership transfers and renovations (including the removal in 1911–12 of the mansard roof), the Park Hotel was replaced in 1961 by the Park Motor Hotel, and its remains were removed to a wrecking company dump on Fair Oaks Avenue.

Tonyawatha (WHi-11250)

Lakeside House
The second incarnation of a tourist attraction on a special site. (WHi-25114)

Meanwhile, across Lake Monona, the early 1870s saw the Lakeside House become the centerpiece of a thriving tourism trade. Pioneer Madison developers George Delaplaine and Elisha Burdick renovated their shuttered Water Cure spa after the war, and from its opening on July 2, 1866, the new facility was a success. The 4,000-square-foot cream-colored resort on the promontory, with a sweeping panorama of the growing city skyline and many amenities, successfully catered to the well-heeled carriage trade, particularly travelers from St. Louis. Thanks to the six rail lines that served the city by the summer of 1871, Madison built on the publicity started by Horace Greeley's 1855 tribute and developed a growing national reputation as a summer resort.

The city worked hard to build its tourist trade, both by active promotion and by providing better recreational activities (including stocking the lakes with 17,000 salmon and trout in just two years).

But the best publicity was no match for bad times, and the national depression that began in 1873 took a toll on the tourist trade. The city also couldn't avoid the inescapable — Madison was largely a summer-only destination.

Then disaster struck, as the Lakeside went up in flames at half past seven on the morning of August 21, 1877. Three hours later, the property was just one great bed of ashes, never to be rebuilt. The sixty guests saved all their personal property, but Madison's future as a northern resort was called back into question.

These two hotel storylines merged at the end of the decade, when the owner of the Park Hotel, Dr. William Jacobs, filled the resort hotel vacuum by opening an elegant new hotel and spa across Lake Monona in the Town of Blooming Grove on July 9, 1879. There was a mineral

water spring on the property, so Jacobs gave his resort a Native American name that meant "healing waters" — Tonyawatha.

The resort's early years were quite successful, especially with tourists from New Orleans. But then business tapered off, Blooming Grove refused to renew the hotel's liquor license, and the resort was sold at a bankruptcy auction during the deep depression of 1893. A new owner reopened the resort in June 1895, only to suffer a total loss when the building burned on July 31.

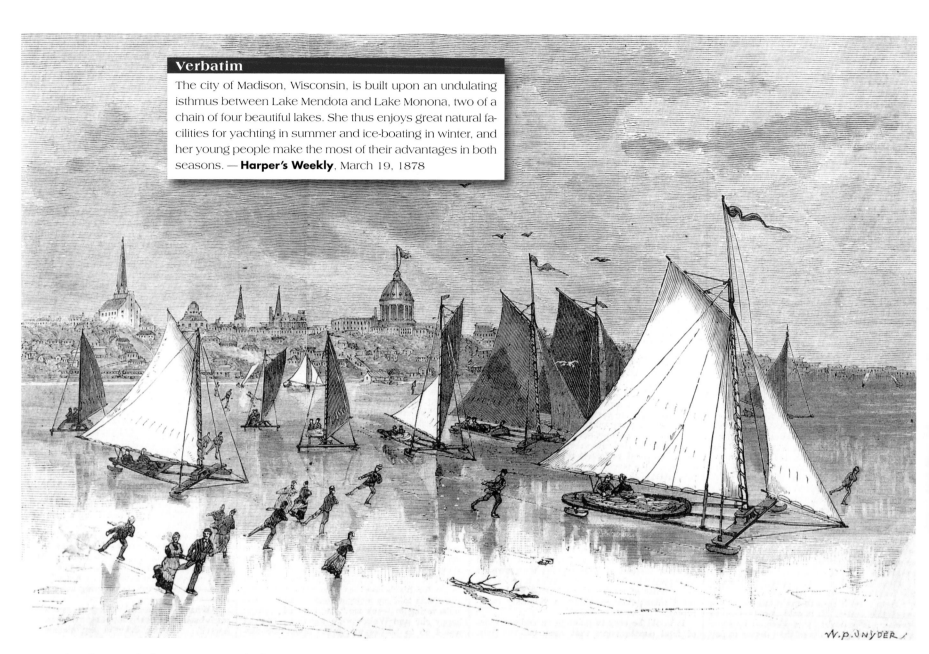

Icy Fun on Lake Monona, 1878

Madisonians had enjoyed iceboating since the mid-1850s, but a revolutionary new design in 1876 caused such an explosion of interest that Madison became a national hotbed of the winter activity. This engraving from an 1878 *Harper's Weekly* was just the latest national publicity for Madison's growing tourist trade. Brewery scion Emil Fauerbach was a nationally ranked ice yachtsman and a prime mover in local ice yachting regattas. (WHi-11257)

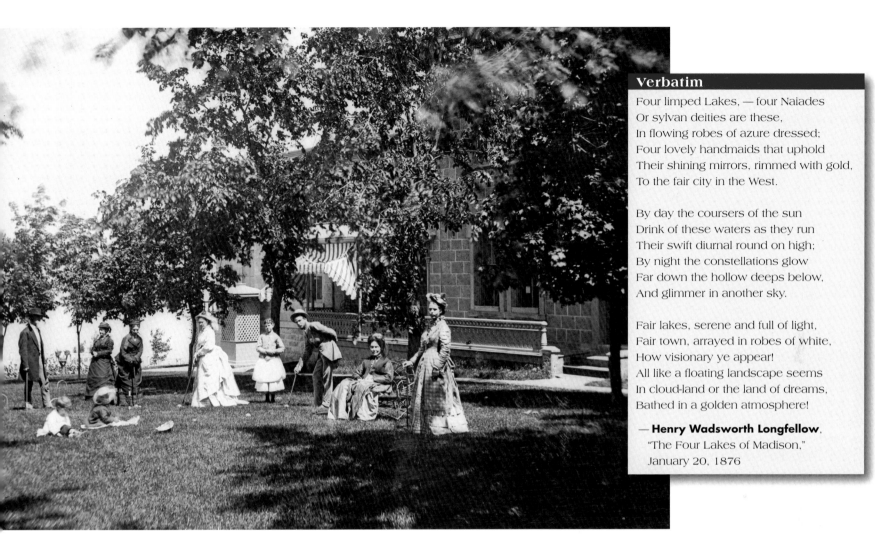

Croquet at the Thorp-Bull House, ca. 1875

Sarah Thorp Bull (standing at right), young wife of famed Norwegian violinist Ole Bull and daughter of millionaire Eau Claire lumberman and politician J. G. Thorp, plays croquet with friends on her lawn at 130 East Gilman Street. Her mother, Amelia Chapman Thorp, is seated at her side. It was Mrs. Thorp, working through daughter-in-law Anna Longfellow Thorp — wife of Sarah's brother John — who prevailed on Anna's father, Henry Wadsworth Longfellow, to write "The Four Lakes of Madison" for the Wisconsin pavilion at the 1876 Philadelphia Centennial. Sadly, the Thomas Moran murals commissioned to illustrate the poem were later hung in the old Science Hall on campus and lost in the fire of December 1, 1884. After Ole Bull died in 1883, the Thorps sold the 1856 property to newly elected governor Jeremiah Rusk for $15,000 and moved to the East. Rusk spent at least that much on extensive renovations and after his defeat two years later sold it to the state — at well below cost. The Executive Residence (as named by Belle Case La Follette) was home to sixteen gubernatorial families until 1950, when it was purchased by the university and converted to the Knapp Memorial Graduate Center. (WHi-27187)

Madison Notable

John Nader (1838–1919) was elected city engineer by the common council in 1876, which position he held off and on for many years. Engaged by the U.S. Corps of Engineers before coming to Wisconsin, Nader designed and superintended the failed "district" system of sewage control in 1899. He designed the St. Patrick's Church, a renovation of Holy Redeemer, the Suhr Building, as well as the asylums for Dane and Sauk counties.

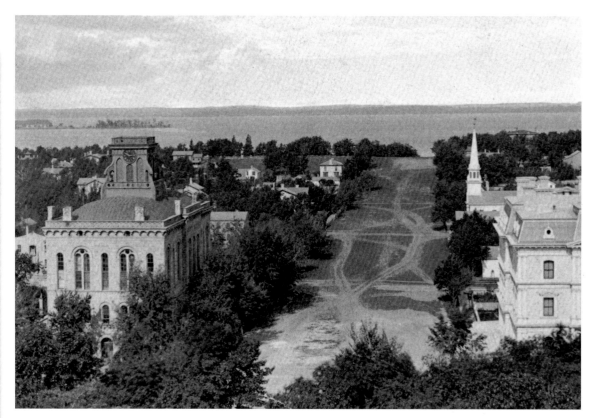

Wisconsin Avenue, ca. 1872

Carriage tracks still traverse Wisconsin Avenue and the village-era academy to the right of city hall is still in use as the high school, but the small structures at the corner of Wisconsin Avenue and East Mifflin Street (page 43) have been replaced by the imposing post office and federal courthouse. Within a few years, the city would finally get the high school shown on page 75. (WHi-35738)

Dateline

September 1871 After sharp competition with a site near the university to house the new Garnhart Reaper Works, east-side interests lure the new manufactory by donating the entire block just west of the river, between Mifflin, Dickinson, and Washington — plus $5,000. When the company does not survive the Depression of 1873, Madison's future as a manufacturing center appears in doubt.

Madison Notable

Captain Frank Barnes was the proprietor of Angle Worm Station, which dominated Lake Monona in an era when Lake Monona dominated leisure activity. A robust and playful man who habitually wore a straw hat through every season, Barnes came from a "fine family of seafaring folk" in Rhode Island; exactly why he came to Madison was never quite clear. A graduate of Yale, Barnes explained the facility's name in a famed twenty-minute address on the wondrous role of the earthworm, which he gave each Independence Day and whenever else the occasion warranted — including during an excursion chartered for President Grant. In 1870 Barnes expanded his enterprise by opening an entertainment complex on ten acres of land across the lake at a place he named "Winnequah," purportedly an Indian word for "good water."

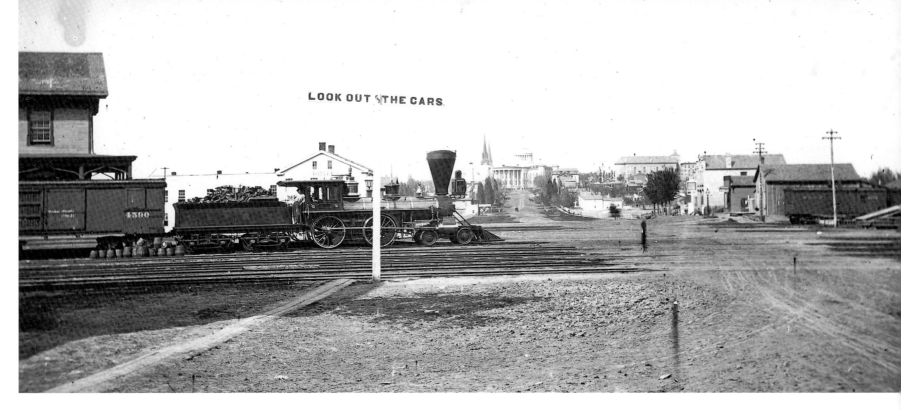

LOOK OUT THE CARS.

Tracks and Spires *(above)*

This photograph, taken between 1874 and 1879, shows an early stage of what grew into one of the twentieth century's most intractable problems — the trains and their tracks that blocked and disrupted West Washington Avenue. The spires of the Congregational and Grace Episcopal churches are visible in the distance, across the street from the Andrew Proudfit property. (WHi-11653)

Lakeshore Tracks and Angle Worm Station *(right)*

Captain Frank Barnes's Angle Worm boathouse at the Lake Monona foot of Carroll Street was one of the social centers in 1870s Madison, home to the sidewheeler steamboat *Scutanawbequon*, the fifty-foot-long *Scut II*, and other steamers with names that might have made sense to the Ho-Chunk who still lived along the lakeshore but not to anyone else. Landfill has since extended the dock line over three hundred feet for John Nolen Drive, Law Park, and the Monona Terrace Community and Convention Center. (WHi-11689)

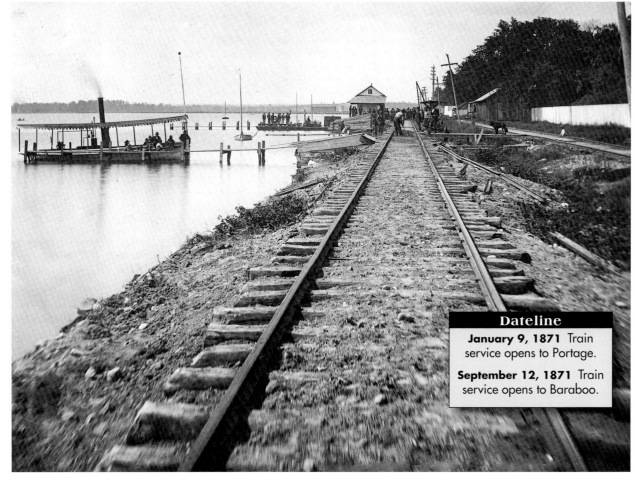

Dateline

January 9, 1871 Train service opens to Portage.

September 12, 1871 Train service opens to Baraboo.

Halle Steensland (1832–1910), a Norwegian goatherd, came to Madison in 1855 to work as a grocery clerk; in 1906, King Kaakon of Norway made him a Knight of the First Class of the Royal Order of St. Olaf. In the interval, Steensland was a founder, in 1871, of the Hekla Insurance Company, which became highly successful until shuttered after a dispute between Steensland and John A. Johnson; founded the Savings, Loan and Trust Company; and served as vice consul in Wisconsin for the then-combined Kingdom of Sweden and Norway from 1872 to 1905. In 1863 he bought 175 acres of farmland in what became Maple Bluff, living there from 1872 until 1892. Steensland's farmhouse, later owned by Robert La Follette and his heirs, is listed on the National Register of Historic Places; his in-town house at 315 North Carroll Street, later the Bethel Parish Shoppe, is a Madison Landmark. The longest-serving member of the board of the Madison Park and Pleasure Drive Association, Steensland for years transplanted maple, linden, and elm trees to city streets and in 1905 donated $10,000 for a stately stone bridge across the Yahara River at East Washington Avenue. He also actively advanced park interests as a progressive Republican alderman from 1906 until his death.

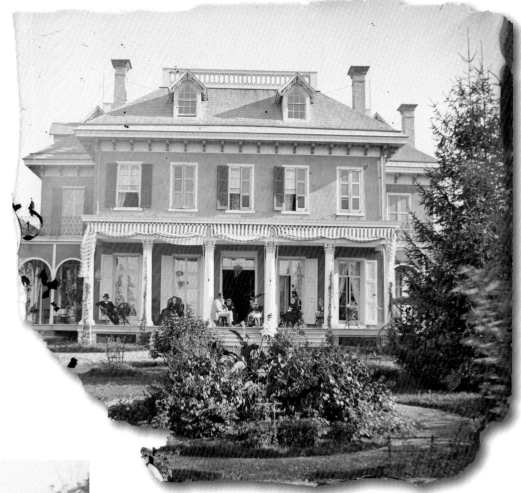

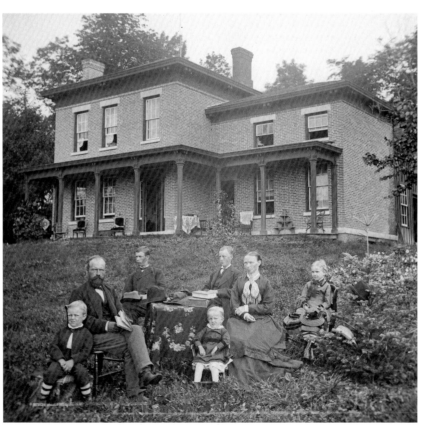

Governor Washburn and Family, Edgewood Villa, ca. 1875 *(above)*

Former governor Cadwallader C. Washburn (left) and family on the piazza of Edgewood Villa. Three governors were involved with this splendid colonial mansion and its accompanying fifty-five acres on Lake Wingra. While in office in 1853, Governor Leonard J. Farwell sold the land for the development of the estate, which Washburn bought while in office in 1873 from pioneer banker Samuel Marshall. As he was dying in 1880, Washburn offered the property to the city, state, and university; seventeen years before extension of streetcar service, they all declined because of its distance from downtown. So in May 1881 Washburn gave it all to the Sinsinawa Dominican Sisters, who had been operating the St. Regina Academy parish school downtown on lots donated by Madison founder and former governor James Duane Doty. The new St. Regina Academy at Edgewood Villa opened on September 5, 1881, with eight Dominican sisters and sixteen students, a milestone in Madison's educational, physical, and cultural development. The villa burned to its foundation on November 16, 1893, killing three young students. (WHi-1825)

Halle Steensland and Family, ca. 1875 *(left)*

Industrialist and diplomat Halle Steensland, wife Soave (Sophia), and children (left to right, Morton, Henry, Edward, Halbert, and Helen) at the Maple Bluff farmhouse that later would be home to the Robert and Belle La Follette family. (WHi-27029)

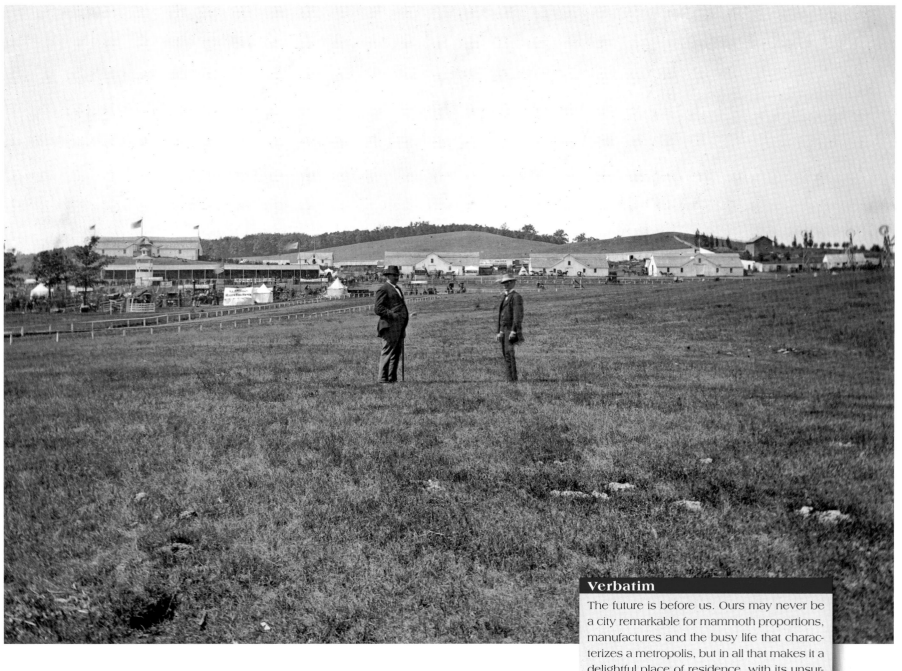

Across Camp Randall to University Heights, September 10, 1875

Two men out standing in the field of the state fairgrounds and former military encampment, with Breese Stevens's farm in the distance. In April 1893 the fairgrounds were given to the university for an athletic and drill field and the farm was platted as University Heights.

(WHi-27137)

The 1880s

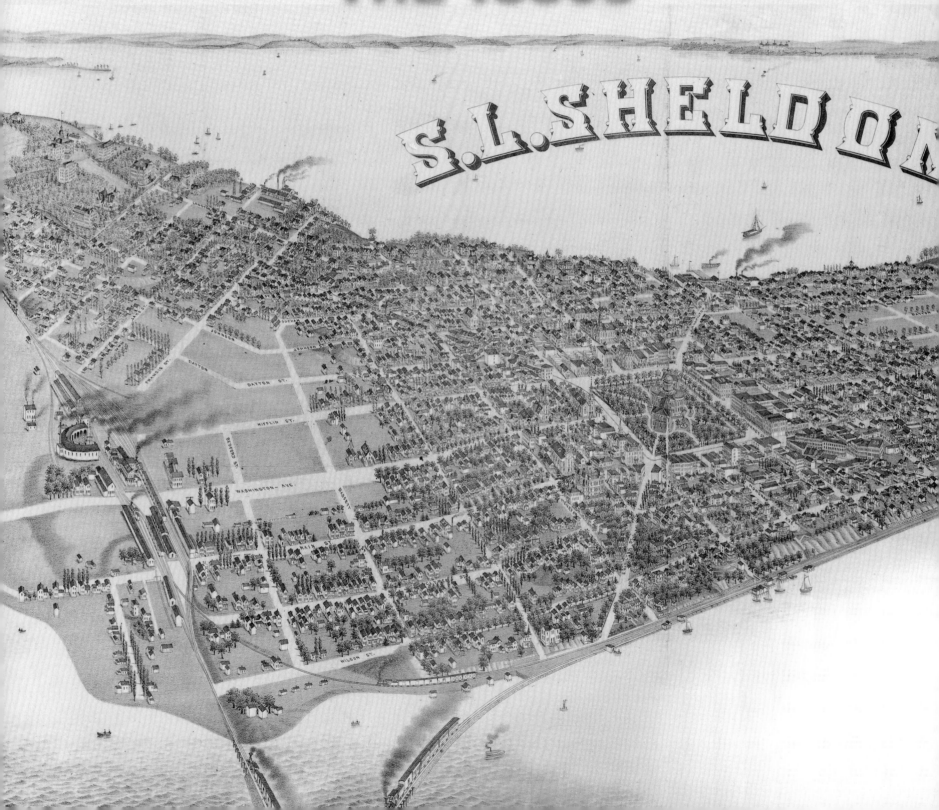

Sheldon Bird's-Eye, 1885

This aerial illustration shows how the city developed since the 1867 and 1871 bird's-eyes on pages 55 and 65, how it didn't, and how those changes were captured or not. Capitol Park properly boasts the ceremonial iron fence and landscaping of 1872 and the centennial fountain at the Monona Avenue entrance, though the rendering of the capitol itself shows no sign of the construction tragedy of 1883 (page 92). The Stephen V. Shipman hat trick — the Park Hotel, the post office, and the Mason-Baker block, all from 1871 — is finally commemorated. The 1874 Congregational Church has joined Grace Episcopal on West Washington Avenue, the Methodists have moved from their 1850 church on Pinckney and Mifflin streets to an impressive structure on the corner of Wisconsin Avenue and Dayton Street, and St. Raphael's is finally accurately portrayed with its steeple. However, the Dane County Courthouse, shown across Main Street, was actually still under construction at this time and would not open until October 1886.

Moving out from Capitol Park, most of the city hall block of West Mifflin Street is used as a lumberyard, as it would be until the opening there of the Fuller Opera House in 1890. Private boathouses and shanties dot the shoreline, the first sign of a controversy that would rage for decades. The east-side railroad depots, which served the city's daily traffic of forty trains on six lines, would soon be replaced by newer ones: the Milwaukee Road depot in 1885 and the Chicago and North Western in 1886, joined across town in 1888 by the new Illinois Central depot on the southwest corner of West Washington and Bedford (page 102).

Three new university buildings appear — two at the base of College Hill and one at its crown. The 1880 Assembly (Music) Hall, at State and Park, and the 1882 Washburn Observatory are still in use, but the first Science Hall, at the foot of Langdon, burned while this illustration was being prepared. This is the first representation of the 1874 high school at 210 Wisconsin Avenue and the best early bird's-eye of Frank Lloyd Wright's Second Ward School (the curious cupola at 720 East Gorham Street) and the Fourth Ward (Doty) School at the corner of West Wilson and Broom streets on Lake Monona.

The natural limitations of the land still constrained development to the east and west. Because of the pond-like conditions that gave the corner of Dayton and Bedford streets the moniker "Bog Hollow," there is nothing other than railroad-related development west of Bassett and north of West Washington, and very little west of Broom. The odd angles that the University Addition of 1850 introduced to the street grid can be seen by tracing its eastern border, connecting Bedford to Gorham streets. The large cattail marshes on the east side are also undeveloped, and as the photograph on page 90 establishes, the actual tree plantings were far less tidy than this illustration suggests. However, we do find an important and positive new industrial development just west of the Yahara River: the factory complex of Fuller and Johnson, soon to be joined in the immediate neighborhood by the Gisholt and Northern Electric plants. Other industrial developments were less positive: a second smokestack mars the North Hamilton axial from the capitol to Lake Monona and the E.W. Skinner foundry off Lake Street has grown into the Madison Manufacturing Company and been joined by the Lake City Tool Company, which was making Conrad Conradson's newly patented windmill.

This bird's-eye was a promotional piece for implements dealer and unsuccessful 1891 mayoral candidate Shepard L. Sheldon, whose $350,000 in annual sales throughout the Midwest and Great Plains made his business the city's biggest. Sheldon's showrooms along East Wilson Street were among those obstructing the King Street axial. (WHi-11431)

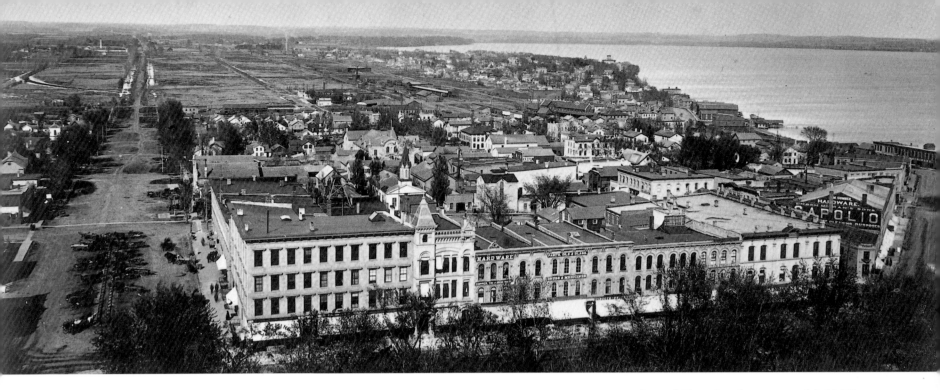

Great men strode Madison's stage in the 1880s, as two generations of leaders worked in ways that echo to our days. The first son of Madison's first great family brought national power and prestige to the hilltop above Lake Mendota. A student scientist caused a broad and vital improvement in public health. The city's longest political career waxed and waned, bringing unprecedented influence at four levels of government. A world-famous fighter for peace and justice began his public life by enforcing local law and order. And the world's greatest architect met a mentor, got his first break . . . and then skipped town.

Thanks to an extraordinary Norwegian inventor-salesman and a successful Yankee developer, the basic split in Madison's land-use and housing patterns was set this decade: the east side with a permanent factory base, the west side with the first suburban plat.

Powerful and legendary leaders — including a revered educator, our greatest advocate for parks and planning, and our most cherished politician — waged epic battles over alcohol regulation, with lasting impact on both city and university.

Twice this decade, a special institution opened on a special site. West of the city, a mansion for faith and education now shared grounds with effigy mounds. South, on the area's most venerable lakeside location for such pursuits, a complex for culture, education and recreation, also sectarian to start, later fully secular.

Near the roundhouse, a railroad milestone, while on the east side two new depots opened, with decidedly mixed results. Local mass transit began, powered by a beast of burden rather than the Iron Horse. It was an age of utilities, both public and private (but all east of the square). The skyline's most famous steeple was finally erected, a quarter-century after it was first pictured. And twice in fifty-six weeks, tragedy struck at either end of State Street — first with loss of life, then with loss of knowledge.

East Marsh and First Settlement, mid-1880s

This eastward view from the capitol dome clearly shows two of Madison's natural and self-imposed limitations. The vast open area starting at the base of the East Washington Avenue hill is the east marsh, low-lying wetlands that would require five hundred tons of sand and fill over the next thirty years before it could be fully developed. The lighter areas that look like wide sidewalks are actually water-filled ditches that John Nolen would photograph in 1910. The self-imposed hardship is on the right edge of the picture, the row of industrial buildings that blocks the view down King Street. Important village-era structures include the 1853 Bruen (by now, Brown's) Block at East Washington Avenue and South Pinckney Street, and the 1854 Farwell mansion, the large building with cupola on the waterfront near the top of the picture. The turreted building to the right of Brown's is the State Bank Building, 7 South Pinckney, where Wright worked as an office assistant to Allan Darst Conover. Behind Brown's block is the firehouse (the building with the rooftop contraption); the steeple across Webster Street marks the Lutheran Church. The squat building with the curved roof on Butler Street past the church is the Turnerhalle, the center of German culture and entertainment. The dark objects on East Washington Avenue are farmer's wagons, moved from the square after the state installed the iron fence around Capitol Park in 1872. The long, low building at the start of the rail corridor through the open area is the Chicago and North Western depot near South Blair Street, from where Frank Lloyd Wright departed in 1887.
(WHi-9825)

90

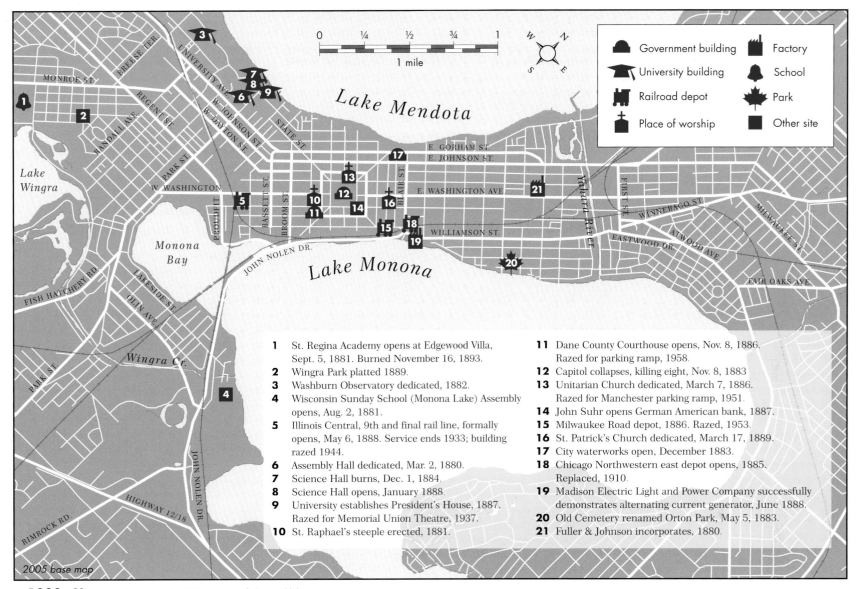

1880s Map (map by David Michael Miller, courtesy of Isthmus Publishing Co.)

1 St. Regina Academy opens at Edgewood Villa, Sept. 5, 1881. Burned November 16, 1893.
2 Wingra Park platted 1889.
3 Washburn Observatory dedicated, 1882.
4 Wisconsin Sunday School (Monona Lake) Assembly opens, Aug. 2, 1881.
5 Illinois Central, 9th and final rail line, formally opens, May 6, 1888. Service ends 1933; building razed 1944.
6 Assembly Hall dedicated, Mar. 2, 1880.
7 Science Hall burns, Dec. 1, 1884.
8 Science Hall opens, January 1888.
9 University establishes President's House, 1887. Razed for Memorial Union Theatre, 1937.
10 St. Raphael's steeple erected, 1881.
11 Dane County Courthouse opens, Nov. 8, 1886. Razed for parking ramp, 1958.
12 Capitol collapses, killing eight, Nov. 8, 1883
13 Unitarian Church dedicated, March 7, 1886. Razed for Manchester parking ramp, 1951.
14 John Suhr opens German American bank, 1887.
15 Milwaukee Road depot, 1886. Razed, 1953.
16 St. Patrick's Church dedicated, March 17, 1889.
17 City waterworks open, December 1883.
18 Chicago Northwestern east depot opens, 1885. Replaced, 1910.
19 Madison Electric Light and Power Company successfully demonstrates alternating current generator, June 1888.
20 Old Cemetery renamed Orton Park, May 5, 1883.
21 Fuller & Johnson incorporates, 1880.

Births and Deaths

1880 Census: 10,342

Births this decade included Madison's second great parks advocate, most important journalist, most significant realtor, the mayor with the longest continuous service, a scientist with the public spirit, and a pharmacist/politician.

- Michael B. Olbrich (1881–1929), founder of Madison Parks Foundation, regent
- William T. Evjue (1882–1970), founder of *The Capital Times*
- Paul R. Stark (1884–1945), realtor
- James R. Law (1885–1952), architect, mayor
- Harry Steenbock (1886–1967), scientist, Wisconsin Alumni Research Foundation
- Oscar Rennebohm (1889–1968), pharmacist, governor

Deaths this decade included four early mayors (one by his own hand), two men who brought diversity to the isthmus, and the man most responsible for our early development.

- William Noland (1807–1880), entrepreneur, mayoral candidate
- James B. Bowen (1815–1881), physician, mayor
- Andrew Proudfit (1820–1883), industrialist, mayor
- Alden Sanborn (1820–1885), mayor, jurist
- Samuel Klauber (1823–1887), businessman, civic leader
- David Atwood (1815–1889), founder of *Wisconsin State Journal*, mayor
- Leonard Farwell (1819–1889), governor, developer

Capitol Collapse, November 8, 1883

Barely a decade after completion of the second capitol in 1869, the state was once again short of office space. In the spring of 1882, the legislature appropriated $200,000 and created a commission — which included Madison men Boss Keyes and N. B. Van Slyke — to oversee construction of four-story extensions of the north and south wings.

But the first round of bids far exceeded the budget, and the rebidding was no more successful. Finally, after the commission slashed the plans by local architect D. R. Jones, a third bid was successful and construction began. By the summer of 1883 the north wing was complete and the south well enough along there seemed to be no problem with the January 1, 1884, deadline. Then, disaster.

It was twenty minutes to two on Thursday afternoon, November 8. The crew of about forty had finished lunch and was back at work on the south wing's center section. Suddenly, a strange crackling sound sliced through the fall air, growing louder and more fierce, its rumble becoming a roar as it rose in pitch and power. Then the terrible climax of a deafening crash as the roof caved in and collapsed all the way to the basement. For a moment there was an ominous silence, as a massive cloud of dust obscured the carnage beneath the rubble. Then came the anguished cries of the injured, their broken and bloodied bodies strewn through the wreckage. Rescue efforts began at once, with makeshift medical facilities put up in several state offices. Four men lay dead and a fifth succumbed a few hours later; another twenty were seriously injured.

Among those who rushed to the scene — just to watch, not help — was sixteen-year-old Frank Wright, a junior at Madison High School a block off the square. In his vivid, third-person account, the self-proclaimed "incipient architect" watched the bloody scene for hours, "too heartsick to go away," then "went home — ill" and replayed the tragedy in repeated nightmares. "The horror of that scene has never entirely left his consciousness and remains to prompt him to this day," Wright wrote, possibly accounting for his practice of aggressively supervising contractors.

State and local authorities immediately began separate investigations. Governor Jeremiah Rusk appointed a committee of non-Wisconsin architects and builders; within a week of the disaster, it issued an eight-page handwritten report blaming substandard materials, primarily the cast iron columns. Dane County, meanwhile, convened a formal coroner's inquest to consider individual responsibility. The inquest jury, which included Allan Conover, stationer James Moseley, banker Lucien Hanks, and liveryman Frank Dorn, heard ten days of testimony and evidence presented by District Attorney Robert M. La Follette. After deliberating all night, it cast blame far more broadly than did the governor's committee.

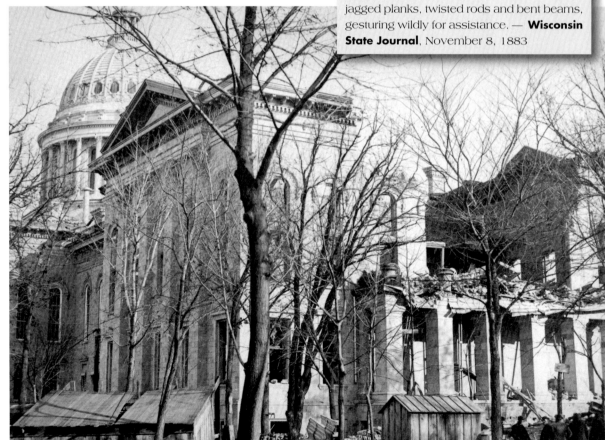

Aftermath of disaster (WHi-5021)

La Follette's Courthouse, ca. 1868 *(right)*

The three-story stone building at center with cupola and columns is the first Dane County Courthouse, where Robert M. La Follette began his public service as district attorney in 1880. Erected in 1851, the building was closed May 5, 1884, six months before La Follette's election to Congress; this view is from about the midpoint of the building's life. It was here that La Follette conducted the coroner's inquest into the capitol collapse in November 1883. By that time, it was the last government building dating to the village decade, in a setting far more metropolitan than it (page 104). Although the 1864 Chicago and North Western tracks are only faintly visible, coming toward the Fourth Ward School to the left of the courthouse, this may be the first photograph of the world's only midwater railroad crossing. (WHi-8701)

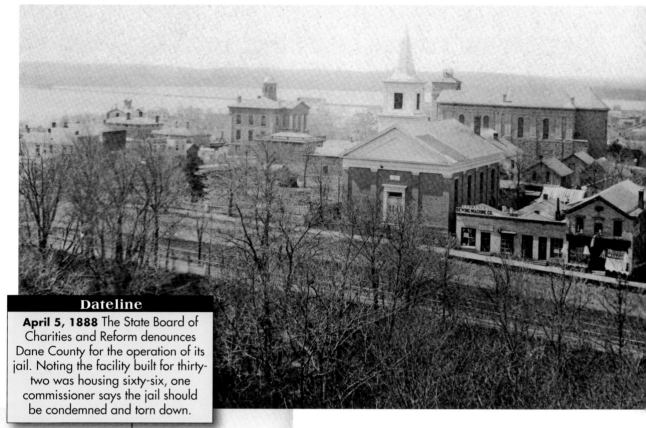

Dateline
April 5, 1888 The State Board of Charities and Reform denounces Dane County for the operation of its jail. Noting the facility built for thirty-two was housing sixty-six, one commissioner says the jail should be condemned and torn down.

Dateline
Spring, 1885 Belle Case La Follette becomes first female graduate of university law school.

Second Dane County Courthouse *(left)*

The second Dane County Courthouse, in the Richardson Romanesque design, shortly before it was razed for a parking lot in 1956. Because architect Henry Koch was too busy with his Milwaukee practice, the county in 1884 hired engineering professor Allan Conover as supervising architect; among Conover's office crew was eighteen-year-old Frank Lincoln Wright. About the time of the building's completion in October 1886, Wright adopted the middle name "Lloyd," reflecting his mother's side of the family. Koch also designed the new Science Hall, again presenting opportunities for Conover and Wright (page 99). (WHi-26221)

Dateline
November 2, 1880 Robert M. La Follette, 25, elected Dane County District Attorney.

May 5, 1884 Former mayors Pinney, Orton, and Keyes (the first two, respectively, a future and current supreme court justice) and former governor Lucius Fairchild are among speakers at ceremonies to mark closing of first Dane County Courthouse.

Madison Mayor

Breese J. Stevens (1834–1903) was a leader in Madison's Gilded Age, an elegant and well-connected man with influence and taste who left a great neighborhood, a landmark house, a stronger university, and a prominent ball field. But as Madison's twentieth mayor (1884–85), he became entwined in a conflict of interest and eventually chose corporate interests over his civic duty.

A descendent of seventeenth-century colonialists and Eastern gentry — his mother's favorite cousin was Samuel Finley Breese Morse, inventor of the telegraph — Stevens was sent to Madison in 1856 to oversee the investments of his uncle, Sidney Breese, and other kinsmen. The energetic young attorney, with two degrees from Hamilton College, soon assumed high standing in the local bar, representing myriad corporate interests, especially railroads. He was also personally involved; his directorships included the First National Bank of Madison and Consumers Gas Company, and he was president of the Madison Land and Lumber and Monona Land companies. "His capitalistic interests were large, varied and important and he was distinctively a man of affairs," a 1903 newspaper remembrance noted. Stevens also was an influential university regent from 1891 until his death, deeply involved in the recruitment of Charles Kendall Adams as president in 1892.

Like another mayor, Robert Bashford, Stevens married a daughter of industrialist Morris E. Fuller, and like Bashford's, his first marriage ended in tragedy, when Emma Curtiss Fuller Stevens died a week after giving birth to daughter Amelia in 1870. In 1876 Stevens married philanthropist and activist Mary Elizabeth Farmer, who as member of the Forest Hill Cemetery Commission funded the streetcar waiting house (now the cemetery office). The Stevens House at 401 North Carroll Street, previously the home of attorney, parks philanthropist, and gadfly Daniel K. Tenney, is a Madison Landmark.

It was when Stevens was both utility executive and mayor in 1884 that his corporate and civic lives clashed. On December 5, 1883, a company started by inventor Charles Van Doeple successfully demonstrated electric lights on the Capitol Square. Intrigued, the common council created a special committee to investigate switching from gas lights to electric. And after the Edison Light Company and its local agent — the former owner of Stevens's house, D. K. Tenney — made a presentation the following March 12 on a competing system that was already being installed in Baraboo, it seemed all the city had to do was choose which electric service to take.

But the next month Stevens, who also was the president of the Madison Gas Light and Coke Company, was elected Madison's twentieth mayor. Rather than risk losing the company's large contract providing the gas for city lights, Stevens simply refused to reappoint the special committee. Thanks to Stevens, electricity wouldn't come to Madison until 1888 — and even then, he would still be acting in corporate self-interest (see page 101).

In April 1893 Stevens sold the 106-acre farm he had owned since his arrival in Madison for $106,000 to a group headed by William T. Fish for developing the exclusive new University Heights suburb. At the same time, the state was acquiring from Stevens's brother-in-law Bashford and others the fifty-three-acre fairgrounds immediately to the east for an athletic field, a deal consummated the day after the University Heights Company was organized. Stevens, both a regent and one of the new company's directors, named the street marking the boundary between the two parcels in his family's honor (although several contemporaneous official plats spell the street "Breeze"; see page 196).

Stevens died in 1903 after a long illness. His honorary pallbearers included Charles Van Hise, former U.S. senator Vilas, State Supreme Court Chief Justice J.B. Cassoday, and Elisha W. Keyes. In 1923 Mary Farmer Stevens sold the entire northern 900 block of East Washington Avenue to the city for an athletic field, which was named in her late husband's honor.

Breese J. Stevens, an elegant industrialist (University of Wisconsin Archives)

From Bascom to Breese

John Bascom autographed this copy of his 1885 baccalaureate address for Breese Stevens, who had just finished his term as mayor. (WHi-36013)

Verbatim

Descended from a line of aristocrats, he looked it, he felt it, he was it; but noblesse oblige! Many with ancestry and wealth and authority back of them, yet need some badge — a front seat or a title perhaps to assert these things. The gentleman was so obvious in Breese Stevens that it needed no vindication. Many men, to hold their prominence, must study their company and avoid situations that will impair their dignity. Mr. Stevens dignified his situations. His position was assured by virtue of himself.
— **Wisconsin State Journal**, October 28, 1903

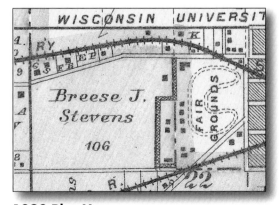

1890 Plat Map

The 106-acre Breese Stevens farm, soon to become University Heights, was roughly twice the size of the once and future Camp Randall (detail from WHi-37379)

Madison Mayor

Hiram Moulton (1818–99) was a carpenter, contractor, and farmer who came to Madison in 1854. He built the Fifth Ward School at the corner of Park and Johnson streets in 1870 and the high school three years later; as the state carpenter, he worked on the north wing of the third capitol. Moulton decisively defeated Daniel Tenney to become Madison's twenty-first mayor in 1885.

Verbatim

I suggest that the ordinances for cleaning streets and sidewalks of rubbish, snow and ice should be more strictly enforced, in order that the money which ought to be applied to street improvement may not be frittered away in doing the work required by law to be done by and at the expense of private individuals.— **Mayor Hiram Moulton**, annual message, 1885

MayorMadison Mayor

James Conklin (1831–99), immigrant son of the university's first janitor, became the city's largest coal and ice dealer and a three-term mayor (1881–83, 1887–88). Conklin came to Madison with his Irish family in 1849; after a few years carrying the mail through southwest Wisconsin, he bought a team of horses and began to trade in wheat and coal, adding ice in 1873. He bought the ice-house on Lake Mendota in 1882, then another on Lake Monona. Conklin served six discontinuous terms on the council between 1866 and 1877, was city treasurer (1868), a member of the school board, a state senator, and mayor. Conklin supported Alderman Heim's successful effort for a municipal waterworks and was president of the enterprise after his first mayoral term ended. When he became mayor the second time he likely could have stayed in the office indefinitely had he not chosen to focus on his business interests. Ironically, one of those business interests did great damage to the city's visual appeal — the huge ice-house at the lakefront end of the North Hamilton Street axial. Still, the area later became known as Conklin Park after civic activist Joe Jackson persuaded the city in 1939 to start buying land there for an auditorium. In 1963 the council renamed the site James Madison Park, again at Jackson's urging, and the historic link between Conklin and the land was lost.

Madison Mayor

Philip L. Spooner Jr. (1847–1918), Madison's first bachelor mayor (1880–81), came with his family from Indiana in 1859. After graduating from the university, he entered the insurance business and served as Wisconsin's first insurance commissioner (1878–87). As principal stockholder of the Madison Traction Company, Spooner in 1901 led a failed attempt to establish transit service between Madison and Janesville. Younger brother of the powerful U.S. Senator John C. Spooner, a leader of the anti-Progressive Stalwart faction, Spooner advocated for a greater manufacturing base. In 1905 Spooner donated land on West Gilman Street to the Woman's Club for its headquarters.

Madison Mayor

Moses Ransom Doyon (1845–1933) was a businessman with varied interests and unexceptional accomplishments around the state. He came to Madison at age thirty-five and became vice president of Capital City Bank, owner of a lumber company, alderman, and school board member before being elected Madison's twenty-fourth mayor in 1888. He was unopposed for reelection. The house at 752 East Gorham Street where he lived with wife Amalia Herrick from 1881 to 1902 stood as of the city's sesquicentennial.

Verbatim

I would call your special attention to the subject of manufacturing, concerning which so much has been said but so little accomplished. . . . While the location of the capital here is a desirable thing, and that of the state university still more desirable, it is doubtless true that the location and building up of manufacturing establishments is the only thing which will cause our city to grow much beyond its present proportions. I suggest that you take some steps to investigate and agitate the matter, that the advantages of Madison as a manufacturing center may be brought to the attention of manufacturers and capitalists. — **Mayor Philip L. Spooner**, annual message, 1880

Dateline

September 5, 1881 St. Regina Academy welcomes its first sixteen boarding and day students and eight Dominican sisters to Governor Washburn's Edgewood Villa.

April 1887 Common council composition changes from three aldermen for each of five wards to two aldermen for each of six wards.

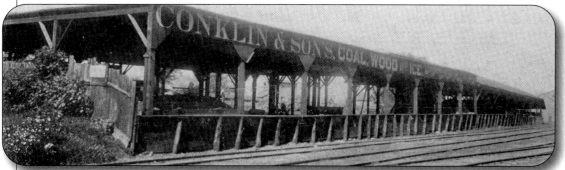

Conklin & Sons, ca. 1901

If it warmed you up or cooled you down, you could get it from Conklin and Sons. This is their coal, wood, and ice yard, 641 West Main Street, about two years after the death of Mayor Conklin. (WHi-34297)

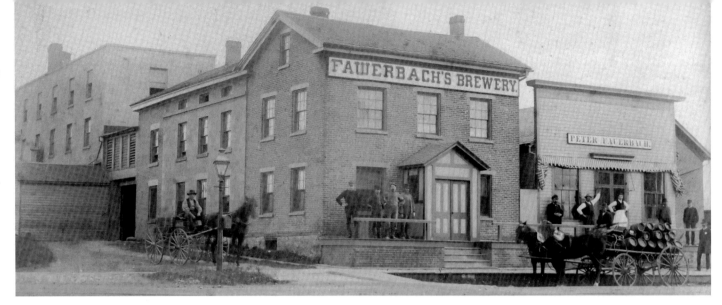

The Fauerbach Brewery, ca. 1880

Peter Fauerbach leased Adam Sprecher's 1848 brewery at the corner of Williamson and Blount streets, Madison's first, in 1868. He later purchased it and changed its name. (WHi-3056)

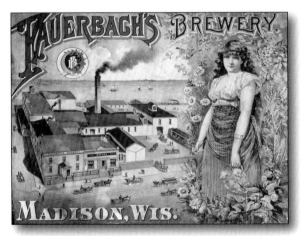

Fauerbach's Brewery Advertisement, ca.1884–92

This poster, originally in full-color, portrays the busy brewery and its attractive barmaid. The mule-drawn streetcar indicates the approximate publication date. (WHi-38009)

THE SUNDAY SALOON STRUGGLE

Through the early spring and summer of 1884, a time of rising prohibitionist power across the country, six of history's most important Madisonians — Robert M. La Follette, John Bascom, John Olin, Elisha W. Keyes, Daniel K. Tenney, and Breese Stevens — battled over booze and brews, a fierce fight that shut saloons on Sundays, cost Bascom and Olin their university jobs, and helped propel La Follette into Congress.

In March, Bascom and Olin formed the Law and Order League to force enforcement of a state law banning the sale of alcohol on Sunday. The president and his protégé were committed and prominent prohibitionists; the National Temperance Society had published Bascom's *Philosophy of Prohibition*, while Olin was only two years away from becoming the Prohibition Party's greatest statewide vote-getter ever. The league's plan was to hire private detectives to patronize bars breaking the Sabbath statute and then file complaints against them.

La Follette, then twenty-nine and in his second term as Dane County district attorney, was usually an aggressive prosecutor, but not of the Sunday statute; Olin even implied that La Follette's lack of success in closing saloons on Sunday had been a major cause for creating the Law and Order League. La Follette still considered Bascom an intellectual and moral mentor, but he did not share his former professor's intensity on this matter. An ambitious politician already eyeing a race for Congress that fall, La Follette knew that most Madisonians opposed strict enforcement of the Sunday closing law.

Once the league detectives began their investigations and prosecutions, saloonkeepers responded by forming — on St. Patrick's Day — the Personal Liberty Society. They pledged to bar from their bars minors and drunks and to restrain — but not end — the illegal Sunday sales.

Not good enough, said Bascom and Olin, who increased public pressure through frequent mass meetings in city hall and the State Assembly chambers. But these two dynamic orators were themselves sometimes stymied by another powerful presence — D. K. Tenney, who successfully filibustered the league's first meeting with a lengthy diversion on municipal reform. At a later meeting, Tenney became so worked up about the league's use of private detectives that he warned Olin to pack a pistol.

Bascom, worried about the damage Madison's reputation was having on the university's ability to attract students, turned to the mass media. In a March 25 letter published in the supportive *Wisconsin State Journal*, he denounced the city for creating "a most evil and disgraceful result" and declared that "Madison is not as safe a place as it might be, as it ought to be, for young men."

Dateline

December 2, 1886 At a suffragette convention featuring Bascom and Susan B. Anthony, John Olin accurately predicts prohibition would come before woman suffrage.

Dateline

August 13, 1886 Council rejects measure setting closing time for saloons.

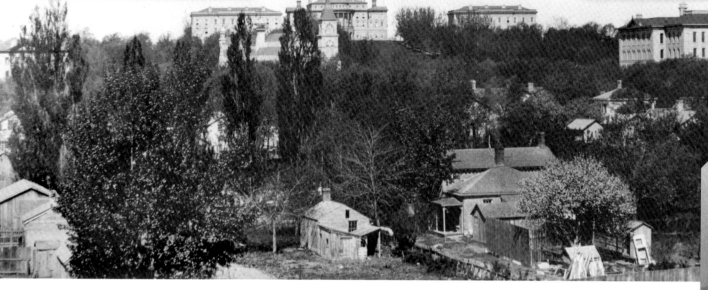

John Bascom late in his tenure as university president.
(University of Wisconsin Archives)

With the league, not La Follette, swearing out arrest warrants and assisting in the prosecution, seventeen saloonkeepers were convicted in a four-day period in early June. Ultimately, almost all the city's saloonkeepers would be charged; most would be convicted and fined $5 — the minimum amount.

The league pressed on, and its strategy proved successful on June 27, when saloonkeepers surrendered, agreeing to close on Sundays and pay the league $500 in costs.

The prohibitionists didn't accept victory gracefully, though. Olin later charged (probably accurately) that the council had "thrown its whole influence" against the league and that even Mayor Stevens, whom the league had endorsed in a tight election that April, had "refused" to do his duty. The prohibitionist provocateur had only slight praise for La Follette, who, he said, had "faithfully and energetically prosecuted the cases brought" but only "when called upon," and that fall Olin ran against La Follette for Congress as the Prohibition Party candidate.

It was the beginning of the end, though, for Bascom, as powerful regents disapproved of his "entangling alliances . . . in partisan politics." Preaching the Social Gospel and supporting women's suffrage and workers' rights caused the regents no concern, but his zealous and aggressive advocacy of prohibition did. Bascom and the regents also differed sharply over their respective roles in university administration, leaving Bascom with a special enemy — the most powerful regent of all, executive committee chair Boss Keyes.

Still smarting over Bascom's effort to block his appointment as regent in 1877, Keyes unleashed a direct assault on his administration at the regents' meeting of June 17, 1884. It took some time and a bit of deliberate miscommunication by the board, but Bascom was gone by 1887, replaced by a rising young geologist, Thomas Chamberlin.

Once again Olin was collateral damage. Welcomed back to campus as professor of law in 1885, he did not survive his mentor's ousting. But after passions cooled and his legal reputation grew, Olin rejoined the faculty in 1897.

Bascom, the university's most brilliant but least tactful president ever, did not go quietly. In an extraordinary 5,000-word farewell in the *Wisconsin Prohibitionist*, he denounced the regents' "slovenly, self-seeking political ways," declared that "the ignorance of the board is very great," and warned that because of the regents' gross mismanagement, Wisconsinites were "in danger of paying the price of a first class University and securing a second class one."

University of Wisconsin, 1880–84 *(top)*

The actuality of the idealized illustration on page 72, seen from about the corner of University Avenue and Murray Street. On the hill, South, Main (Bascom), and North halls; along Park Street, Ladies (Chadbourne), Assembly (Music), and Science halls. (University of Wisconsin Archives)

FIGHTING BOB AND THE BOSS

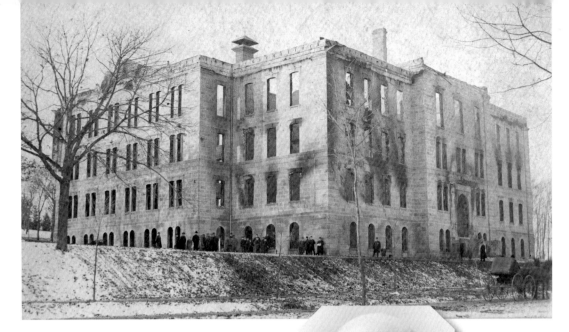

T he past and future of Republican politics in Madison and Wisconsin crossed paths in the 1880s in the persons of Elisha W. Keyes and Robert M. La Follette.

In 1880, when La Follette was six months out of law school, he ran for Keyes's old job of district attorney. La Follette later claimed Keyes imperiously rebuked him for being an upstart, which only caused his fire to burn brighter. While that sounds like Keyes, it is also possible that in 1880 his own career was a higher priority than some twenty-five-year-old running for district attorney.

Keyes himself was twenty-nine when he was elected district attorney in 1859 and in the 1880s he still held important offices, but he wasn't the kingmaker he once was. He couldn't control the legislature's selection of a U.S. senator in 1875, lost a bitter contest for the nomination in 1879, and was facing another stiff election fight (which he again lost) in 1881. Keyes had also been weakened after President Rutherford Hayes barred federal officials from partisan political activity in 1877 and he had chosen his postmastership over his party post. Despite La Follette's later claim, there's no evidence Keyes did anything overtly to block La Follette's entry into politics.

As district attorney, La Follette soon showed the crusading moralism of his intellectual men-

Robert M. La Follette, member of Congress, ca. 1885 (WHi-30279)

tor, John Bascom. He conducted trials ably from 1881 to 1885 and managed to discharge his duties in tavern matters without alienating the German and Irish blocs (John Olin's praise for his work for Sunday closings was of the faintest sort).

On the advice of his political mentor, General George E. Bryant, La Follette ran for Congress in 1884 and beat incumbent Democrat (and future supreme court justice) Burr Jones. Reelected in 1886 and 1888, La Follette was an energetic and earnest, if unexceptional, member of the U.S. House of Representatives. The Democratic tide of 1890 swept him out of office and back to Madison, where Keyes was still postmaster.

A powerful and controversial regent after 1877, Keyes ably represented Madison (and its university interests) in the State Assembly in 1882, but his election required him to quit his federal position (which he later regained). In 1886 Keyes was returned to the mayor's office he left in 1867, where he continued to press for public improvements. Never a wealthy man, Keyes had to accept appointment to the minor post of municipal judge in 1889, and remained as postmaster until his death in 1908 — a record of presidential appointment from the Lincoln administration through Theodore Roosevelt's. Keyes published a voluminous history of Dane County in 1906.

Keyes had four children (one of whom died in infancy) by three wives. His home at 102 East Gilman Street, now a Madison Landmark, was

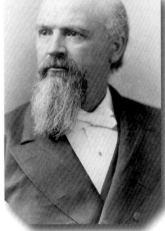

Elisha W. Keyes, ca. 1883

The postmaster and regent a few years before his third term as mayor. (WHi-33715)

built by pioneer Lansing Hoyt in 1853. For several years after Keyes's death the Attic Angels used the house as a nursing home. The Madison Community Co-Op bought the property for women's housing in 1980.

Dateline

November 4, 1884 La Follette defeats incumbent U. S. Representative Burr Jones by 495 votes, serving as an earnest if unexceptional member of Congress until his own unexpected defeat in 1890.

Fall 1887 Geologist Thomas Chamberlin, 44, succeeds Bascom as president of the University of Wisconsin.

December 30, 1888 State employee Captain A. E. Bauer, 60, shoots himself to death in his office in the capitol basement.

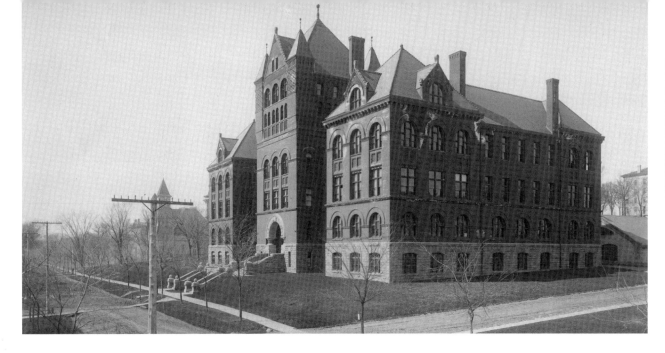

Frank Lloyd Wright, ca. 1885

The world's greatest architect as a teenager, about the time he went to work as an office assistant to Allan Darst Conover. (WHi-3403)

"A Majestic Ruin": Science Hall after the Fire of 1884 *(facing page)*

It was the best building on campus, an Italianate design of Madison sandstone that housed vast educational riches — books, devices, and a costly collection of rare curiosities. Then — for the second time in barely a year — disaster. It was about 8:30 on Monday night, December 1, 1884, when students returning from a military drill saw an odd and lurid light through the rear windows of Science Hall; it was a fire in the basement engine room, still small and easily contained. But as excited students flew around, the fire department was nowhere to be found. When the engine company finally arrived fifteen minutes later, it got no closer than two blocks away and then couldn't find a proper connection. It wasn't until shortly before 9 o'clock that the first water was thrown upon the blaze, by this time beyond all control. Soon the structure was a raging, crackling mass of flames, as floors collapsed and chemicals and cartridges exploded in volleys. By midnight, the building was entirely gutted, with irreparable damage done; although students saved some items, the ten thousand specimens in Increase Lapham's geological collection were all lost, as were books, specimens and other belongings of professors Birge, Van Hise, Conover, and others. The fourth floor art gallery was also destroyed, including paintings of Lakes Mendota and Monona, exhibited to great acclaim at the Centennial Exposition in 1876. (University of Wisconsin Archives)

Science Hall, ca. 1892 *(above)*

Even when they should have been working together, Bascom and Keyes battled. After Science Hall burned, everyone wanted its successor to be fully fireproof. At a cost of $285,000, it was. But it was also so far over budget that the legislature investigated. Bascom disavowed responsibility and said the building was larger and more expensive than necessary, but Keyes defiantly declared the regents "were not tied down" to the approved appropriation but should spend whatever they felt necessary. A "monstrous perversion of the law," legislators cried, denouncing the regents for their "carelessness and negligence," before providing the funds needed to open the building — five stories of red brick in the Romanesque style, topped with gables and a slate roof — in January 1888. The oldest existing structural steel building on an American campus, and possibly the first, Science Hall received National Landmark status in 1974. Engineering professor Alan Darst Conover was construction superintendent; among his crew was sophomore Frank Lloyd Wright, sent scrambling one winter's day over icy, open lattice to fix steel clips atop the main tower roof. (University of Wisconsin Archives)

Dateline

Early 1887 In debt and facing unemployment due to the Science Hall cost overruns, Wright secretly pawns his father's most valuable books and hops a train for Chicago.

Madison Notable

Allan Darst Conover (1854–1929) was one of the few architects or teachers whom Frank Lloyd Wright respected. The native Madisonian graduated from the university and taught civil engineering there from 1875 to 1890; as city engineer (1881–84) he prepared the city's first sensible sewerage plan, but the council balked at its expense. Conover was architect or superintending engineer on numerous campus projects, including the Armory and Science Hall. Conover's father, Obadiah, a professor of ancient languages and the third member of the university faculty, was removed in an 1858 reorganization after a clash with President John Lathrop. Conover's mother, Julia Darst, died when he was nine. Sarah Fairchild Dean, daughter of the first mayor and sister of the three-term governor, became Conover's stepmother when his father remarried late in life.

Madison Notable

McClellan Dodge (1862–1956) platted two important, but quite different, west-side neighborhoods while serving as city engineer. Dodge graduated from the University of Wisconsin in 1884, was named city engineer in 1887, and later elected county surveyor. He designed the grid-based Wingra Park in 1889 and the curvilinear University Heights in 1893.

John Johnson Creates the Industrial East Side

Madison's industrial east side was born in the 1880s, thanks largely to the efforts of Norwegian immigrant John A. Johnson, one of the country's most progressive and successful industrialists.

Johnson joined the farm implement company of Fuller and Williams as a salesman in 1869, and was so honest and successful that in 1873 he was made a partner. In January 1880 Johnson and Morris E. Fuller bought out the small Madison Plow Company and assumed the empty Garnhart factory at Dickinson Street and East Washington Avenue; by 1882 the Fuller and Johnson Manufacturing Company was capitalized at $200,000 and was Madison's largest private employer.

Fuller's distribution skills and Johnson's knowledge of customer needs helped the company grow rapidly; by 1897, it had more than 2,000 products, led by the formidable Bonanza Prairie Breaker. Two years later, the $1.5 million company had more than four hundred workers in its 40,000-square foot factory, with annual sales around the world of more than $1 million. Johnson didn't just help create the industrial east side — he helped make Madison an important part of the global economy.

Yet even as Johnson was helping lead one company, he was creating another — the Gisholt Machine Company, which he founded in 1885 to manufacture machine tools and named after an aunt's Norwegian farm. Incorporated in 1889, the company weathered difficult days before turning the corner in the mid-1890s. Gisholt designs won medals at the 1893 Columbian Exhibition in Chicago and the 1900 World's Fair in Paris, and Johnson was later named to the Wisconsin Industrial Hall of Fame.

Johnson also made Gisholt a model workplace — the factory he built in the 1200 block of East Washington Avenue in 1899 included a library and auditorium for workers and free kindergarten for their children. He was also one of the first employers in the country to start a profit-sharing plan (although it was limited to supervisors).

Johnson's success did not please all community leaders, many of whom saw Madison's future resting on tourism, government, and the university, without a significant industrial base. The council rejected Johnson's initial efforts to vacate a street for plant expansion, and even the Madison Businessmen's Association rebuffed his request for financial support during Gisholt's start-up.

By locating his plants where he did, Johnson had a major impact on two aspects of land-use development. The east side became the base of industrial activity, the basis of the Madison Compromise (factories east, faculty west). And his large and growing force of educated and well-paid employees — over six hundred workers at the turn of the century — caused the Marquette and Tenney-Lapham neighborhoods to grow far faster than the city average.

Madison Notable

John Anders Johnson (1832–1901) was not just the wellspring of Madison's manufacturing base and one of the country's most progressive industrialists. He also applied his considerable energy and talents to journalism, politics, religion, education, and insurance. He was instrumental (with Halle Steensland) in forming the Hekla Insurance Company in 1871, successfully leading it through the bad economic times of 1873 to 1880. From 1872 to 1876, Johnson was part owner of the country's largest and most influential Norwegian newspaper, the anti-slavery *Americka* (later, *Skandinaven*), and often offered essays on the importance of public schools.

John A. Johnson, progressive industrialist
(courtesy of David Mollenhoff)

Johnson's support for public schools also had great impact on worship in Madison. In the late 1860s, his Norwegian Lutheran Synod was split between conservatives who demanded that Norwegian children attend Norwegian-language Lutheran schools and liberals who favored American schools with religion kept in the church. Johnson didn't just *agree* with the liberals; he helped found their Evangelical Lutheran Immanuel Church. The church is now known as Bethel Lutheran Church, the second largest Lutheran church in the United States. Ironically, the Bethel Parish Shoppe is located in the North Carroll Street home of Johnson's estranged former partner, Halle Steensland.

Johnson also sparked creation of the country's first Department of Scandinavian Studies by an 1869 letter to university president Chadbourne suggesting his protégé Rasmus Anderson as the first instructor of Norwegian at an American college. After Anderson started in 1870, Johnson raised money to support the program. He also created an early scholarship program open to women.

Somehow, Johnson also found time to return to politics. Although he lost an 1868 assembly race, he won a seat in the State Senate in 1872. A week into his term, he authored a bill creating a three-member railroad commission, the model for the measure finally passed in 1904. He was also ahead of his time with a bank reform act that passed several years later. Johnson was successful in the crucial area of women's rights, securing passage of a measure letting married women own property and conduct business. He declined the Republican nomination for lieutenant governor in 1877 and the mayoral nomination of the Law and Order League in 1884.

In November 1900 Johnson undertook one last great act — making a $40,000 donation to Dane County for the Gisholt Home for the Aged, open to all without regard for nationality or religion. One stipulation — the five-member governing board had to include at least one woman.

Johnson died at his Wisconsin Avenue home on November 10, 1901. His honorary pallbearers included three men with wildly divergent politics — William F. Vilas, Elisha Keyes, and Robert M. La Follette.

THE UTILITIES ERA

The eighties were a decade of, by, and for utilities, both public and private. In Madison's first mayoral message in 1856, Jairus Fairchild declared that "water should be free, or so cheaply supplied as to be accessible to all." A quarter century later, the city acted to fulfill that pledge.

In the summer of 1880, University of Wisconsin senior Magnus Swenson devised purity tests showing sewage had contaminated most of Madison's thousand backyard wells, leading to high rates of diphtheria, typhus, and scarlet fever. The next spring, a Milwaukee firm and a New Jersey concern fronted by local super-heavyweights such as Simeon Mills, D. K. Tenney, William Vilas, and John A. Johnson submitted competing proposals for a private waterworks.

But then John Heim, a foreman at the Park Book Bindery, was elected to the council from the second ward (the western part of the modern Tenney-Lapham neighborhood) and started to fight for a municipal system. On May 14, 1881, barely six weeks after his election, Heim blocked a contract with the Milwaukee firm; on August 6 the council voted unanimously that "the city itself should own, operate, and control entirely so important a corporate safeguard as a water system," and created a special committee to seek necessary enabling legislation. Former mayor Elisha Keyes, now a state representative, pushed the measure through the following spring, and the city promptly issued the necessary contracts. In October the council acknowledged Heim's leadership by electing him the first waterworks superintendent.

The first substantial test of the city waterworks on December 5, 1883, was a complete triumph, and the waterworks went on-line. But soon it seemed the system would be too successful, as demand for cheap, clean water outpaced supply. So in May 1888 Heim decided to install water meters. Consumption dropped immediately and substantially, making Madison and Heim national models for municipalized systems. But for a self-imposed hiatus (1889–90), Heim served as superintendent until 1911, when he was elected mayor (see page 199).

But while water flowed, electricity faced static, thanks to Mayor Stevens's conflicts between his corporate and civic identities.

In a remarkable coincidence, the first demonstration by the Van Doeple Electric Light company was also on December 5, 1883, just hours after the waterworks test. It was equally successful, producing such a bright light along East Main Street that "the poor old moon seemed rayless and lifeless."

But the following spring, Stevens was elected mayor and killed the select study committee. The Madison Electric Light and Power Company built a small generating plant at the Hausman Brewery on State Street in 1885, and in 1886 the Monona Lake Assembly grounds were lit with arc lamps powered by a generator on the grounds. But there were no further efforts to provide electricity on a wide basis until 1888, when the Madison Electric Light and Power Company applied for a franchise.

The council granted Madison Electric a non-exclusive franchise on

Madison Notable

Magnus Swenson (1855–1936) was a brilliant scientist whose discoveries and inventions profoundly affected the industries and infrastructure of Madison and beyond, a Norwegian immigrant at age thirteen knighted by that country's king in 1912; his work on the city water system was only the start. Appointed city chemist, Swenson also taught chemistry at the university until 1883, perfected a new method of extracting sugar from sorghum, and with William Arnon Henry, founded the College of Agriculture. After inventing the Swenson Sugar Evaporator and building plants in three states — and also inventing an award-winning cotton baler and designing new methods for making soap — Swenson returned to Madison and founded the U.S. Sugar Company in 1906 (page 161). He later supervised construction of power dams on Wisconsin's rivers, joined various corporate boards, served as president of the university's Board of Regents for a decade, and advocated for food conservation. He served as federal food administrator for Wisconsin during World War I, and as director general for food supplies in northern Europe afterward. In December 1917, Swenson was the moving force behind the expulsion of Senator Robert La Follette from the Madison Club because of the senator's opposition to the war. Swenson and wife, Anna, also an 1880 university graduate and a member of the Woman's Club, lived on the west-side drive that bears his name.

Magnus Swenson, city chemist, 1882
(University of Wisconsin Archives)

April 13, and on June 10 the company began illuminating twenty-two new arc lights. The company was technologically savvy, and wisely installed an alternating current generator at its State Street plant. Later that month, MELPO became a major provider for street lighting — giving Madison Gas Light and Coke Company its first competition since its founding in 1855.

Whereupon the gas company cut its rates by more than a half, and asked for its own electricity franchise. Historic figures battled before the council on July 18, 1888 — beloved jurist Burr Jones for Madison Electric, pioneer banker/politico N. B. Van Slyke for Gas Light and Coke. The council, not looking fondly on the gas company's business history and understanding that such competition would soon result in a new and expanded monopoly, rejected its request. Madison would have competition between its gas and electricity providers — at least for a while.

As it explored the new technologies of the future, the council still had to grapple with that longstanding problem of the past — sewage. On April 18, 1885, the council adopted a modified version of city engineer John Nader's so-called district system of sewage, collecting and sending untreated human waste directly into the lakes. Unfortunately, the council cut the proposed purification plant for budgetary reasons, leaving the lakes a teeming mess of sewage, scum, and stench. At least the council did first adopt tenth ward alderman J. C. Gregory's motion banning the discharge of sewage directly into Monona Bay.

RAILROAD SKULLDUGGERY

Ever since the Chicago, Milwaukee and St. Paul Railroad opened the first line to Madison on May 22, 1854, the city had been assured that one day nine tracks would converge on the isthmus. As the Milwaukee Road added three more routes, and the Chicago and North Western opened another four after its arrival in 1864, number nine remained an elusive goal.

Finally, in 1886, the Chicago, Madison and Northern Railroad — later known as the Illinois Central — asked the council to approve a route through the city. Operating out of its normal region, the railroad quickly won approval for a west-side route, but it also wanted access to the industrial east side. With former mayor Breese Stevens as its attorney, the railroad in late September won council approval, 16-1, for a track along Lake Monona and past the existing east-side depots of the other railroads.

But then the political and physical clout of the established lines came into play. First, they persuaded the council in early October to rescind its initial approval and refer the matter back to committee. Then, about midnight on October 13, 1886, the Milwaukee Road got physical, sending seventy-five laborers out under cover of darkness to lay a rickety new track along the lakeshore from South Hamilton Street to the east-side depot. Company officials insisted the track was legal and on their property, but their purpose was as dark as the circumstances — to prevent the new Illinois Central from having access to the east-side industrial sites, by hemming it in. "A Deed of Darkness," the *Wisconsin State Journal* called it, explaining, "the general impression is that the new line was built to prevent the Chicago, Madison & Northern from running along the lakeshore between the St. Paul and North Western tracks." The paper was right, and the hastily constructed, poorly engineered track did just that. The CM & N didn't get sufficient support from local businessmen, the September ordinance didn't hold, and all the railroad could get was a track without access to the east-side industries. The council's offer was so worthless the railroad didn't even bother to pursue it, leaving its Madison activities to consist solely of passenger and freight stations on the west side.

The first Illinois Central train from Freeport to Madison arrived on February 2, 1888, with the formal opening of Madison's ninth and final railroad line on May 6. The Illinois Central passenger depot was on Bedford Street between West Washington Avenue and West Main Street, on the site later occupied by the Badger Bus depot. After the Illinois Central ended passenger service in 1933, it leased the depot to the City Car Company; in 1944 it razed the building. The brick freight house still stands across Washington Avenue, part of the U-Haul complex.

At least when the Milwaukee Road responded to the C & NW's new 1885 depot (facing page) with one of its own the following year, it did so with this cute Victorian Gothic (bottom) at the foot of South Franklin Street. Called "the little daisy," it was razed in 1953. The C & NW depot, just off South Blair Street, was replaced in 1910 by one not as grand as the railroad had planned (see page 203).

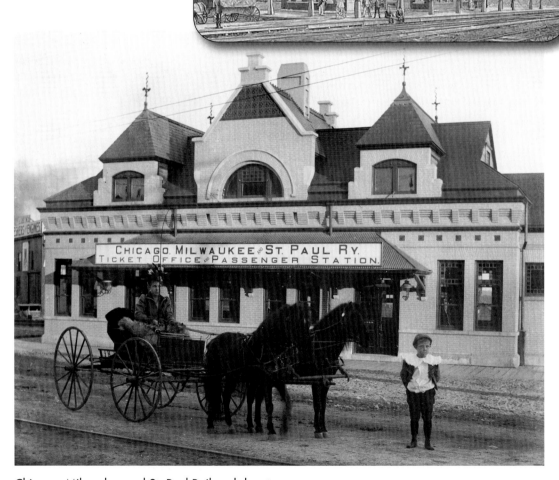

Chicago, Milwaukee and St. Paul Railroad depot (WHi-36082)
Inset: The Illinois Central Passenger depot (WHi-37800)

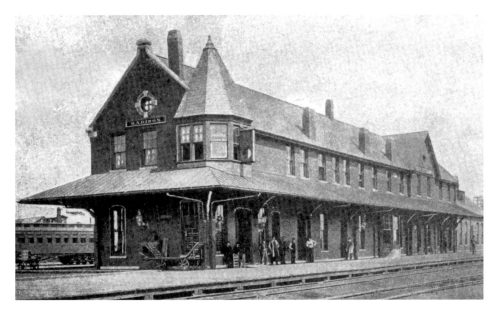

Chicago and North Western depot (WHi-32150)

Madison Notable

Henry Cullen Adams (1850–1906), a descendent of John Adams, was a dairyman, developer, and politician. A state representative in 1882 and 1885, Adams later served as superintendent of public property, state dairy and food commissioner, and member of the state agriculture board, and was active in pushing for pure food laws. Elected to the House of Representatives in 1902, Adams died while in office. Adams owned a large tract of land bordered by Monroe, Regent, Edgewood Avenue, and the Illinois Central tracks; West Lawn Avenue is named after the Adams farm. It was Adams who thought to turn the swampy, unsold lots in Wingra Park into public parkland.

Dateline

April 18, 1885 Council adopts city engineer John Nader's "district" plan to collect and send untreated sewage into Lakes Mendota and Monona.

Mule Team Mass Transit

Madison's mass transit system — of a sort — began on November 15, 1884, when the first fourteen-foot-long car left the Madison Street Railway depot on Williamson Street, two large white mules pulling the twenty-seater on four-by-six-inch pine tracks to the end of the line at Park Street and University Avenue. With former mayor Elisha W. Keyes at the fore as the nominal president (behind quiet Chicago investors with controlling interest), the cars were thrown from the track several times, a foreshadowing of problems to come. Patrons were on their honor to deposit the nickel fare, but not all did, so the company secretly padded revenue to create false profits and entice new investors. A consortium of such luminaries as D. K. Tenney, Burr Jones, and future mayor Robert Bashford bought the company; puzzled as to why they were losing four cents on each ride, they sold at a 25 percent loss in 1887. The new company extended service to the old state fairgrounds at Monroe and Warren streets, and east to Brearly, but cut back from fifty mules to twenty-six, pulling only six cars. Service continued to decline until 1892, when the council, after toying with revocation, awarded a new franchise for an electric streetcar to the Madison City Railway Company (see page 142). The last mule team ended its work on September 30, 1892.

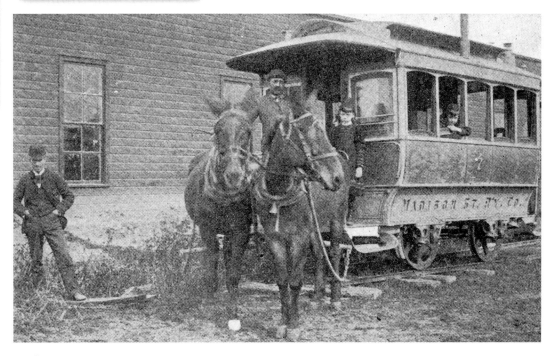

Mule Team Transit

Company superintendent George Shaw's daughters Aldythe and Emma pose with driver Tom Shipway. (Madison Public Library)

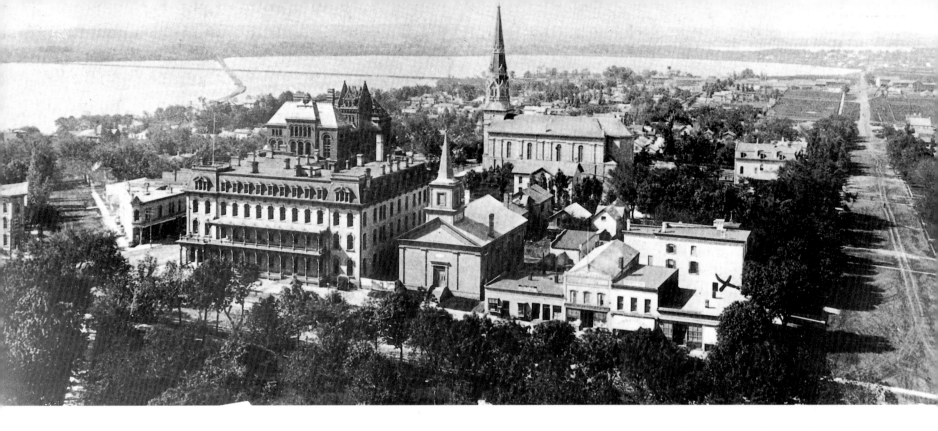

Capitol View to the Southwest

West Washington Avenue (right) and South Hamilton Street (left) are still unpaved in this photograph from the late 1880s, with the western cattail marsh beginning at about Bedford Street and running down to the railroad roundhouse. Of the four landmarks grouped together, only two remain, and in different forms. St. Raphael's Church (later Cathedral), was severely damaged by arson on March 14, 2005. The Park Hotel first lost its double veranda and mansard roof through a series of remodelings and in 1961 was razed for construction of the Park Motor Inn, retaining only the structural skeleton from a 1912 addition. The First Baptist Church on South Carroll Street, one of the finest in the village when it opened in 1854, was torn down in 1922. The Dane County Courthouse across from St. Raphael's was razed for a parking ramp in 1956. The dense trees at West Washington and Fairchild Street mark the Proudfit family homestead, residence of the city's ninth mayor and eventual site of the Hotel Loraine (and its successors, a state office building and upscale condominiums). The Smith and Lamb Block across West Main Street from the Park Hotel, built in 1876, is an extant Madison Landmark, home to a popular lounge. In the distance is the world's only midwater railroad crossing, far more fully developed in this photograph than in the view on page 93. (WHi-8712)

Angels from the Attic

When Elva Bryant, eldest daughter of General Edward E. Bryant, heard about twins of a local family so poor they weren't properly clothed, she and her sister Mary started sewing the necessary garments for these and other "unfortunates." Enlisting friends such as Ida Johnson and Mary Vilas, they soon moved from sewing to collecting family clothes from storage for wide distribution. As the girls came down one day in October 1889 with arms full of clothes, Bryant greeted them as the "attic angels." They liked the name. From that modest beginning, the Attic Angel Association grew into one of Madison's most successful and enduring nonprofit welfare agencies. Among its many accomplishments, the association raised money to build and furnish Madison General Hospital, created the Visiting Nurse Service in 1908, and established child health centers in city schools. An Attic Angel visiting nurse, Mary Saxton, was key in the creation of Neighborhood House in 1916. The association operated a small nursing home in the former Keyes House at 102 East Gorham Street from 1953 to 1963. It opened a 32-bed facility on North Segoe Road in May 1963, adding a 70-unit tower in July 1975 and a 120-bed complex on the far west side in 2003.

MONONA LAKE ASSEMBLY

From its opening on August 2, 1881, as the Wisconsin Sunday School Assembly and into the early twentieth century, the best merger of culture and community in Madison was the Monona Lake Assembly on the grounds of the former Lakeside House.

For more than twenty years Madison maintained the largest and most successful Chautauqua in the West, as a program to train Sunday school teachers grew into a more secular activity featuring recreational activities and renowned lecturers and political figures. The assembly bought the twenty-eight-acre grounds from pioneer Henry Turville for $3,000 in 1882 and constructed several buildings, including a 450-seat lecture hall in 1884 (designed by local architect David R. Jones, shortly before he was disgraced by the capitol collapse) and a 5,000-seat circular pavilion in 1885, which could also hold another 10,000 standees. In 1892, William McKinley drew 10,000, part of the season's record crowd of 50,000. Sometimes, programming outpaced the community; in 1900, a talented troupe of South African boys was booked to sing native Zulu songs but could not secure decent lodging in the city proper.

The railroads offered reduced excursion rates, and thousands came for the two-week program, filling the hotels and an extensive tent city on the grounds. An important component in Madison's growing tourist trade, the assembly started to decline after about twenty-five years, and some stockholders sought to sell for a housing subdivision. Litigation brought by John Olin and others stalled the sale until 1911, when the city issued $40,000 in bonds to buy the land outright — the first city purchase of parkland without outside assistance.

The city opened "Monona Park" in 1919, the first municipal campground east of the Rocky Mountains. Michael Olbrich and the Madison Parks Foundation revived the Chautauqua in 1922 with Senator La Follette as the headliner performing "Hamlet." In November 1923, the council renamed the area Olin Park. The former lecture hall was renovated and restored in 2000; as the Olin Park Pavilion, it remains the most popular shelter in the Madison parks system.

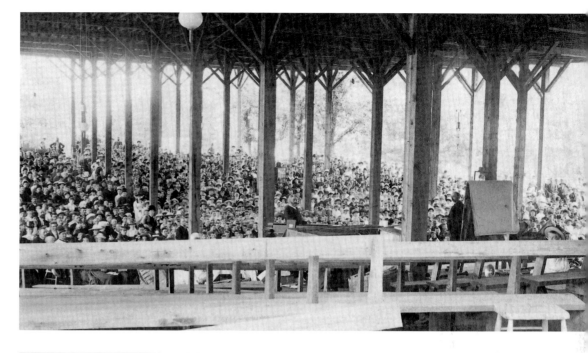

Main Hall, Monona Lake Assembly *(above)*

When John H. Findorff, Madison's first general contractor, built this unique five-thousand-seat circular auditorium in 1885, it was the largest auditorium of any kind in the state. (WHi-11247)

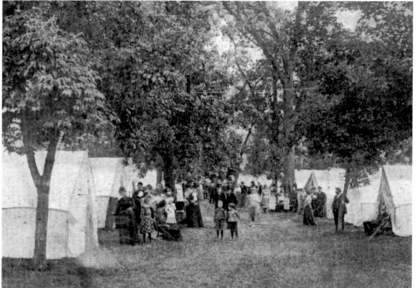

Monona Lake Assembly, tent city (Madison Public Library)

Verbatim

To thousands, especially the preachers, teachers, merchants, the bright minds of hundreds of communities in southern and western Wisconsin, Madison suggests first of all the "Lakeside Assembly." While many of these institutions are palpably private speculations of a real estate or trolley character, often short-lived, badly and sometimes discreditably managed, the Madison Chautauqua year after year puts up a two weeks' programme carefully arranged long in advance and furnishes entertainment, instruction, and inspiration to hundreds of families who come within the Lakeside enclosure on the shore of Third Lake.
— **Madison Past and Present**, 1902

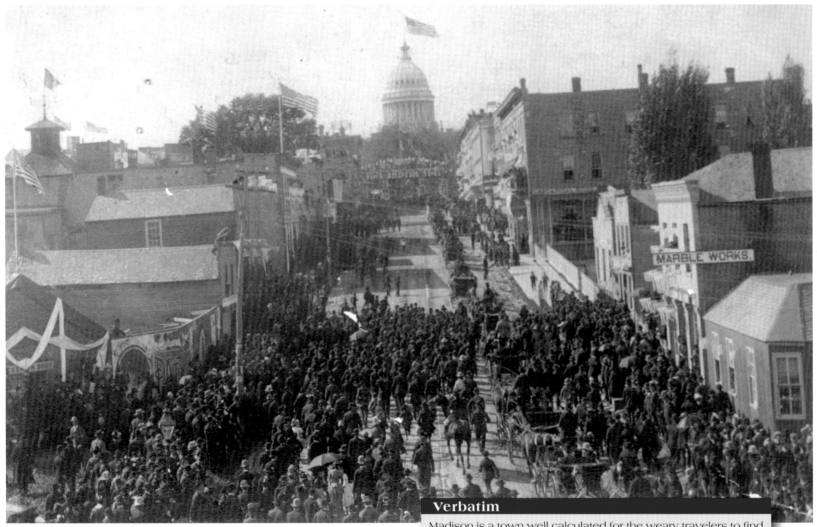

The President and the People

Hordes of well-wishes follow President and Mrs. Grover Cleveland up King Street after their arrival at the Chicago and North Western depot on October 7, 1887, for a three-day stay with Postmaster General William F. Vilas at his Gilman Street mansion. Up from the marble works is the venerable Capitol House hotel, and beyond that the Simeon Mills buildings from the village era. Breckheimer's Brewery is across from the Capitol House, and there's a roller skating rink on the corner of Clymer (Doty) Street, across from the Fess Hotel (neither visible). This same view, a decade later, appears on page 146. Among Mr. Cleveland's activities: several receptions and dinners, a few hours at the Dane County Fair, fishing by Maple Bluff, a concert by the German singing group Maennerchor, and services at Grace Episcopal Church. Although the chief executive had to curtail his handshaking duties, most of the twenty thousand visitors who crowded into town for a presidential peek seemed satisfied. (WHi-37376)

Verbatim

Madison is a town well calculated for the weary travelers to find some rest in. Like most capital cities, it has no business and can boast only of its pretty situation among half a dozen sheets of water. It is a little country town, pure and simple. Its good folks dine at midday and read the newspapers only as a source for fault-finding and general scandal. In the principal streets of the town, which have not changed their appearance in years, the people pass by slowly, quietly, and sedately. There is no sign of hurry or thought of change. To count the flagstones or the bricks in the sidewalks seems their whole duty. The store-keepers dawdle and yawn before their open stores. The old houses have the air of being bored. Nobody troubles himself about the time of day. If the town clock were to stop the citizens of Madison would never know the difference. Such is the city and the surroundings among which Postmaster-General Vilas was reared and to which he has invited the President. — **New York Tribune**, October 7, 1887. The liberal Republican newspaper, founded by early Madison booster Horace Greeley, was a consistent critic of Democratic President Grover Cleveland.

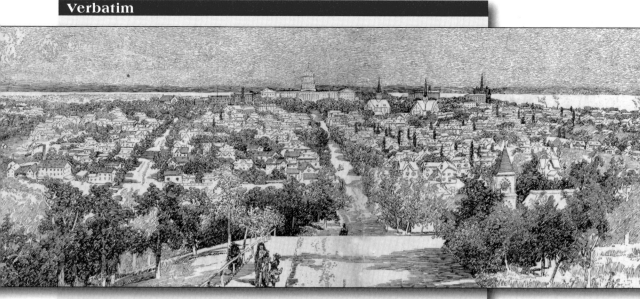

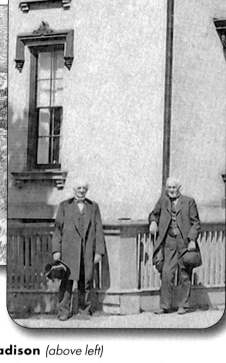

The chief charm of Madison in the eyes of the wayfarer is the harmony of her adjustment to nature. Had the Indian-fighting pioneers of Wisconsin been slower to realize the great scenic beauty of the peninsula between Lake Mendota and Lake Monona, had they neglected to locate the State capitol there when fifteen other places were stretching out ambitious hands for the prize, or had the city overgrown its site and marred the landscape with noisy streets and smoking chimneys, the present delicate tone of that harmony would never have existed. As it is, the size and character of the city fit the surroundings so perfectly that any change in the general scheme would almost necessarily be for the worse.

Madison's position toward nature has been unique from the first. She owes her existence, in fact, to the beauty of her lake scenery. In a time when civilization was hewing its slow and painful way into the gloomy Wisconsin forests, and when men's actions were dominated mainly by desire for commercial gain, the selection of the site solely by reason of its scenic charm was a significant prophecy of the capital's future character.

By her social character, together with her excellent educational advantages, Madison has attracted to herself many persons from all parts of Wisconsin, and even from neighboring states; by her natural beauty and her invigorating climate she has become a summer resort of more than local distinction. Any city that could build up a historical society of equal scope and completeness as that at Madison would assuredly gain a name for seriousness of purpose and solidity of character that only an old university town could hope to possess.

Madison can, of course, darken her skies with the smoke of countless furnaces, and cover her vacant lots with long rows of tenement houses, if she so wills it. It would be a great pity if she did so, however, for the industrial West can ill afford to sacrifice those shining qualities that have made Madison famous, for the paltry sake of a larger census return and the sale of a few acres of vacant land. Madison ought to be content with, as well as proud of, her present. She is rich and prosperous and cultured. Let her, then, exist for the sake of being beautiful. — **William W. Howard**, "The City of Madison," *Harper's Weekly*, March 30, 1889

General View of Madison (above left)

Harper's Weekly continued its promotional service to the city with this illustration and an accompanying essay. (WHi-23912)

Founders, Fifty Years On, June 10, 1887 (above)

Simeon Mills (right) and Darwin Clark (left), fifty years to the day after they arrived in Madison within hours of each other, in front of Mills's mansion at the corner of Monona Avenue and West Wilson Street. (WHi-36035)

Thinking Globally, Acting Locally

Two measures adopted by the council on July 2, 1886:

Resolution

"The spirit of the age is against injustice and oppression, and it is meet and proper that the national congress of the United States, the legislatures of the different states, and the common councils of the cities of the union, embrace every opportunity of showing their sympathy for those who are struggling for a larger measure of liberty, and endeavoring to throw off the yoke of bondage and oppression. We earnestly hope that in the coming contest to elect a new parliament, that those in favor of home rule in Ireland will secure a decided majority in favor of this measure, that its passage will be assured, at an early day, and that Ireland will once more take her place among the nations of the earth."

An Ordinance

"An ordinance to prevent the pasturing of cows and other domestic animals in the more populous portions of the city."

WINGRA PARK, THE FIRST SUBURB

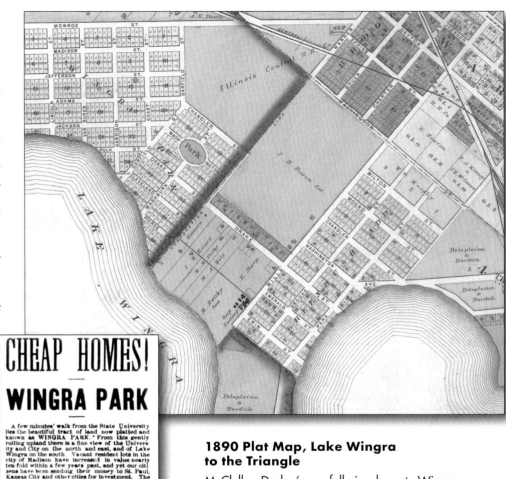

Madison's suburban development began in 1889 when William T. Fish, a leading building contractor and real estate dealer, bought the 106-acre Van Dusen dairy and truck farm just outside the western city limits. In that space he platted Wingra Park, 380 lots surveyed by McClellan Dodge and offered for sale by his newly formed Madison Land and Improvement Company.

Just a few years later, Dodge drew the plat for University Heights, the city's first residential development with a curvilinear design. Here, however, he failed to capitalize on the contours of the land, providing no sensitive landscape architecture to the rolling slope from Monroe Street to Lake Wingra. As this 1890 plat map shows, he also failed to integrate the two sections of the plat, creating two distinct street grids that simply do not relate to each other; it is as if the presidential streets parallel to Monroe Street and the streets parallel to Chandler were part of competing plats, rather than the same one, with Garfield Street a barrier to sensible internal circulation. And other than the small park that bore a bear effigy mound, the plat provided no community open space, a failure not fixed until the land south of Jackson and Drake streets was transformed into Henry Vilas Park fifteen years later. There would be similar parkland inadequacy in University Heights, not to be rectified by an adjacent lakefront park.

Fish marketed the lots as ideal for "cheap homes" for "the retired farmer, mechanic and the laborer," but his timing was terrible — a national depression and the lack of public transportation thwarted his efforts. Even repositioning the pitch in 1891 to portray the subdivision as an upscale suburb was only partially successful. In 1893 Fish sold all his remaining lots to a trio of investors and moved across Monroe Street to develop University Heights with Breese Stevens and others.

Wingra Park's real development began on Halloween 1893, when the investors, including superintendent of public property and future congressman Henry Cullen Adams (also an investor in University Heights), formed the Wingra Park Advancement Association "to beautify and improve" the subdivision. They built a neighborhood center and in 1895 raised funds to establish electric streetlights — aided by the fact that another investor, H. C. Thom, was manager of the Four Lakes Light and Power Company. In 1896, Edward Riley, father of architect Frank Riley, bought the Illinois Central land and formed Oakland Heights Addition, as a sort of adjunct to Wingra Park. But the most important development was the extension of the electric streetcar line in 1897, made possible when Adams and Fish obtained a franchise, levied special assessments, donated roadway, and supervised construction. That year Wingra Park also considered and rejected annexation to the city. In 1901, the association secured passage of legislation granting unincorporated villages the same rights as incorporated villages, other than representation on the county board, and it maintained that status until its annexation in 1903.

CHEAP HOMES!

WINGRA PARK

A few minutes' walk from the State University lies the beautiful tract of land now platted and known as WINGRA PARK. From this gently rolling upland there is a fine view of the University and City on the north and east, and of Lake Wingra on the south. Vacant resident lots in the city of Madison have increased in value nearly ten fold within a few years past, and yet our citizens have been sending their money to St. Paul, Kansas City and other cities for investment. The city of Madison is growing rapidly in every direction, and room must be given for cheaper homes. To supply this demand, a limited number of lots in WINGRA PARK are now placed upon the market, at

Low Prices and on Easy Terms.

INQUIRE OF

WILLIAM T. FISH.

1890 Plat Map, Lake Wingra to the Triangle

McClellan Dodge's woefully inadequate Wingra Park plat, just outside the city limits (dark line), is the highlight of this 1890 map. In 1896 university official Edward Riley would turn the railroad land into Oakland Heights. The square by Chandler Street is the estate of Mayor James Barton Bowen, pictured on page 68. In the early 1900s, Mary Bowen Ramsey's bequest would lead to construction of St. James Catholic Church. About that same time, immigrant George Pregler would fill in the swampy isosceles triangle, here owned by pioneers Delaplaine and Burdick, expanding the Greenbush Addition. The soap factory between Erin and Emerald streets, just west of Mills, shows the city still isn't separating industrial from residential land uses. (WHi-37382)

Inset: The modest beginnings of the Vilas neighborhood, October 15, 1889 (courtesy of David Mollenhoff)

THE 1890s

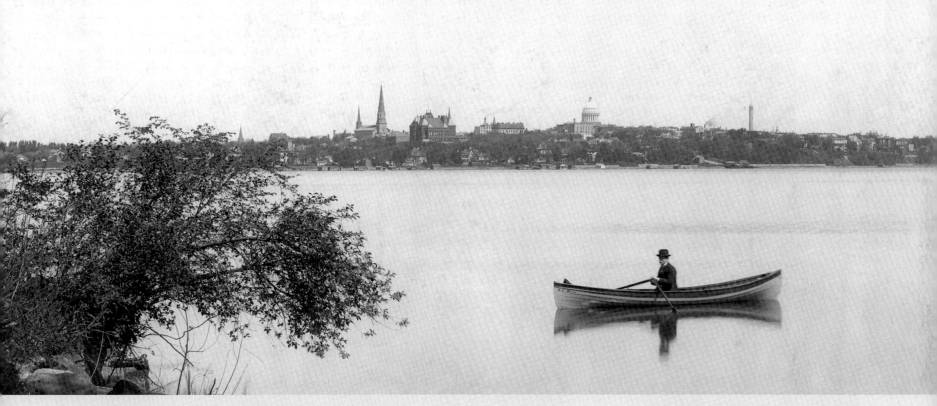

Lake Monona Skyline with man in rowboat, June 1894 (WHi-2123)

<div style="float:right">
Verbatim

The present method of discharging sewage into the lakes must be discontinued if the health of the city is to be maintained. Anyone having doubts as to the pollution of the waters of our lakes has only to go to the foot of Broom or Blair streets on a calm day and observe the dark streams discharged far out into the lake by main sewers at these points and in warm weather with the wind from the opposite shore the sewage may be detected along the shores of that lake even if not seen. — **Mayor John Corscot**, annual message, 1893
</div>

Madison got more metropolitan in the 1890s. A grand new theater opened on the Capitol Square and high society flourished on Mansion Hill. Private citizens formed associations to advance public health and welfare and to make the scenic countryside more accessible. The electric streetcar opened vast new areas for suburban development on both sides of town (although efforts to make Madison a summer resort fell victim to another national depression). There was further industrialization and the birth of truly organized labor. On campus, a successful leader built several signature buildings of enduring architectural, social, and cultural importance. The city confronted corruption and a constitutional crisis, and survived both. And just blocks from his boyhood home, the world's greatest architect built his first public commission (sadly, scaled back due to the national economy).

Births and Deaths

1890 Census: 13,426

Wisconsin's most important and tragic brothers (and their younger sister) were born, as was the man who created fudge bottom pie and integrated a neighborhood of west-side liberals halfway through the next century.

- Alfred Bareis (1893–1976), city clerk, acting mayor
- Robert La Follette Jr. (1895–1953), U.S. senator
- Carson Gulley (1897–1962), chef, civil rights figure
- Phil La Follette (1897–1965), governor
- Mary La Follette Sucher (1899–1988), artist
- Fred Halsey Kraege (1899–1982), attorney, mayor, acting city manager

The last of the great pioneers died in the 1890s, including a beloved and heroic former governor, two men who arrived in the brand new settlement within hours of each other six decades prior, and Madison's first innkeeper. Seven significant mayors died, three of them among our most accomplished.

- Lyman Draper (1815–1891), historian
- Jared C. Gregory (1828–1892), attorney, mayor
- John Baltzell (1827–1893), attorney, mayor
- Simeon Mills (1810–1895), pioneer entrepreneur
- George Delaplaine (1814–1895), pioneer speculator
- Harlow Orton (1817–1895), mayor, supreme court justice
- Cordelia Harvey (1824–1895), hospital founder
- Horace Rublee (1829–1896), journalist, diplomat, party leader
- Lucius Fairchild (1831–1896), war hero, governor
- William Leitch (1808–1897), businessman, mayor
- Darwin Clark (1812–1899), pioneer carpenter, civic leader
- Hiram Moulton (1818–1899), contractor, mayor
- Silas Pinney (1833–1899), mayor, supreme court justice
- David Atwood (1815–1899), journalist, mayor, industrialist
- Rosaline Peck (1807–1899), pioneer innkeeper

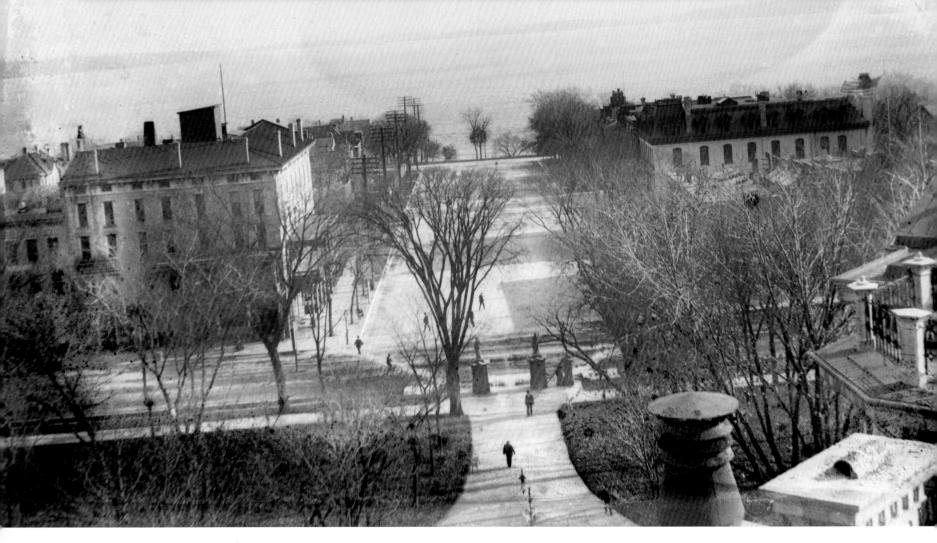

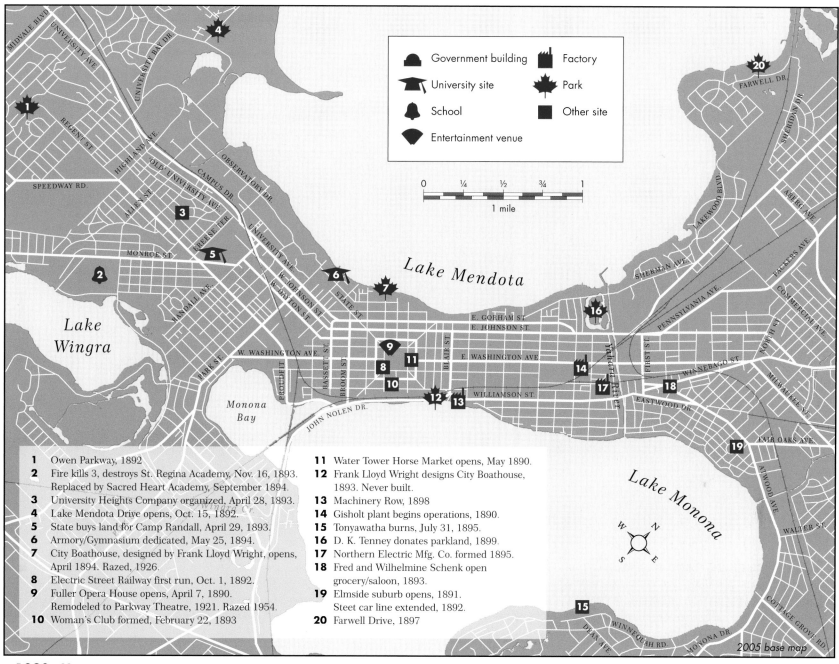

Legend:

- Government building
- University site
- School
- Entertainment venue
- Factory
- Park
- Other site

Lake Mendota

Lake Wingra

Monona Bay

Lake Monona

0 ¼ ½ ¾ 1
1 mile

Streets labeled: MIDVALE BLVD, UNIVERSITY AVE, UNIVERSITY BAY DR, OBSERVATORY DR, REGENT ST, HIGHLAND AVE, OLD UNIVERSITY AVE, CAMPUS DR, SPEEDWAY RD, ALLEN ST, PICNIC PIER, MONROE ST, RANDALL AVE, UNIVERSITY AVE, W. JOHNSON ST, W. DAYTON ST, STATE ST, PARK ST, PROUDFIT, W. WASHINGTON AVE, BASSETT ST, BROOM ST, BLAIR ST, E. GORHAM ST, E. JOHNSON ST, E. WASHINGTON AVE, WILLIAMSON ST, JOHN NOLEN DR, Yahara River, FIRST ST, WINNEBAGO ST, EASTWOOD DR, SHERMAN AVE, PENNSYLVANIA AVE, LAKEWOOD BLVD, SHERIDAN DR, FARWELL DR, ABLER AVE, PACKERS AVE, COMMERCIAL AVE, MILWAUKEE ST, FAIR OAKS AVE, ATWOOD AVE, WALTER ST, COTTAGE GROVE RD, WINNEQUAH RD, MONONA DR, DEAN AVE, Wingra Cr.

2005 base map

1. Owen Parkway, 1892
2. Fire kills 3, destroys St. Regina Academy, Nov. 16, 1893. Replaced by Sacred Heart Academy, September 1894.
3. University Heights Company organized, April 28, 1893.
4. Lake Mendota Drive opens, Oct. 15, 1892.
5. State buys land for Camp Randall, April 29, 1893.
6. Armory/Gymnasium dedicated, May 25, 1894.
7. City Boathouse, designed by Frank Lloyd Wright, opens, April 1894. Razed, 1926.
8. Electric Street Railway first run, Oct. 1, 1892.
9. Fuller Opera House opens, April 7, 1890. Remodeled to Parkway Theatre, 1921. Razed 1954.
10. Woman's Club formed, February 22, 1893

11. Water Tower Horse Market opens, May 1890.
12. Frank Lloyd Wright designs City Boathouse, 1893. Never built.
13. Machinery Row, 1898
14. Gisholt plant begins operations, 1890.
15. Tonyawatha burns, July 31, 1895.
16. D. K. Tenney donates parkland, 1899.
17. Northern Electric Mfg. Co. formed 1895.
18. Fred and Wilhelmine Schenk open grocery/saloon, 1893.
19. Elmside suburb opens, 1891. Steet car line extended, 1892.
20. Farwell Drive, 1897

1890s Map (map by David Michael Miller, courtesy of Isthmus Publishing Co.)

Monona Avenue, ca. 1895 *(facing page)*
Madison's entryway still struggles for identity in this view from about 1895. The village-era Vilas House, by now known as the Pioneer Block, shares the street with the Avenue Hotel, formerly the site of the Democrat Printing Company. Hidden by the trees (right foreground) is Simeon Mills's 1868 business block, where parks impresario John Olin had his law offices. Closer to the unimproved waterfront, the street is a private preserve home to the Fairchild, Mills, Atwood, and Hoyt mansions. A string of utility poles further mars the vista. (WHi-30696)

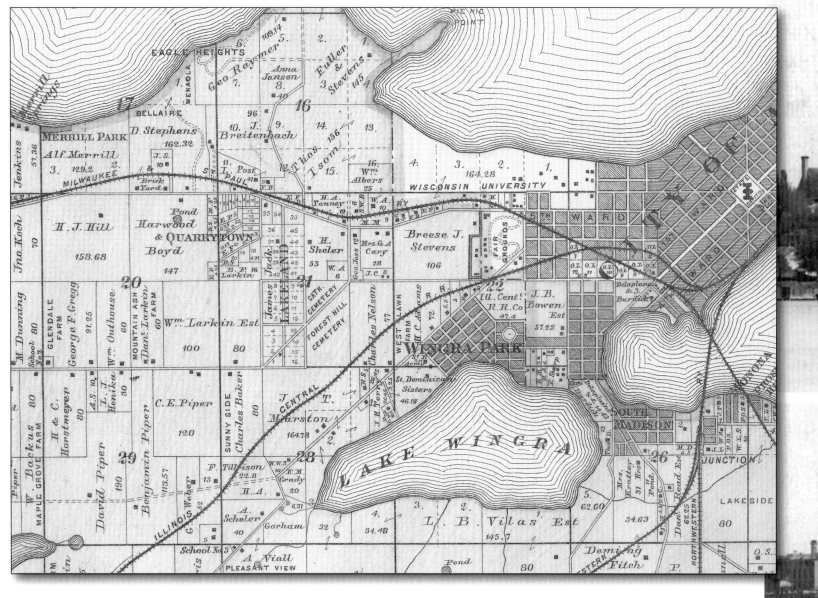

Town of Madison, 1890 Plat Map

The city's future west side, from the square to Whitney Way. In the lower left, the 320-acre parcel Benjamin Piper bought in the early 1850s, which he farmed with sons David and Charles; a hundred years later, their land became the heart of the Midvale Heights neighborhood. The borders of the Charles Piper property are now, clockwise from the top, Mineral Point Road, Midvale Boulevard, and Tokay Boulevard, with the broken dashes through the bottom half of the other Piper properties describing the current path of Odana Road. Across the Illinois Central tracks, School No. 3 is on a site used continuously for educational purposes from 1854 to the present Thoreau School. A generation after this map, the Madison Realty Company developed the area around the school as the Nakoma neighborhood, but Leonard Gay failed with his Lake Forest development on the eastern part of the Vilas property. Thanks to the efforts of Michael Olbrich, Joe Jackson, and Paul Stark, this land later became part of the university Arboretum (page 244). Southeast of that is the land of Deming Fitch, pioneer undertaker. Wingra Park had just been platted when this map was published, with the Breese Stevens land set to become University Heights in 1893. Shortly after that, Henry Adams turned West Lawn Farm into the West Lawn subdivision and Frank Riley developed the Illinois Central land as Oakland Heights. The creation of the Madison Park and Pleasure Drive Association in 1892 involved the Fuller and Stevens, Raymer, and Merrill properties (top) and a section of the Larkin estate just beyond Lakeland, south of Quarrytown. Below Eagle Heights is the forty-acre parcel that German immigrant Jakob Breitenbach, a former farmhand on the Fuller and Stevens property on Picnic Point, bought in 1854; the marshy land became the nucleus of developer John T. McKenna's College Hills subdivision in 1912 (after 1927, part of the Village of Shorewood Hills). (detail from WHi-37379)

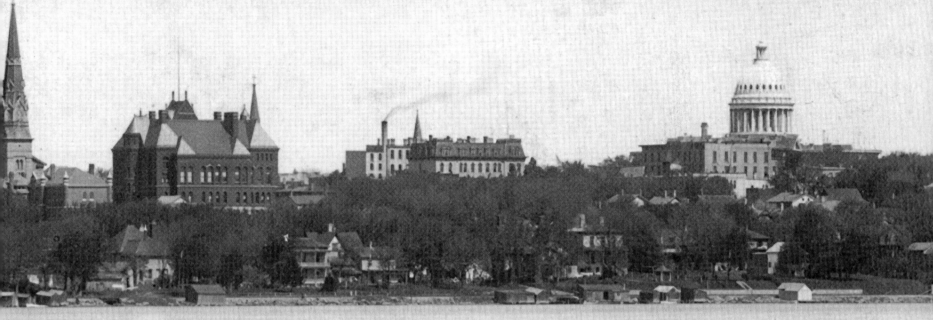

Skyline Detail (West), 1894

From left, the steeples of Congregational, St. Raphael's, Grace Episcopal, and First Baptist churches — the last three still standing at the city's sesquicentennial — with the Dane County Courthouse, Park Hotel, Fox/Atwood Block, and second state capitol — none of which remain. (detail from WHi-2123)

Dateline

August 19, 1895 After a lakefront homeowner sues the city for $5,000 in damages caused by sewage being dumped directly into Lake Monona, Mayor Alford orders city crews in rubber boots to wade through muck and mud behind the Fauerbach Brewery to clean the filth.

Dateline

June 30, 1897 State fishery board completes stocking Lake Mendota with several hundred thousand trout from the fish hatchery south of the city.

Skyline Detail (East), 1894

Ending it's fourth decade, the city has still failed to improve the Lake Monona shoreline, leaving the land in private hands and recreation to private enterprise. The open embankment to the left of the houses (far right) is part of the most important parcel in the city, the terrace below Monona Avenue. The large covered structures down the shoreline to the left are the Carroll Street boathouses of the Askew brothers; the smaller structures are private boathouses, eyesores that dotted the shoreline for decades. It was at the other end of Carroll Street just two months before this photograph was taken that the Madison Improvement Association opened the public boathouse designed by Frank Lloyd Wright (pages 118 and 119). (detail from WHi-2123)

THE MADISON PARK AND PLEASURE DRIVE ASSOCIATION

No group outside government or the university has meant more to the city than the Madison Park and Pleasure Drive Association. What it started in the 1890s transformed the city on both the physical and metaphysical planes.

Lake Mendota Drive
This photograph of the first park and pleasure drive evokes the 1852 Hoeffler pencil sketch on page 20. (WHi-38998)

As the decade dawned, private citizens began adding to Madison's meager tally of public parkland, which since 1879 had consisted entirely of the former cemetery on Spaight Street, recently named after former mayor Orton. In 1888 *Madison Democrat* publisher George Raymer purchased a 150-acre parcel on Eagle Heights just west of Picnic Point, built a winding lakeshore drive more than two miles long, and opened it all to the public — providing the drivers could navigate the narrow, often rutted and muddy roadway. In 1892 Edward Owen, a university foreign language professor and land speculator, bought a heavily wooded fourteen-acre tract three miles west of the capitol and started building a parkway and drive connecting Regent Street with Hoyt Park (then called Sunset Point). He gave the $3,000 park and parkway to an informal group of citizens who took care of the drives as a memorial to daughters Ethel, 4, and Cornelia, 10, who had died within two weeks of each other during a diphtheria epidemic in the winter of 1890.

But full enjoyment of the drives still required better access to the Raymer property and a way to link the two projects. That's when John Olin found his life's true calling.

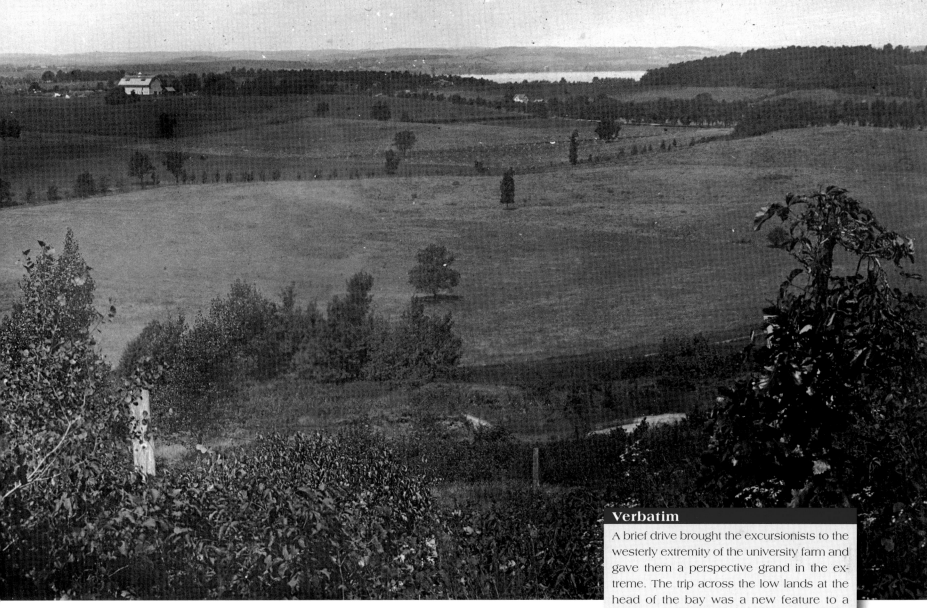

Olin's skills at planning and publicity were evident even in the first project, Lake Mendota Drive. Once Olin had the route, engineering, and easements all settled he went public with the plan to finish the $5,000 financing.

"The grandest pleasure drive ever laid out in a Wisconsin city," the *State Journal* declared on June 20, 1892. Four days later, Olin convened a citizens committee at city hall and formally unveiled the project.

The citizens committee, the Lake Mendota Pleasure Drive Association, raised the money and built Willow Drive, skirting the shores of the bay. The twelve-mile-long Lake Mendota Drive formally opened on October 15. About seventy carriages made the three-hour maiden voyage past the Breese Stevens farm, through Eagle Heights, all the way to the springs on the Merrill property. Then they went south and connected with Professor Owen's drive for the return.

And that was just the beginning. On July 10, 1894, Olin's informal group incorporated as the Madison Park and Pleasure Drive Association. Twenty-six members paid their $25 dues that first year. The next two years would bring donations of about $2,500 — enough to maintain and landscape Lake Mendota Drive but not enough to open new areas.

In early 1897, Olin announced plans to build a 5.5-mile drive along the eastern edge of Lake *continued on page 116*

Sunset Point *(above)*
The view from Sunset Point in Owen Park, part of the original park and pleasure drive circuit. Pictured here in 1907, this view today overlooks the Midvale Shopping Center area.
(WHi-35799)

Mendota all the way to Governor's Island. Halle Steensland gave a forty-foot easement through his Maple Bluff property, memberships shot up from 132 to 402, and contributions cracked the $10,000 mark. The city did its part as well, spending $3,000 to pave Sherman Avenue (with the owners of abutting property contributing the remaining $6,000).

After much debate, the new road was named in honor of the man who built much of early Madison and later lived near the drive's ending point — Leonard J. Farwell.

The association's exclusive focus on pleasure drives was about to change, thanks to an unlikely protagonist — Olin's old nemesis from the brewery battles of fifteen years prior, Daniel K. Tenney. With one single act of philanthropy, Tenney transformed the association — and in so doing, transformed Madison.

In 1899 Madison had about 19,000 residents, a 30 percent increase in population from ten years earlier, and almost double the number in 1880. But Orton Park was still the city's only official open space other than the capitol grounds. Since its inception, the MPPDA had spent twelve times what the city did on outdoor amenities.

With pressure building for more public open space, brewer Joseph Hausmann and other property owners near the Lake Mendota head of the Yahara River made the city a generous offer in early 1899 — 460 feet of lake frontage for only $1,500. Olin and the association urged the city to move quickly — but Tenney was quicker, offering to buy the land for park purposes and to donate an additional $2,500. All the association had to do was take title in trust for the city, improve and maintain the property, and raise an additional $2,500.

Despite his strong belief that the acquisition and development of parks was a municipal function, and not one properly left to a voluntary citizens association, Olin was a realist; he knew the city was not likely to create its own parks program, especially at a time of high capital expenditures for water and sewer plants. So on his recommendation the association accepted Tenney's offer.

One part of this dramatic change in the association's mission — from providing pleasure drives for the carriage set to creating parks for the middle and working classes — appealed to Olin. The site's location, Olin said, made the new park ideal for the "laboring portion of our City," and offered a new relationship that Olin sought to strengthen by reducing membership from $25 to $5.

After Sherman Avenue residents and others raised the first $1,000, the council on July 14, 1899, appropriated the remaining $1,500 to the MPPDA. The council also declared that "it would be most proper and fitting that said park should by named 'Tenney Park.'"

With one well-timed challenge grant, Tenney had thus caused the democratization of the association and set the precedent for it to act as a quasi-official city parks department.

The association hired the noted Chicago landscape architect O. C. Simonds to plan the park's improvements. But to make sure the marsh was suitable for the design, Olin had it pumped and tested before undertaking)the work; ironically, Olin hired Leonard W. Gay, who would outrage Olin in 1911 by building the city's first skyscraper and whose own Lake

Rustic Bridge
A highlight of the Lake Mendota Drive was this rustic bridge over a woody ravine (just after the modern 4800 block), shown here in 1901. Although Judge A. G. Zimmerman here poses proudly in one of the city's first "locomobile steamers," within a few years "cars on the drives" would be a major controversy. (WHi-35716)

Forest development would sink into the Lake Wingra marsh in the 1920s (page 191).

In the decade that followed, a small group of philanthropists and a large group of citizens would take what Olin and Tenney had started to new heights, bringing to Madison a profound and permanent physical transformation.

Daniel Kent Tenney (1834–1915), the man who began the era of parks philanthropy and changed the focus of the Madison Park and Pleasure Drive Association, was the great gadfly of the city's first century. Opinionated curmudgeon, successful attorney, generous benefactor, failed transit mogul, defeated mayoral candidate, Tenney had a public career that lasted for over fifty years.

Descendent of a colonial family that landed in Massachusetts in 1638, Tenney was born in upstate New York, the youngest of ten children. He learned to set type at age eight and came to Madison in 1850 to work for his brother Horace at the *Wisconsin Argus* newspaper. Shortly after his arrival he made his way through the thickets up university hill, where he helped lay the cornerstone of the first building on campus, North Hall. Tenney was an unexceptional student, but he did found the Athenian Literary Society. He read the law in the Portage office of his brother Henry, simultaneously serving as deputy clerk of courts; he was admitted to the bar three weeks before turning twenty-one and was a charter member of the Dane County Bar Association. Tenney served on the common council from 1860 to 1863; not yet twenty-six, he was its youngest member and for a time its only Republican, a war hawk in a city that Lincoln never carried. Tenney moved to Chicago in 1870 and soon became both prominent and rich suing insurance companies that failed to pay on claims after the fire of 1871. During his time in Chicago, Tenney remained involved in Madison, both as a vocal observer and as a participant; in the mid-1880s, he very publicly sought to stymie the prohibition activities of John Bascom and John Olin and undertook the ill-fated purchase of the mule-team-era Madison Street Railways Company. Tenney ran for mayor in 1885 but lost decisively to Hiram Moulton. When he came back to Madison for good in 1897, Tenney became even more vocal and unpredictable, commenting with varying degrees of insight on Madison's future (he favored tourism over industry), the ongoing sewage crisis (his solution: pump the sludge further out into the deeper waters of Lake Mendota), a city hospital (his wife an invalid for many years, Tenney strongly supported fundraising efforts), black suffrage (the former Republican war hawk was dead set against it), and religion (he had no use for it). After making his 1899 donation, Tenney continued to contribute to develop the park — and twice lost very public disagreements with Olin, once on design (Tenney wanted to install an iron bridge that Olin found aesthetically lacking) and again over purpose (Tenney opposed Olin's plan to develop the Yahara River for motor launches). In 1906 Tenney's forty-six-year-old son John, an attorney and real estate dealer working as a streetcar motorman in Oakland, was shot to death trying to protect his conductor during a robbery. Tenney's home at 401 North Carroll Street is a Madison Landmark, mainly due to its subsequent ownership by Breese Stevens. Tenney's unique globe-shaped gravestone declares that he "revered the truth, despised hypocrisy, loved his fellow man."

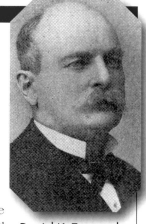

Daniel K. Tenney, the city's first great parks philanthropist, ca. 1902 (WHi-36057)

Charles N. Brown (1855–1926), official photographer of the MPPDA, was one of Madison's most prominent attorneys and active citizens in the early twentieth century. First ward alderman (1897–1905) and an organizer with Solomon Levitan of the Commercial National Bank, he also served as treasurer for Madison General Hospital and Wisconsin Alumni Association and as curator and finance chair of the State Historical Society.

February 1890 Horace Taylor buys *Wisconsin State Journal* from estate of David Atwood and fires almost entire staff. Among those let go is managing editor O. D. Brandenburg, who had succeeded famed historian Reuben G. Thwaites upon his election as secretary of the Wisconsin Historical Society in January 1887. Brandenburg soon joins rival *Madison Democrat* as editor and co-owner with Attic Angles patriarch and law school dean E. E. Bryant and parks philanthropist George Raymer. In December the company opens a large new plant at 114 South Carroll Street, on land purchased from Elisha Keyes.

Lagoon in Tenney Park, 1902
An illustration from the Madison Park and Pleasure Drive Association Annual Report. (WHi-41366)

FRANK LLOYD WRIGHT'S CARROLL STREET BOATHOUSE

Wright's city boathouse, viewed from Lake Mendota (WHi-34327)

This public boathouse on the Lake Mendota shoreline at Carroll Street was Frank Lloyd Wright's first important Madison commission when it opened in April 1894. But its demolition in early 1926 sparked no public outcry — those who might have cared didn't know about Wright's role and those who knew didn't care.

Not that Wright was such a big deal when he was chosen — an 1895 report by the board of the Madison Improvement Association, which commissioned the work, never identified him by name, only that a "satisfactory bid [was] received" and was "accordingly commenced and pushed to completion."

Wright's city boathouse, perspective from North Carroll Street (WHi-34325)

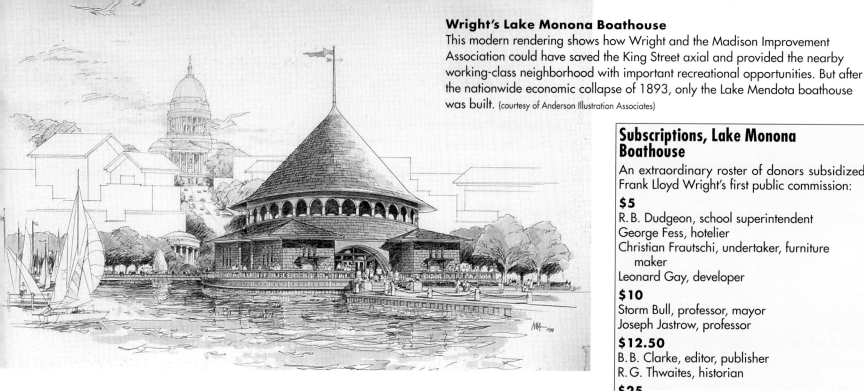

Wright's Lake Monona Boathouse

This modern rendering shows how Wright and the Madison Improvement Association could have saved the King Street axial and provided the nearby working-class neighborhood with important recreational opportunities. But after the nationwide economic collapse of 1893, only the Lake Mendota boathouse was built. (courtesy of Anderson Illustration Associates)

At the time, Wright was living in Oak Park but had very strong ties to the association's executive committee, which included former neighbor (and former mayor) Moses Doyon, bank president Lucien S. Hanks, the father of a childhood friend, and John Olin.

The Madison Improvement Association, formed on February 27, 1893, to address everything from sewage to safety to lakeshore boat shanties, boasted one of the most glittering rosters in a glittering age. Olin convened the meeting that rain-soaked night, and former governor Lucius Fairchild served as chair; other charter directors included former mayors Breese Stevens and Alden Sanborn, banker N. B. Van Slyke, and industrialist and diplomat Halle Steensland.

The association's first major project was to replace the decrepit private boathouses that marred both lakefronts. Wright won the $7,000 competition with two designs — a graceful structure in cream stucco and brown shingles, built for $4,600 and holding twenty-eight rowboats; and a more impressive and far more prominent boathouse at the Lake Monona foot of King Street that would have been Wright's first circular building (above) had it not been delayed, then killed, by the national economic crisis of 1893.

With its conical roof set seventy feet above lake level, plus flagpole, the Monona boathouse would have provided a nine-story punctuation mark for this axial street, and it would have dominated the Monona skyline.

It would have also provided a vital social benefit to the working-class neighborhood down by the railroad tracks and the burgeoning implement row up Wilson and Williamson streets. Nestled in the leafy crook on Mansion Hill, the Carroll Street boathouse was a lovely amenity for a neighborhood already enjoying an exceptional lifestyle; but it was the concentration of shanties on Lake Monona that really needed replacement.

Although a popular and professional success, the Mendota boathouse fell on hard times after the improvement association shut down in 1907. Support and even instigation for demolition came from two immediate neighbors — realtor and architect Chandler Chapman, known as the "father of the Wisconsin National Guard" and who, as acting mayor, had shut the saloons in 1873; and Mrs. Frank Brown, widow of a Madison Improvement Association board member who didn't like Olin. Eager to see their property values rise by having the boathouse gone, they wisely waited until Olin died in December 1924 before pursuing demolition. Boathouse patrons failed to get the property transferred to the Madison Parks and Pleasure Drive Association, and in February 1926 Chapman, his friends, and city crews razed Frank Lloyd Wright's first public building.

Subscriptions, Lake Monona Boathouse

An extraordinary roster of donors subsidized Frank Lloyd Wright's first public commission:

$5
R. B. Dudgeon, school superintendent
George Fess, hotelier
Christian Frautschi, undertaker, furniture maker
Leonard Gay, developer

$10
Storm Bull, professor, mayor
Joseph Jastrow, professor

$12.50
B. B. Clarke, editor, publisher
R. G. Thwaites, historian

$25
John B. Heim, waterworks superintendent, mayor
Joseph Hobbins, physician
Beverly Jefferson, livery proprietor
W. S. Main, pioneer sheriff, developer
Phil L. Spooner, mayor

$50
Chas. K. Adams, university president
R. M. Bashford, mayor, justice
Chas N. Brown, parks advocate
Brittingham & Hixon, lumber company
Geo. B. Burrows, pioneer, realty speculator
Conklin & Son, mayor's coal company
Geo. P. Delaplaine, pioneer developer
Lucius Fairchild, governor
Morris E. Fuller, industrialist
Burr W. Jones, jurist
La Follette law firm, Fighting Bob's law firm
Halle Steensland, industrialist, diplomat
John J. Suhr, banker

$100
Frank W. Hoyt, pioneer, parks advocate
Silas Pinney, jurist, mayor
D. K. Tenney, gadfly, parks philanthropist
Joseph Hausman, brewery owner
John C. Spooner, U.S. senator
Breese Stevens, industrialist, mayor
State Bank, first state-chartered bank

$300
Edward T. Owen, professor

$310
Est. Timothy Brown, pioneer speculator

THE WOMAN'S CLUB

T he progressive surge that Madison enjoyed the first two decades of the twentieth century likely would have happened in some form without the Woman's Club. It just wouldn't have been so comprehensive and successful.

Toward the end of the nineteenth century, this national movement to involve women in community and philanthropic causes flourished in select cities. It was Mary Louise Atwood, daughter of the former mayor, who called the first meeting of the Woman's Club of Madison at her Monona Avenue home on February 22, 1893.

Among the other women who met that night were Frances Bull Fairchild, Mary Farmer Stevens, Anna Wells Fuller, and Margaret Andres Allen, the very accomplished wives, respectively, of a former governor, a developer and former mayor, a leading industrialist, and a prominent university professor. Three nights later, an organizational meeting drew seventy women, the core of a charter membership of ninety-six. The club held its first regular meeting on April 21 at the Langdon Street home of Mary Barnes Adams, wife of the university president; Atwood was named president, with Adams, Fairchild, Stevens, and Fuller being joined on the executive committee by Helen Remington Olin and Mary Clark Hoyt. Mary Atwood's sister, Elizabeth Atwood Vilas (a mayoral daughter as well as a mayoral daughter-in-law by her marriage to Levi Vilas's son Edward), donated a gavel. Starting in May 1895 the club met in the Guild Hall of Grace Episcopal Church (endowed by Elizabeth's brother-in-law, Senator William F. Vilas).

Without question, it was the greatest concentration of great women in Madison's history — women the equal of their historic husbands but without their access to high office or capital.

Reflecting the consensus about nascent feminism, the club focused in its early years on purely intellectual and cultural pursuits — interesting and informative for those involved but without much relevance to the rest of the city.

All that changed in November 1900 after a presentation by Samuel E. Sparling, founder and executive director of the League of Wisconsin Municipalities, alderman, and university political science instructor. His topic was "How May Women Assist in the Government of Our Cities?" His answer — by becoming the "rightful leaders of public sentiment" to "develop a wholesome physical and moral environment in the city."

Sparling cleverly took what had been a limitation on women's political activity in the pre-suffrage era — that they could only be involved in issues that related to the home — and made it a license. After all,

Mary Louise Atwood, the woman behind the Woman's Club of Madison (WHi-36011)

The Woman's Club, the physical presence of a powerful force for change and progress (WHi-35736)

what is a neighborhood or a city but a collection of homes?

With this renewed inspiration, the Woman's Club quickly became a powerful and productive progressive force. Combining education with action at the height of progressive municipal activism, the Woman's Club was unmatched in range and accomplishment. The club's achievements were primarily in health (starting and sustaining city garbage pickup, crusading for clean milk and against the housefly, urging annual physical exams for children) and education (including in-school hot lunches, kindergarten expansion, the high school bond referendum, and libraries). The club also actively supported the Community Union of nonprofit social welfare organizations, forerunner to United Way.

As they were amassing this record of success, the Woman's Club was also seeking a permanent home. It found one in 1905, when former mayor Philip L. Spooner donated the land at 240 West Gilman Street. The Women's Building Association retained Chicago architect Jeremiah Cady, whose design was an amalgam of Spanish Colonial, Mission Revival, and Arts and Crafts. The $32,000 building featured a kitchen and dining room for 250, an auditorium seating over 300, and lecture and meeting rooms, but not the bowling alley Cady originally included.

Over the decades, as other venues and opportunities for involvement opened, the building was used less and less frequently, and the club eventually decided to sell. The City of Madison considered the structure for a community center in 1971 but passed; in 1973 the InterVarsity Christian Fellowship bought the building and the club moved its meetings to the YWCA. In 1986 InterVarsity sold the building to Reed Design, which made extensive repairs before selling the property for $2.95 million in January 2003 to a development corporation.

The Woman's Club of Madison continues to meet for bridge and monthly luncheons at the Inn on the Park.

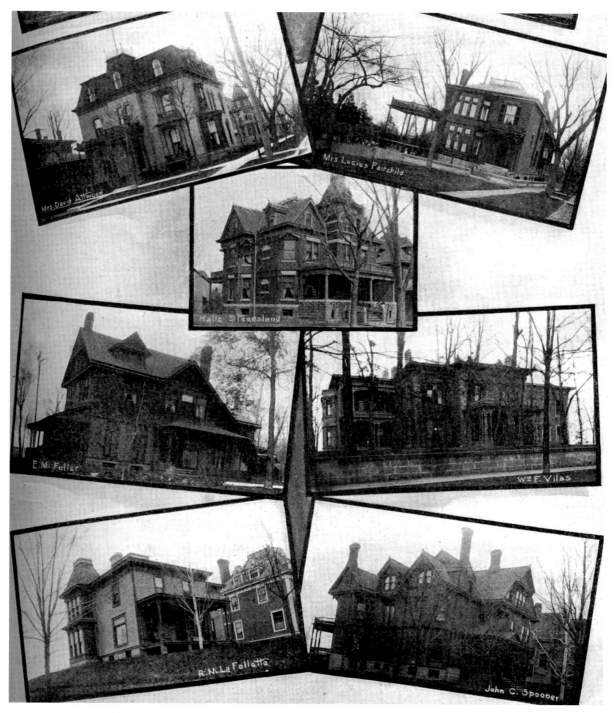

Homes of the Rich and Powerful, ca. 1902

Only three of these houses remain: the Steensland House (315 North Carroll Street), now the Parish Shoppe of Bethel Lutheran Church; the La Follette House (302 South Broom Street), since expanded and divided for student housing; as was the Spooner House (150 Langdon Street), which was also relocated to the interior of the block. Mary Louise Atwood convened the first meeting of the Woman's Club in the house at upper left, which was replaced by a surface parking lot in the 1930s and the City County Building in 1957. Upper right is the house at the end of Monona Avenue that Jairus Fairchild built in 1849, where his daughter-in-law Frances Bull Fairchild presided as gubernatorial and ambassadorial wife and widow from 1866 to 1925. (WHi-35752)

Madison Notable

Frances "Frank" Bull Fairchild (1845–1925) was a pretty and flirtatious sixteen-year-old orphan when she met Mayor Jairus Fairchild's son Lucius, eighteen when she married him, and barely twenty when he became governor. Throughout Fairchild's long political and diplomatic career, and for twenty-nine years after his death, Frances brought charm, wit, and a graceful competence to her many and varied duties. When the Northwoods town of Peshtigo was destroyed by fire in 1871 while Governor Fairchild was in Chicago offering aid after that city's fire the same day, Frances personally organized disaster relief. An early suffragette leader, Frances maintained her Monona Avenue home as one of the social and philanthropic centers of Madison.

Dateline

November 16, 1893 A fire kills three young girls and destroys the St. Regina Academy at Edgewood Villa. A new, renamed Sacred Heart Academy replaces the splendid mansion the following September and an educational and religious phoenix rises from the ashes.

November 13, 1896 Council enacts ordinance "to compel owners of dogs to pay an annual license therefore."

January 13, 1899 Five hundred drunken university students disrupt Fuller Opera House performance of "Fra Diavolo" with loud catcalls and rowdy behavior. Five are arrested and suspended from the university, later readmitted on recommendation of President Adams.

FULLER OPERA HOUSE

When Madison's first great theater opened on April 7, 1890, with a dramatized version of Mark Twain's "The Prince and the Pauper," the city had been without a stage for traveling companies since the Hooley Opera House closed January 8, 1885.

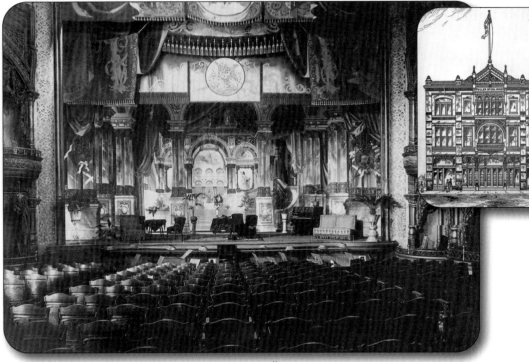

Fuller Opera House stage (WHi-11208) *Inset:* Fuller Opera House exterior (WHi-11710)

Where the Greatest Generation Lived

The men who lived on Mansion Hill in the 1890s and early twentieth century had a lasting impact on the city, state, and nation. In addition to political and business dealings, there were relationships of the heart that created intricate family trees. Banker and politician N. B. Van Slyke's cousin Mary "Minnie" Mears married her neighbor, banker Joseph Hobbins; their son William married his neighbor, Bertha Suhr, daughter of John Suhr, founder of the German-American Bank; Joseph Hobbins's cousin Sydonia married his step-brother, James Jackson; their son Reginald married neighbor Elizabeth Stevens, daughter of industrialist-politician Breese Stevens, who built a home for them next door.

The physical proximity of Mansion Hill proved especially serendipitous within the close community of the university. Longtime dean E. A. Birge lived just three doors down from the president's residence at the corner of Langdon and Park streets; when economics professor Richard T. Ely (620 State Street) was accused of fomenting radicalism in 1893, his defense was mounted by Burr Jones (112 Langdon Street); and when a vacancy arose in the presidency, two distinguished professors living in the 600 block of North Frances Street — Frederick Jackson Turner and Charles Sumner Slichter — worked successfully to fill it with a third, Charles Van Hise.

For five years the city could neither muster the private donations nor legally issue bonds. Finally, industrialist Morris E. Fuller and his son Edward bought vacant land on Mifflin Street next door to city hall and said they'd spend $60,000 for a theater if the public would pledge $15,000. The pledges came in and the cornerstone was laid on September 21, 1889. The facility was, for its time in this place, exceptional, particularly its elegant interior of gilt walls, parquet floors, and rich tapestries. The modern and well-equipped stage was broad and deep and high, with five drop curtains and three trap doors, enabling the widest array of operatic and theatrical performances. Artistically, the opera house was a great success, with two or three shows every week during the fall-spring theater season throughout the nineties. Among the artists who appeared on the Fuller stage were Sarah Bernhardt, Eddie Cantor, and John Philip Sousa.

Accommodations were set by class. The floor, dress balconies, and private boxes held chairs and divans of plush upholstery, while the balcony and gallery benches had hard chairs. Opening night coverage noted that the gallery was "reached by a door on the side, so that those who climb into the 'heaven' do not mingle with the people occupying other parts of the house." In casual conversation and journalistic parlance, the "heaven" was further defined by a racial epithet beginning with "n." Sadly, not all patrons behaved themselves; balcony hooligans, frequently from the university, could be loud and rowdy, and often snagged hats and scarves from the silk-stocking set down below. On occasion, they even organized into mobs to rush the stage and disrupt the performance.

The facility was fine, but the Fullers claimed the finances weren't. When the first full season closed in May 1891, house manager Edward Fuller reported that his $16,000 revenue for the year's eighty performances barely matched his daily $60 overhead. Noting how the house "brings people to the city" and "helps the hotels and trades," he complained to the press that the city had reneged on its promise to lower his $500 tax bill and annual license fee of $50, both vastly higher than corresponding costs in Oshkosh and Janesville. "I think the city should reduce the tax and license or remit them altogether," he said.

In 1921, the Fuller was remodeled into a movie theater, operating as the Parkway until it was demolished along with city hall for a Woolworth's in 1954.

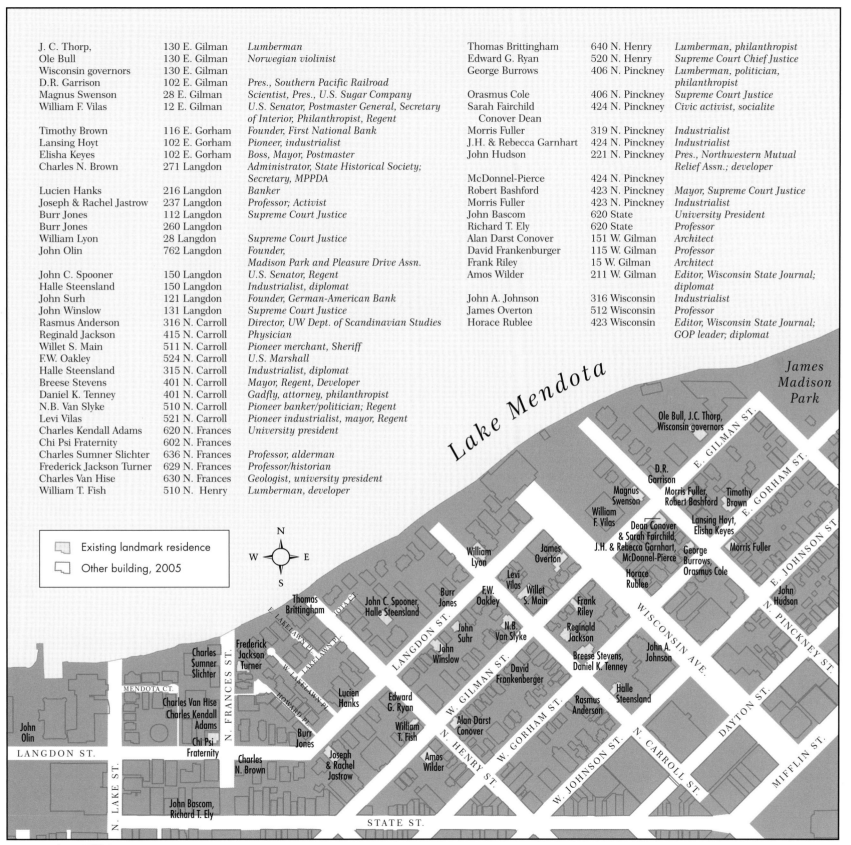

J. C. Thorp,	130 E. Gilman	*Lumberman*
Ole Bull	130 E. Gilman	*Norwegian violinist*
Wisconsin governors	130 E. Gilman	
D.R. Garrison	102 E. Gilman	*Pres., Southern Pacific Railroad*
Magnus Swenson	28 E. Gilman	*Scientist, Pres., U.S. Sugar Company*
William F. Vilas	12 E. Gilman	*U.S. Senator, Postmaster General, Secretary of Interior, Philanthropist, Regent*
Timothy Brown	116 E. Gorham	*Founder, First National Bank*
Lansing Hoyt	102 E. Gorham	*Pioneer, industrialist*
Elisha Keyes	102 E. Gorham	*Boss, Mayor, Postmaster*
Charles N. Brown	271 Langdon	*Administrator, State Historical Society; Secretary, MPPDA*
Lucien Hanks	216 Langdon	*Banker*
Joseph & Rachel Jastrow	237 Langdon	*Professor; Activist*
Burr Jones	112 Langdon	*Supreme Court Justice*
Burr Jones	260 Langdon	
William Lyon	28 Langdon	*Supreme Court Justice*
John Olin	762 Langdon	*Founder, Madison Park and Pleasure Drive Assn.*
John C. Spooner	150 Langdon	*U.S. Senator, Regent*
Halle Steensland	150 Langdon	*Industrialist, diplomat*
John Surh	121 Langdon	*Founder, German-American Bank*
John Winslow	131 Langdon	*Supreme Court Justice*
Rasmus Anderson	316 N. Carroll	*Director, UW Dept. of Scandinavian Studies*
Reginald Jackson	415 N. Carroll	*Physician*
Willet S. Main	511 N. Carroll	*Pioneer merchant, Sheriff*
F.W. Oakley	524 N. Carroll	*U.S. Marshall*
Halle Steensland	315 N. Carroll	*Industrialist, diplomat*
Breese Stevens	401 N. Carroll	*Mayor, Regent, Developer*
Daniel K. Tenney	401 N. Carroll	*Gadfly, attorney, philanthropist*
N.B. Van Slyke	510 N. Carroll	*Pioneer banker/politician; Regent*
Levi Vilas	521 N. Carroll	*Pioneer industrialist, mayor, Regent*
Charles Kendall Adams	620 N. Frances	*University president*
Chi Psi Fraternity	602 N. Frances	
Charles Sumner Slichter	636 N. Frances	*Professor, alderman*
Frederick Jackson Turner	629 N. Frances	*Professor/historian*
Charles Van Hise	630 N. Frances	*Geologist, university president*
William T. Fish	510 N. Henry	*Lumberman, developer*

Thomas Brittingham	640 N. Henry	*Lumberman, philanthropist*
Edward G. Ryan	520 N. Henry	*Supreme Court Chief Justice*
George Burrows	406 N. Pinckney	*Lumberman, politician, philanthropist*
Orasmus Cole	406 N. Pinckney	*Supreme Court Justice*
Sarah Fairchild Conover Dean	424 N. Pinckney	*Civic activist, socialite*
Morris Fuller	319 N. Pinckney	*Industrialist*
J.H. & Rebecca Garnhart	424 N. Pinckney	*Industrialist*
John Hudson	221 N. Pinckney	*Pres., Northwestern Mutual Relief Assn.; developer*
McDonnel-Pierce	424 N. Pinckney	
Robert Bashford	423 N. Pinckney	*Mayor, Supreme Court Justice*
Morris Fuller	423 N. Pinckney	*Industrialist*
John Bascom	620 State	*University President*
Richard T. Ely	620 State	*Professor*
Alan Darst Conover	151 W. Gilman	*Architect*
David Frankenburger	115 W. Gilman	*Professor*
Frank Riley	15 W. Gilman	*Architect*
Amos Wilder	211 W. Gilman	*Editor, Wisconsin State Journal; diplomat*
John A. Johnson	316 Wisconsin	*Industrialist*
James Overton	512 Wisconsin	*Professor*
Horace Rublee	423 Wisconsin	*Editor, Wisconsin State Journal; GOP leader; diplomat*

Existing landmark residence

Other building, 2005

Mansion Hill Map (map by David Michael Miller, courtesy of Isthmus Publishing Co.)

123

Madison Mayor

Robert McKee Bashford (1845–1911), descendant of a revolutionary soldier, fought municipal corruption as Madison's twenty-fifth mayor in 1890 and rose from the city attorney's office to the Wisconsin Supreme Court. He sold the state the land for Camp Randall, twice married very well, and lived in a landmark mansion.

Yet he was a thoroughly disagreeable man whose final years were spent in sorrow and disappointment.

An 1871 graduate of the University Law School, Bashford began his career as editor and part owner of the *Madison Democrat* newspaper, making it more liberal than the party it purported to support. Active in William Taylor's successful 1873 gubernatorial campaign, Bashford married Taylor's daughter Florence and became the governor's private secretary, while retaining his interest in the paper. Shortly after railroad interests caused Taylor's defeat in 1875, Bashford sold his newspaper interest and began practicing law; his partners included Daniel K. Tenney, among others. From 1881 to 1886, Bashford served as the council-designated city attorney and wrote the legal opinions that helped block the privatization of the waterworks and create a municipal system.

Florence Taylor Bashford died at age thirty-three in 1886. In 1889 Bashford married Sarah Fuller, youngest daughter of wealthy industrialist Morris E. Fuller. An invalid for many years, she was a leading philanthropist. The two families lived at 423 North Pinckney Street in one of Madison's earliest mansions, now a Registered Historic Landmark.

Bashford became mayor in 1890 when the city was suffering both ethically and financially. The city didn't have enough money to pay its bills, and three popular officials — two aldermen and the fire chief — stood accused of improprieties in the purchase of fire hose. As chair of the investigating committee, Bashford brought about the expulsion of the aldermen and the removal of the fire chief on May 26, 1890. By selling some city lots and finding a way to issue bonds backed by special street assessments, Bashford was able to buy the stone quarry and a steam road roller for necessary street repairs, and provide for an iron bridge across the Yahara on Williamson Street. He also improved the school system, after telling the council in his inaugural message that a new schoolhouse was "needed at once in the Greenbush addition. The little children from that part of the city are obliged to walk a long distance, without sidewalks and across the railroad tracks, to reach the 4th ward school" at Broom and Wilson streets.

In 1892 Bashford was elected to the State Senate, where he fought vigorously for women's suffrage. Aggressive and often caustic in debate, he once caused another senator to weep in embarrassment when he denounced those — like his humiliated colleague — who "have the hardihood to oppose woman suffrage on the grounds that women are not competent to exercise the ballot yet who are willing to live off the earnings of those wives who have more business activity and acumen than themselves."

Long considered one of Wisconsin's leading lawyers, Bashford in 1904 successfully defended Governor La Follette's ticket against challenge from Republican stalwarts (represented by John Olin) and in 1906 made the winning argument before the State Supreme Court to sustain the inheritance tax. In 1908 Governor Davidson appointed him to the state high court, but Bashford was unexpectedly defeated for election the following April. "His defeat was due to his personality rather than any criticism of his legal abilities," a friend later recounted. This unexpected defeat broke Bashford's spirit, and he fell into depression and ill health. The Bashfords are buried at Forest Hill Cemetery.

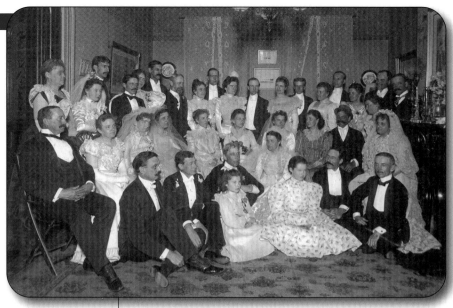

A White Tie Affair

The A. E. Proudfits celebrate their silver anniversary with some of Mansion Hill's most prominent residents. Banker Proudfit, son of the ninth mayor, is the fair-haired man seated in the second row, his wife to his left. Seated behind him, fourth from the left, is Esther Vilas, widow of mayor Levi and mother of senator William. Her grandson Henry, who died of diabetes shortly after this party, is against the wall, in front of the picture. Mary Louisa Atwood stands at left, next to Henry's sister Mollie Vilas Hanks. Industrialist Carl Johnson, John's son, is third from the right in the back row. Industrialist and school namesake Frank W. Allis is at the far right. Oscar D. Brandenburg, former editor of the *Wisconsin State Journal,* now co-owner of the rival Democrat Printing Company, is seated on the floor, left. To his left is the prominent professor David B. Frankenburger. (WHi-36064)

Verbatim

The estimated current expenses of the city are greater by several hundred dollars than the estimated income. This condition of affairs is extraordinary and extremely discouraging. This practice approaches too nearly an evasion of the charter, which prohibits the creation of a debt for any purpose, to be followed as a precedent. We are not responsible for the condition of affairs, but we are compelled to act according to the present emergencies. — **Mayor Robert Bashford**, annual message, 1890

Madison Mayor

John Corscot (1839–1926) came from Holland to America with his family at age seven and to Madison at sixteen in May 1855. He took a job at the Farwell mill and later worked as a printer and for a delivery company. He served on the common council (1865–67), then began a twenty-two-year run as city clerk in 1868. He resigned in 1890 to become secretary of the Madison Gas Coke and Light Company, later serving as general manager, vice president, and chairman of the board of directors of the new Madison Gas and Electric Company. He continued to hold those utility positions while serving as mayor (1893–94) and signed payments to the utility despite a state law banning such activity. Corscot was mayor when the city installed a fire alarm system and its first sewage disposal system. He served on the school board for seventeen years, including as its president from 1897 to 1904. Corscot was one of the most prominent Masons in Wisconsin and one of the city's most beloved figures. More than a thousand mourners attended his funeral at the Masonic temple. Corscot's wife, Julia, worked at the Harvey Hospital during the Civil War and was the first librarian of the Madison Institute. They lived at 1222 East Johnson Street for seventy years and are now interred at Forest Hill Cemetery.

Verbatim

The practice of tearing up three or four blocks of street late in the fall, putting paving material on one block of the graded portion and leaving the balance till the following spring, neither pleases the residents where the work is being done, nor adds to the amiability of those who are of necessity required to pass over the unfinished portion, and should not be tolerated, and can be avoided by a little care at the time of inviting bids and making contracts.
— **Mayor John Corscot**, annual message, 1893

Madison Mayor

William Rogers (1850–1935) was the mayor who moved Madison's mass transit from mule teams to electric trolleys and improved city streets. The city's twenty-sixth mayor (1891–92), Rogers also served as Dane County district attorney, second ward alderman, and assistant U.S. attorney before his administration and as general agent for the Equitable Life Insurance Company after.

Madison Mayor

Charles Whelan (1862–1928), one of the country's most prominent Masons, served as mayor from 1898 to 1899. Formerly city editor of the *Wisconsin State Journal*, Whelan was an assistant attorney general before his election as mayor over incumbent Mathias Hoven. A reform Republican assumed to be tougher on saloons, Whelan won by eleven votes; Hoven won the rematch. Renowned for his after-dinner talks, Whelan was the "supreme lecturer" for the Modern Woodmen of America (an early mutual insurance company) from 1898 to 1926 and publisher of its magazine at the time of his death.

Verbatim

The conditions of the city treasury is such that it will be impossible to give to the public schools improvements and extensions which are now actually necessary for the best interests thereof. The overcrowded condition of many of the schools is such that it is difficult to obtain for the individual scholar that attention on the part of the teacher so essential to his obtaining the fullest benefit of the educational advantages. — **Mayor Charles Whelan**, annual message, 1898

Verbatim

Personally Judge Bashford was not magnetic and an intimate acquaintance with him was necessary to recognize his strong points. He was often repellant and his gruff and sarcastic tongue precluded a popularity that might have been of great value to him. — **John Winter Everett**, *Wisconsin State Journal*, February 28, 1937

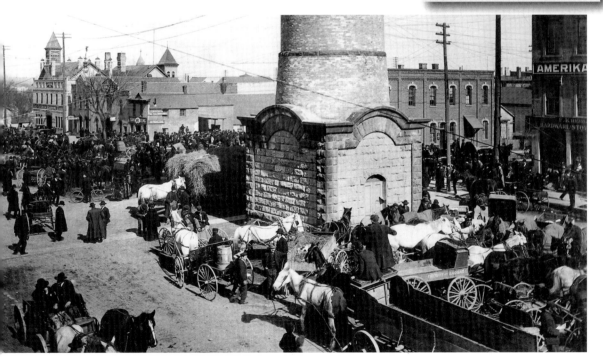

Water Tower Horse Market

After the state installed the elegant wrought iron fence around Capitol Park in 1872, farmers moved their market to the first block of East Washington Avenue. The Madison Businessmen's Club added a horse market there in May 1890, in the shadow of the 125-foot-high water tower built the year before. Open the first Wednesday of each month, the market enjoyed a better reputation among horse traders than Madisonians. This picture from late 1890 shows the base of the 60,000-gallon tower, the horse traders, and the towers of Brayton School. The water tower was razed in early 1921. (WHi-4648)

Madison Mayor

Mathias J. Hoven (1845–1901) was Madison's first German and first Catholic mayor. Born near Cologne, Hoven opened a butcher shop on the square in 1878 and a second one on State Street twelve years later. Hoven served on the council from 1885 to 1891 and later chaired the Public Health Board. When a "turgid, filthy, murky mess" of sewage piled up on the Lake Monona shoreline in the summer of 1895, "thick and strong enough to support quite heavy weights," Hoven ordered the Yahara River dams open to dispel the sludge. Helped by a few days of stiff wind, things cleared up a bit, and Hoven got some credit. Hoven was a major contributor to the university's School of Agriculture and athletic programs; thanks to a strong student vote and a political backlash against Yankee prohibitionists, Hoven in 1897 won the first of three mayoral terms — to John Olin's great disdain. He began his term with an outrageous abuse of power, convening the council in secret session to confirm his appointments to the new Police and Fire Commission. Hoven lost his reelection bid to Charles Whelan by eleven votes, then beat Whelan by 140 votes in 1899 and developer Leonard Gay by 86 votes in 1900. Hoven ran for Congress that year but lost the nomination to his city attorney, John Aylward. He once personally arrested a con man who had swindled him. The city hall flag flew at half-staff for ten days after his death. A one-block court off Wingra Street near Vilas Park is named in Hoven's honor.

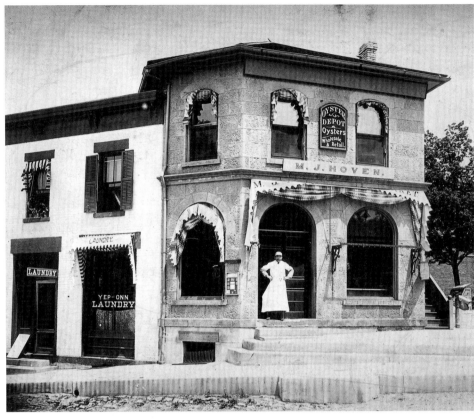

Mayor Hoven
Mayor Mathias J. Hoven in front of his butcher shop on the corner of East Mifflin and North Hamilton streets, which was built in 1867, the same year Hoven emigrated from Germany. (WHi-11037)

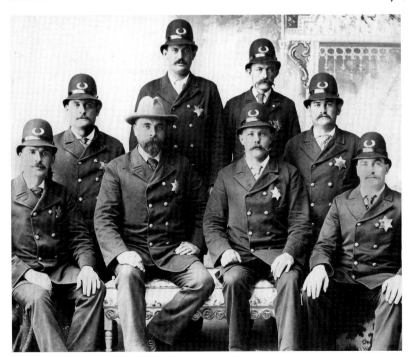

Police Chief Adamson and Officers, June 1895 *(left)*
John "Big Jack" Adamson (felt hat) and his men pose in their new uniforms (which cost each officer $35). The following spring, under the usual practice that made the police subject to political patronage, incoming mayor Dr. A. A. Dye replaced all these officers but one. Adamson was also under fire from the *Madison Democrat* for his hands-off approach when striking employees allegedly threatened scab printers and for his after-hours activities while attending a police convention in St. Louis. Before Dye left office, Madison used a new state law to create a Police and Fire Commission to take the protective services out of politics. At least, that was the plan. At left in second row is Thomas Shaughnessy, who was dismissed by Dye, brought back by Hoven, and made chief in 1907. (WHi-36081)

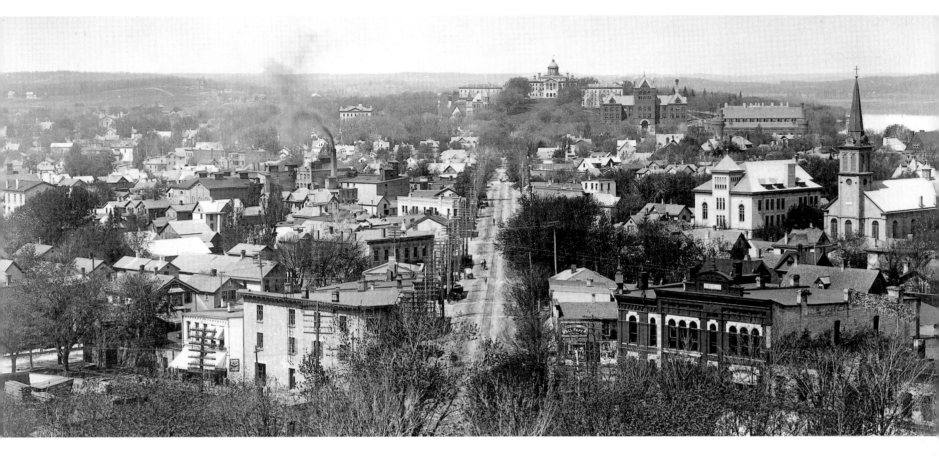

Constitutional Crisis of 1897

A new mayor played politics with the police in 1897 and created a constitutional crisis, as local implementation of a progressive state statute got off to a rocky start.

Under a new statute authorizing cities to establish a Police and Fire Commission, outgoing mayor Dr. Albert Dye clearly had full authority to appoint the city's first commissioners. Dye, a Civil War hero, retired physician, and philanthropist, was a reform Republican mayor elected after only two years in Madison. He offered to let incoming Democrat Hoven pick his party's two (of four) commissioners, but Hoven thought that he should have all the appointments or none, so he declined.

On Sunday morning April 18, 1897, two days before he left office, Dye announced he would appoint the commissioners on Monday for confirmation at the council's last meeting at 10 a.m. on Tuesday. Hoven sued, but Judge Robert Siebecker ruled that Dye was still the mayor and could act, which he did early Monday evening. But shortly after midnight, Hoven declared that Dye's term had expired, and he made his own appointments.

Later that morning, Hoven took an even bolder move, convening the new council's Democrat majority behind locked doors at 8 a.m., two hours before the scheduled final session of the old council. When Dye arrived at 10 a.m. and tried to take the chair, Hoven refused to yield, again claiming Dye's term had ended at midnight. There the matter stood — competing commissions, a police force in limbo.

Cooler heads finally prevailed, and on May 4 the council confirmed a compromise — Dye and Hoven each to name two commissioners, one from each party. Among the first panel were two former mayors, Jabe Alford and James Conklin. But the commissioners couldn't save Dye's chief and three of his officers, forced out in favor of Hoven's men.

Things soon settled down, and the commission made the force far more professional than it had ever been by requiring officers and applicants to take standardized exams and provide references.

View Down State Street, 1895

The development in University Heights (upper left) means this photograph was taken after 1894–95; the thick woods on lower campus means it was taken before construction of the State Historical Society began in early 1896 (page 131). Moving from the smoke-spewing chimney toward the lake, four decades of university development: Ladies (1871), the towers of Music (1880) and Old Law (1891), South (1855), Main (1858), North (1851), and Science (1884) halls, and the Armory/Gymnasium (1894). Showing an 1880 John Nader renovation to its spire and roof and an 1892 enlargement, the Holy Redeemer Church and school dominate the right side of the picture. Partially hidden by branches in the left foreground is Willet S. Main's 1855–56 sandstone building, the oldest surviving commercial building on the square. A decade or so after this picture was taken, John Nolen would castigate the city for the shabby appearance of State Street, especially the many utility poles. (WHi-11211)

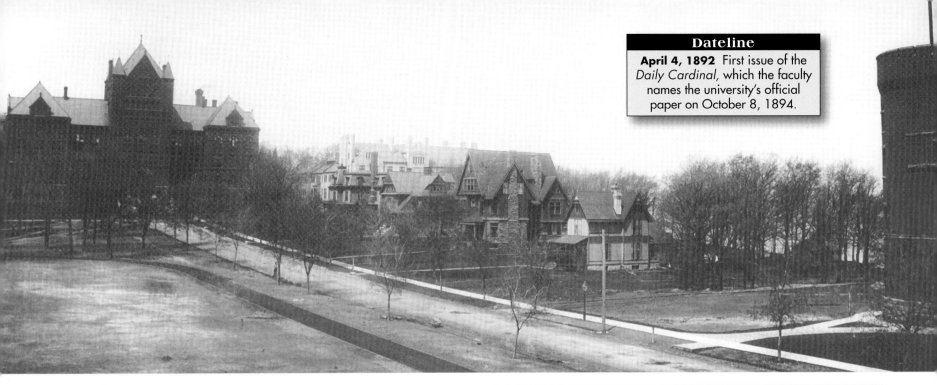

Dateline

April 4, 1892 First issue of the *Daily Cardinal*, which the faculty names the university's official paper on October 8, 1894.

Lower Campus, 1898

Science Hall and the Armory frame the homes, right to left, of E. A. Birge, George Raymer, John and Helen Olin, and the university president. The first three houses were razed in 1925 to make way for the Memorial Union. The president's home came down in the late 1930s for the Union Theater. (University of Wisconsin Archives)

Charles Kendall Adams, ca. 1895

In his library at the presidential residence, 762 Langdon Street. (University of Wisconsin Archives)

Madison Notable

Charles Kendall Adams (1835–1902), president of two great universities, was a popular and successful leader of the University of Wisconsin. Chosen without opposition a few months after resigning the presidency of Cornell University, he maintained good terms with regents, legislators, and faculty throughout his tenure with considerable benefit to the campus. At fifty-eight, Adams was the oldest man yet chosen to lead the university and arguably the best prepared.

Adams's inauguration in Madison on January 17, 1893, was a significant civic event; its glow helped generate good feelings that lasted throughout his tenure, as Adams advanced and implemented programs largely begun by immediate predecessor Thomas Chamberlin. A clever politician — he gave legislators access to the campus pool and other recreational facilities — Adams got almost every appropriation he sought, including funds for the State Historical Society and university library, a new engineering building, and additions to Bascom and Chadbourne halls. Adams was interested in students and strongly supported athletics. He successfully pushed for the university to acquire the old state fairgrounds and Civil War encampment for use as playing fields, modified the design of the Armory gymnasium, and even once bent rules to preserve eligibility for an important football player.

Personally conservative, Adams strongly supported Professor Richard Ely when he was attacked in 1894 for alleged radicalism, and he helped draft the report that declared the university's devotion to "that fearless sifting and winnowing" essential to academic freedom. When Adams's health broke in 1900, the regents at first declined to accept his resignation; they finally did so, with great reluctance, in January 1902. Adams died seven months later, leaving the bulk of his $40,000 estate to the university for graduate scholarships. He had already given his library, and Mrs. Adams had given many of her "trophies of European travel," to the State Historical Society. Although the Adamses both died in California, their remains were returned to Madison for interment at Forest Hill Cemetery.

Faith on Campus?

In January 1898 President Adams reported an unusual problem to the regents — a protest from attorney D.K. Tenney "against the custom of having any form of religious service" at commencement, "founded on the constitutional requirement that within the university no sectarian instruction should be allowed." Tenney wanted Adams to cancel the religious services *and* to throw the YMCA and YWCA out of their building next to the Armory. Adams's analysis: doing away with the Y's would be "scarcely less than a calamity," would depress admissions, and "create an unfriendly spirit in the legislature." They took his advice.

Hallowe'en 1899

The events of October 30–31, 1899, shocked the city and campus, as four hundred university men, egged on by an unruly element of city toughs, wrought havoc on Ladies Hall — looting the basement laundry, breaking up the ladies' annual ball, even stealing their valuables.

Under the leadership of the Women's Self-Government Association, the women responded by evoking Aristophanes and promptly passing a resolution to "have no social relations with the men of the University" until the university had "satisfactorily dealt with the offenders in the disturbance."

President Adams denounced the depredation at his weekly meeting with students at Library Hall. "No man has any right to be called a gentleman who will keep an article of ladies' wearing apparel as a trophy," Adams said, adding he would personally pay for the clothes to be cleaned.

Dean of women Annie Emery urged the women to hold firm, and they did, refusing to rescind the resolution on nonrelations until the faculty dealt with the offenders. It did so on November 16, supending thirteen students, five of them indefinitely. Social relations were thereupon resumed.

Sadly, this was not the last Halloween to be plagued by chaos and crisis.

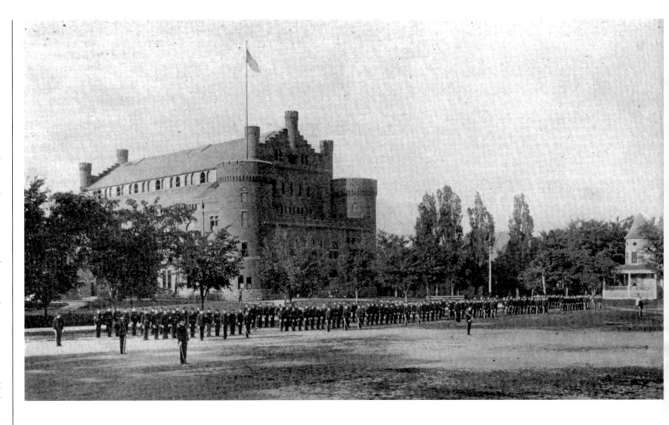

University Armory/Gymnasium

The Red Gym looks like a Norman fortress for a reason. Reflecting fears over the serious civil disorders of the time, those who approved its 1891 funding referred specifically to the need for an armory. But the campus had also been without indoor athletic facilities since the old wooden gym on College Hill burned, and university officials touring armories that also served as gymnasiums on eastern campuses realized how compatible the two functions were. So the plans by Alan Darst Conover and Lew Porter incorporated this dual use, with everything from a drill hall and rifle ranges to running track, swimming pool, and batting cage. But it was President Adams who noticed one unmet need — a public assembly hall to seat several thousand, which he proposed for the second floor. It was thanks to Adams that the facility could house such historic events as the 1902 and 1904 Republican conventions that renominated Robert La Follette for governor and be made available to the Attic Angels for a charity ball to open Madison General Hospital. There were apparently some limits to the university's support for free speech in the facility; while the Wisconsin League of Progressive Women was denied its use in 1920 and author Upton Sinclair was allowed to speak in 1922 only when he promised to avoid certain controversial topics, William Jennings Bryan was allowed to denounce Darwinism in 1921 as "the cause of a preponderance of brutality over brotherhood in present day life." Construction took two years and cost $122,058.48. The building's dedication on May 25, 1894, would "undoubtedly be recorded as most important in the university's history," the *Daily Cardinal* said. Classes were canceled, the railroads gave reduced rates, the Madison Choral Union performed Handel's *Messiah;* there was a parade, military review, boat races, and a gala ball. The building, 196 feet by 106 feet and 101 foot high, was officially opened for use on September 17, 1894. Only the campus women were disappointed — they were denied use of the gym and had to wait for athletic facilities to be added to Ladies Hall in 1896. This photo shows the cadets of the Student Army Training Corps on the drill field in front of the Armory in 1915. (University of Wisconsin Archives)

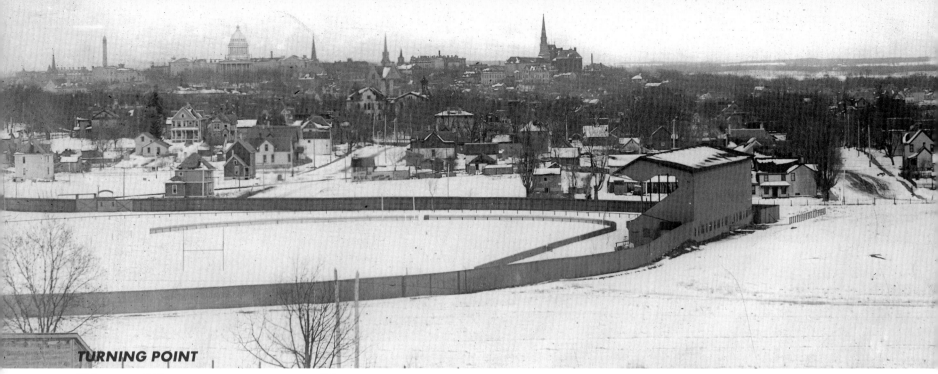

THE UNIVERSITY GETS CAMP RANDALL, 1893

Camp Randall Grandstand with Skyline, ca. 1898
View from the west of the first Camp Randall grandstand, two years after its 1896 construction. From left on the skyline, St. John's, the water tower, the capitol, Grace Episcopal, Congregational, and St. Raphael's. Johnson and Dayton streets run perpendicular to Warren (Randall) Street. (WHi-38999)

I t's hard now to imagine Madison with a fifty-acre subdivision between Breese Terrace and Randall Street, or Regent Street without the economic impact of a nearby football field. But that's the future Madison faced in early 1893.

In the years after the Civil War, Camp Randall was again used for fairgrounds. But when the state fair moved to Milwaukee and the county fair went south of town, pressure to develop the parcel mounted — particularly with former mayor Breese Stevens about to sell and plat his 106-acre farm just to the west as University Heights.

Outraged that their hallowed training ground might be put to such a mundane use as a new suburb, veterans of the Grand Army of the Republic fought to save the site for a more appropriate purpose. University officials and students, eager for facilities to replace the lower campus ball fields in front of the Armory, joined the fight.

The outlook wasn't brilliant for the Badger teams that spring, especially when the legislative committee twice voted to kill the bill to buy the land. But just as a residential plat was being drawn, a very personal appeal by war hero and three-term governor Captain Lucius Fairchild won the day. "Gentlemen," he told the committee on reconsideration, "there is the property; the university needs it; the price is cheap; if you don't buy it, I will."

Whether awed, cowed, or just unwilling to let Fairchild get the credit for donating the land, the committee reversed itself and included the necessary funds in the general university appropriation. On April 29, 1893, the regents paid a group that included Robert M. Bashford — by then another former mayor and Stevens's brother-in-law — $25,000 for the property.

Sixty years later, a leading regent would want to revisit that decision. During deliberations over the 1957 Camp Randall expansion, board president Wilbur Renk tried to get the board to move the athletic stadium "out in the country," meaning the west campus. He argued, rightly on both accounts, that the university needed the site for classrooms and offices, and that parking would be easier farther away. But the rest of the regents recognized that the stadium was too established, and its economic benefit to downtown and Regent Street too great, to give the notion serious consideration.

In the beginning, though, the picture wasn't pretty. President Charles Kendall Adams, a strong athletic program supporter, was particularly dismayed at the state of the grounds. "Not very creditable," he reported to the regents on January 16, 1894, adding that the field had been used the past season, and remained, "a common pasture."

More bad news — many spectators didn't pay. "The financial loss from lack of an enclosure was not inconsiderable," he reported. But Adams had an idea: "Great advantage would be experienced," he told the regents, "if Camp Randall could be fitted up so that it could be used whenever there is any intercollegiate contest."

Great advantage, indeed. By the end of the decade, Camp Randall had a grandstand and a new identity.

University Heights, 1898

Five years after former mayor Breese Stevens sold his 106-acre farm just west of the fairgrounds to the University Heights Company for $106,000, and five years before the suburb was annexed to the city, only a few homes dot the hills that would soon become one of Madison's premier neighborhoods. Thanks to the ongoing growth of the university and the 1892 extension of the electric streetcar line to the state fairgrounds, sales were very brisk at first; half the lots were sold within a week of the company's organization on April 28. But when the nationwide depression hit later that year, sales dried up and construction was put on hold. Finally, in 1894, Martha and Charles Buell built the first significant house in the Heights, faintly visible at the crest of the hill behind the large white house in the middle center. The large Queen Anne, designed by prominent local architects Alan Darst Conover and Lew Porter, was thought to be so far out in the country that it was derisively dubbed "Buell's Folly." The white house on the smaller hill in front of Buell's is the 1896 home of Anna and Richard T. Ely, built two years after the economics professor was vindicated on charges of radicalism. Ely was purportedly the first to purchase a lot, but it is Buell's house, not his, that is on Ely Place. In addition to Stevens, the University Heights Company boasted some of the city's best businessmen, including developer William T. Fish, who had opened the Wingra Park subdivision in 1889, attorney Burr Jones, insurance company president John Hudson, and pharmacist Albert Hollister — men who all lived near each other on Mansion Hill. The company hired surveyor and former city engineer McClellan Dodge to create Madison's first residential curvilinear plat. Further extension of streetcar service to Forest Hill Cemetery in 1897, coupled with the availability of city services after annexation in 1903, brought about a new growth spurt. The "University" appellation was more than mere marketing and the naming of streets; at least 120 of the 346 single family residences within the neighborhood were built and first occupied by senior faculty and university administrators. In this 1898 photo from the Bascom Hall roof, University Avenue runs on a diagonal from the middle of the foreground left, past the first Camp Randall and a neighborhood (center) that was razed in the 1920s to accommodate Wisconsin General Hospital. The row of young trees perpendicular to University Avenue at the base of the hill marks Breese Terrace. (WHi-2225)

Up State Street from Bascom Hill, November 24, 1898

The magnificent State Historical Society building rises in the foreground of this view from Main (Bascom) Hall, about forty years after the image on page 46. With the university library in Library Hall inadequate and the Historical Society collections in the state capitol largely inaccessible, university president Thomas C. Chamberlin in 1891 proposed a joint building to house both functions. Charles Kendall Adams secured the necessary state funding in 1895, and, working with society director Reuben Gold Thwaites, guided all facets of the project. Construction began in early 1896 on the design by prominent Milwaukee architects Ferry and Clas. The building, four stories of steel and Bedford limestone, opened with an elaborate ceremony on October 19, 1900, at a cost of about $580,000. On its centennial, the building was listed on the National Register of Historic Landmarks. (WHi-35697)

Dateline

April 11, 1898 By a 13-2 vote, lame-duck council authorizes contract with American Sanitary Engineering Company of Detroit to construct a sewage purification plant on the "International" system and issue corporate bonds for funding. Professor Charles S. Slichter, the council's expert, votes no.

Madison Notable

Charles Sumner Slichter (1864–1946) was an early embodiment of the Wisconsin Idea, a university professor who first volunteered his services to help the city deal with its growing sewage crisis, then actually got elected to the common council in 1896 with that same goal. Slichter joined the university faculty as an instructor in 1886 and was made full professor of applied mathematics six years later. He served as dean of the Graduate School from 1920 to 1934. President of the Wisconsin Academy of Sciences from 1900 to 1903, Slichter coauthored several textbooks on mathematics and a highly regarded collection of essays, *Science in a Tavern*. A university residential dorm is named in his honor.

Madison Notable

Richard T. Ely (1854–1943), one of the most important figures in American economics, came to the university in 1893 to organize and lead the School of Economics, Political Science, and History. In 1894 state superintendent of public instruction Oliver Wells charged Ely with advocating revolutionary doctrines; an investigation led to the regents' report, written at the instigation of John Olin, declaring that the university "should ever encourage that continual and fearless sifting and winnowing by which truth alone can be found." In 1918 Ely was a leader in the movement to destroy Senator Robert M. La Follette, who he said had "pernicious" influence. Ely went to Northwestern University in 1925 and later Columbia University.

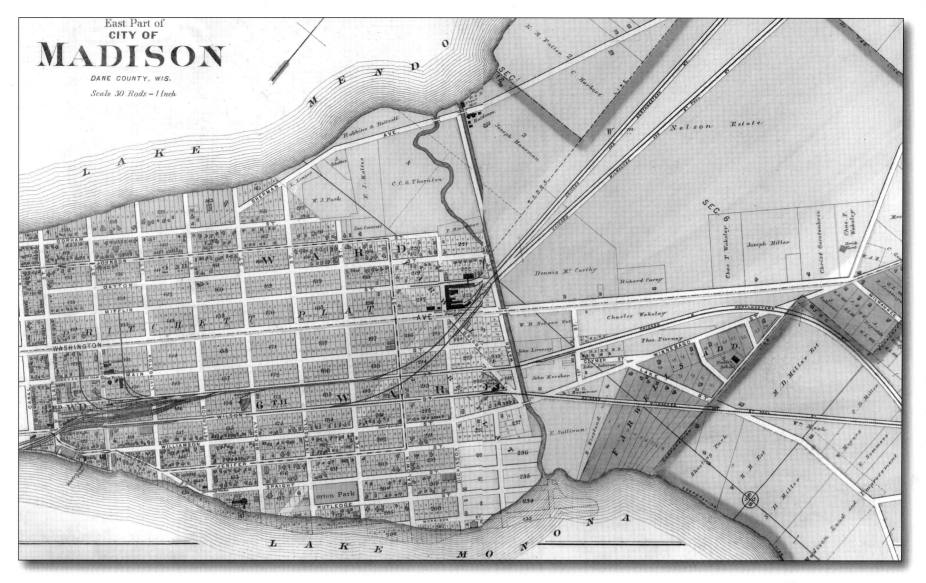

East Part of
CITY OF
MADISON
DANE COUNTY, WIS.
Scale 30 Rods = 1 Inch

East Side, 1890

In 1890, much of Madison's east side was still open and marshy, with few structures east of Blount Street between Dayton and Wilson streets, and only one major factory, the Fuller and Johnson plant. By the end of the decade, there would be significant development, from Implement Row clear to the river. And as the century closed there was another profound change, as D. K. Tenney donated the Thornton property for the park that bears his name. Change was coming east of the river, as well, both within and beyond the city limits (dark line). In April 1890 the newly chartered Madison Land and Improvement Company — the same men behind the University Heights Company, minus one former mayor (Stevens) but with another (Moses Doyon) — purchased the parcel at lower right for $16,000; within a year, the Madison Lakes and Improvement Company bought the land and adjoining tracts for its Elmside resort development (page 134). South of Winnebago Street, an oddly shaped parcel was among the land that Leonard Farwell purchased and platted before he went bankrupt in 1857; he must have figured that the juncture of two Indian trails would make a good business corner. In 1893 he was proved right, as Fred and Wilhelmine Schenk moved onto Lot 14 of Farwell's Addition and opened a grocery and saloon that grew into a regional com-

mercial center (page 160). Around the corner in the next block was the school that opened in 1868. The Schenk family's business success and civic accomplishment over several generations is noted in the name of this new neighborhood, sharing space with an early mayor who had nothing to do with the region. But David Atwood's record was so great that the council renamed the other historic path in his honor while he was still alive, setting the stage for the Schenk's-Atwood neighborhood. Oddly, this plat, published the year after Atwood's death, still reads "Lake Street." This plat also foreshadows another important street; in the 1970s the city took its cue from the Chicago, Milwaukee and St. Paul Railroad in laying out Eastwood Boulevard, with a city bicycle path later going on the rail bed itself. The "Shooting Park" just outside the city limits is the former Schuetzen Park; in 1902 it was subdivided into ninety-six lots, encompassing the area between Division Street and Evergreen Street/Schiller Court. Early in the twentieth century, the Nelson Estate was platted as Madison Square, a saloon-free subdivision bordered by First, East Johnson, and North streets and Pennsylvania and Commercial avenues, and including the future site of the East Side High School (here, the Chas. T. Wakeley property). (WHi-37380, WHi-37381)

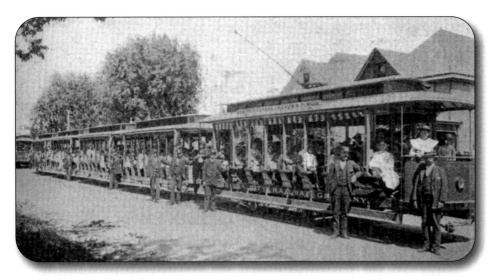

Summer Excursion of the Electric Street Railway *(above)*
The first iteration of the city's trolley system, Madison's mass transit from 1892 to 1935. (Madison Public Library)

Elmside, the Resort Suburb *(right)*
Despite its reputation as the home of workers and artisans, the east side also boasts the only neighborhood that began as a summer resort, Elmside. Backed by out-of-state money men, the Madison Lakes Improvement Company began buying lakefront land in the Town of Blooming Grove in early 1891. By March, it had unveiled ambitious plans to bring to the Lake Monona shoreline the lifestyle of Lake Geneva and Oconomowoc, complete with a renovated Tonyawatha Hotel and a streetcar extension that it subsidized. The company also did the right thing, although possibly with incomplete understanding, in highlighting what is here called "Lake Front Park." These are actually the sites of numerous conical and linear effigy mounds, not noted on the 1890 plat, which the company accommodated in laying out Lakeland (here, Lake) Avenue. A century later, only two or three of the twenty or so originally there remained. That several streets would change names (Park Place to Sommers Avenue, Monona Avenue to Welch) is understandable; that the company would mislabel Atwood Avenue as Milwaukee Avenue and place the Simeon Mills mansion two blocks from its actual location, is less so (but perhaps is attributable to the owners' greater familiarity with Chicago and St. Paul). Despite aggressive marketing and strong support from the railroads, the company could not survive the withering depression that soon hit and declared bankruptcy in June 1893. (WHi-33367)

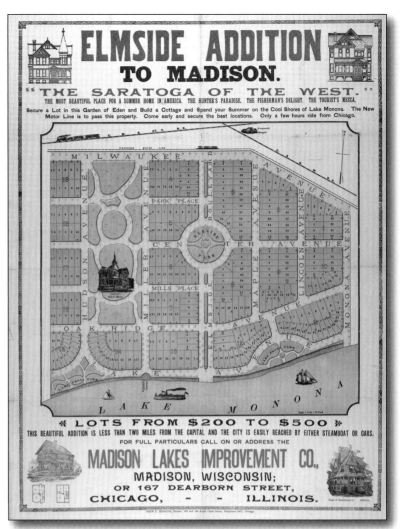

Trolley Timetable

Madison first flirted with an electric streetcar system in 1885, when D. K. Tenney toyed with upgrading his mule line (before he learned he was losing four cents on every ride). Further proposals, both informal and serious, fell through in 1888 and 1890. Finally, in 1892 — some six years after the first municipal electric trolley systems in Montgomery, Alabama, and Appleton, Wisconsin — the city and its citizens were ready. Within five years, the streetcar would sculpt the city in its own image, opening almost two thousand acres of land for platting and development, both within and beyond the corporate limits. During the decade, the Elmside and Forest Hills extensions opened up 1,093 and 722 acres for development, respectively, more than doubling Madison's original 1,361 acres. The availability of easy rapid transit from the outskirts of town thus provided the first push toward urban sprawl, while the convergence of the trolley tracks on the Capitol Square ensured that the central city would retain its commercial dominance (at least, for as long as mass transit was also dominant).

continued on facing page

Hausmann Malt House
The first brewery near the Yahara River outlet of Lake Mendota opened in 1850. After the boom-and-bust experience of John Rodermund, Joseph Hausmann acquired the property and business, pictured here in about 1899. (WHi-36065)

Dateline
May 12, 1893 Council ordains midnight closing time for saloons.
April 4, 1898 In wet/dry referendum, city votes 2,392 to 1,587 to continue issuing liquor licenses.
June 27, 1898 Council rejects university request and committee recommendation, votes 11-5 to continue issuing liquor licenses in campus fifth ward.

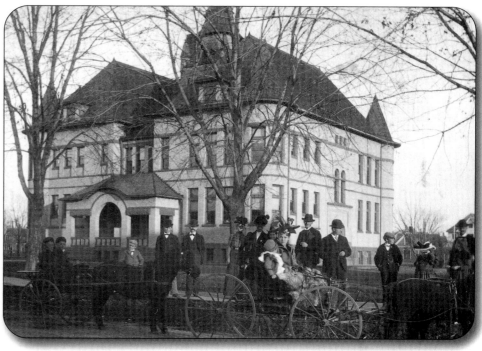

Sixth Ward School
When the sixth ward schoolhouse opened in 1894 at 1237 Williamson Street, it was the city's finest. Designed by Allan Conover and Lew Porter, the school was renamed after Father Marquette in 1904 and abandoned in 1940. Just across the street from Henry Neibuhr's notorious saloon at 1254 Williamson, the school's site is now occupied by the Williamson Street Grocery Co-Op. (WHi-7188)

Trolley Timetable *continued from facing page*

April 19, 1892 Mayor William Rogers attacks mule train company for poor service; asks council to consider revoking its charter.

May 1892 Mayor Rogers calls a public meeting to hear the Thompson-Houston company — maker of the generator that powered the Madison Electric Light Company — offer a 5.5-mile, $125,000 electric streetcar system if Madisonians would buy $25,000 in stock. The people endorse the proposal and send a committee to see similar systems the General Electric subsidiary installed in Des Moines, Iowa, and Rockford, Illinois. The committee, which includes former mayor James Conklin and the man who sold the 1857 railroad bonds, Napoleon Bonaparte Van Slyke, gives an enthusiastic recommendation and the stock subscription is successful.

June 10, 1892 Council awards franchise to Madison City Railway Company.

July 1892 Railway company agrees to provide service to Elmside — a car every twenty minutes, from 6:30 a.m. to 11 p.m., for forty years — after Madison Lakes Improvement Company offers to underwrite cost of track extension.

October 1, 1892 Modern mass transit in Madison begins at 2 p.m., as the first electric street railway cars take off from the Park Hotel. Thousands watch happily as three handsome coaches circle the Capitol Square and head down State Street, past the university, and out to the turnaround at the old fairgrounds. Then it's back uptown for a trip down Williamson Street, easily crossing the jumble of railroad tracks at the east depots, taking the three miles out to Elmside, and back to the capitol at a lively clip. To celebrate the smashing success, there's a formal banquet at the Park Hotel, where John Olin gives a talk on the citizens committee that would grow into the Madison Park and Pleasure Drive Association.

Fall 1893 The developers and residents of University Heights and Wingra Park offer a cash bonus for their own line the following fall, but the deal falls through.

1893–1894 Unable to pay the interest on its bonds during the Depression, company goes into receivership for several years, becoming the Madison Electric Railway Company in the first of many corporate reorganizations.

August 9, 1897 Extension through Wingra Park to the cemetery finally opens, after the company accepts a $10,000 contribution toward the $12,000 cost of the added infrastructure.

1899 Company ends century with daily ridership of about 3,000 in thirty-one cars on 10.25-mile-long system. Fare remains a nickel.

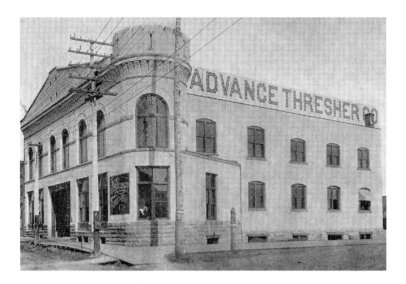

IMPLEMENT ROW

While the heavy industrial uses were developing near the river, the implements trade continued to grow in an L-shaped area centered around the railroad depots. For about forty years, Implement Row was where farmers and agriculture retailers from all around came for their planting and plowing needs.

Two of the most important were the McCormick-Harvesting Machine Company building, 301 South Blount Street, which opened in 1895, and Advance Thresher, which leased space in an early strip mall for farmers, the aptly named Machinery Row. Designed by prominent Madison architect Lew Porter, 601–627 Williamson Street was built in sections starting in 1898. It was made a Madison Landmark in 1982. In 1902 more than thirty showrooms and warehouses worth about $500,000 filled the area, doing annual business of about $2 million with an annual payroll of about $325,000 for the three hundred workers. But by World War I larger forces had come into play to curtail the industry. As university discoveries made Wisconsin dairy farming more profitable, and as wheat production moved to the vast new western lands, the machinery row market withered and its dealers departed.

Dateline
May 1895 After Bell System patents expire, investors led by former mayor Philip Spooner and publisher B. B. Clarke form the Dane County Telephone Company. With better service at lower rates than Wisconsin Telephone, within seven months it has four hundred subscribers; after thirteen years, the former Wisconsin Telephone Company monopoly has only about 250.

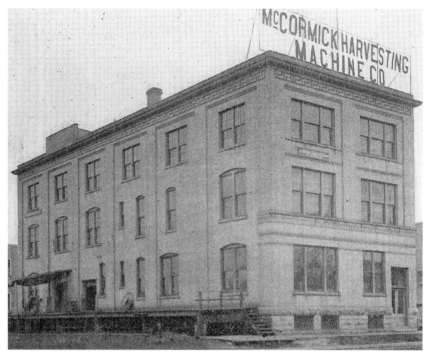

Advance Thresher (WHi-11511) *(left)* and McCormick Harvesting (WHi-9707) *(above)*

MADISON LABOR

Madison's modern labor history began in 1893 with the creation of the Federated Trades Council, two failed strikes, and the city's first celebration of Labor Day on September 2.

The year started with a strike that was more embarrassing to management than beneficial to the workers, when on January 13 union printers at the Democrat Printing Company — publisher of the purportedly pro-union *Madison Democrat* — walked out for recognition, a closed shop, and a nine-hour day (an event the paper didn't report until four days later). Owners E. E. Bryant, George Raymer, and O. D. Brandenburg put business above principle and hired members of the so-called Printers' Protective Fraternity, from Nebraska, as strikebreakers with two-year contracts. The company refused even to meet with union negotiators.

The carpenters' strike that spring was a more serious matter. When the employers' consortium failed to show up at a negotiating session, the newly organized union voted to strike over its demands for a 22½-cent hourly wage, an apprenticeship system, a closed shop, and an agreement to use locally made material whenever practical. Although only 157 of the city's 260 carpenters were in the union, 200 workers walked out on May 24 — just as a building boom was about to start with the construction of 250 structures. Within days, practically every carpenter in the city had quit work, and the building boom burst. The carpenters talked about forming a cooperative mill and yard.

The employers vowed on May 25 not to import strikebreakers, but on May

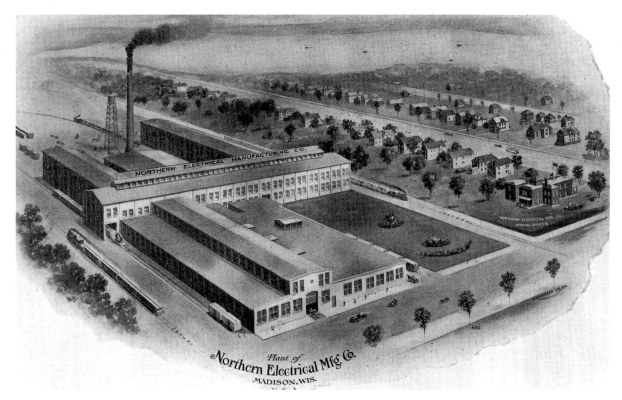

Plant of Northern Electrical Mfg. Co.
MADISON, WIS.

Northern Electrical Manufacturing Company

The mechanical genius behind the Gisholt turret lathes was Conrad A. Conradson, but he wasn't around to enjoy its success. Instead, John A. Johnson fired him because he was spending too much time tinkering with electric motors. So Conradson, who received a master's degree from the university in 1881 and was considered one of America's true mechanical geniuses, got William Vilas and others to back a new venture, the Northern Electrical Manufacturing Company. Capitalized in 1895 at $50,000, the factory in the block bound by South Dickinson, East Wilson, Railroad streets, and South Thornton Avenue produced more than $1 million worth of electric dynamos and motors by the time of this 1902 bird's-eye; its workforce of 350 was almost three times the size of the university faculty. At the sesquicentennial, this complex was owned and occupied by the State of Wisconsin, with plans for private development.

(courtesy of David Mollenhoff)

26 their recruitment advertisements began in nearby cities. At first, strikers meeting incoming trains were successful in getting the imported strikebreakers to leave. But a few of the men soon drifted back to work and within a few weeks a hundred scabs were in town; by mid-July the growing depression of 1893 proved overwhelming and the strike collapsed.

Despite these setbacks trade unionism grew quickly. The machinists, butchers, postal clerks, stonecutters, and cigar makers had all organized in January; over the next two months, led by Milwaukee organizers, the carpenters, painters, printers, cigar makers, and tailors, accounting for about 375 workers, formed the Federated Trades Council. And even though it failed, the carpenters' strike created added enthusiasm, as new workers joined unions and new unions — bricklayers, bartenders, bakers, and brewers — joined the council, which adopted its constitution and by-laws on April 11, 1893. But again macro-economic forces weighed in as the depression suddenly, if temporarily, halted the organizing drive.

Dateline: Power for, Not by, the People

August 25, 1892 Unable to get an electricity franchise for the Four Lakes Light and Power Company they secretly control or drive the four-year-old Madison Electric Light and Power Company out of business, the directors of the Madison Gas Light and Coke Company simply buy the upstart company. The next night the council transfers the electric franchise to the men who had owned the monopoly on power production since 1854.

January 10, 1896 After Four Lakes acts as monopolies often do — raising prices and lowering services — the council creates a special committee "to investigate and report as early as possible on the question of the city's establishing its own electric lighting plan for street lighting." Within a few months, the committee retains a consultant, prepares estimates, and receives twenty-two bids for a municipally owned electric plant.

April 1, 1896 Three weeks after its creation by a Wall Street syndicate, the Madison Gas and Electric Company acquires from Madison Gas Light and Coke and Four Lakes Light and Power their respective franchises for manufacturing and selling gas and electricity. On the new board: Morris Fuller, William Vilas, Breese Stevens, John Corscot, and Napoleon Van Slyke.

October 23, 1896 Impressed by general manager Henry L. Doherty, and concerned over the $24,000 price tag for a municipal plant, the council unanimously accepts new MG & E rate structure, killing — for now — drive for public ownership of the means of production.

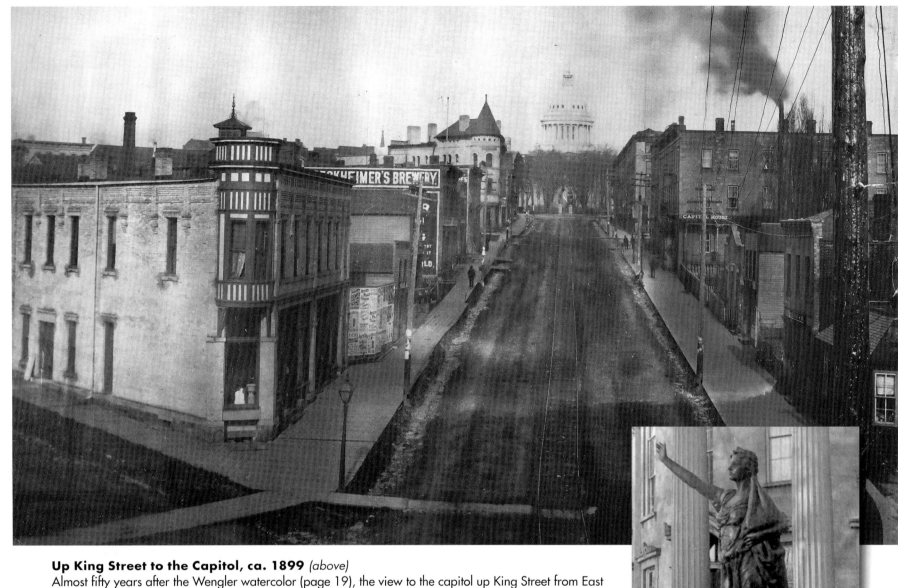

Up King Street to the Capitol, ca. 1899 *(above)*

Almost fifty years after the Wengler watercolor (page 19), the view to the capitol up King Street from East Wilson. The turreted building on the corner of Doty Street is the 1889 Christian Dick block, designed by Frank Lloyd Wright's professor and employer, Allan Darst Conover. A few years after its construction, Wright echoed its image in a boathouse intended for the end of this very axial (page 119). Halfway up the odd side of the 200 block is the Breckheimer's Brewery complex, including a malt house, tap room, and ice-house. Across the street is the 1857 Capital House, which burned in 1922. King Street is graded, rolled, and oiled but not paved, with a single trolley track in the middle; gutters of rock and pottery shard line the wood-plank sidewalks. There are gaslights on the corners, a growing tangle of utility wires, and soot from soft coal wafting overhead. (WHi-36032)

Forward *(right)*

After a clay version of this Jean Pond Miner Coburn statue was exhibited at the 1893 World's Columbian Exposition in Chicago, the women of Wisconsin raised funds to have the work reproduced in copper and placed on a pedestal of rusticated granite. They named the statue *Forward*, after the state's motto. When it was installed between the King Street and Monona Avenue approaches in 1895, it became the first freestanding work of art in the Capitol Park. The statue was cleaned and repaired in 1990. In 1995, a bronze casting was installed on a new pedestal at the State Street entrance and the original was moved to the Wisconsin Historical Society building. (WHi-23092)

THE 1900s

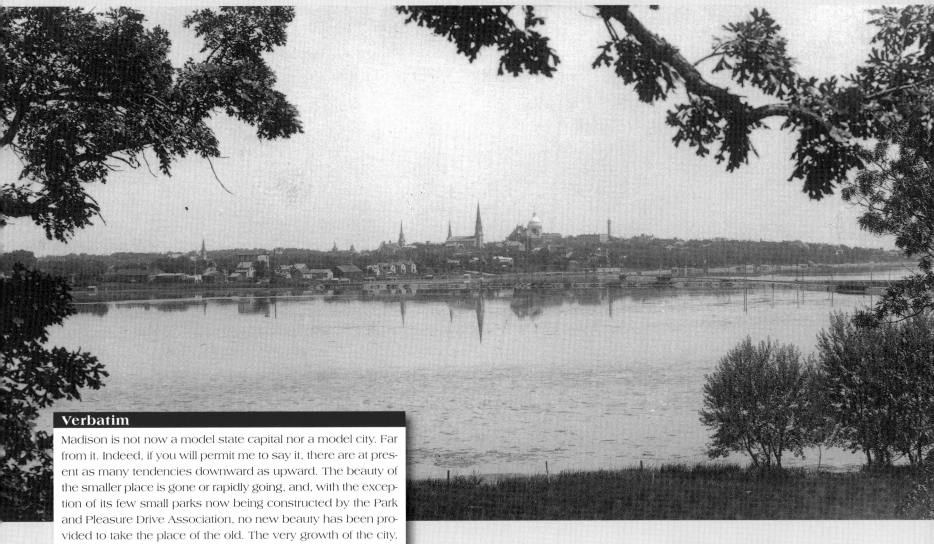

Skyline, ca. 1900
The view from Lakeside Street, just after the turn of the century. (WHi-35704)

View of Main Hall from Lake Mendota Drive, 1908 (WHi-41367)

Some of the best things that ever happened in Madison happened in the first decade of the twentieth century, as a legendary leader developed the city's greatest parks and instigated its greatest plan. Within the span of these few years, John Olin did as much for Madison as any mayor, governor, or university president, making him the most important private citizen in the city's history.

Thanks to Olin, five major parks bloomed, benefiting both sides of town and all economic classes. And thanks to Olin, John Nolen started to write *Madison: A Model City* and unveiled the Grand Mall and Great Esplanade. It was that kind of time.

As the city finished its fifth decade, there were historic dedications galore — the first new high school and the first library building, a block away from each other; the first real hospital and the first lasting synagogue, also just as close. The first church for blacks formed. On campus, a marble monument to history and learning and a new social center both opened. Progressive female activists and lovers of vaudeville both got fine new buildings that would last for generations (although their functions would change).

There was great growth just off the isthmus in either direction. To the west, the city annexed four important suburbs in 1903; to the east, industrialization gathered steam, even if some of the growth was — for now — in the new village of Fair Oaks.

Even setbacks had silver linings. The capitol burned, but without loss of life, as the fire of 1904 only accelerated planning for a palace of politics and government fit for the modern age.

But things were happening that would soon bring trouble. A landfill of garbage was used to turn a low-lying triangle into a new neighborhood of old homes and harsh conditions. Prohibitionist reformers made two wide swaths of the city dry. Over the next two decades, those storylines would converge with tragic consequences.

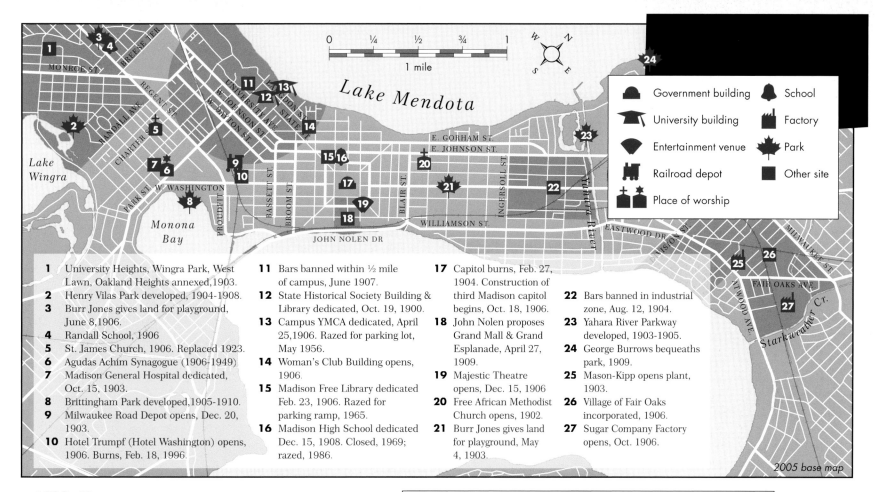

1900s Map (map by David Michael Miller, courtesy of Isthmus Publishing Co.)

1 University Heights, Wingra Park, West Lawn, Oakland Heights annexed, 1903.
2 Henry Vilas Park developed, 1904-1908.
3 Burr Jones gives land for playground, June 8, 1906.
4 Randall School, 1906
5 St. James Church, 1906. Replaced 1923.
6 Agudas Achim Synagogue (1906-1949)
7 Madison General Hospital dedicated, Oct. 15, 1903.
8 Brittingham Park developed, 1905-1910.
9 Milwaukee Road Depot opens, Dec. 20, 1903.
10 Hotel Trumpf (Hotel Washington) opens, 1906. Burns, Feb. 18, 1996.
11 Bars banned within ½ mile of campus, June 1907.
12 State Historical Society Building & Library dedicated, Oct. 19, 1900.
13 Campus YMCA dedicated, April 25, 1906. Razed for parking lot, May 1956.
14 Woman's Club Building opens, 1906.
15 Madison Free Library dedicated Feb. 23, 1906. Razed for parking ramp, 1965.
16 Madison High School dedicated Dec. 15, 1908. Closed, 1969; razed, 1986.
17 Capitol burns, Feb. 27, 1904. Construction of third Madison capitol begins, Oct. 18, 1906.
18 John Nolen proposes Grand Mall & Grand Esplanade, April 27, 1909.
19 Majestic Theatre opens, Dec. 15, 1906
20 Free African Methodist Church opens, 1902.
21 Burr Jones gives land for playground, May 4, 1903.
22 Bars banned in industrial zone, Aug. 12, 1904.
23 Yahara River Parkway developed, 1903-1905.
24 George Burrows bequeaths park, 1909.
25 Mason-Kipp opens plant, 1903.
26 Village of Fair Oaks incorporated, 1906.
27 Sugar Company Factory opens, Oct. 1906.

2005 base map

Dateline

August 9, 1900 Five thousand Madisonians—a quarter of the city — take to the streets to celebrate Robert M. La Follette's nomination for governor. Fighting Bob receives the throng at his home, 405 West Wilson Street.

Foreign Population, 1905

City Total Population: 24,301 Total Foreign Born: 3,782

Total Foreign Born, by Country

1. Germany – 1412	6. Sweden – 128
2. Norway – 782	7. Denmark – 91
3. Ireland – 437	8. Russia – 90
4. England – 247	9. Italy – 73
5. Canada – 161	10. Switzerland – 67

Births and Deaths

1900 Census: 19,164

This decade brought the birth of another great set of brothers, a powerful mayor, a great journalist, and one of the city's most revered spiritual leaders, while nature's debt was paid by some of the city's most important early leaders and benefactors.

- Walter Frautschi (1901–1997), businessman, philanthropist
- Henry Reynolds (1905–1988), businessman, mayor
- Lowell Frautschi (1905–2000), businessman, civic leader
- Manfred Swansensky (1906–1981), rabbi
- Cedric Parker (1907–1978), city editor, *The Capital Times*
- Breese J. Stevens (1834–1903), industrialist, mayor

- Susan Bowen Ramsay (1840–1904), philanthropist, matriarch
- Stephen V. Shipman (1825–1905), war hero, architect
- Horace A. Tenney (1820–1906), pioneer journalist, civic leader
- Henry C. Adams (1850–1906), congressman, developer
- Storm Bull (1856–1907) engineering professor, mayor
- William F. Vilas (1840–1908), philanthropist, U.S. senator, secretary of interior
- Napoleon B. Van Slyke (1822–1909) banker, alderman
- George Burrows (1832–1909), park philanthropist, politician

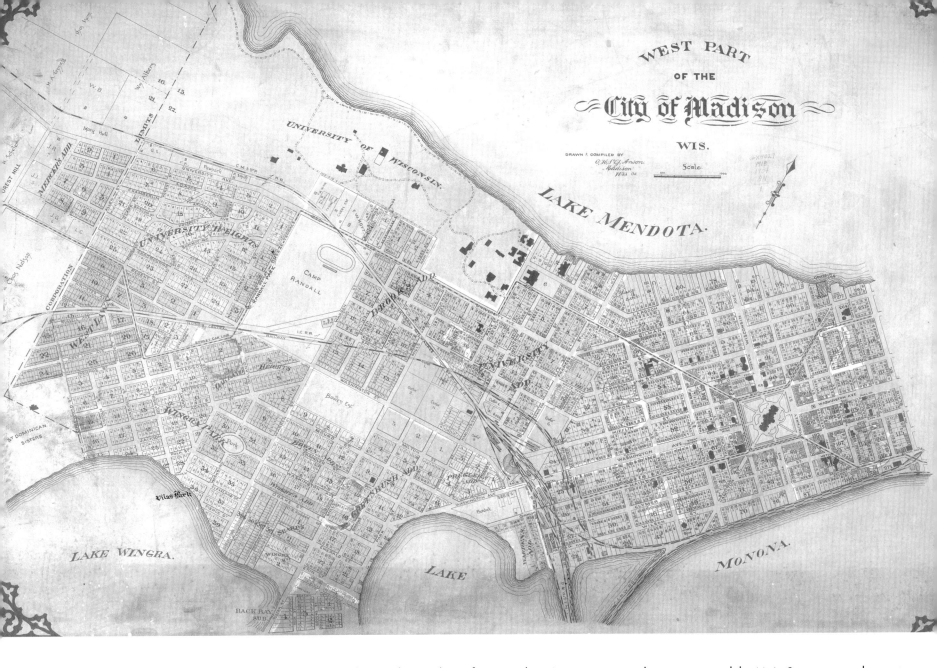

West Part, 1904

This is the first map to show the city's new western border, following the July 1903 annexations of University Heights, West Lawn, Wingra Park, and Oakland Heights. It's also the last map with the old capitol, which burned the year of its publication. Later this same year, reflected here by the calligraphic notation, the start of Henry Vilas Park; not noted are the streets vacated and land donated for the park's creation, southwest of Drake and Warren (Randall) streets. The Greenbush, Bowen, and Pregler additions all have greater street definition here than is evi-

dent in photos taken a few years later (pages 166–167). Yet the map neglects to include something already active — Madison General Hospital, opened in 1903, at just about the "h" in Greenbush.

On campus, the most important new building is the State Historical Society at the base of the hill. The presidential residence and other prestigious homes still share the last block of Langdon Street with only the Armory/Gymnasium, and the field at Camp Randall is still on its original axis.

The streetcar route shows the 1897 extension

to the cemetery and the Main Street spur to the railroad yards, with double tracks to come on Pinckney Street in 1905.

As John Nolen would soon decry, Doty's abject failure to make proper use of the axial streets is painfully evident at three of the four corners. And as had been the case since 1849, and would remain so until 1929, only one property occupies the entire block southwest of Monona Avenue and Wilson Street — the Fairchild residence. (WHi-37394)

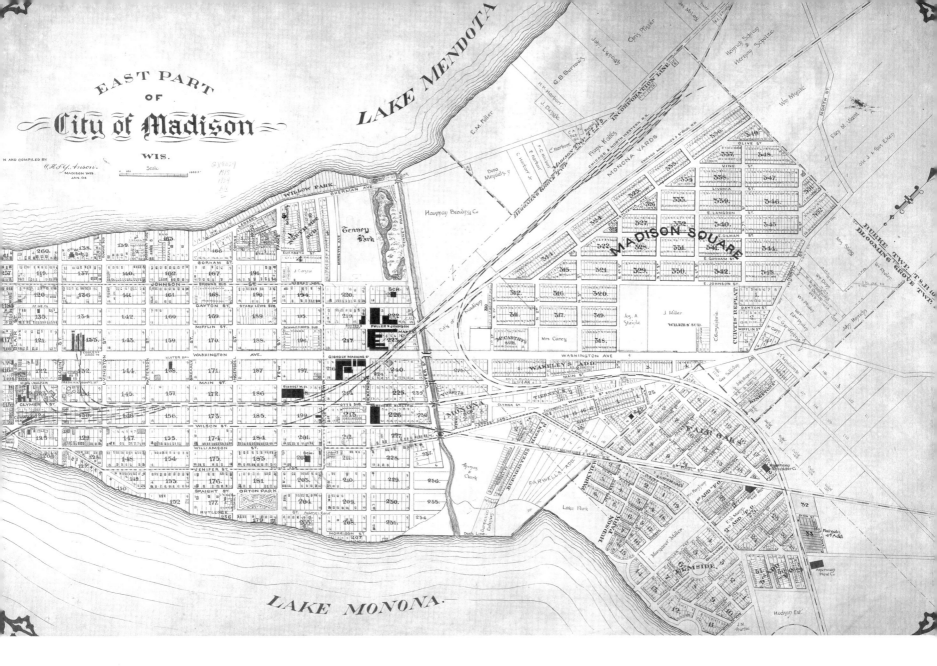

East Part, 1904

The east side shows great growth since the 1890 plat (see page 112) areas of German and Norwegian influence.

What John A. Johnson began has begat two Fuller and Johnson factories, two for the Gisholt Machine Company, and the first Northern Electric plant. As advertised (page 159), Fair Oaks also got industrialized — from the left, Mason-Kipp (soon renamed after the city), American Shredder, and American Plow; the Sugar Beet factory opens in 1906. South of Atwood Avenue (unlabelled), Hudson Park and Parkview have joined the Elmside resort suburb; Schuetzen

Park is now Lake Park, under direction of dance master Frederick Kehl. North, the Fair Oaks Land Company opened its 322 lots, advertised as "homes for working men!" in December 1901. These Blooming Grove subdivisions developed rapidly. But they also developed a rowdy reputation, as town officials paid little heed to their saloons. In 1906, the area east of Division Street incorporated as the Village of Fair Oaks.

The next year, workers started moving into the city's Madison Square subdivision, where industrialist Joseph Steinle has bought the Wakeley parcel on East Washington Avenue. In 1920, he would provide the land for the East Side High

School. The Thornton property's transformation to Tenney Park is well underway, with more to come; it's separated from the Hausmann malt house by the Yahara River parkway, where work has only just begun. The map mislabels the Second Ward School, 720 East Gorham Street (soon renamed for Abraham Lincoln) as the Third Ward's.

Fifty years after Farwell planked and planted the avenue, the marsh still stymies development; twenty blocks between Livingston and Few streets have no structures at all. One of the few buildings, 911 East Main Street (Block 157) is the Blue Goose brothel. (WHi-36498)

JOHN OLIN AND THE MADISON PARK AND PLEASURE DRIVE ASSOCIATION

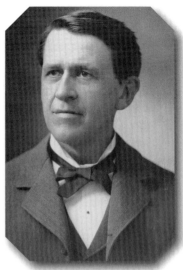

John Olin
Madison's greatest private citizen, during the heyday of the Madison Park and Pleasure Drive Association.
(University of Wisconsin Archives)

Thanks to John Olin, the Madison Park and Pleasure Drive Association (MPPDA), some very special philanthropists, and hundreds of ordinary Madisonians, the first decade of the twentieth century was a golden age of parks development. A hundred years later, their legacy endures. When Olin began his work in 1892, the city's sole park was the 3.5-acre former cemetery on Spaight Street; by the time he retired in 1909, Madison had 229 acres of parks with close to eight miles of water frontage.

The association, which earned national and international renown, raised $243,283.50 during Olin's tenure and built a membership base through a unique system of postcard solicitation. But Olin knew that the long-range health of the park system required municipal involvement, through both bonds and direct taxation. "We wish to aid the city, not to displace it," Olin told the 1903 annual meeting. At Olin's urging, the city that year finally issued its first bonds for park development. Business leader Clarke Gapen, founder of the Forty Thousand Club, was outraged and railed against these "vast proposed expenditures" to benefit the rich and "raise the taxes to such an extent as to frighten people away." "I had not before supposed that the swamp and bogs out of which Tenney Park had been built and the formerly filthy Yahara river were especially the abode of the rich of this city," Olin dryly replied, noting that the city had so far given nothing for the pleasure drives and only $3,000 toward the $15,000 cost of Tenney Park. In 1905, the council endorsed another, even larger bond issue.

That summer, the MPPDA's extraordinary status led to the unique arrangement whereby the city hired its first parks superintendent, Emil Mische. Mische was selected and supervised by the association, but the city was the primary source of funds. Mische's $1,200 salary was to have been shared equally by the association and the city. When Alderman Halle Steensland, a longtime member of the MPPDA board of directors, sought to increase the city's contribution to $900 and reduce the association's accordingly, he was challenged by an antagonistic colleague to explain the difference between the parks group and the Standard Oil Company. Steensland replied, "The difference between the two corporations, is that the one attempts to hold up the country at large while the other is accomplishing good results for the municipality." Steensland's amendment passed.

For reasons both financial and philosophical, Olin's greatest accomplishment came on December 2, 1908, when the council enacted a tax of 0.5 mill dedicated for park purposes. The tax, which brought in about $50,000 annually over the next decade — more than double the association's voluntary contributions during the peak years of the nineteen hundreds — showed that the city now knew parks development to be a *municipal* responsibility.

But some people still complained, because they — mistakenly — thought a 1.5 mill tax hike the year before was due to the parks spending. So to prove that parks spending was good for business, Olin induced the council to appoint a citizens' committee to make a comprehensive and detailed analysis. By March 1909 the committee, which included a veteran member of the state tax commission, a supreme court justice, and even the president of Gapen's Forty Thousand Club, concluded that "from ten to fifteen percent of the increase in the value of taxable property in the city of Madison . . . is attributable to the establishment of parks, drives, playgrounds and open spaces."

Not all of Olin's plans bore fruit, of course. Despite years of effort, a few key landowners kept him from creating a pleasure drive around Lake Monona. Development of Monona Lake Park — now known as B. B. Clarke Beach and Park — took fifteen frustrating years. And when Olin and O. C. Simonds proposed a 132-foot-wide boulevard for East Washington Avenue, featuring a fifty-foot strip of landscaped parkland totaling ten acres of greenspace running from the base of Capitol Square for more than two miles, the city opted instead for a more rudimentary plan by engineer John Icke.

Olin, who was also one of the city's leading lawyers, had awe-inspiring work habits. He not only provided vision and organization for the association; he also purchased its supplies, made contracts for dredging, negotiated easements, wrote the voluminous and well-regarded annual reports, solicited donations — even staked out driveways and cleared brush.

By 1909, it all proved too much, and Olin suffered a breakdown, possibly an early sign of the Parkinson's disease that led to his death on December 7, 1924. On his doctor's orders, Olin resigned as president of the MPPDA on September 20, 1909.

Verbatim

There is a particular fitness in buying lands for parks by issuing long time bonds. The lands are constantly increasing in value. They do not wear out like streets or decay like buildings. Bonds issued for these improvements should be paid by the generation that has the benefit of them. But if some future generation should be called upon to pay the principal of bonds that this generation issues to purchase lands for parks, no complaint will be made. On the contrary, we shall be thanked for having made possible the ownership and enjoyment of these lands to the generations that come after us. — **John Olin**, April 1903

YAHARA RIVER PARKWAY

J ust as Leonard Farwell's construction of a mill at the Lake Mendota mouth of the Catfish River in 1849 had sparked Madison's initial economic development, John Olin's bold bid to widen and landscape the river fifty-three years later served to jump-start Madison's golden age of parks.

Olin unveiled the idea at the MPPDA annual meeting in April 1902. Bemoaning the lack of public parkland and public access to the lakes, and the paucity of city support, Olin made what he later termed an "exceedingly visionary" suggestion. "One of the unique features of Madison and one possessing great possibilities for the beautifying of the city is the Yahara river," he said, suggesting that the land adjoining the waterway be dedicated for park purposes, the river be cleaned and deepened, the railroad bridges be raised, and a lock installed. "It does not require much imagination to see what a revolution such an improvement would work in our city," he said.

In January 1903, Olin laid out a detailed plan to a small but powerful group meeting at William F. Vilas's Mansion Hill estate. Despite opposition from philanthropist/curmudgeon Daniel K. Tenney, everyone else gave enthusiastic support to the design by Chicago landscape architect O. C. Simonds. The newspapers championed the concept, Vilas got the railroads to agree to raise their four bridges (and in case they balked, Olin secured legislation to force them to do so), the council endorsed the project, nearly five hundred individuals gave more than $20,000 — $5,000 more than the fund-raising goal — and by June dredging was underway.

The only missing element, in some minds, was a boathouse. The Power Boat Association sought to interest Olin in the idea, but he was cool to the concept and the parks board later officially opposed any boathouse at all along the parkway. Which was too bad. Cudworth Beye, commodore of the university crew squad, spent considerable time in December 1905 working with an architect eager to undertake the project — Frank Lloyd Wright. "We are always ready when 'Alma Mater' calls," Wright wrote Beye, adding he would design anything the university wanted "from a chicken house to a cathedral, no matter how busy we may be." But the project was not to be.

Despite the lack of bathing or boating facilities, the Yahara Parkway plan was a great success, transforming a shallow and swampy semi-industrial creek into a deep and straight waterway fit for even large craft and supplemented by ample landscaping.

By the time the project was finished in 1906, the railroads had spent almost $47,000 to raise their bridges, Halle Steensland had given an impressive $10,000 stone bridge, MPPDA donors had contributed $25,279, and the city had provided slightly more than $4,000.

But Olin didn't rest on this success; instead, he used the excitement from the Yahara project to create more support and more parks.

Vilas and Olin, ca. 1904
Standing in the southern part of Wingra Park, William Vilas (in black, with bowler) views the woods and marsh that John Olin (seated, on end) gets him to buy for public parkland on Lake Wingra. (WHi-3512)

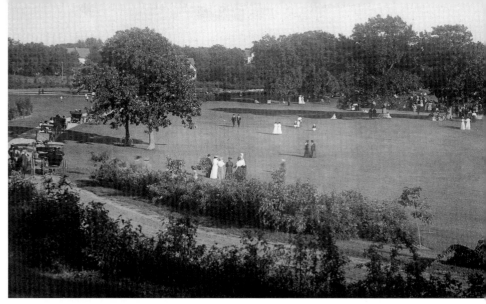

Henry Vilas Park, ca. 1910
A Sunday outing, a few years after completion of the park John Nolen said had "ineffable charm" and beauty. "The Madison parks are for the people," he wrote in *A Model City*. (WHi-3088)

HENRY VILAS PARK

It took a developer's enlightened self-interest to create Madison's favorite park. In its first fourteen years, Wingra Park had seen only modest development by 1903, and none in the area down by Lake Wingra. That's when U.S. Representative Henry C. Adams — one of the subdivision developers, as well as the owner of the farmland that became the nearby West Lawn suburb that same year — had an idea: get someone to buy a large tract of the subdivision for park purposes.

So just as the Yahara Parkway project was hitting high gear, Adams and Edward Kremers, dean of the university's School of Pharmacy, suggested to John Olin that a twenty-five-acre lakefront parcel from Randall Street to Edgewood Avenue, worth about $20,000, be secured for a public park.

Olin approached William F. Vilas, the former U.S. senator, secretary of the interior, and postmaster general grown rich in lumber, manufacturing, and investments. The following spring, Vilas bought the land and offered it to the association. His initial gift on April 25, 1904, carried only these conditions: that all streets within the park be vacated, that Wingra Creek be dredged and deepened, that at least $10,000 be spent over the next two years to drain and fill the park, and that a pleasure drive be built through the woods on the land that Governor Cadwallader Washburn had given to the Dominican Sisters for their school. And one final request: Vilas said he and his wife "shall be pleased" if the association adopted the name Henry Vilas Park, "that it may remain a memorial of our son," who had died in 1899 of diabetes at age twenty-seven.

Work began the following year, again on a design by Olin's favored landscape architect, O. C. Simonds. From the original 23.2 acres of high ground, the park would grow to comprise 64 acres — 8.5 covered by lagoons — as a dredge was used to fill in the low wet bog. It would also feature 53,656 newly planted trees and shrubs and a macadamized drive.

By the time work was substantially completed in 1907, the park cost $63,138.42. The city contributed $15,000, association members proffered $13,138.42, and Vilas gave $35,000 — the largest parks gift by an individual in an era of great parks philanthropy, and the same amount, as it happened, that Vilas paid for renovation of his home at 12 East Gilman. After Vilas died in 1908, his family continued the legacy, contributing another $47,500 by 1920.

William Freeman Vilas (1840–1908) stands unsurpassed among all Madisonians for the range of his talents and accomplishments; he was a soldier, lawyer, educator, orator, statesman, businessman, and philanthropist. Son of Madison's fourth mayor, Levi Vilas, he took the advantages offered him by his birth and multiplied them.

Vilas graduated first in his class of 1858 at the University of Wisconsin, attended law school, and was admitted to the bar at age twenty. He had already come to public notice with an eloquent argument before the Wisconsin Supreme Court before the Civil War interrupted his early career. A Democrat like his father, he nonetheless opposed secession, and compiled a sterling record of service that would serve as a crucial element in his later public career. Vilas returned to Madison in 1863, and in 1866 married Anna Matilda Fox, daughter of pioneer physician William Fox. The couple had four children and buried three of them: Levi (1869–77), Cornelia (1867–93), and Henry (1872–99).

Satisfied to practice law and serve on the faculty of the law school from its founding in 1868 until 1885, Vilas declined Governor William Taylor's offer of appointment as chief justice of the supreme court in 1874 as well as the Democratic Party's nomination for governor in 1877.

Vilas came to national notice with an address at the 1878 reunion of the Army of the Tennessee and a speech at its 1879 banquet honoring Grant. Considered a classic of American oratory, the latter even impressed Mark Twain. Again like his father, Vilas served as a university regent (1880–85 and 1898–1905) and as a member of the assembly (1885), where he was largely responsible for securing the financing that helped rebuild Science Hall after the fire of 1884.

Vilas chaired the Democratic National Convention that nominated Grover Cleveland for president in 1884, and served as Cleveland's postmaster general (1885–88) and then secretary of the interior (1888–89), earning high marks in both posts. The Vilases also became the closest Washington friends of Cleveland and his young bride, Frances, often entertaining the First Couple and hosting their visit to Madison in 1887. When the Democrats regained the Wisconsin Legislature in 1890, they naturally sent Vilas to the U.S. Senate, succeeding his Mansion Hill neighbor, Stalwart Republican John C. Spooner (a mayor's son replacing a mayor's brother). A conservative, doctrinaire Democrat, Vilas split with the party in 1896 when it endorsed the free silver policies of William Jennings Bryan and was denied renomination to the Senate.

Vilas then turned his talents to business, turning an estate worth $300,000 when he entered Cleveland's cabinet into one valued at $1,828,934.71 at his death. He was the key financial figure in the merger that created the Nekoosa-Edwards Paper Company, and he amassed such vast land and timber holdings throughout northern Wisconsin that an entire county bears his name. A messenger in his father's Dane County Bank at age fourteen, Vilas invested successfully in bank securities, was president and a major stockholder of the Northern Electric Manufacturing Company, and served as director of the Madison and Milwaukee and the Wisconsin Central railroads.

But it is not for his soaring oratory, fine legal mind, or dedicated public service that Vilas is today remembered; it is for his philanthropy. During his life, Vilas's chosen charity was the Madison Park and Pleasure Drive Association. But upon his death on August 27, 1908, at age sixty-eight from a series of strokes, it was the University of Wisconsin that benefited to an unprecedented degree. The terms of Vilas's handwritten will were complex, but its results have been clear — a current market value of over $120 million, with millions already contributed for research, scholarships, and such construction projects as Vilas Communications Hall. The Civil War veteran added one more important clause — 20 percent of the scholarships were to go to "those of Negro blood, if such present themselves."

Vilas sought to do one more favor for his alma mater, offering his mansion at 12 East Gilman Street — like his father's was in 1851, the most lavish in Madison — as a residence for the university president. Inexplicably, the university declined the offer, and the estate was razed in 1963 to make way for the offices of a life insurance company.

The New Library, Vilas Residence, ca. 1915

The opulent library features an oil portrait of the late William Freeman Vilas, who spent as much — $35,000 — renovating the mansion at 12 East Gilman as he spent to create Henry Vilas Park. (WHi-35753)

Dateline

May 8, 1903 Council votes unanimously to issue $35,000 in bonds for parks and playgrounds (later used to buy land around Tenney Park and Yahara River, but not a five-acre parcel that Susan Bowen Ramsay offered south of Washington [Regent] and west of Mills streets). Council also unanimously votes to ban private sewer pipes from discharging into lakes and river.

August 9, 1904 After raucous Republican convention at university armory re-nominates Governor Robert M. La Folette, John Olin, attorney for Stalwart Republicans, gets legal authority from State Supreme Court to begin unsuccessful lawsuit to knock La Follette off ballot.

Verbatim

The death of Col. Vilas closes a great career. For nearly forty years he has been a powerful influence in the life of this commonwealth. For nearly a quarter of a century he has been a man of marked eminence in the political life of the nation. . . . For fullness and roundness of achievement from any point of view it is the career of a great man. It will be long before we look upon his like again. — **Robert M. La Follette**

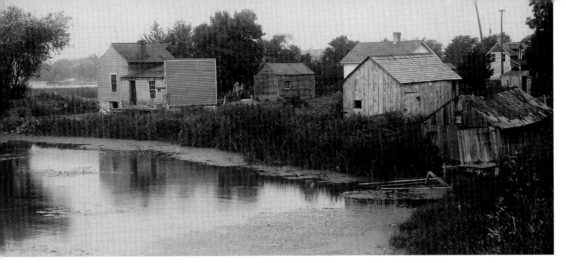

Shacks and Dredge, ca. 1905

A few years after George Stacy described the deplorable state of the Triangle at the MPPDA meeting in April 1904, some shacks remain in the swamp. But change is coming — in the distance, a dredge has begun pumping tons of sand to create new shoreline. (WHi-35797)

Verbatim

A body of water, the surface of which is covered with a green, nasty, obnoxious scum, slimy in its nature, very unsightly to the eye of cleanliness and beauty, detestable to a manly mind, and to a great degree very productive in its motherly care of the Mosquitoes and Frogs. This is a mild description of the conditions which every summer exists in the Triangle and Bay district. — Traveling salesman **George Stacy**, to the MPPDA annual meeting at the Woman's Building, 1904. John Olin hoped his account would spur private aide to improve shoreline land the city had started to buy, and it did — lumberman Thomas E. Brittingham offered an $8,000 challenge grant, which the city and association met. Ironically, the project's first phase in 1905 did not extend to the triangle itself; that would await Brittingham's second $4,000 contribution in 1906. The next year Brittingham gave $5,000 for a parkway to South Madison (today called West Shore Drive), and, in 1908, $7,500 for a bathhouse by the beach (part of another challenge grant, which secured $5,000 in city funds for a boathouse). All were all named in Brittingham's honor.

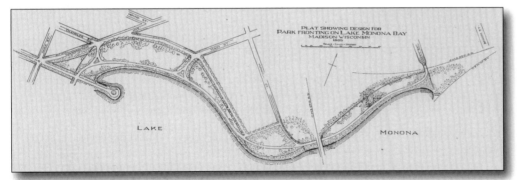

Plat for Brittingham Park

O. C. Simonds's plat for what became Brittingham Park, published in the 1905 MPPDA Annual Report. By the end of the decade, the city and its citizens would spend about sixty thousand dollars to acquire the half-mile strip, dredge 1,850,000 cubic yards of sand onto twenty new acres of usable parkland, plant about twenty thousand trees and shrubs, and start construction on a boathouse and a bathhouse designed by John Nolen. The lakeside road now describes the route of the bicycle path.

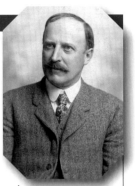

Triangle Post-Dredge, 1908

As identified in the 1909 MPPDA Report, this is "The Triangle, 1908," pictured from the Milwaukee Road trestle, near the area shown opposite. The broad swath of dredged sand would finally be planted with trees and shrubs in 1910. That was also the year the Brittingham Boathouse was built a bit beyond the pool of water, where it stood until moved a ways west in a 2006 renovation. (WHi-11139)

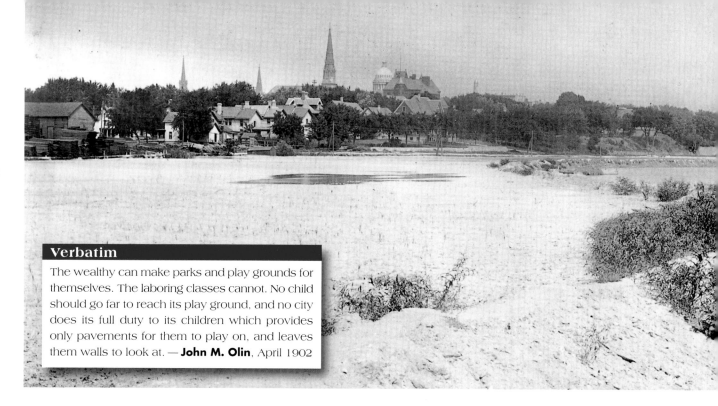

Verbatim

The wealthy can make parks and play grounds for themselves. The laboring classes cannot. No child should go far to reach its play ground, and no city does its full duty to its children which provides only pavements for them to play on, and leaves them walls to look at. — **John M. Olin**, April 1902

Madison Notable

Burr W. Jones (1846–1935), widely considered Wisconsin's most beloved citizen at the time of his death, was a central figure in civic and legal affairs of city and state for over half a century. An 1870 graduate of the university, Jones practiced law with future senator William Vilas, future mayor Alden Sanborn, and his future supreme court colleague E. Ray Stevens. He served as Dane County district attorney (1873–77) and was elected to the U.S. House of Representatives in 1884 but was defeated after one term by then district attorney Robert M. La Follette. Jones served as Madison city attorney in the late 1880s, taught law at the university (1885–1915), and chaired the state tax commission in the late 1890s. Jones was an officer of the Madison Land and Improvement Company, which developed Wingra Park and other early suburbs. He was appointed to the State Supreme Court in 1921, elected to a term of his own, and served until 1926 — alongside three of his former students and one former partner. In other civic activities he was president of the Madison Literary Club and a curator of the Wisconsin Historical Society for thirty-five years. Jones's wife Olive, daughter of pioneer Lansing Hoyt, was a charter member and president of the Woman's Club. She died on April 19, 1906 — at the very hour that her friend and fellow Woman's Club founder Mary L. Atwood was being buried. About two years later, Jones, 62, married a longtime family friend, 43.

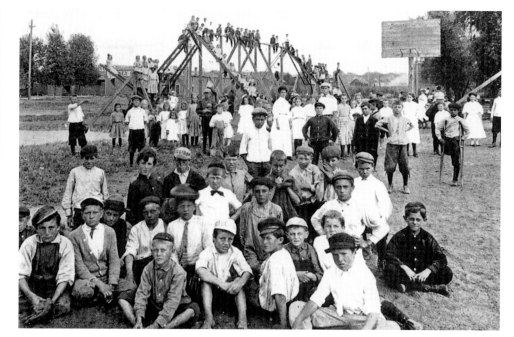

Burr Jones Field

One month after John Olin called for a system of children's playgrounds, attorney Burr W. Jones, brother-in-law of longtime MPPDA treasurer Frank Hoyt, gave the city 4.5 lots at East Washington Avenue and North Livingston Street, worth about $4,000, for just that purpose. The city added 1.5 lots and opened its first public playground, named after its benefactor. Burr Jones Field, pictured here from the 1909 MPPDA annual report, no longer exists, but the additional playground Jones gave adjacent to Randall School — named after his late first wife, Olive Hoyt Jones — does. Olive's brother Frank is also memorialized by the park off Regent Street that bears his name. (Madison Public Library)

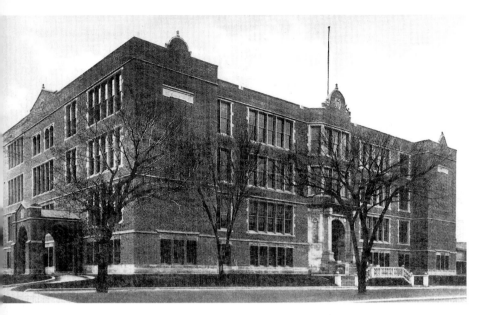

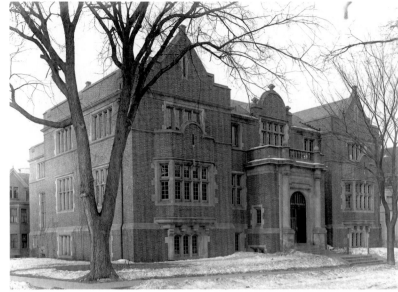

Madison High School

It was the city's women who built the high school. If it had been up to the men, Madison's move to the modern era of education would have taken more time and money. The deficiencies in the 1873 high school (even with the 1887 addition) had long been apparent, and by April 1901 the school board seemed poised to act. A special committee weighed in, as well, declaring on July 2 that the existing facility was "wholly inadequate for its purposes and a serious menace to the health of the children" and formally urging the "immediate erection of a new building." But it wasn't until late 1903 that the school board began a design competition; prominent Minneapolis architect Cass Gilbert was named in January 1904.

The council authorized $250,000 in bonds in May 1904, but a quick taxpayer petition forced a special referendum on July 25. Under the limited suffrage before the nineteenth amendment, women could vote in municipal elections concerning school matters. The council allowed women to vote on the bond, and women determined the outcome. A majority of men voted no, but even more women voted yes; the bond passed, 2,075 to 1,790. "Women save the day," a *State Journal* headline declared. Still, opponents dragged the matter out, filing a lawsuit that delayed ground-breaking until May 30, 1906.

The sturdy brick and stone facility, 210 Wisconsin Avenue at Johnson Street, was in full use when school opened on September 8, 1908. Nearly six hundred attended the formal dedication on December 15. Despite Superintendent Richard B. Dudgeon's hope that the structure would "stand through decades and perhaps through centuries," the building — which was renamed Central High with the construction of East High in 1922 — was razed in 1986, leaving only the Wisconsin Avenue entrance arch. Its last commencement was June 1969. The vocational school building (now the downtown campus for Madison Area Technical College) has occupied the Carroll Street side of the lot since 1922. (WHi-11068)

Verbatim

The favorable result of the election was due in a large measure to the women of the city who were greatly interested in the question of a new high school building and did most intelligent and efficient work in all parts of the city. Much credit is also due to the press of the city, which took a positive stand in favor of a liberal policy towards the schools of the city and did much to shape public sentiment in favor of enlarged school facilities.

— **Superintendent Richard B. Dudgeon**, August 1905

Madison Free Library

Since its creation in 1877, the Madison Free Library had operated out of cramped and insufficient quarters in the cramped and insufficient city hall. Then word came in late 1901 that Andrew Carnegie was offering $75,000 — provided the city would supply both the site and $7,500 in annual operating funds. The site was soon in hand; declining an offer for the southwest corner of Washington and Fairchild — the site later occupied by the YMCA and a state office building — the Library Board on February 5, 1902, agreed on the northwest corner of Carroll and Dayton. On June 10, 1902, the council agreed to Carnegie's terms and accepted the gift — the largest among the sixty Wisconsin cities so favored by the Scottish industrialist. After a competitive review process that included school board meetings on Christmas Eve and New Year's Day 1903–4, the board chose the Frank Miles Day architectural firm of Philadelphia. Groundbreaking was on August 30, 1904, with formal opening on February 23, 1906. The Elizabethan Gothic structure, extensively trimmed in Bedford limestone, featured handsome wainscoting with quarter-sawed oak and a basement auditorium that seated 350. One of the mainstays of the Library Board for many years was E. A. Birge, an officer even during the period of his university presidency. The first woman to serve on the board was Katherine MacDonald Jones (the second wife of Burr Jones), whom Mayor Schubert appointed in October 1908. The library, 206 North Carroll Street, seen here in 1912, was razed for a parking ramp in 1965. (WHi-35801)

CAPITOL CONFLAGRATION

I t was a quarter to three on Saturday morning, February 27, 1904, when a gas jet in the assembly cloakroom flared and set fire to the recently varnished ceiling. Night watchman Nat Cramton tried to douse the blaze with pails of water but couldn't. Madison Fire Department crews responded in time to save the building, but there was no water coming from the tank atop University Hill because the university engineer had emptied it to clean the boilers.

The fire was not fully out until ten o'clock Sunday night, leaving the south wing badly damaged, the east and west wings a total loss. Governor La Follette, awakened by phone at 4:30 a.m., proved a hero in forcefully marshaling efforts to both extinguish the fire and save papers, books, and artifacts. With La Follette dashing about amidst fire and water, scores of townspeople in bucket brigades passed items out of the building to safety. Almost all executive office records were saved, but the collection of Civil War memorabilia owned by the state Grand Army of the Republic, housed in the south wing's upper floors, was completely destroyed — including Old Abe, the stuffed remains of the bald eagle mascot of the Eighth Wisconsin Regiment.

The economic impact was also devastating. Stating he was opposed to "paying profit-seeking companies to share risks of this character," La Follette had recently moved the state into self-insurance. Policies worth $600,000 had been canceled, and the state's fund held only about $6,000 at the time of the million-dollar fire. Nostalgia and money aside, few mourned the loss of the capitol as a functioning office building for state government. Built in 1857 — thanks to $50,000 in City of Madison bonds — the wood-and-plaster building was clearly inadequate; even with the expansion of the early 1880s — itself the occasion for a far greater tragedy — the building's lifespan was limited. Indeed, the 1903 legislature created a special Capitol Improvement Commission, which had just started to meet when this disaster — this opportunity — struck. It would take two competitions, two commissions, and more than two years, but on July 17, 1906, the reconstituted Capitol Commission hired George B. Post as architect. Construction on the third capitol began on October 18 and continued until 1917.

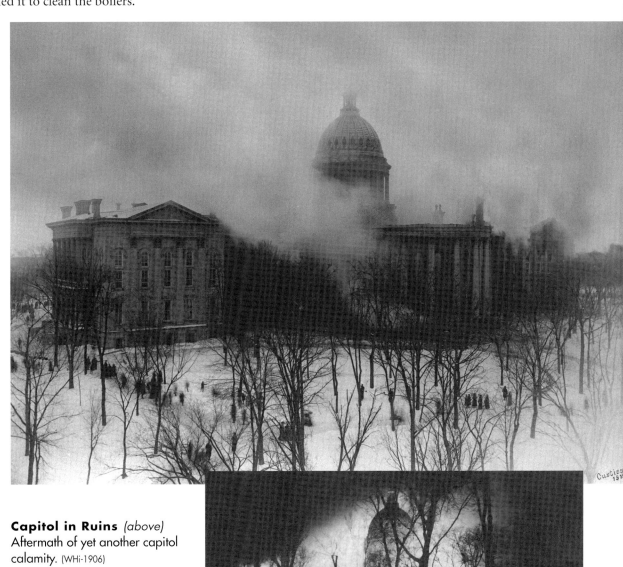

Capitol in Ruins (above)
Aftermath of yet another capitol calamity. (WHi-1906)

Capitol Ablaze (right)
Teenager Joseph Livermore took this picture at about 4 a.m., February 27, 1904. (WHi-4845)

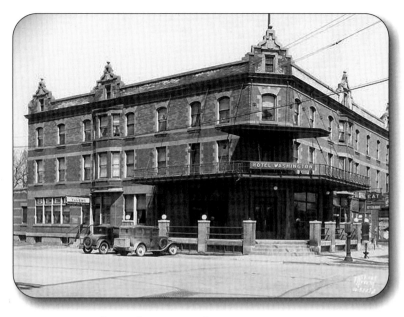

Madison Mayor

William Dexter Curtis (1857–1935), who served one term as Madison's thirty-fifth mayor (1904–6) was a banker, industrialist, and philanthropist called "Cattail Bill" because of the horse collar factory he built in the swampy 800 block of East Washington Avenue. Producing a design patented by his father — a successful lumberman and stock breeder — Curtis also operated in England and France and crossed the Atlantic more than any other Madisonian (about thirty times). During Curtis's administration, the city eliminated the practice of prostitutes working in saloons' backrooms and opened the Williamson Street bridge. A strong supporter of planning and park expansion, Curtis worked with John Olin to secure a commitment from the Chicago and North Western Railroad company to build a $500,000 depot on Blount Street (later scaled back due to neighborhood opposition). Curtis led the fundraising campaign for the Methodist Hospital, contributing $50,000 to the effort. The home he built at 1102 Spaight Street, across from Orton Park, later the residence of Mayor Milo Kittleson, is a Madison Landmark. When someone proposed changing the name of Spaight Street to Curtis Boulevard, he offered an endowment for new trees, but the change wasn't made.

Hotel Washington (above)

Madison's grandest railroad hotel opened across the tracks from the Milwaukee Road depot in 1906 as the Hotel Trumpf. Renamed the Washington Hotel around 1915, and called the New Washington Hotel between 1920 and the late 1940s, the building boasted a dining room, barbershop, Luckey's Pharmacy, and a saloon (which purportedly remained active in the basement pool hall during Prohibition, with access through a secret door in the barbershop). By the late 1970s, the building had become one of Madison's most vibrant entertainment and cultural centers, with live music, a saloon, late-night dining, an elegant cocktail lounge, a gay pick-up bar, a rooming house, and the original offices of the *Isthmus* newspaper. The Hotel Washington, pictured here in 1935, burned to the ground in December 1996; after valiant efforts to recreate the building failed, the site was sold for a mixed-use gas station. (WHi-4118)

Fire Department, 1902 (right)

A pump team poses amid the mud and plank sidewalks in the 200 block of East Washington Avenue. The spire of St. John's Lutheran Church is in the background. (WHi-23433)

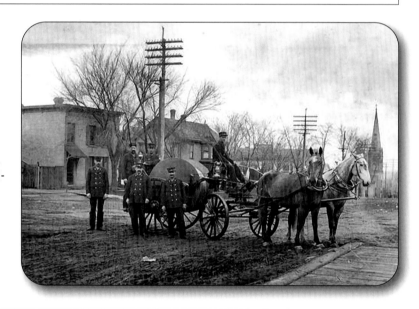

Verbatim

Whereas, the records in the city clerk's office have never been properly indexed, thus making it difficult for the clerk or the public to satisfactorily use the records;

Whereas, cities throughout the country are installing systems which will give the city officials and the public easy access to public records;

Be it resolved, that the mayor appoint a special committee of three aldermen to investigate and report upon a system of indexing and the cost thereof, which will be adequate to the needs of the city clerk's office. — **Madison Common Council Proceedings**, May 9, 1902

Madison Mayor

Storm Bull (1856–1907), invited to join the university engineering faculty in 1879 thanks to his world-famous uncle, violinist Ole Bull, brought fiscal responsibility to city government as Madison's first (and so far only) faculty mayor in 1901. As an alderman in the late 1890s, the Norwegian native became aware that "not one person connected with the city government has any idea what the books of the city will show at the end of the fiscal year." As mayor, Bull successfully pushed a comprehensive reform package that featured annual prospective budgets and the requirement for a three-fourths council vote for budget amendments. Ironically, although the academic advocated for city fiscal affairs to be "conducted as much like those of private enterprise as possible," he was ousted after one term by a private-sector candidate espousing more aggressive development strategies, John W. Groves.

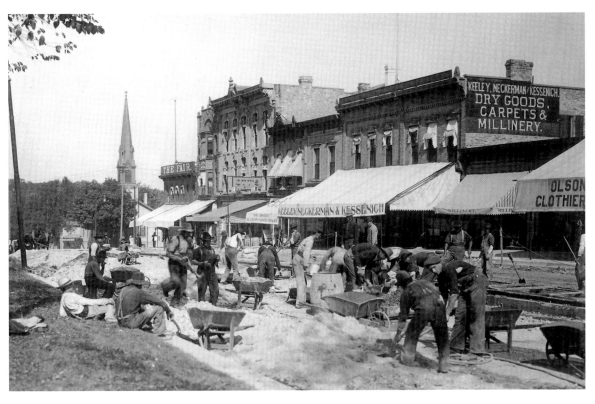

North Pinckney Street, 1905

As the city and state battle over where to place the utility poles, workers build a double streetcar track around Capitol Square. The three-story building with decorative lintels is the Ellsworth Block, built in 1871; it remains in active use a century after this picture, as do the two buildings to its right. Four years after this picture, Keely, Neckerman and Kessenich built their own four-story store; in 1916, Kessenich sold his interest to go into business with his sons across the square at Mifflin and Carroll streets, later opening the first major department store on State Street (page 229). In 1924, the year after Kessenich made that bold move, the eleven-story Belmont Hotel replaced the Fair on the corner of Pinckney and Mifflin streets. The steeple is the German Lutheran Church, its North Hamilton Street site occupied in 1929 by an Art Deco Montgomery Ward. (WHi-11040)

It's Sticky for Icke

What would become one of Madison's most successful construction careers was on the line on October 9, 1903, when twenty-eight-year-old city engineer John Icke faced five charges of public misconduct and a motion of censure. A special council investigative committee offered evidence that Icke, in his second year in office, had used city employees on private work and that he secretly lowered the engineering standards for the Greenbush pumping station and sewers so a friend could get the contract. Icke, assistant engineer under Professor Turneaure while still in college, admitted using city staff to lay out a subdivision in Sauk County but said that was standard practice for the office under both Turneaure and McClellan Dodge. He also admitted changing the bid specifications for the pump house and altering the sewer elevations and telling only one person about it (the successful bidder), but said it made economic and engineering sense, and that Mayor Groves knew about it before he signed the contract (a claim Groves denied). The council declared the use of city staff on private work to be "wrong and liable to abuse," but voted 11 to 6 to drop the censure motion because "all of the acts in said charges were done without improper motive." The lenient majority included two future mayors (Sayle and Schmedeman), a prior one (Corscot), a good government reformer (Professor Sparling), and Turneaure himself. The council kept Icke as city engineer until 1912, when he opened his own construction company, which became one of Madison's most successful. But the council did make one change — two months later, it unanimously adopted an ordinance banning city officials from using city employees "in any work other than for the city of Madison."

Madison Mayor

Joseph Schubert (1871–1959), a photographer by trade, was Madison's youngest and longest-serving mayor of his era, 1906–12. The native Madisonian served seven years on the council before being elected mayor on a liberal anti-temperance, pro-parks platform. "His allegiance to the saloon interests could barely be more servile were he a paid agent," the disapproving *Madison Democrat* declared during his first mayoral campaign. Despite his wet views, Schubert worked closely with Olin and succeeded him as president of the MPPDA — a position he held at the same time he was mayor and the city was hiring, then firing, John Nolen. Schubert also strongly supported commission government. He was twice reelected by increasing margins before stepping down to run a candy business, return to photography, and open an apple orchard in Gays Mills. Under his administration Madison opened the new high school, city market, Brittingham boathouse and bathhouse, and an addition to Madison General Hospital, and laid the first creosoted pavement. Schubert is buried at Forest Hill Cemetery.

Verbatim

The water tower — a great, big, useless and unsightly pile of discolored bricks — is being repaired at a cost of $50.

This alleged standpipe does two things:

First — it operates the elevator at the Park Hotel.

Second — it frightens people.

The tower is a fizzle, and it always has been. Citizens should rise up and demand Mayor Schubert to have it removed. Public safety is entitled to that consideration.

If it ever falls — well, get it down before that happens! — **Wisconsin State Journal**, June 29, 1906. The paper's efforts would pay off with the deconstruction of the water tower — in 1921.

MADISON GENERAL HOSPITAL

Despite the provisions in the city charter empowering the council to establish a board of health, provide a hospital, and "regulate, prevent and control" the movements of persons with contagious or infectious diseases, health care was initially seen as primarily a private, not public, concern.

When Joseph Hobbins, an English physician who organized the medical department at the university in 1855, introduced the first council resolution to build a city hospital just weeks after incorporation, it was referred to the health committee and never acted upon. The city didn't even appoint its first health officer until 1885.

Throughout the nineteenth century, as those with homes and extended families received care there — and those without looked to hotels, the jail, or Milwaukee — Madison followed a fitful course in providing medical treatment to the sick. An 1881 effort to establish a nondenominational hospital in Orton Park fell afoul of intense opposition from sixth ward neighbors. In 1887, the city gave a prime lakefront lot on the western corner of North Paterson and West Gorham streets to the Sisters of the Franciscan Order at Milwaukee for a nondenominational hospital for the poor, but fundraising failed.

Physicians James Boyd and William Gill opened the first modern hospital in 1890, the thirty-five-bed "Madison Hospital," 413 South Baldwin Street. Billed as the "best hospital accommodations in the state," it even offered a rudimentary health insurance (not available, however, for hospitalizations due to insanity, venereal disease, or injury caused by intoxication or fighting). When Boyd and Gill finally broke even in the third year, they hoped the city would take over the hospital and operate it as

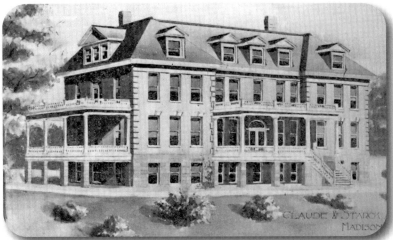

Madison General Hospital, Park Street elevation, by architects Claude and Starck. (Madison Public Library)

a public facility. But the city not only refused to acknowledge public health as a public responsibility — it wouldn't even offer a tax break. The Madison Hospital closed in 1893 and was converted into an apartment building many years later. At the turn of the century, it seemed the city was about to obtain a real hospital. Four lots across from Camp Randall were for sale, and the new Hospital Association was trying to raise the necessary $12,000 by offering lifetime medical care for a $500 donation. But then a special sixth ward parcel became available — the corner of Brearly and Spaight, site of the old Farwell mansion/Harvey Hospital/Soldier's Orphans Home. Despite the connection with the historic use of the property, and an early $1,000 toward the $10,000 cost from Attic Angels, the neighbors who had earlier prevented the use of Orton Park for a hospital vigorously fought this proposal, as well. They thought that using eighty feet of lakefront for a hospital was bad land use and would hurt their property values, so they started a petition drive and talked about litigation.

Then, on the Fourth of July 1900, Susan Bowen Ramsay, daughter of homeopathic physician and former mayor James Barton Bowen, offered 4.5 acres of her eleven-acre estate to the Hospital Association, also for only $10,000. But this proposal fell through as well.

In March 1902, real and permanent progress when the association secured an option on a block in the Greenbush Addition. Thanks to lobbying by Mary Means Hobbins (whose bank

president husband was the nephew of Dr. Joseph Hobbins), the council appropriated $15,000, conditioned on the association raising another $10,000. Thanks again to the women — especially the ladies of Attic Angels — that target was easily met. The association bought the block and retained noted local architects Claude and Starck.

Madison General Hospital opened on October 15, 1903, at 925 Mound Street. Hospital president W. A. Henry was restrained in his remarks, ruefully commenting that the story of the hospital's founding "may as well be left unwritten, and should perhaps be forgotten."

Some physicians said the site was too inconvenient, and it was — West Washington Avenue wasn't even improved past Bedford Street when construction began. So they opened their own facility — ironically, in the same Spaight Street neighborhood that had opposed the hospital. That private hospital lasted little more than half a year before it closed and the doctors associated themselves with the Greenbush facility — helping to push the new facility to capacity in under a year, and the neighborhood to a new identity.

An Unhealthy Hospital

Within a few years, controversy enveloped the hospital. In 1908, the council found that the facility was so "badly overcrowded" and took so many nonresident patients that city patients had to wait a week or more for a room, often filling the hallways; that "there has been a great deal of insubordination, quarreling and dissension among the nurses and those in charge," made worse by "the interference of a certain member of the Board of Directors"; and that the physicians were paying commissions to outside doctors for patient admissions. On July 10 the council endorsed sweeping reforms, "to run the hospital for the benefit of the city sick rather than for the accommodation of the physicians' practice." Among the recommendations to the Hospital Association: giving city patients preference, stopping the commission practice, making the matron supreme and free from interference, and removing all physicians, clergy, and women (except the chair of the Women's Auxiliary) from the board.

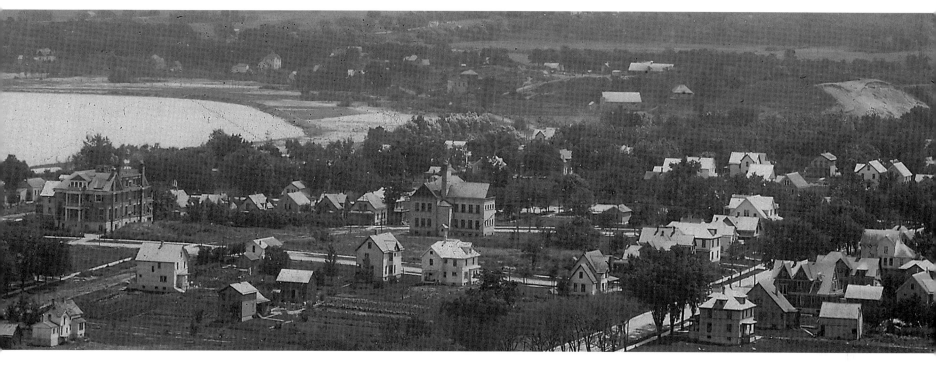

Hospital, School, Ridge, ca. 1908

This unique photo shows destruction of the ancient and construction of the temporary. At left is Madison General Hospital, a bit before its fifth anniversary. At center is the 1893 Greenbush School, as called for by Mayor Bashford. The improved street in the right foreground is Mills, the primary north/south road and dividing line between the Greenbush and Bowen additions. The Bowen-Ramsay estate is faintly visible at right, the far right corner of Mills and Chandler.

Behind them, remnants of the Ice Age — the Dividing Ridge recessional moraine, extending south from about Erin Street. When Horace Tenney became street superintendent in the 1840s, the ridge was a half-mile long and as high as the eight-story St. Mary's Hospital that now occupies part of the site to the left of the main ridge. More than twenty conical, effigy, and linear mounds graced the ridge, along with relics, campsites, and graves. But it was all atop huge piles of sand and gravel that were ideal for cement, street construction, and marsh reclamation (including nearby Vilas Park). Six decades later, the ridge remained, but much reduced; another decade or so, and it was gone. Although archeologist Charles E. Brown denounced the destruction as "a crime which should never have been perpetrated," preservation of the full ridge would have presented overwhelming challenges to Madison's modern development. (WHi-36063)

Horse Grazing on the Ridge

Disregarding the spiritual and cultural significance of the ancient relics, locals let their horses graze along the Dividing Ridge. (WHi-39008)

Dateline

August 12, 1904 First-term alderman John H. Findorff, 37, announces he will resign from council so he can accept city construction contract for sixth ward schoolhouse and other projects without being accused of improper dealings. Findorff, Madison's first and most successful general contractor, was elected after the Icke controversy.

Bar Wars, Round Two

Twenty-three years after John Bascom battled bars, his successor Charles Van Hise took up the fight and found greater success using a new temperance tactic — incrementally making it more difficult and more expensive to buy a drink.

In January 1897, the council had unanimously imposed a *cordon sanitaire* around the campus, banning bars within a sixteen-block area around Langdon, State, and Lake streets. But that was only the start. Under a state law that let municipalities set tavern fees by referendum every three years, the dries were slowly making progress on their plan to shut saloons by making it too costly for them to operate. In April 1901, Madison voters approved the issuance of liquor licenses by better than 2 to 1, but that September, the prohibitively "high" fee of $500 — which would have closed about 20 percent of the city's saloons — lost by only nine percentage points. Three years later, after the election of reformer William Dexter Curtis as mayor, the low fee's victory margin had narrowed to about two points.

In August 1904, apparently believing industrial workers needed to be protected from themselves, the city created a saloon-free zone surrounding the Gisholt and Fuller and Johnson factories on East Washington Avenue — twenty-two blocks, from Ingersoll and Railroad streets to the Yahara River.

Then it was back downtown, where Van Hise was worried — rightfully — about the impact Madison's saloon culture was having on the campus. After reform candidate Leslie Rowley's 1906 mayoral campaign attacking the liquor interests sparked statewide concern, the growth in student enrollment dropped from 7 percent to essentially zero. The solution, university leaders said, was to increase the dry zone around the campus. And if the city wouldn't do it, then the state would have to. Mayor Schubert, who authored the ban on bars in the industrial zone, opposed this effort and got some unique personal attention: "Baptists Pray for Mayor Schubert," the *Wisconsin State Journal* declared in a front-page headline in January 1907. Still, the city seemed unlikely to extend the dry zones that spring: "Booze Holds Fort in Madison Council," and "Saloons Score Usual Victory in the Council" were typical *State Journal* headlines in March and early April.

That's when the heavy hitters got involved, filing a petition with the council on April 12 demanding a larger saloon-free zone around the campus. President Van Hise led the list, followed by such luminaries as Burr Jones, Magnus Swenson, Steven Babcock, Daniel K. Tenney, and about two hundred other influential — and wealthy — property owners. And if that didn't grab the council's attention, their next move two nights later did — a huge mass meeting at the Red Gym of more than four thousand booze bashers, about one-seventh of the city's population.

Thanks to the number and status of the attendees, on April 16, 1907, a unique wave of reform struck the council. Not only did the aldermen add three blocks to the campus dry zone, for good measure they revoked a license for a saloonkeeper convicted of selling to minors.

Dry forces pushed on, still seeking a state statute. The legislature had almost seemed ready to impose an even larger zone when tavern industry lobbyists agreed on a half-mile radius — closing a handful of saloons but stopping just short of the venerable Hausmann brewery at State and Gorham. Another referendum on the license fee, which had been kept low by a plurality of 211 in 1904, was set for September 17, 1907. Saloonkeepers threatened to use smaller glasses and end the practice of providing free lunches if the annual license went from $200 to $500. Their tactic backfired, as Madisonians voted 2,254 to 1,306 for the $500 license. The temperance team was on the move, and would press its advantage to the logical — and totally dry — conclusion.

The Bar at the Hausmann Brewery
The 1907 ban on bars around the campus stopped just across the street from the venerable institution, pictured here in 1895. (WHi-3054)

Stall Saloons

Reformers had another target in the early twentieth century — prostitution. In addition to the fancy Blue Goose incongruously located in the middle of the marsh at 911 East Main Street and a row of cottages on Tonyawatha Trail, several downtown taverns for years featured cubicles or stalls where prostitutes could service clients.

"About fifty percent of our saloons are thus fitted and we find it almost impossible to stop this evil," Police Chief Henry Baker said in 1903, urging the council to outlaw the so-called stall saloons. That year, they finally were; enforcement started on the Ides of March and accomplished what Baker called "an important moral reform in this city."

Baker also understood the economics of stall saloon prostitution. "The liquor dealer who allows these women to come to his place of business should be punished equally with those unfortunate creatures," he said, "as through them the saloon man derives a profit from the sale of liquors."

> ### Dateline
>
> **August 12, 1904** Council adopts Alderman Schubert's ordinance banning saloons between Ingersoll and Railroad streets and the Yahara River. Council refers to committee Alderman Smith's proposal to spend $5,000 to create a lakeshore park at the end of Monona Avenue.
>
> **September 7, 1905** Judge E. Ray Stevens issues order compelling Mayor Curtis and council to revoke Henry Niebuhr's saloon license because he kept his bar at 1254 Williamson Street open after the midnight closing time.

The Carnival That Launched a Business Group (left)

With Madison only the ninth-largest city in Wisconsin in 1895, business leaders looked for new promotional ideas; at their behest, the council created a Carnival District around the square, controlled by a private Carnival Association (the council also contributed $50 for public lavatories). More than sixty thousand visitors came, spending about $2,000 (mostly at concessionaires rather than local merchants) and enjoying entertainment ranging from the burlesque tents and Sappho show on King Street to Mrs. B. B. Clarke's chariot of ten thousand carnations. There were lectures, too, and the formal dedication of the magnificent new State Historical Society building on campus.

But it was the afterparty that made real news. That was when surgeon Clark Gapen proposed a business club dedicated to doubling, within the decade, Madison's population to reach the level state law set to be a city of the first class—forty thousand. The Forty Thousand Club was unveiled in January 1901 with Carnival Association president John W. Groves as its first president. In 1902, Groves unseated incumbent mayor and Democratic academic Storm Bull, with more accomplishments to come. Stock drives helped recruit the Mason-Kipp Company and finance the U.S. Sugar Company, while negotiations with the railroads secured better passenger schedules (which helped recruit various conventions).

But the 1910 census counted only 25,531, and the Forty Thousand Club, having failed, faded away. So did its successor, the Commercial Club, leaving Madison again without any organized effort to promote its private sector.

Madison Notable

Amos P. Wilder, father of Pulitzer Prize–winning playwright Thornton Wilder, was the successful editor of the *Wisconsin State Journal* from 1894 to 1906. The cosmopolitan Dr. Wilder was a vibrant writer and excellent editor who deplored newspapers that "magnify triviality and make vice commonplace." When Wilder assumed control of the afternoon paper, it was a distant second to the stodgy morning *Madison Democrat*; within Wilder's first decade, *State Journal* circulation nearly doubled and easily surpassed the *Democrat*. Wilder supported Governor La Follette until 1903, when he sold control of his editorial page to the anti–La Follette state Republican committee for $1,800. Wilder said later he should have charged more. Wilder retained majority ownership of the paper when he was appointed American consul to Hong Kong in 1906, ceding editorial control to business manager August Roden.

Dateline

May 12, 1902 Mayor Groves directs Police Chief Baker to warn proprietor of Blue Goose at 911 East Main that she is not to reopen as a brothel. Property had been recently listed as a "female boarding house" for insurance purposes.

April 10, 1903 In impromptu discussion after council meeting, Supreme Court Justice John Winslow, emphatically jabbing his index finger, angrily lectures Mayor Groves on his duty to direct police department to enforce liquor laws.

Madison Mayor

John W. Groves (1855–1921) helped found the Forty Thousand Club of business boosters and as its first president served one term as Madison's thirty-fourth mayor (1902–4). Groves became a carpenter at age fourteen and later taught school, ran a music and book store on East Main Street, was a traveling piano salesman, and served as assistant superintendent of public property before striking success as a real estate dealer.

TITANS' TAX TANGLE

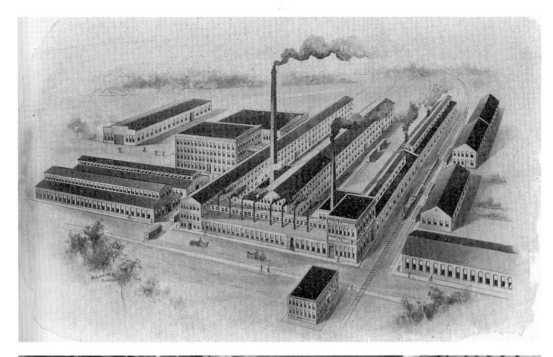

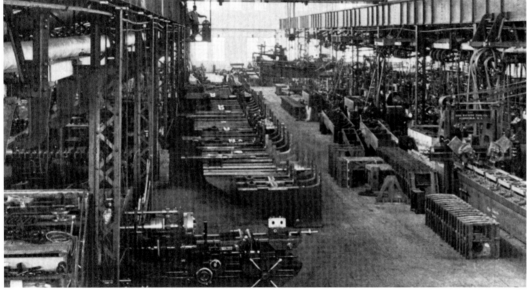

Fuller and Johnson Manufacturing Company and Gisholt Factory Floor, ca. 1902
Some of the industrial legacy of John Anders Johnson, seen shortly after his death in November 1901. The Fuller and Johnson complex, filling the 1400 block of East Washington Avenue, held 400,000 square feet of floor space, where about four hundred workers earned $200,000 using six thousand tons of iron and steel, four thousand tons of fuel, and one million feet of lumber to produce $1.5 million worth of plows, cultivators, and gasoline engines. This general view incorrectly shows the railroad track *on* East Washington, rather than crossing it. The building in the center foreground is the main office on the west corner of North Dickinson Street, restored eight decades later as a successful restaurant and bar. Most of the other structures have been razed, although some remain as the Washington Square office complex. The interior of the Gisholt factory shows some of the 75,000 square feet where about three hundred workers manufactured machine tools around the turn of the century. The companies were in 1902 the fourth and eleventh largest taxpayers, respectively, and would grow through the decade. (WHi-35741, WHi-35790)

Two titans tangled over taxes in the summer of 1900, as Daniel K. Tenney tried to raise the assessments on John A. Johnson's two east-side factories just a few blocks away from the lakefront park Tenney recently endowed.

Tenney, who unapologetically favored tourism over manufacturing as an economic base, thought that the assessments — $105,000 on the Fuller and Johnson plant and $56,000 on the expanded Gisholt works — were woefully low; Johnson called Tenney's effort "pernicious," his conduct "improper and outrageous," and Tenney himself "dumb as an oyster." When Tenney said the assessment should be $500,000, Johnson offered to sell him the plants at that price; Tenney declined.

The Gisholt plant, which opened new works earlier that year, employed 250, with the Fuller and Johnson plant payroll one hundred more. The same week that Tenney attacked, Gisholt won a gold medal at the Paris World's Fair — and international sales to German shipbuilders and South African gold mines — for its new ten-ton turret lathe.

Johnson said his plants brought value to the city beyond just their tax bill, and noted that "some towns in some states even exempt manufactories from taxation entirely for a long term of years." He revealed that he had received several enticements from around the region, including offers of free land and factories. "Fuller and Johnson company can get just as good shops for nothing in some town in Illinois as it now has in Madison, and probably a bonus beside," he said, adding city property values would drop sharply without factories, "and Mr. Tenney is doing his best to kill them or drive them out." Johnson also turned the tables on Tenney, noting that Tenney had recently rejected an offer of twice the assessment for his business block at the corner of Pinckney and Main streets. "It seems he should have told the assessor that his own property should be assessed at least $80,000," Johnson said.

The Board of Review let the assessments stand.

Workforce Statistics

Number of employees	1904	1906
Gisholt Machine Co.	250	500
Northern Electric Mfg. Co.	281	400
Fuller and Johnson	250	250
Badger State Shoe	37	113
John Findorff Co.	50	60
Mason-Kipp	17	33
Madison Muslin Underwear	35	25
Fauerbach Brewery	17	20
Hausmann Brewing Co.	25	20

Union Membership	1902
Barbers	25
Bartenders	30
Bricklayers	70
Carpenters	90
Cigarmakers	30
Electrical workers	25
Federal	40
Lathers	25
Machinists	50
Molders	40
Musicians	50
Painters	50
Plasterers	30
Plumbers	25
Printers	50
Stonecutters	20
Tailors	70

The Leading Lubricators

Two implement salesmen quit the J. I. Case Company in 1901 to go into business selling an automatic oil injector for steam tractors developer O. G. Mason. They incorporated the Mason Lubricator Company that December and soon opened a factory at 621 Williamson Street. Sales were brisk, prompting a quick move to a larger plant on East Main. Under general manager Albert Stelting, the company in 1902 merged with an Illinois firm, creating the Mason-Kipp Manufacturing Company on September 23. La Crosse and Milwaukee tried to woo Stelting away, but he stayed for the incentive package offered by the Fair Oaks Land Company and opened a new factory the following fall. In 1904, Thomas Coleman, an official with the McCormick Farm Implement Company, acquired a controlling interest; his son and grandson have each been successors and Republican Party heavyweights. Within fifteen years, Madison-Kipp (so renamed in 1906) led the world in machine lubricators and held more than half the American market. World War I brought very good business, but labor unrest followed (page 208). By 1918, the company equipped two-thirds of all gas and steam tractors made in America and was the largest oil lubricator company in the world. By 1927, the company employed 450 workers. In 1937, the company bought the old Four Lakes Ordnance plant at 2824 Atwood Avenue and enjoyed further expansion during World War II, again with disruption afterward. From a high of 1,500 during World War II, Madison-Kipp employed about 425 in 2005.

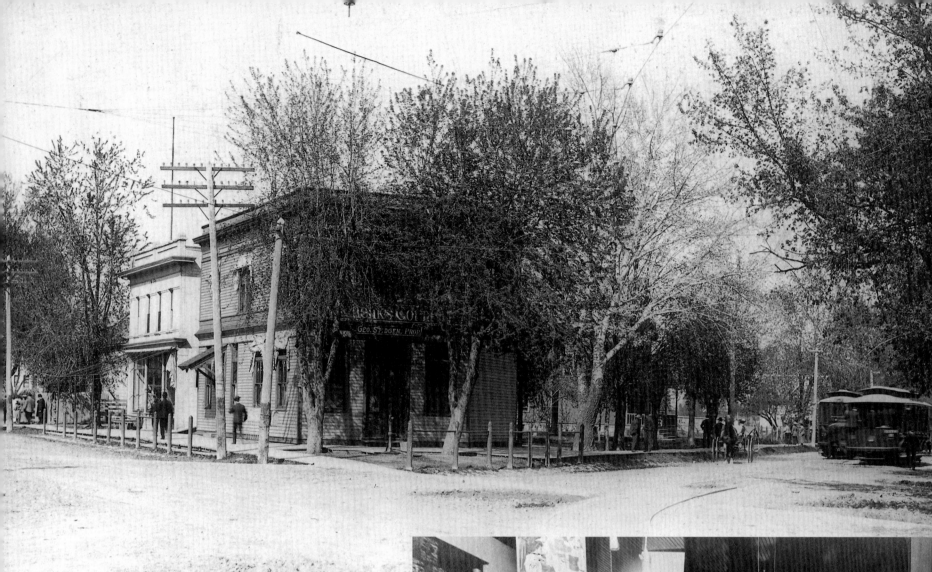

Schenk's Corners, ca. 1900 *(above)*

Unlike neighborhoods named after streets or marketing plans, Schenk's Corners was named after people. This is where Frederick and Wilhelmine Schenk started it all in 1893, at the juncture of historic Native American trails. The single structure shown in the remnants of Farwell's Addition in 1890 (page 133) has expanded to encompass a saloon, general store, and more. The Elmside trolley heads east on Atwood Avenue, sharing the street with a horse-drawn carriage (note the hitching posts). The white building to the rear is the Schenk General Store, 2009 Winnebago Street. Streetcar service came to the Fair Oaks neighborhood in 1892, five years before the west-side line was extended to the cemetery. Mass transit, manufacturing, and affordable housing helped the east side grow more rapidly than neighborhoods across town. (courtesy of Jane Huegel)

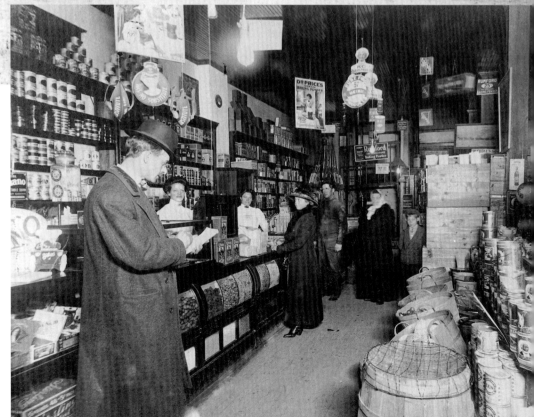

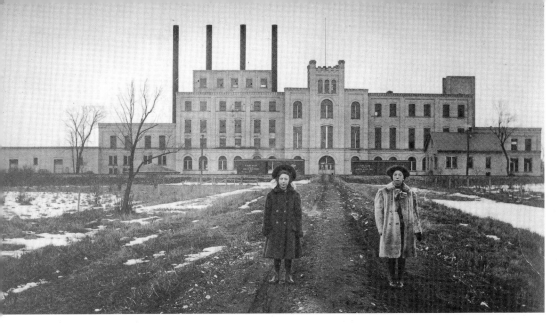

Sugar Beet Factory

A quarter-century after he warned Madisonians about the dangers in their water supply, Magnus Swenson applied his genius to create a new industry. By perfecting and patenting methods of extracting sugar from sorghum, Swenson laid the groundwork for the sugar beet industry, which he then joined as an incorporator and president of the Madison Sugar Company.

After a name change, the foreboding factory pictured here opened in October 1906 as the United States Sugar Company, the latest development in the growth of the Fair Oaks suburb as an industrial center. Located at the end of the aptly named Sugar Avenue, the $750,000 plant could process better than five hundred tons of beets daily and provide two months' work for several hundred men. Unfortunately, even as the factory was refining its product into finely granulated sugar, it was dumping effluent and other waste into Starkweather Creek and Lake Monona. It would take decades to address this environmental degradation. Subject to economic forces beyond its control, the industry went from boom to bust and back again. In peak years like 1912, the plant hired as many as 350 transient workers, mostly Bohemian and Hungarian, for about $150 per month. Running two twelve-hour shifts, they processed 24,000 railway carloads of beets into fifteen million pounds of sugar in a season. But the next two years the plant stayed shut, reopening October 15, 1915. As late as 1922, the plant's production hit about 30,000 tons of beets and ten million pounds of sugar. But industry economics became less favorable, especially when tariffs were lifted and foreign sugar became too cheap to compete with. The company, which had three other Wisconsin plants, filed a bankruptcy petition in May 1924. James R. Garver acquired the property in 1929 and, after removing parts of the original structure, used it for his feed and supply company. (WHi-11038)

Schenk's General Store, ca. 1909 *(facing page, bottom)*
Frederick Schenk's daughter Matilda works the cash register at her father's general store at about the same time John Nolen was working on *A Model City*. (courtesy of Jane Huegel)

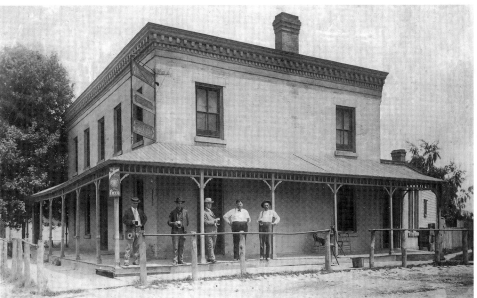

Union House Tavern, ca. 1900
Just inside the city limits at the Union Corners juncture of East Washington Avenue and Milwaukee Street, the Union House Tavern was a popular watering hole as early as the Civil War. (WHi-3105)

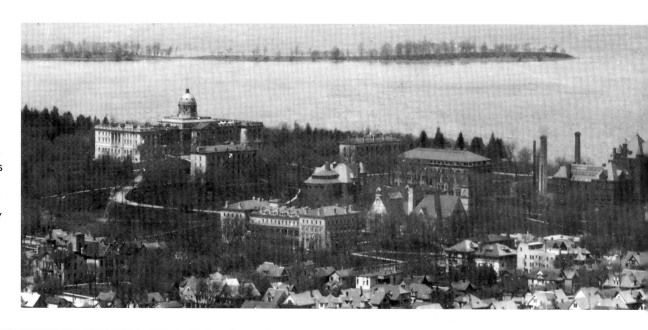

Lower Campus Aerial
The new 1906 YMCA shines in bright white cement next to the red brick Armory and Gymnasium in the lower right. Other notable structures in this close-up from the 1908 kite aerial are, from left, Main (Bascom), South, Ladies (Chadbourne), Old Law, North, and Assembly Halls, the Engineering Building, Science Hall, the Historical Society building, and Chemistry Hall. (detail from WHi-10328)

Madison Notable

Charles R. Van Hise (1857–1918) — whose 1903 appointment as the first university alumnus to become its president was engineered by his former classmate, Governor Robert M. La Follette — was the most celebrated leader of one of America's most renowned public university. "In a class by himself among college presidents," the muckraking journalist Lincoln Steffens said of him.

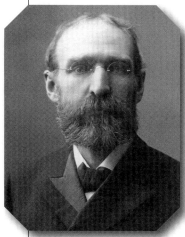

Charles Van Hise, ca. 1904
The university's most influential modern president, at the start of his fourteen-year administration.

(University of Wisconsin Archives)

Crystallizing a concept first stated by John Bascom — whose Sunday seminars he and La Follette cherished — Van Hise institutionalized what became known as the Wisconsin Idea. "I shall never be content," he declared, "until the beneficent influence of the University of Wisconsin reaches every family in the state." Five years into his administration, forty-one members of the faculty were serving on one or more state commissions, with Van Hise and E. A. Birge each serving on five. "In no other state in the union," Theodore Roosevelt remarked, "has any university done the same work for the community that has been done . . . by the University of Wisconsin."

Born on a farm in southern Wisconsin and raised in various Rock County villages, Van Hise entered the university in 1874 and became an instructor in metallurgy and chemistry upon his graduation; after receiving the university's first doctoral degree in 1892, he became head of the geology department and was soon recognized as an authority on pre-Cambrian geology. His book *The Conservation of Natural Resources in the United States* was the leading treatise of the early conservation movement, and his expert advice was sought in addressing landslides that endangered Roosevelt's Panama Canal.

He was not, however, particularly charismatic, often seeming ill at ease in casual conversation and an awkward public speaker. Van Hise had not pursued the presidency after Adams's resignation in 1901, but his neighbors on North Frances Street — Frederick Jackson Turner, Charles S. Slichter, and Moses Slaughter — thought he should be tapped; La Follette agreed and starting packing the Board of Regents with pro–Van Hise appointees. In April 1903, by a vote of five to four — William F. Vilas among those in opposition — the regents chose Van Hise over Birge. The Van Hise era opened with a five-day jubilee in 1904 that also marked the fiftieth anniversary of the university's first commencement. Van Hise's inaugural address foretold many of his achievements to come (including some, like new dormitories, that would not come until years after his administration).

It was a good time for the university. With Progressives in command of the capitol and broad public support, the state appropriation increased nearly 500 percent, from $327,000 in 1903 to $1.6 million in 1918. The faculty, which numbered 184 in 1902–3, had 751 members by 1916–17 (still but a fraction of the industrial workforce across town). During the Van Hise administration the university doubled in area. Nearly $3 million was added in new buildings, equipment, and land, including the Stock Pavilion, Sterling Hall, Barnard Hall, Lathrop Hall, the Agricultural Chemistry Building, Wisconsin High School, the biology and chemistry buildings, a number of smaller buildings, and the sites for Memorial Union and Wisconsin General Hospital. The university established the College of Medicine under Charles Bardeen in 1907, although a full medical course leading to a medical degree was not possible until Wisconsin General Hospital was built in 1924. There was also a very important development through joint state and federal action: the establishment of the Forest Products Laboratory in 1910.

Campus growth greatly affected city housing. Even as enrollment grew from 2,426 in 1903–4 to 5,318 in 1916–17, the 1870 Ladies (Chadbourne) Hall remained the only on-campus housing until the Van Hise dorms were built in 1926. This housing demand for undergraduates fueled the growth of the fraternity and sorority houses that transformed Langdon Street from an elite residential district to the crowded and noisy Latin Quarter. Student spending also fueled the local economy with close to a million dollars each year.

Verbatim

[Van Hise] has the broadest conception of what a university should teach, how it should teach it, what it should represent and stand for, and what its relations to the people and the problems of the present should be, of any college president in the United States, bar none. — **Lincoln Steffens**

For the first ten years of the Van Hise administration, the university enjoyed strong support from a series of Progressive Republican governors (La Follette, James O. Davidson, Francis E. McGovern). But then Stalwart Republican Emanuel L. Philipp, who campaigned on a platform of cutting the university budget, raising nonresident tuition, barring faculty from receiving outside salaries, and creating a central board of control to oversee the budgets of all public institutions, including the university, was elected in 1914. Van Hise was able, however, to navigate the shifting political currents successfully, and Philipp did not realize the university's worst fears. While total appropriations did dip in 1914–16, the cut came in the building fund, with the budget for operations and maintenance still increasing.

Van Hise endured extraordinary stress during the world war and was eagerly anticipating new campus growth at its conclusion. But first he had a minor health matter to address, some simple sinus surgery. A week after the armistice, he went to Milwaukee for the operation, taking proofs of his new book to correct while recuperating; most people didn't even know he was gone. The operation seemed a success, but infection set in. Van Hise died on November 19, 1918, at age sixty-one.

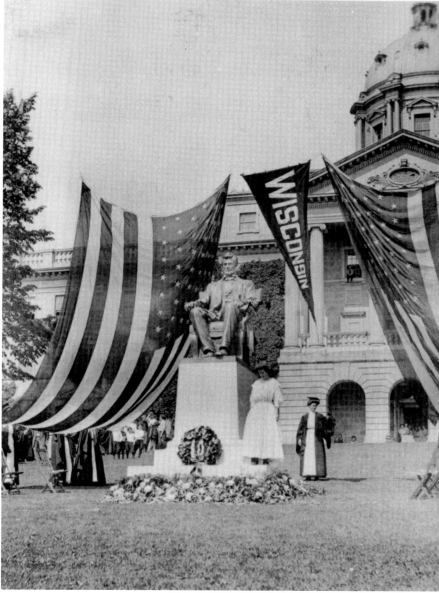

Dedication of the Lincoln Statue, May 15, 1909

Even as he was striving to save the Union, Abraham Lincoln in 1862 helped save the struggling young University of Wisconsin by signing into law the Morrill Act, which predecessor James Buchanan had vetoed, giving public lands to states to endow and support higher education. That the Wisconsin Legislatures of the era squandered this munificence by selling prime lands at bargain rates, and allocating the proceeds inappropriately, does not negate Lincoln's commitment to equal educational opportunity.

Lumberman and philanthropist Thomas Brittingham paid for the casting and pedestal of this statue, the only replica of one installed in Lincoln's Kentucky hometown. Pursuant to Brittingham's only stipulation, a "suitable plaza" was built in 1919 and the statute rededicated in memory of Wisconsin's war dead. (University of Wisconsin Archives)

Sewers 1900

Madison's seemingly intractable sewage problem of the late-nineteenth- and early-twentieth-centuries may have been the first example of the Wisconsin Idea in action, with professors actually joining city government in supervisory, technical, and legislative posts. Not that all went well at first. In fact, their initial advice was roundly disregarded, to the city's detriment.

The desperate need for an efficient and economical way to dispose of human waste wasn't new. Former city engineer John Nader's "district" plan of 1885 had been important in recognizing the need for a municipal solution, but the untreated discharge of waste was doing clear damage to the lakes — particularly in the summer, when raw sewage collected along the Monona shoreline southeast of the capitol and sewage-soaked weeds choked the waterways.

In the mid-1890s, the city for the second time hired a national expert, and for the second time disregarded both his advice and that of university experts. George Waring, supported by Charles Van Hise, Charles S. Slichter, and N. O. Whitney, urged the council to adopt a land-disposal process and to avoid a chemical purification process. Using chemicals, they all said, would only make the weeds and algae grow quicker. But the cost-cutting council in August 1897 ordered the chemical plant built. That's when James MacDougall, director of the American Sanitary Engineering Company and proponent of the "international process" of chemical treatment, entered the scene and offered to build a model plant at a reduced rate. The slight Scotsman was a great salesman — within two weeks of his arrival, he had a contract. Only Slichter, who had been elected to the council on this very issue, voted no.

The council should have listened to Slichter. Following two lawsuits (including one from Daniel K. Tenney, who favored simply sending the sewage into deep water farther from shore), the plant opened in June 1899, with positive results. City engineer MacClellan Dodge himself drank some effluent without apparent harm. But things soon went terribly wrong, even during the ninety-day trial period. Huge amounts of sludge piled up, the smell was suffocating, and costs were steadily rising. Yet the city didn't act until January 1900, when Mayor Hoven and other officials toured the plant on North First Street and were shocked by the shaky foundation and inadequate drainage. The next day, the company and its workers simply walked away. Hoven directed the city attorney to take over the plant, rehire the company's men, and sue to recover the $25,000 bond the company forfeited. The suit was successful, but the city's operation of the plant wasn't; in January 1901, the city also abandoned the effort, leaving 600,000 gallons of untreated sewage to empty into the Yahara River every day.

The university, meanwhile, had made an offer the city really couldn't refuse if it wanted to solve its refuse problem — elect Frederick E. Turneaure, professor of sanitary engineering, as city engineer, and get the services of other faculty for free: J. B. Johnson, dean of the College of Engineering; bacteriologist Harry Russell; and Van Hise, an eminent geologist and the university's future president. But with the council evenly split — eight Democratic votes for incumbent engineer Dodge, eight Republican votes for Turneaure — a deadlock lasted through twenty-six ballots as Democratic mayor Hoven refused to break the tie. Finally, on May 11, the Democratic butcher voted for the Republican professor.

On December 3, 1900, the council voted to close the plant, giving Turneaure a New Year's Eve deadline to submit plans for a new system. Turneaure designed a revolutionary new septic system that used bacteria to break down the sewage, which the council endorsed on December 14. The septic system treatment facility opened in July 1901 and was an immediate, if limited, success. Though the effluent was clear, it was still rich in nutrients, and the plant's Yahara River discharge pipe caused great growth in Lake Monona weeds.

What Turneaure and his faculty colleagues had done wouldn't be called the Wisconsin Idea for a few more years, but they had shown how academic expertise could have important and immediate practical application.

Another unanticipated problem soon arose, as Madison's continuing growth put the plant far beyond capacity and substantially cut its efficiency. By 1907, the city was once again pumping sewage that was only partially treated directly into the waterways — this time, close to 100 million gallons each month. The search for a sewage solution would continue.

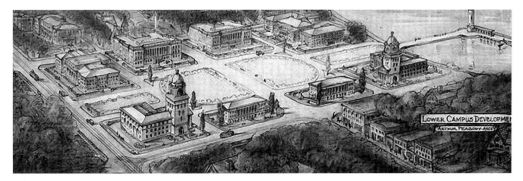

Lower Campus Development Plan, 1908

State architect Arthur Peabody's plan would have provided buildings for music, finance, administration, and applied arts along Lake Street, with a breakwater and lighthouse. The only structure proposed here that was actually built was the Memorial Union (upper right), two decades later. (WHi-24073)

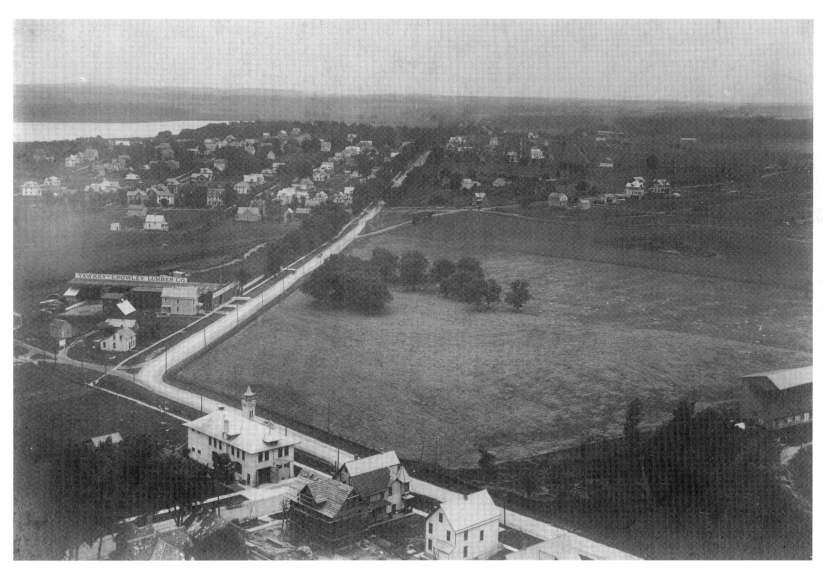

Camp Randall and Environs, 1908

This view down Warren Street (Randall Avenue) and out Monroe Street also shows part of the 1896 Camp Randall bleachers (right), with Randall School faintly visible on Regent Street. In the left foreground is fire station number 4, in operation from 1905 to 1983, when a new stationhouse was built a bit west of the Yawkey-Crowley Lumber Company. (University of Wisconsin Archives)

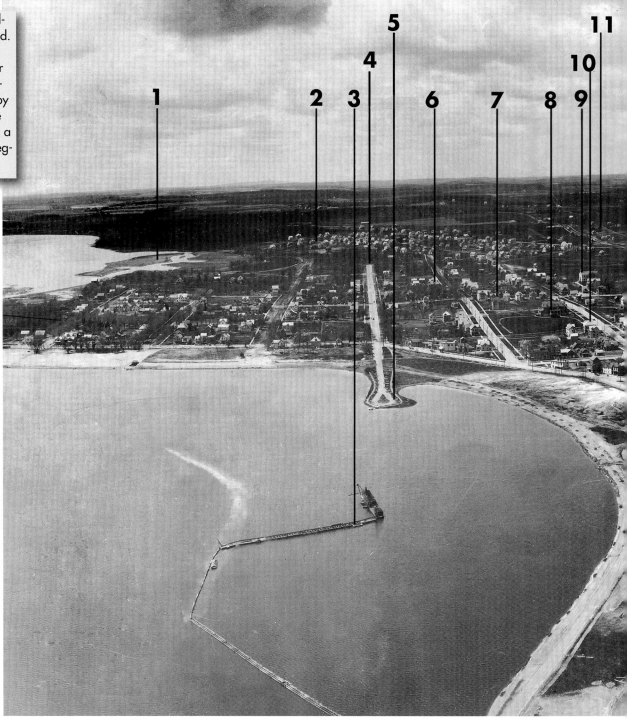

West Madison Kite Photo, 1908

(WHi-4568)

1. The just-completed Henry Vilas Park, after four years and $65,000 in dredging and planting. The need for, and result of, the vacation of platted streets southwest of Drake and beyond is evident.

2. Wingra Park, the future Vilas neighborhood, with development from Monroe Street down to Adams.

3. A steam-powered dredge, still sucking and spewing tons of sand to add to Brittingham Park.

4. Bear effigy mound, just past West Washington (Vilas) Avenue and Warren Street (Randall Avenue).

5. The turn-around, at about the site of the modern Brittingham Park shelter, now part of solid land.

6. Van Bergen-Bowen-Ramsay homestead, 302 South Mills Street (1854–extant; ML).

7. Longfellow (Greenbush) School, 1010 Charter Street (1893, 1901–18). A new Longfellow School was erected on the same site in 1918, and, with major additions, remained in use until 1980.

8. Madison General Hospital, 925 Mound Street (1904). Meriter Hospital now occupies this site, and more.

9. St. James Church and rectory. When Susan Bowen Ramsay, daughter of physician and mayor James B. Bowen, was on her death bed in 1904, she bequeathed land for an unspecified religious purpose; her family later gave the German Catholic congregation of Holy Redeemer six lots just up Mills Street from the homestead. The first St. James Church — named after James Bowen — opened in 1906. Although the century-old rectory is still in use, the congregation opened an impressive new church, designed by Ferdinand Kronenberg, in 1923. Susan Bowen Ramsay, whose son James Bowen Ramsay cofounded the French Batter Company (later Ray-O-Vac), also gave land for a Methodist church at 1123 West Washington, in addition to offering land for Madison General Hospital.

10. Agudas Achim (Knot of Brothers) synagogue, 827 Mound Street (1904/6–49). The Russian Jews in the residential cluster between Murray and Park streets — the first ethnic ghetto in the Greenbush — who built this orthodox shul did not assimilate like the German Jews of the 1860s, and thus formed the basis of Madison's continuing Jewish community. Here, their housing ends at the unimproved Milton Street; the open area from there to Regent Street, platted but not fully improved, will soon host a large Italian population.

11. Randall School, 1802 Regent Street (1905/6–extant).

12. University Heights.

13. Dredge landfill, creating a site to house thirty homes.

14. Camp Randall (1896–1915).

15. The land between Park and Mills streets that John Nolen wanted for a large park; instead, it has become the South Campus neighborhood, the planned development of several hundred housing units with retail, office, and light industrial uses.

16. 2 South Frances Street, where tragedy would soon strike the Martin Lemberger family.

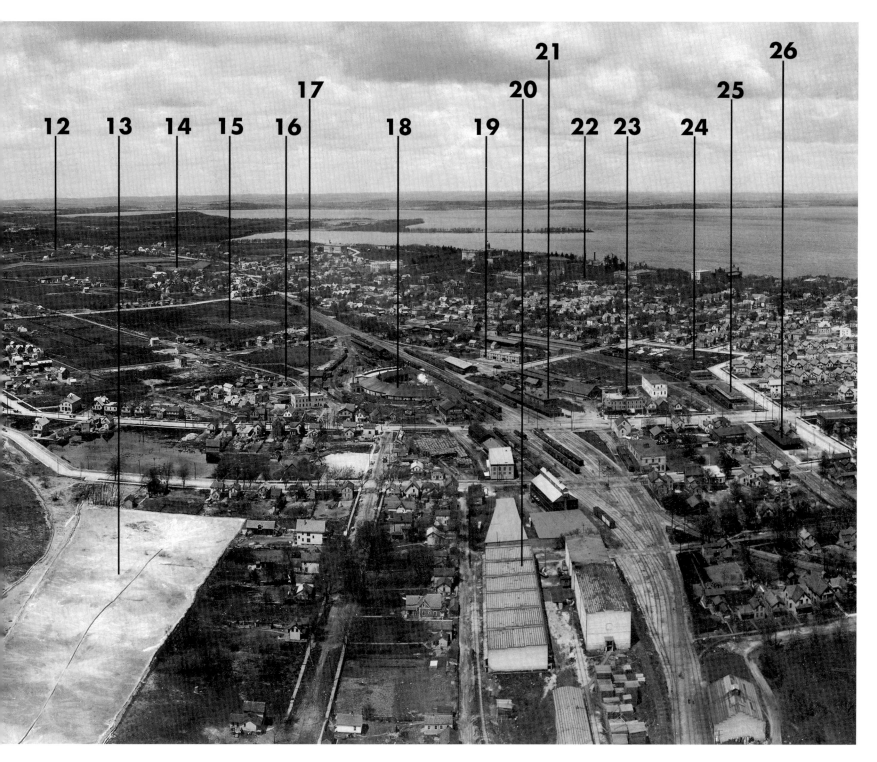

17. French Battery Company, the future Ray-O-Vac, at 615 Washington (Regent) Street. In 1916, the company would open a large plant at 2317 Winnebago Street.

18. Railroad roundhouse.

19. Frances Court apartments. Built for railroad supervisors, sixty years later it become home to an enclave of activists, radicals, and pranksters. The Kohl Center opened on the site in 1998.

20. American Tobacco Company warehouses (1900–extant), where a thousand or so Madisonians, many of them women, worked each winter, sorting and grading tobacco for cigar wrappers.

21. Milwaukee Road depot, 644 West Washington Avenue (1903–extant; ML, NRHP).

22. University of Wisconsin campus.

23. Hotel Trumpf (Hotel Washington), 636 West Washington Avenue (1906–96).

24. Bog Hollow, swampy and somewhat toxic land, the edge of the 1850 University Addition. The polluted parcels became Barry Park (page 225) and in 1940 the site of the Washington School, 545 West Dayton Street.

25. Illinois Central freight depot, 604 West Washington Avenue (1881–extant), still used for transfer and storage.

26. Illinois Central passenger depot, 603 West Washington Avenue (1888–1944), its purpose and design continue in current use as a bus depot.

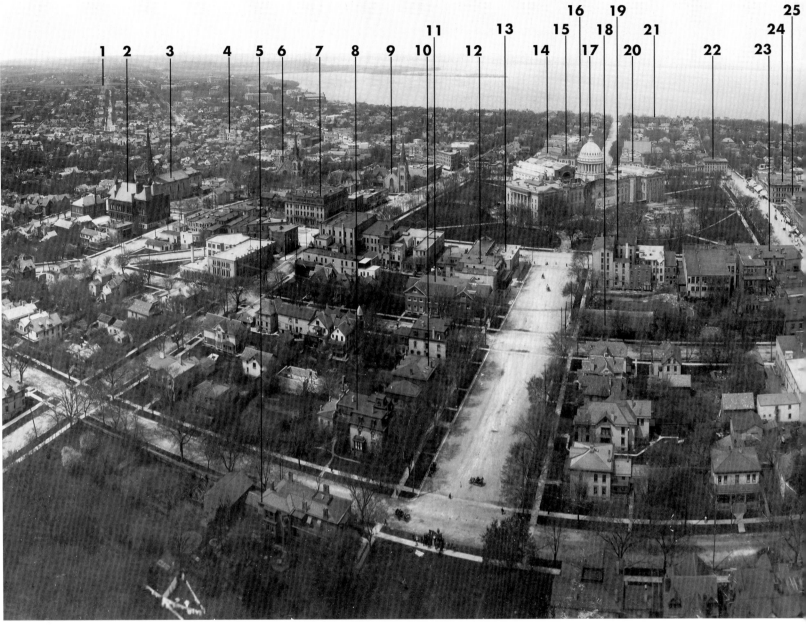

The numbered labels on the photo read: 1 2 3 4 5 6 7 8 9 10 11 12 13 14 15 16 17 18 19 20 21 22 23 24 25

Downtown and East Madison Kite Photo, 1908 (WHi-10328)

The view of downtown and the near east side the month after Madison hired John Nolen as its part-time landscape architect and future city planner. Nolen quickly concluded the improvements did not equal the site: "The Lake Monona approach to the capitol is certainly unexcelled and probably unequalled in any American commonwealth," he declared, but it featured "no important buildings." Among the structures Nolen proposed to raze for his Grand Mall (page 174) were the Fairchild (**5**), Mills (**8**), and Atwood (**10**) mansions; the 1905 Elks Club (**11**); the Avenue Hotel (**12**); and the Mills (**13**) and Pioneer (**19**) buildings. A few years after this photo, Frank Lloyd Wright would design the Madison Hotel for the vacant lot (**18**).

Other important buildings include:

1. Camp Randall.

2. Dane County Courthouse and Jail (1884/86–1958).

3. St. Raphael's Church (later, Cathedral), 216 West Main Street (1854/62, 1881; burned March 14, 2005, partially extant).

4. George Washington School, 217 North Broom Street (1890/1902–40), where Orson Welles briefly attended fourth grade.

6. First Congregational Church, 202 West Washington Avenue (1874–1930).

7. Park Hotel, 30 South Carroll Street (1871, 1912, 1961–extant).

9. Grace Episcopal Church, 102 West Washington Avenue (1855/58–extant; ML, NRHP).

14. Fuller Opera House, 8 West Mifflin Street (1890–1954).

15. City Hall, 4 West Mifflin Street (1858–1954).

16. Madison High School, 210 Wisconsin Avenue (1904/08–partially extant).

17. State Capitol (1906/17–extant; ML, NRHP).

20. Post Office (1871–1929).

21. Vilas residence, 12 East Gilman Street (1850–1963).

22. Hotel Madison, 33 East Mifflin Street (1855–1965).

23. Fairchild block (1853–1954).

24. Mason-Baker Block, 1 North Pinckney Street (1871–partially extant; ML, NRHP).

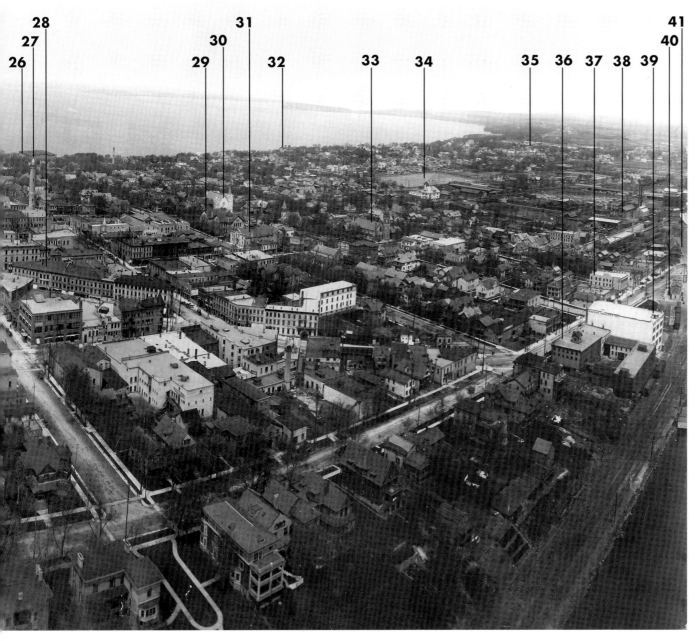

25. Bruen's (here, Brown's) block (1853–1920).

26. Conklin Ice House, 314–324 East Gorham (burned 1915; rebuilt; razed for park 1939).

27. Water Tower (1889–1922).

28. Simeon Mills Historic District, 104–106 King Street (1852 & 1855–extant), now mainly occupied by places to eat or drink. The low, light building across King Street, with its rear

door on Doty, is the 1906 Majestic Theater. The turreted building on the corner is the Dick Building (page 138).

29. Brayton School, 305 East Washington Avenue (1887, 1893–1940).

30. St. John's Lutheran Church, 322 East Washington Avenue.

31. Turnhalle (Turner Hall), 21 South Butler Street (1863–1940). Pride of the Turnverein, where Germans improved their bodies and minds. The Turners

sponsored the first kindergarten, and the year after this picture welcomed public school children to its gymnasium — the only one in Madison.

32. Abraham Lincoln (Second Ward) School, 720 East Gorham Street (1867 & 1915/16–63).

33. St. Patrick's Church, 410 East Main Street (1889–extant; ML, NRHP).

34. Future site of City Market (1910).

35. Tenney Park, Yahara River Parkway (1899–extant, 1904–extant).

36. Union Transfer and Storage, 303–309 East Wilson Street (replaced 1916; converted to luxury condominium building 1999).

37. Cardinal Hotel, 416–418 East Wilson Street (1908–extant).

38. Madison Gas and Electric turbine station, 115 South Blount Street, the first gas engine electric

generating station in the nation at its construction in 1902.

39. Madison Saddlery, 313–317 East Wilson Street (1907–extant), now a furniture store.

40. Milwaukee Road "Little Daisy" depot, 501 East Wilson Street (1886–1953).

41. Chicago and North Western depot, 201 South Blair Street (1885–1910 & 1910–extant).

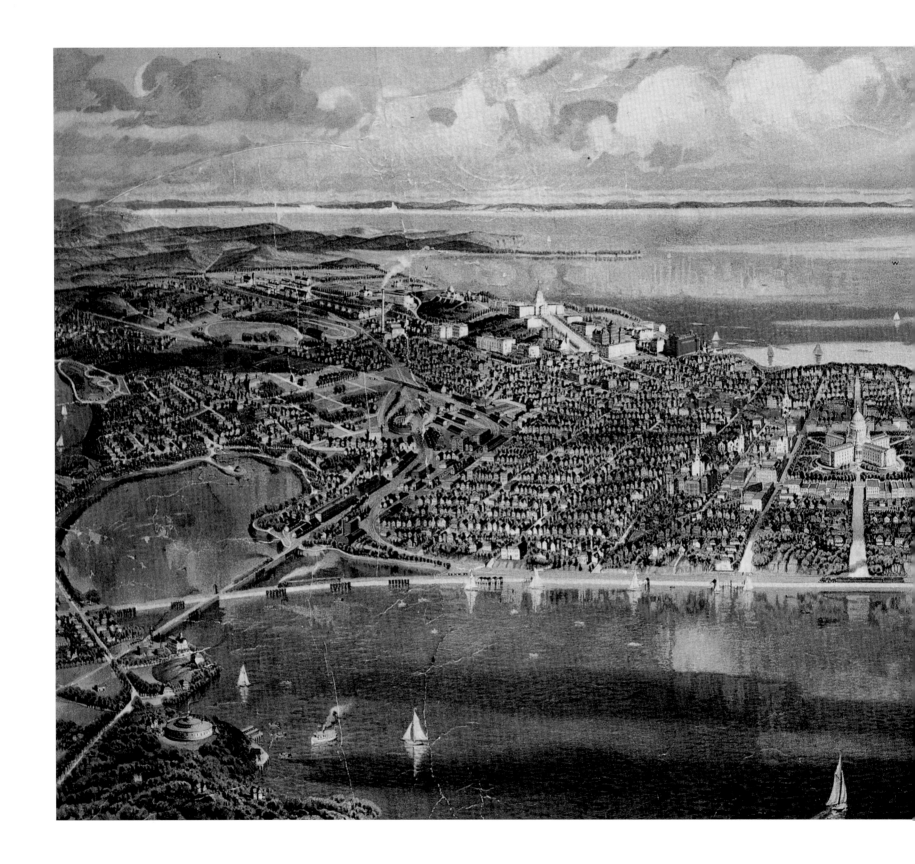

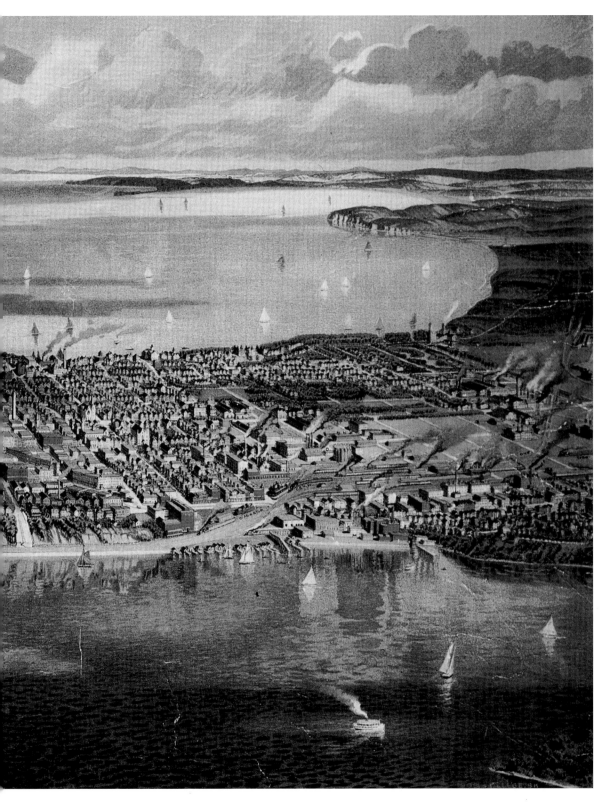

1908 Bird's-Eye

A suggestive illustration of the city the year John Nolen became part-time landscape architect. Among its fanciful features are the capitol, which would not look like this until 1917; full build-out of Brittingham Park, along with housing and factories, where in reality there was fresh dredge; orderly rows of trees, both east and west, where there was really still marsh; far more density in the Bowen Addition than existed at the time; and an even worse industrial use of the North Hamilton axial than the Conklin ice house and city water works. Otherwise, allowing for its promotional hue, this is a generally accurate representation of the city's primary buildings and physical reality. Readers of this volume should be familiar with this illustration — David Mollenhoff used the color version as the cover for *Madison: A History of the Formative Years.* (WHi-3160)

MADISON HIRES JOHN NOLEN, 1908

The most important plan in Madison's history would never have been prepared if the city had given parks superintendent Emil Mische a $300 raise in 1907. But the council refused to pay him more than $1,200, so Mische took a better-paying job in Portland, Oregon. His departure created a vacancy that John Olin filled by recruiting a rising young landscape architect named John Nolen.

Nolen, thirty-eight, had been practicing for only two years, but he was already marked for greatness. Valedictorian of his elite Philadelphia prep school at age fifteen and an honors graduate in economics and public administration at the Wharton School of Business, Nolen spent a decade directing the People's University at the University of Pennsylvania, an ambitious program for adult education.

But in 1904 he quit his job and took a tour of European cities, where he saw the value of government involvement in land use planning and economic development. Upon his return, Nolen moved with his family to Cambridge, Massachusetts, to study landscape architecture at Harvard. Two years later, he began his career as an urban planner. Although he came of age during the heyday of the City Beautiful movement, Nolen quickly became a leader of the new City Functional school. Looking good was no longer good enough; now cities had to work well, too, with integrated plans for housing, transportation, economic development, and recreation.

Well before Nolen became the dean of urban planners, Olin wanted him for Madison. But he had to find a way to supplement the $1,200 annual salary the council had set. A university appointment as the first chair of a new department of landscape architecture fell through, but

John Nolen
The landscape architect who tried to make Madison a model city. (John Nolen Jr.)

John Nolen's Great Esplanade
John Nolen's watercolor rendering of his staggeringly ambitious Monona Lake Front Improvement — sixty acres of landfill, a highly landscaped area a mile long and six hundred feet wide. In words that Frank Lloyd Wright would later echo, Nolen said he had built on "the organic relationship between the new capitol and Lake Monona." And, like Wright, Nolen was not unduly modest, predicting the esplanade "might very readily be better than anything of the kind that has so far been done in this country [and] equal any similar development anywhere in the world."
(Architectural Archives of the University of Pennsylvania)

Olin was able to cobble together some smaller state and campus jobs to supplement the city salary (including drafting a landscape plan for the new state capitol), and on March 30, 1908, the council gave Nolen a three-year contract to work part-time on landscape design for the city's parks and boulevards.

"Nolen is Elected by Council," the *State Journal* declared in a front-page headline, the sub-head adding, "President John M. Olin Recommends Him." But Olin and Nolen had more in mind than just good park design. Together, they were going to remake Madison, putting the city

continued on page 174

Officers

JOHN M. OLIN, President
ANDREW S. BROWN, Vice-President
CHARLES N. BROWN, Secretary
FRANK W. HOYT, Treasurer

Directors

WILLIAM R. BAGLEY
CHARLES N. BROWN
W. D. CURTIS
J. M. NAUGHTIN
JOHN M. OLIN
JOHN C. PRIEN
HALLE STEENSLAND
J. C. SCHUBERT
F. M. SCHLIMGEN

Madison Park and Pleasure Drive Association

Madison, Wis., Jan. 14, 1908.

Mr. John Nolen,

Landscape Architect,

1382 Harvard Square,

Cambridge, Mass.

My Dear Sir:—

Mr. Emil T. Mische, who has been park superintendent here for the past two years, has received a call to Portland, Oregon, at a salary of $2500. He has accepted the call and will probably give up his work here some time about the first or middle of March, and this necessitates our securing some other man. We have liked the work of Mr. Mische and regret that he is

Olin to Nolen

The letter that made modern Madison. John Olin's first letter to John Nolen asked if he'd be interested in becoming Madison's part-time park superintendent. (Wisconsin Historical Society Archives)

JOHN NOLEN *continued from page 173*

at the forefront of urban planning in America. In an hour-long presentation at the annual MPPDA meeting in April 1908, Nolen praised the MPPDA and the "public spirit" it helped arouse, but said more was needed: "If the city of Madison is jealous of its future and intends to secure the advantages of its peculiar situation it must soon take up the consideration of radical and far-reaching improvements." The city needed a plan, he said, to address problems that were "not simply aesthetic but largely economic and sanitary."

That winter, after just two visits, Nolen told Madisonians the harsh truth — haphazard growth had already done much damage to the city and was threatening its very future. State Street was a mess; the railroads were dangerous and disruptive; children lacked playgrounds;

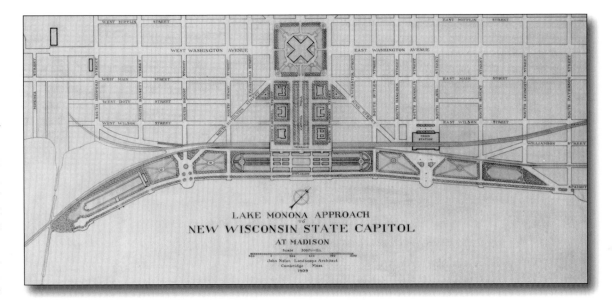

LAKE MONONA APPROACH
TO
NEW WISCONSIN STATE CAPITOL
AT MADISON

Scale 300Ft=1In.

John Nolen Landscape Architect
Cambridge Mass.
1909

Verbatim

IMPROVEMENT OF MADISON IS THEME AT CITIZENS' BANQUET

— — —

Comprehensive Plans for Civic Betterment Are Outlined in Meeting.

— — —

Nolen Is Chosen to Plan

— **Wisconsin State Journal**, January 27, 1909

the lakefront was being wasted. Nolen told his audience at the Madison Free Library that there were two critical periods in the making of Madison — its founding and the present time. In each, he said, there was "considerable to commend, but much more to condemn." What was needed, he said, was a comprehensive plan. Nolen elaborated on that need in a presentation Olin scheduled before 350 prominent Madisonians in the banquet room at the Woman's Building on January 26, 1909. As arranged, the glittering group unanimously endorsed Olin's call for a Committee of Fifty to oversee the preparation and publication of Nolen's work. And quite a committee it was: Governor James O. Davidson, Charles Van Hise, former congressman and future chief justice Burr Jones, industrialist Magnus Swenson, and others, with

Olin in the lead. Leaving nothing to chance, Olin had already secured the necessary $2,500 for the enterprise.

Four months later — precisely a year since his first presentation — Nolen gave the MPPDA annual meeting a sneak peak at his plan. It was both critical and inspirational. Olin had told the large crowd in the high school cafeteria they would soon be "convinced Mr. Nolen is a visionary dreamer," and he was probably right. "You have the power and means to make Madison itself a work of art," Nolen said as he unveiled the centerpiece of his plan, the breathtaking proposal for a Great Esplanade and Grand Mall on the Lake Monona approach to the capitol. "If properly carried out," Nolen predicted, his plan "would contribute more than any one thing to the making of Madison, and, in a measure, to Wisconsin."

Two similar ideas had been floated in quick succession in early 1907 — one by James Stout, a wealthy lumberman and state senator from Menomonie, the other by Forty Thousand Club founder Clarke Gapen. The Stout and Gapen plans quickly faded. But Nolen's proposal captivated leading Madisonians and caused property values on the proposed mall to jump sharply. But despite Nolen's enthusiasm, a number of forces — the $6 to $10 million price tag, growing anti-Madison sentiment in the legislature, and Olin's resignation for health reasons that September — doomed his ambitious plan as well. At least for the time being.

John Nolen's Plan for the Grand Mall and the Great Esplanade

John Nolen unveiled this ambitious plan at the MPPDA annual meeting on April 27, 1909. He proposed the state buy and raze the six square blocks between the capitol and Lake Monona, creating a mall four hundred feet wide and more than twice as long. On the four sites closest to the capitol, Nolen placed state office buildings in the classical style, with the two lakefront parcels devoted to the "pleasure interests of the people." Setting the stage for a debate that would rage the better part of the century, Nolen proposed one parcel be used for a first-class hotel, the other for "perhaps a really fine theatre and opera house, [a] valuable educational feature of the new Wisconsin ideal." (Architectural Archives of the University of Pennsylvania)

Verbatim

But the greatest need of the city, not only in its park work but in every other department, is a radical change in our present form of government. Madison needs to adopt what is commonly spoken of as commission government. Our present form of city government is about as bad as could well be. It is asking a good man a good deal to serve as a member of the council under present conditions. — **John Olin**, "The Future," MPPDA annual meeting, 1909

THE 1910s

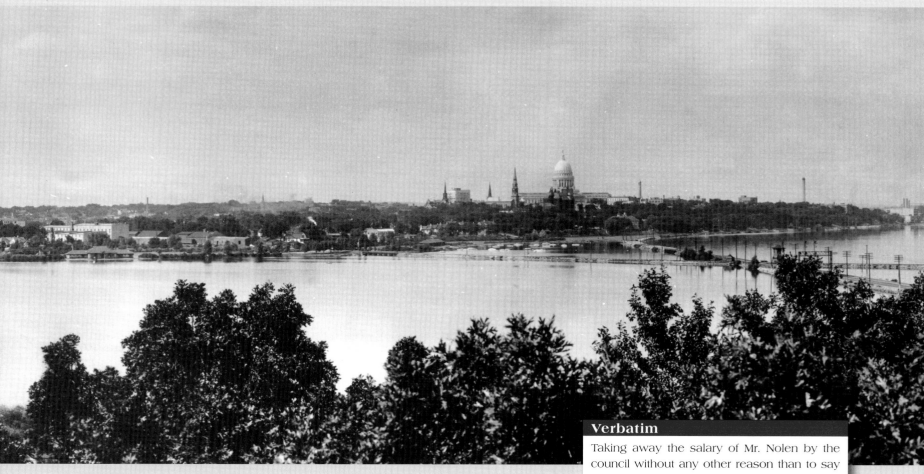

Skyline, ca. 1917
This photograph, taken shortly after completion of the third Madison capitol, shows some of John Nolen's successes and setbacks. In the lower left is the Brittingham bathhouse, with its companion boathouse between the railroad trestles; Nolen helped bring both of these about. But on the west side of the square, amidst the historic steeples, is the first encroachment on the new capitol — the nine-story Gay Building, built despite Nolen's urgent call for height limitations to protect the capitol view. (WHi-35737)

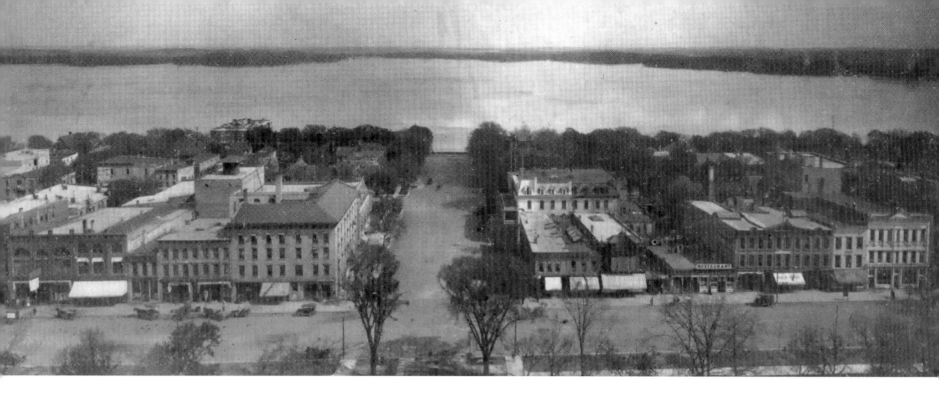

Madison's world turned upside-down this decade. At its outset, talk was of *A Model City*; by its close, we had been through a world war and global pandemic and were on the verge of a general strike.

Our greatest public servant, once revered, became reviled. Sudden and avoidable death came to one of the university's greatest leaders. The world's greatest architect designed a hotel for the city's most important block, but it wasn't built.

The city's most troubled neighborhood was developed this decade, as squalid conditions, substandard housing, discrimination, and ethnic alienation, combined with criminal opportunities from prohibition, produced a predictable pathology. And within that neighborhood, a heinous crime started the saga of the city's greatest tragedy, and the first police officer fell.

It was that kind of time.

There were, to be sure, highlights. The magnificent new $7 million capitol was finally finished after a decade of construction. The great progressive surge, largely spurred by Madisonians, swept through the city, lifting it to new heights in health, safety, welfare, and good government. Four important elementary schools opened, their locations — the recently annexed Fair Oaks, Madison Square, Tenney-Lapham, and Greenbush — a snapshot of population growth. East-side industrialization accelerated with the start of the city's most important private employer, while unique suburbs were platted to the west. Important and lasting new clubs for all classes opened, as did a new hospital and train depot. The university dedicated a stadium and a monument (even as it lost a historic dome). There was even a striking public bathhouse and boathouse (the latter still extant and recently renovated) to finish the change from swamp to park, while a new zoo opened by the shores of Turtle Lake.

Finally, freedom of the press took on new and permanent meaning, as two editorial giants twice waged war — first alongside, then against each other. And the local news about the electronic media was also profound — the campus birth of the first radio station in the nation.

It was that kind of time, too.

Wisconsin's **View Down Monona Avenue, ca. 1914**
This perspective from a bit below the eyes of the statue atop the capitol dome shows how the lake makes Monona Avenue Madison's front door, and what a great opportunity Doty missed in failing to enhance and preserve this view. Not evident, but also critical, is the steep drop at street's end, about fifty feet down to a series of railroad tracks.

Sixty years of construction is seen here, from the village-era Pioneer (Vilas) Block at 1 East Main to the impressively modern 1913 Bellevue Apartments at 29 East Wilson. Within a few years, the six-story Bank of Wisconsin will replace Simeon Mills's 1868 two-story office building at 1 West Main (although his 1887 mansion at 222 Monona, then occupied by his daughter, would last until razed for a gas station in the 1930s). Past the Pioneer Block, across from the white Avenue Hotel, the G.A.R. building, and Elks Club, is the lot on the corner of Doty Street for which Frank Lloyd Wright designed the Madison Hotel in 1912; it would remain vacant until erection of the Beaver insurance building in 1921. From there to the lake, the rest of the avenue still consists of private homes and mansions. (WHi-35714)

> ### Verbatim
> Finally, people may also contribute in many ways to the individuality of a city. The character of the population of Madison from the very earliest settlement was somewhat unusual and might reasonably have been expected to express itself in unusual ways in city making. — **John Nolen**, *A Model City*

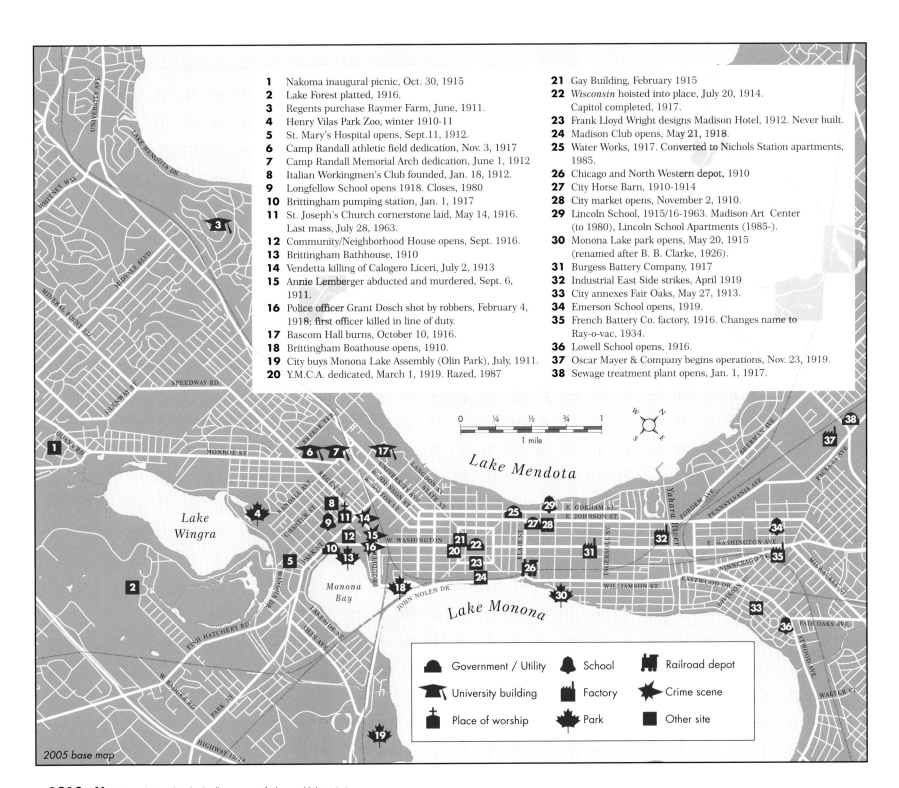

1 Nakoma inaugural picnic, Oct. 30, 1915
2 Lake Forest platted, 1916.
3 Regents purchase Raymer Farm, June, 1911.
4 Henry Vilas Park Zoo, winter 1910-11
5 St. Mary's Hospital opens, Sept.11, 1912.
6 Camp Randall athletic field dedication, Nov. 3, 1917
7 Camp Randall Memorial Arch dedication, June 1, 1912
8 Italian Workingmen's Club founded, Jan. 18, 1912.
9 Longfellow School opens 1918. Closes, 1980
10 Brittingham pumping station, Jan. 1, 1917
11 St. Joseph's Church cornerstone laid, May 14, 1916.
 Last mass, July 28, 1963.
12 Community/Neighborhood House opens, Sept. 1916.
13 Brittingham Bathhouse, 1910
14 Vendetta killing of Calogero Liceri, July 2, 1913
15 Annie Lemberger abducted and murdered, Sept. 6,
 1911.
16 Police officer Grant Dosch shot by robbers, February 4,
 1918; first officer killed in line of duty.
17 Bascom Hall burns, October 10, 1916.
18 Brittingham Boathouse opens, 1910.
19 City buys Monona Lake Assembly (Olin Park), July, 1911.
20 Y.M.C.A. dedicated, March 1, 1919. Razed, 1987

21 Gay Building, February 1915
22 *Wisconsin* hoisted into place, July 20, 1914.
 Capitol completed, 1917.
23 Frank Lloyd Wright designs Madison Hotel, 1912. Never built.
24 Madison Club opens, May 21, 1918.
25 Water Works, 1917. Converted to Nichols Station apartments,
 1985.
26 Chicago and North Western depot, 1910
27 City Horse Barn, 1910-1914
28 City market opens, November 2, 1910.
29 Lincoln School, 1915/16-1963. Madison Art Center
 (to 1980), Lincoln School Apartments (1985-).
30 Monona Lake park opens, May 20, 1915
 (renamed after B. B. Clarke, 1926).
31 Burgess Battery Company, 1917
32 Industrial East Side strikes, April 1919
33 City annexes Fair Oaks, May 27, 1913.
34 Emerson School opens, 1919.
35 French Battery Co. factory, 1916. Changes name to
 Ray-o-vac, 1934.
36 Lowell School opens, 1916.
37 Oscar Mayer & Company begins operations, Nov. 23, 1919.
38 Sewage treatment plant opens, Jan. 1, 1917.

Government / Utility School Railroad depot

University building Factory Crime scene

Place of worship Park Other site

2005 base map

1910s Map (map by David Michael Miller, courtesy of Isthmus Publishing Co.)

MADISON: A MODEL CITY

No document since its charter has meant more to Madison than John Nolen's *Madison: A Model City*. It has been a challenge, an inspiration, a goal. If only the council hadn't fired Nolen the month before its formal publication in March 1911, it might have *really* had an impact.

Combining established City Beautiful design concepts with the emerging City Functional ideals, Nolen submitted his seventeen-point plan to the Committee of Fifty in late August 1910. The committee approved its release in draft form a few weeks later. But the thrill was gone. While the *State Journal* was still encouraging in its "Great Plan for Future Madison," headline, its placement was far below what Nolen and John Olin were used to: page two, in a story only two paragraphs longer than an account of the annual business meeting of the Majestic vaudeville house.

It was a bad sign. A backlash was building. After Olin retired in September 1909, some anti-park aldermen thought they saw their chance. In February 1910, not yet two years into Nolen's three-year contract, and even before he finished his draft, a cohort tried to eliminate the position of landscape architect from the budget. They failed, but by the following February, after Nolen's scathing analysis and visionary recommendations were in the public record, they succeeded. One month before the publication of *Madison: A Model City*, the city of Madison dismissed John Nolen.

Prophets apparently have no honor in their clients' hometown, either. But it's easy to see how the average alderman would be both angered and frightened by Nolen's ambitious plan. Nolen found that as a state capital, home to a great university, and a place of residence, the city had failed in many respects. Contrasting the "community poverty" that this wealthy city chose over the community spirit that poorer European cities displayed, Nolen warned that "as a beautiful city, Madison has a present tendency not upward but downward." The city's lakes and parks have given Madison "a place of high distinction among residence cities of the Middle West," he wrote, but it was "a place it cannot continue to hold without a radical change with regard to future civic improvements."

Nolen saw failure and foolish choices everywhere he looked, dating from Doty's original plat to the present day. A lack of lakeshore access, a tangled forest of utility poles, meager street trees, inadequate housing, no separation between residential and commercial uses, a crooked and crowded State Street; to Nolen's discerning eye, Madison was a mess.

Births and Deaths

1910 Census: 25,531
Death played doubles this decade, with two important mayors, two great university presidents, even a pair of powerful brothers. The state's leading historian and the city's first great parks philanthropist also passed. There were brothers born, as well.

- Elisha Keyes (1828–1910), mayor, postmaster, boss
- John Bascom (1827–1911), university president
- Robert Bashford (1845–1911), mayor, supreme court justice
- Reuben Thwaites (1853–1913), historian
- Daniel Kent Tenney (1834–1915), gadfly, philanthropist
- Deming Fitch (1826–1917), pioneer undertaker
- Philip Spooner (1847–1918), mayor, insurance commissioner
- Charles Van Hise (1857–1918), university president
- John Coit Spooner (1843–1919), U.S. senator
- Irwin Goodman (1915–), athlete, jeweler, philanthropist
- Bob Goodman (1919–), athlete, jeweler, philanthropist

Nolen was particularly critical of the railroads, which he labeled "the most serious factor in Madison's unmaking." Their approaches were "inconvenient and ugly," their yards were located too near the city's center, their tracks occupied what had been "a particularly beautiful stretch of lake front," their dozen different entrances and frequent grade crossings were objectionable and dangerous, and they even ran through the very grounds of the university.

Not that Nolen was surprised, blaming the railroads for "wholesale city corruption and municipal misgovernment," as city councils did "irreparable harm and financial loss due to the reckless fashion" in which "they gave the railroads apparently whatever they asked for." Nolen naturally honored Olin and the parks association, but cautioned against treating their work "as a substitute for public action instead of a supplement."

"Large and permanent results are possible only through the regular machinery of city government," Nolen wrote, "and democratic ideals of city life should make citizens unwilling to accept the benefits to public improvements without contributing their share toward the expenses that are necessarily involved." The power and purse of the public were needed, he said. Calling private efforts "altogether inadequate," he declared that "a radical change of policy is called for," including the creation of a city parks commission and the use of bond issues to develop a coordinated parks system. These, he said, were the city's "two greatest needs."

Like Olin, Nolen was conscious that members of the carriage set could create their own recreational opportunities, but others could not. "Children and young people and the working classes should be much more fully provided for," he wrote. Despite being greeted with apparent indifference or even outright hostility, Nolen's plan did not fade away. Instead, it lodged itself deep in the city's consciousness — an invitation to dream of Madison not as it is, but as it could become. In the years since, most of those dreams have come true.

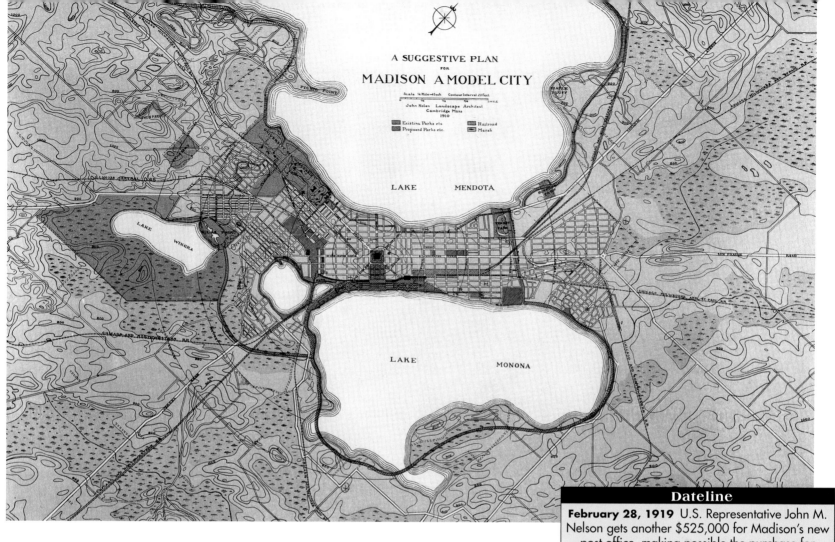

A SUGGESTIVE PLAN
FOR
MADISON A MODEL CITY

Scale ½ Mile=1 Inch Contour Interval 20 Feet

John Nolen Landscape Architect
Cambridge Mass
1910

Existing Parks etc. Railroad
Proposed Parks etc. Marsh

LAKE MENDOTA

LAKE WINGRA

LAKE MONONA

Nolen's Suggestive Plan

John Nolen's comprehensive plan for a park system, close enough to modern reality as to indeed be suggestive. Nolen called for "a really large park, say 500 to 1,000 acres," completely encircling Lake Wingra; the university Arboretum, encompassing about 1,200 acres, now protects almost the entire shoreline. Law Park does not approach the grandeur of Nolen's full esplanade, but the modern alignment of causeway, parkland, and bike path certainly evokes its spirit and surpasses its length. And though the city didn't even pay lip service to Nolen's Grand Mall until 1927, and again has failed to match its scale, the concentration of public buildings there, coupled with the Monona Terrace Community and Convention Center, at least shows the city again seeking to address a drawback dating to Doty's day. Some elements have been completely disregarded, including the acquisition for parkland of all the

lowland between Park and Mills streets, from Regent Street to the railroad tracks. "Unless the city takes the land, it is likely to be developed in a cheap and undesirable fashion," Nolen warned of the modern South Campus area.

Nolen's Lake Monona counterpart to Tenney Park today finds but the faintest echo in the small area flanking the Yahara outlet, while his pleasure drives around the lakes (with a connection through the isthmus) exist only as incomplete bicycle paths.

As shown here, and emphasized in the text, Nolen was an early and ardent advocate of extending University Avenue from Bassett through to West Washington Avenue, although on a slightly different axis than that proposed in the 1920s (page 215). "It must be done as soon as possible," he declared. Surprisingly, for all Nolen's strong calls to widen and improve the major thoroughfares, it does not appear that he has included an automobile causeway ad-

Dateline

February 28, 1919 U.S. Representative John M. Nelson gets another $525,000 for Madison's new post office, making possible the purchase for $1,075,000 of the entire Monona Avenue block to further Nolen's plan for a Grand Mall.

joining the railroad trestles. The first such proposal would come in the 1920s, and only prove successful in the mid-1960s. In some ways, reality has surpassed these suggestions. Nolen knew Michael Olbrich, but he could hardly have anticipated then that the young attorney would spark development of a large park and garden on the northeast shore of Lake Monona. Nor did he know that a few years later the city would extend the cemetery green space to the Illinois Central tracks to create the city's first municipal golf course, or that a full athletic field and stadium would rise on the East Washington marshland. And Nolen would no doubt be thrilled by the Urban Open Space Foundation's ongoing efforts to transform the east railroad corridor into Madison's Central Park. (courtesy of David Mollenhoff)

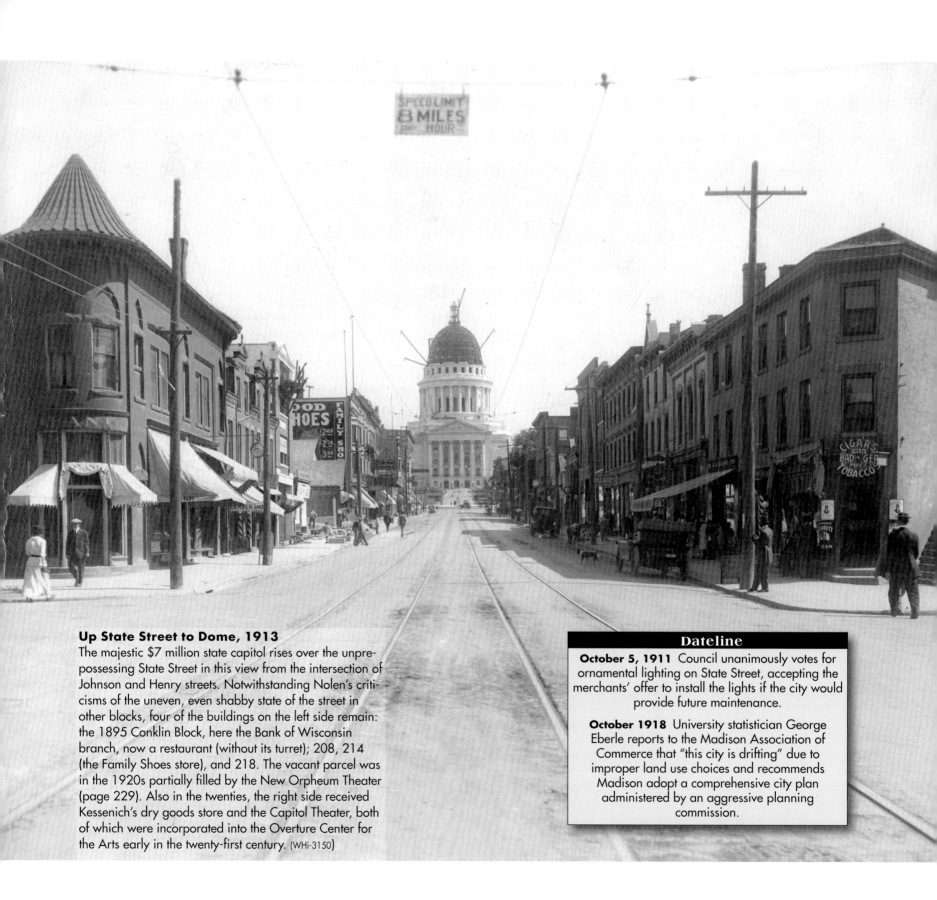

Up State Street to Dome, 1913

The majestic $7 million state capitol rises over the unprepossessing State Street in this view from the intersection of Johnson and Henry streets. Notwithstanding Nolen's criticisms of the uneven, even shabby state of the street in other blocks, four of the buildings on the left side remain: the 1895 Conklin Block, here the Bank of Wisconsin branch, now a restaurant (without its turret); 208, 214 (the Family Shoes store), and 218. The vacant parcel was in the 1920s partially filled by the New Orpheum Theater (page 229). Also in the twenties, the right side received Kessenich's dry goods store and the Capitol Theater, both of which were incorporated into the Overture Center for the Arts early in the twenty-first century. (WHi-3150)

(page 229)

Dateline

October 5, 1911 Council unanimously votes for ornamental lighting on State Street, accepting the merchants' offer to install the lights if the city would provide future maintenance.

October 1918 University statistician George Eberle reports to the Madison Association of Commerce that "this city is drifting" due to improper land use choices and recommends Madison adopt a comprehensive city plan administered by an aggressive planning commission.

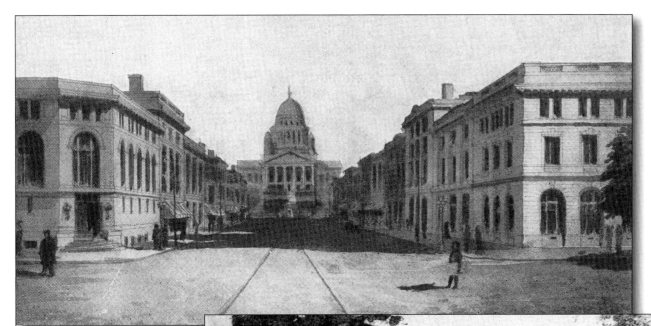

Nolen's State Street

Evidence that even brilliant visionaries can make big mistakes. Nolen wanted to make State Street 150 to 200 feet wide, but would settle for "only 100 feet" in light of the high property values. And his proposed use and mass of the new buildings would have been totally out of keeping with the street's character. Today's State Street is better than the one Nolen proposed. (WHi-40667)

Nolen's State Street Park

Nolen's sketch of the triangle park he proposed, looking east from the intersection of Broom and Gorham streets. Nolen called it "an ornamental space of inestimable value, adorning the city's main thoroughfare," that could be even better than Boston's Copley Square, "for it has a much more significant location." (WHi-40669)

Verbatim

No one who knows Madison and the Wisconsin way of using skill, experience and foresight can fail to believe that there is a latent power in the population that if successfully drawn upon would surmount all difficulties and make Madison a model city, the hope of democracy. Of all the cities in the United States, it appears to me that Madison has the best opportunity to become in the future . . . a model modern American city. It has the site, the environment, the climate, the population, the high civic spirit, the traditions, the permanent attractions of government and higher education. It lacks only the increase of wealth and population, which time will certainly and quickly bring, the co-operation of various public bodies, and a well-considered plan of city making, which it is the purpose of this report to at least inaugurate. It is within the power of the people of Wisconsin to make Madison in the future what Geneva is today — a beautiful, well-ordered, free, organic city. — **John Nolen**, A Model City

665. Girls' Swimming Class, Brittingham Park, Madison, Wis.

Girls Swim Class, Brittingham Beach *(left)*

John Nolen, who did the preliminary design, called it "a model for a small city." The Milwaukee firm of Ferry and Clas, architects for the State Historical Society building, did the final designs for the boathouse and bathhouse. In 1911 the parks association declared it was "doubtful if the bathing suits were dry from beginning of the season until its end." The association bought more than three hundred suits, but with more than 50,000 bathing visits, "there was a line waiting to take the wet suits as soon as the wearers came out of the water." The school board paid for a swimming instructor, who gave about 16,000 lessons in 1911 and close to 30,000 a year later. The bathhouse was razed in the mid-1960s. (WHi-31865)

Brittingham Boathouse *(right)*

The oldest surviving public park building in Madison, also based on a preliminary design by John Nolen. Erected in 1910 and expanded in 1921, the boathouse was designated a Madison Landmark in 1977. In 2006, the boathouse was moved two hundred feet down Monona Bay and renovated and expanded on a more stable foundation. (Madison Public Library)

Who Knew? New Zoo

Nolen also contributed to the success of one of Madison's most popular attractions, the Henry Vilas Zoo. When attorney Thomas C. Richmond offered the MPPDA a herd of five deer from his farm in South Madison in the winter of 1910–11, it was Nolen who advised the association to place them in a stable in Henry Vilas Park, on the south slope of the ridge a little west of Warren (Randall) Street. They were joined the next year by a raccoon; a red fox; three groundhogs; cages of white rats, guinea-pigs, and rabbits; a red squirrel; an eagle; and, thanks to the university, "a flock of fine sheep." With landscaping by O. C. Simonds and buildings designed by prominent local architects Claude and Starck (the bird house) and Frank Riley (the lion house), the zoo grew in reputation and size. In 1983, the zoo's regional appeal was recognized by its separation from the city-owned Vilas Park proper and transfer to Dane County, which now provides 80 percent of operating funds to the city's 20 percent. As the zoo approaches its centennial, it receives more than a half-million visits annually; thanks to the provisions of the Vilas bequests, all of them are free.

T. C. Richmond's Deer

The first animals in what became the Henry Vilas Park Zoo. (Madison Public Library)

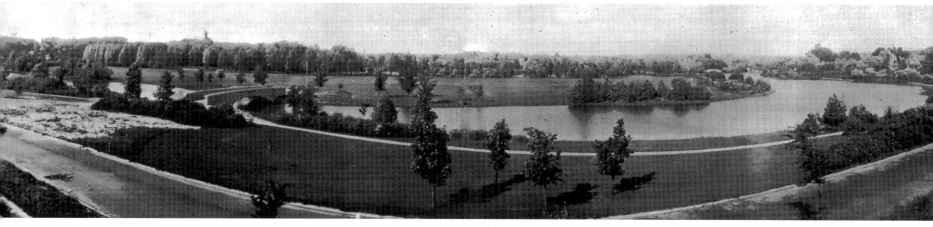

Tenney Park Panorama *(above)*
The living legacy of Daniel K. Tenney, photographed for
the 1913 MPPDA Annual Report. (WHi-41363)

Tenney Park Concert, 1912 *(right)* (WHi-41361)

Vilas Park Parking Lot, 1916 *(below)*
The Park and Pleasure Drive Association finally surrenders
in its fight against the automobile. (WHi-41364)

Dateline
December 7, 1916 W. W. Warner offers the city two challenge grants for parks: $75,000 to acquire the Conklin icehouse site if the city provides $200,000, and $20,000 for a breakwater from Blount Street to Monona Avenue if the city will provide twice that. The council refers the proposal to committee, where it dies.

Dateline
October 10, 1918 As influenza epidemic rages, Madison Board of Health orders immediate and indefinite closing of all public places, including schools, churches, and theaters. The city lifts the order in mid-November but instates a quarantine system the following month. Close to two hundred people die of the so-called Spanish Flu, including forty-nine on campus. "It has certainly been a year of disaster so far as public health is concerned," says city Health Officer Henry E. Purcell.

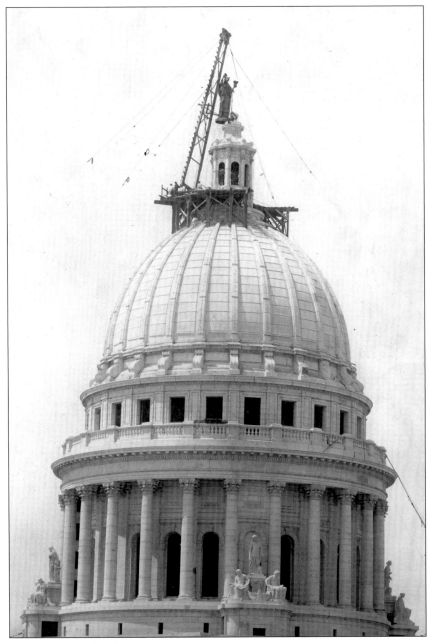

Wisconsin Rising

Hundreds watched as the three-ton, fifteen-foot gilded bronze statue _Wisconsin_ was hoisted into place on July 20, 1914, and positioned atop the lantern the way John Nolen wanted. Sculptor Daniel Chester French, who also crafted the magnificent figure in the Lincoln Memorial, had recommended the $20,000 work be oriented either west to the university or east to the railroad depots. But the son of the capitol architect, the late George Post, said his father strongly recommended the figure face Lake Monona to the southeast, as that entrance was the building's most important. Supervising architect Lew Porter and the Capitol Commission agreed, thus giving the first official endorsement to Nolen's notion of the Grand Mall. (WHi-10457)

To Make Madison a Model City

Nolen listed these recommendations "as of supreme importance for the future" of Madison (details of implementation, if any, follow in parentheses):

1. _To pass suitable laws for the protection of the environs of the State Capitol._ (The State Supreme Court in 1923 upheld a 1921 law setting height limits on buildings on the square.)
2. _To acquire the property between Capitol Square and Lake Monona and adopt an appropriate plan for its development._ (The council in 1927 designated Monona Avenue as the official "civic center" for future government buildings, including the federal post office that year, the state office building in 1929, and the City-County Building in 1954.)
3. _To widen and improve State Street from the Capitol to the university._ (Under Mayor Paul Soglin, the city created the State Street mall in 1977 but never expanded the sixty-six-foot right-of-way to the one hundred feet Nolen recommended.)
4. _To establish, widen, and improve the main thoroughfares in and near Madison._ (The city has done so consistently, sometimes, to some minds, excessively so.)
5. _To secure for public use the most important lake frontages with a view to the formation of a Four Lakes District._ (Most of the Lake Monona frontage, and the most important parts of Lake Mendota's, have been saved for public use through the city's 1921 purchase of Olin Park, acquisition in the 1930s of the lakefront at the end of North Hamilton Street, and the landfill creation of Law Park a few years later. Also, in the 1920s Michael Olbrich created the Madison Parks Foundation to acquire lakefront from the Yahara eastward to the park since named in his honor. Finally, the rest of the Lake Wingra shoreline was in the early 1930s enveloped by the university Arboretum, just as Nolen had drawn. Although there is considerable regulation of the lakes, the precise regulatory body Nolen envisioned does not exist.
6. _To inaugurate a plan for the redemption and use of all marsh lands within or near the limits of Madison._ (The last of the Great Central Marsh was filled in while Nolen was writing, in 1910.)
7. _To forecast the future needs of the university and more adequately provide for them._ (As far back as Nolen's day, the university has undertaken several comprehensive planning efforts, with varying degrees of success and implementation.)
8. _To secure the improvement of the railroad approaches to the city and the gradual abolition of grade crossings._ (Not completed, and a matter of continuing controversies — when there were lots of trains, over their terrible impact on traffic; now, with only a few trains each day, over the city's attempt to ban their whistles.)
9. _To adopt a better method of locating and improving streets and making land subdivisions._ (The city created its Plan Commission in 1920, based on the statute Nolen drafted in 1909.)
10. _To remove from the public streets all wires, poles, and other obstructions._ (Done gradually over the ensuing decades.)
11. _To pass a shade tree ordinance providing for the systematic public planting and maintenance of street trees._ (The council enacted such an ordinance in 1926. James Marshall became the first city forester in 1927.)
12. _To organize the park work of Madison under a new park law._ (The city created its Parks Commission in 1931.)

continued on facing page

A Wright Hotel Goes Wrong

Nineteen years after Frank Lloyd Wright's ill-fated Lake Monona Boathouse and sixteen years before his failed first attempt at Monona Terrace, Madison missed out on a yet another innovative Wright plan — a hotel on Monona Avenue.

Milwaukee businessman Arthur Richards, who controlled the corner of Monona Avenue and Doty Street, commissioned Wright in 1912 to seize the opportunity of Madison's growing convention trade. Three of the city's hotels were from the 1850s, and most predated fireproof construction, private baths, and electricity. The Park Hotel had just completed its second major renovation, but it was still a structure from 1871 and seen as inadequate.

Wright designed an eight-story, 126-room hotel, budgeted at $250,000, with an aggregate concrete exterior and copper and glass lobby. He cleverly protected the tower's light and air by placing a three-story lobby on the inside of the lot, thus creating a setback from future construction. While there were several exceptional features — a leading Wright authority has labeled the lobby "fairly spectacular" and each floor provided a balcony with a lake view — there were some deficiencies, including having just a single stairwell for all six floors. And though all the

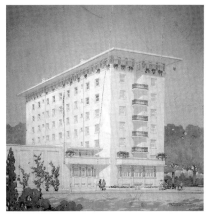

Frank Lloyd Wright, Madison Hotel
View from Monona Avenue, east toward Doty Street. (The drawings of the Frank Lloyd Wright Foundation are © 2003, the Frank Lloyd Wright Foundation [1110.001])

rooms had washbasins, not all of them had toilets; some guests would use public bathrooms down the hall (not uncommon in the era).

In seeking support and financial backing, Richards couldn't have asked for a better situation: His architect's cousin, Richard Lloyd Jones, was the energetic and talented editor of the *Wisconsin State Journal*, which trumpeted the design and predicted its success in an elaborate display on March 6, 1912. The shortage of hotel rooms was so pronounced that Jones's archcompetitor, the *Madison Democrat*, also gave enthusiastic coverage of the unveiling.

The hot market may also explain why Richards was working again with Wright after the difficulties they endured on an ongoing hotel project in Lake Geneva. And Richards's financial losses from that project may help explain why the Madison Hotel was never built.

Richards and Wright were also up against the formidable John Olin and other supporters of John Nolen, whose recent call for a Grand Mall on Monona Avenue had captivated influential Madisonians; a tall, private building lacking an expansive setback on the site where Nolen envisioned a single public building occupying the entire block was completely unacceptable.

Olin and his associates also pursued height limits all around the square, as Nolen had proposed, but they did not come soon enough to stop Leonard Gay from building the city's first skyscraper (page 189). The state finally enacted a ninety-foot limit in 1921, but construction on two new hotels — the Piper brothers' Belmont and Walter Schroeder's Loraine — had started before the supreme court upheld the legislation and was allowed to proceed (page 239).

Richards's weakened financial state and the serious land-use issues helped doom the project. Instead, eight years later Law, Law and Potter — the same firm that designed the pedestrian Gay Building and whose work Wright derided — designed the undistinguished seven-story commercial Beaver Building. Its inadequacies are evident in the photograph on page 241. A tall, private-use building without proper setback on a prominent corner in the middle of the Grand Mall, it is another of Madison's many miscues on Monona Avenue.

But Wright suffered a far greater loss this decade — the August 1914 murder-arson at Taliesin, in which an unhinged employee killed Mamah Cheney, her two children, and four others. And he also enjoyed a far greater accomplishment than the Madison Hotel could ever have been — the 1919 start of construction of the $5 million Imperial Hotel in Tokyo.

To Make Madison a Model City *continued from facing page*

13. *To take the existing parks of Madison as a nucleus and by supplementing them with small open spaces, larger parks, and parkways, as already outlined, secure a well-balanced park system of the city.* (Following creation of the Parks Commission, the city assumed the assets of the Park and Pleasure Drive Association and has continued its efforts. Two other private groups have also continued the legacy of the MPPDA — Olbrich's Madison Parks Foundation, revived in 2005, and the Urban Open Spaces Foundation.)
14. *To provide playgrounds and large school grounds in every residence section of the city.* (A continuing enterprise, and a requirement of all neighborhood plans and certain land use approvals.)
15. *To adopt reasonable regulations for the control of all buildings so as to differentiate neighborhoods and protect real estate values.* (The city adopted its first zoning code in 1922.)
16. *To consider methods of improving the housing of people of small means.* (The city has undertaken various efforts with varying degrees of success, including creation of a Madison Housing Authority [later abolished], creation of a Community Development Authority with broad administrative and bonding authority, enactment of measures to protect tenants, and adoption of an inclusionary zoning ordinance.)
17. *To investigate and report upon city finances for Madison in regard to bond issues, current taxes, and relation to the state government.* (Both governments continue to refine their accounting practices and develop innovative financing plans.)

NEIGHBORHOOD HOUSE

An established advocate and a young academic tag-teamed in the spring of 1916 to expose the decay and discrimination plaguing the low-income, Italian neighborhood around Park and Regent streets known as Greenbush, or the Bush. By that fall, social workers, philanthropists, and Americanization activists had taken their message to heart and, thanks to two dedicated women, created one of Madison's most enduring institutions, Neighborhood House.

The advocate was Lawrence Veiller, secretary of the National Housing Association and a national leader in planning and affordable housing. Invited to Madison by the women of the Civics Club, he unloaded what one newspaper called "the most biting commentary on local conditions" the group had ever heard. The academic was Henry Barnbrock, who had come to the university to study under Richard Ely and John Commons. His senior thesis was a painstaking study with hard numbers documenting life in the Bush. Together, they exposed a situation most Madisonians wanted to believe didn't exist. But Helen Dexter, the Associated Charities visiting housekeeper, and Mary Sexton, visiting nurse for Attic Angels, knew it was true.

"You've got as bad a slum as any city in the country," Veiller declared on May 20, 1916, calling the Bush a "civic cancer" that needed a quick and liberal knife. Reminding his audience that until the new sewage system was built, Veiller said Madison was "barbaric enough to turn all of your human waste into your beautiful lake so that you couldn't even use it for bathing. You and every citizen of Madison have your share of the responsibility." Author of a model housing and tenement law, Veiller also recommended the city form a company to build quality affordable housing, letting the residents buy stock in the company "so they will have some ownership in their homes." And Veiller explicitly evoked Nolen's comprehensive plan, now five years old: "You can still be a model city," he said, urging quick action.

The prominent women of the Civics Club responded, promptly appointing a committee to turn Veiller's recommendations into results. They also undertook to erect a block of stucco houses across from St. Joseph's Church on South Park Street.

Almost immediately, they were given useful data documenting the "repulsive environment" in which eleven hundred Madisonians lived; Barnbrock's thesis contained comprehensive facts and figures on housing conditions, sanitation, crime, and employment that the city couldn't ignore. As with Magnus Swenson thirty-six years prior, a university student affected Madison's history. It wasn't any defect in the Italian character that created the deplorable conditions in Greenbush, Barnbrock concluded, it was the terrible physical condition of the area, made worse by landlord greed and the city's malevolent disregard.

Helen Dexter and Mary Sexton, who were the only Madisonians other than Barnbrock and some representatives of the Methodist church to have any extended personal contact with the Italian community, used Barnbrock's thesis to secure support from their parent organizations to underwrite the opening of Community House at 807 Mound Street in late September 1916. Like many of the structures in the Bush, the building was a remnant of early Madison, moved from downtown; it was former governor James O. Davidson's old home, originally on Gilman Street.

In 1917, Community House moved to 25 South Park Street, one of the Civics Club's stucco houses. Thomas E. Brittingham, who had already donated $24,500 for the nearby park, paid the rent. Its name changed to Neighborhood House after a young girl from the Bush asked Dexter, "Are you going to be my neighbor?" They were, and for the next five years Neighborhood House offered classes similar to those in Americanization efforts around the country — English, health, cooking, sewing, citizenship, and cleaning.

External affairs were also key, as America's entry into World War I intensified the crusade-like atmosphere of Americanization efforts. By 1918, hundreds of volunteers were swarming into Neighborhood House to do their patriotic — and often paternalistic — duty and help the immigrants. Most of the volunteers came from the university, including many from honorary Ku Klux Klan society.

With the war's end, the fervor for Americanization abated, and in 1920 the Public Welfare Association (the former Associated Charities) discontinued operation of this phase of Neighborhood House. In its place would arise another important Madison institution — Neighborhood House as a settlement house with live-in social workers Gay Braxton and Mary Lee Griggs.

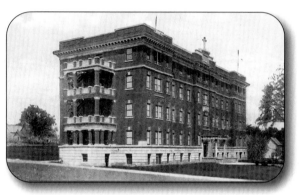

St. Mary's Hospital
After an initial attempt at a five-story facility proposed for the hilltop at Johnson and Baldwin streets fell through, the Sisters of St. Mary settled on the site of the settlement-era Catholic cemetery, between the Dividing Ridge and Monona Bay. This seventy-bed, $157,000 facility designed by F. L. Kronenberg, 722 South Brooks Street, was dedicated on September 11, 1912. It admitted a thousand patients its first year, part of the city's tremendous health care expansion that included a maternity hospital on Wisconsin Avenue (1911), an eighty-five-bed addition to Madison General Hospital (January 1912), and the first modern physicians' clinic and home of Madison's first family of medicine, the Jackson Clinic (1919). There were also two important health advances on campus: a student infirmary in 1910 (the second in the country) and the medical school's first affiliated teaching hospital, Bradley Memorial. From 1900 to 1920, the city progressed from thirty-two hospital beds to nearly three hundred, and from two health facilities to eight. (WHi-11033)

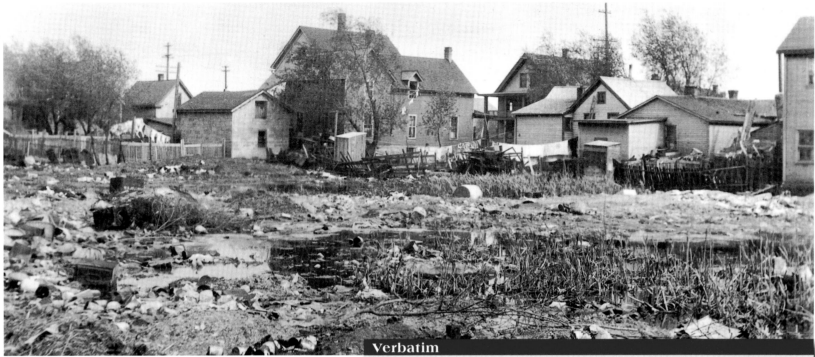

Park and Regent, 1911

This photograph from a 1911 university thesis on public health issues shows the situation that Lawrence Veiller and Henry Barnbrock exposed five years later. (WHi-11131)

Handbook, Societia Mutualia

Handbook of the mutual aid society later known as the Italian Workmen's Club, founded January 18, 1912, by forty-two Greenbush residents in the back room of Angelo Maisano's store at 821 Regent Street, with Francesco Barbano serving as the first president. The design is the Sicilian symbol Trinacria, with its three bent legs (representing the island of Sicily's three corners) surrounding the head of Medusa. The club no longer conducts its meeting in Italian, but still meets monthly and is thought to be one of the oldest continuously active organizations of its type in the country. (Tim Chatman)

Statuto e Regolamento
Club Lavoratori Italiani
SICILIA
Di Mutuo Soccorso e Beneficenza

Fondata il 18 Gennaio 1912
MADISON, WIS.

STAMPERIA ITALIANA
V. Ciocia
247 Centre Street, New York, N. Y.

Dateline

September 12, 1915 City health director hears a report that Madison is the most unsanitary city in the state. A recommendation is made to immediately ban retail sale and delivery of bulk milk.

Verbatim

The housing problem associated with the defective buildings is aggravated by the numerous dumps for rubbish and garbage. Scarcely a vacant lot exists in the community which is not covered with decaying vegetables, filthy stagnant water, and all kinds of refuse. . . . Although often credited to the Italians, (many of) these dumps are owned and developed by American people. Draymen notoriously throw off their refuse from stores and dwellings elsewhere, and leave the heaps exposed. During the warm months the nauseating odors arising from them are sensed keenly for one or two blocks. The people who live on Regent, Murray and West Milton Streets never breathe pure, fresh, invigorating air. . . . At an elevation of only two to six feet above the surface of Lake Monona, the Community is built upon extensive areas of swampy, undrained land. Filthy stagnant water, polluted by refuse dumped upon the land promiscuously, partially covers the unoccupied areas. . . . The remainder of these lands is an unsanitary dump filled with ashes, rubbish, tin cans and rotting vegetables and fruits.

These dwellings that are housing the Italians barely offer 50 percent of the comforts and conveniences essential to health, sanitation and general well-being of the individual. The notoriously low standard of these dwellings suggest that they are beyond effective alteration and repair. . . . Insufficient capital or credit prohibits the Italians from building the new houses that are imperative for permanent improvement.

The constructive influence of education is partially neutralized by the expressed "anti dago" sentiments of city officials. While the schools teach . . . principles of hygiene, sanitation and citizenship, the Departments of Health, Streets and Buildings deliberately neglect the general health, sanitation and appearance of the Italian community. When complaints or petitions are registered by the Italians with officials in these departments, they seldom receive attention. As long as the city authorities exhibit negligence and discrimination against the Italians, the Italians find political adjustments difficult. — **Henry Barnbrock Jr.**, "Housing Conditions of the Italian Community in Madison, Wisconsin"

Annie Lemberger

Annie Lemberger was just seven years old when she was abducted from her family's home at 2 South Frances Street on September 6, 1911, starting a tragic saga second only to the kidnapping of the Lindberg baby for the national headlines it generated. Panic gripped the city, as the new owner of the *Wisconsin State Journal*, Richard Lloyd Jones, and his managing editor, William T. Evjue, shamelessly exploited the tragedy. Annie's body was found floating in Monona Bay near the foot of Erin Street two days later; thousands attended her funeral at St. James Church the next day. By that time, police had already quietly arrested John A. "Dogskin" Johnson, a neighbor whose criminal record included attempted murder, train-wrecking, family abandonment, and molestation of little girls. Johnson quickly confessed and was sentenced to life imprisonment. But on his way to the penitentiary in Waupun, he suddenly recanted and declared his innocence — starting a clever campaign that ten years later would lead to a terrible miscarriage of justice and a shocking display of judicial misconduct (see page 222). (Ani Lemberger)

(see page 222)

Greenbush and Triangle, 1916

Population, 1900	15
Population, 1910	446
Population, 1916	1,100
Percentage of population under 30	80
Under age 5	22
Over age 40	5
Ratio of males to females	7:4
Ratio single males to single females	30:1
Value of assets, 1910	$28,000
Value of assets, 1916	$91,000
Number of saloons in Greenbush	0

Primary enclaves

Sicilians: Milton Street

Sicilian/Albanians: Lower Regent Street

Lombardans: Proudfit Street

Dateline: The Bush Begins

July 2, 1913 Calogero Liceri, 824 Regent Street, is brutally murdered and disfigured two days after coming to Madison. Police find his watch and wallet still on his person, call the killing a vendetta, and make no arrests.

December 14, 1913 Milwaukee Archbishop Messmer presides at dedication of St. James Church, 1204 Church Court.

May 11, 1916 Residents of Italian section plead with Board of Health to stop practice of dumping refuse in low swamp lands of fifth and ninth wards.

May 14, 1916 Cornerstone laid for St. Joseph's Church, 20 South Park Street.

February 4, 1918 Patrolman Grant Dosch becomes the first Madison police officer killed in the line of duty, shot when he surprises three burglars at the Cohn general store, 754 West Washington Avenue. A two-year veteran of the force, Dosch, age thirty, had finished his beat in Fair Oaks at 3 a.m., stopped for a cup of coffee at the Milwaukee Road depot, and was on his way home to his wife and two children on Emerald Street when he tried to apprehend the burglars and was shot twice in the head. He died a few hours later at St. Mary's Hospital. Three Greenbush men — Tony Mazarro, his brother John, and Peter Messina — are charged with the crime. At their trial a year later, Judge E. Ray Stevens orders members of the Mazarro family expelled from the courtroom for allegedly giving threatening "black hand" signals to witnesses. On April 18, 1919, the three were found not guilty.

An Umbrella Organization Opens

Associated Charities, one of the founding agencies of Neighborhood House and the progenitor of one of Madison's most important nonprofit human services agencies, was formed on January 6, 1910, by representatives of Volunteers of America, Attic Angels, Christ Presbyterian Church, First Methodist Church, the Common Council, and the Fifth Ward Sewing Society. It was organized and led by Alderman Peter Schram, who died on December 14, 1910, after a lengthy illness. Its board of trustees elected on December 31, 1910, was one of the most impressive bodies in Madison's history, and included Mayor Schubert; Judges Siebacker and Barnes; E. F. Riley, secretary to the Board of Regents; Thomas E. Brittingham; Daniel K. Tenney; John R. Commons; bank president Lucien M. Hanks; former mayor W. D. Curtis; the Reverend Frank Gilmore; Joseph W. Hobbins; industrialist Hobart Johnson; and streetcar company president F. W. Montgomery In September 1919, it changed its name to the Public Welfare Association, which it remained until it became Family Service in 1946.

Madison Notable

George Pregler (1854–1930) was the man who made what many consider the core of the Bush, hauling ashes and trash to fill in the marshy triangle of land east of Murray Street, between Regent and West Washington. Pregler emigrated from Germany at age twenty-eight and settled in a rented cottage on the marsh in 1884. He shoveled coal at the railroad station and eventually bought the nineteen acres around him for $5,000, creating a little more landfill each night after work. Pregler completed the development by buying houses about to be razed uptown and moving them.

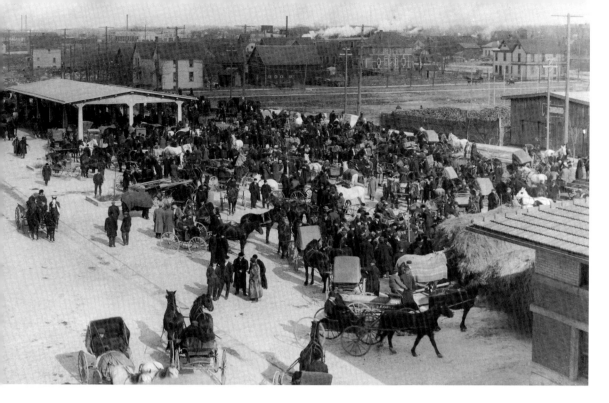

City Market Neighborhood, ca. 1915

The Water Tower Horse Market in the first block of East Washington Avenue was a success, but the hustle and bustle of the ongoing farmers' market that it spawned — with its animals, produce, and garbage — proved too much for the business community and city officials. So in 1908 the council bought the block of low-lying ground bordered by Blount, Livingston, Mifflin, and Dayton streets to open a regulated municipal market. The city retained local architect Robert Wright, who designed a $14,000, 10,000-square-foot Prairie-style building with catchy color scheme of red, yellow, and green. The market opened with joy and celebration and a crushing crowd of five thousand on November 2, 1910. "It was great," an enthusiastic *Madison Democrat* reported. "There isn't another city in America of its size that can boast anything like it. It showed Madison's fine spirit of brotherhood and democracy." But there were only two vendors selling fresh produce, and the market was soon floundering. Shoppers thought the location inconvenient, and farmers found it insulting. The women's market committee of the Dane County Council of Defense Food Board brought some flickering success during World War I, but the market eventually closed. The edge of the market building is visible in this view across Livingston Street to the working class east side. Converted to a city maintenance facility in the 1930s, the building was renovated into loft apartments in the late 1980s. The City Market is a Madison Landmark and is listed on the National Register of Historic Places. (WHi-2259)

A Place for Young Men

Madison's new YMCA opened on the southwest corner of Fairchild Street and West Washington Avenue on March 1, 1919. John H. Findorff's first job as Madison's first general contractor, the $335,000 building of Bedford stone, terra cotta, and pressed brick exterior provided 144 rooms at reasonable rates, a cafeteria, bowling alley, classrooms, and reading and club rooms. In his dedicatory address, board chair Emerson Ela said programs like the YMCA protect America from assault, "whether from the brutal-handed mailed fist of the neo-Darwinistic Hun or from the red-handed, self-seeking virtue-destroying government-wrecking bolshevism." The building was razed in 1982, with the site remaining vacant until construction of the Tommy G. Thompson Commerce Building in 1990.

Dateline
June 2, 1913 Rotary Club of Madison becomes the seventy-first affiliate member of Rotary International.

Madison's First Skyscraper

In early 1911, just months after John Nolen urged an immediate height limit on buildings on the square, developer Leonard Gay revealed plans for a nine-story office building across from the capitol at 16 North Carroll Street. It was to be the tallest building in the state outside Milwaukee, and opposition to the encroachment at both local and state levels was swift but unsuccessful. An unexceptional design by future mayor James R. Law, the Gay Building boasted reinforced concrete fireproof construction and high-speed elevators when it opened in February 1915. The tallest building in town until the Belmont Hotel in 1923, it underwent a name change, to the Churchill Building, in the 1970s. Gay, who lost a close race to unseat Mayor Hoven in 1900, also developed the doomed Lake Forest Park this decade (page 191). (WHi-11137))

Verbatim

Unfortunately, the city market was placed in as isolated a part of the city as could possibly be found. But that should not discourage us. We should use our best endeavor to make it a success. It will require a great deal of hard work, a great deal of advertising, but eventually we may reap the reward. — **Mayor John Heim**, annual message, April 16, 1912

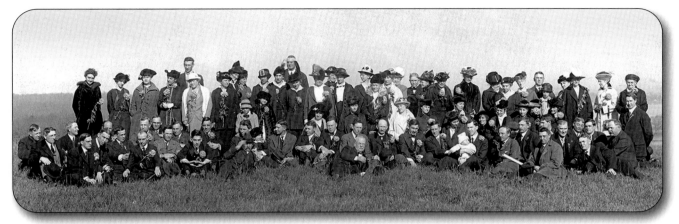

NAKOMA

Nakoma, which would become one of Madison's most successful planned communities, failed in its first two incarnations.

An early example of suburban sprawl, Nakoma had a sputtering start in early 1911, when the University Land Company platted the curvilinear seventy-seven-lot "Gorham Heights" on forty acres of Town of Madison farmland on the hill overlooking the Spring Tavern, the 1854 stagecoach stop about four miles southwest of downtown. Well past the Edgewood campus end of the streetcar line, and before widespread auto ownership, only a few scattered lots were sold, and in 1914 the Madison Realty Company bought the parcel, along with another forty-six acres of adjoining farmland, and called the new 292-lot plat Nakoma, the Ojibwa word for "I honor my oath."

The Native American imagery was appropriate for this former Ho-Chunk village, where several skeletons had earlier been excavated from six prehistoric mounds. As a November 1915 newspaper account of construction on Nakoma Road accurately surmised, "judging from the implements found while grading, this spot was formerly an Indian camp."

The name also was meant to assure prospective buyers that the company would provide and maintain the extensive municipal infrastructure needed at the rural location. Unlike the streetcar suburbs of University Heights and Wingra Park, which did not provide basic municipal services until their annexation in 1903, Nakoma offered water, gas, electricity, gravel streets, and a sanitation system from the day the subdivision was placed on the market in July 1915.

The company also replaced an existing 1854 one-room, white frame schoolhouse on the Monroe Road with a $15,000 two-room Prairie-style schoolhouse, and contributed $450 for library books. The site later housed the Thoreau Elementary School, giving the location an unbroken skein of more than 150 years in educational use — by far the longest such single-use record in the city's history.

These investments took their toll on company finances (the bus service was especially expensive). Although almost a third of the lots sold in the first few months, actual construction went slowly. "It was a financial tragedy," Madison Realty corporate secretary Alfred Rogers — Robert La Follette's former law partner — reflected years later. "We lost our money in the investment."

As a marketing gimmick, the company in 1916 sponsored a contest to name the plat's new streets. Winners got a twenty-dollar gold piece, but had to submit their entries on site. There were four thousand entries, representing about one-seventh the city's population. Nakoma settler Charles E. Brown, the archeologist and curator of the State Historical Society who preserved the area's Indian mounds, ran the contest and made sure the new names hewed strictly to the neighborhood's Native American concept. One street, though, did stand out as an oddity; in the heart of the former Gorham Heights, traversed by Oneida Place and Seneca Place, the street now called Council Crest was for a time known as Custer Road.

Despite prominence and publicity, Nakoma struggled to reach critical mass. By the end of the decade, only twenty-four homes had been built.

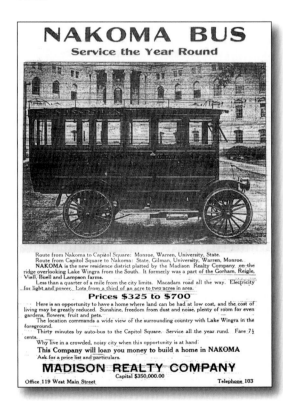

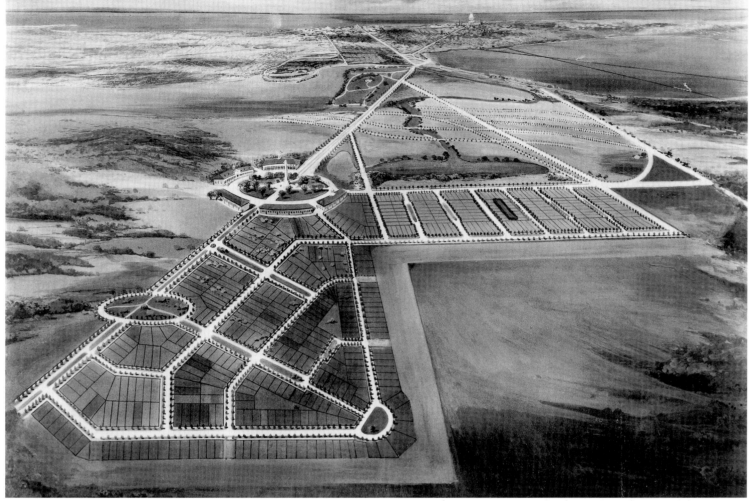

Lake Forest, "The Lost City" (WHi-38231)

SUBMERGED SUBDIVISION

The most ambitious and ill-fated suburban development of the era was the work of two men with spotty records in city beautification efforts: Chandler B. Chapman, who would instigate the demolition of the Frank Lloyd Wright boathouse on Lake Mendota, and Leonard P. Gay, whose downtown skyscraper was the first to mar the capitol skyline.

Chapman and Gay organized the Lake Forest Land Company in August 1911 and unveiled the subdivision south of Lake Wingra five years later. With a central core of stores, public buildings, and offices, modestly sized housing lots and a trackless trolley to South Mills Street, it's an early example of what's now known as new urbanism. Unfortunately for Chapman and Gay, however, the water that gave the plat its scenery and proposed series of Venetian-style lagoons also proved its undoing.

Company crews undertook wide-scale dredging to clear drainage ditches and stabilize the swampy land. But then the company secretly opened a Lake Wingra dike to facilitate the operation, thus reducing water levels by about two feet — exposing the unsightly and unsanitary shoreline and lowering the water levels in newly sculpted lagoons in Henry Vilas Park till they became stagnant and offensive. The city and the MPPDA had to go to the Railroad Commission to get the company to repair the dike and restore the lake to its original level.

The lots — generally about 4,200 square feet and averaging about $1,000 (ten dollars down) — sold well at first. But then the world went to war, and sales ground to a halt. After the armistice, the company sank a 219-foot artesian well (that still serves the area), erected the first (and only) public building (a pumping station), started construction on the main thoroughfare (Capitol Avenue), provided electricity, published an internal newsletter (the *Lake Forester*), and advertised heavily.

But nothing worked and by 1920 only sixty-one lots had been sold and one home built. Then in 1921, the Madison Bond Company, which handled the development financing, defaulted. The president was imprisoned, the company went bankrupt, and the Lake Forest Company was unable to do as it promised. A handful of additional homes were built that year, but by 1922 the development had failed.

Before long, the plat returned to its original state, as the lagoons silted over, the concrete roads crumbled, and Lake Forest became known by another name — Lost City. A bold and progressive attempt at urban planning, Lake Forest stands today as a mute reminder that nature bats last.

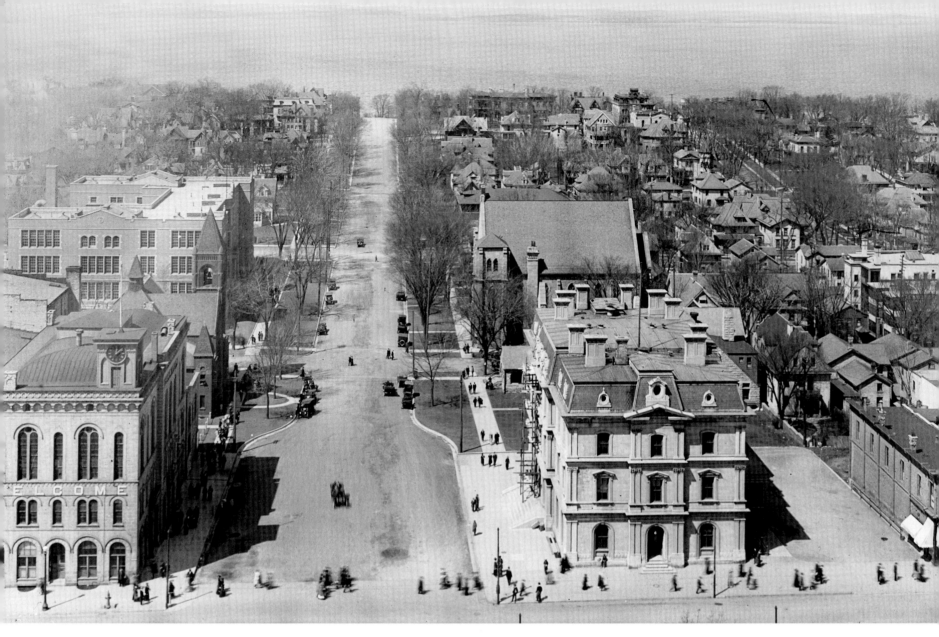

Law and Order, January 30, 1915

Madison's first-ever grand jury, called to investigate the police department, issues two indictments and recommends dismissal of half the police force for "discipline and harmony," but finds that the city is one of the cleanest in the country, without organized gambling, open prostitution, or rampant drunkenness. The report says some police do drink on duty, but not that many; still, it recommends "a stringent ordinance . . . to prohibit loitering and loafing in the saloons." Indicted are members of the Home Rule and Taxpayers League, a political action committee, for alleged violations of the corrupt practices act, "as a test case for what constitutes political activity and political disbursements." Also indicted is a Chicago advertising agency for unauthorized and unreported political advertising on behalf of the league. The report confirms that a chop suey shop on East Main is "frequented by an undesirable class of women who go there for improper purposes" and is also selling liquor, and recommends it be shut as a nuisance. Finding that new officers "as a rule are without knowledge or experience in police work and have little instruction following their appointment," the report recommends a training program. To raise standards, the panel also urges that pay raises — which Mayor Sayles recently vetoed — be granted: "The city does not pay its police force sufficient salary to invite the necessary talent to make it a first class force, as the city of Madison should have. If the proper tests were given . . . few would qualify for appointment."

Wisconsin Avenue, 1915
City hall, Christ Presbyterian Church, high school to the left; post office and portico of the First Unitarian Church to the right. (WHi-30475)

Dateline
October 26, 1914 Beset by crime wave of strong-arm robberies, the city hires detectives from Burns Agency of Detroit.

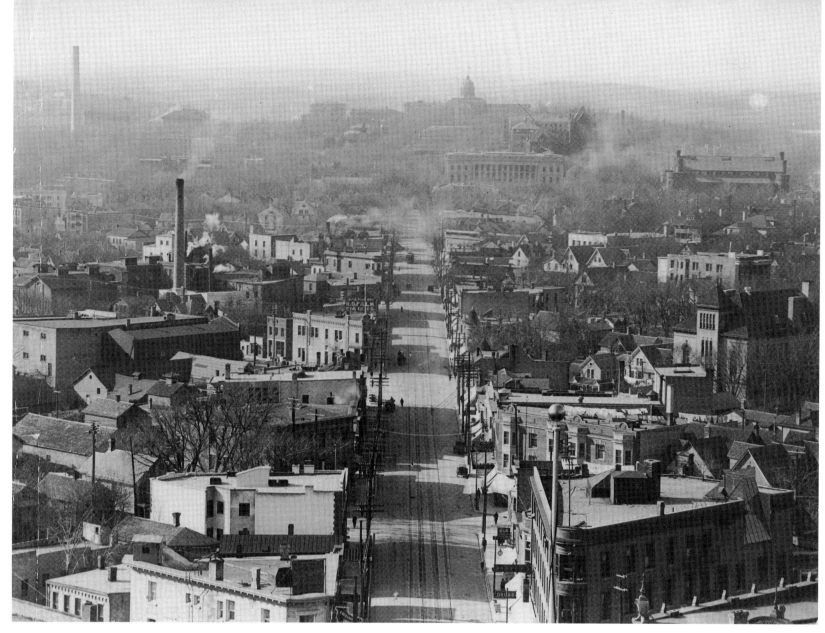

Down State to Campus, ca. 1915

Without major improvements, John Nolen warned, "State Street will remain the present unhappy example of a commonplace and inconvenient city street, notwithstanding its apparently permanent pre-eminence in location." Over time, the city cut back on the soft coal creating these hazy conditions and buried the ubiquitous utility lines. But the street is still sixty-six feet wide and most of the buildings seen here still stand, including the village-era Main Building (left foreground). The smokestack at center left marks the back of the historic Hausmann Brewery, which almost became the site of a new city hall after a devastating fire in 1923. (WHi-35710)

Dateline

April 17, 1917 Special city hall site committee recommends the A. E. Proudfit property on southeast corner of West Washington and South Fairchild. The son of the former mayor has offered the 132-by-186-foot property for $85,000, less than he could get from commercial interests. No action taken.

A Decade of Referenda

1910	Issue liquor licenses? pass, 3122-2398
1912	Adopt commission government? fail, 2189-2669
1913	Annex Fair Oaks? pass, 689-65
1914	Issue liquor licenses? pass, 3705-3632
1915	Issue liquor licenses? pass, 4310-4066
1916	$150,000 Bond for new city hall? pass, 4076-2626
1917	Issue liquor licenses? fail, 4156-4563
1918	Issue liquor licenses? fail, 3985-3986
1919	Issue liquor licenses? pass, 4008-3189
1920	Acquire Madison Railways Company? fail, 2868-4265
1920	Adopt Daylight Savings Time? fail, 2645-5116

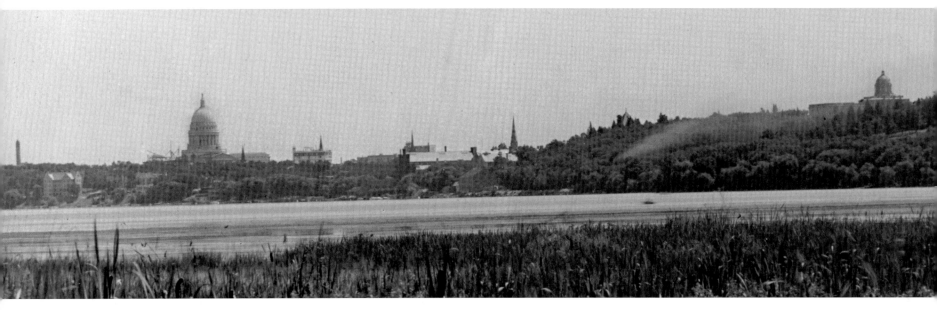

Skyline from Picnic Point, ca. 1915
Likely the last photograph of this tableau before the Main Hall fire. (WHi-33735)

VOTERS REJECT COMMISSION GOVERNMENT

The nature and future of Madison government was at stake when progressives used the new Referendum Act of 1911 to schedule a binding vote on abolishing the weak mayor/strong council system and instituting government by three full-time commissioners. As with some other Progressive Era initiatives, the campaign split the city along class and cultural lines. Upper class reformers led by John Olin, mayor Joseph Schubert and editor Richard Lloyd Jones championed the change, which was adopted in Eau Claire, Appleton and Superior; German-Americans and the working class were largely opposed. Opting for a government more personal than professional, and more friendly than efficient, voters on January 30, 1912 rejected the commission system, by 55-45 per cent. In 1946, the people reconsidered the value of at least having an executive with expertise, and created the post of city manager, with policy and oversight from a seven-member council. But Madisonians soon missed politics as usual, and reverted to the mayor/council system in 1950.

Verbatim

MADISON

Fair city of our commonwealth,
Our fathers' rich bequest:
The child of noble heritage
And queen of all the West.
Isled in by limpid waters
Enfolding like the sea:
Thy dream of beauty seemeth
Like fairy-land to me.
Killarney's lakes are bonnie,
And Como's lake is bright:
But fair Monona shineth
Like a gem of silvery light.
O city of enchanted lakes!
O pearl of beauty rare!
Earth hath not anywhere to
 show
A spot one half as fair.

On all thy hilltops rising,
Vast domes and shining spires;

Where law and love and
 learning
Have lit their beacon fires.
And each red sunset mirrored
In Mendota's crystal deeps;
Shows through the drowned
 ages
God still his vigil keeps.
But not alone in splendours
That nature hath conferred;
Shall live thy name full lasting
Where e'er thy name is heard:
But to the farthest zone-line
Where men for freedom fight;
Thy name shall light the
 darkness
Till darkness shall be light.

— **"Madison," by William Dawson,** *Community Business,* Madison Board of Commerce, February 27, 1915

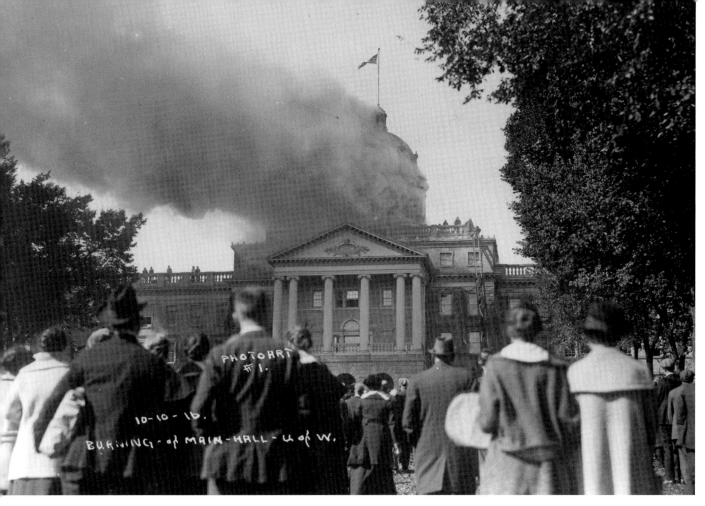

Main Hall Burns, October 10, 1916

Student volunteers struggled successfully to save the university's Main Hall — but not its dome — from a fire of unknown origin. The first alert came from other end of State Street, after a capitol clerk saw the billowing smoke. More than a thousand students were safely evacuated within three minutes of the first alarm at 10:25; at 11, the dome collapsed — thankfully, into a large tank of water situated immediately below. Unlike the 1904 fire at the capitol, the $25,000 loss — one-tenth the value of the building and its contents — was completely covered by the state insurance fund. (University of Wisconsin Archives)

Dedication of the "Sifting and Winnowing" Plaque, June 15, 1915

President Van Hise speaks to members of the class of 1910 at the dedication of its plaque, which quotes from the report celebrating academic freedom that followed the vindication of Professor Richard T. Ely against charges of radicalism in 1894. The plaque gathered dust in the Main Hall basement for several years before this low-key celebration. (University of Wisconsin Archives)

Dateline

March 7, 1910 Two Negro athletes on the Detroit basketball team are lodged at a downtown hotel while their teammates stay at the Chi Psi fraternity house.

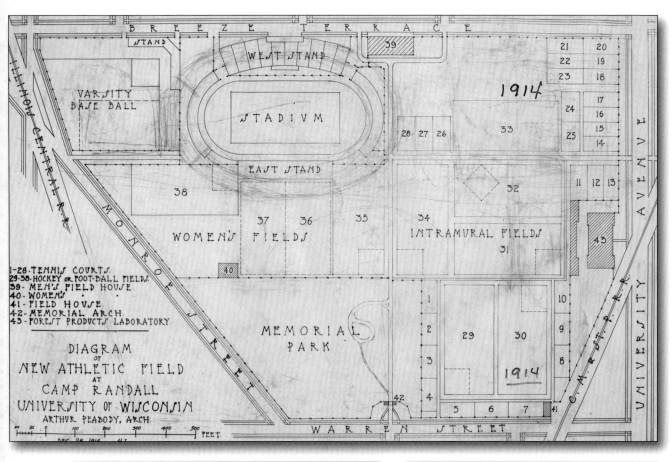

Labels within the site plan diagram:

BREEZE TERRACE

STAND

WEST STAND

VARSITY BASE BALL

STADIVM

1914

EAST STAND

WOMEN'S FIELDS

38

37 36 35

40

MEMORIAL PARK

42

INTRAMURAL FIELDS

34 33 32 31

29 30

1914

1-28.TENNIS COURTS.
29-38.HOCKEY or FOOT-BALL FIELDS.
39-MEN'S FIELD HOUSE.
40-WOMEN'S
41-FIELD HOUSE.
42-MEMORIAL ARCH.
43-FOREST PRODUCTS LABORATORY.

DIAGRAM OF
NEW ATHLETIC FIELD
AT
CAMP RANDALL
UNIVERSITY OF WISCONSIN
ARTHUR PEABODY, ARCH.

FEET

WARREN STREET

ILLINOIS CENTRAL R.R.

MONROE STREET

C. M. & ST. P. R.Y.

UNIVERSITY AVENUE

Site Plan, Camp Randall, 1914

When the original 1896 stands near Dayton and Warren (Randall) streets were condemned in December 1914, the legislature finally heeded the university's longstanding call and provided some funds — $20,000, half the regents' request — for a new stadium. This site plan by state architect Arthur Peabody moved the field across the Camp Randall grounds and tucked it under the hills of University Heights; at twenty-five feet below ground level, the impact on the neighborhood was somewhat softened (though the concrete stand, projected to hold ten thousand spectators at completion, still rose twenty feet above the street). Peabody also altered the field's alignment to north-south, thus providing shelter from winter winds and removing the sun from the players' eyes. A fund-raising campaign started on campus, and the *Daily Cardinal* noted that "alumni who are contributing towards its cost will be given an option on the best seats." (University of Wisconsin Archives)

Dateline: Big Red Letter Days

November 20, 1915 The legendary writer Ring Lardner is among the fifteen thousand in the house for the last football game in the original Camp Randall, against archrival Minnesota. A few minutes into the second quarter, just as city health inspector J. P. Donovan tries to warn the crowd, three hundred feet of temporary bleachers on the west side collapse and 1,800 fans come crashing down. Thankfully, there are no serious injuries, and play stops only briefly. Then the band blows the varsity toast, and the huge crowd soon is again absorbed in the game (which Wisconsin loses, 22-0).

October 6, 1917 With the country at war, fewer than two thousand fans brave wintry winds to see the Badgers batter Beloit 34-0 in the opening game at the new Camp Randall, already fitted with more than eight thousand seats along the west embankment.

November 3, 1917 Governor Emanuel Philipp and university president Van Hise lead an impressive ceremony of flags and patriotic pyrotechnics at the formal Camp Randall dedication. Former lettermen and contributing alumni have reserved sections up front for the 10-7 victory in the homecoming game against Minnesota.

School Room Building Boom

The city built four new schools this decade, mainly honoring literary lions, mainly on the east side. Frank Lloyd Wright's old school, already renamed after Abraham Lincoln, was replaced at 720 East Gorham Street in 1915–16. The city also retained an earlier tribute in 1918 when it opened a new Henry Wadsworth Longfellow school in Greenbush at 1010 Chandler. But the Schenk's-Atwood neighbors didn't like the old name chosen in 1908, and when a new Washington Irving school opened at 401 Maple Street in 1916 they got it renamed after James Russell Lowell. The literary legacy was continued in 1919, with the Ralph Waldo Emerson School at 2421 East Johnson Street. All except Lincoln, since converted to apartments, are still in educational use. Outside the city, the Madison Realty Company opened its Nakoma School on the Monroe Road in 1917.

Double Domes

The shadow of the Main Hall dome falling over May Fest 1915 mirrors its counterpart at the top of State Street. With construction not yet begun on the north wing, the capitol is still two years from completion. To its right, the city's first skyscraper, the just-opened Gay Building. (University of Wisconsin Archives)

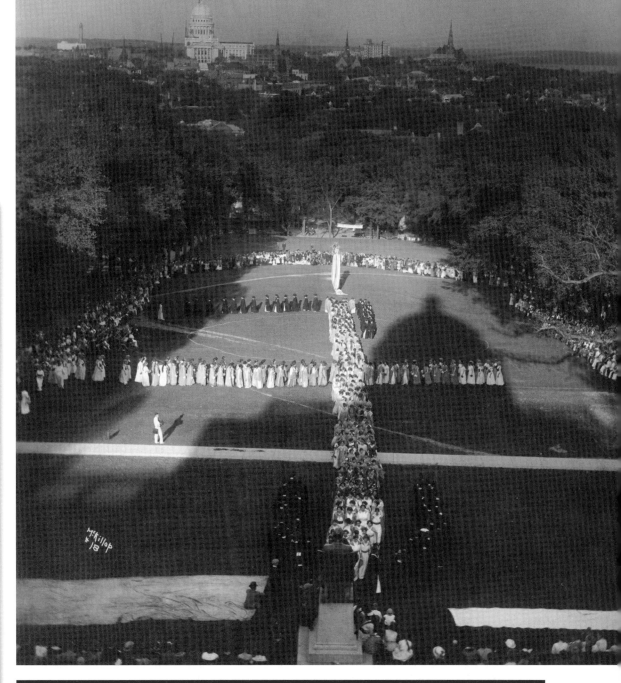

Dateline

Fall 1910 Edwin Emil Witte (1887–1960), "the father of Social Security," begins work as teaching assistant in the university history department, also serving later in the decade as legislative aide and statistician and secretary with the State Industrial Commission. Witte becomes a part-time lecturer in 1920 and professor of economics in 1933, and in 1934 is named executive director of FDR's Committee on Economic Security. He later serves on several state and federal labor boards. One of the university's high-rise dormitories is named in Witte's honor.

1912 Charles McCarthy (1873–1921), director of the Legislative Reference Library, publishes *The Wisconsin Idea,* the best summary of progressive philosophy and programs, largely the work of university experts. Theodore Roosevelt praises its "sane radicalism," says country needs "to learn the Wisconsin lesson of scientific popular self-help and of patient care in radical legislation."

April 4, 1919 Joint committee of Madison school board and board of vocational education approves architect F. L. Kronenberg's plans for an addition to high school and asks council to buy land at Johnson and Carroll for its construction. Matching and connecting with the current structure, the $300,000 project will provide about seventy-five thousand square feet within its five floors.

April 10, 1919 Mass meeting of two hundred tenth ward citizens protests firing of Randall schoolteacher Don Birdsall, discharged, according to Superintendent R. B. Dudgeon, for his activity on behalf of fellow teachers.

December 31,1919 Superintendent Dudgeon attacks school board for failing to address growing problem of under-nourished children, who receive lunches of crackers and milk supplied without charge by various women's clubs.

Madison Notable

Edwin A. Birge (1851–1950) began teaching in the university preparatory department in 1875 when Charles Van Hise was a freshman and became president of the university in 1918 when Van Hise died. A Williams College student (with John Olin) of future presidents Bascom and Chadbourne, Birge became zoology professor in 1879 and essentially founded limnology, the study of lakes. The first dean of the College of Letters and Science in 1891, Birge was acting president (1900–3) after the death of Charles Kendall Adams but lost the permanent post to Van Hise. Birge both continued and embodied the Wisconsin Idea, serving for many years on state fishery, forestry, and conservation commissions, and as president of the Madison Free Library Board. Hard-working and competent but with a more modest view of his office and himself than several predecessors, Birge was finally allowed to retire in 1925. The former Botany Building and a small street west of campus are both named in Birge's honor.

PROHIBITION

Prohibition finally prevailed this decade, as progressivism and preparedness for war combined to make Madison dry more than two years before prohibition became national policy.

Wets won the first referendum of the decade, but their victory margin in 1910 was sharply down from their easy win in 1901. In 1912, only a serious tactical error cost the dries the mayoralty, when the Prohibition Party candidate took almost a quarter of the vote, cut into the dry Republican's tally, and let wet Democrat John B. Heim squeak through in the last election before the Non-Partisan Primary Act limited general elections to just two candidates. The prohibitionists platform was explicitly progressive: civil service, public ownership of utilities, and commission government, all reforms the saloon lobby staunchly opposed

Despite losing the mayor's office, dries still had two powerful allies — the progressive prohibitionist editor of the *Wisconsin State Journal*, Richard Lloyd Jones, and district attorney Robert Nelson, who, on June 17, 1913, declared that the Sunday closing laws would be enforced aggressively come July. The Norwegian even accused the German Heim and the Irish police chief Thomas Shaughnessy of "brazen defiance" of the law and threatened to bring charges against them if they didn't act.

Blasting the dry hypocrisy of the "self-appointed guardians of the people" who would prevent "the ordinary laboring man" from visiting a saloon while the doors of the University Club and Madison Club were always open, Heim had Shaughnessy order the Sunday closing not only of all saloons, pool halls, and bowling alleys but also of all theaters and all moving picture shows. The crackdown lasted a few months, before it was back to business as usual.

But other forces were coming together to propel the prohibitionists: the great growth in the university enrollment following the 1907 establishment of the half-mile *cordon sanitaire* and the formation of the Madison Dry League, an affiliate of the Anti-Saloon League.

In April 1914, there were two stunning developments: Heim's defeat by his next-door neighbor, dry Republican lumberman Adolph Kayser, and the narrowing of the wet victory margin to less than one percent, 3,687 to 3,620. Kayser used his inaugural address to press for a reduction in licenses, and the council complied, cutting the number of saloons from ninety-four to eighty-one. With the wet margin still under 2 percent in a 1915 referendum, Kayser called for further limits and got them.

As prohibitionists gained strength throughout the country, the 1916 election brought a solidly dry local contingent to the State Assembly — including *Wisconsin State Journal* business manager (and future *Capital Times* founder) William T. Evjue, the La Follette acolyte whose bill for a statewide prohibition referendum was vetoed by conservative governor Emanuel Philipp.

With progressivism their base, the prohibitionists needed a second standard for victory— the gathering storm of war. Grain and coal were needed for the Allied war effort, so the Dry League expertly identified temperance with loyalty, making prohibition patriotic. The tactic worked, and on April 3, 1917 — thirty-two months before the start of national constitutional prohibition in January 1920 — Madison voters said no to licensing saloons, 4,560 to 4,145. Three days later, President Wilson declared war on Germany. At midnight on June 30, 1917, the city's sixty-three breweries closed, costing Madison about $40,000 in license revenues. But just as the breweries had predicted, this was not the end of alcohol in Madison; the Fauerbach and Hausmann breweries simply established warehouses in the town of Middleton, where they sold beer without checking patrons' residency. They even provided delivery service.

That fall, the Anti-Saloon League elected enough members of Congress to approve the eighteenth amendment, banning the manufacture and sale of "intoxicating" beverages, subject to ratification by the states. Although Madison stayed dry by a smaller margin in April 1918 — the thirty-six-vote margin was whittled to just one vote after a recount and court case — the war again aided the prohibitionists that fall, as Wilson ordered the breweries shut in December to save coal and grain.

The armistice brought a wet revival. In a re-

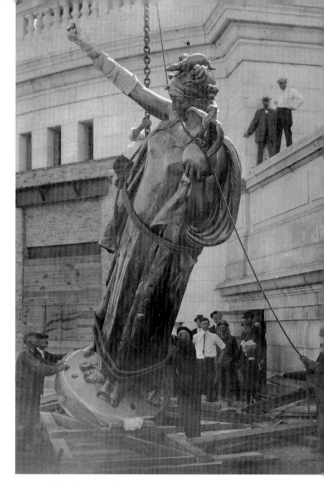

Bound *Wisconsin*
Workers from Woodbury Granite prepare to crown the capitol dome. (WHi-9566)

sounding reversal, Madison voted 4,008 to 3,189 on April 1, 1919, to license saloons. In late August, after the legislature authorized the sale of "near beer," the council licensed the Fauerbach and Hausmann breweries and thirty-six saloons.

But victory was short-lived, as the Anti-Saloon League got Congress to adopt the Volstead Act, extending conservation efforts until the country was fully demobilized and defining "intoxicating" beverage as any beverage with an alcohol content of more than 0.5 percent by weight. So after two months of near beer, Madison's breweries and saloons were once again shut down in October 1919, not to reopen for almost fourteen years. During that time, Madisonians would still drink, of course, and cause social disruptions far worse than were found in any tavern or saloon.

Because now they would get their booze in the Bush.

Madison Mayor

Adolph H. Kayser (1851–1925) moved to Sauk County with his family from Cologne when he was four, and soon thereafter to Madison. He worked with his father-in-law in what became the A. H. Kayser Lumber Company and with his son operated the Monona Dairy Farm on the old Allis property in Blooming Grove. A dry Republican, Kayser unseated his second ward neighbor John Heim in 1914 and successfully pushed the council to reduce the number of liquor licenses. During his one two-year term, the city adopted numerous other progressive health, safety, and welfare initiatives, including extension of the fire limits, inspection of electrical and plumbing work, inspection of dairy equipment, a ban on carrying dangerous weapons, improvement of the sewer system, regulation of taxicabs, limits on slaughterhouses, and improvement of lakefront street ends. The city built Lincoln and Lowell schools and provided land for a packing plant company. The city bought a motorcycle and automobile for the police department and, responding to its first ever grand jury, hired its first police matron. Kayser was a director of the Bank of Madison and a leader in the Madison Turnverein, the German choral group Madison Maennerchor, and the Maple Bluff Golf Club. Kayser, with his wife, Hedwig, lived at 802 East Gorham and 425 North Livingston streets, and is buried at Resurrection Cemetery.

Madison Mayor

George Sayle (1864–1951) was a grade-school dropout whose four years as mayor (1916–20) were marked by war, strikes, prohibition, and violent crime. A first-generation Irish American born in his parents' house at 220 North Broom Street, Sayle was a carpenter, contractor, and firefighter who worked on the Randall School addition and built the Fauerbach Brewery tavern. Sayle served several terms on the council between 1895 and 1905, and as member and chair of the Police and Fire Commission from 1923 to 1927, returning in 1930. After his final resignation, Mayor James Law appointed Sayle's daughter to the post.

Western Rail Yards
The freight yards of the Chicago, Milwaukee and St. Paul Railroad, three blocks from campus and five from the capitol, with residential neighborhoods even closer. (WHi-35792)

Verbatim

One unfortunate event has darkened the history of our beloved city, and that is the mixing in of the student body in our municipal election. . . . This is a very serious and grave matter and our last municipal election was the most corrupt election held in our city. Talk about Tammany — Madison fared far worse. Transients taking the matter of control of our city in their own hands and dictating the management of our city government. Our citizens ought to rise en masse and take this matter into the court to test the legality of the election and settle the same — whether the city is to be run by the student body, who are only here during the time they attend the school. Are the taxpayers to be deprived of their rights by citizens of other cities and states and by non-taxpayers? — **Mayor John Heim**, April 21, 1914

Madison Mayor

John B. Heim (1848–1919), father of the Madison Waterworks, was a thirty-two-year-old, first-generation German American bookbinder who faced off against powerful economic interests and led the successful fight for municipalization. The eldest of ten children, Heim was sixteen when his mother died. Apprenticed to a publishing house, he became foreman at age twenty-two. Nominated for alderman by the Second Ward Democratic caucus against his will in 1881, Heim won and surprised everyone by fighting — and beating — a contract for a private waterworks system, up for consideration at his very first meeting (page 93). Upon the creation of the municipal system in 1882, Heim was made superintendent; after a very successful twenty-seven-year career in that post, Heim served one colorful term as mayor (1912–14). In his first message to the council, Heim warned about the "temptation for skyscrapers . . . that might obscure the vision of the dome at a distance," and urged adoption of "an ordinance prohibiting the building of any structure higher than the cornice of the new capitol building." In his second message, Heim declared the City Market a resounding failure, the method of street repairs unsatisfactory, and the city railyards a disgrace; he called for a new city hall, and said the city's other "great need is a woman's rest room." Refusing to sign the 1913 budget because he felt the levy too high, Heim said he was so frustrated with the Common Council that he now favored commission government. Heim refused to join the Madison Club and Chamber of Commerce, to maintain neutrality in case of official dealings with organizations or their members. Heim was defeated for reelection by his longtime neighbor, the anti-saloon lumberman Adolph Kayser, after he and his fellow beer-loving police chief, Thomas Shaughnessy, failed to enforce the Sunday closing law for saloons. Following his defeat, Heim bitterly denounced university students, the voting block he blamed for his loss. Heim then served one term in the assembly before retiring from public life. Active in many Catholic societies, Heim died at his home, 406 Washburn Place, and is buried at Resurrection Cemetery.

RAY-O-VAC

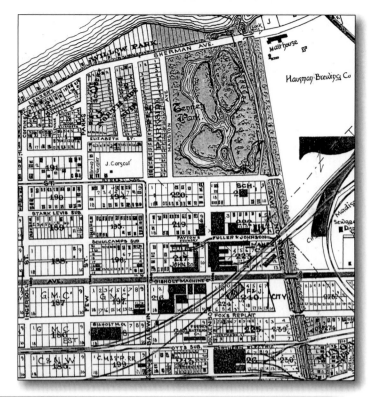

Despite the physical separation between faculty and factories, Madison has seen a century of university-industry partnerships that proved beneficial to both. One of the first was in a field that passed for high technology in the early twentieth century — dry cell batteries. They were key to powering such devices as automobiles, telephones, and a hand-held light that was portable but lasted for only a flash.

James Bowen Ramsay (1869–1952), grandson of pioneer physician and mayor James Barton Bowen, was the driving business force behind the creation of the French Battery Company in January 1906. The name honored the ancestry of Alfred Landau, the inventor of an improved method for making dry cells and president of the new company. From modest offices on both the east and west sides, using primitive methods, the French Battery Company produced thirty-seven thousand batteries in just its first year.

The second year, not so good. Landau, also company general manager, exceeded the budget and produced a bad product (about seventeen thousand defective batteries). Pressured by his local investors, Ramsay fired Landau and looked for a new expert. He found one in C. F. Burgess, founder of the university's Department of Chemical Engineering. Burgess joined the board and became its chief engineer, and in 1910 the company turned its first profit.

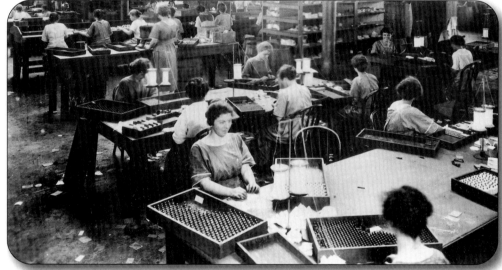

But Burgess also undertook his own enterprise, the Northern Chemical and Engineering Laboratory, where he developed the standard D cell and a new tubular flashlight case. Burgess and Ramsay struck a new deal, using French company resources to make and sell Burgess's new batteries. The joint venture was a success, helped by both quality technology and clever marketing of the "French flasher" logo. Then a fire in 1915 destroyed the plant, and disagreement about who was responsible destroyed the relationship between Burgess and Ramsay. The next year, each man built his own factory — the French Battery Company at 2317 Winnebago Street, the Burgess plant at 1015 East Washington Avenue (which moved to 15 South Brearly in 1919).

Both firms were successful — World War I was especially good for the manufacturers of batteries for military radios — and within a few years Madison was in the national forefront of battery production. By 1920, the French company had sales of $2.75 million and six hundred employees — four hundred in Madison — made it one of the largest industries in town. Burgess also did well, with his Madison plant employing seven hundred (with seasonal spurts double that) by the late 1920s. Burgess relocated his plant to Illinois in 1938, but the French Battery Company — which in 1934 renamed itself Ray-O-Vac (later, Rayovac), after its Ray-O-Lite trade name and the vacuum tube technology — remained a mainstay of the east side until it opened world headquarters on the West Beltline in 1999. In 2004, its name changed to Spectrum Brands.

Factories, Brewery, Lagoon *(top)*
This excerpt from the 1911 Plat Map shows business and pleasure in close quarters — completion of Tenney Park, expansion of Northern Electric, and the continuation of the Hausmann Brewery. (Madison Public Library)

French Battery and Carbon Company, ca. 1920
The French Battery and Carbon Company (later, Ray-O-Vac), moved from 615 Regent Street to a large new plant at 2317 Winnebago Street in 1916. Here, women wrap flashlight batteries a few years later. In 1931, when its one thousand employees made the battery business the biggest employer in Madison, 486 were women. Only Lorillard Tobacco had a higher percentage of female employees. (courtesy of David Mollenhoff)

Oscar G. Mayer Attends an Auction

I f it hadn't been for family ties and a bit of bad weather, Madison might never have had its most important private employer.

Seeking to avoid the hated Chicago beef trusts, five thousand area farmers formed the Farmers' Cooperative Packing Company in the summer of 1914. Denied its preferred site just north of the intersection of Fair Oaks and At-wood avenues, the co-op eventually bought twenty acres from the city next to the sewage plant (getting city services in exchange for annexation) and unveiled a $600,000 plant in May 1917.

Opening the month after America entered the war presented great challenges, but the company survived — until a strike during the labor unrest of early 1919, after which it was shuttered and put up for sale. Only one Chicago concern expressed interest in the facility, and that was only to lease it. Desperate for an income stream, company stockholders set a meeting for June 17, 1919 to approve the lease.

While the co-op directors were preparing for the crucial meeting, Oscar G. Mayer — the thirty-year-old general manager and secretary of his father's Chicago packing plant, Oscar F. Mayer and Brother — was visiting in-laws on Mansion Hill. As they had for several summers, Oscar and his wife, Elsa, with youngsters Oscar Jr. and Harold, were staying with Elsa's sister, Laura, and her husband, Frederick W. Suhr, the second-generation president of the bank which, on June 1, 1918, under wartime pressure, had changed its name from the German-American Bank to the American Exchange Bank.

It was raining on June 16 when the group set out on a drive to Mount Horeb, and their car got mired in the mud. After they returned to the large lakeside home at 512 East Gorham Street, Suhr remembered the upcoming auction — news that excited Mayer, long eager to decentralize his operations through a rural slaughter-

ing facility. The men drove to the site a bit past the river, where a quick inspection convinced Mayer he had found his facility. When his father gave him the go-ahead, Mayer was set to start a new chapter in the city's industrial history. The next day, as company directors were urging the unhappy shareholders to accept the lease, Mayer told the co-op's attorney that he might want to buy the facility but said he needed time to appraise it and arrange financing. The co-op directors and shareholders quickly agreed, and on July 15 Mayer offered $300,000 for the entire operation. Two weeks later, the members voted 1,911 to 128 to accept the offer.

Under manager Adolph C. Bolz, a young former army aviator, the new operation made its mark even before it opened. To ensure that employees could get to work, the company on October 20 agreed to subsidize the extension of streetcar tracks to the plant; it was only then that Madison Railways would agree to provide service to the remote site. The company also built fifty modest homes for workers.

The facility was a success almost from the start. By 1922, annual sales had passed the $2 million mark, hitting $9.5 million by 1928. From 250 employees in 1919, the company workforce grew to 400 in 1929 and tripled over the next decade. The company recognized a union, the Amalgamated Meat Cutters and Butcher Workmen of North America, in 1934, and maintained generally harmonious relations with it and its successor, the United Food and Commercial Union, Local 538 (east-side native Pat Richter was in charge of labor relations between careers as a football star and university athletic director). At its thirty-fifth anniversary in 1954, the company employed 4,763 workers, about one-third the city's entire industrial workforce.

The company moved its headquarters to Madison in 1955 following the death of Oscar F. Mayer at age ninety five. It went public in 1971 and merged with Kraft Foods North America in 1989. In 2005, the Madison facility employed about 2,200 workers.

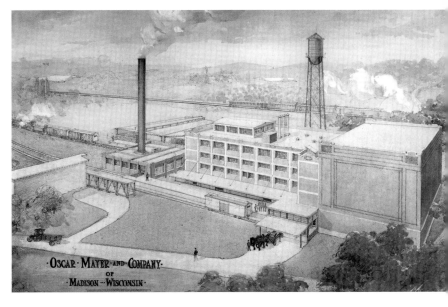

Oscar Mayer & Company
An early view of Madison' most important private employer. (Oscar Mayer Foods)

SENATOR ROBERT M. LA FOLLETTE OPPOSES THE WAR

No single act of conscience by any individual caused more personal and political repercussions in Madison than Robert M. La Follette's opposition to World War I. All cities and states with large and politically active German populations suffered upheaval during the war. But while the anti-German prejudice in Madison and Wisconsin would eventually fade (at least until the next time Germany took the world to war), the impact of La Follette's role never really did.

By his actions before and during the war, La Follette established the archetype of the maverick Wisconsin politician: independent, proud, and totally committed to a cause, regardless of the political consequence. But La Follette did more than just inspire future politicians; he unleashed a local political whirlwind that overturned the existing order and led directly to a new and lasting era in Madison journalism and philanthropy.

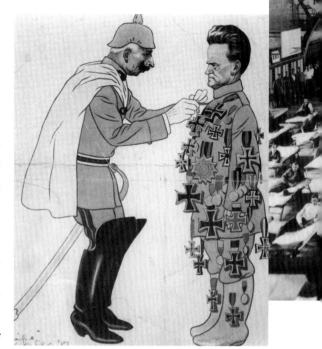

The Beast of Berlin and Fighting Bob
Capturing the country's perception of Wisconsin's senior senator during the height of wartime hysteria, *Life Magazine* published this color cartoon of Kaiser Wilhelm pinning another medal on Senator Robert M. La Follette in its "Traitors" edition of December 13, 1917, the same day the first *Capital Times* hit the streets.
(University of Wisconsin Archives)

Although La Follette supported most of President Wilson's war-related bills in 1917, he waged high-profile battles against some of the most important, including the Conscription Act (which he thought unconstitutional) and the Espionage Act (which he rightly believed was an assault on free speech). When La Follette used a senatorial filibuster to kill a bill giving Wilson authority to arm American merchant ships, the *New York Times* editorialized that "the odium of treasonable purpose" would mark him forever. And when he delayed for twenty-four hours, and then voted against, the declaration of war, he was lumped with Judas and Benedict Arnold.

But it was when the Associated Press misquoted La Follette as saying "we had no grievances against Germany" that public revulsion became unrestrained, as La Follette was routinely described as a vile traitor knowingly doing the Huns' handiwork. The U.S. Senate considered whether to expel him, the Wisconsin Legislature recommended that it should, and the Madison Club actually did. La Follette could both shrug off and sue over the Madison Club matter, but he suffered deeply when the university added its rejection as well. It was bad enough that 421 faculty signed a statement charging him with giving "aid and comfort to German and her allies"; far worse was President Van Hise's signature as well, along with a letter calling his former classmate's policies "dangerous to the country."

Eventually, the Associated Press acknowledged its error, and the Senate voted against expulsion. But certain scars would never fully heal.

Verbatim

The day will come when the Madison Club men will be ashamed of their mock heroic deed and when the University will be anxious to blot out this disgrace. — **Jenkin Lloyd Jones**, Richard's father, in his magazine, *Unity.* The groundbreaking anti-war Unitarian minister praised La Follette as "the most formidable foe [of] the plutocracy and aristocracy" that was profiting by economic injustice.

Verbatim

LA FOLLETTE AND NEW PAPER ARE BURNED IN EFFIGY
University Students Stage "Hanging Bee" on Campus
Following Loyalty Demonstration

— **Wisconsin State Journal**, December 13, 1917, reporting events after the mass meeting of seven hundred students and faculty to form a loyalty legion. "Good red-blooded American students (who were) in the great big game . . . stimulating patriotism," Jones said of the fifteen who burned representations of their senator and of newspaperman William T. Evjue, whose paper debuted that day.

Verbatim

WHEREAS, Robert M. La Follette, a member of this Club, has been guilty of unpatriotic conduct and of giving aid and comfort to the enemy of his country in this great crisis when this country is fighting for its very existence and to make the world safe for democracy.

NOW THEREFORE be it resolved by the Board of Directors of The Madison Club in meeting duly assembled that the said Robert M. La Follette be and hereby is expelled from the Club. — **Text of the resolution expelling La Follette from the Madison Club on December 27, 1918**. La Follette was not notified of the meeting because the board, acting on advice from attorney Burr Jones, whom La Follette had unseated as a member of Congress in 1884, first eliminated the notice requirement "where expulsion is for unpatriotic conduct." Among those pressing for La Follette's ouster: scientist/industrialist Magnus Swenson, the first chair of the State Council of Defense; streetcar company president and club president F. W. Montgomery; Gisholt executives Carl and Hobart Johnson; and bankers A. E. Proudfit and E. B. Steensland.

THE WAR AT HOME, V. 2.0

The summer of 1918 brought about one of the most unusual and most difficult periods in the history of the University of Wisconsin — its conversion into a school to train soldiers, subject to significant federal control.

Phil La Follette called it "this war mad university of ours," and by October 1918 there was complete subordination of academic study to military training. There was also a militarized version of Van Hise's Wisconsin Idea, as campus chemists (gases and explosives), physicists and engineers (aviation, submarines), linguists (translations), historians (propaganda), agronomists (wheat production), and others all contributed to the war effort. In Sterling Hall, Earle M. Terry continued his work on experimental radio station 9XM — the oldest station in the nation — under special dispensation from the navy; what began in 1917 as the first successful transmission of voice and music became a regular schedule of broadcasts by 1919. Faculty contributed in a far more personal way as well; the Wisconsin campus oversubscribed to the various Liberty Loan bond drives and sent more faculty officers into the military than any other educational institution. A February 1919 report noted that the university was near the top in students serving in the military — 2,650, with at least 1,200 receiving commissions. In addition, about five thousand enlisted soldiers received university training in one of four branches. No fewer than forty-eight students died in combat — about the same number that died of the Spanish influenza as the war was winding down in the late fall of 1918. The use of the Armory as a men's dormitory, as pictured here, was a significant factor in the deadly spread of the disease on campus.

The Armory Dorm, 1918 (University of Wisconsin Archives)

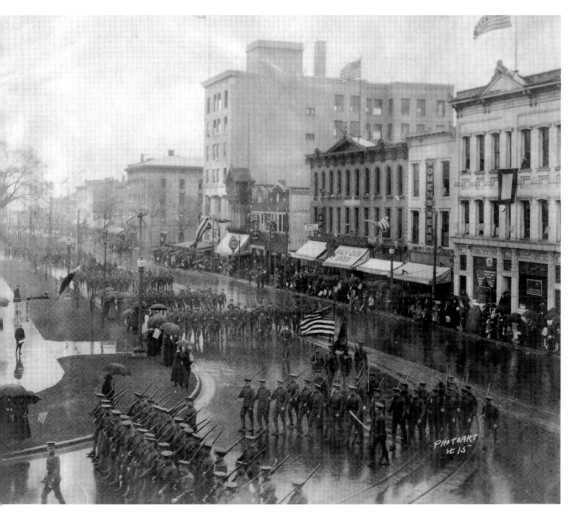

Student Soldiers in the Rain, April 6, 1918
On the first anniversary of America's entry into the war, cadets of the Student Army Training Corps turn the corner of West Main onto South Carroll, heading for a patriotic program at the Stock Pavilion. One speaker from the National Security League, Robert McNutt McElroy, doesn't like their attitude and calls them traitors in the *New York Tribune.* Van Hise writes an angry rebuttal, while cadets burn McElroy and the Kaiser in effigy (just as they had done to La Follette and the *Capital Times* not five months before). (University of Wisconsin Archives)

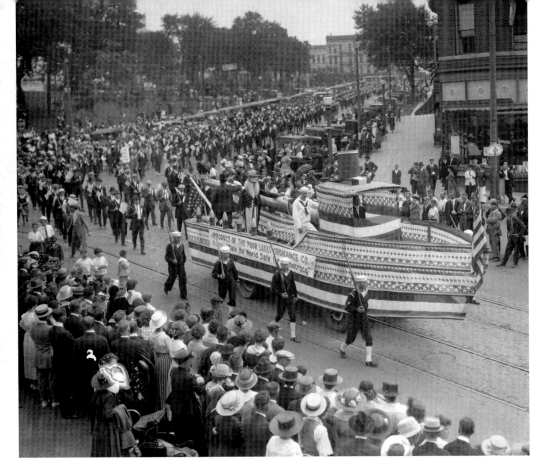

Brothers in Arms, Labor Day 1918 *(top)*
Looking up Carroll Street, as five thousand friends of labor celebrate solidarity between soldier and worker by marching from the capitol to Vilas Park for an address by John R. Commons. The float of the Four Lakes Ordnance Company bore one of its ten-inch guns, the Goddess of Liberty rode with the Burgess Battery workers, and the Gisholt float pulled a lathe. Companies K and J, commanded by a major from the Eighth Infantry of the State Guard, led the parade, followed by sixteen clergy from the Madison Ministerial Association. Members of the building trades were in the forefront of the workers' units, whose members all carried small American flags. Thanks to the war, the industrial east side was booming; the Northwest Ordnance Company built a large plant next to the Gisholt works on East Washington Avenue, where it made various guns and armaments in what later became the city's bus barn, while just west of Division Street on Atwood Avenue, in a facility later acquired by the Madison-Kipp Corporation, George Steinle started the Four Lakes Ordnance Plant to make guns for the navy (including the ones pictured). In 1918, the machinists union grew from 39 members to 1,600 in two locals. With about three thousand Madison men in the armed forces, women became a labor force, organizing a federal union and a machinists union, with 300 and 95 members, respectively. A few women were even allowed into the Board of Commerce. But the underlying economics were bad for wage-earners; from 1917 to 1919, the combined average increases in the cost of coal, food, and rent more than doubled, while wages grew by only half that. And once the war ended, twin traumas threatened — reduced demand for manufactured goods and the return of thousands of workers. (WHi-36026)

Loyalty Parade, March 31, 1917 *(bottom)*
A week before the declaration of war, even the young boys of Wisconsin High School were marching down State Street, with a crowd of adults stretching for blocks behind them. Every permanent structure in this view of the 400 block remains, occupied by such entities as a hat store, bicycle shop, bar and grill, and others. (University of Wisconsin Archives)

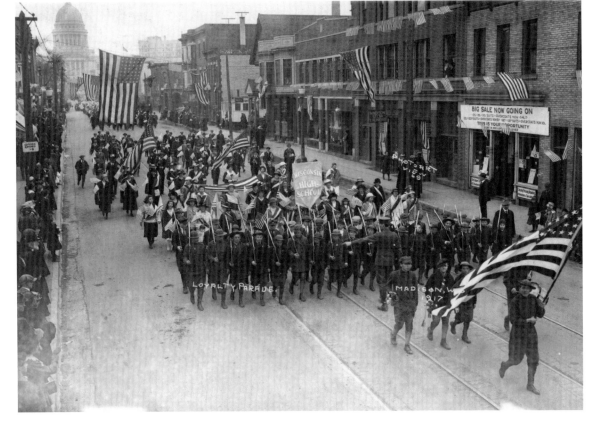

Dateline
April 27, 1917 All public buildings in Madison are put under guard, to remain so until the war is over. City hall is especially well protected — Company G soldiers are on duty during the day in its armory and sleep there at night.

Draftees at the Station, May 25, 1918 *(right)*

Some of the three thousand Madisonians who went to war in 1917–18 arrive at the Chicago and North Western station on Blair Street on their way to basic training and then overseas. At the entreaty of John Olin and Mayor William Dexter Curtis, railroad officials in 1905 offered to build a large and luxurious half-million dollar facility to replace its 1885 depot. Even though some area business owners objected that the larger passenger platform would force the closure of Blount Street, the council granted the railroad's request. But the ordinance it adopted was technically defective. Rather than try a second time, the railroad abandoned the project until 1910, when it built this scaled-down, $250,000 station. Madison Gas and Electric has nicely adapted the depot and the nearby freight station as offices. To the left is the Elver House, built in 1873 as the East Madison House, expanded in 1891 by Charles Elver, and developed as the Hotel Rose Marie bed and breakfast in 2002. (WHi-35079)

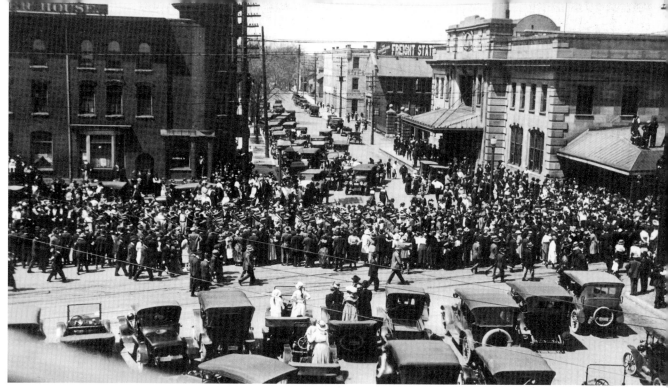

Pledge Putsch

In an odd foreshadowing of a controversy that would arise in 2001, a veteran school board member engendered community wrath in the early days of the war by appearing to oppose the Pledge of Allegiance during the run-up to World War I.

When high school principal William Volney had students declare their loyalty to President Wilson and support for the war by reciting the pledge, prominent German American businessman George Kronke, a sixteen-year-veteran of the board and its president, challenged the idea that loyalty to the country required support for Wilson's policies. The principal publicly attacked the board president, and in the ensuing furor a *State Journal*–sponsored petition drive demanding Kronke's resignation got almost fifteen hundred signatures. Kronke didn't quit, and the state Council of Defense didn't force him out, but the voters did when he ran for reelection two years later in April 1919.

Dateline

February 1918 Legislature unanimously orders that American flags be used to cover a figure depicting Germany holding the book of Science in an allegorical painting in the state senate.

May 15, 1918 Stockholders of German-American Bank change name to American Exchange Bank, effective June 1.

November 7, 1918 *Wisconsin State Journal* publishes an extra edition with the United Press announcement of Germany's surrender, but *Capital Times* editor William T. Evjue holds off pending confirmation from the Associated Press. Crowds gather outside the *Capital Times* offices on King Street, taunting Evjue for this supposed display of pro-German sentiment. Three nerve-racking hours later, the future of his paper on the line, Evjue goes to press — and calls the *State Journal* report wrong. He was right.

November 11, 1918 It was 1:30 a.m. when official word of the armistice finally came, but soon the whole city was awake. The capitol was thrown open as thousands swarmed the square in a pandemonium of joy. That afternoon was Madison's greatest parade, 15,000-strong marching from the capitol to Camp Randall. Mayor Sayle declares an official holiday, and *State Journal* editor Richard Lloyd Jones presides at the ceremony. But new *Capital Times* is first on the street with the great news—a coup that doubles that day's sales to more than 16,000.

War Heroes

Morris O. Togstad (1897–1918), sportswriter for the *Wisconsin State Journal* and *Madison Democrat* during high school and winner of the French Croix de Guerre, was killed in action in France the day before the armistice. Togstad had been honored in May for extreme gallantry commanding a trench mortar section in the first unit to fight on German soil. Madison's chapter of the Disabled Veterans of the World War was named in his honor, as was a street in the Midvale neighborhood (an honor shared with Victor S. Glenn, Madison's first casualty of World War II).

Cap. Myron C. West (1888–1918), assistant high school principal and head of the its math department, died on August 3, 1918, of wounds received while commanding an infantry company. He died not knowing that his wife had just given birth to a daughter, Adeline Jane.

Colonel Joseph W. Jackson (1878–1969), recipient of the Purple Heart for service with "Black Jack" Pershing's last cavalry unit, returned home in 1919 to manage his family's medical clinic. He read *A Model City*, dedicated himself to John Nolen, and became Madison's most important economic development activist since Farwell (and Frank Lloyd Wright's most implacable foe). Something important should be named in his honor.

THE BIRTH OF THE CAPITAL TIMES

M odern Madison journalism began on a lovely August night in 1911 as Richard Lloyd Jones and William T. Evjue sat on the veranda of the Phi Gamma Delta fraternity house — Levi Vilas's 1851 mansion on Langdon Street — and planned the progressive crusades they would wage as the new owner/editor and managing editor, respectively, of the *Wisconsin State Journal*, starting on September 26.

Richard Lloyd Jones, ca. 1916
The *Wisconsin State Journal* editor/publisher in his South Carroll Street office. (WHi-3879)

Jones was the son of Chicago's fiery Unitarian minister Jenkin Lloyd Jones and cousin of Frank Lloyd Wright; Evjue was a second generation Norwegian American from the Lincoln County lumber town of Merrill and a former part-time *State Journal* reporter during his college days. Their partnership thrived, until Evjue quit over Jones's attacks on Senator La Follette and founded the *Capital Times* in December 1917.

La Follette had helped arrange the financing for Jones to buy the *State Journal* from Amos Wilder, and from the beginning the Janesville native returned the favor, aggressively supporting the man and his agenda. He even gave Belle Case La Follette a column, "Thoughts for Today," a precursor to Eleanor Roosevelt's "My Day." An enthusiastic Evjue at his side, Jones aggressively supported peace, workers' rights, women's suffrage, academic freedom, civil rights, prohibition, municipal utility ownership,

William T. Evjue
Madison's most important journalist, about the time he started the *Capital Times*.
(The Capital Times)

commission government, Madison, and his architect cousin, and railed against big business, the liquor interests, child labor, government corruption, and vice. Shamelessly, but quite successfully, the two also exploited the Annie Lemberger tragedy quite successfully.

Honoring the example of publisher David Atwood and other journalist/ politicians, La Follette urged Evjue to run for the State assembly in 1916. Blasting the brewery lobby and other special interests, supporting organized labor and strong utility regulation, Evjue won in a landslide. His signal legislative victory, a prohibition referendum, was vetoed in 1917 by conservative governor Emanuel Philipp because it would kill a $54 million industry and cost fifteen thousand brewery jobs. Jones also placed ideology above income, and was a far better editor than businessman. He continued Roden's hostility toward Madison Gas and Electric, denouncing it and filing more complaints even when the utility was one of the paper's biggest advertisers. In 1913, it took a $10,000 loan from a millionaire member of Congress and $6,600 from Charles Van Hise for Jones to keep publishing. It was "of vital importance to the progressive movement and the university to hold the paper under the present management," Van Hise explained to his wife.

Then came the war. Jones, who admired German efficiency and called for Madison to become "a German-like town" through commission government and other reforms, supported Wilson's reelection in 1916 because he kept us out. But the next year Jones started demanding the president to bring us in. Editorial policy affected the whole paper, with the word "traitor" appearing in news articles.

Jones broke with La Follette on February 13, 1917, calling his support for a munitions embargo "un-American"; in April, he called him "half-baked and insincere" and unfit to serve in the Senate, later adding his "pro-German tendencies" inclined him towards autocracy. In part, Jones denounced La Follette's foreign policy so strongly because he still supported the senator's domestic agenda; the nation was already suspicious of heavily Germanic Wisconsin, and Jones sought to safeguard the state's progressive legacy from assault over patriotism.

By September 1917, Evjue had had enough of the shrill attacks on La Follette's personal integrity and finally quit to start his own paper, supporting both La Follette and the war once it had been constitutionally declared. Housed in a former ice cream parlor at 106 King Street in the Simeon Mills block, the *Capital Times* published its first edition on December 13, 1917.

But in that fevered first winter of war, with La Follette reviled both

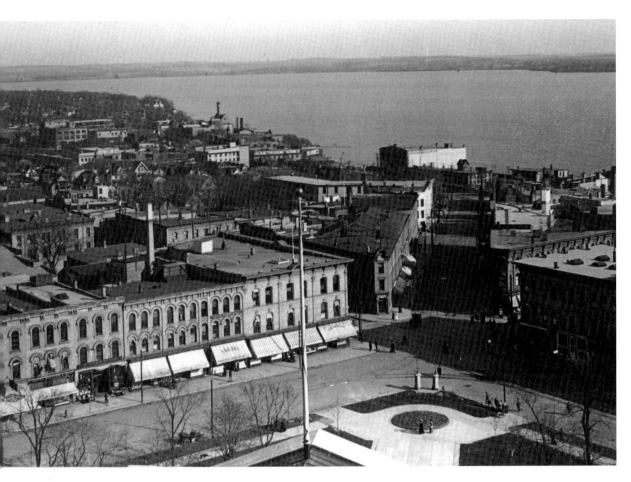

locally and nationally, the loyalty leaguers didn't believe you could support both the senator and the country. Led by Jones and the Council of Defense, they tried to kill the new paper. Jones even triggered a Justice Department probe into Evjue's finances by spreading lies that he had taken money from La Follette to publish a pro-Germany paper. Potential advertisers were threatened with boycotts and ads plunged from forty-two in the first edition to just ten a week later. On January 2, 1918, the paper had just one display ad, from clothier R. L. Schmedeman, brother of future mayor and governor A. G. Schmedeman. Mobs chased newsboys, the university refused to provide interns (standard for other papers), and the Board of Commerce refused the paper membership and told members to avoid its reporters. Evjue and La Follette were burned in effigy on the university campus the night before the paper's debut — an event Jones celebrated in print.

Undeterred, Evjue traveled the countryside, selling stock for a dollar to area farmers and soliciting support from like-minded progressives (including a $2,000 loan from bank president Sol Levitan to buy newsprint). Evjue went after those profiting from the war, especially the east-side industrialists. In January 1918, the paper published five years of state income tax returns showing that the net earnings of several manufacturing plants had doubled even during the lead-up to war. Evjue gleefully reported that Gisholt Machine, whose executives Carl and Hobart Johnson were behind the ouster of La Follette from the Madison Club, had net earnings in 1916 of $2,378,884. Evjue also denounced the industrialists for undercutting their workers, winning support from the Federation of Labor.

While Evjue was exposing manufacturers with million-dollar profits, Jones started an odd crusade against small grocers over the price of eggs. Soon, grocers were flocking to the *Capital Times* and the advertising boycott fizzled. Jones made more missteps. His attacks on La Follette finally brought a libel suit in January 1918, during which Jones had to retract his attacks on La Follette's loyalty and admit there was no German subsidy of the *Capital Times*. And Jones's attack on the university led Van Hise, who had earlier subsidized the *State Journal*, to do likewise for the *Capital Times* shortly before his death that November.

Evjue and his paper somehow survived, and soon thrived, and within two months *Capital Times* circulation approached five thousand. Jones, at least had the honor of serving as master of ceremonies at the huge armistice celebration. It was his last hurrah. After the war, Jones went after Bolsheviks. But he was in a weakened position. *State Journal* circulation had peaked at fifteen thousand and was slowly declining; the *Capital Times*, after its harrowing birth, quickly hit ten thousand and was still climbing.

Losing money, his progressive well run dry, Jones looked for a way out. He found one when a former university classmate, Aaron Brayton, editor of the La Crosse *Tribune and Leader Press* —a paper owned by the Lee Syndicate — convinced the corporation to buy the *Wisconsin State Journal* for $200,000 in late June 1919.

Richard Lloyd Jones was off to Oklahoma, as the powerful publisher of the *Tulsa Tribune*. William T. Evjue and the *Capital Times* were here to stay (as was the Lee Syndicate).

THE MADISON STRIKE OF 1919

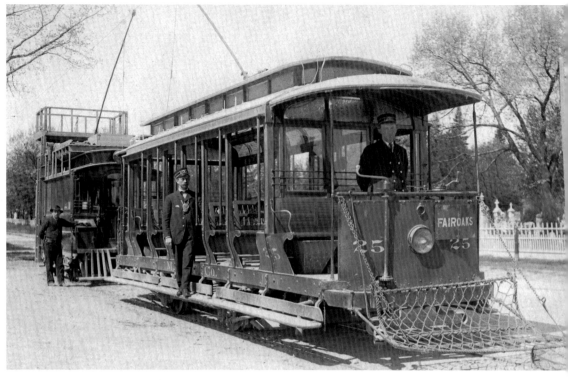

End of the Line
The trolley at its western terminus, Forest Hill Cemetery, about 1910.
(WHi-24965)

The same week that demobilized doughboys were returning to Wisconsin in April 1919, the refusal by industrial employers to honor two clear pro-worker awards from the National War Labor Board created so much unrest on the east side that Madison seemed on the verge of a general strike.

The Madison Strike of 1919 had its origins in the refusal by the manufactories to honor the collective bargaining principles in a proclamation President Wilson issued in April 1918. The unions scheduled a strike for August 1 but held off and participated in a lengthy hearing instead, expecting a quick answer from the labor board. For more than six months the workers waited, as hundreds of jobs were lost due to reduced production after the armistice. But the labor board couldn't agree and referred the case to a federal judge sitting as umpire. Finally, the following February, Judge J. C. McChord awarded the workers almost everything they sought: higher wages, an eight-hour day, time-and-a-half pay for overtime and Sundays, an end to piecework, meaningful collective bargaining, and equal pay for women.

But the employers asked for a rehearing, putting the award on hold. They also tried to get the employees to surrender significant elements from the board's award. Unfortunately, McChord's award had no provision for its enforcement, leading to its total disregard by employers.

"The dissatisfaction of the employees became so intense," a city panel investigating the strike reported later, that 2,500 workers, including 1,300 machinists and 900 federal workers, took and approved another strike vote on March 31. They even reduced their demands from what they had already won. When the companies — all except Burgess Battery, which agreed to implement the award — refused the offer, the workers walked out at 10 a.m. on April 1. They were joined two days later by the large carpenters union.

On April 8, close to two thousand striking workers and supporters paraded around Capitol Square and packed committee rooms during the legislature's consideration of a bill mandating an eight-hour day. Despite — or perhaps because of — this outpouring, the assembly narrowly killed the bill.

Worker unrest grew, as did talk of a general strike — especially when more unions, including plumbers and bakers, walked out over their own disputes. Mayor Sayle appointed a special committee; stymied by the employers' refusal to participate, the committee issued a report very favorable to the strikers. In mid-May, the national board denied the employers' appeal for rehearing and granted back pay to the workers, who had already volunteered to take it in Liberty Bonds. Yet the employers still refused to honor the award, preferring to let the strike drag on.

"General Strike Looms," a *Wisconsin State Journal* headline declared on May 16. The story reported that a move to "call out every union man and woman in the city is threatening Madison." Three days later, a federal mediator obtained agreement on a new master contract — but once the workers returned to their jobs, the employers simply refused to honor their agreement.

On June 5, fourteen unions struck again and sent delegates directly to Washington to seek the board's help. There they found the board had been dissolved and its successor powerless to enforce its awards. This latest setback effectively broke the strike. The workers returned to the plants, having achieved neither the eight-hour day nor collective bargaining. It was "a paralyzing blow" to unionism in the factories, a New Deal analyst wrote twenty years later, as wages dropped sharply and seven hundred machinists left town. "Though labor had won three substantial victories before Federal bodies," the historian wrote, "in no case was either Government or union able to compel the employers to live up to the awards or to the signed agreements. This victory for the employers broke the back of the machinists' union."

When organized labor in Madison rose anew a few years later, it would be led by the far more conservative unions in the building trades.

THE 1920S

Skyline from Lakeside Street, ca. 1925
Encroachment on the capitol continues with erection of the Hotel Loraine, between the spires of Grace Episcopal and St. Raphael's churches. East of the square, the water tower has been razed and Bruen's Block replaced by the First Central Bank building. (WHi-37377)

Verbatim

My opinion of Madison and its possibilities has never been changed, although I realize that the time is near when it will be too late for Madison to carry out an adequate improvement plan, even with the liberal backing of the state. In the old days when the plan was first presented to the public, John M. Olin and a few others stood almost alone in backing the plan. There seemed to be no widespread public interest at the time. I believe that the passage of years has demonstrated the soundness of the plans and their recommendations, and although the difficulties have naturally increased, there is still a possibility of securing effective action. — **John Nolen to Michael Olbrich**, May 1921

Births and Deaths

Census 1920: 38,378
Census 1930: 57,815

The city's three greatest private citizens died this decade, as did its greatest public figure, two leading educators, four former mayors, and the mentor to the world's greatest architect. And the city's last living link to its settlement days was severed.

- Beverly Jefferson (1839–1920), biracial presidential grandson, livery owner
- James Madison Stoner (1837–1921), first white male born in Madison
- John Groves (1844–1921), businessman, mayor
- Richard Dudgeon (1853–1922), school superintendent
- Helen Remington Olin (1854–1922), feminist, activist
- John M. Olin (1851–1924), founder of Madison Park and Pleasure Drive Association
- Thomas E. Brittingham Sr. (1860–1924), lumberman, philanthropist
- Robert M. La Follette (1855–1925), statesman
- John Corscot (1839–1926), city clerk, mayor
- Jabe Alford (1850–1927), mayor
- Charles Whelan (1862–1928), orator, attorney, journalist, mayor
- Thomas Chamberlin (1843–1928), university president
- Allan Darst Conover (1854–1929), architect
- Michael B. Olbrich (1881–1929), attorney, regent, parks activist
- Ernest Warner (1868–1930), developer, legislator, parks activist

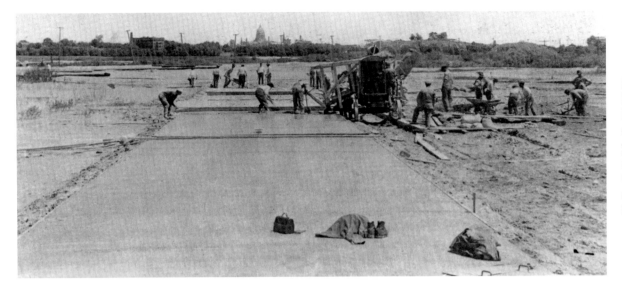

Road from Nowhere, Capitol Boulevard, July 17, 1920
Looking northeast up the main thoroughfare in Lake Forest, about two years before the final collapse of the subdivision now recalled as the Lost City. The closest large building is St. Mary's Hospital, on South Brooks Street. (University of Wisconsin Archives)

The twenties were a time of tragedy and strife in Madison, with but some glimmers of hope and happiness. There was civic frustration and failure, as the city proved incapable of addressing long-standing problems. Everyone knew of the need for a new city hall and municipal auditorium, and most agreed as well that University Avenue should be extended to West Washington Avenue. Yet no progress was made on any of these critical issues.

It was a time of traffic jams and parking problems that would never go away, and continuing travails in transit (itself in transition).

Once again, there was a District Attorney La Follette confronting crimes relating to alcohol; but Phil La Follette faced far more serious challenges than did his famous father, including violent bootleggers and the Ku Klux Klan (some even on the police force). And there was a terrible miscarriage of justice that let a killer go free, left a grieving father looking guilty, and led a judge into debt to criminals to pay hush money to a perjurer.

Thrice in three years, Madison flirted with architectural greatness, unique structures that Frank Lloyd Wright designed for select groups in special places. But in keeping with the era's record of disappointment, none were built.

Positive change came to the Capitol Square, as Madison's first great business block, a remnant of the village era, was replaced, starting a series of developments that ushered in the modern age. Fancy new stores made downtown Madison the regional shopping center, impressive hotels rose to historic heights, and great new movie palaces made State Street an entertainment enclave.

New schools east and west served the spreading population, although their construction was not without controversy.

On campus, the university made great progress in programs, personnel, and the physical plant; several signature buildings opened, two unique and profoundly important university agencies were founded, and the youngest president succeeded the oldest to begin what augured as a new golden age. But even here, undercurrents of trouble, as many of the university's young leaders proudly espoused the supremacy of white Protestants. There was transition, too, along Langdon Street, as fraternities and sororities gobbled up prime parcels in Madison's premier residential district, turning Mansion Hill into the Latin Quarter. At least it was a great time for parks and planning, as the city finally followed through on several recommendations John Nolen had made in 1910. As the era ended, Madison had a Plan Commission, a zoning code, and a Parks Commission, and had designated Monona Avenue the Civic Center for future government buildings (starting with the new federal post office). The state cooperated, setting height limits on the Capitol Square, letting Madison extend the Lake Monona dock line, and locating the Capitol Annex within the Civic Center. The Arboretum and Olbrich Park were both well underway.

Finally, it was a time when the city's most important politician — who never held city office — and four of its greatest citizens passed away. We may never see their likes again.

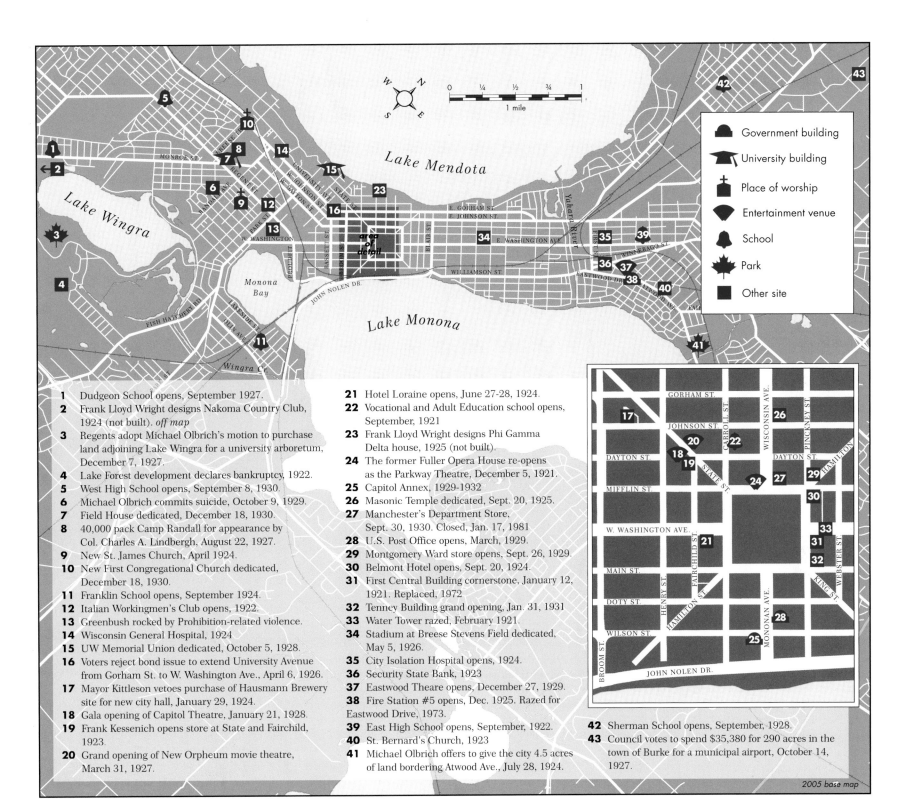

1 Dudgeon School opens, September 1927.

2 Frank Lloyd Wright designs Nakoma Country Club, 1924 (not built). *off map*

3 Regents adopt Michael Olbrich's motion to purchase land adjoining Lake Wingra for a university arboretum, December 7, 1927.

4 Lake Forest development declares bankruptcy, 1922.

5 West High School opens, September 8, 1930.

6 Michael Olbrich commits suicide, October 9, 1929.

7 Field House dedicated, December 18, 1930.

8 40,000 pack Camp Randall for appearance by Col. Charles A. Lindbergh, August 22, 1927.

9 New St. James Church, April 1924.

10 New First Congregational Church dedicated, December 18, 1930.

11 Franklin School opens, September 1924.

12 Italian Workingmen's Club opens, 1922.

13 Greenbush rocked by Prohibition-related violence.

14 Wisconsin General Hospital, 1924

15 UW Memorial Union dedicated, October 5, 1928.

16 Voters reject bond issue to extend University Avenue from Gorham St. to W. Washington Ave., April 6, 1926.

17 Mayor Kittleson vetoes purchase of Hausmann Brewery site for new city hall, January 29, 1924.

18 Gala opening of Capitol Theatre, January 21, 1928.

19 Frank Kessenich opens store at State and Fairchild, 1923.

20 Grand opening of New Orpheum movie theatre, March 31, 1927.

21 Hotel Loraine opens, June 27-28, 1924.

22 Vocational and Adult Education school opens, September, 1921

23 Frank Lloyd Wright designs Phi Gamma Delta house, 1925 (not built).

24 The former Fuller Opera House re-opens as the Parkway Theatre, December 5, 1921.

25 Capitol Annex, 1929-1932.

26 Masonic Temple dedicated, Sept. 20, 1925.

27 Manchester's Department Store, Sept. 30, 1930. Closed, Jan. 17, 1981

28 U.S. Post Office opens, March, 1929.

29 Montgomery Ward store opens, Sept. 26, 1929.

30 Belmont Hotel opens, Sept. 20, 1924.

31 First Central Building cornerstone, January 12, 1921. Replaced, 1972

32 Tenney Building grand opening, Jan. 31, 1931

33 Water Tower razed, February 1921.

34 Stadium at Breese Stevens Field dedicated, May 5, 1926.

35 City Isolation Hospital opens, 1924.

36 Security State Bank, 1923

37 Eastwood Theare opens, December 27, 1929.

38 Fire Station #5 opens, Dec. 1925. Razed for Eastwood Drive, 1973.

39 East High School opens, September, 1922.

40 St. Bernard's Church, 1923

41 Michael Olbrich offers to give the city 4.5 acres of land bordering Atwood Ave., July 28, 1924.

42 Sherman School opens, September, 1928.

43 Council votes to spend $35,380 for 290 acres in the town of Burke for a municipal airport, October 14, 1927.

1920s Map (map by David Michael Miller, courtesy of Isthmus Publishing Co.)

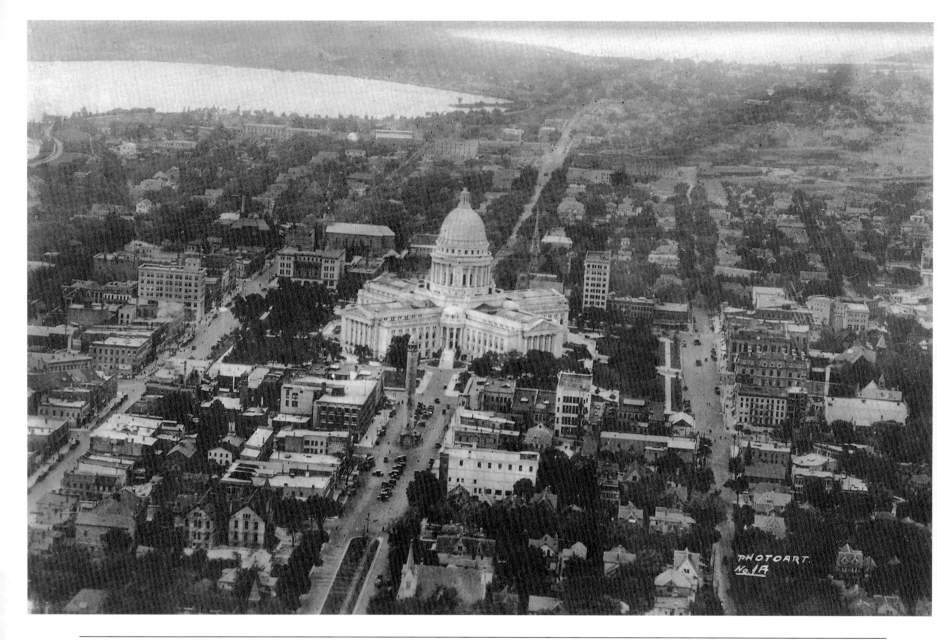

The Square Turns Around

The Capitol Square changed dramatically during the 1920s, with the removal and construction of several historic buildings. At the decade's outset (above), there were more buildings from the village era than from the twentieth century; at its close (bottom right), government, business, and tourism all had special new structures on critical corners.

How many can you identify? Here are some clues (answer key on page 252):

- A new financial powerhouse replaces city government's first home (1920 → 1922).
- A towering relic of the Gilded Age falls (1920 → 1922).
- A mayor's estate becomes the city's leading hotel (1922 → 1929).
- Power for the people (1922 → 1929).

- A site that could have been Wright goes very wrong instead (1922 → 1929).
- The Boss's base crumbles (1922 → 1929).
- Brothers build the city's tallest building (1922 → 1929).
- The Civic Center takes shape (1922 → 1929).

The views to the south (1922 and 1929) cry out for an alternate reality, in which Doty had preserved the King Street axial — here further destroyed by the massive 1916 Union Transfer and Storage building — and enhanced Monona Avenue. The view to the west (1920) highlights city efforts to enhance nature: the Brittingham Park turnaround juts into the bay, with the lagoons of Vilas Park at upper right. Beyond Lake Wingra, the land that will become the Arboretum.

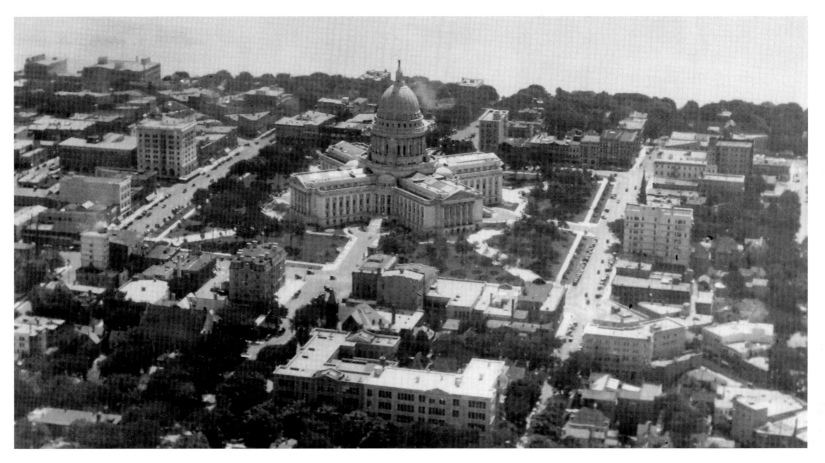

Capitol Square,
1920 *(facing
page)* (WHi-31356)

Capitol Square,
1922 *(right)*
(WHi-31035)

Capitol Square,
1929 *(below)*
(WHi-31148)

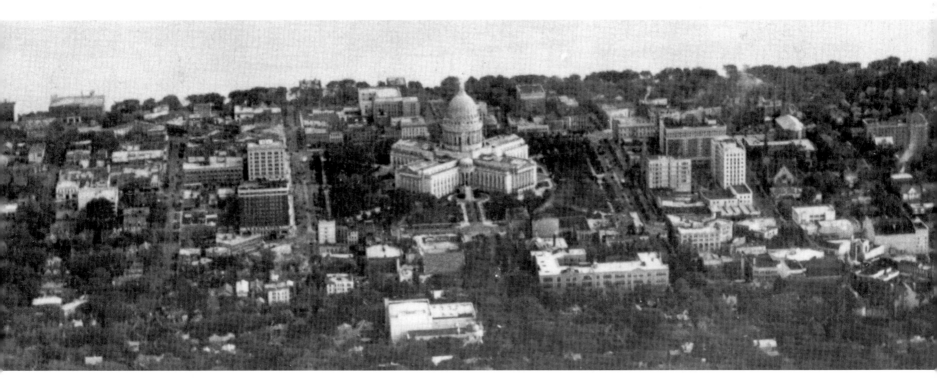

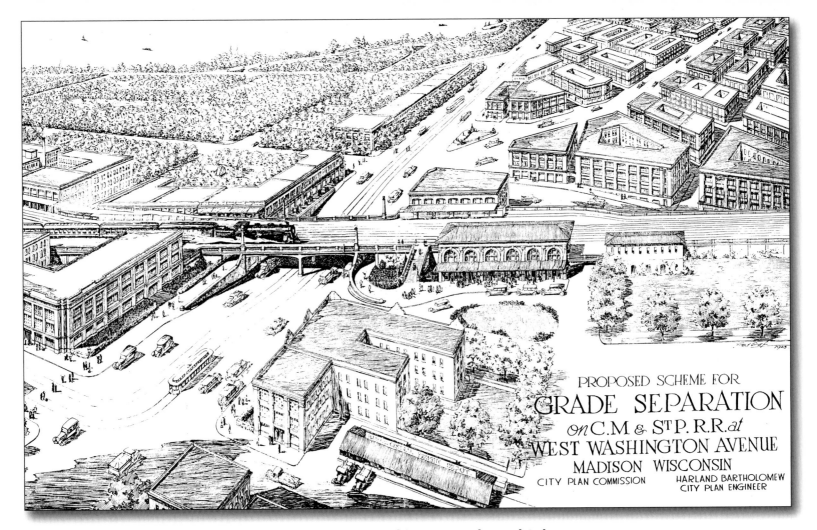

PROPOSED SCHEME FOR
GRADE SEPARATION
on C.M & St P. R.R. *at*
WEST WASHINGTON AVENUE
MADISON WISCONSIN
CITY PLAN COMMISSION HARLAND BARTHOLOMEW
 CITY PLAN ENGINEER

ROADS NOT TAKEN

Shortly after the city created the Plan Commission in February 1920, the panel retained a consultant to advise it — Harland Bartholomew, a rising young star in the new field of urban planning.

Bartholomew, who succeeded John Nolen as the sixth and youngest president of the prestigious American City Planning Institute in 1926, was far more successful than his predecessor; from 1920 to 1926, he drafted twenty of the country's eighty-seven comprehensive plans, for cities encompassing more than 1.8 million people — far more than any other consultant and more than three times Nolen's constituency. Bartholomew submitted a professional, if unexceptional, zoning text that the council approved in November 1922, less than a month after its introduction. His recommendations for major streets found a far different response.

West Washington Tracks and Subway

In 1922, the Chicago, Milwaukee and St. Paul Railroad ran seventeen freight trains — each containing fifty to seventy-five cars — through Madison each day. With another twenty or so passenger trains also coming through just the west-side depot, the railroad blocked travel to and from the southwest several times an hour for much of the day.

This eye-popping plan was Harland Bartholomew's solution — a grade separation with six tracks raised about twelve feet and a reconstructed West Washington Avenue "subway" about six feet down on a 4 percent grade (enough clearance for a standard streetcar, lower left). Despite its grand ambition, though, the plan failed to align Regent and Proudfit streets — a simple and vital improvement that didn't occur until 1957. Bartholomew's plan, or parts of it, would be a central issue in city business and politics for thirty years, as the city tried to get the railroad to relocate the roundhouse or make sufficient financial contribution toward construction of a grade separation. Led by Madison native Leo Crowley, a legendary Roosevelt-era administrator and philanthropist honored by the Pope, the Milwaukee Road refused to do either. The grade separation certainly would have substantially improved Madison's quality of life for the next forty years or so. Its early implementation would also have eliminated from public life a highly divisive, high-stakes issue. But once the eventual decline in railroad travel and shipping made these elevated tracks unnecessary and unsightly, a new debate would have raged over the financial and land use impact of their removal. Although Bartholomew's proposed scheme failed implementation, his design standards live on in the architectural style used for the office buildings that replaced the roundhouse in the 1980s. (Madison Department of Transportation)

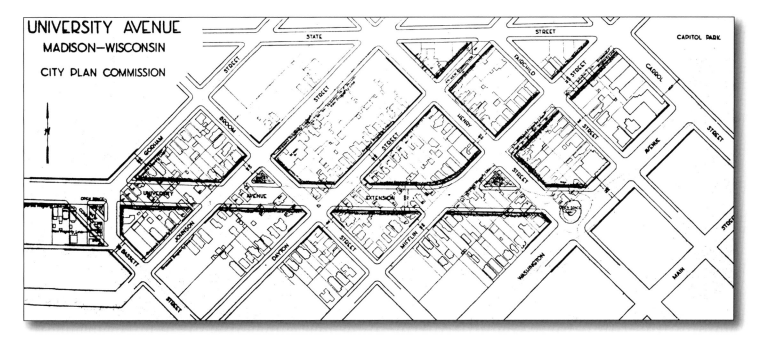

UNIVERSITY AVENUE
MADISON—WISCONSIN
CITY PLAN COMMISSION

University Avenue Extension (above)

In those days, when University Avenue went both ways, its eastbound traffic was diverted down Bassett Street, a maneuver made more difficult by the misalignment caused by the 1850 University Addition. To ease the traffic jams, Bartholomew urged extending eastbound University Avenue from the bend at Gorham Street all the way to West Washington, widening West Mifflin Street to one hundred feet and taking the streetcar line off of State Street. "The congestion of traffic on this narrow thorofare is becoming acute and some means must soon be evolved to care for future traffic in this vicinity," Bartholomew wrote. John Olin championed the cause and mayors Milo Kittleson and Albert Schmedeman advocated it in several annual messages. For several years, it was considered an even higher priority than a civic auditorium or new city hall. A majority of aldermen supported construction, and put a $285,000 bond issue to start purchasing property on the April 1926 ballot. In a sharp and unexpected rebuke of the experts and the elite, the people overwhelmingly rejected the referendum, 8,639 to 4,652. In so doing they lived with traffic jams for a few more decades, but saved these downtown blocks for several hundred units of housing, a large city parking ramp, a grocery, and the headquarters of Alliant Energy and Wisconsin Telephone. (Madison Department of Transportation)

Orton Park Boulevard (below)

Thinking the turns on and off Rutledge Street were too sharp for eastsiders to handle, Bartholomew also proposed a forty-eight-foot-wide boulevard through Orton Park. City engineer E. E. Parker announced its imminent construction on March 4, 1924, but opposition was so immediate, universal, and intense that the city abandoned the proposal just four days later. Bartholomew also proposed several major streets — some one hundred feet wide — through the land that became the Arboretum and Lost City. (Madison Department of Transportation)

TROLLEY TROUBLES

Madison voters had two chances in the 1920s to municipalize mass transit, and took neither. At decade's dawn, the city had suffered through years of mediocre service and increasing fares from the Madison Railway Company. And there was little hope of improvement; as an investigation by city attorney William Ryan revealed, the company had watered its stock and exceeded its ability to borrow. It couldn't even maintain existing tracks properly, let alone undertake expansion into the new suburbs.

The company principals, however — particularly F. W. Montgomery and his sons — were making a personal profit of more than 15 percent on their investment.

In February 1920, the council created a committee to look into municipal ownership ("M.-O." to the newspapers, which strongly supported the effort). The mayoral primary became an early test; printing company owner Frank C. Blied aggressively endorsed M.-O, mayor George Sayle gave the idea soft support, and banker Milo Kittleson resolutely refused to take a stand.

"This city has been run too long by financial parasites," Blied said, citing the city's success in operating its municipal waterworks as proof Madison had the ways and means for successful public ownership of such an enterprise.

Blied's 44 percent in the primary seemed to augur well for advocates of municipal ownership. The council immediately scheduled a referendum to coincide with the general election between Blied and Kittleson on April 6.

But as further facts emerged about the company's watered assets and weakened condition, doubts began to grow. There were even questions about the long-term future of the streetcars themselves. The first bus line from Madison to Middleton started service that year, and many thought the speed and flexibility of buses would soon prove a more attractive transit option than the fixed route streetcars. Even some advocates of M.-O. worried that the financial arguments against the proposal were just too strong.

After the brief but intense campaign, Blied and M.-O. both went down to defeat. Each got about 40 percent of the vote, and no further efforts for municipalization were made during Kittleson's six years in office.

The next year, the state Railroad Commission ignored city concerns about service and safety of cars with only one operator, and let the company add twelve one-man cars to its existing fleet of eight. The union of streetcar workers responded by lowering their salary of fifty-to-sixty cents an hour by three cents.

In 1924, the company was allowed to raise its fare from six cents to eight. Two years later, it finally agreed to rebuild and raise its tracks around the Capitol Square — but soon sought a new taxpayer subsidy, which Mayor Schmedeman soundly rejected. So the company went back to the Railroad Commission, which authorized a ten-cent fare, or three for a quarter.

Fed up with ever-higher fares and ever-diminishing service, the council in February 1928 scheduled another referendum on municipal ownership. A few weeks before the vote, Montgomery and his sons Dudley and Warren pled guilty to filing false financial statements with the Railroad Commission in February 1926 as part of a refinancing scheme. Under the plea bargain, Montgomery was fined $2,000, his sons $500 each.

Despite this latest outrage, the long-range forecast for streetcars was sufficiently cloudy to dampen the electorate's desire to acquire the system. On April 3, 1928, the referendum failed, with an even lower percentage (38.5) than in 1920.

Schmedeman didn't consider that a vote of confidence in the company, using his annual message later that month to blast it for the "failure to do their share of the paving work," leaving "many of our streets in a deplorable condition." He urged the council to "insist" that the company cooperate in necessary paving projects.

The decade ended with more bad legal news for the Montgomerys: on October 8, 1929, the State Supreme Court ruled the company's abandonment of the Harrison-Regent car line in 1928 was illegal.

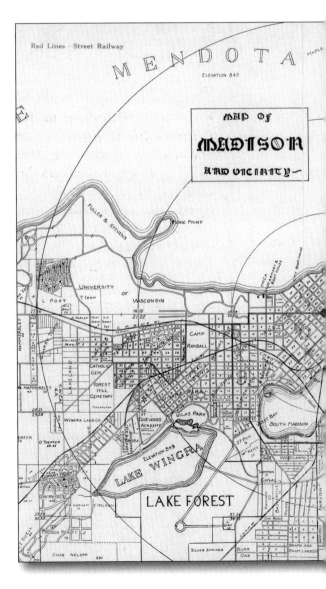

Streetcar Map, 1920 *(below)*
This 1920 map shows the streetcar routes at their height, after the 1919 extension to the Oscar Mayer plant in the town of Blooming Grove. There will be no more "streetcar suburbs" like Fair Oaks or Wingra Park; new areas such as Nakoma and Maple Bluff will need buses — first by developers, then by the streetcar company — along with autos. Madison Railways began bus service in March 1925 and ended electric trolley service on February 23, 1935. (Whi-36497)

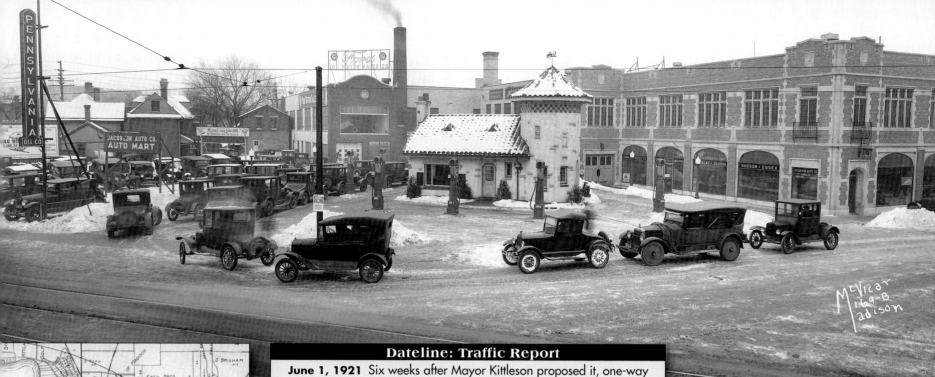

June 1, 1921 Six weeks after Mayor Kittleson proposed it, one-way traffic around Capitol Square begins. Police direct traffic at the corners and paint white arrows on the pavement as reminders for drivers to turn right. Merchants say new way hurts business, but council rejects repeal.

Summer 1925 City opens Commercial Avenue and starts East Johnson Street grading near North Street to connect Highways 10 and 31 directly to State Street.

August 19, 1926 Merchants complain about parking problems.

November 24, 1926 Dane County Humane Society blocks removal of horse trough at Schenk's Corner as equestrian cruelty.

February 23, 1927 After testimony that Vibrolithic Paving Company tried to bribe city engineer E. E. Parker, city ends its affiliation with the company and its paving method.

April 14, 1927 To improve sight lines for a garage sign, city crews cut down last maple trees on State Street, at juncture of Henry and Johnson.

December 30, 1927 State highway engineers announce plans to reroute highways to divert traffic from State Street.

January 18, 1928 Madison Garage Company opens $250,000, three-floor, 450-car ramp at 120 South Fairchild Street.

April 6, 1928 Madison Auto Club asks for traffic signal to replace stop sign at University Avenue and Park Street during rush hour.

September 14, 1928 To ease traffic jams, council bans left turns off first four blocks of State Street. When seventy-eight downtown merchants and property owners protest, Mayor Schmedeman vetoes the measure.

1929 Police department forms traffic squad.

January 11, 1929 Council bans curbside gas pumps.

July 26, 1929 Stop sign set at State and Johnson streets.

May 9, 1930 Council again bans left turns off State Street, now at request of the State Street Association.

Pennsylvania Oil Company, State Street, 1927

Men had been coming to drink beer at the Hausmann brewery at the corner of State and Gorham streets since before (and certainly during) the Civil War, making this State Street's first commercial node. But when the brewery burned during a fierce blizzard on March 19, 1923, Prohibition forced a new use. Automobiles had assumed an important role in the economic and cultural life of the city, so devoting this prime parcel to a filling station and auto dealerships made good business sense. Angus McVicar took this promotional photo of the Pennsylvania Oil Company's offer of free oil changes on January 17, 1927. The Tudor Revival building, here Jacobson's showroom for Cadillacs and Hudsons, has been creatively adapted for booksellers and an inn. (WHi-6357)

FRANK LLOYD WRIGHT'S COUNTRY CLUB

Native Americans had been coming to the highlands west of Lake Wingra for many years when whites first reached the area. The Algonquians, and later the Winnebago or Ho-chungara ("fish eaters") tribe, staked summer campgrounds in what is now Nakoma as recently as Madison's settlement. But by the early 1920s, the Ho-Chunk campground along Dead Lake (or Turtle Lake) was part of the Madison Realty Company's Nakoma Plat, and seen as an ideal site for a golf course.

Indian heritage was certainly prevalent at the opening of the temporary nine-hole course in 1923. A Winnebago feather flag flew alongside the Stars and Stripes, a peace pipe was propped in a forked stake, and a tray of Indian tobacco was thrown to the winds in an offering to the Great Spirit.

Originally, the clubhouse was to reflect northwoods Wisconsin, with pine logs and native boulders. But then, evidently through family and friends in the neighborhood, Frank Lloyd Wright got the contract, and the design returned to the neighborhood motif.

Incorporating Native American imagery came naturally to Wright, who likely encountered Indian bark huts scattered in Fuller's Woods while growing up on Livingston Street. Later, his Oak Park bedroom featured two murals of an Indian female and male.

On August 2, 1924, club members approved a geometric design, focusing on an octagon fifty feet wide, with a pyramidal roof equally high. Although it somewhat resembled a Plains Indian tepee, Wright labeled it as "wigwam," consistent with his loose application of Native American styles and terminology. Wright also identified another octagonal room "tea pavilion," a Japanese rather than Native American element.

But at least Wright incorporated an idea from Nakoman Charles E. Brown, museum director for the State Historical Society, to use the animal symbols for the twelve Winnebago clans as the interior design motif.

Newspaper accounts were enthusiastic, if ungrammatical: "the most unique building of its kind in America," the *Wisconsin State Journal* declared.

But the combination of inaccurate cost estimates and Wright's personal scandals doomed the project. In June 1930 club members marked their seventh anniversary with the dedication of a permanent clubhouse, a traditional neo-Gothic structure designed by the architectural adviser to the Nakoma Homeowners Association. Wright had been paid about $3,000 for his work.

Nakoma Country Club Scale Model

Bruce Severson fabricated this scale model for a comprehensive exhibition at the Elvehjem Art Museum of Wright's eight decades of life and work in Madison. From right to left, it shows a segment of a twenty-four-vehicle carport, the tea pavilion, women's locker room, the "wigwam," the main entrance (partly concealed), service entrance, and men's locker room. (Chazen Museum of Art, 1992.147, building designed 1923–24, model fabricated 1987, plywood and paint, National Endowment for the Humanities Grant purchase)

Dateline
February 19, 1926 Crews begin demolishing Frank Lloyd Wright's only public commission in the city of Madison, the 1893 boathouse at the head of North Carroll Street. "The boathouse has been the cause of much agitation in the past," the *Capital Times* states, adding that "residents in the vicinity felt that it should be removed." Press accounts fail to note the identity of the architect.
September 19, 1928 Madison leads nation in number of entries per capita in new edition of *Who's Who*. Among first-time listees: *Capital Times* founder William T. Evjue, editor/publisher Bascom B. Clarke, and public-spirited scientist Harry Steenbock.

FRANK LLOYD WRIGHT'S FRAT HOUSE

In November 1924, the Mu chapter of Phi Gamma Delta decided to move from the quarters it had occupied since 1911 — the great stone mansion which Levi Vilas built at Langdon and Henry streets in 1851 (page 21) — and build new quarters at 16 Langdon Street. Richard Lloyd Jones, the former editor and publisher of the *Wisconsin State Journal* and an influential member of the chapter's alumni board, knew just the man for the job — his world-famous cousin, Frank Lloyd Wright. On Jones's enthusiastic recommendation, the fraternity retained Wright, riding high after his Imperial Hotel was one of the few structures to survive the Tokyo earthquake of 1923.

Along with an innovative architect, Jones had the innovative idea of providing full and separate alumni quarters along with areas for studying and socializing. To find the full flavor of fraternity life, and figure out how to meet Jones's tripartite plan, Wright, fifty-eight, even bunked with the Fijis for a few days in early 1925.

Wright showed this drawing, one of a series, to the Phi Gamma Delta board of directors in a meeting at Taliesin on April 14, 1925. "The best plan for a house that had ever been submitted to satisfy the requirement of a fraternity program," chapter board minutes gushed.

Objective observers were equally enthusiastic. It would be, one newspaper commented accurately if ungrammatically, "the most unique of all of the Madison Greek letter houses."

Certainly, no other fraternity house had ever been designed as a Mayan temple made of concrete blocks. And Wright cleverly used the unusual topography — the lot was long and narrow, sloping steadily from Langdon Street to

Phi Gamma Delta Fraternity House
Aerial perspective from Langdon Street toward Lake Mendota. (WHi-3203)

Lake Mendota — to separate alumni from active members, studying from socializing.

But within the week, crisis came, when lightning struck Taliesin and started a fire that did $500,000 in damage, covered by less than $40,000 in insurance. In December, Wright's personal life flared into the news again, when his young mistress, Olgivanna Milanoff, gave birth to their daughter, Iovanna.

The Fijis, who a few years earlier had organized the junior honors Ku Klux Klan society, apparently could handle personal scandal, and kept working with Wright. But when the respected contractor John Findorff told them Wright's $80,000 estimate was about $20,000 too low, they asked Wright to revise the plans. He did so, even while on the run from a warrant Olgivanna's husband had issued.

But those plans also came in at more than $100,000. In October 1926, the same week Wright and Olgivanna were arrested hiding in a cabin near Minneapolis, the fraternity cancelled his commission and retained a firm

Wright disdained, Law, Law and Potter — the same firm that designed the Beaver Building on Monona Avenue after Wright's Madison Hotel wasn't built.

Told to keep Wright's functional scheme but spend no more than $75,000, the new architects produced a simplified Tudor design that used some, but not all, of his plan. Appearing as a modest manor house from the street but a massive estate from the lake, the Fiji House opened in the fall of 1928, at a cost of $90,000. Press accounts did not note the original architect.

Wright and Olgivanna married in August 1928. Over the next two years, Wright tried in vain to affiliate with the university, lost a large New York apartment building contract after the crash, designed the Tulsa home of Richard Lloyd Jones, and had his first exhibit in Madison. In 1932, sixty-five and without much money, he started the Taliesin Fellowship. In 1938, Wright conceived Olin Terraces for the Monona Avenue lakefront, forever altering Madison's downtown development.

CAMPUS KLAN

In the early 1920s, university student life was dominated by a group of young men who proudly espoused patriotism, Protestantism, and white racial superiority — the interfraternity Ku Klux Klan honorary society.

After a secret meeting called in May 1919 by the juniors of Phi Gamma Delta, the chapter was officially chartered in January 1920; with members from fifteen other fraternities, it was the second such organization in the country, following one at the University of Illinois at Urbana-Champaign. Members of the campus Klan served in or on the student senate, student court, alumni committee, and prom and homecoming committees, and were directors of the *Daily Cardinal* board of control, the athletic board, the YMCA cabinet, Student Union board, and Memorial Union fund-raising committee. Between 1920 and 1924, four of five senior class presidents, including Walter Frautschi and Fred Bickel (later known as the actor Frederic March), were members of the honorary Klan; in 1921–22, members of the honorary Klan edited both the *Daily Cardinal* and the *Badger* yearbook (which published coarse anti-Semitic illustrations). The society's membership also included financial guru and philanthropist Thomas E. Brittingham Jr., longtime Memorial Union director Porter Butts, football star Frank "Red" Weston, and future city school superintendent Phillip Falk.

With almost no African Americans on campus — there were three in the freshman class of 1923, a total of six enrolled in 1927 — racism and anti-Semitism were both rampant and routine. Consistent with the policies of the National Interfraternity Conference, university fraternities routinely proposed and dean of students Scott K. Goodnight routinely approved charters with racial and ethnic restrictions on Jews, Catholics, and nonwhites.

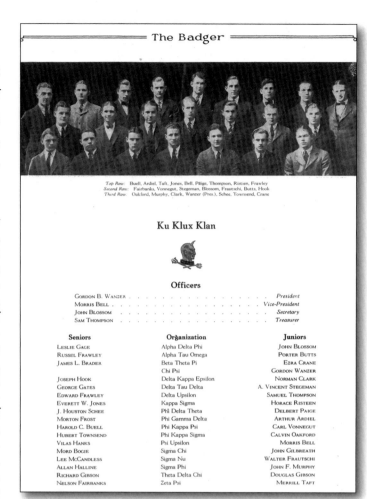

The Badger

Top Row: Buell, Ardiel, Taft, Jones, Bell, Paige, Thompson, Ristien, Frawley
Second Row: Fairbanks, Vonnegut, Stegeman, Blossom, Frautschi, Butts, Hook
Third Row: Oakford, Murphy, Clark, Wanzer (Pres.), Schee, Townsend, Crane

Ku Klux Klan

Officers

GORDON B. WANZER	President
MORRIS BELL	Vice-President
JOHN BLOSSOM	Secretary
SAM THOMPSON	Treasurer

Seniors	Organization	Juniors
LESLIE GAGE	Alpha Delta Phi	JOHN BLOSSOM
RUSSEL FRAWLEY	Alpha Tau Omega	PORTER BUTTS
JAMES L. BRADER	Beta Theta Pi	EZRA CRANE
	Chi Psi	GORDON WANZER
JOSEPH HOOK	Delta Kappa Epsilon	NORMAN CLARK
GEORGE GATES	Delta Tau Delta	A. VINCENT STEGEMAN
EDWARD FRAWLEY	Delta Upsilon	SAMUEL THOMPSON
EVERETT W. JONES	Kappa Sigma	HORACE RISTEEN
J. HOUSTON SCHEE	Phi Delta Theta	DELBERT PAIGE
MORTON FROST	Phi Gamma Delta	ARTHUR ARDIEL
HAROLD C. BUELL	Phi Kappa Psi	CARL VONNEGUT
HUBERT TOWNSEND	Phi Kappa Sigma	CALVIN OAKFORD
VILAS HANKS	Psi Upsilon	MORRIS BELL
MORD BOGIE	Sigma Chi	JOHN GILBREATH
LEE McCANDLESS	Sigma Nu	WALTER FRAUTSCHI
ALLAN HALLINE	Sigma Phi	JOHN F. MURPHY
RICHARD GIBSON	Theta Delta Chi	DOUGLAS GIBSON
NELSON FAIRBANKS	Zeta Psi	MERRILL TAFT

Campus Ku Klux Klan, 1924 *Badger*
(University of Wisconsin Archives)

There were minstrel shows on campus starting in 1897, and when they were revived after World War I, they were important events. A highlight of Homecoming 1920 was the Engineers' Minstrels, a "regular old-fashioned nigger Jubilee" featuring "seventy sons of St. Patrick," whites smeared with burnt cork and performing as "Rastus," "Sassasfras," "Dum Bell," and other like nicknames. "Laugh at the niggers," proclaimed the university-endorsed souvenir program, replete with the most racist language and imagery.

It was the same off-campus; a 1926 minstrel show produced by Luther Memorial Brotherhood was so successful it was later broadcast over *Capital Times* radio station WIBA.

The students of the honorary Klan also played junior G-men in the Greenbush neighborhood. In early 1921, student Klansmen conducted surveillance, made liquor buys, and filed complaints with federal liquor control agents; then they joined in the nighttime sweep that led to eight arrests and the confiscation of three hundred gallons of liquor.

It was local organizing by the authentic Klan that led to the end of the campus honorary version.

The official Invisible Empire of the Ku Klux Klan began a secret recruiting drive on campus in the fall of 1922, and by the following January there were knights on campus. Several faculty members joined, including an officer from the campus military cadets and an engineering instructor. Dozens of students donned the white hood as well.

Unlike the leaders in the honorary Klan, the students of the real Klan were generally losers. The typical honorary Klan man was an urban, out of state, liberal arts major; these new recruits were typically engineering majors from Wisconsin, likely in the campus military and likely not an athlete or elected to any campus positions.

The members of the honorary Klan didn't so much object to the philosophy or activities of the new group as disdain them on a class basis. Within a few months of its arrival, the honorary Klan in April 1923 changed its name to Tumas, roughly translated from the Latin as "you're the man."

Once the interfraternity honorary Klan ended, the campus Klan got university approval for its own fraternity in May 1924 — Kappa Beta Lambda (its initials also stood for "Klansman Be Loyal"). The modest two-flat KBL house south of campus at 302 Huntington Court had the strictest rules and about the lowest grade point average on campus, and was put on probation its second year.

As the state Klan fell victim to scandal and internecine struggle, the campus Klan declined as well, attracting only four pledges in 1926 before changing its name the next semester to Delta Sigma Tau.

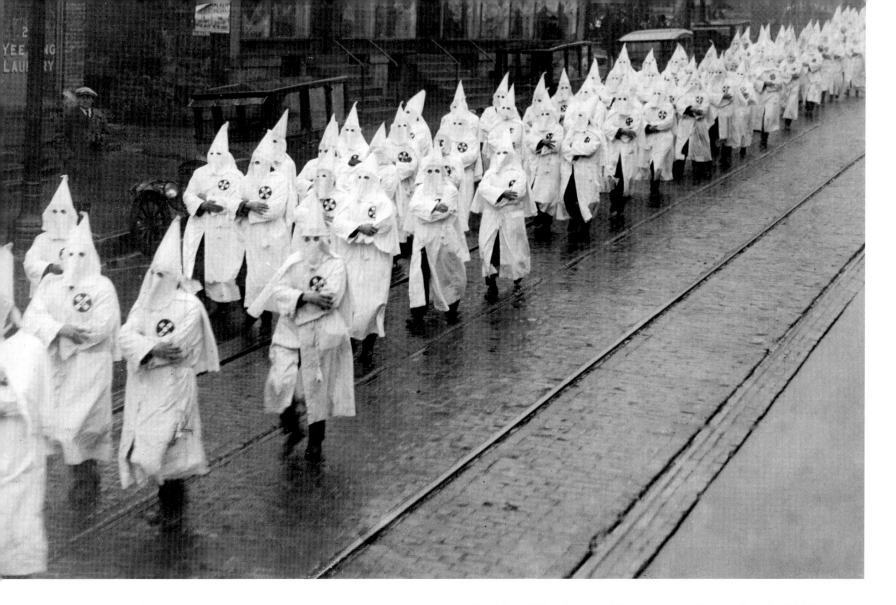

BAD TIMES

Ku Klux Klan Funeral Procession, December 5, 1924
Some of the two hundred Klansmen who marched down King Street to the Schroeder Funeral Home for services for police officer Herbert Dreger.
(WHi-1902)

The twenties roared in Madison, a terrible howl of corruption, violence, and evil. Murders in Greenbush, a Klan-infested police department, even a crooked judge. Thanks to that "noble experiment" of Prohibition, Madison had it all.

The Greenbush neighborhood certainly had some great moments early in the decade, especially the 1922 opening of the Italian Workmen's Club at 914 Regent Street. Built by neighborhood volunteers using equipment donated by former city engineer John Icke, the facility would serve as the neighborhood's social focal point for generations. In 1923, a new St. James Church, designed by Frederick Kronenberg in the late Romanesque Revival style, opened at 1130 St. James Court.

But just a few blocks away was the intersection they called Death (or Deadman's) Corners, Desmond Court at Murray Street, halfway between Regent and Milton, where five men were shot to death between 1922 and 1928.

For the full decade, in the seventeen blocks bordered by Washington, Mound, Brooks, and Regent streets, there were eleven fatal shootings (including two patrolmen and a two-year old) and two bombings, all related to bootlegging or Old World vendettas, all making Madison fertile ground for the Klan to plant its fiery cross. In 1924 alone, there were five fatal shootings (usually with a shotgun) and a bombing.

The Klan enjoyed official sanction and special status, as Mayor Milo Kittleson in 1924 secretly deputized about thirty Klansmen for intelligence and enforcement work. And it was widely believed that the president of the Police and Fire Commission, Dr. E. H. Drews, was a Klan sympathizer and possibly even a member.

Decade of Death

The decade's drumbeat of death and hate (a partial list):

August 26, 1921 Ad in *Wisconsin State Journal:* "Wanted: Fraternal Organizers, men of ability between the ages of 25 and 40. Must be 100 percent Americans. Masons preferred." On August 30, *Capital Times* reveals the ad, which it rejected, was placed by Klan.

October 11, 1922 *Capital Times* reveals Klan, organizing under name Loyal Business Men's Society, has eight hundred adherents. When the Klan announces plans for full induction ceremony on farm south of town, Mayor Kittleson says he sees "no reason in the world why they should not be given the same consideration as any other organization."

November 3, 1922 "Time to send somebody to jail!" the *Capital Times* cries in front-page editorial denouncing bootleggers.

November 8, 1922 Federal grand jury indicts twenty-one on narcotics and liquor charges; five days later, police seize 475 gallons of wine in early morning raids along Regent Street. More raids follow through the winter. Some secret stills are revealed when they explode.

July 28, 1923 More than forty thousand attend Klan initiation ceremony in Racine, where announcement is made of plans for a Madison headquarters.

November 18, 1923 The Reverend Norman B. Henderson, pastor of the First Baptist Church and president of the Lion's Club and the Ministerial Union, calls Klan indispensable in fight against liquor and "the best friend the negro in the south ever had."

January 1924 Judge Ole Stolen visits Anton Navarra's grocery at 746 West Washington Avenue, borrows $500 from "Little Pete" La-Bruzzo.

March 8, 1924 After two Greenbush murders within three weeks, about two dozen robed and hooded Klansmen meet by Lake Mendota for first public initiation of new members and burning of cross. Klan insignia begin appearing around town, and another cross is burned.

March 16, 1924 Anton Navarra is shotgunned to death at in his grocery store, dying just about on the spot where LaBruzzo loaned money to Judge Stolen. The Neighborhood

Ole Stolen, Corrupt Judge

Judge Ole Stolen was an aggressive progressive, stern moralist, and staunch prohibitionist who committed the most shocking betrayal of the public trust in Madison's history. Shortly after losing a tight race for district attorney in 1921, Stolen convinced Governor John J. Blaine to order a pardon hearing for Dogskin Johnson, the confessed murderer of Annie Lemberger. Using perjured testimony from scrubwoman Mae Sorenson, Stolen got Johnson's sentence commuted and Annie's innocent father charged with manslaughter. Although the charges against Martin Lemberger were dropped because of the statute of limitations, Stolen rode the publicity to election as superior court judge in April 1922. Soon after, Sorenson started shaking Stolen down. To get cash to pay the blackmail, the judge borrowed heavily from bootleggers in the Bush, several of whom appeared before him; within a year, he had borrowed $2,500, more than half his annual salary. Stolen didn't pay the notes back, but he did take care of the bootleggers and their families through his official capacity. District Attorney Phil La Follette found out, but did nothing beyond telling Stolen to straighten up. Even after La Follette ran a John Doe probe — the first ever of a Dane County judge — his only action was to convince the newspapers not to report the scandal. Finally, on his last day as DA, January 1, 1927, La Follette sent the John Doe transcript to the bar association. Three weeks later, the State Supreme Court charged Stolen with taking loans from bootleggers and set a hearing date to his disbarment. Then the *Capital Times* unleashed a journalistic thunderbolt — publication of the entire transcript of the John Doe proceeding. On March 5, Stolen resigned — but the court disbarred him anyway. In August, Governor Fred R. Zimmerman appointed Stolen a state human officer; when that position was abolished in 1929, Mayor Albert Schmedeman made him a justice of the peace. Stolen was readmitted to the bar in 1930, and began a long campaign seeking compensation for Johnson (and legal fees for himself). Stolen retired to California in 1958, where he died a few years later. (WHi-34328)

House volunteer was apparently assassinated on orders of Tony Musso, leader of the Milton Street gang, because he posted bond for members of the Regent Street faction. Navarra's killer was never caught. Two weeks later, about four hundred Klansmen march to Brittingham Park for a cross-burning rally.

June 26, 1924 The largest police raid in months — six officers searching eighteen pool parlors and soda shops — comes up empty, leading to whispers that the Bush bootleggers were tipped by someone with a badge.

July 1, 1924 About two thousand attend — some watching, some participating — the burning of a huge cross at the first large public Klan rally at Miller's Park on Oregon Road.

December 1, 1924 Rookie patrolman Herbert Dreger is murdered in a shotgun ambush at Milton and Murray streets. Two neighborhood men, Salvatore Di Martino and Frank Vitale, are arrested and identified by eyewitness, but are later found not guilty by a Sauk County jury. Dreger, on the job for only six

months, is the first police officer in Madison to die while on duty.

December 8, 1924 Seven Sicilians seek to lodge official protest against police brutality, but Police and Fire Commission (PFC) denies them a hearing. Their attorney, Ernest N. Warner, addresses commission briefly, but no action is taken.

December 10, 1924 Police Chief Shaughnessy, on the force since 1898, announces he will retire on April 1, 1925.

December 20, 1924 Mayor Milo Kittleson and E. H. Drews, PFC president, secretly deputize about thirty Klansmen to conduct raids in the Bush, paid for through the mayor's official contingency account. Kittleson lies and denies the Klan connection, and refuses to disclose the deputies' names. Seven city officers also participate, but Shaughnessy is kept in the dark as fifteen arrests are made. The Woman's Club, Women's Christian Temperance Union, and the Baptist Church all support the raid, which the council later endorses by voting to reimburse Kittleson's account. Judge Hoop-

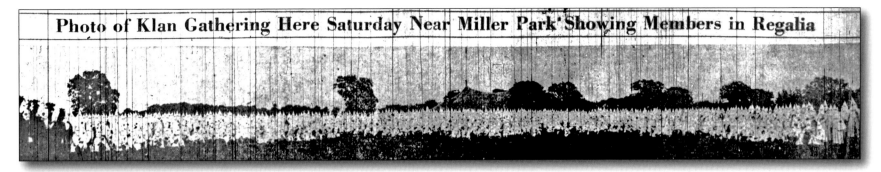

Photo of Klan Gathering Here Saturday Near Miller Park Showing Members in Regalia

Klan Gathering in Miller Park, October 4, 1924

The *Capital Times* believed in exposing rather than ignoring Klan activities. It splashed this startling photo of a Klan conclave on the Oregon Road south of town across the top of its front page.

mann bars mention of Klan involvement at trial.

December 24, 1924 State Representative Herman W. Sachtjen, candidate for speaker of the assembly and a state Prohibition commissioner, sends Christmas cards wishing recipients "a little glass of wine or a mug of lager beer/to bring you joy and happiness at times this coming year." Sachtjen says he sent the cards as a private citizen, not as state dry chief.

January 4, 1925 Phil La Follette sworn in as Dane County district attorney, the same position his father, Robert M. La Follette Sr., held 1880–84. Phil proves an aggressive prosecutor, organizing raids and seeking stiff penalties.

June 9, 1925 The first fiery cross since last summer burns at Death Corners, on the exact spot where Dreger was murdered in December.

September 7, 1925 Final major Klan event in Dane County.

January 4, 1926 Claiming self-defense, restaurateur and "former" bootlegger Rudolph Jessner shoots Patrolman Palmer Thompson to death outside his restaurant on Lake Street near Mound. Jessner had turned a $125 investment in a taxi cab into a $13,000 profit in just six months supplying riders with moonshine and prostitutes before going to prison; his café on South Lake Street had been bombed in early 1924. Charged with first-degree murder,

Jessner later testifies he paid several police officers to stand guard while his liquor shipments were unloaded. Jessner produces his book of customers, but it is kept out of the official record. Several police officers testify that they were or had been members of the Ku Klux Klan, and that one officer told Jessner, "I'll beat your head off, you dirty little Jew." Thompson's partner testifies that he had formerly belonged to the Klan, but denies he had boasted of being protected by PFC president Drews. Jessner also testifies he knew others who distributed Klan membership cards. Kittleson says that he and Drews will investigate Jessner's allegations. On April 10, Jessner becomes the only man convicted and imprisoned for a Greenbush murder this decade.

January 7, 1927 Night patrolman Arnold DeVries alleges he had to join the Klan to get job with police department, and that he was fired as soon as he quit the Klan. A private detective supports DeVries's claim about Klan influence in department; forty years later, so does future police chief William McCormick. DeVries produces a membership card in the Bow Tie Club, which he identified as the secret sign of membership in the secret society. Drews flatly denies all allegations.

March 2, 1927 During State Senate investigation into highway corruption scandal, campaign worker for Governor Zimmerman alleges governor was affiliated with Klan. Committee chair Walter S. Goodland bars testimony on matter.

April 9, 1928 Joseph DiMartino, brother and brother-in-law to the two men found not guilty for the 1924 murder of Dreger, is killed by a shotgun blast while standing in a neighbor's kitchen.

September 22, 1929 Joe Gelosi, a suspect in

the DiMartino shooting and the recipient of a light sentence from Judge Stolen, is shot outside his garage while carrying his two-year-old son in his arms. Joe survives, but the infant, Frankie, becomes the youngest victim of the ongoing rum war. Gelosi names his assailants, but quickly recants when an anonymous caller threatens to kill the entire family. The Gelosis soon move to New York.

January 2, 1930 Police night lieutenant Clarence Bullard is demoted in wake of stationhouse murder last July of a Minneapolis craftsman, killed by fellow inmate. Investigation also uncovered evidence that on several occasions injured men had been kept at station all night without medical attention.

May 1930 Drews's appointment to PFC expires. Mayor Schmedeman does not reappoint him.

May 1, 1930 Ending six-month standoff over job security, embattled Police Chief Trostle finally agrees to resign and accept new post heading traffic division.

September 30, 1930 PFC names the city's third police chief of the year, William H. McCormick, by a vote of 3-2 over George O'Connell, the new PFC president, who finally broke a deadlock by voting for McCormick. Known as an honest and capable officer, McCormick conducted several successful raids to seize stills in 1925–26.

December 8, 1946 Circuit Court Judge Herman Sachtjen, the former state Prohibition officer, revokes Klan state charter, saying it was formed for no legal purpose. Sachtjen says the Klan stands for principles that are un-American and contrary to letter and spirit of state and federal constitutions.

A Community's Center

The end of the world war also brought an end to the first intense Americanization crusade that Madison progressives waged in the Greenbush. In May 1920, the Public Welfare Association, successor to Associated Charities, changed its existing programs to a residential settlement house.

Lumberman and philanthropist Thomas E. Brittingham Sr., who had been paying the rent on the facility that opened at 807 Mound Street in 1917, bought a former furniture store at 768 West Washington Avenue for $6,800 in 1921; conversion of the store to a full Settlement House cost another $3,200, funds mainly provided by the Kiwanis and Rotary clubs. And there were also early donors from the neighborhood; grocer and Bush bail bondsman Anton Navarra raised almost a hundred dollars from twenty-two countrymen, an important indication the residents welcomed the effort (or were at least seen to).

Neighborhood House began operation as a settlement house on November 11, 1921. "An investment in good citizenship," the *Capital Times* declared. "To educate foreigners to adjust themselves to American customs and methods of living is the kind of work we are trying to accomplish in the foreign settlement of Madison," head resident Gay Braxton said in 1929.

The National Office of Vocational Education authorized the local vocational school to pay the salaries for Braxton and her assistant, Mary Lee Griggs — making Madison the only settlement house in the country with such an arrangement. And in an early example of a work-study program, senior sociology majors got university credits for teaching Neighborhood House classes and working with play groups. Other students — including members of the campus Ku Klux Klan honorary society — volunteered through the university YMCA.

In the settlement house's first year, there were 641 activities or meetings; seven nations and three races were represented in the total attendance of 14,359. Within five years, Neighborhood House was offering thirty-three separate classes a week. To give neighborhood residents a sense of ownership, Braxton insisted they pay at least nominal dues; in 1926, about four hundred members did so, ranging from a nickel to a quarter a month.

The Lions Club, organized in 1922, undertook a comprehensive Americanization program in 1923 and adopted Neighborhood House as its chief civic project. Club members donated about $9,000 for manual arts equipment, dance lessons from Leo Kehl, and to help buy the adjoining lot and construct a $23,000 addition in 1926.

In 1924, attendance hit about thirty thousand visits, with over fifteen hundred separate activities or meetings. In 1929, nearly a thousand residents were registered at Neighborhood House.

One academic analyst, decrying progressive paternalism, concluded that "local Italians would be in a better position today" without the past influence of Neighborhood House. That is not the prevailing attitude.

After Braxton's 1949 retirement, Neighborhood House joined the Madison Neighborhood Centers. The building was razed for the Triangle Redevelopment in 1963, its programming relocated to South Mills Street.

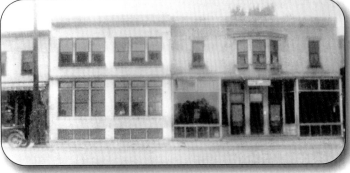

Neighborhood House, ca. 1926
(WHi-36086)

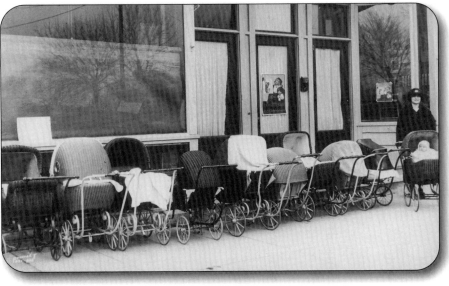

Casa di Bambini, ca. 1925
The Well-Baby Clinic was one of the most important and popular services offered at Neighborhood House. (WHi-35730)

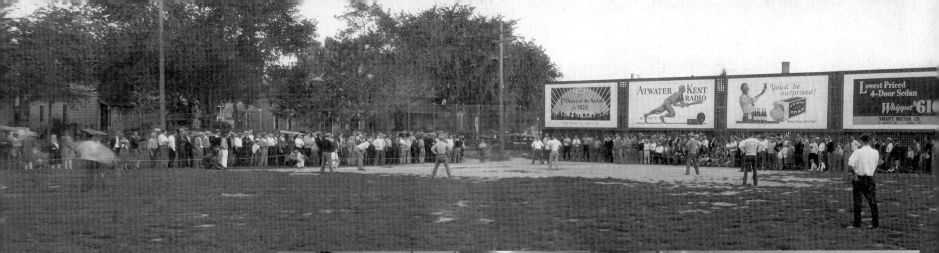

Baseball at Barry Park, 1928
(top)

Looking across Barry Park toward Bedford Street from the 500 block of West Dayton Street. Bordering railroad tracks and coal yards, the land at this awkward juncture — a legacy of the University Addition of 1850 — wouldn't make a good modern ball field. But in 1928 it was all this low-income neighborhood had. Named after longtime Alderman Patrick J. Barry in 1926, the park became the site of the new Washington School in February 1940. Only the Prohibition-era reference to nonalcoholic home brew distinguishes these billboards — two for automobiles, one for consumer electronics — from those at a modern stadium. At the sesquicentennial, all the houses on Bedford Street remained — including two built in 1864, and one dating to 1849. (WHi-35717)

Citizenship Class, Neighborhood House, 1940 *(center)*

Head resident Gay Braxton stands at the rear behind this group of Greenbush adults studying the English language and American institutions. (WHi-35722)

Children of the Bush, ca. 1925
(bottom)

Youngsters of many lands gather at Neighborhood House. (WHi-36088)

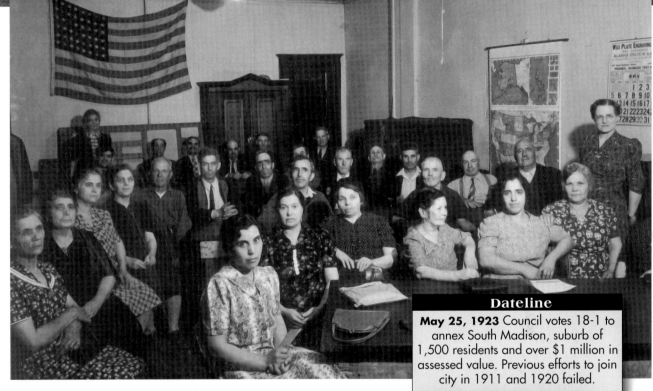

Dateline

May 25, 1923 Council votes 18-1 to annex South Madison, suburb of 1,500 residents and over $1 million in assessed value. Previous efforts to join city in 1911 and 1920 failed.

MAYOR KITTLESON VETOES JOHNSON STREET CITY HALL

JANUARY 29, 1924

The entire downtown would have been different, and Madison would have avoided thirty years of controversy and crisis, if Milo Kittleson hadn't vetoed a Johnson Street site for the new city hall. By 1924, city hall showed its sixty-six years. "Antiquated, inadequate and not a credit to a city the size and importance of Madison," the mayor said even as he was saving it.

Ever since the voters' approval of a $100,000 bond issue in 1912, the city had looked hard for a new site for city hall. Now one seemed at hand — the back end of the historic Hausmann brewery, destroyed in a $100,000 fire during a blizzard on March 19, 1923. On January 25, 1924, the council voted to buy three lots fronting on Johnson Street, from mid-block almost to the corner of Broom Street, for $57,000 — $39,500 more than their assessed value.

Kittleson did not approve. "Your action," he told the council in his veto message four days later, "has brought forth from our people in every section of the city and from all walks of life, regardless of personal interest, storms of protest and objections."

Kittleson noted that the city had in the past year bought the Breese Stevens block for an athletic field, a downtown block for school and playground, land to open both Doty Street from Hamilton to Henry and Second Street from Atwood to Main, the Nine Springs tract for a new sewage disposal plant — and would need to spend $1 million over the next few years for "absolutely necessary additional sewerage disposal facilities," a gymnasium/auditorium for East High, a new junior-senior high school for the south and west sides, a new quarantine hospital, and the extension of University Avenue. "Is it not time we begin to refrain from making unnecessary expenditures and purchases?" he asked rhetorically.

"There is no person living but will make mistakes," Kittleson concluded. "But he will not be blamed if, when he realizes his mistake, admits and corrects it."

Although the State Street Realty Company claimed the site it was trying to sell was "in harmony" with Nolen's comprehensive plan, John Olin — who knew more about making a model city — applauded the mayor's veto, which was sustained. The fight to site a new city hall was kept alive until the City-County Building was approved in 1953.

Eight decades after Kittleson's veto, the property is being put to a historically appropriate purpose — as the site of a brewpub.

Madison Mayor

If only **Milo Kittleson** (1874–1958) hadn't secretly deputized members of the Ku Klux Klan as special police officers in 1924, he'd likely be remembered as one of Madison's greatest mayors. Still, he was undoubtedly one of the most influential and visionary. Kittleson was the first mayor to propose an auditorium (along with a municipal boathouse) on the Lake Monona shoreline, he annexed South Madison, and he said a municipal athletic field was more important than a new city hall (and in two years opened the Memorial Stadium at Breese Stevens Field).

In his first message in April 1920, he said the city would need a high school on the east side in "the near future," and accurately predicted the future of Central High four decades early: "The present Central High will undoubtedly be given over largely to Vocational education," he said in 1925. Kittleson called for the consolidation of the city and school board health services under one full-time physician and a "comprehensive health program," including a modern hospital to treat contagious diseases and a permanent board of health. Citing "muck and other sediment from the sugar factory and other sources" for ongoing odors and contamination, Kittleson said the city should dredge Lake Monona and acquire the adjacent lowlands. Because garbage collection "is too important a task to be shouldered onto the street superintendent," Kittleson advocated a full-time superintendent of waste removal, along with expanded sewerage facilities. He decried the city's failure to crack down on the "abominable nuisance" of pollution-generating soft coal: "This nuisance has become unbearable and should be abated." Kittleson proposed a full-time purchasing agent, a forestry department, and purchase of the Conklin property for parkland (accomplished in the late 1930s and later renamed James Madison Park). And he noted a new concern: traffic congestion on the square and State Street was "becoming serious." Kittleson's 1920 recommendation: "All traffic should move one way around the Capitol Square and parking on State Street and King Street should be prohibited." He also urged the "early completion" of the extension of University Avenue through to the Capitol Square. He achieved the first goal in 1921, but State Street didn't go car-free until the administration of Paul Soglin in 1977. And University Avenue would never be extended.

Kittleson was the second mayor to live at 1102 Spaight Street and the second to serve six consecutive years (1920–26). He was just passing through Madison on his way to Valparaiso University in Indiana in 1889, but he liked the city so much he stayed, enrolling at the Wisconsin Academy and earning a law degree in 1902 as a special adult student at the university. Employed at the Savings Loan and Trust and later at Commercial Trust, Kittleson served one term on the common council in 1912. He was elected mayor in 1920, when the position was still part-time with an annual salary of $2,000. Keeping office hours at city hall every morning, Kittleson prompted the move to a full-time mayor when he quit his personal job to attend to his public duties. His wife, Ida, was a founder and thirty-year president of the Dane County Humane Society and received a national Good Neighbor Award. A past master of a Masonic lodge, Kittleson was a member of the Odd Fellows, Knights of Pythias, and Loyal Order of Moose. After leaving office, he became a hearing examiner for the state Industrial Commission.

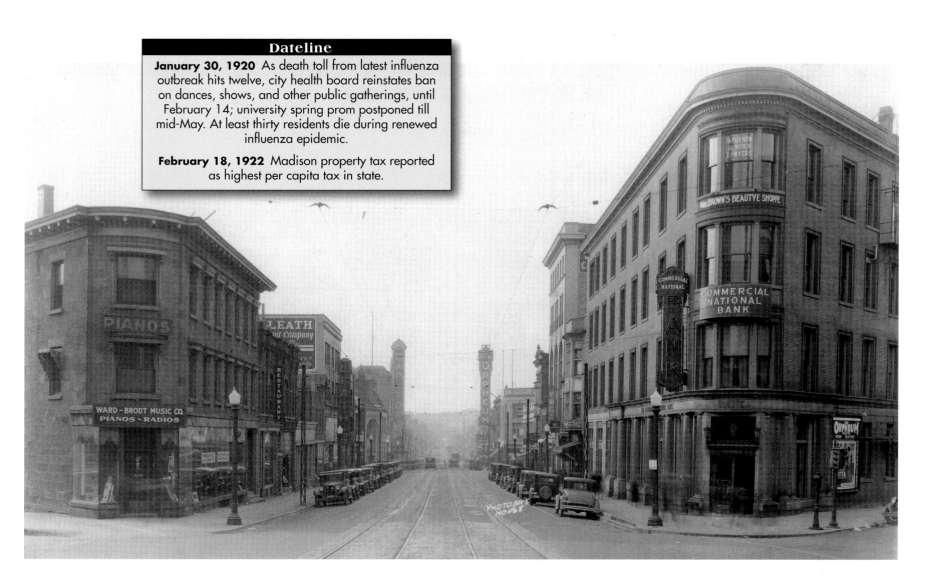

100 Block of State Street, 1929

In addition to its significance in the city's social, cultural, and economic life, State Street also showcases a wide variety of architectural styles, including Italianate, Queen Anne, Romanesque Revival, High Victorian Gothic, Craftsman, Prairie School, Tudor Revival, Mediterranean Revival, Art Moderne, and Art Deco. At left, the Italianate sandstone that Stephen Shipman designed for Willet Main in 1855, here the home of Ward-Brodt Music Company. Across the street, the Commercial National Bank, organized by Solomon Levitan and A. O. Paunack, anchors the Neo-Classical Revival Wisconsin building, its lower level remodeled by Robert Wright in 1908. Next door, Palace Drugs occupies the storefront in the 1905 Queen Anne–style Lamb Building, the only individual property on State Street listed on the National Register of Historic Places; it was designed by Claude and Starck, also responsible for the new façade for the historic Madison Fire Station no. 2 at 125, here occupied by the Castle & Doyle coal company. Just past the YWCA, another Queen Anne building, designed by Ferdinand Kronenberg and here occupied by Clark's clothing. Although efforts to create a State Street Historic District have so far been unsuccessful, every structure in this block remained as of the sesquicentennial. (WHi-25119)

Madison Mayor

The only mayor of Madison to become governor of Wisconsin, **Albert G. Schmedeman** (1864–1946) rid the police of its Ku Klux Klan influence, but he failed to make progress toward a civic auditorium, new city hall, or extension of University Avenue. A first generation German American, Schmedeman was President Wilson's ambassador to Norway (1913–21) and was honored for helping get American supplies past the German blockade during World War I. A graduate of Madison public schools and a local business college, Schmedeman started as a clerk for a downtown clothier, soon becoming senior partner. He ran for the council in 1904 to get a new school for his fourth ward, and did — the Doty School, in 1906. During his mayoral administration (1926–32), the city built West High, expanded East High, and made progress on several grade schools. Education was the only exception to his strict fiscal conservatism; otherwise, he so routinely disapproved of any new large public expenditure that he was called the

"veto mayor." And even for schools, Schmedeman was frugal, favoring function over form. The one large item Schmedeman unreservedly favored was the extension of University Avenue through to West Washington Avenue; he urged its construction throughout his tenure, calling it "the best solution for the most acute traffic problem which we have, namely the congestion of State Street," as well as "one of the finest possible solutions for our present unemployment situation." Schmedeman favored getting tough with the Madison Railways Company and creating a Parks Commission to continue the work of the parks association.

Taking office less than two years after Mayor Kittleson had deputized Klansmen for a raid on the Greenbush neighborhood, Schmedeman stood up to the Klan and to the man seen as its protector, E.H. Drews, president of the Police and Fire Commission. Schmedeman harshly criticized the department in 1927, trounced Drews in the 1928 mayor's race, and removed him from the PFC after his easy reelection in 1930. During Schmedeman's successful campaign for a fourth term in April 1932, the Klan burned a cross on his lawn. That fall, Schmedeman was elected governor, the first Democrat to attain that office in the twentieth century. Turning the mayoralty over to architect James R. Law, Schmedeman took office at the depths of the Depression. His one two-year term as governor was not easy; the Roosevelt landslide had brought into office a number of conservative Democrats who sought to undo measures enacted under

Schmedeman's Progressive predecessor, Phil La Follette, and Roosevelt often preferred to work with the Progressives over the state Democrats. Schmedeman also lost favor with the national administration for his fiscal conservatism and for using National Guard troops against striking farmers and workers. Still, he did bring $300 million in federal relief money to Wisconsin, and after he lost to La Follette in 1934, Roosevelt named him Federal Housing Administrator for the state. Quiet and reserved, preferring time alone in his library to more social diversions, Schmedeman suffered a freak accident late in his gubernatorial term. Giving an address near Wausau, he stepped awkwardly on a stone and broke a bone in his foot; gangrene developed, and doctors had to amputate his left leg six inches above the knee. Schmedeman died at his home, 504 Wisconsin Avenue, hours after turning eighty-two, and is buried at Forest Hill Cemetery.

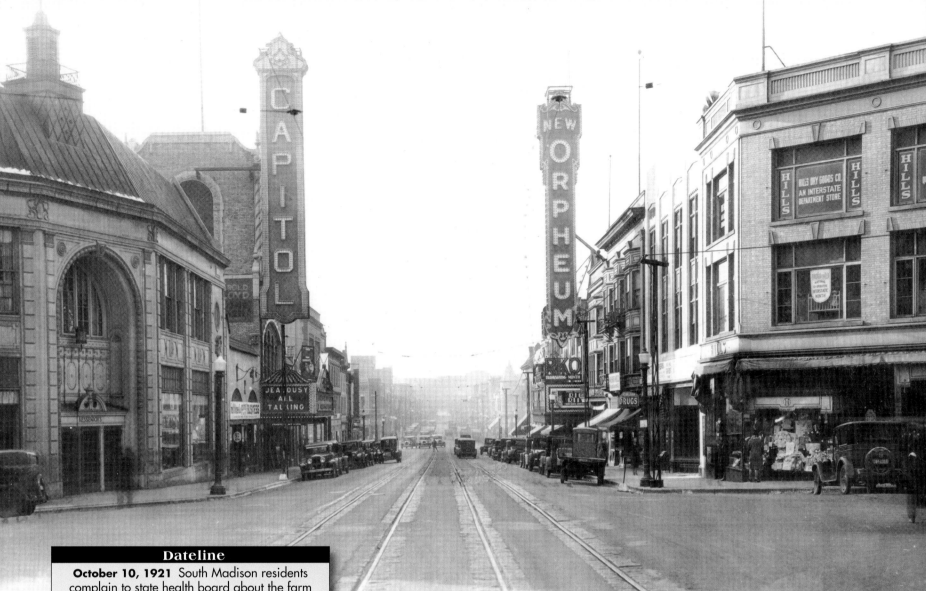

200 Block of State Street, 1929

The heart of State Street's identity as a shopping center and entertainment enclave. At left is Frank Kessenich's grand emporium for women's dry goods, an impressive Frank Riley design in French Renaissance Revival style that cost $250,000 and sparked the street's commercial development when it replaced the 1856 Nolden Hotel in 1923. Soon afterward, Hills department store expanded on the opposite corner, serving middle-class shoppers. Then came the theaters, striking designs by Chicago's Rapp and Rapp that opened within a year of each other: the $1 million New Orpheum, possibly the first use of Art Deco for a theater exterior, and the Spanish Revival Capitol (see pages 232 and 233). Some thought the New Orpheum's $18,000, sixty-three-foot-tall beacon was a bad fit for the streetscape, but the council decided it made the city more metropolitan and amended the sign ordinance to allow it. The Capitol's sign soon followed. At the urging of patron Jerome Frautschi and some preservationists, architect Cesar Pelli incorporated the Kessenich's and Capitol façades when designing Frautschi's $200 million Overture Center for the Performing Arts on this site in 2003. Flanking the New Orpheum are the 1907 Queen Anne–style Schumacher building, here occupied by the Singer Sewing Machine company, and two Craftsman designs from 1913, the Weber building (designed by F. L. Kronenberg) and the Rentschler building, seen more clearly on page 180. (WHi-3157)

FACTORY FACTS

Organized labor began the decade still reeling from the failed machinist strike of 1919. But then the roster of unions, which shrank from thirty-five in 1914 to twenty-nine in 1921, suddenly grew to forty-five by 1923; among the newer unions were the electrical workers, the federation of teachers, and

Among the forty-seven occupations in the 1890 city directory not included in the 1920 edition: dressmakers, blacksmiths, carriage and wagon works, harness and saddlery shops, flour and feed mills, meatpackers, and midwives. Among the new endeavors: 146 garages and gas stations, 37 beauty shops, 24 investment firms, 23 pool rooms, 22 loan offices, 20 radio shops, 7 motion picture theaters, and 7 advertising agencies. Biggest growth areas: real estate and law.

On January 6, 1920, a federation of nineteen unions levied a day's pay on each member to begin the process of acquiring a building; after more assessments, it began using Kehl's dance hall, 309 West Johnson Street, which it purchased the following December.

Throughout the twenties, the carpenters and other building trades became dominant in the Madison federation. This led to caution and conservatism by the coalition, and it meant that when the Depression struck Madison labor was led by those most vulnerable to an economic downturn. Because of its large public sector workforce, Madison did not suffer great economic dislocation with the collapse of the stock market in October 1929. Still, the decline in construction activity was quick, broad, and steep.

During the decade, only printers and teachers organized aggressively. "The industrial plants are unorganized as far as labor is concerned," the Association of Commerce reported, not unhappily, in early 1930.

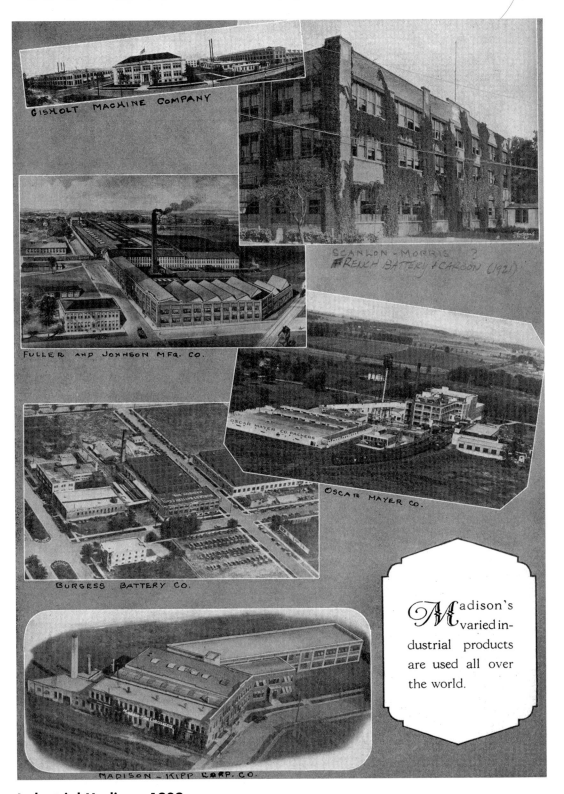

GISHOLT MACHINE COMPANY

SCANLON-MORRIS ? FRENCH BATTERY & CARBON (1921)

FULLER AND JOHNSON MFG. CO.

OSCAR MAYER CO. PACKERS

OSCAR MAYER CO.

BURGESS BATTERY CO.

MADISON-KIPP CORP. CO.

Madison's varied industrial products are used all over the world.

Industrial Madison, 1929

About six thousand Madisonians — more than 10 percent of the city's population — held industrial jobs, a payroll of over $7 million. Madison-Kipp, Burgess Battery, Fuller and Johnson, Gisholt, and French Battery and Carbon show 228,000 square feet in recent expansion in this Association of Commerce promotional pamphlet (which mislabels the future Ray-O-Vac as Scanlan-Morris). Planners said the city still needed 75,000 square feet in incubator space. (WHi-35718)

Depression Datelines

The Depression also brought a new sense of militancy to organized labor:

January 30, 1930 Ten-day strike by city barbers ends as union accepts offer of $25 weekly minimum plus 65 percent of all receipts over $33.

March 1, 1930 A group of thirty-three unemployed men, with two out-of-work women acting as spokespersons, march on city hall and issue thirteen demands to Mayor Schmedeman, who three days later announces hiring of eighty men for street and sewer repairs, two months earlier than planned. Another group of unemployed march on city hall five days later and are mobbed by university students.

March 28, 1930 The council rejects plea from laborers' union for an eight-hour day for all city laborers and truck drivers.

April 30, 1930 Five hundred union carpenters settle month-long strike for ten-cent raise to $1.20 an hour. Other trade unions are already back to work.

March 13, 1931 The council unanimously adopts fifty-cent minimum wage for all laborers on city work, whether done directly by city departments or under private contract, with penalties of $10 to $100 per violation.

December 25, 1931 Public Welfare Association issues 112 meal tickets to transient men. About 60 percent of the men are from Wisconsin, many of them lumberjacks.

December 28, 1931 A shelter where ninety transient men can stay for twenty-four hours opens at 9 South Webster. Sponsored by the city and several social agencies, the transient depot has laundry and bathing facilities, a kitchen, blankets, and cots from Camp Douglass and furniture donated by the Frautschi company.

December 30, 1931 Council adopts 1932 budget putting city laborers on eight-hour day and setting up a reserve for a possible city unemployment program. Budget, which maintains tax rate of 23.5 mills, also cuts $75,000 from school board, leading to either school closing, salary cuts, or deferred maintenance.

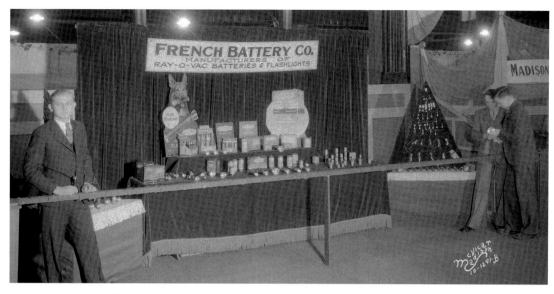

French Battery Company Display, November 7, 1929
For many years, a highlight of the fall season was the East Side Businessmen's Association festival. Angus McVicar captured this display of one of Madison's most enduring businesses, later known as Ray-O-Vac, one week after the stock market collapses. (WHi-20970)

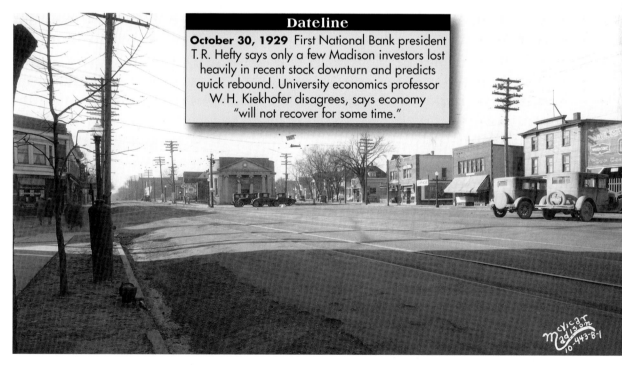

> ### Dateline
> **October 30, 1929** First National Bank president T. R. Hefty says only a few Madison investors lost heavily in recent stock downturn and predicts quick rebound. University economics professor W. H. Kiekhofer disagrees, says economy "will not recover for some time."

Schenk's Corners, January 22, 1928
Looking down Winnebago Street, with Atwood Avenue crossing in from the left — the ancient Native American paths just east of the Yahara River, now with trolley tracks and autos. Angus McVicar took this photo for an advertising supplement to the East Side High School yearbook; the focal point is the Security State Bank, a 1923 Italian renaissance design by Frank Riley, who also designed the nearby high school. At the end of the block on which McVicar stands, the continuing enterprises of the Schenk family, who gave their name to these corners. (WHi-5007)

Three Theaters

The opening of three new theaters in less than three years transformed Madison in ways that still have meaning today. August McVicar took these photographs around the time they opened.

New Orpheum Theatre, 216 State Street, Dedicated March 21, 1927 Mayor Schmedeman gave a welcoming talk and headliner Will Higgie, who introduced the Charleston, unveiled his latest dance, the Higgiejig, as more than seven thousand pack Madison's first movie palace for three performances of vaudeville and filmed photoplays.

Capitol Theatre, 211 State Street, Dedicated January 21, 1928 Six thousand or so jam the Capitol Theatre for two shows of stage and screen entertainment. Governor Zimmerman says the building "rivals our great state Capitol, for which it was named. It may even come to rival it as a place of amusement." The Capitol ends its movie career on July 23, 1974; its auditorium became the Oscar Mayer Theatre in the 1980 Civic Center. In 2006 the theater was adapted again, and its original name restored, in the second phase of the Overture Center.

Eastwood Theatre, 2090 Atwood Avenue, Dedicated December 27, 1929 "The East side is the only section of the city that could construct and support such a project," Mayor Schmedeman tells the thousand at opening night for a bill that included Mack Sennett's all-talking comedy *Midnight Daddies*. It was two months after the stock market crash, and the neighborhood project by Herman Loftsgordon and the East Side Businessmen's Association soon went bankrupt. Along with its hacienda-at-night design and thirty-seven-foot ceiling in the tower room, the $200,000 Eastwood was the state's first theater with a built-in movie sound system. Madison Twentieth Century Theatres bought the Eastwood in 1967, demolished the Spanish interior, and featured adult films at the renamed Cinema. The Schenk's-Atwood Revitalization Association now owns and operates the facility known as the Barrymore Theatre, once again a neighborhood asset featuring the finest in live music and family friendly fare.

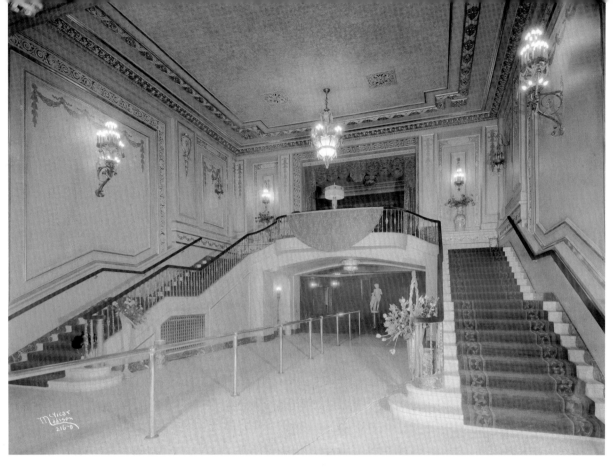

New Orpheum Theatre Lobby
Thanks to activists and a supportive businessperson, the French Renaissance interior, seen here opening week, has been substantially preserved. (WHi-21891)

Dateline
December 5, 1921 The former Fuller Opera House reopens as the Parkway Theatre with a presentation of *Miss Lulu Bett* by Zona Gale, the Pulitzer Prize–winning author and university regent from Portage. Artists appearing before the theater is razed for a Woolworth's in 1954 include Tallulah Bankhead, Katharine Hepburn, Helen Hayes, Mae West, and W. C. Fields.
February 21, 1927 Acting on complaint of several women's organizations alleging lewdness and immorality, Mayor Schmedeman shuts down showing of *Night of Love* motion picture.
January 13, 1928 Council refers to committee an ordinance banning smoking in city theaters and assembly halls. No action is taken.
April 11, 1930 Council rejects bid to revoke exhibition license of the Majestic Theatre for showing lewd films, orders investigation to see if theater has shown films without the approval of the mayor and the censorship committee. After theater shows the birth control film *No More Children* without approval of censorship committee, council issues formal censure on May 6.
April 18, 1930 Orpheum Theatre is filled and hundreds are turned away when over 2,200 attend Good Friday services.
April 27, 1931 RKO takes total control of Madison's first-run movie market by leasing the Parkway and Strand. With the Capitol and Orpheum theaters, the firm has 7,100 downtown seats.

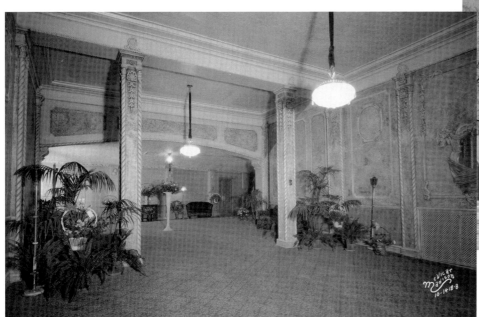

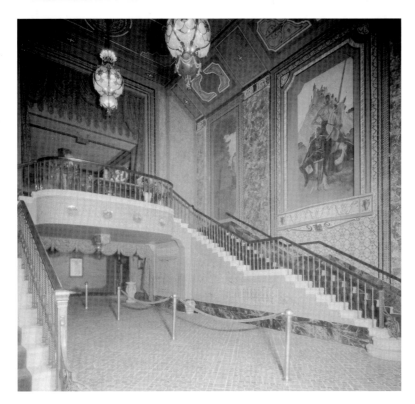

Eastwood Theatre Lobby *(left)* (WHi-20794)
Eastwood Theatre Exterior *(above)* (WHi-5006)

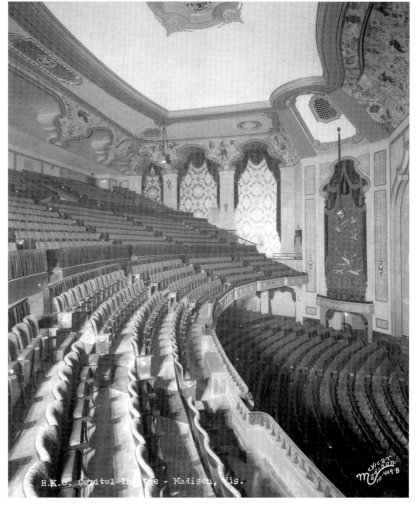

Capitol Theatre Lobby *(above)*
Some of the lavish Moorish interior with stenciled wall panels, imported tiles, velvet drapes, and colored chandeliers that Rapp and Rapp designed for Paunack and Levitan. (WHi-11339)

Capitol Auditorium *(right)*
The once and future Capitol Theatre, when it had 2,280 seats (thirty-four more than its rival across the street). (WHi-4024)

Central High Cheerleaders, ca. 1929
Beloved journalist/historian Frank Custer (right), his twin, Rudy, and Monty Hacker. (WHi-21319)

City Schooldays

February 28, 1920 Madison faces an exodus of teachers as neighboring towns offer higher wages, warns the president of the 135-member Madison Federation of Teachers. "The scarcity of teachers has resulted in a teacher panic," R. A. Walker says. "The scene is one of wild bidding in an open market, with Madison in danger of being closed out" unless it raises wages.

March 4, 1920 After a series of closed sessions, the school board removes Richard B. Dudgeon as superintendent of schools, replacing him with San Antonio educator Charles S. Meek. Dudgeon, who had led the school system since 1891, is given a one-year contract as assistant superintendent, with the understanding that he retire thereafter. He replaces Mary O'Keefe, who is "asked" to resign to make way for Dudgeon.

July 19, 1920 Three years after it abolished the teaching of German, the school board offers it as an elective if there is sufficient demand.

September 6, 1921 An elaborate program marks the opening of the vocational school, adjacent to the high school and across from the Madison Free Library. The $550,000 facility, designed by F. L. Kronenberg, is expected to accommodate 2,500 students this year; enrollment when the school opened in 1912 was thirty-one.

January 6, 1925 School board deadlocks 3-3 on motion to allow Klan to use Central High auditorium, thus denying the request. Supporters include Neighborhood House volunteer Mrs. William Kittle; opponents include east-side businessman Herbert C. Schenk and Madison Federation of Labor.

September 1925 Madison teachers are placed on a salary schedule for the first time, which Superintendent Thomas W. Gosling says is "vital to maintaining the morale of a teaching force and to inspiring the members of the staff to render the highest type of service."

February 26, 1926 Council votes to buy land just west of Yahara River for a new Marquette school and a parcel on the city's western border, at Monroe and Western streets, for a new elementary school to be named after the late long-time superintendent Richard B. Dudgeon, whom the board dismissed six years earlier. The Dudgeon School opens in September 1927 with 195 children and seven staff.

June 23, 1926 Mayor Schmedeman announces investigation into accounting irregularities, including missing bonds for Franklin School. On July 7, Schmedeman demands and gets resignation of city auditor Ernest Bunn, who defaced and destroyed bonds for Franklin School.

Schools and the Single Woman

Throughout the era, the school system hired unmarried women over married ones where their qualifications were equal. But news that over 13 percent of the staff was wed prompted school board member H. H. Pickford to introduce a resolution flatly barring employment of married women as teachers or clerks, "to provide employment for single women and widows who have to support themselves." The resolution would not apply to women already married, but held that "any woman teacher, secretary or clerk who marries . . . after the passage of this resolution automatically cancels her contract with the board." On February 1, 1927, the board rejected Pickford's resolution, 5-1.

But the issue flared the following fall, after reports that eight teachers wed over summer vacation. "It is basically unfair," said east-side businessman and board member H. C. Schenk, "that any girl who wants to make teaching a life profession be required to compete with married women for her job and it is a policy that ought not to be encouraged." Professor William Gorham Rice, a new member of the board, agreed that "marriage is a distracting influence," but saw no "generic reason for discrimination against married teachers." Marriage "may help a girl to become a better teacher. It is a well-known fact that some women are made more human by marriage." Superintendent Richard Bardwell doubted the wisdom of a fixed policy, saying each situation should be considered on its merits. The board agreed with Bardwell's recommendation to retain the eight, but directed him to review their situation closely next year.

December 7, 1926 School board unanimously rejects Klan request to use either Central or East High auditorium.

December 20, 1927 School board appropriates $2,500 to purchase musical instruments to enable band students to enter the University of Wisconsin with four credits in music.

April 3, 1928 Gosling tells school board he is quitting to take same post in Akron, Ohio, at about double his current $6,500 salary.

March 12, 1930 Figures show Madison schools have highest per capita costs in state, averaging $131 per pupil in 1928–29.

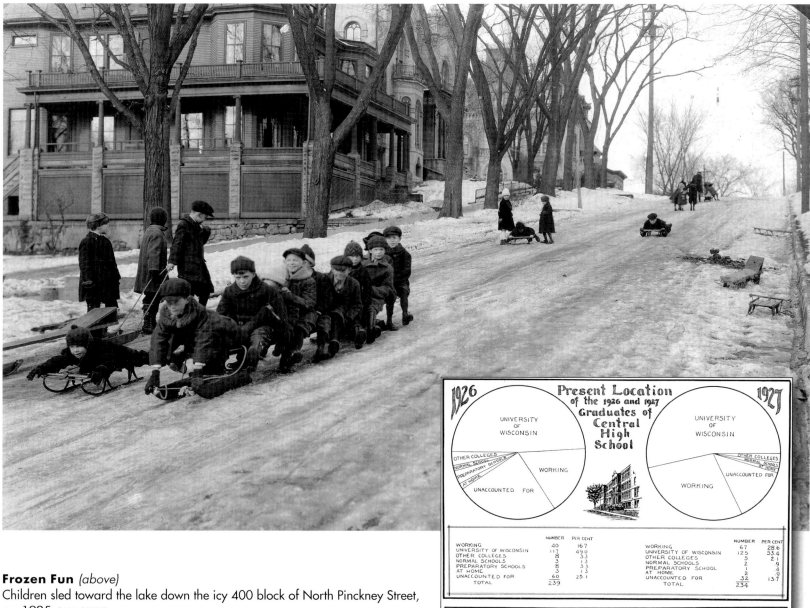

Frozen Fun *(above)*
Children sled toward the lake down the icy 400 block of North Pinckney Street, ca. 1925. (WHi-35720)

School Pie Charts *(right)*
An illustration of the impact of family educational and employment status. The young men and women of the east side, children mainly of factory workers, artisans, or shopkeepers, attended college at a much higher percentage than their parents, but at a lower percentage than teenagers from downtown and the west side, where a higher percentage of adults were professionals.
(WHi-37378)

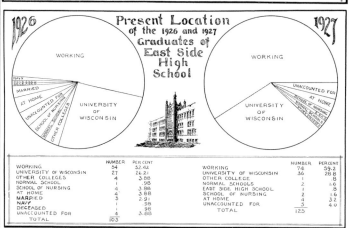

Present Location of the 1926 and 1927 Graduates of Central High School

	NUMBER	PER CENT		NUMBER	PER CENT
WORKING	40	16.7	WORKING	67	28.6
UNIVERSITY OF WISCONSIN	117	49.0	UNIVERSITY OF WISCONSIN	125	53.4
OTHER COLLEGES	8	3.3	OTHER COLLEGES	5	2.1
NORMAL SCHOOLS	3	1.3	NORMAL SCHOOLS	2	.9
PREPARATORY SCHOOLS	8	3.3	PREPARATORY SCHOOL	1	.4
AT HOME	3	1.3	AT HOME	2	.9
UNACCOUNTED FOR	60	25.1	UNACCOUNTED FOR	32	13.7
TOTAL	239		TOTAL	234	

Present Location of the 1926 and 1927 Graduates of East Side High School

	NUMBER	PER CENT		NUMBER	PERCENT
WORKING	54	52.42	WORKING	74	59.2
UNIVERSITY OF WISCONSIN	27	26.21	UNIVERSITY OF WISCONSIN	36	28.8
OTHER COLLEGES	4	3.88	OTHER COLLEGE	1	.8
NORMAL SCHOOL	1	.98	NORMAL SCHOOLS	2	1.6
SCHOOL OF NURSING	4	3.88	EAST SIDE HIGH SCHOOL	1	.8
AT HOME	4	3.88	SCHOOL OF NURSING	2	1.6
MARRIED	3	2.91	AT HOME	4	3.2
NAVY	1	.98	UNACCOUNTED FOR	5	4.0
DECEASED	1	.98	TOTAL	125	
UNACCOUNTED FOR	4	3.88			
TOTAL	103				

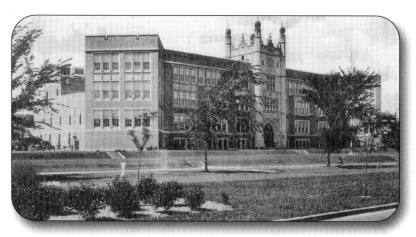

East Side High School

As the manufacturing east side grew through the late teens, it became obvious that the children of factory workers needed an area high school. Finally, in December 1920, after the board declined an offer of the land later occupied by the Eastwood Theatre, industrialist and military contractor George Steinle offered to sell the school board 10.9 acres on East Washington Avenue for $60,000 (and contribute $10,000 toward the purchase). The board accepted and quickly hired prominent Madison architect Frank Riley for one of his largest projects. Riley produced this fine Collegiate Gothic Revival style building of red brick and Bedford stone, with a central tower surmounted by four copper domes. The name was chosen by a citizen's committee, after protests were raised to any name (such as the proposed Vilas) that would connote a connection to the university. In May 1922, the board hired Foster Randle, a principal at Fond du Lac, who served as East Side High's first and only principal until his retirement in 1954. The school opened on September 11, 1922, with 647 students and a staff of thirty-six. Enrollment grew by an average 7.65 percent through the twenties; by 1930, there were 1,159 students in space for only 750, with another two hundred expected the next school year. The crowded conditions made normal operations impossible, and in 1930 the board retained Riley to design an addition to accommodate a junior high. That addition would open in 1932, followed by further expansion in 1938–39 and 1962–63 and interior alterations in the early 1970s. As the school population grew, so too did its activities, from seven clubs or programs in 1922 to more than twenty extracurriculars by decade's end, including Debate Club, Cartoon Club, John Muir Club, and two clubs devoted to developing Christian character. This view is from 1925, after the rear addition. (WHi-34842)

West Junior-Senior High School

The West Side Junior-Senior High School opened on September 8, 1930, with 590 junior high and 510 senior high students and a staff of seventy-one. Volney Barnes, the former principal at Central High, was the first principal, serving until his retirement at the end of the first semester, 1942–43. Construction was delayed for several years by fights over sites and finances, as west-side political and economic power was split between University Heights/College Hills to the north and Wingra Park/Nakoma to the south. The two groups jockeyed over locations for the new high school, while their children endured cramped quarters downtown. On April 14, 1922, the council killed a $75,000 bond issue to purchase land near the corner of Regent and Highland streets; it wasn't until November 20, 1928, that the school board approved Superintendent Richard W. Bardwell's recommendation to issue $400,000 in bonds for construction at that same site. Crews broke ground on August 6, 1929, with J.H. Kelly the general contractor on the $720,000 project, designed by Law, Law and Potter for $27,000. On November 5, 1929, the school board adopted a motion favoring subcontracts going to local firms employing local labor. On October 17, 1930, about two thousand citizens toured the building and attended a short dedication service. (WHi-19021)

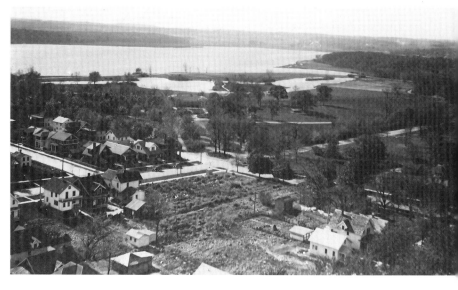

Vilas Park Aerial, 1924 *(right)*

A view from just east of the corner of Randall Avenue and Drake Street, looking past Henry Vilas Park, across Lake Wingra toward Nakoma and the future University of Wisconsin Arboretum. Michael Olbrich lived and died just out of frame to the right, at 216 Campbell Street.

(University of Wisconsin Archives)

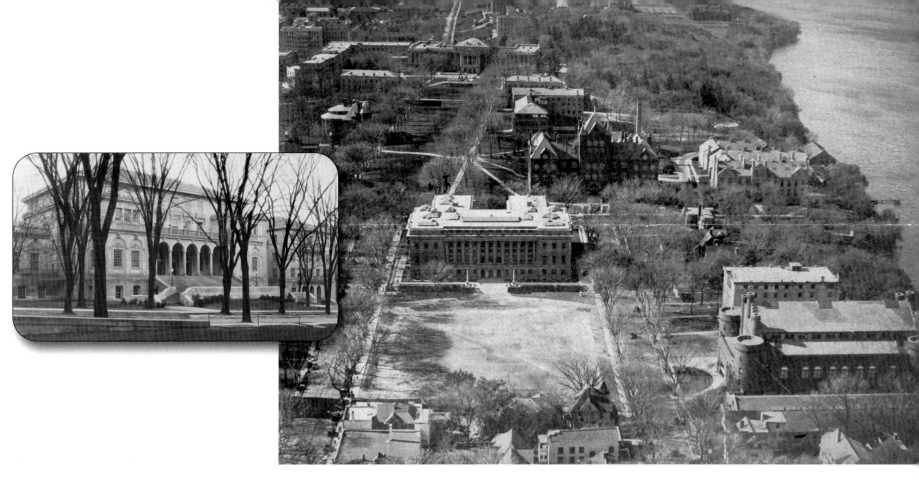

Memorial Union, 711 Langdon Street *(above left)* (University of Wisconsin Archives)
A belated legacy of Charles Van Hise, brought to life years later by businessman-regent (and future governor) Walter Kohler, the University of Wisconsin Memorial Union has survived uneven design, poor budgeting, job-site violence, and gender discrimination to become one of the most important buildings in the city. Its signposts of creation:

Armistice Day, November 11, 1925 By the ceremonial groundbreaking, state architect Arthur Peabody has labored for several years, contentiously at times, on a design evoking a Renaissance palace of northern Italy. "Yes, it speaks Italian," Frank Lloyd Wright opines, "very bad Italian." Peabody's work also had technical flaws: early plans lacked rear doors to the lake. Wisconsin Union president Lowell Frautschi and Union director Porter Butts lay the first stone the following February.

May 20, 1927 On the night when university dropout Charles Lindbergh is making aviation history, about two hundred striking union men attack the construction company shanty housing non-union workers, beat its scab occupants, and deface the Union stonework. Madison police don't intervene until the attorney general tells the city it's responsible for future damage.

Memorial Day, May 27, 1927 Wreath-bearing women in white lead an emotional cornerstone ceremony.

October 5–6, 1928 Elaborate dedication "To the Memory of the Men and Women of the University of Wisconsin Who Served in Our Country's Wars." Women, not included in Van Hise's idea of an all-men's union, only allowed in certain areas.

July, 1937 Rathskeller finally opened to women (but only for the summer session).

University of Wisconsin, ca. 1925 *(above)*
This aerial view to the west was taken shortly before construction began on the Memorial Union, which replaced the four large lakefront homes. Adjacent to the turreted Armory/Gymnasium is the campus YMCA, razed in 1956 for open space and parking. Between the large, dark Science Hall in the middle distance and Lake Mendota is the Chemistry Building, replaced in 1970 by Helen C. White Memorial Library. (WHi-24043)

University Datelines

July 31, 1921 Dean of Students Scott Goodnight puts sixteen students on probation for attending unregistered party thrown by Hollywood star Norma Talmadge at roadhouse on Middleton Road.

January 13, 1922 Call letters of University of Wisconsin radio station 9XM, the oldest station in the nation, change to WHA.

November 14, 1923 Mass meeting of all two thousand women at the university unanimously adopts resolutions opposing drinking and urging federal action against liquor sources. President Birge says there were more drunk alumni than students at Homecoming, which the *Daily Cardinal* calls "The Annual Drunk."

April 29, 1924 Formal opening of Wisconsin General Hospital, "Erected in Gratitude by the People of the State of Wisconsin" as "A Memorial to Those Who Served the Country in the World War." The hospital admits its first patients on September 29.

May 20, 1925 Glenn Frank, former boy preacher and editor of *Century* magazine, accepts presidency of the University of Wisconsin. "Wisconsin's golden age is here," declares regent Michael Olbrich, and it was, for a while.

August 22, 1925 Regents approve creation of an independent nonprofit corporation, operated by university alumni, to hold and market Harry Steenbock's patent rights for his inexpensive irradiation process to enhance vitamin D content. The Wisconsin Alumni Research Foundation becomes a lynchpin in the university's development as one of the country's leading research institutions, eventually holding several hundred patents worth billions of dollars.

January 23, 1926 Frank announces appointment of Dr. Alexander Meiklejohn, who quit as president of Amherst College after trustees called him too radical, as Brittingham professor of philosophy. Meiklejohn leads the Experimental College, housed in Adams Hall, from its opening in the fall of 1927 to its closing in June, 1933.

March 4, 1926 State architect Arthur Peabody unveils master plan for university development, with Vilas theater at Park and University and creation of Murray Street plaza.

September 1926 Twenty-two years after president Charles Van Hise proposed English-style communal dormitories, the lakeside compound named in his honor opens to about five hundred students — the first on-campus housing for men since North and South Halls were converted to classrooms following the Science Hall fire of 1884. Dorms were named after president Adams and university benefactor Stephen Tripp; the refectory memorialized Van Hise until 1965, when it was renamed in honor of longtime university chef and television personality Carson Gulley — the only nonwhite so memorialized on the University of Wisconsin campus.

July 14, 1928 University's Bascom theatre, responding to numerous complaints over having ushers of mixed races, forces black female to quit. Professor D. D. Lescohier's students at the School for Workers lodges official protest.

October 10, 1929 American Legion officials to investigate why university stopped flag-raising ceremony before football games.

Charles Lindbergh Returns, August 22, 1927

Charles A. Lindbergh (ex '24) returns to the thunderous acclaim of forty thousand packed into Camp Randall, three months after his historic solo flight to Paris. Inspired by Lucky Lindy's advocacy for commercial aviation, civic leaders announced a committee to seek a municipal airport for Madison. The city moved with startling speed, and on October 14, 1927, the council voted to spend $35,380 for 290 acres in the town of Burke for a municipal airport. When Lindbergh returned the following summer for an honorary doctorate of laws, he attended a waffle breakfast at the home of Walter Frautschi, president of the class of 1924, which the aviator called the "most fun I've had in a year." (WHi-5126)

Dateline

December 18, 1930 A capacity crowd of 8,600 watches basketballers under Coach Walter "Doc" Meanwell beat the University of Pennsylvania, 27-12, in the dedication game at the UW Field House, 1402 Regent Street. Planned for the corner of University Avenue and Breese Terrace, a 1926 petition drive from University Heights neighbors forced its relocation to Regent Street, a far better location. State architect Arthur Peabody again offered an Italian Renaissance design, with the building's most prominent symbol — the graceful "W" adorning the north and south faces — the work of an anonymous assistant.

Campus Congestion

Twice this decade, state and university officials proposed plans that would have made access to and through campus even more difficult than it ultimately became. On March 17, 1923, President E. A. Birge and regent president Theodore Kronshage outlined an ambitious building plan that included closing the last block of Langdon Street for expansion of the State Historical Society building. In April 1928, Governor Zimmerman called on the city to vacate Lake Street from State to Langdon as a site for a new university library (even as he was vetoing a $500,000 appropriation for just that purpose). Thankfully, neither plan advanced.

January 10, 1930 A university junior, Mildred Gordon, files a $10,000 lawsuit against the Langdon Hall rooming house, claiming she was denied admission on account of being Jewish.

March 5, 1930 University's economic impact greater than that of state, with payroll of $5.125 million compared to state's $4.686 million. University also has ten thousand students, each spending an average $900 annually.

May 10, 1930 President Frank calls charges by a Chicago judge that the university is a hotbed of radicalism "ridiculous, a sample of the idiotic, groundless generalization in which some types of public men engage."

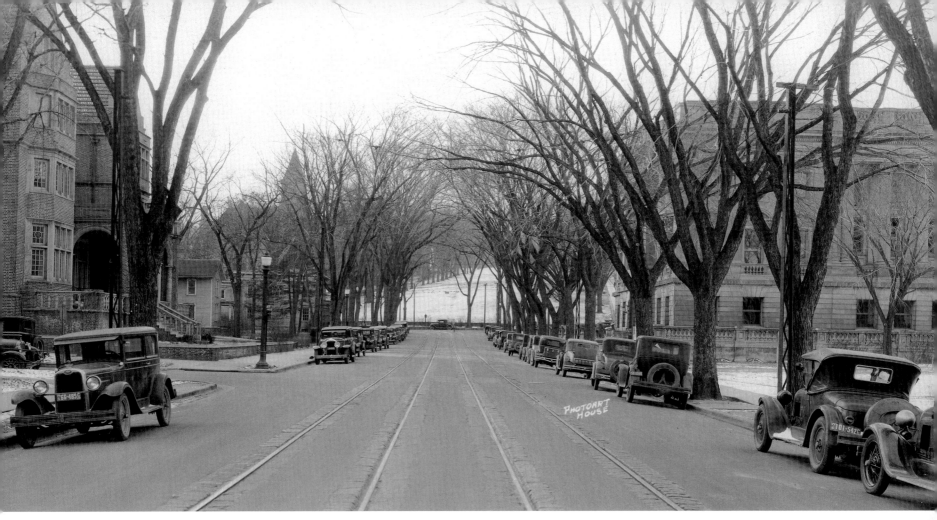

Two Hotels, Part 2

Two of modern Madison's most important hotels opened within a few months of each other in 1924, adding 450 rooms downtown and increasing the pressure for a municipal auditorium.

January 15, 1923 Grace Episcopal Church congregation declines Milwaukee hotelier Walter Schroeder's offer of $350,000 for its Carroll Street site. A month later, Schroeder buys the historic Proudfit property across the street.

May 25, 1923 State Supreme Court strikes down 1921 statute limiting the height of buildings around the Capitol Square to ninety feet, a Nolen recommendation enacted after the city failed to prevent construction of the Gay Building. Finding the law an unreasonable exercise of the state's police power and a taking without just compensation, the court also kills city ordinance limiting building height to one hundred feet. Less than three weeks later, the city issues a building permit to the Piper brothers to erect their 115-foot Belmont Hotel at 101 East Mifflin Street. The legislature then enacts a 100-foot height limit; the Pipers challenge the law and continue construction.

October 23, 1923 Court upholds new statute but exempts Piper project because it was begun under a valid permit and compliance would cause an annual loss of $25,000.

June 27–28, 1924 Grand opening of the city's largest and most luxurious hostelry, the eight-story, $1.25 million Hotel Loraine, 123 West Washington Avenue.

September 20, 1924 The Belmont Hotel, the tallest building in the city at eleven stories, opens, serving traveling businessmen with two-dollar rooms (a dollar more for a private bath). The class distinctions remain — the Loraine, home for many years to the state Justice Department, has been converted to upscale condominiums, while the Belmont now houses the YWCA.

800 Block of State Street, 1929
Thirty years later, from the other direction, the trees first seen opposite the title page. (WHi-25144)

Dateline

May 5, 1926 Governor Blaine throws out the first ball to Mayor Schmedeman, former mayor Whelan orates, and the Masonic Band plays at the dedication of the Breese Stevens Memorial Athletic Field. Per the mayor's proclamation, most businesses close, and four thousand fans pack the park on East Washington Avenue at Patterson Street. The only discouraging note — the Madison Blues fall to the Beloit Fairies, 7-5. In October 1927, the city forbids the field's use for dog races, which are then held at the county fairgrounds.

CONVENTION CENTER CRUSADE
THE BATTLE BEGINS

Auditorium Design, 1929
Architect James R. Law sent Plan Commission chair Arthur Peabody this design in early 1929. The *Capital Times* put it on the front page on March 16.

Seven decades after Madison's first mayor, Jairus Fairchild, called for a public meeting hall, the city's business and arts communities combined in a crusade that would become Madison's longest-running and most important downtown development fight — the location, design, and financing of a performing arts and convention facility. Consistent with its theme, "Madison, Ideal Convention City of the West," the Association of Commerce spent the decade trying to make a convention center a focus of the postwar building boom.

In early 1922, the association got the city to create an auditorium committee, which then declared that the city's high debt put a municipal auditorium "entirely out of the question."

The association tried again in April 1925, after Alderman Thomas J. Ross proposed a multi-function facility on landfill at the Monona Avenue lakeshore. Mayor Milo Kittleson endorsed the concept of an auditorium and municipal boathouse in his annual message that month, and the council quickly created a new Auditorium Committee. But despite the aggressive support of the business community — and the appeal of several hundred new downtown parking spaces on the extensive landfill — the council balked at the $400,000 price tag and refused to schedule a bond referendum on the proposal.

Desperate to develop the tourism trade, the association in 1927 even called for higher taxes for five years to fund a $425,000 facility. But the council rejected this as well.

This effort did produce one major achievement, however — a 1927 state statute letting the city extend the dock line 350 feet from the original retaining wall. Unfortunately, the purposes that the state intended to authorize were open (in some minds) to interpretation, seriously clouding later efforts to construct a later iteration of Alderman Ross's idea — Frank Lloyd Wright's Monona Terrace.

In January 1928, the council created a third auditorium committee. Although Mayor A. G. Schmedeman strongly favored a combined city hall/auditorium — he said the city was bound to sustain annual losses for a building used exclusively as auditorium — the committee he appointed proposed instead a $500,000 auditorium and exposition center without city offices, financed by city bonds and a small tax hike. On March 15, 1929, architect James R. Law, whom the council would name to succeed Schmedeman in 1932, submitted a design for a multi-use $450,000 facility featuring flat-floor exhibition space and a seating capacity of 6,500.

But once again, these efforts proved futile. First the Auditorium Committee bizarrely passed over the Lake Monona location, proposing instead two low-lying sites on East Mifflin street just past the City Market, several blocks from the capitol and far removed from either of the beautiful lakes. "A great mistake," an association leader declared. To cap this latest failure, the council then rejected even the modest tax hike.

The decade saw one last effort in August, when real estate developer Dr. W. G. Beecroft offered to site and build a 400,000-square foot, 4,500-seat auditorium for $800,000 and lease it to the city under favorable terms, with a sale to the city afterwards for one dollar. Mayor Schmedeman insisted there not be any direct profit from the auditorium, and again stressed the economic importance of including a new city hall in the plans. What Beecroft and the city would have done became irrelevant with the stock market collapse later that month.

It would be several years before the city could resume its quest for a proper civic auditorium, and seven decades before it would succeed.

Dateline

February 13, 1920 Council creates Plan Commission, consisting of mayor, city engineer, president of the Madison Park and Pleasure Drive Association, three citizens appointed by mayor, and an alderperson elected by the council. Charter members are Alderman Frank Alford, hardware merchant and Rotary leader Louis Hirsig, Leo Crowley, and Alderman George Gill.

May 8, 1931 City enacts charter ordinance to create Parks Commission, fulfilling another Nolen recommendation (more than twenty years later).

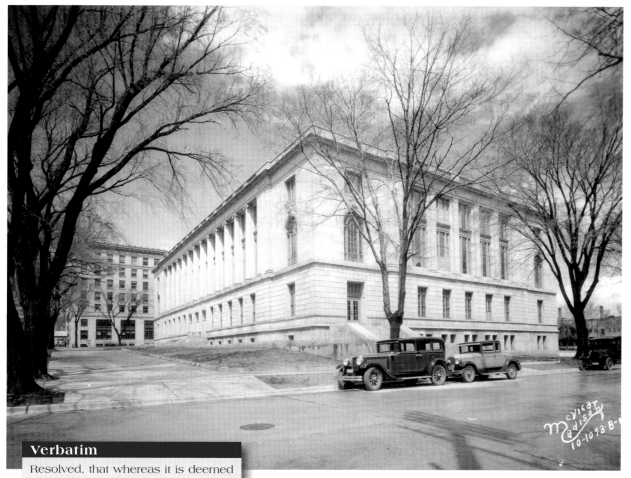

The U.S. Courthouse and Post Office

Twenty years after John Nolen first proposed the Grand Mall, in February 1929 the federal government opened its first physical manifestation — the United States Courthouse and Post Office. The city had nothing to do with selecting the site or approving the design, but it did mark the groundbreaking in 1927 with a resolution proclaiming Monona Avenue the city's "Civic Center." Unfortunately, as this photograph looking north from Wilson Street shows, the declaration was too late to ensure comprehensive compliance with Nolen's concepts of setback and design; they had already been violated in 1922 by the nondescript Beaver Insurance Company headquarters across Doty Street, where Frank Lloyd Wright's innovative Madison Hotel was to have been. In his 1928 annual message, Mayor Schmedeman celebrated "the fact that the new Post Office is being erected substantially in accordance with the original recommendation of Mr. Nolen," but acknowledged that "it is probably too late to work this matter out in the manner originally recommended." In 1979, under Mayor Paul Soglin, Madison bought the building for municipal offices and the federal functions were later divided between the Robert W. Kastenmeier Courthouse on North Henry Street and the main post office on Milwaukee Street. Angus McVicar took this photograph on April 28, 1929. (WHi-21245)

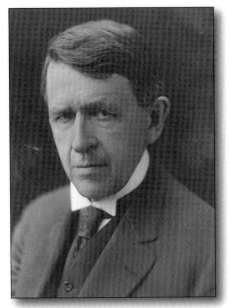

John Myers Olin
The greatest private citizen in the city's history, before his death at age 73 from Parkinson's Disease on December 7, 1924. Olin founded the MPPDA, retained John Nolen as landscape architect and master planner, bequeathed his home as residence for the "academic head" of the University of Wisconsin, and left a trust fund for park development. His work has enriched our lives for more than a century and continues to inspire our tomorrows. (University of Wisconsin Archives)

Dateline

July 16, 1922 Robert La Follette presents his oration "The World's Greatest Tragedy: Hamlet," as he headlines revived Chautauqua on site of former Monona Lake Assembly.

November 9, 1923 Council unanimously renames Monona Park after John M. Olin in recognition of the "self-sacrifice and indefatigable labor which [he] has given to matters of general public interest."

August 19, 1931 Belle Case La Follette, political partner and matriarch, dies at age seventy-two of peritonitis, three days after her colon was punctured during a routine proctoscopic examination.

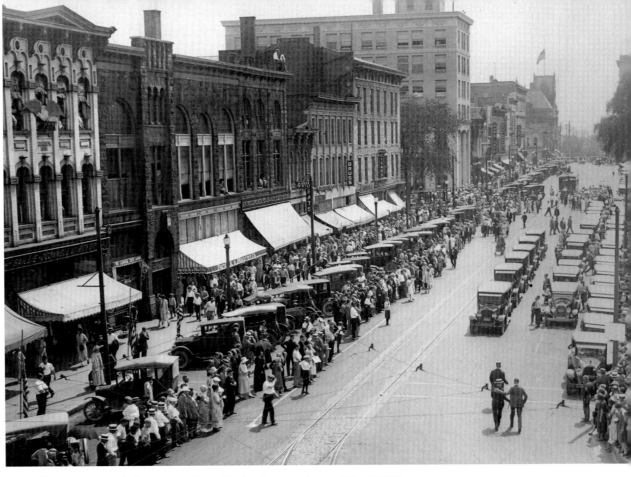

La Follette Funeral Cortege, East Main Street, June 22, 1925
The funeral cortege of Senator Robert Marion La Follette Sr. leaves the capitol en route to Forest Hill Cemetery following a simple ceremony in the rotunda. Most of Madison was closed during the funeral, including all federal, state, and local government offices, and hotels were packed past capacity. A quiet crowd of about forty thousand persons viewed the body. As they carried the casket to the hearse, the crowd began a quavering version of "America," singing of the "sweet land of liberty" that La Follette fought to preserve, protect, and defend. At a Loraine Hotel reception after the interment, Congressman Henry Cooper suggested that Wisconsin honor La Follette by placing his likeness in Statuary Hall in the U.S. Capitol. The *Capital Times* took up the cause, and on June 24 the legislature designated La Follette "as one of the deceased residents of Wisconsin of historic renown worthy of the national commendation." Jo Davidson's larger-than-life statue of the seated senator, about to rise in debate, was unveiled on April 15, 1929. (WHi-32417)

Madison Notable

Ernest N. Warner (1868–1930), a political and parks heir to both La Follette and Olin, also died this decade, while still performing valuable service. Son of Civil War hero and legislator Clement Edson Warner, Warner wrote the state's civil service law in 1904 when he was assembly floor leader for the La Follette progressives. Cousin of the noted landscape architect O. C. Simonds, Warner in 1910 dredged Spring Harbor, which he donated to the Madison Park and Pleasure Drive Association, with other properties. In 1911 Warner developed the Highlands, a far west plat with thirty-seven large estates. The following year he succeeded John Olin as president of MPPDA, a position he still held at his death. In February 1930, Warner was named the first president of the new Madison Metropolitan Sewage District. On July 9, he was killed in a one-car accident while returning from the Green Lake Bible Conference. His son-in-law Frederick E. Risser carried on the Warner tradition of legislative accomplishment, as has Frederick A. Risser, the longest-serving state legislator in America in 2006. A park on the city's northwest side is named in Warner's honor.

MICHAEL OLBRICH

No one really knows why Michael Balthasar Olbrich hanged himself at age forty-eight, or the many great things he could have done had he survived. At least we have two highlights of Madison's landscape as part of his physical legacy: the University of Wisconsin Arboretum and the east-side park that bears his name.

A poor farm boy from Illinois, Olbrich became a debating champion and Phi Beta Kappa at the University of Wisconsin. Graduating from its law school in 1904, he followed his model John Olin in becoming an instructor of oratory and then one of the state's leading lawyers (although with markedly more progressive clients). Olbrich's forensic skills brought him to the attention of another great debater, Robert M. La Follette, who aroused in him an abiding interest in public service. He returned the favor, making the presidential nominating speeches for La Follette at the Republican national conventions of 1912 and 1916. A deputy attorney general and commissioner on uniform state laws, Olbrich served as executive counsel (1921–26) to progressive governor John J. Blaine.

But it was nature that Olbrich loved best, from the swamps around Lake Wingra to the array of wildflowers he carefully nurtured in his backyard garden at 216 Campbell Street.

Concerned that the industrial east side was lacking in parkland and suffering from pollution, Olbrich began buying up land around Starkweather Creek in 1916. He offered the land at cost — provided it was named La Follette Park, an unacceptable condition to many still angry over the senator's opposition to World War I. Olbrich amassed more land, La Follette asked his name not be used, and on July 22, 1921, the city took possession of 3,700 feet of shoreline from Welch Avenue to the city limits, including six acres for playgrounds. On September 30, 1921, Obrich organized the Madison Parks Foundation to purchase additional lakeshore land; over the next few years, another thirty acres were provided for public use.

Like Olin an acolyte of John Nolen's, Olbrich also sought to advance another element of *A Model City*, the Grand Mall. In January 1926, he proposed an innovative financing plan to acquire for public parkland the Fairchild property at the end of Lake Monona. Unfortunately, his efforts were unsuccessful.

In 1925, Blaine bypassed La Follette's former law partner Alfred Rogers and named Olbrich to the university Board of Regents, where he quickly became a leader. Olbrich was on the selection committee that chose Glenn Frank as the new president and remained one of his strongest supporters.

As regent, Olbrich championed the Arboretum, where the stone gates at the western entrance were dedicated in his memory in 1938.

In October 1929, Olbrich was involved in litigation that challenged his extensive investments in western sheep lands. He was also weakened in body and mind from a recent attack of the flu that required several weeks of hospitalization. Still, no one anticipated the sudden and tragic end to such a brilliant life.

On October 9 there was an early winter chill, and late that night Olbrich

 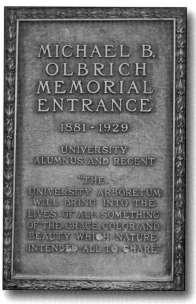

Michael B. Olbrich
Arguably the city's second greatest private citizen, shortly before his suicide in October 1929. It would be fitting tribute to rename Campbell Street, where he lived and died, in his honor. (University of Wisconsin Archives)

Olbrich plaque, Seminole Highway entrance, University Arboretum *(above right)* (University of Wisconsin Archives)

Verbatim

Michael Olbrich was an acolyte at the altar of the beautiful. It was a joy to watch this bulky man tenderly nurse a rose into loveliness. But the care he lavished on a rose garden was a symbol of something deeper. Whether he was tending a rose or throwing his boundless energy into the development of parks and playgrounds or swinging into a political campaign, the dream that drove him on was the dream of the beautiful life for himself and his fellows. The Arboretum, to which he gave so much of himself, was the climax of his public contribution to the life of city and state; the Arboretum is an enterprise that deserves the best all of us can give to its development.

His mind was so transparently honest in its operations, his character so unreservedly genuine, his spirit so consecrate to causes beyond the boundaries of his own private interests, and his family life so saturated with sweetness and considerate devotion, that I cannot reconcile myself to the fact that he is gone. It must be a lavish universe that can afford to allow a life like his to stop at the very moment of its flowering.
— **Glenn Frank on Michael B. Olbrich**, 1929

went to set the furnace. A rope hung over a basement pipe. They found his body in the morning.

The day Olbrich was laid to rest, Mayor Schmedeman proposed the park he created be named in his honor. On November 22, 1929, it was.

THE ARBORETUM

<p>The University of Wisconsin Arboretum is Madison's second-most transcendent natural attraction, after only the four lakes. But while the lakes already existed and just needed to be protected, the Arboretum had to be created.</p>

It was John Nolen who first echoed Lapham's call in 1911, declaring that the university should have "a good-sized arboretum, say, 200 acres," along with "a University forest of from 1,000 to 2,000 acres." But without immediate academic or economic impact, state funds for forest and flowers were not forthcoming.

The platting of Lake Forest destroyed, at least on paper, a large parcel just south of Lake Wingra ideally suited for the arboretum Lapham and Nolen envisioned. But its 1922 bankruptcy turned the threat into an opportunity that Michael Olbrich and Paul Stark soon seized.

Olbrich often walked the woods and meadows around Lake Forest, just across the lake from his Wingra Park home; he knew of its possibilities, and of the financial difficulties the adjoining farmer, Charles Nelson, was facing. When Governor Blaine named Olbrich a university regent in 1925, the pieces started to align.

It was about then that Stark, principal salesman of Nakoma and other west-side suburbs for the Madison Realty Company, suggested to Olbrich that a road be built along the south shore of Lake Wingra to serve an eight-hundred-acre arboretum. Olbrich agreed with the road, but set the size at two thousand acres.

Olbrich proposed the university trade lots it already had for thirty acres of shorefront, including an MRC duck pond (featuring a decorative wall designed by Frank Lloyd Wright). He also devised a way to obtain the 245-acre Nelson farm (now occupied by Longenecker Gardens and visitor's center).

On December 7, 1927 — the third anniversary of John Olin's death — Olbrich proposed, and the regents promptly agreed, that "the unpledged balance of the Tripp Estate, approximately $83,000, be appropriated to aid in the purchase of land adjoining Lake Wingra and the Nakoma golf course for a forest preserve, arboretum and wild life refuge, when and as available with the understanding that at least as much must be provided from other sources."

In May 1928, after getting a pledge of $50,000 from the Parks Foundation, Olbrich turned to the city's leading service club, the Madison Rotary. With Joe Jackson, administrator of his family's medical clinic and an equally devoted Nolen disciple, presiding, Olbrich gave an enthusiastic and captivating pitch, closing with some favored words from Thoreau: "In wildness is the preservation of the world." Also in the Rotary crowd was

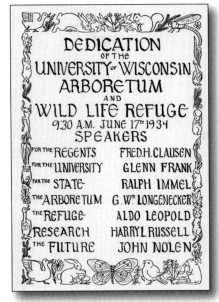

Arboretum Dedication Poster
Madison becomes more
of a model city.
(University of Wisconsin Archives)

the new head of the Game Refuge Commission, Aldo Leopold. The naturalist, not yet associated with the university, was thrilled by Olbrich's message and offered his support, as did Jackson.

But just when the idea was set to become reality, shadows of trouble, then tragedy, fell. The first concern was Vilas Heights, a 143-acre, 350-lot plat that Nelson Realty proposed in the spring of 1928 for the area between the country club and Lake Forest. Capitalizing on its closeness to the country club, the company named the sixty-six-foot-wide streets after famous golf courses, including St. Andrews Road. Thankfully, this project didn't survive.

But then came tragedy — Olbrich's suicide, two weeks before the stock market crash in October 1929. Although Madison did not suffer extreme economic dislocation, the Depression era was no time to be fund-raising for trees and flowers, especially without the energetic Olbrich.

There matters lay until the equally energetic Jackson, contending that state and federal funds could be obtained, revived the project in October 1931. In January the Parks Foundation, disbanded upon the creation of the Madison Parks Commission, was reorganized to push the plan. That July, Jackson, Stark, and Supreme Court Justice Marvin Rosenberry completed the transfer of the 245 acres that Olbrich was working to acquire before his death.

Progress continued, thanks largely to support from Friends of Our Native Landscape and other conservationist groups and individuals. University president Glenn Frank appointed two committees for administration (led by G. William Longenecker, with Leopold, newly named professor of Game Management, as research director) and advice (featuring former university president E. A. Birge, State Historical Society curator Charles E. Brown, and contractor John Icke, along with Jackson, Stark, and others).

In spring 1933, Jackson persuaded Jessie Bartlett Noe, daughter of pioneer Seth Bartlett, to grant the university a warranty deed on 190 acres, a partly wooded tract fronting on Seminole Highway. Ralph Immel, state conservation commissioner, gave 15,000 pine and spruce seedlings, and Madison nurseryman William McKay gave 150 trees. Brown had marked the Indian mounds, workers on county relief were clearing and planting, and the state legislature declared the site a natural refuge.

The shadows that once fell on the enterprise had now fallen away.

Native Lands (right)

A century or so after the Ho-Chunk were removed, their old summer campground west of Turtle Lake has become a neighborhood, a golf course (lacking, alas, its Frank Lloyd Wright clubhouse), and now, in the summer of 1934, an incipient arboretum.

From high above Nakoma Road, this view to the northeast highlights the Arboretum's precarious existence in the season of its dedication, celebrated in the Charles Nelson barn just right of center. The land between the golf course and the thick trees is the area the Nelson Realty Company tried to develop as Vilas Heights in 1928; beyond the trees, the late Lake Forest plat. Had either succeeded, this would now be Arboretum Estates. Instead, the Nelson farm became the first Arboretum land in 1932. A construction road has been cut through the Noe Woods (foreground), a parcel Joe Jackson obtained in the spring of 1933; the lone tree where the gravel road bows is the Jackson Oak, named in his honor in May 1963. A symbol of the Arboretum for many years, the Jackson Oak died in the late 1990s but still stands. The area between the woods and the tree, and a bit beyond, was later planted as the (Aldo) Leopold Pines; the Curtis Prairie, the world's oldest restored prairie, occupies sixty-four acres past and north of the pinery. In the distance, Highway 12 and 18 skims the track at the county fairgrounds. (University of Wisconsin Archives)

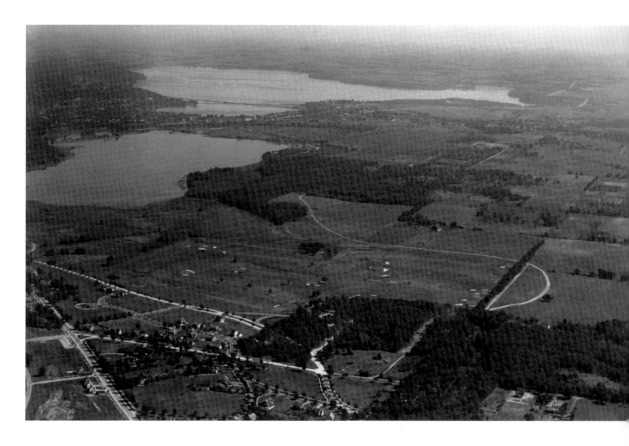

Dateline

1931 Outdoor relief program includes the retaining wall and fill at the foot of Monona Avenue for Capitol Annex, completion of lakefront park from the Yahara River to Dunning Street, and 1.8 miles of sidewalks. The city grades the eastern part of Olbrich Park from Welch Avenue to the city limits and grades and surfaces Wingra Drive from Mills Street to Fish Hatchery Road. Garbage (still taken to West's hog farm) and sewage are each up about 10 percent over 1930.

April 5, 1931 Lee Siebecker, 40, son of the late Chief Justice Robert Siebecker, follows his former law partner Michael Olbrich by hanging himself.

April 21, 1931 Council creates Department of Garbage Collection, elects Alderman Patrick Barry, retiring dean of the council and chairman of finance committee, as first superintendent.

No Negroes in Nakoma

In 1920, as the Madison Realty Company's Nakoma plat still struggled, it formed the Nakoma Homes Company, under which homeowners agreed to abide by covenants restricting building design, location, and use in exchange for the extensive services (police and fire, bus, lights, parks and sanitation, etc.) the company provided. The NHC agreement, which helped the subdivision prosper, thus gave Nakomans self-imposed zoning two years before Madison adopted its own general ordinance.

The day before the Fourth of July 1931, enough homeowners signed a petition to amend the NHC agreement by adding a thirteenth covenant: "No part of these premises shall ever be owned or occupied by any person of the Ethiopian race." Among those signing the petition were Conrad Elvehjem, renowned biochemist and future president of the University of Wisconsin, and builder John Icke. Among those who did not sign the petition — Oscar Rennebohm, the pharmacy magnate and future governor, and Paul Stark, MRC sales manager and the man most responsible for Nakoma's success.

Neither newspaper noted the petition or the new covenant; apparently such restrictions weren't thought unusual or newsworthy in 1931 Madison.

On July 24, 1931, the council voted to annex Nakoma, effective October 22. "The suburb is one of the most valuable ever taken in by the city," the *Capital Times* reported the next day, putting its population at about two thousand. The *Wisconsin State Journal* set the census at five hundred and gave coverage below a story it held far more significant: "Council Votes Ban on Gilman Parking in Early Morning."

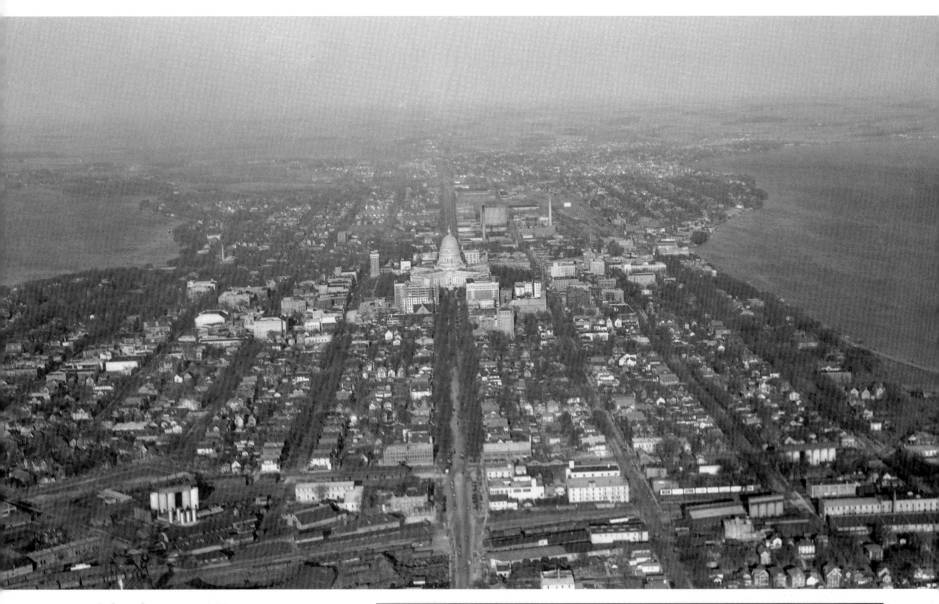

Aerial to the East, 1928

The city in its seventy-second summer still shows its most important parcel in private hands, the Fairchild property at the foot of Monona Avenue. And several important corners on the square are still occupied by structures from the 1870s, including the post office on Wisconsin Avenue and a business block at the corner of South Pinckney and East Main streets. But change is coming; the new post office on Monona Avenue nears completion, with the Wisconsin Telephone Company building on West Washington Avenue well underway. In the foreground, evidence of the terrible toll on traffic and residential life from the tracks and toxic yards of the Milwaukee Road.

(WHi-34753)

<div style="border:1px solid black">

Dateline

December 28, 1928 Madison reported to be paying more debt service than any city in state; at $6 per capita it is more than double the cost of general government.

November 29, 1929 Council rejects petition for annexation from Lakewood subdivision, which in September 1931 joins with an adjoining plat to form the Village of Maple Bluff.

February 1, 1930 Mayor Schmedeman orders end to city crews cleaning residential sidewalks of snow and ice, after several "slip and fall claims" are filed against the city. Workers had been doing the job when homeowners violated ordinance requiring them to clean their walk by noon following a snowfall, with assessment against the property.

June 4, 1931 Federal regulators approve merger of WISJ and WIBA, owned respectively by the *Wisconsin State Journal* and the *Capital Times*. The new station, WIBA, will be operated by the Badger Broadcasting Company and will have no connection with either newspaper. On July 18, more than forty radio stations around the country carry the dedicatory program as WIBA joins the NBC national lineup.

</div>

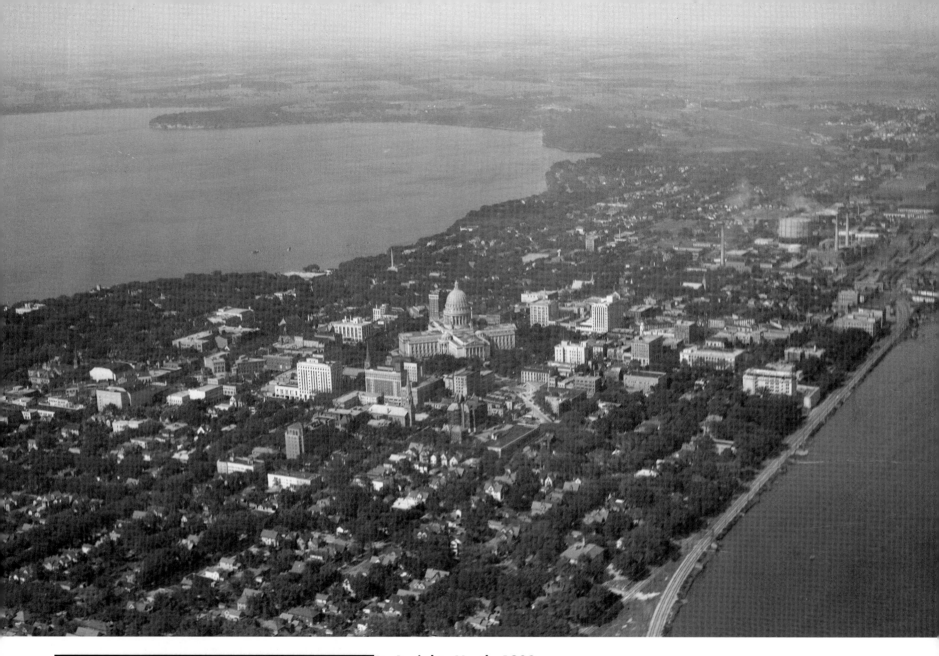

Aerial to North, 1932

Four years later, much of modern Madison is now in place. The Capitol Annex has joined the post office in making Monona Avenue the city's civic center; Manchester's department store and Montgomery Ward have brought new style to shopping on the square; and the Tenney Building balances the First Central Building on South Pinckney Street. But vestiges of village-era Madison remain on three important corners — West Main and Carroll, East Main and Monona, and Mifflin and Pinckney — and will do so until the 1950s and 1960s. And before the landfill creation of Law Park, there's room for only railroad tracks along the Lake Monona shoreline. This view also captures the inadequacies of Doty's design for the Hamilton street axials; within a few years, the northern vista would be much improved, after the Conklin icehouse on Lake Mendota closed and economic development activist Joe Jackson got the city to purchase the property now known as James Madison Park (but which rightfully should be referred to as the Conklin-Jackson Park). Sadly, the view up South Hamilton Street, here already constrained, would be further and forever tarnished in 2006 by the fourth county courthouse and jail. (WHi-34754)

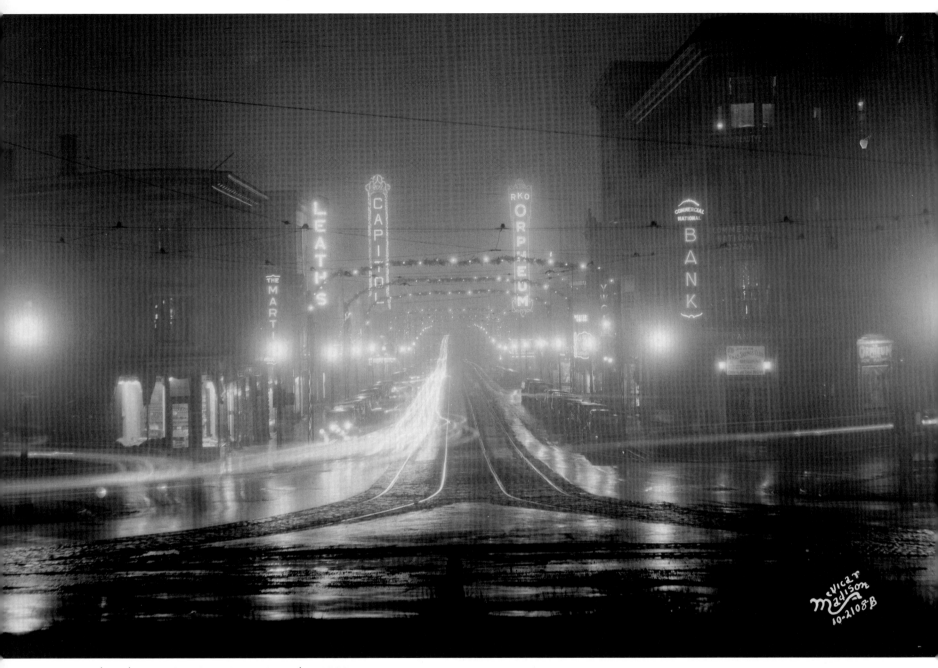

Bright Lights, Big City: State Street, December 1930 (WHi-4582)

Dateline

March 7, 1931 City celebrates the seventy-fifth anniversary of its incorporation.

June 4, 1931 Twenty thousand men, women, and children — a third of Madison's population — jam State Street for a jubilee celebrating the new 3,000-candlepower lighting system. State Street Association officials claim the downtown artery is now the second-brightest street in the world. Fireworks flare over Lake Mendota as university president Glenn Frank tells a crowd from the steps of the Historical Society library of his hopes "that the illumination of this street may symbolize the breaking of the shroud of darkness that has surrounded business."

EPILOGUE

A MAN AND HIS PLAN

FINAL WORDS

In June 1934, more than a quarter-century since his first arrival, John Nolen returned for the consummation of another of his recommendations, the dedication of the University of Wisconsin Arboretum. But he wasn't in the mood for celebrating, or letting the city rest on its laurels; instead, he summoned the spirit behind *A Model City* one last time.

Addressing the annual banquet of the Association of Commerce a few nights before the dedication, Nolen praised Madison for its parks and playgrounds, but said the city was "unfit for the motor age." He also deplored the fact that the city had neglected his advice to widen the "unworthy" State Street, was aghast to find the 1858 city hall still in use, and urged construction of a viaduct adjacent to the railroad tracks. Reflecting on his last time in Madison, Nolen was blunt: "Today the city looked different, and I cannot say altogether better. While improvements are always being made in the city, they are carried out in piecemeal fashion and are not as connected as they should be." He cautioned that "doing things in a haphazard way results in economic waste," and criticized those who "think we are shrewd and economic when we keep the tax rate down and fail to develop the city. Summoning the spirit of John Olin and Michael Olbrich, Nolen closed with a call to continue their work.

Birth of the Arboretum, Late Summer, 1934

Barracks for about three hundred Wisconsin Emergency Relief Administration workers, just left of center, indicate Arboretum construction is about to begin. The following summer, the transients were replaced by the 2670th Company of the Civilian Conservation Corps, which operated Camp Madison — the only CCC camp on a university campus — until November 1941. In the foreground is Lake Forest, twelve years after its failure; the roadway emanating from the circle is Capitol Boulevard (see page 210). The most complex negotiations involved these Lost City lots, which Joe Jackson did not fully secure from the Chandler Chapman estate until 1947; the city even had to transfer fifty acres to the Town of Madison on February 14, 1936, for roadway construction. Out of the frame to the lower right is the 190-acre Gardner Marsh, which prominent baker and Nakoma resident Louis Gardner gave in 1935. Gardner also purchased and donated a crucial thirty-acre parcel along Monroe Street, visible just beyond Lake Wingra before splitting into Odana Road (up) and Nakoma Road (out). The clump of trees to the left of the junction marks the Old Spring Tavern, built in 1854 as the first traveler's establishment between Madison and Monroe. The natural springs across Nakoma Road from the tavern, an important site for Native Americans, was part of a fifty-five-lot addition to Nakoma, complete with parkway, which was platted in 1926, then abandoned. In 1932, Paul Stark and the Madison Realty Company donated the area as the Arboretum's second site. (University of Wisconsin Archives)

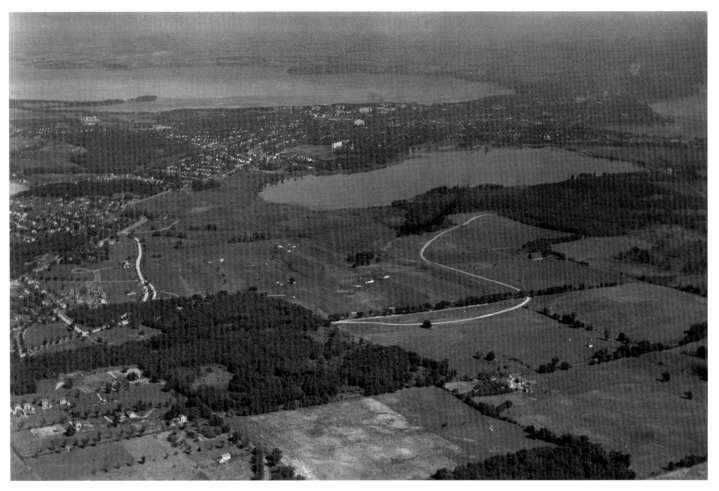

Centennial View

Madison in 1934, a few months shy of the one hundredth anniversary of the first survey map (page 7). The white farm-house at lower left became a popular bar and grill, overlooking the West Beltline at Seminole Highway. (University of Wisconsin Archives)

Here, then, in a marked type of topography and natural scenery, in the conscious establishment of a city for governmental and higher educational ends, in a varied, strong and virile population, and in a picturesque history, there are ample forces for the expression of civic life in a city of striking individuality, one might almost say personality. So far that expression has manifested itself only in subordinate and minor ways. In larger matters it has failed. As a Capital City, Madison should possess dignity and even some restrained splendor; as a University City it should manifest a love of learning, culture, art, and nature; as a residence city it should be homelike, convenient, helpful and possess ample facilities for wholesome recreation. Fortunately, much of the opportunity for all three directions still stands open and it is one of the main purposes of this report to show how the natural and adequate provision for the improvement of Madison will lead to a direct development of its individuality as a city. — **John Nolen**, *Madison: A Model City*

A city becomes great by having a purpose, a point of view, standards which it tries to realize. This cannot be done by chance, it must be planned for, worked for, and skillfully sought. Even routine things can be done in an individual manner. You have made a good start here, but the work is not finished. Let us look now into the future and get things started. — **John Nolen**, June 14, 1934

NOTES AND BIBLIOGRAPHY

Answer key to pages 212 and 213

- A new financial powerhouse replaces city government's first home (1920→1922): In the summer of 1921, the First Central Building (center left in 1922 photo), the joint effort of the First National Bank and two other financial institutions, continued the site's predominance in city affairs when it replaced the village-era Bruen's Block (at this time known as Brown's building), home of city government from 1856 to 1858.

- A towering relic of the Gilded Age falls (1920→1922): On February 20, 1921, the city finished razing the 1890 Water Tower.

- A mayor's estate becomes the city's leading hotel (1922→1929): In 1923–24, the Hotel Loraine was built on the site of the historic Proudfit property, home of the city's ninth mayor, at the corner of Fairchild Street and West Washington Avenue.

- Power for the people (1922→1929): In 1928, Wisconsin Power and Light built its ten-story Art Deco headquarters across from the Loraine.

- A site that could have been Wright goes very wrong instead (1922→1929): In 1922, the Beaver Insurance Company built its headquarters on the corner of Monona Avenue and East Doty Street, the site for which Frank Lloyd Wright had earlier designed the Madison Hotel.

- The Boss's base crumbles (1922→1929): Upon completion of the new U. S. Courthouse and Post Office on Monona Avenue in 1929, the 1871 post office across Wisconsin Avenue from city hall was razed, to be replaced in 1930 by the Harry S. Manchester Department Store.

- Brothers build the city's tallest building (1922→1929): The Piper brothers, whose American lineage dates to 1653 and whose family homestead later formed the nucleus of the Midvale Heights neighborhood, opened the Belmont Hotel on the site of their dry goods store at the corner of Pinckney and Mifflin streets in 1924.

- The Civic Center takes shape (1922→1929): The Monona Avenue mansions of pioneer Lansing Hoyt and others are replaced in 1929 by the new post office, in partial fulfillment of John Nolen's call for a grand mall.

NOTES

ABBREVIATIONS

CT *Capital Times*
MCCP Madison Common Council Proceedings
MPL Madison Public Library
WHSA Wisconsin Historical Society Archives
WSJ *Wisconsin State Journal*

PROLOGUE

3–5 — **Prologue:** Thomas Ford, *History of Illinois* (Chicago: S. C. Griggs and Co., 1854), 143; Durrie, *History of Madison*, 18–23; Butterfield, *History of Dane County*, 356–67; Butler, "Tay-cho-pe-rah"; Parkinson, "Notes on the Black Hawk War," 2; Mollenhoff, *Madison*, 10–19.

5 — **Knapp Verbatim:** Knapp, "Early Reminiscences of Madison," 370.

1834 TO 1856

7 — **The First Map of Madison:** Field notes for town 7 North, Range 9 East, in Surveyor's Field Notes, c. 1830–1865, Interior East vol. 18–86, records of the Commissioner of Public Lands, reel 37, series 701, WHSA; J. Y. Smith, "History of Madison," 15–16; Durrie, *History of Madison*, 27; Butterfield, *History of Dane County*, 373, 730; Mollenhoff, *Madison*, 20; *Comprehensive Historic Structure Report*, 5.1.

7 — **Wakefield Verbatim:** Quoted in Durrie, *History of Madison*, 23.

8–9 — **Madison's Founding:** Durrie, *History of Madison*, 45–48, 87–88, 98–99, 122; Butterfield, *History of Dane County*, 660–69; A. E. Smith, *From Exploration to Statehood*, 254–59; A. E. Smith, *James Duane Doty*, 192–204; Pickford, "Beginning of Madison, Wisconsin," 19–24; Mollenhoff, *Madison*, 20–27; Draper, "Naming of Madison and Dane County," 388–96.

9 — **Suydam Verbatim:** Draper, "Naming of Madison and Dane County," 390–92.

10 — **Nolen Verbatim:** Nolen, *Madison*, 21–29.

11–12 — **A Capital City, but Not a Capital Plat:** *WSJ*, Apr. 28, 1909; MPPDA Annual Report, 1909, at MPL and WHSA.

12 — **Doty Biography:** A. E. Smith, *James Duane Doty;* Mollenhoff, *Madison*, 20–34; Mollenhoff and Hamilton, *Frank Lloyd Wright's Monona Terrace*, 7–9; Durrie, *History of Madison*, 28–37; Butterfield, *History of Dane County*, 660–69; *WSJ*, Dec. 21, 1888.

13–15 — **Madison's Settlement:** Knapp, "Early Reminiscences of Madison," 370–80; Peck, "Reminiscences of the First House and the First Resident Family of Madison"; C. E. Jones, *Madison, Dane County and Surrounding Towns*, 54; Durrie, *History of Madison*, 45–150, 161–64, 183, 187; J. Y. Smith, "History of Madison," 18–22; *Madison: The Capital of Wisconsin*, 5–8; Thwaites, *Story of Madison*, 3–12; Mollenhoff, *Madison*, 28–43; Butterfield, *History of Dane County*, 669–713; *Madison Democrat*, Apr. 1, 1906, June 12, 1919; *CT*, Nov. 15, 1960.

16 — **Mills Verbatim:** Butterfield, *History of Dane County*, 680.

16 — **Mills Biography:** *Daily Patriot*, Apr. 11, 1859; Durrie, *History of Madison*, 75–79; Butterfield, *History of Dane County*, 680–84, 748; *Biographical Review of Dane County*, 125–28; Hermolin, *Schenk's-Atwood Neighborhood*; Historic Madison, *Forest Hill Cemetery*, 22–24; Mollenhoff, *Madison*, 41; *CT*, Aug. 17, 1954, Feb. 8, 1967; City of Madison Landmarks Commission Landmark Sites Nomination Form, at City of Madison Department of Planning and Development.

17 — **Settlement Schooldays:** Thwaites, *Public Schools of Madison;* Historic Madison, *Forest Hill Cemetery*, 24; *WSJ*, May 23, 1917.

18–19 — **Capitol Construction, 1.0:** Durrie, *History of Madison*, 73; Cravens, "Capitals and Capitols in Early Wisconsin," 117–36; A. E. Smith, *James Duane Doty*, 211–27, 235–37; J. Y. Smith, "History of Madison," 18–21.

18 — **Keyes Verbatim:** Cited in Cravens, "Capitals and Capitols in Early Wisconsin," 136.

18 — **Report of Committee to Investigate Capitol Construction Verbatim:** Quoted in Durrie, *History of Madison*, 71–72.

19 — **Knapp Verbatim:** Knapp, "Early Reminiscences of Madison," 385–87.

19 — **Strong Verbatim:** Quoted in Durrie, *History of Madison*, 71.

20–23 — **Village People:** *Wisconsin Express*, Feb. 25, 26, Mar. 6, 19, May 7, Aug. 19, Sep. 12, Oct. 3, 1850; *Wisconsin Argus*, Jan. 21, Mar. 4, June 4, 18, Nov. 19, 26, 1850, Dec. 17, 1851; *Wisconsin Democrat*, Mar. 20, 1852; *Daily State Journal*, Apr. 9, 1853, May 3, 30, 31, June 2, 6, 1854; *Argus and Democrat*, Sep. 6, 1853, Feb. 18, June 6, 1855; *Daily Journal*, May 30, Dec. 13, 1854, July 20, 1855; *Madison Democrat*, Jan. 11, 1906; *WSJ*, Aug. 25, 27, 1900; Draper, *Madison, the Capital of Wisconsin;* J. Y. Smith, "History of Madison," 22–25; Durrie, *History of Madison*, 166–252; Thwaites, *Story of Madison*, 13–21; Mollenhoff, *Madison*, 45–69; Butterfield, *History of Dane County*, 713.

20 — **Village Population and Births:** Durrie, *History of Madison*, 170, 243, 251; Butterfield, *History of Dane County*, 714, 728.

24 — **Farwell Biography:** *WSJ*, Apr. 12, 1889; Cassidy, "Naming of the Four Lakes"; Durrie, *History of Madison*, 192–94, 220, 228–29; Butterfield, *History of Dane County*, 728; J. Y. Smith, "History of Madison," 22–24; Mollenhoff, *Madison*, 44–55; *Statistics of Dane County;* Draper, *Madison, the Capital of Wisconsin;* Thwaites, *Story of Madison*, 19–20.

24 — **Naming the Four Lakes:** C. E. Jones, *Madison, Dane County and Surrounding Towns*, 204–7; Cassidy, "Naming of the Four Lakes"; Butler, "Tay-Cho-Pe-Rah." Butler endorses the notion, which Cassidy appears to reject, that Mendota "really signifies Great Lake in Dakota, a tongue of the same family with Winnebago."

24 — **Durrie Verbatim:** Durrie, *History of Madison*, 194.

25 — **The Railroad Arrives:** *WSJ*, May 24, 1854.

28 — **Sterling Biography:** *Dictionary of Wisconsin Biography*, 338; *Biographical Review of Dane County*, 550–52.

28 — **Lathrop Biography:** Curti and Carstensen, *University of Wisconsin*, 1:160–63; Schafer, "John Hiram Lathrop."

29 — **Village Schooldays:** "First Annual Report of the Board of Education and the Superintendent of the Public Schools of Madison for the Year 1855," 1–13, at Madison Pubic Library; Thwaites, *Public Schools of Madison*, 30–39.

30 — **Butler Verbatim:** Quoted in Butterfield, *History of Dane County*, 726–27.

31 — **A Call to Become a City:** *Argus and Democrat*, Dec. 20, 1852; Mollenhoff, *Madison*, 69.

31 — **Village Fourths:** Durrie, *History of Madison*, 224, 233, 251.

1856 THROUGH THE 1860s

36 — **The First Election:** *Daily Patriot,* Mar. 8, 10, 12, 1856; *WSJ* and *Argus and Democrat,* Feb. through April 1856; Current, *Civil War Era,* 226–30; Current, *Wisconsin,* 176–77; Gajewski, "Madison Becomes A City"; Custer, "Politics in the 1850s."

37 — **Mayor Fairchild:** *WSJ,* Aug. 3, 1853; *Argus and Democrat,* Apr. 7, 1856; Durrie, *History of Madison,* 252; Butterfield, *History of Dane County,* 532–35; *CT,* Aug. 16, 2004; *WSJ,* Mar. 4, 1956.

37 — **Butterfield Verbatim:** Butterfield, *History of Dane County,* 534–35.

38 — **City Structure and Powers:** Chapter 75, Laws of Wisconsin, 1856.

38 — **Fairchild Verbatim:** *WSJ,* Apr. 7, 1856.

39 — **Taxpayer Revolt:** MCCP, June 18, 1856; *Daily State Journal,* Jan. 13, Dec. 17, 18, 1857; *Daily Patriot,* Dec. 21, 1857; Durrie, *History of Madison,* 260–62; Mollenhoff, *Madison,* 70–83.

39 — **Bird Verbatim:** *Daily Patriot,* Apr. 4, 1857.

41 — **Van Slyke Biography:** *Biographical Review of Dane County,* 486–87; Historic Madison, *Forest Hill Cemetery,* 168; Gruber, *Madison's Pioneer Buildings,* 9; *Madison, Past and Present,* 194.

41 — **The Budget's Bumpy Ride:** *WSJ,* Mar. 19, 1872; Margaret Devlin Sennett, "History of Madison 1850–1875."

41 — **Mayor Smith:** Historic Madison, *Forest Hill Cemetery,* 239.

41 — **Smith Verbatim:** *Argus and Democrat,* Apr. 5, 1858.

42 — **City Hall:** *WSJ,* Feb. 23, 1858; MCCP, Apr. 26, 1858; Burrows, "Theatrical and Entertainment Reminiscences," 57; Custer, "The Original City Hall"; Mollenhoff, *Madison,* 82–84; Wagner, "Municipal Buildings of the City of Madison," 19–20.

44–45 — **The Fuller Ovals:** Holzhueter, *Madison During the Civil War Era.*

46 — **Leitch Verbatim:** MCCP, Apr. 21, 1863.

46 — **Shipman Biography:** Historic Madison, *Forest Hill Cemetery,* 135.

47 — **The Two General Bryants:** *Dictionary of Wisconsin Biography,* 56; R. M. La Follette, *La Follette's Autobiography,* 21; *Biographical Review of Dane County,* 534–35; *History of Dane County: Biographical and Genealogical,* 126–29; Historic Madison, *Forest Hill Cemetery,* 382–83; *Madison, Past and Present,* 62.

48 — **The War at Home, Part 1:** Mollenhoff, *Madison,* 85–100; Mattern, *Soldiers When They Go;* Hanson, "Madison during the Civil War"; Merk, "The Labor Movement in Wisconsin during the Civil War"; Merk, *Economic History of Wisconsin during the Civil War Decade;* Glazer, "Wisconsin Goes to War"; *WSJ,* Apr. 19, 24, May 1, June 11, 12, 1861; Butterfield, *History of Dane County,* 615; J. Y. Smith, "History of Madison," 30; *CT,* Mar. 14, 15, 1998; Durrie, *History of Madison,* 274.

50 — **Cooke Verbatim:** Cook, "Badger Boys in Blue."

51 — **Mayor Vilas:** Merrill, *William Freeman Vilas,* 12; Durrie, *History of Madison,* 271; Butterfield, *History of Dane County,* 536–37; *Dictionary of Wisconsin Biography,* 361; Historic Madison, *Forest Hill Cemetery,* 239–41; *WSJ,* Apr. 1, 1862.

51 — **Vilas Verbatim:** MCCP, Apr. 16, 1861.

51 — **Vilas Verbatim:** *Daily Patriot,* Apr. 15, 1862.

52 — **Students and Staff at the Soldier's Orphan Home, ca. 1870:** Harvey, "A Wisconsin Women's Picture of President Lincoln," 255; Harrasch, "This Noble Monument"; Custer, "The Orphans' Christmas," 19–26; Mollenhoff, *Madison,* 93, 148; Durrie, *History of Madison,* 300–301.

53 — **Mayor Leitch:** Mollenhoff, *Madison,* 109; Federal Writers' Project of Wisconsin, Field Notes, "East Side Tour," 6, at WHSA; Gruber, *Madison's Pioneer Buildings,* 20; Historic Madison, *Forest Hill Cemetery,* 241; Durrie, *History of Madison,* 294.

53 — **Leitch Verbatim:** MCCP, Apr. 19, 1864.

53 — **Titans' Tracks Tangle:** MCCP, Jan. 19, Apr. 3, 1863; *Daily Patriot,* Apr. 3, 1863; Mollenhoff, *Madison,* 102–3.

53 — **Mayor Sanborn:** Durrie, *History of Madison,* 314; Historic Madison, *Forest Hill Cemetery,* 242.

54 — **Mayor Keyes:** *WSJ,* Apr. 4, 1894.

54 — **Noland Biography:** *WSJ,* Apr. 3, 1866; Custer, "Madison's First Black Entrepreneur"; Mollenhoff, *Madison,* 149.

56 — **Mayor Atwood:** *WSJ,* Sep. 30, 1852, Dec. 12, 1889; Durrie, *History of Madison,* 321–22; *History of Dane County: Biographical and Genealogical,* 46–49; *Biographical Review of Dane County,* 365–68.

56 — **Atwood Verbatim:** MCCP, Apr. 21, 1868.

57 — **Klauber Biography:** Swarsensky, *From Generation to Generation,* 6–16; Historic Madison, *Forest Hill Cemetery,* 324–25.

57 — **Shaare Shomaim (Gates of Heaven) Synagogue:** *WSJ,* Sep. 5, 1863; City of Madison Landmarks Commission Landmark Sites Nomination Form, at City of Madison Department of Planning and Development; Gruber, *Madison's Pioneer Buildings,* 19; Swarsensky, *From Generation to Generation,* 7–41; *CT,* Sep. 1, 1944; Dean and Custer, *Sandstone and Buffalo Robes;* Goldsmith, "German-Jewish and Russian-Jewish Immigration."

58 — **City Schooldays:** "Second Annual Report of the Board of Education and the Superintendent of the Public Schools of Madison for the Year 1856," 3–12, at Madison Public Library; *Madison City Directory and Business Mirror* (Milwaukee: Smith, Du Moulin & Co., 1858), 113–19; *WSJ,* Jan. 1, July 1, Aug. 8, Sep. 14, 24, 27, 1859; Thwaites, *Public Schools of Madison,* 9–48, 55; Durrie, *History of Madison,* 257; Butterfield, *History of Dane County,* 770–72; *CT,* July 29, 1958, Feb. 8, 1966.

58 — **Kilgore Biography:** *Argus and Democrat,* Feb. 10, 11, 13, Mar. 16, 20, 1858; *WSJ,* Mar. 16, 1858; B. W. Jones, *Reminiscences of Nine Decades.*

59 — **School District Report Verbatim:** "Second Annual Report of the Board of Education," 3.

59 — **Kilgore Verbatim:** "Second Annual Report of the Board of Education," 8–9.

61 — **Annual report of the Secretary of State Verbatim:** Quoted in Butterfield, *History of Dane County,* 436.

61 — **Chadbourne Biography:** Curti and Carstenson, *University of Wisconsin,* 1:218–35; Feldman, *Buildings of the University of Wisconsin,* 32–35; Slichter, "Paul Ansel Chadbourne."

61 — **Allen Verbatim:** Allen, "University of Wisconsin Soon after the Civil War."

62 — **Allen Biography:** Historic Madison, *Forest Hill Cemetery,* 489–90.

62 — **Keyes Verbatim:** MCCP, Apr. 17, 1866.

62 — **Kilgore and the Board:** Thwaites, *Public Schools of Madison,* 48–56.

63 — **Capitol Construction, 2.0:** Cravens, "Capitals and Capitols in Early Wisconsin," 137–43; Mollenhoff, *Madison,* 81–82; *Comprehensive Historic Structure Report,* 4.3–4.6, 5.8–5.10.

THE 1870s

65 — **Pinney Verbatim:** MCCP, Apr. 21, 1874.

68 — **Pinney Verbatim:** *History of Dane County: Biographical and Genealogical,* 339.

68 — **Mayor Bowen:** Durrie, *History of Madison,* 336; Historic Madison, *Forest Hill Cemetery,* 244; Daniel Erdman, "A City Neighborhood Surrounds the James Bowen House."

68 — **Bowen Verbatim:** MCCP, Apr. 18, 1871.

69 — **Mayor Pinney:** MCCP, Apr. 21, Nov. 21, 1874, Apr. 20, 1875; *WSJ,* Apr. 20, June 2, 1875, Apr. 3, 4, 5, 1899; *Madison, Past and Present,* 37; Historic Madison, *Forest Hill Cemetery,* 105, 246; Ela, *Free and Public.*

69 — **Mayor Proudfit:** Durrie, *History of Madison,* 323–24; Historic Madison, *Forest Hill Cemetery,* 243–44; *WSJ,* Nov. 12, 1883, Apr. 28, 1948.

69 — **Gregory Verbatim:** MCCP, Apr. 15, 1873.

70 — **Mayor Orton:** *Dictionary of Wisconsin Biography*, 272–73; *WSJ*, July 5, 1895; Historic Madison, *Forest Hill Cemetery*, 256–58; Glazer, "Wisconsin Goes to War," 157.

71 — **Orton Verbatim:** MCCP, Apr. 17, 1877.

71 — **Baltzell Verbatim:** MCCP, Apr. 15, 1879.

72 — **John Bascom's Campus, ca. 1882:** Curti and Carstensen, *University of Wisconsin*, 1:296–327, 2:138–39; Feldman, *Buildings of the University of Wisconsin*, 22–25, 32–42.

73 — **John Bascom's Presidency of the University of Wisconsin:** La Follette, *La Follette's Autobiography*, 12–13; Thwaites, *University of Wisconsin*, 107–27; Curti and Carstensen, *University of Wisconsin*, 1:246–95; Haight, "John Bascom"; Weisberger, *La Follettes of Wisconsin*, 12–14.

73 — **Olin Biography:** Eulogy, Olin Papers, Wisconsin Historical Society Archives; *Biographical Review of Dane County*, 259–60; *Dictionary of Wisconsin Biography*, 271; Butterfield, *History of Dane County*, 671–73; Historic Madison, *Forest Hill Cemetery*, 142–43; *CT*, Dec. 8, 1924; *WSJ*, Dec. 8, 1924; correspondence with Williams College archivist.

74 — **Fox Biography:** Historic Madison, *Bishops to Bootleggers*, 67; *CT*, June 24, 1932.

75 — **Schooldays:** Durrie, *History of Madison*, 363–65; Thwaites, *Public Schools of Madison*, 57–60; *WSJ*, Oct. 30, 1873, July 2, 1875; Historic Madison, *Forest Hill Cemetery*, 325; Butterfield, *History of Dane County*, 770–74.

75 — **Bascom Verbatim:** Bascom, "University in 1874–1887," 307.

75 — **La Follette Verbatim:** La Follette, *La Follette's Autobiography*, 13.

76 — **King Street Pedestrian Entrance, Capitol Park, ca. 1875:** Holzhueter, "Capitol Fence of 1872"; *Comprehensive Historic Structure Report*, 5.10–5.15.

78 — **Bar Wars, Round One:** Rolling, "Madison Turners and the German Immigrant Community in the Nineteenth Century"; Mollenhoff, *Madison*, 142–52; *WSJ*, June 5, Aug. 9, Sep. 1, 1873, June 11, 1946; MCCP, Nov. 2, 1873. *Madison, Past and Present*, 108, gives 1858 as the start of the Voight brewery; Butterfield, *History of Dane County*, 762–63, states 1854.

78 — **The Capital Brewery, 1879:** *Madison, Past and Present*, 102–3; *CT*, Mar. 20, 1923; Mollenhoff, *Madison*, 146.

79 — **Hooley's Opera House:** Youngerman, "Theatre Buildings in Madison, Wisconsin"; *WSJ*, Feb. 23, 1871; *Madison, Past and Present*, 57; Thwaites, *Story of Madison*, 35.

79 — **Sunday Billiards Ban Repeal:** MCCP, July 2, 1870.

80–81 — **Two Hotels, 1.0:** Mollenhoff, *Madison*, 128–34, 164–67; *WSJ*, Mar. 18, 25, Apr. 30, 1870, Aug. 21, 1871, May 24, Aug. 21, 1877, July 10, 1879, Aug. 1, 1895; *CT*, Jan. 1, 1939, Dec. 28, 1954, Aug. 5, 1961; Custer, "The Park Hotel"; Durrie, *History of Madison*, 338–40; Historic Madison, *Forest Hill Cemetery*, 46; *Madison Democrat*, July 10, 1879.

83 — **Croquet at the Thorp-Bull House:** Gruber, "Madison's Pioneer Buildings," 11; Brock, "Old Governor's Executive Residence"; Mollenhoff, *Madison*, 144–45.

84 — **Nader Biography:** *Biographical Review of Dane County*, 215–16.

84 — **Barnes Biography:** Mollenhoff, *Madison*, 130; *WSJ*, July 1, 1925, Jan. 16, 1944.

86 — **Steensland Biography:** Steensland, "Halle Steensland, 1832–1910"; Historic Madison, *Forest Hill Cemetery*, 430–31; *WSJ*, Aug. 9, 1945.

86 — **Governor Washburn and Family, Edgewood Villa:** Paynter, *Phoenix from the Fire.*

87 — **Durrie Verbatim:** Durrie, *History of Madison*, 381.

THE 1880s

89 — **Keyes Verbatim:** MCCP, Apr. 20, 1886.

92 — **Capitol Collapse:** *WSJ*, Nov. 8, 9, 21, 1883; *Madison Democrat*, Nov. 9, 10, 1883; Wright, *An Autobiography*, 55–56; Mollenhoff and Hamilton, *Frank Lloyd Wright's Monona Terrace*, 53; Cravens, "Capitals and Capitols in Early Wisconsin," 150–54; *Comprehensive Historic Structure Report*, 4.6–4.7.

93 — **Second Dane County Courthouse:** Mollenhoff and Hamilton, *Frank Lloyd Wright's Monona Terrace*, 53–59.

94 — **Mayor Stevens:** *History of Dane County: Biographical and Genealogical*, 846–50; Memorial to Breese Stevens (1903) in Breese Stevens Papers, at WHSA; *WSJ*, Mar. 13, 1884, Oct. 28, 1903; *CT*, May 26, 1925; Historic Madison, *Forest Hill Cemetery*, 247.

95 — **Mayor Moulton:** Historic Madison, *Forest Hill Cemetery*, 247; MCCP, Apr. 18, 1885.

95 — **Moulton Verbatim:** MCCP, Apr. 21, 1885.

95 — **Mayor Conklin:** *Biographical Review of Dane County*, 232–33; *WSJ*, Feb. 27, 1899; *CT*, Aug. 5, 1966; *Madison Press Connection*, Mar. 28, 1978; Mollenhoff and Hamilton, *Frank Lloyd Wright's Monona Terrace*, 33.

95 — **Mayor Spooner:** Historic Madison, *Forest Hill Cemetery*, 246–47; *WSJ*, Jan. 2, 1918.

95 — **Spooner Verbatim:** MCCP, Apr. 20, 1886.

95 — **Mayor Doyon:** Historic Madison, *Forest Hill Cemetery*, 48.

96–97 — **The Sunday Saloon Struggle:** Thelen, "La Follette and the Temperance Crusade"; *WSJ*, Mar. 17, 24, 25, 27, 31, June 13, 27, Dec. 19, 1884; *Madison Democrat*, Mar. 13, 22, 24, June 13, 1884, Feb. 2, 1886; *Wisconsin Prohibitionist*, June 23, 1887; Unpublished memoir, Keyes Papers, Wisconsin Historical Society; Curti and Carstenson, *University of Wisconsin*, 1:247–74; Thwaites, *University of Wisconsin*, 107–27; Haight, "John Bascom."

97 — **Keyes Verbatim:** Unpublished memoir, Keyes Papers, Wisconsin Historical Society.

98 — **Fighting Bob and the Boss:** R. M. La Follette, *La Follette's Autobiography*, 17–59; Thelen, "The Boss and the Upstart," 103–15; Hantke, "Elisha W. Keyes and the Radical Republicans"; Hantke, "Elisha W. Keyes, the Bismarck of Wisconsin Politics"; Weisberger, *La Follettes of Wisconsin*, 18–19; *Dictionary of Wisconsin Biography*, 217–19.

99 — **"A Majestic Ruin":** *WSJ*, Dec. 2, 1884; *Madison Democrat*, Dec. 2, 1884.

99 — **Science Hall:** *WSJ*, Sep. 1, 1885; Feldman, *Buildings of the University of Wisconsin*, 55–57; Curti and Carstenson, *University of Wisconsin*, 1:323–26; Wright, *An Autobiography*, 57; Mollenhoff and Hamilton, *Frank Lloyd Wright's Monona Terrace*, 51.

99 — **Conover Biography:** Historic Madison, *Forest Hill Cemetery*, 135, 486–87; City of Madison Landmarks Commission Landmark Sites Nomination Form, Buell House, at City of Madison Department of Planning and Development; UW Facilities Report, 11.

99 — **Dodge Biography:** Historic Madison, *Forest Hill Cemetery*, 569–70.

100 — **John Johnson Creates the Industrial East Side:** Larson, *John A. Johnson*; Mollenhoff, *Madison*, 172–82; *WSJ*, Nov. 29, 1881, Apr. 21, 23, 1883; MCCP, May 5, 1883.

100 — **Johnson Biography:** Mollenhoff, *Madison*, 172–82; Levitan, "The Way We Were: Madison 1900," *Madison Magazine*, Apr. 2000, 23; Levitan, "The Way We Were: Madison 1900," *Madison Magazine*, Dec. 2000, 82; *WSJ*, Mar. 31, 1884, Nov. 11, 12, 1901; *Biographical Review of Dane County*, 439–41; *CT*, Aug. 11, 1961.

101 — **The Utilities Era:** MCCP, July 1, Aug. 6, 1881, Dec. 5, 1882, Apr. 18, 1885; *Madison Democrat*, Dec. 6, 1883, Mar. 13, 1884, Apr. 19, 1885; *WSJ*, June 11, July 20, 1888, Nov. 3, 1919, Sep. 17, 1944; *CT*, Nov. 3, 1919, Feb. 21, 1964; Mollenhoff, *Madison*, 197–201; Sonjia Short, "The Electric Story," Madison Gas and Electric employee newsletter; *Madison, Past and Present*, 72–73; *Biographical Review of Dane County*, 425–26; *History of Dane County: Biographical and Genealogical*, 396–99.

101 — **Swenson Biography:** Thomas H. Lemon, "An Industrial Inheritance"; Historic Madison, *Forest Hill Cemetery*, 441–42; Mollenhoff, *Madison*, 197; *CT*, Dec. 19, 1917.

102 — **Railroad Skullduggery:** *WSJ*, Oct. 14, 1888, Aug. 20, 1944; Gruber, "Illinois Central Reaches North to Madison"; Tipler, *First Settlement Neighborhood*, 17–18.

103 — **Rogers Verbatim:** MCCP, Apr. 19, 1892.

103 — **Mule Team Mass Transit:** Mollenhoff, *Madison*, 201–3; *Madison Democrat*, Oct. 2, 1892; *WSJ*, Mar. 8, Sep. 10, Oct. 22, Nov. 10, 17, 19, 1884, Sep. 1, Nov. 25, 1885, May 29, 1886, Feb. 12, 1887; *CT*, Mar. 4, 10, 1931; *Madison, Past and Present*, 229.

103 — **Adams Biography:** Historic Madison, *Forest Hill Cemetery*, 229–30; *WSJ*, July 10, 1906.

104 — **Butterfield Verbatim:** Butterfield, *History of Dane County*, 826.

104 — **Angels from the Attic:** Attic Angel Association, *One Hundred Year History*, 7.

105 — **Monona Lake Assembly:** *Madison, Past and Present*, 56; Mollenhoff, *Madison*, 168–69; www.cityofmadison.com/parks; Levitan, "The Way We Were: Madison 1900," *Madison Magazine*, Sep. 2000, 52; City of Madison Landmarks Commission Landmark Sites Nomination Form, at City of Madison Department of Planning and Development; Thwaites, *Story of Madison*, 34.

106 — **The President and the People:** *WSJ*, Oct. 7, 8, 10, 1887; *CT*, July 7, 1986; Merrill, *William Freeman Vilas*, 127–32.

107 — **Thinking Globally, Acting Locally:** MCCP, July 2, 1886.

108 — **Wingra Park, the First Suburb:** Nolen, *Madison*, 135; Nekar, "Progressives, Suburbs and the Prairie Spirit," 111–14; *Madison, Past and Present*, 25; Mollenhoff, *Madison*, 186–95; Heggland, *Greenbush-Vilas Neighborhood*; *WSJ*, Apr. 29, 1893, Sep. 26, Oct. 26, 1895, Aug. 19, 1909, Apr. 14, 1944.

THE 1890s

109 — **Corscot Verbatim:** MCCP, Apr. 18, 1893.

112 — **Town of Madison, 1890 Plat Map:** Punwar, *Forests, Farms and Families*, 7–9.

114–116 — **The Madison Park and Pleasure Drive Association:** MCCP, July 14, 1899; MPPDA Annual Reports, 1899–1902, at MPL and WHSA; *Madison Democrat*, Oct. 16, 1892, Mar. 19, May 8, 11, 14, 1897, Mar. 3, 1898; Historic Madison, *Forest Hill Cemetery*, 143; *Madison, Past and Present*, 6–7; *WSJ*, June 24, 1892, Mar. 8, 1897, Feb. 11, 1906, Nov. 11, 1954; Mattern, "Madison Park and Pleasure Drive Association"; Mollenhoff, *Madison*, 218–22, 309.

117 — **Tenney Biography:** *History of Dane County: Biographical and Genealogical*, 888–90; *WSJ*, Sep. 3, 1895, Feb. 11, 1915; Historic Madison, *Forest Hill Cemetery*, 145–46; Mollenhoff, *Madison*, 311; *Madison, Past and Present*, 6.

117 — **Brown Biography:** Historic Madison, *Forest Hill Cemetery*, 144; *WSJ*, Jan. 1, 1926.

118–119 — **Frank Lloyd Wright's Carroll Street Boathouse:** Holtzhueter, "Lakes Mendota and Monona Boathouses"; Mollenhoff and Hamilton, *Frank Lloyd Wright's Monona Terrace*, 62–63; Mollenhoff, *Madison*, 220–21; *WSJ*, Feb. 28, 1893, Oct. 22, 1895; *CT*, Feb. 16, 1926; MCCP, May 12, 1893.

119 — **Subscriptions, Lake Monona Boathouse:** *WSJ*, Oct. 22, 1895.

120 — **The Woman's Club:** Pabian, "Woman's Club of Madison"; Secord, "Women's Club Movement in Madison and Public Health Concerns"; Phillips, "Woman's Club of Madison"; Mollenhoff, *Madison*, 350–52; *Madison, Past and Present*, 77; *CT*, Mar. 4, 1936; www.cityofmadison.com/assessor.

121 — **Fairchild Biography:** Williams, *First Ladies of Wisconsin*, 64–69.

122 — **Fuller Opera House:** *WSJ*, Apr. 7, May 18, 19, 1890, Jan. 14, Feb. 13, 1899; Mollenhoff, *Madison*, 225–26.

122 — **Where the Greatest Generation Lived:** Gary Tipler, "Mansion Hill"; Curti and Carstensen, *University of Wisconsin*, 2:12–13; Cartwright, *Langdon Street Historic District*.

124 — **Mayor Bashford:** *History of Dane County: Biographical and Genealogical*, 68–71; MCCP, Apr. 15, 1890, Apr. 21, 1891; *Biographical Review of Dane County*, 221–26; Historic Madison, *Forest Hill Cemetery*, 248–49; Custer, "Old Fashioned Politics."

124 — **A White Tie Affair:** Tipler, "Mansion Hill," 12.

124 — **Bashford Verbatim:** MCCP, Apr. 15, 1890.

125 — **Mayor Corscot:** MCCP, Apr. 4, 1894; *Madison Democrat*, Apr. 3, 4, 1894; *CT*, May 14, 1926; *WSJ*, May 14, 1926; Historic Madison, *Forest Hill Cemetery*, 249–50.

125 — **Corscot Verbatim:** MCCP, Apr. 18, 1893.

125 — **Water Tower Horse Market:** Mollenhoff, *Madison*, 175; *CT*, Sep. 27, 1972.

125 — **Mayor Rogers:** Historic Madison, *Forest Hill Cemetery*, 249.

125 — **Mayor Whelan:** Historic Madison, *Forest Hill Cemetery*, 250; *CT*, Nov. 30, 1928.

125 — **Whelan Verbatim:** MCCP, Apr. 19, 1898.

126 — **Mayor Hoven:** Historic Madison, *Bishops to Bootleggers*, 112–13; *Biographical Review of Dane County*, 597–98; *Madison Democrat*, Apr. 4, 1897; *WSJ*, Aug. 21, 24, 30, 31, Nov. 18, 22, 1895, Oct. 1, 1901; Levitan, "The Way We Were: Madison 1900," *Madison Magazine*, July 2000, 47–52; Mollenhoff, *Madison*, 226.

126 — **Police Chief Adamson and Officers:** Strand, *Story of the Democrat*, 64; *CT*, Aug. 27, 1970.

127 — **Constitutional Crisis of 1897:** MCCP, Apr. 20, 22, May 4, 7, 14, 1897; *WSJ*, Mar. 30, Apr. 8, 1896, Apr. 19, 20, 21, 23, May 3, 10, 12, 1897; *Madison Democrat*, Apr. 18, 20, 21, 23, May 2, 5, 1897; "Madison Police," in Frank Custer research files at WHSA.

128 — **Adams Biography:** Curti and Carstenson, *University of Wisconsin*, 1:561–710; Ely, "Charles Kendall Adams."

129 — **Faith on Campus?:** Reports to the Regents, Jan. 1898, UW Archives.

129 — **Hallowe'en 1899:** *Daily Cardinal*, Oct. 31, Nov. 2, 3, 10, 17, 1899.

129 — **University Armory/Gymnasium:** Feldman, *Buildings of the University of Wisconsin*, 75–79; Armory and Gymnasium Historic Structure Report, 11–19, 23, at UW Archives, Memorial Library.

130 — **The University Gets Camp Randall:** Feldman, *Buildings of the University of Wisconsin*, 168–72; Thwaites, "History of Camp Randall," *Daily Cardinal*, Dec. 19, 1901; *Daily Cardinal*, Feb. 9, Mar. 25, 27, 28, Apr. 1, 13, 14, 18, May 1, Oct. 10, 1893, Apr. 17, 1894, Sep. 25, Oct. 30, Nov. 15, 22, Dec. 15, 1894, Apr. 22, Sep. 21, Oct. 15, 26, 1895, Oct. 12, 15, Nov. 13, 17, 21, 1896; *WSJ*, Apr. 29, 1893, Apr. 20, 1894, Aug. 7, 1895; Nomination Papers for National Register of Historic Places, at Historic Preservation Offices, WHS; Taylor, *The Story of Camp Randall*, 1953, University of Wisconsin Archives Subject Folder (Camp Randall #1).

131 — **University Heights:** MCCP, June 10, 1892; *WSJ*, Apr. 24, 29, Aug. 16, 1893, Oct. 26, 1895, June 11, 1896, July 21, 1918; Heggland, *University Heights Historic District*; Mollenhoff, *Madison*, 193; Thwaites, *Story of Madison*, 36.

132 — **Slichter Biography:** *Dictionary of Wisconsin Biography*, 329; Historic Madison, *Forest Hill Cemetery*, 495.

132 — **Ely Biography:** *Dictionary of Wisconsin Biography*, 117–18; Buenker, *Progressive Era*, 42; Curti and Carstensen, *University of Wisconsin*, 1:502, 508–26, 2:200–202, 342.

133 — **East Side:** *Madison City Directory, 1890–91* (Madison: Angell & Hastreiter), 25; *WSJ*, Apr. 10, 1890, Mar. 10, Apr. 3, May 4, Aug. 10, 11, 1891.

134 — **Elmside, the Resort Suburb:** Mollenhoff, *Madison*, 167, 189–92; *WSJ*, Apr. 10, 1890, Mar. 10, Apr. 3, May 4, Aug. 10, 11, 1891, Oct. 16, 1892.

136 — **Implement Row:** Mollenhoff, *Madison*, 74; *Madison, Past and Present*, 26; Tipler, *Williamson Street*, 5, 19.

136–137 — **Madison Labor:** Miner, *History of Madison Labor*, 7–11; Thwaites, *Story of Madison*, 36; *Madison Democrat*, May 25, 1893; *Madison, Past and Present*, 63–65.

137 — **Northern Electrical Manufacturing Company:** Mollenhoff, *Madison*, 179–80; *Madison, Past and Present*, 165.

137 — **Power for, Not by, the People:** Mollenhoff, *Madison*, 200–201; *Madison Democrat*, Aug. 26, 27, 1892; *WSJ*, Jan. 11, 1896; MCCP, Oct. 23, 1896; Madison Gas and Electric Company, Articles of Incorporation; *Madison, Past and Present*, 189–92.

138 — **Forward:** *Comprehensive Historic Structure Report*, 5.14.

139 — **Nolen Verbatim:** MPPDA Annual Report, 1909, 88, at MPL and WHSA.

141 — **Foreign Population:** *WSJ*, July 3, 1905.

144 — **John Olin and the MPPDA:** MPPDA Annual Reports, 1900–1910, at MPL and WHSA; MCCP, May 8, June 17, 1903; Aug. 10, 1905; Apr. 5, 1907; Dec. 2, 1908, Mar. 12, 1909; *WSJ*, Aug. 11, 1905, Apr. 6, 1907; Sep. 20, 21, 1909; MCCP, Mar. 12, 1909. Sadly, the city also failed to follow through on some of Olin's other initiatives. Stung that he couldn't create the Lake Monona drive, Olin spent eighteen years seeking to increase Madison's authority over lands outside its borders. In 1897, he wrote and secured passage of a bill giving Madison the power to own parkland outside the city limits, but the council, figuring the MPPDA was doing all that needed to be done, didn't use its new authority. Olin got an even stronger bill passed in 1905, enabling cities to condemn land outside their borders, but Governor La Follette vetoed it. Finally, the culmination of his efforts came in the Park District Law of 1915, which authorized the city to assume the association's assets and activities, condemn and own land outside its borders, and apply property taxes to their improvement. Inexplicably, the city failed to seize this opportunity.

144 — **Olin Verbatim:** MPPDA Annual Report, 1903, at MPL and WHSA.

145 — **Yahara River Parkway:** MPPDA Annual Reports, 1902–1908, at MPL and WHSA; MCCP, May 9, 1902, May 8, Sep. 25, 1903; June 27, 1904; Holzhueter, "Yahara River Boathouse."

146 — **Henry Vilas Park:** MPPDA Annual Reports, 1904, 41–50, 1905, 31–34, 1907, 32, 1908, 27–31, 1909, 32–34, 1910, 9–10, 26–28, 1911, 30, 1912, 15, 1913, 13–20, at MPL and WHSA; *WSJ*, May 22, 1905; *Madison Democrat*, Oct. 6, 1906.

147 — **Vilas Biography:** Merrill, *William Freeman Vilas;* B. W. Jones, "William Freeman Vilas"; Lokken, "William F. Vilas as a Businessman"; *Chicago Times*, May 26, 1894; Historic Madison, *Forest Hill Cemetery*, 233–35; *History of Dane County: Biographical and Genealogical*, 932–34; *WSJ*, Aug. 27, 28, 29, 1909; *CT*, Dec. 1, 1977.

147 — **La Follette Verbatim:** *WSJ*, Aug. 29, 1908.

148 — **Brittingham Biography:** MPPDA Annual Reports, 1905, 43–49, 1906, 50–53, 1907, 32, 1908, 31–44, 1909, 35–39, at MPL and WHSA; *WSJ*, May 3, 1924, Apr. 8, 1973; *CT*, May 3, 1924, Apr. 18, 1960; "The University Loses a Great Friend and Benefactor," *Wisconsin Alumni Magazine*, June 1960, 12–13.

148 — **Stacy Verbatim:** MPPDA Annual Report, 1904, 71–75, at MPL and WHSA.

149 — **Olin Verbatim:** MPPDA Annual Report, 1902, 58, at MPL and WHSA.

149 — **Jones Biography:** MPPDA Annual Report, 1904, 51–52, at MPL and WHSA; *Biographical Review of Dane County*, 285–86; Historic Madison, *Forest Hill Cemetery*, 260; B. W. Jones, *Reminiscences of Nine Decades.*

150 — **Madison High School:** *WSJ*, July 2, 1901, July 22, 26, 1905, Dec. 16, 1908.

150 — **Dudgeon Verbatim:** "Report of the Madison Public Schools," 1905, 60, at Madison Pubic Library.

150 — **Madison Free Library:** MCCP, Jan. 10, May 9, 1902; *Madison Democrat*, June 16, 1903; *WSJ*, Oct. 10, 1904, Dec. 2, 1905, Feb. 24, 1906; Ela, *Free and Public.*

151 — **Capitol Conflagration:** *WSJ*, Feb. 27, 28, Mar. 10, 17, 1904; *Madison Democrat*, Feb. 27, 28, 1904; *CT*, Feb. 27, 2005; Clair B. Stampley, "The Wisconsin Capitol Fire of 1904" in *Comprehensive Historic Structure Report*, 1.9–1.11.

152 — **Hotel Washington:** Nomination Papers for National Register of Historic Places, at City of Madison Department of Planning and Development, Aug. 1992.

152 — **Mayor Curtis:** MCCP, Apr. 19, 1904, Apr. 18, 1905, *CT*, Dec. 19, 1935; *WSJ*, Dec. 19, 1935.

152 — **Mayor Bull:** Mollenhoff, *Madison*, 292; MCCP, Apr. 16, June 17, 1901; *WSJ*, Nov. 17, 1907; Historic Madison, *Forest Hill Cemetery*, 250–51.

153 — **Mayor Schubert:** *Madison Democrat*, Mar. 29, 1906; *WSJ*, Apr. 4, 1906, Apr. 6, 1910; *CT*, Nov. 11, 1959; Historic Madison, *Forest Hill Cemetery*, 251.

153 — **It's Sticky for Icke:** MCCP, Sept. 25, Oct. 9, Dec. 11, 1903.

154 — **Madison General Hospital:** Mollenhoff, *Madison*, 372–77; *WSJ*, Apr. 23, 1856, June 10, 1886, Mar. 12, 1902, Oct. 15, 1903; MCCP, Apr. 19, 1887; *Madison Democrat*, Oct. 16, 1903; *Madison, Past and Present*, 54–55; Levitan, "The Way We Were: Madison 1900," *Madison Magazine*, Sep. 2000, 53.

154 — **An Unhealthy Hospital:** MCCP, July 10, 1908.

155 — **Hospital, School, Ridge:** Mollenhoff, *Madison*, 12, 372.

156 — **Bar Wars, Round Two:** *WSJ*, May 13, 1902, Mar. 28, 29, 1906, Jan. 14, 1907, Feb. 22, Mar. 20, Apr. 4, 12, 15, 16, June 4, 6, 19, 29, Sep. 11, 18, 1907; *Madison Democrat*, April 17, 1907; Regents Reports, Apr. 16, 1907, at UW Archives, Memorial Library; MCCP, Aug. 12, 1904, Apr. 16, Sep. 20, 1907; Levitan, "Temperance Tempests," *Isthmus Annual Manual 2005–2006*, 12.

156 — **Stall Saloons:** MCCP, Feb. 12, 1903; *WSJ*, May 13, 1902, Feb. 27, 1903.

157 — **The Carnival That Launched a Business Group:** *WSJ*, Oct. 15–20, 1900, Oct. 26, 1901; Levitan, "The Way We Were: Madison 1900," *Madison Magazine*, Dec. 2000, 81; *Madison, Past and Present*, 23; Mollenhoff, *Madison*, 239–56.

157 — **Wilder Biography:** Weissman, "A History of the *Wisconsin State Journal* since 1910," 1–7; *WSJ*, Aug. 21, 1977; *Dictionary of Wisconsin Biography*, 377; Mollenhoff, *Madison*, 281–82.

157 — **Mayor Groves:** *CT*, Dec. 5, 1921; *WSJ*, Dec. 5, 1921. The latter erroneously gives Groves' mayoral term as 1892–1894.

158 — **Fuller and Johnson Manufacturing Company:** *Madison, Past and Present*, 156–58, 214.

158 — **Titans' Tax Tangle:** Levitan, "The Way We Were: Madison 1900," *Madison Magazine*, Sep. 2000, 52.

159 — **Workforce Statistics:** *Madison, Past and Present*, 63.

159 — **The Leading Lubricators:** *WSJ*, Sep. 24, 1902; Hermolin, *Schenk's-Atwood Neighborhood*; Mollenhoff, *Madison*, 260–61; *CT*, Feb. 5, 1964.

159 — **Groves Verbatim:** MCCP, Apr. 15, 1902.

159 — **Groves Verbatim:** MCCP, Apr. 21, 1903.

161 — **Sugar Beet Factory:** *WSJ*, July 11, Sep. 7, 1905, Oct. 8, 22, 1906, Jan. 3, 1907, Dec. 31, 1915. *Madison Democrat*, Oct. 14, 1906; *CT*, Dec. 30, 1974; Lemon, "An Industrial Inheritance."

162 — **Van Hise Biogrpahy:** Curti and Carstensen, *University of Wisconsin*, 2:3–122; *CT*, Nov. 19, 20, 21, 1918; *WSJ*, Nov. 19, 20, 21, 1918; Leith and Vance, "Charles Richard Van Hise"; *Dictionary of Wisconsin Biography*, 359.

163 — **Steffens Verbatim:** Curti and Carstensen, *University of Wisconsin*, 2:111; Leith and Vance, "Charles Van Hise."

163 — **Dedication of the Lincoln Statue:** "How the Lincoln Statue Came to the Campus," *Wisconsin Alumnus*, Feb. 1927, 140; "Ask Abe," www.uwalumni.com/home/coolstuff/askabe/askabe_buildings/askabe_buildings.aspx; Leith and Vance, "Charles Richard Van Hise."

164 — **Sewers 1900:** Mollenhoff, *Madison*, 214–15, 364–65; Levitan, "The Way We Were: Madison 1900," *Madison Magazine*, Apr. 2000, 26, Dec. 2000, 82; Ingraham, *Charles Sumner Slichter*, 206–8.

165 — **Lower Campus Development Plan:** Wand, "Henry Mall."

172 — **Madison Hires John Nolen, 1908:** MPPDA Annual Report, 1908, 73–78, at MPL and WHSA; *WSJ*, Feb. 26, July 9, 1907; MCCP, Apr. 9, 1909; Mollenhoff, *Madison*, 323–26.

172 — **John Nolen's Great Esplanade:** Nolen, *Madison*, 43.

174 — **John Nolen's Plan for the Grand Mall and the Great Esplanade:** Nolen, *Madison*, 35–51; MPPDA Annual Report, 1909, 75, 87–95, at MPL and WHSA; Mollenhoff, *Madison*, 326–35; Mollenhoff and Hamilton, *Frank Lloyd Wright's Monona Terrace*, 5–23; *WSJ*, Feb. 26, 1907, April 28, 1909.

174 — **Olin Verbatim:** MPPDA Annual Report, 1909, 68–69, at MPL and WHSA.

175 — **Schubert Verbatim:** MCCP, Apr. 18, 1911.

176 — **Nolen Verbatim:** Nolen, *Madison*, 29.

178 — **Madison: A Model City:** MPPDA Annual Report, 1910, 45–46, 53–57, at MPL and WHSA; MCCP, Feb. 11, 1910; *WSJ*, Sep. 10, 1910; Nolen, *Madison*.

178 — **Nolen Verbatim:** Nolen, *Madison*, 19.

179 — **Nolen's Suggestive Plan:** Nolen, *Madison*, 150.

181 — **Nolen Verbatim:** Nolen, *Madison*, 137, 149–50.

182 — **Brittingham Boat *and* Girls Swim Class:** MPPDA Annual Reports, 1910, 28–29, 1911, 31–34, 1913, 21–23, 1914, 14, at MPL and WHSA; Nomination Papers for National Register of Historic Places, at City of Madison Department of Planning and Development.

182 — **Who Knew? New Zoo:** MPPDA Annual Reports, 1911, 31, 1912, 17–19, 1913, 20, 1914, 25–30, 1917, 11–13, 1918, 23–25, 1920, 71–73, at MPL and WHSA; Katherine Rankin, memo to Landmarks Commission, Dec. 1, 1993.

184 — *Wisconsin* **Rising:** *Comprehensive Historic Structure Report*, 4.32–4.33.

184–185 — **To Make Madison a Model City:** Nolen, *Madison*, 141–43.

185 — **A Wright Hotel Goes Wrong:** Hamilton, "Madison Hotel"; Mollenhoff, *Madison*, 286; Mollenhoff and Hamilton, *Frank Lloyd Wright's Monona Terrace*, 70–72.

186 — **Neighborhood House:** *WSJ*, May 20, 21, Nov. 21, 1916, May 12, 1917, Dec. 31, 1918, Oct. 5, 8, 12, 1941, Nov. 20, 1966, Jan. 14, 1968; *CT*, Oct. 5, 6, 9, 10, 1941, Jan. 21, 1964, May 13, 19, 1966, April 26, 1969; *Milwaukee Journal*, Oct. 9, 1941; Dix, "Neighborhood House," 10; Custer, "Neighborhood House"; Kittle, "An Account of the Beginning Years of Neighborhood House"; Kittle, "Neighborhood House"; Mary Lee Griggs, "Neighborhood House-The Past: 1916–1949," speech at Neighborhood House Annual Dinner, May 26, 1960; Barnbrock, "Housing Conditions of the Italian Community"; Valentine, "A Study in Institutional Americanization."

186 — **St. Mary's Hospital:** *Madison Democrat*, Sep. 12, 1912, Nov. 15, 1913; *WSJ*, Sep. 12, 1912, Feb. 9, 1926; Mollenhoff, *Madison*, 377–80.

187 — **Handbook, Societia Mutualia:** *CT*, Jan. 24, 1962.

188 — **Annie Lemberger:** Lemberger, *Crime of Magnitude*.

188 — **Greenbush and Triangle:** Barnbrock, "Housing Conditions of the Italian Community," 5–7, 48–49.

188 — **Pregler Biography:** *WSJ*, Nov. 9, 1916.

188 — **An Umbrella Organization Opens:** Constitution and First Annual Report Associated Charities, Family Service collection at WHSA; *WSJ*, Nov. 30, 1910; Mrs. William Kittle, "History of the Organization," Public Welfare Association Annual Report, Sept. 1, 1920, Family Service collection at WHSA; Report, Madison Public Welfare Association Fifteenth Annual Meeting, March 19, 1925, Family Service collection at WHSA; Valentine, "A Study of Institutional Americanization," 130–31.

189 — **City Market Neighborhood:** Nomination Papers for National Register of Historic Places, at City of Madison Department of Planning and Development, 1978; MCCP, Oct. 12, 1906; *WSJ*, July 11, 1906, Nov. 26, Dec. 27, 1909, Nov. 2, 1910, July 1, 1917; *Madison Democrat*, Nov. 3, 1910; *CT*, Sep. 27, 1972; Mollenhoff, *Madison*, 274–75; Nixon, "Madison's Outdoor Markets."

189 — **A Place for Young Men:** *Madison Democrat*, Feb. 26, Mar. 1, 1919; *WSJ*, Oct. 13, 1918, Mar. 1, 2, 1919; *The New Y.M.C.A. Building for Madison Wisconsin* (Madison: Y.M.C.A., 1919).

189 — **Heim Verbatim:** MCCP, Apr. 16, 1912.

190 — **Nakoma:** Madison Realty Company, Price List, 1915; Madison Realty Company, *Nakoma Tomahawk*, June, July, Aug., Sep., Oct. 1920, Autumn 1921; Nakoma Homes Company Agreement, July 1920; *WSJ*, Oct. 31, 1915, June 16, 1985; *CT*, Jan. 12, 1918; Groy, "Suburban Development in Madison," 20–23; Nekar, "Progressives, Suburbs and the Prairie Spirit," 106–10; *Isthmus*, Jan. 11, 1991; National Register of Historic Places Registration Form, Nakoma Historic District; Heggland, *Nakoma Neighborhood*, 2–7.

191 — **Submerged Subdivision:** *CT*, Feb. 8, 1918, Jeffrey Groy, "Suburban Development in Madison"; Mollenhoff, *Madison*, 344–46; MPPDA Annual Report, 1918, 26–29, at MPL and WHSA; Vukelich, *North Country Notebook*, 125.

192 — **Law and Order:** *WSJ*, Nov. 22, 1914, Jan. 31, 1915; *Madison Democrat*, Jan. 31, 1915.

193 — **Down State to Campus:** Nolen, *Madison*, 52.

193 — **A Decade of Referenda:** MCCP, Apr. 8, 1910, Feb. 9, 1912, Apr. 10, 1914, Apr. 9, 1915, Apr. 14, 1916, Apr. 13, 1917, Apr. 12, 1918, Apr. 11, 1919, Apr. 9, 1920.

194 — **Voters Reject Commission Government:** MCCP, Feb. 9, 1912, Nov. 8, 1946, Nov. 10, 1950; Mollenhoff, *Madison*, 290–91; *WSJ*, Jan. 27, 1909, Dec. 9, 1911, Jan. 17, 27, 31, 1912; MPPDA Annual Report, 1909, 68–69, at MPL and WHSA.

195 — **Main Hall Burns:** *Daily Cardinal*, Oct. 11, 1916; Feldman, *Buildings of the University of Wisconsin*, 22–25.

196 — **Site Plan, Camp Randall:** Feldman, *Buildings of the University of Wisconsin*, 168–72; Report of the Board of Regents, 1911–12, 239–41, 1914–16, 251, 1916–17, 273–74, 1918–20, 215, at UW Archives, Memorial Library; Ehler, "A New Camp Randall"; *Daily Cardinal*, Dec. 16, 1914, Nov. 20, 21, 1915, July 1, Sept. 26, 1917; fundraising letter, Mar. 20, 1916, Stadium Committee, University of Wisconsin Archives Subject Folder (Camp Randall #1).

196 — **School Room Building Boom:** Hermolin, *Schenk's-Atwood Neighborhood*, 8; Heggland, *Greenbush-Vilas Neighborhood*, 13; Heggland, *Nakoma Neighborhood*, 6.

195 — **Dedication of the "Sifting and Winnowing" Plaque:** Curti and Carstensen, *University of Wisconsin*, 1:522–27, 2:68–71; *WSJ*, June 16, 1915.

196 — **"Wisconsin Forward Forever" Verbatim:** *WSJ*, May 27, 1917.

197 — **Birge Biography:** Birge, "Edward A. Birge"; Curti and Carstensen, *University of Wisconsin*, 2:123–58.

198 — **Prohibition:** Weisensel, "Wisconsin Temperance Crusade to 1919," 118–35; *WSJ*, Mar. 28, Apr. 6, 1910, Jan. 31, 1912, Feb. 14, June 11, 12 13, 15, 17, July 3, 1913, Apr. 8, 1914, Apr. 4, June 30, July 1, and Dec. 31, 1917; *CT*, Dec. 31, 1917, Apr. 3, May 21, Nov. 16, 1918, Jan. 20, Apr. 2, 12, 1919; *Daily Cardinal*, Apr. 2, 4, June 29, 1917; Evjue, *A Fighting Editor*, 263–74.

199 — **Mayor Kayser:** MCCP, Apr. 20, 1915, Apr. 18, 1916; *Historic Madison, Bishops to Bootleggers*, 115–16; *WSJ*, Dec. 31, 1915.

199 — **Mayor Sayle:** *WSJ*, Apr. 5, 1916.

199 — **Heim Verbatim:** MCCP, Apr. 21, 1914.

199 — **Mayor Heim:** *WSJ*, Nov. 4, 5, 11, Dec. 9, 11, 1913; MCCP, Apr. 16, 1912, Apr. 15, 1913, Apr. 21, 1914; *Historic Madison, Bishops to Bootleggers*, 111.

200 — **Ray-O-Vac:** Rublee, "The Rayovac Story"; Madison Association of Commerce, "Community Business," May 16, 1921, 1–2; Mollenhoff, *Madison*, 258–61; *WSJ*, May 19, 1952; Rankin and Heggland, *Madison Intensive Survey*, 8.

200 — **The French Battery and Carbon Company:** Madison Association of Commerce, "Industrial Survey of Madison, Wisconsin," 1931, at WHSA.

201 — **Oscar G. Mayer Attends an Auction:** Aehl, "The Oscar Mayer Story"; *CT*, Oct. 21, 1919; *WSJ*, Oct. 21, 1919, Jan. 1, 1953, Sep. 2, 1956; *Madison Democrat*, Nov. 24, 25, 1919; *Madison and Wisconsin Foundation* (newsletter), Sep. 23, 1949; *East Side News*, Nov. 25, 1954; "The Link" (Oscar Mayer Foods newsletter), October–November 1969, 4–5; Mollenhoff, *Madison*, 256–58; *Historic Madison, Forest Hill Cemetery*, 452.

202 — **Senator Robert M. La Follette Opposes the War:** Weisberger, *La Follettes of Wisconsin*, 179–231; P. La Follette, *Adventures in Politics*, 37–51; Evjue, *A Fighting Editor*, 338–39.

202 — **Lloyd Jones Verbatim:** Evjue, *A Fighting Editor*, 318.

202 — **Text of the Resolution Verbatim:** *CT*, Dec. 28, Feb. 16, 1918.

203 — **The War at Home, v. 2.0:** Curti and Carstensen, *University of Wisconsin*, 2:111–22; "Report of the Committee on the Student Life and Interests, Submitted by Scott H. Goodnight," *Biennial Report of the Board of Regents, 1918–1920*, at UW Archives, Memorial Library; "Report Upon the Collegiate Section of the SATC at the University of Wisconsin, Submitted by S. H. Goodnight, Jan. 7, 1919," at UW Archives, Memorial Library; Robert Van Valzah, "Report of Influenza Epidemic for the University Year, 1918–19," at UW Archives, Steenbock Library, Paul F. Clark research box; *Daily Cardinal*, Oct. 4, 10, 11, Dec. 9, 10, 1918; *CT*, Oct. 10, 11, Dec. 5, 1918; Dr. Harry E. Purcell, "Annual Report of the Health Department of the City of Madison for the Year Ending December 31, 1918," at Madison Public Health Department.

203 — **Student Soldiers in the Rain:** Curti and Carstensen, *University of Wisconsin*, 2:117–19; *Madison City Directory* (Madison: G. R. Angell & Co., 1918).

204 — **Brothers in Arms:** *CT*, Sep. 2, 3, 1918; *WSJ*, Sep. 2, 3, 1918; Evjue, *A Fighting Editor*, 304; Federal Writers' Project of Wisconsin, Field Notes, "Economic Development," 31, at WHSA; Mollenhoff, *Madison*, 388.

205 — **Draftees at the station:** *WSJ*, Sep. 23, 1918, Dec. 19, 1935; MCCP, Apr. 18, 1905; Mollenhoff, *Madison*, 263.

205 — **Pledge Putsch:** Mollenhoff, *Madison*, 390; *WSJ*, Apr. 2, 1919; *CT*, May 22, 2006.

206–207 — **The Birth of the Capital Times:** Weissman, "A History of the *Wisconsin State Journal* since 1910," 70–124; Evjue, *A Fighting Editor*, 162–85; Mollenhoff, *Madison*, 284–88.

207 — **King Street:** *WSJ*, Aug. 16, 1910.

208 — **The Madison Strike of 1919:** Spohn, "The Madison Strike of 1919"; *CT*, July 31, Aug. 1, 3, 1918, Jan. 2, Apr. 7, 8, 11, 23, 29, May 1, 3, 5, 6, 9, 17, Oct. 29, 1919; *WSJ*, July 31, 1918, Jan. 2, 3, Mar. 1, Apr. 13, 15, 21, 26, 29, May 3, 5, 6, 8, 9, 16, 20, Aug. 1, 2, 3, 1919; Federal Writers' Project of Wisconsin, Unpublished Field Notes, "Madison Labor," at WHSA.

THE 1920s

209 — **Nolen Verbatim:** *WSJ*, May 22, 1921.

214 — **Roads Not Taken:** MCCP, Aug. 25, 1921; Harland Bartholomew, "Madison, Wisconsin: Report on Major Streets, Transportation and Zoning" (Madison: 1922); Johnston, "Harland Bartholomew"; *CT*, May 24, Aug. 23 1921. Bartholomew's plan also would have betrayed Nolen and given the railroads pride of place along the Lake Monona frontage. Just eleven years after Nolen proposed the heavily landscaped Great Esplanade, Bartholomew recommended nine new tracks (making thirteen total), with a union depot eventually plopped right in the middle. At least Bartholomew kept alive the critical idea of extending the Lake Monona shoreline through landfill—even if he did cut Nolen's recommended width in half. In 1927, the state authorized the city to extend the shoreline out to 350 feet from the retaining wall—the first physical step towards construction of a lakeside convention center.

215 — **University Avenue Extension:** *CT*, Dec. 31, 1922, Jan. 23, 1926; *WSJ*, June 17, 1910, Jan. 26, Feb. 11, 1922, May 25, 1925; MCCP, Jan. 22, 1926. The voters' rejection was not necessarily seen as final; in March 1929, a Philadelphia company began acquiring options on much of the property between the Gorham/Bassett/University interchange and West Washington Avenue, planning to extend the street in a joint venture with the city. A special committee worked on the plan for two years before giving up in May 1931. "It is definitely impossible for the city to proceed with this project," the council agreed, because "the unreasonable and inflated values" which some owners claimed "rendered financing impossible and unsound."

215 — **Orton Park Boulevard:** *WSJ*, Mar. 4, 5, 6, 7, 8, 1924; *CT*, Mar. 4, 5, 6, 7, 8, 1924.

216 — **Trolley Troubles:** Mollenhoff, *Madison*, 294–96; *CT*, Apr. 6, 1920, Feb. 23, Oct. 3, 1927; *WSJ*, Dec. 10, 1927; MCCP, Mar. 26, Apr. 9, 1920, July 14, 1922, Apr. 13, 1928; Madison v. Railroad Commission, 199 Wis. 571 (1929).

217 — **Pennsylvania Oil Company:** Zane Williams rephotographed this view for *Double Take*, 179.

218 — **Frank Lloyd Wright's Country Club:** Hamilton, "The Nakoma Country Club"; Evjue, *A Fighting Editor*, 677; Groy, "Suburban Development in Madison"; *WSJ*, June 20, 23, 1923, Aug. 4, 1924, Sep. 29, 1929. The men who developed the Nakoma Country Club were losers in the fight to site the first west-side golf course, won by residents of College Hills and University Heights on June 15, 1921, with the selection of their rolling land on Mendota Heights and its rapid development as the Blackhawk Country Club. Nakoman William T. Evjue recalls his visit to Taliesin to discuss this project as his first meeting with Wright.

219 — **Frank Lloyd Wright's Frat House:** Mollenhoff and Hamilton, *Frank Lloyd Wright's Monona Terrace*, 75–77; Hamilton, "The Phi Gamma Delta Fraternity House"; "Phi Gams Have New $90,000 Home," *Wisconsin Alumnus*, Jan. 1929, 121; *CT*, Oct. 26, 1925, Mar. 3, 1926; *WSJ*, Nov. 9, 1928.

220 — **Campus Klan:** Messer-Kruse, "The Campus Klan of the University of Wisconsin"; *Daily Cardinal*, Mar. 2, 1922, Apr. 18, 1923.

221–223 — **Bad Times:** Goldberg, "The Ku Klux Klan in Madison"; Evjue, *A Fighting Editor*, 466–76; P. La Follette, *Adventures in Politics*, 100–110; Kasparek, "Fighting Son," 48–51.

222 — **Ole Stolen Biography:** Lemberger, *Crime of Magnitude*; *WSJ*, Apr. 1, 1927; *CT*, Jan. 27, 31, Mar. 5, Apr. 1, 8, 1927; *Isthmus*, Jan. 10, 1992.

224 — **A Community's Center:** *WSJ*, May 20, 21, Nov. 21, 1916, May 12, 1917, Dec. 31, 1918, Oct. 5, 8, 12, 1941, Nov. 20, 1966, Jan. 14, 1968; *CT*, Oct. 5, 6, 9, 10, 1941, Jan. 21, 1964, May 13, 19, 1966, April 26, 1969; *Milwaukee Journal*, Oct. 9, 1941; Dix, "Neighborhood House," 10; Custer, "Neighborhood House"; Kittle, "An Account of the Beginning Years of Neighborhood House"; Kittle, "Neighborhood House"; Mary Lee Griggs, "Neighborhood House-The Past: 1916–1949," speech at Neighborhood House Annual Dinner, May 26, 1960; Barnbrock, "Housing Conditions of the Italian Community"; Valentine, "A Study in Institutional Americanization."

224 — **Braxton Biography:** Neighborhood House Records, 1915–1980, at UW Archives, Memorial Library.

226 — **Mayor Kittleson Vetoes Johnson Street City Hall:** MCCP, Jan. 15, 1924, Feb. 7, 29, 1924; *WSJ*, Jan. 25, 30, 1924; *CT*, Jan. 25, 30, 1924.

226 — **Mayor Kittleson:** MCCP, Apr. 17, 1923; *WSJ*, Dec. 31, 1926, Apr. 3, 1958; *CT*, Apr. 3, 1958.

227 — **100 Block State Street:** State Street Historic District Nomination Papers for National Register of Historic Places, at City of Madison Department of Planning and Development.

227 — **Paunack and Levitan Biography:** Schumann, *No Peddlers Allowed*; *CT*, Feb. 27, 1940; Historic Madison, *Forest Hill Cemetery*, 183, 326.

228 — **Mayor Schmedeman:** MCCP, Apr. 13, 1928, Apr. 15, 1930; *WSJ*, Nov. 26, 1946; *CT*, Nov. 26,1946.

228 — **Schmedeman Verbatim:** MCCP, Apr. 19, 1927.

228 — **Schmedeman Verbatim:** MCCP, Apr. 19, 1927.

228 — **Schmedeman Verbatim:** MCCP, Apr. 2, 1928.

230 — **Factory Facts:** *WSJ*, Dec. 31, 1926; *Community Business*, Mar. 15, 1920, May 16, 1921; *CT*, Dec. 2, 1923.

231 — **Schenk's Corners:** Williams, *Double Take*, 216–17; MCCP, Dec. 30, 1927; Hermolin, *Schenk's-Atwood Neighborhood*, 24.

232–233 — **Three Theaters:** Kostecke and Rankin, "Madison's Historic Movie Palaces"; City of Madison Landmarks Commission Landmark Sites Nomination Form, at City of Madison Department of Planning and Development; State Street Historic District Nomination Papers for National Register of Historic Places, at City of Madison Department of Planning and Development; *CT* and *WSJ*, Mar. 12, 31, Apr. 1, 1927; Jan. 22, 1928; Dec. 26, 27, 28, 1929; *CT*, July 23, 1974.

236 — **East Side High School:** Ross, Martinson, Lake, and Shands, "The Early Years at East High School."

236 — **West Junior-Senior High School:** *CT,* Sep. 6, 9, Oct. 18, 1930; MCCP, May 8, 1925.

237 — **Memorial Union:** Feldman, *Buildings of the University of Wisconsin,* 202–10; *WSJ,* Jan. 21, 1920, May 21, 1922, Apr. 14, 21, 23, 28, 29, May 1, 20, 21, 26, 27, 1927, Oct. 5, 6, 1928; *CT,* Apr. 14, 21, 23, 28, 29, May 1, 20, 21, 26, 27, 1927, Oct. 5, 6, 1928; *Wisconsin Alumnus,* June 1927, 274, Feb. 1928, 162–63, Oct. 1928, 18, Nov. 1928, 43, 46; *Daily Cardinal,* Nov. 6, 1921, June 29, 1923.

238 — **Charles Lindbergh Returns:** *CT* and *WSJ,* Aug. 22, 23, Sep. 28, 29, Oct. 8, 14, 15, 1927; June 17, 1928; MCCP, Oct. 14, 1927; Vandenburgh, *Lindbergh's Badger Days,* 20–40.

238 — **Campus Congestion:** *Daily Cardinal,* Mar. 17, 1923; *WSJ,* Mar. 17, 1923, Apr. 9, 1928.

239 — **Two Hotels, Part 2:** Piper v. Ekern, 180 Wis. 586 (1923); Building Height Cases, 181 Wis. 519 (1923); *CT,* Feb. 19, May 25, Oct. 16, 1923, June 27, 28, Sep. 19, 1924; *WSJ,* May 25, Oct. 16, 1923, June 27, 28, Sep. 19, 1924.

240 — **Convention Center Crusade:** Mollenhoff and Hamilton, *Frank Lloyd Wright's Monona Terrace,* 27–31; *CT,* Dec. 31, 1922, May 6, Dec. 15, 1927, Jan. 14,1928; *WSJ,* Dec. 31, 1925, Dec. 17, 1927; MCCP, Jan. 13, 1928.

241 — **The U.S. Courthouse and Post Office:** Madison Association of Commerce, "Community Business," Oct. 15, 1921, 1; *WSJ,* Nov. 14, 1918; *CT,* Jan. 20, June 10, 11, 1927; Nomination Papers for National Register of Historic Places, at Historic Preservation Offices, WHS.

241 — **Common Council Verbatim:** MCCP, June 10, 1927.

242 — **La Follette Funeral Cortege:** *CT,* June 18 to 25, 1925; Evjue, *A Fighting Editor,* 417–33; Weisberger, *La Follettes of Wisconsin,* 273–75.

242 — **Warner Biography:** Warner and Warner Risser, *Ernest Noble Warner and His Family; CT,* July 9, 10, 1930; *WSJ,* July 9, 10, 1930.

243 — **Michael Olbrich:** *CT,* July 22, Sept. 30, 1921; *WSJ,* July 9, 16, 1922, Nov. 11, 1924; Frank, "Michael Balthasar Olbrich"; UW Archives Biographical File, Michael B. Olbrich; Cronon and Jenkins, *University of Wisconsin,* 43–45; Cybart and Minnich, *Olbrich Botanical Gardens.*

243 — **Frank Verbatim:** Frank, "Michael Balthasar Olbrich."

244 — **The Arboretum:** Sachse, *A Thousand Ages,* 11–44; Sachse, "Madison's Public Wilderness"; *WSJ,* Apr. 22, 1928, June 14, 15, 17, 1934, Feb. 26, 1969; *CT,* Dec. 17, 1927, June 14, 15, 17, 1934; *Dictionary of Wisconsin Biography,* 227–28; Nolen, *Madison,* 69–74.

245 — **No Negroes in Nakoma:** MCCP, July 24, 1931; *CT,* July 25, 1931; *WSJ,* July 25, 1931; Dane County Register of Deeds, vol. 96, page 205; Heggland, *Nakoma Neighborhood,* 9.

EPILOGUE

249 — **A Man and His Plan:** Joseph W. Jackson letter to Nolen, June 5, 1934, in the Nolen Papers, at WHSA; *CT,* June 14, 15, 17, 1934; *WSJ,* June 14, 15, 17, 1934.

250 — **Nolen Verbatim:** Nolen, *Madison,* 31.

250 — **Nolen Verbatim:** *CT,* June 14, 15, 1934; *WSJ,* June 14, 15, 1934.

BIBLIOGRAPHY

Aehl, James P. "The Oscar Mayer Story." *Journal of Historic Madison, Inc.* 3 (1977): 13–20.

Alexander, Edward P. "Wisconsin, New York's Daughter State." *Wisconsin Magazine of History* (1946): 11–13.

Allen, Mrs. W. F. "The University of Wisconsin Soon after the Civil War." *Wisconsin Magazine of History* 7 (1923): 18–29.

Alvord, John W. *Report on the Cause of Offensive Odors from Lake Monona, Madison, Wisconsin.* Chicago: Alvord & Burdick, 1920.

Attic Angel Association. *One Hundred Year History: 1889–1989.* Madison: Attic Angel Association, 1990.

Balousek, Marv. *Wisconsin Crimes of the Century.* Madison: William C. Robbins and Straus Printing Co., 1989.

Barnbrock, Henry Jr. "Housing Conditions of the Italian Community in Madison, Wisconsin." Thesis, University of Wisconsin, 1916.

Barton, Albert O. "John Whelan Sterling." *Wisconsin Alumnus* (April 1940): 219–27.

Bascom, Florence. "The University in 1874–1887." *Wisconsin Magazine of History* 8 (1918): 300–308.

Bauhs, Fr. E. J. "The Renovation of Saint Raphael Cathedral." *Wisconsin Magazine of History* 39 (Spring 1956): 171–77.

Berman, Nathan. "The German-Jewish Congregation at Madison, Wisconsin: 1850–1930." B.A. thesis, University of Wisconsin, 1931.

Biographical Review of Dane County, Wisconsin: Containing Biographical Sketches of Pioneers and Leading Citizens. 1893. Reprint, La Crosse, WI: Northern Micrographics, 1997.

Birge, Edward A. "Edward A. Birge." *Wisconsin Alumnus* (November 1942): 9–18.

Birmingham, Robert A. "Charles E. Brown and the Indian Mounds of Madison." *Historic Madison: A Journal of the Four Lake Region* 13 (1996): 17–29.

Birmingham, Robert A., and Katherine Rankin. *Native American Mounds in Madison and Dane County.* Madison: City of Madison, 1994.

Brady, Frank. *Citizen Welles: A Biography of Orson Welles.* New York: Charles Scribner's Sons, 1989.

Brock, Thomas D. "The Old Governor's Executive Residence." *Historic Madison: A Journal of the Four Lake Region* 14 (1997): 22–32.

Brown, Charles E. "The Springs of Lake Wingra." *Wisconsin Magazine of History* 10 (1927): 298–310.

Buenker, John D. *The Progressive Era, 1893–1914.* Vol. 4 of *The History of Wisconsin.* Madison: State Historical Society of Wisconsin, 1998.

Butler, James D. "Tay-cho-pe-rah — The Four Lake Country — First White Foot-Prints There." *Report and Collections of the State Historical Society of Wisconsin* 10 (1885): 64–89.

Butterfield, Consul, ed. *History of Dane County, Wisconsin.* Chicago: Chicago Western Historical Company, 1880.

Cady, Kendall. "The Business Development of State Street." Master's thesis, University of Wisconsin, 1929.

Cartwright, Carol Lohry. *The Langdon Street Historic District: A Walking Tour.* Madison: City of Madison, 1986.

Cassidy, Frederick G. *Place-Names of Dane County, Wisconsin.* Madison: University of Wisconsin Press, 1968.

———. "The Naming of the Four Lakes." *Wisconsin Magazine of History* 29 (1945–46): 7–24.

Chapman, C. B. "Early Events in the Four Lake Country." *Report and Collections of the State Historical Society of Wisconsin* 4 (1859): 343–49.

Charter and Ordinances of the Village of Madison. Madison: Carpenter & Tenney, 1851.

Childs, Ebeneezer. "Childs's Recollections." *Report and Collections of the State Historical Society of Wisconsin* 4 (1859): 153–95.

Comprehensive Historic Structure Report. 6 vols. Madison: State of Wisconsin, Department of Administration, Division of Facilities Development, 2005.

Cooke, Chauncey H. "Badger Boys in Blue: Life at Old Camp Randall." *Wisconsin Magazine of History* 4 (1920–21): 75–77.

Cook, Diana. *Wisconsin Capitol: Fascinating Facts.* Madison: Prairie Oak Press, 1991.

Cornwell, Karen J. "Comparison of Pedestrian- and Automobile-Oriented Suburbs in Madison, Wisconsin." Master's thesis, State University of New York, Syracuse, 1994.

Cravens, Stanley H. "Capitals and Capitols in Early Wisconsin." In *Blue Book, 1983–84.* Madison: Department of Administration, 1983.

Cronon, E. David, and Jenkins, John W. *The University of Wisconsin: A History, 1925–1945.* Vol. 3, *Politics, Depression, and War.* Madison: University of Wisconsin Press, 1994.

Current, Richard N. *The Civil War Era, 1848–1873.* Vol. 2 of *The History of Wisconsin.* Madison: State Historical Society of Wisconsin, 1976.

———. *Wisconsin: A History.* New York: W. W. Norton & Company, 1977.

Curti, Merle, and Vernon Carstenson. *The University of Wisconsin: A History, 1848–1925.* 2 vols. Madison: University of Wisconsin Press, 1949.

Custer, Frank. "Capitol Square North." *Madison Magazine,* July 1986.

———. "East Main Street." *Madison Magazine,* December 1986.

———. "Madison: 1856." *Madison Magazine,* October 1983.

———. "Madison's First Black Entrepreneur." *Madison Magazine,* February 1985, 38–43.

———. "Old Fashioned Politics." *Madison Magazine,* May 1986, 85–89.

———. "The Original City Hall." *Madison Magazine,* April 1986, 84–87.

———. "The Orphans' Christmas." *Madison Magazine,* December 1987, 19–26.

———. "The Park Hotel." *Madison Magazine,* April 1985, 49–55.

———. "Politics in the 1850s." *Madison Magazine,* January 1987, 75–78.

———. "State Street: The Colorful Beginnings." *Madison Magazine,* August 1983.

———. "You've Come a Long Way, 'dinkie,'" *Madison Magazine,* December 1984.

Cybart, Sharon, and Jerry Minnich, eds. *Olbrich Botanical Gardens: Growing More Beautiful.* Black Earth, WI: Trails Media Group, 2002.

Dane County Biographical Review. Chicago: Biographical Review Publishing Company, 1893.

Dean, Jeffrey, and Frank Custer. *Sandstone and Buffalo Robes: A Walking-tour Guide to Madison's Historic Downtown Buildings.* Madison: Madison City Planning Department, 1969.

Dedrick, Calvert L. "Incomes and Occupations in Madison, Wisconsin." Ph.D. thesis, University of Wisconsin, 1933.

Derleth, August. "John H. Twombly." *Wisconsin Alumnus* (November 1940): 23–28.

Dictionary of Wisconsin Biography. Madison: State Historical Society of Wisconsin, 1960.

Draper, Lyman C. *Madison, the Capital of Wisconsin, Its Growth, Progress, Conditions, Wants and Capabilities.* Madison: Conklin and Proudfit, 1857.

———. "Michael St. Cyr, an Early Dane County Pioneer." *Report and Collections of the State Historical Society of Wisconsin* 6 (1872): 397–400.

———. "Naming of Madison and Dane County and the Location of the Capitol." *Report and Collections of the State Historical Society of Wisconsin* 6 (1872): 388–96.

Durrie, Daniel S. *A History of Madison, the Capital of Wisconsin; Including the Four Lake Country to July, 1874*. Madison: Atwood and Culver, 1874.

East Side High School. *Tower Tales*. Madison, 1929–31.

Ehler, George. "A New Camp Randall." *Wisconsin Alumnus* (December 1914): 194–95.

Ela, Janet. *Free and Public: One Hundred Years with the Madison Public Library*. Madison: Friends of the Madison Public Library, 1975.

Ely, Richard T. "Charles Kendall Adams." *Wisconsin Alumnus* (July 1941): 303–12.

Erdman, Daniel. "A City Neighborhood Surrounds the James Bowen House." *Journal of Historic Madison, Inc.* 7 (1981–82): 39–48.

Evjue, William T. *A Fighting Editor*. Madison: Wells Printing Company, 1968.

Feldman, James. *The Buildings of the University of Wisconsin*. Madison: University of Wisconsin Archives, 1997.

Flannery, James J. "The Madison Lakes Problem." Master's thesis, University of Wisconsin, 1949.

Frank, Glenn. "Michael Balthasar Olbrich." *Wisconsin Alumnus* 31 (November 1929): 56.

Gajewski, Mark. "Kehl: First Family of Dance." *Historic Madison: A Journal of the Four Lake Region* 20 (2005): 30–45.

———. "Madison Becomes a City." *Historic Madison: A Journal of the Four Lake Region* 20 (2005): 2–15.

Gilmore, Frank A. *The City of Madison, The Capital of Wisconsin*. Madison: Blied Printing Co., 1916.

Glad, Paul W. *War, a New Era, and Depression, 1914–1940*. Vol. 5 of *The History of Wisconsin*. Madison: State Historical Society of Wisconsin, 1990.

Glazer, Walter S. "Wisconsin Goes to War: April, 1861." *Wisconsin Magazine of History* 50 (Winter 1967): 147–64.

Goldberg, Robert A. "The Ku Klux Klan in Madison, 1922–1927." *Wisconsin Magazine of History* (Autumn 1974): 31–44.

Goldsmith, Leslie H. "German-Jewish and Russian-Jewish Immigration: Assimilation and Ghetto in Madison." *Journal of Historic Madison, Inc.* 3 (1977): 28–44.

Goroff, Carol Goodwin, Iza Goroff, and Catherine Tripalin Murray. "The Spirit of Greenbush: The Greenbush Memorial Public Dedication Ceremony." Verona: Park Printing House, Ltd., 2000.

Groy, Jeffrey. "Suburban Development in Madison, 1900–1930." *Journal of Historic Madison, Inc.* 7 (1981–82): 15–23.

Gruber, John. "Illinois Central Railroad Reaches North to Madison." *Journal of Historic Madison, Inc.* 7 (1981–82): 49–59.

———. *Madison's Pioneer Buildings: A Downtown Walking Tour*. Madison: Madison Landmarks Commission and Historic Madison, Inc., 1987.

———. "A Railroad Changes in the Twentieth Century." *Journal of Historic Madison, Inc.* 4 (1978): 27–40.

Haight, George. "John Bascom." *Wisconsin Alumnus* (February 1941): 121–33.

Hamilton, Mary Jane. "The Madison Hotel." In *Frank Lloyd Wright and Madison: Eight Decades of Artistic and Social Interaction*, ed. Paul Sprague, 57–63. Madison: Elvehjem Museum of Art, University of Wisconsin, 1990.

———. "The Nakoma Country Club." In *Frank Lloyd Wright and Madison: Eight Decades of Artistic and Social Interaction*, ed. Paul Sprague, 77–82. Madison: Elvehjem Museum of Art, University of Wisconsin, 1990.

———. "The Phi Gamma Delta Fraternity House." In *Frank Lloyd Wright and Madison: Eight Decades of Artistic and Social Interaction*, ed. Paul Sprague, 69–76. Madison: Elvehjem Museum of Art, University of Wisconsin, 1990.

Hanson, Gene. "A Case Study of Newspaper Muckraking: The *Wisconsin State Journal*'s Crusade for Better and Lower Gas Rates." Master's thesis, University of Wisconsin, 1966.

Hanson, Mary Goggins. "Madison during the Civil War." Thesis, University of Wisconsin, 1932.

Hantke, Richard W. "Elisha W. Keyes and the Radical Republicans." *Wisconsin Magazine of History* (Spring 1952): 203–9.

———. "Elisha W. Keyes, the Bismarck of Western Politics." *Wisconsin Magazine of History* (September 1947): 29–41.

Harrasch, Patricia G. "This Noble Monument: The Story of the Soldiers' Orphans' Home." *Wisconsin Magazine of History* (Winter 1992–93): 83–120.

Harvey, Cordelia. "A Wisconsin Woman's Picture of President Lincoln." *Wisconsin Magazine of History* 1 (March 1918): 233–55.

Heggland, Timothy F. *The Greenbush-Vilas Neighborhood: A Walking Tour*. Madison: Madison Landmarks Commission and the Brittingham-Vilas Neighborhood Association, 1991.

———. *The Nakoma Neighborhood: A Walking Tour*. Madison: Madison Landmarks Commission and the Nakoma Neighborhood, 2002.

———. *The Tenney-Lapham Neighborhood: A Walking Tour*. Madison: Madison Landmarks Commission and the Tenney-Lapham Neighborhood Association, 1997.

———. *The Third Lake Ridge Historic District: A Walking Tour*. Madison: Madison Landmarks Commission and the Madison Trust for Historic Preservation, 1987.

———. *The University Heights Historic District: A Walking Tour*. Madison: Madison Landmarks Commission and the Regent Neighborhood Association, 1987.

Heggland, Timothy F., and Hilary Anne Frost-Kumpf. *The Old Market Place Neighborhood: A Walking Tour*. Madison: Madison Landmarks Commission and the Old Market Place Neighborhood Association, 1991.

Helfrecht, Donald J. "A Saga of 147 Years from Madison Gas Light and Coke Company to Madison Gas and Electric Company, 1855–2002." Madison, 2002.

Hermolin, Joseph. *Schenk's-Atwood Neighborhood: A Walking Tour*. Madison: Madison Landmarks Commission, 1987.

Hines, Thomas S. Jr. "Frank Lloyd Wright — The Madison Years: Records versus Recollections." *Wisconsin Magazine of History* 50 (Winter 1967): 109–19.

Historic Madison, Inc. *Bishops to Bootleggers: A Biographical Guide to Resurrection Cemetery, Madison, Wisconsin*. Madison: Historic Madison, Inc., 1999.

———. *Forest Hill Cemetery: A Biographical Guide to the Ordinary and Famous Women and Men Who Shaped Madison and the World*. Revised and expanded. 2 vols. Madison: Historic Madison, Inc., 2002.

———. *Greetings from Madison, Wisconsin: Historic Madison's Calendar*. Madison: Historic Madison, Inc., 2006.

Comprehensive Historic Structure Report. 6 vols. Madison: State of Wisconsin, Department of Administration, Division of Facilities Development, 2005.

History of Dane County: Biographical and Genealogical. Madison: Western Historical Association, 1906.

Holter, Darryl. *Workers and Unions in Wisconsin: A Labor History Anthology*. Madison: State Historical Society of Wisconsin, 1999.

Holzhueter, John O. "The Capital Fence of 1872: A Footnote to Wisconsin Architectural History." *Wisconsin Magazine of History* 53 (Summer 1970): 243–55.

———. "The Lakes Mendota and Monona Boathouses." In *Frank Lloyd Wright and Madison: Eight Decades of Artistic and Social Interaction*, ed. Paul Sprague, 29–35. Madison: Elvehjem Museum of Art, 1990.

———, ed. *Madison During the Civil War Era: A Portfolio of Rare Photographs by John S. Fuller, 1860–1863*. Madison: State Historical Society of Wisconsin, 1997.

———. "The Yahara River Boathouse." In *Frank Lloyd Wright and Madison: Eight Decades of Artistic and Social Interaction*, ed. Paul Sprague, 37–44. Madison: Elvehjem Museum of Art.

Howard, William Willard. "The City of Madison." *Harper's Weekly*, March 20, 1889.

Ingraham, Mark H. *Charles Sumner Slichter: The Golden Vector*. Madison: University of Wisconsin Press, 1972.

Jackson, Alfred Augustus. "Abraham Lincoln in the Black Hawk War." *Collections of the State Historical Society of Wisconsin* 14 (1898): 118–36.

Jenkins, John W. *A History of the Rotary Club of Madison*. Madison: Rotary Club of Madison, 1990.

Jensen, Alfred H. "A Study of the Succession of Uses of Property on the Capitol Square." Master's thesis, University of Wisconsin, 1923.

Johnston, Norman J. "Harland Bartholomew: Precedent for the Profession." *AIP Journal* (Mar. 1973): 115–24.

Jones, Burr W. *Reminiscences of Nine Decades*. Madison: State Historical Society of Wisconsin, 1936.

———. "William Freeman Vilas." *Proceedings of the State Historical Society of Wisconsin* (1908): 155–64.

Jones, C. E. *Madison: Its Origin, Institutions and Attractions, Persons, Places and Events*

Geographically Delineated; A Reliable Guide for the Tourist. Madison: W. J. Park and Company, 1876.

———. *Madison, Dane County and Surrounding Towns.* Madison: W. J. Park and Company, 1877.

Kasparek, Jonathan. "Fighting Son: A Biography of Phillip F. La Follette." *Wisconsin Magazine of History* (Summer 2006): 48–51.

Kehler, Elizabeth Bryan. "Control of Public Outlay in Madison, Wisconsin, as a Measure of Employment Stabilization." Thesis, University of Wisconsin, 1931.

Keyes, Elisha W., ed. *History of Dane County.* Madison: Western Historical Association, 1906.

Kittle, Mrs. William. "An Account of the Beginning Years of Neighborhood House 1916 to 1926." In *Neighborhood House Twenty-Fifth Anniversary,* pamphlet at WHSA.

———. "Neighborhood House: An Answer to a City Need." Privately published report for Neighborhood House, Fall 1947.

Knapp, J. Gillett. "Early Reminiscences of Madison." *Report and Collections of the State Historical Society of Wisconsin* 6 (1872): 366–87.

Kostecke, Diane, and Katherine Rankin. "Madison's Historic Movie Palaces." *Journal of Historic Madison, Inc.* 7 (1981–82): 25–37

La Follette, Isabel Bacon. "Early History of the Wisconsin Executive Residence." *Wisconsin Magazine of History* 21 (December 1937): 139–50.

La Follette, Robert M. *La Follette's Autobiography: A Personal Narrative of Political Experiences.* Madison: University of Wisconsin Press, 1960.

La Follette, Phil. *Adventures in Politics: The Memoirs of Phillip La Follette,* ed. Donald Young. New York: Holt, Reinhart and Winston, 1970.

Larson, Agnes M. *John A. Johnson: An Uncommon American.* Northfield, MN: Norwegian-American Historical Association, 1969.

Laugesen, Peter N. "The Immigrants of Madison, Wisconsin: 1860–1880." Master's thesis, University of Wisconsin, 1966.

Leith, C. K., and M. M. Vance. "Charles Richard Van Hise." *Wisconsin Alumnus* (November 1941): 13–30.

Lemberger, Mark. *Crime of Magnitude: The Murder of Little Annie.* Madison: Prairie Oak Press, 1993.

Lemon, Thomas H. "An Industrial Inheritance: The United States Sugar Company 1906–1924." *Journal of Historic Madison* 6 (1980–81): 13–19.

Leuchter, Sara, and Carole Zellie. *The Third Lake Ridge Historic District: A Walking Tour.* Madison: Madison Landmarks Commission and Madison Trust for Historic Preservation, 1987.

Levitan, Stuart. "The Way We Were: Madison 1900." *Madison Magazine,* April, July, September, December, 2000.

Lokken, Roy N. "William F. Vilas as a Businessman." *Wisconsin Magazine of History* 45 (Autumn 1961): 32–39.

Loew, Patty. *Indian Nations of Wisconsin: Histories of Endurance and Renewal.* Madison: Wisconsin Historical Society Press, 2001.

Long, Barbara Jo. "John Nolen: The Wisconsin Activities of an American Landscape Architect and Pioneer, 1908 to 1937." Master's thesis, University of Wisconsin, 1978.

Madison: The Capital of Wisconsin, Its Progress, Capabilities and Destiny. Madison: Rublee & Gary, 1855.

Madison, Past and Present. Wisconsin State Journal Semi-Centennial, 1852–1902. Madison: Wisconsin State Journal, 1902.

Madison, Dane County and Surrounding Towns; Being a History and Guide to Place of Scenic Beauty and Historical Note Found in the Towns of Dane County and Surroundings, Including the Organization of the Towns, and Early Intercourse of the Settlers with the Indians, Their Camps, Trails, Mounds, etc. Madison: Wm. J. Park & Co., 1877.

Madison, Wisconsin and Its Points of Interest. Madison: Commercial Pub. Co., 1899.

Madison Board of Commerce. *Madison, Wisconsin: The Four Lake City.* Madison: Cantwell Printing Company, 1914.

———. *Madison: The Four Lake City Recreational Survey.* Madison: Tracy & Kilgore, 1915.

Marshall, James G. "The Madison Park System, 1892–1937." *Journal of Historic Madison, Inc.* 5 (1979–80): 3–17.

Mattern, Carolyn J. "Crestwood: A Pioneer Cooperative Housing Project." *Historic Madison: A Journal of the Four Lake Region* 14 (1997): 14–21.

———. "The Madison Park and Pleasure Drive Association and the Problem of Progressive Landscape Design in University Heights." *Historic Madison: A Journal of the Four Lake Region* 12 (1995): 18–23.

———. *Soldiers When They Go: The Story of Camp Randall, 1861–1865.* Madison: State Historical Society of Wisconsin, for Department of History, University of Wisconsin 1981.

McCarthy, Charles. *The Wisconsin Idea.* New York: MacMillan Company, 1912.

Merk, Frederick. *The Economic History of Wisconsin during the Civil War Decade.* Madison: State Historical Society of Wisconsin, 1916.

———. "The Labor Movement in Wisconsin during the Civil War." *Proceedings of the State Historical Socity of Wisconsin* (1914): 168–91.

Merrill, Horace Samuel. *William Freeman Vilas: Doctrinaire Democrat.* Madison: State Historical Society of Wisconsin, 1991.

Messer-Kruse, Timothy. "The Campus Klan of the University of Wisconsin: Tacit and Active Support for the Ku Klux Klan in a Culture of Intolerance." *Wisconsin Magazine of History* (Autumn 1993): 3–38.

Miner, Harold E. *History of Madison Labor.* U.S. Works Progress Administration, Federal Writer's Project.

Mollenhoff, David. *Madison: A History of the Formative Years,* 2nd ed. Madison: University of Wisconsin Press, 2003.

Mollenhoff, David, and Mary Jane Hamilton. *Frank Lloyd Wright's Monona Terrace: The Enduring Power of a Civic Vision.* Madison: University of Wisconsin Press, 1999.

Mollenhoff, Leigh, James R. Sanborn, Lois Stoler. *Sandstone and Buffalo Robes: A Walking-tour guide to Madison's Historic Downtown Buildings and Sites.* 2nd ed. Madison: City of Madison Planning Department for the City of Madison Landmarks Commission, 1973.

Nafziger, Ralph Otto. "A Journalism Survey of the City of Madison, Wisconsin." Master's thesis, University of Wisconsin, 1930.

Nekar, Lance. "Progressives, Suburbs and the Prairie Spirit: Suburban Development in Madison, Wisconsin, 1890–1920." Master's thesis, University of Wisconsin, 1981.

Nesbit, Roger C. *Wisconsin: A History.* Madison: University of Wisconsin Press, 1973.

Nixon, Geri. "Madison's Outdoor Markets." *Journal of Historic Madison, Inc.* 11 (1993): 31–36.

Nolen, John. "City Making in Wisconsin." *The Municipality* (May 1910).

———. *Madison: A Model City.* Boston: n.p., 1911.

Pabian, Dorothy. "Woman's Club of Madison." *Historic Madison: A Journal of the Four Lake Region* 13 (1996): 37–42.

Parkinson, Peter, Jr. "Notes on the Black Hawk War." *Report and Collections of the State Historical Society of Wisconsin* 10 (1888): 184–212.

The Pathfinder: A Guidebook for Madison, Wisconsin, and Vicinity. Madison: Madison Board of Commerce, 1914.

Paul, Barbara, and Justus Paul, eds. *The Badger State: A Documentary History of Wisconsin.* Grand Rapids: Eerdmans Publishing Co., 1979.

Paynter, Mary O. P. *Phoenix from the Fire: A History of Edgewood College.* Madison: Edgewood College, 2002.

Peck, Rosaline. "Reminiscences of the First House and the First Resident Family of Madison." *Report and Collections of the State Historical Society of Wisconsin* 6 (1872): 343–65.

Phillips, Louise. "The Woman's Club of Madison." *The American Club Woman* 2.1 (1899): 1–2.

Pickford, Merle S. "The Beginning of Madison, Wisconsin." Master's thesis, University of Wisconsin, 1902.

Punwar, Alice, ed. *Forests, Farms and Families: A History of the Midvale Heights Neighborhood.* Madison: Midvale Heights Community Association, 2004.

Rankin, Katherine H., and Timothy Heggland. *Madison Intensive Survey: Historic Themes.* Madison: City of Madison and State Historical Society of Wisconsin, 1994.

Rankin, Katherine H., and Elizabeth Miller. *The Historic Resources of Downtown Madison.* Madison: Downtown Historic Preservation Task Force, 1997.

Rawson, Michael J. "A Landscape of Ideas: The Early Evolution of the University of

Wisconsin–Madison Campus, 1849–1908." *Historic Madison: A Journal of the Four Lake Region* 16 (1999): 3–9.

Reaves, Sheila. *Wisconsin: Pathways to Prosperity.* Northridge: Windsor Publications, 1988.

Reisner, Edward J. "First Woman Graduate: Belle Case La Follette or Elsie Buck." *Gargoyle: University of Wisconsin Law School Forum* (Winter 1991–92).

Rolling, Cynthia. "The Madison Turners and the German Immigrant Community in the Nineteenth Century." *Journal of Historic Madison, Inc.* 9 (1985–86): 19–30.

Ross, Pete, David Martinson, Jim Lake, and George Shands. "The Early Years at East High School." *Historic Madison: A Journal of the Four Lake Region* 14 (1997): 33–41.

Ruble, Kenneth D. *The Rayovac Story: The First Seventy-five Years.* Madison: North Central Publishing Company, 1981.

Ruff, Allen, and Tracy Will. *Forward! A History of Dane: The Capital County.* Cambridge, WI: Woodhenge Productions / Dane County Historical Society, 2000.

Russell, Harry L. "Thomas C. Chamberlin." *Wisconsin Alumnus* (April 1941): 215–27.

Sachse, Nancy D. "Madison's Public Wilderness: The University of Wisconsin Arboretum." *Wisconsin Magazine of History* (Winter 1960–61): 117–31.

———. *A Thousand Ages: The University Arboretum.* Madison: Regents of the University of Wisconsin, 1965.

Sandrock, Laura Mae. "Frontier Aspects of Early Madison." Master's thesis, University of Wisconsin, 1919.

Schafer, Joseph. "John Hiram Lathrop." *Wisconsin Alumnus* (November 1939): 11–24.

Schelshorn, Christine, ed. *Back to Beginnings: The Early Days of Dane County.* Madison: Dane County Cultural Affairs Commission, 1998.

Schumann, Alfred R. *No Peddlers Allowed.* Appleton: Nelson Publishing Co., 1948.

Secord, Jane Kresge. "The Women's Club Movement in Madison and Public Health Concerns." *Journal of Historic Madison* 7 (1990): 28–47.

Sennett, Margaret Devlin. "History of Madison: 1850–1875." Senior thesis, University of Wisconsin, 1918.

Seymour, William North. *Madison Directory and Business Advertiser.* Madison: Atwood & Rublee, 1855.

Slichter, Charles S. "Paul Ansel Chadbourne." *Wisconsin Alumnus* (July 1940): 317–32.

Smith, Alice E. *From Exploration to Statehood.* Vol. 1 of *The History of Wisconsin.* Madison: State Historical Society of Wisconsin, 1973.

———. *James Duane Doty: Frontier Promoter.* Madison: State Historical Society of Wisconsin, 1954.

Smith, John Y. "History of Madison." *Madison City Directory.* Madison: B. W. Suckow, 1866.

Spohn, George D. "The Madison Strike of 1919." Bachelor's thesis, University of Wisconsin, 1920.

Stampen, Jacob O. "Madison, a School for Immigrants: The Nineteenth-Century Norwegians." *Journal of Historic Madison, Inc.* 8 (1982–84): 3–13.

———. "The Norwegian Element in Madison, 1850–1900." Master's thesis, University of Wisconsin, 1965.

Stark, Jack. "The Wisconsin Idea: The University's Service to the State." In *Blue Book, 1995–96,* 99–179. Madison: Department of Administration, 1996.

Statistics of Dane County, Wisconsin: With a Business Directory in Part, of the Village of Madison. Madison: Carpenter and Tenney, 1851.

Steensland, Halberta. "Halle Steensland, 1832–1910." *Journal of Historic Madison, Inc.* 6 (1980–81): 3–12.

Strand, Norman. *Story of the Democrat: A History of the* Madison Democrat, *a Newspaper Published 1868–1921.* Madison: Webcrafters, 1973.

Swarsensky, Manfred. *From Generation to Generation: The Story of the Madison Jewish Community, 1851–1944.* Madison: n.p., 1955.

Taylor, Fannie. *The Wisconsin Union Theatre: Fifty Golden Years,* ed. Mollie Buckley. Madison: Memorial Union Building Association, 1989.

Thelen, David P. "The Boss and the Upstart: Keyes and La Follette." *Wisconsin Magazine of History* (Winter 1963–64): 103–15.

———. "La Follette and the Temperance Crusade." *Wisconsin Magazine of History* (Summer 1964): 291–300.

———. "Robert M. La Follette, Public Prosecutor." *Wisconsin Magazine of History* (Spring 1964): 214–23.

Thwaites, Reuben G. *Historical Sketch of the Public Schools of Madison, Wisconsin, 1838–1885.* Madison: Cantwell Printers, 1886.

———. "Madison: The City of the Four Lakes." In *Historic Towns of the Western States,* ed. Lyman P. Powell. New York: G. P. Putnam & Sons, 1901.

———. *The Story of Madison, 1836–1900.* 1900. Reprint, Madison: R. H. Hunt, 1973.

———. *The University of Wisconsin: Its History and Its Alumni, with Historical and Descriptive Sketches of Madison.* Madison: J. N. Purcell, 1900.

Tipler, Gary. *The First Settlement Neighborhood: A Walking Tour.* Madison: Madison Landmarks Commission and Capitol Neighborhoods, 1988.

———. "Mansion Hill: Glimpses of Madison's Silk Stocking District." Madison: n.p., 1981.

———. *Williamson Street, Madison, Wisconsin: An Historical Survey and Walking Tour Guide.* 2nd ed. Madison: Madison Landmarks Commission, 1979.

Tuttle, Charles R. *An Illustrated History of the State of Wisconsin, Being a Complete Civil, Political, and Military History of the State from Its First Exploration Down to 1875.* Boston: B. B. Russell & Co., 1875.

Valentine, John. "A Study of Institutional Americanization: The Assimilative History of the Italian-American Community of Madison." Master's thesis, University of Wisconsin, 1967.

Vandenburgh, Anne. *Lindbergh's Badger Days: Life as a Student at the University of Wisconsin–Madison, 1920–1922.* Madison: Goblin Fern Press, 2003.

Vukelich, George. *North Country Notebook.* Madison: North Country Press, 1987.

Wagner, R. Richard. "The Municipal Buildings of the City of Madison, Wisconsin: An Inventory to 1900." *Journal of Historic Madison, Inc.* 2 (1976): 19–28.

Wand, Philip. "Henry Mall: Development of the 'Lesser Mall' as Proposed in the 1908 Campus Plan." *Historic Madison: A Journal of the Four Lake Region* 16 (1999): 10–20.

Warner, Fanny, and Elizabeth Warner Risser. *Ernest Noble Warner and His Family.* Madison, 1950.

Weisberger, Bernard A. *The La Follettes of Wisconsin: Love and Politics in Progressive America.* Madison: University of Wisconsin Press, 1994.

Weisensel, Peter Roy. "The Wisconsin Temperance Crusade to 1919." Master's thesis, University of Wisconsin, 1965.

Weissman, Norman. "A History of the *Wisconsin State Journal* since 1900." Master's thesis, University of Wisconsin, 1951.

Wilkinson, Harry. *Pictorial Souvenir of the Police and Fire Departments of Madison, Wisconsin.* Des Moines: American Lithographing & Printing Co., 1912.

Williams, Nancy Greenwood. *First Ladies of Wisconsin: The Governors' Wives.* Kalamazoo: -ana Publishing, 1991.

Williams, Zane. *Double Take: A Rephotographic Survey of Madison, Wisconsin.* Madison: University of Wisconsin Press, 2002.

Wright, Frank Lloyd. *An Autobiography.* New York: Duell, Sloan and Pearce, 1943.

Young, Kimball, John Lewis Gillin, and Calvert L. Dedrick. *The Madison Community.* University of Wisconsin Studies in Social Sciences and History 21. Madison, 1934.

Youmans, Theodora W. "How Wisconsin Women Won the Ballot." *Wisconsin Magazine of History* 5 (1921–22): 3–32.

Youngerman, Henry C. "Theatre Buildings in Madison, Wisconsin, 1836–1900." *Wisconsin Magazine of History* 30 (March 1947): 273–88.

Zmudzinski, Florence. "Leaving Greenbush." *Historic Madison: A Journal of the Four Lake Region* 20 (2005): 46–63.